VENICE ILLUMINATED

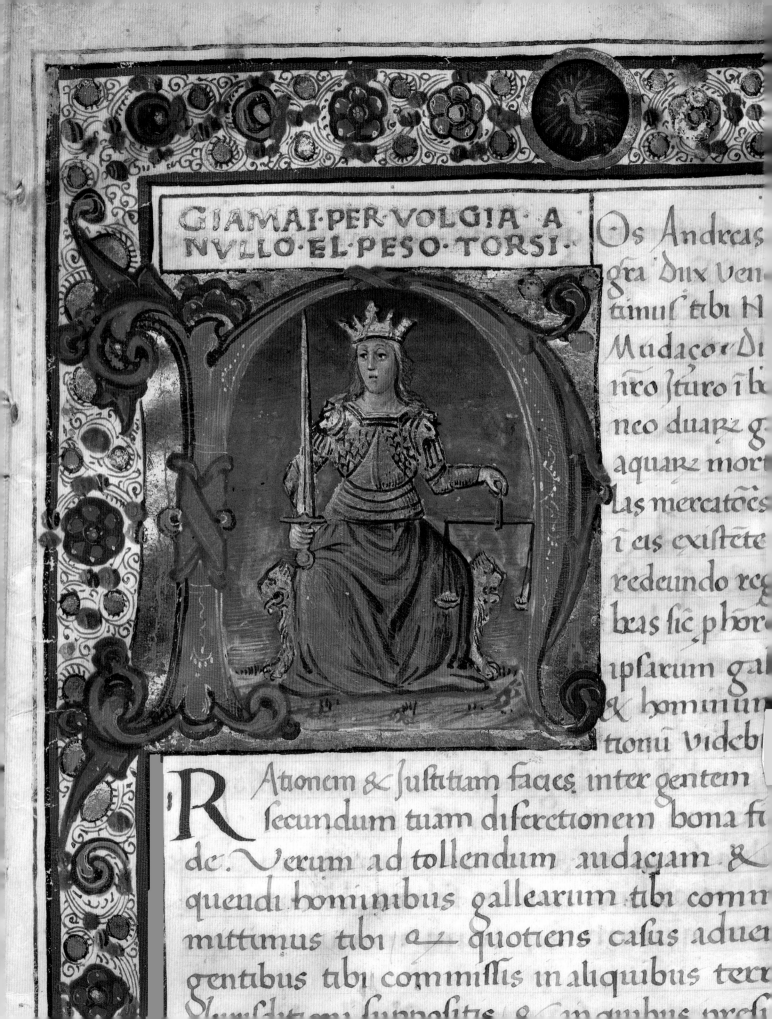

GIAMAI·PER·VOLGIA·A
NVLLO·EL·PESO·TORSI·

·Os Andreas
gra Dux Ven
timus tibi H
Mudaçor Di
nro sturo i b
neo duarz g
aquarz mort
las mercatões
i eis existete
redeundo reg
bras sic p hor
ipsarum gal
& hominum
tionu videb

R Ationem & Justitiam facies inter gentem
secundum tuam diseretionem bona fi
de. Verum ad tollendum audaciam &
quendi hominibus gallearum tibi comn
mittimus tibi e quotiens casus adue
gentibus tibi commissis in aliquibus terr

VENICE ILLUMINATED

Power and Painting in Renaissance Manuscripts

Helena Katalin Szépe

YALE UNIVERSITY PRESS
New Haven and London

In memory of my mother, Helena Karin Szépe

First published by Yale University Press 2018
302 Temple Street, P.O. Box 209040,
New Haven CT 06520-9040
47 Bedford Square, London WC1B 3DP
yalebooks.com / yalebooks.co.uk

ISBN 978-0-300-226744 HB
Library of Congress Control Number: 2017954569

10 9 8 7 6 5 4 3 2 1
2022 2021 2020 2019 2018

Design: Isobel Gillan
Copy-editing: Christine Considine

Printed in China

Illustrations
Front cover and page 194: detail of fig. 6.25
Back cover: detail of fig. 6.37
Page 2: detail of fig. 5.8
Page 5: detail of fig. 6.2
Page 6: detail of fig. 5.38
Page 37: detail of fig. 1.14
Page 74: detail of fig. 4.29

The chart on page 24 (fig. 0.11) draws on
Elizabeth G. Gleason's in *Gasparo Contarini: Venice,
Rome, and Reform.* © 1994 by the Regents of the
University of California. Published by the University
of California Press.

Author's note
I have covered aspects of this topic in earlier articles.
I wish to thank the Museo Correr for permission
to republish here a few brief passages of my essay
"Painters and Patrons in Venetian Documents"
in Piero Lucchi, ed. 'Collezioni,' section in *Le
Commissioni ducali nelle collezioni dei Musei Civici
Veneziani*, special edition of *Bollettino dei Musei Civici
Veneziani*, Camillo Tonini and Cristina Crisafulli, eds,
3rd series, 8 (2013), 25–61.

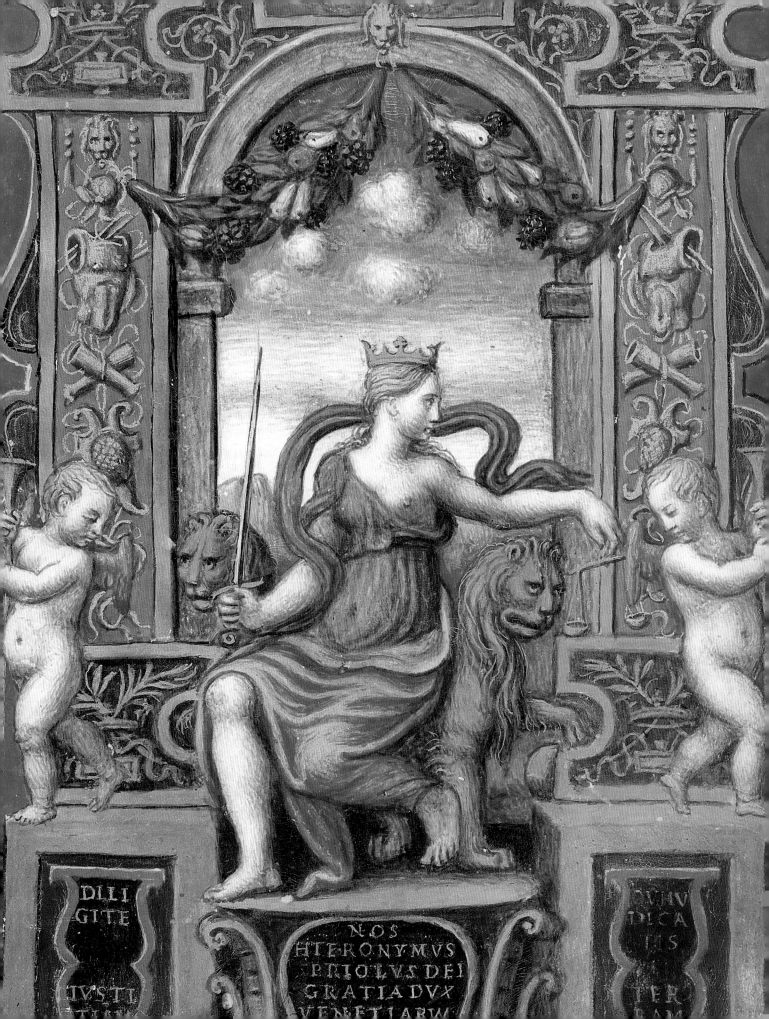

DILI
GITE

IVSTI
TIAM

NOS
HIERONYMVS
PRIOLVS DEI
GRATIA DVX
VENETIARVM

IVDI
CATIS

TER
RAM

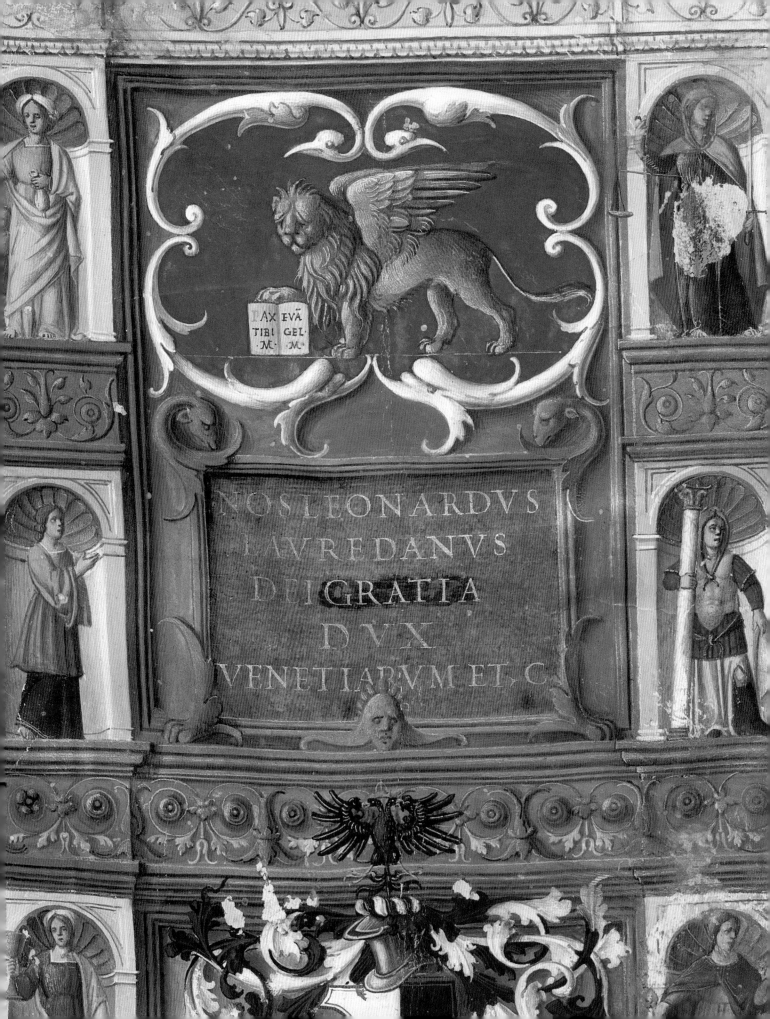

NOS LEONARDVS
LAVREDANVS
DEI GRATIA
DVX
VENETIARVM ET C

PAX
TIBI
M
EVA
GEL
M

CONTENTS

os xpoforus man
ro da gratia dux ue
netiarum i c. Com
mittimus tibi nobi
li uiro Nicolao ma
cello procuratori ec
clesie nostre sancti
mara apostoli et e
uangeliste. patrono
et uexilifen nostri. quatenus officium
procuratie antedicte. nunc tibi comis
sum facere et exercere debeas iuxta te
norem infrascripti capitularis tibi nuc
dati. et nostra bulla plumbea pendenta
ad maiorem certitudinem communiu.

C Sacramentum :····
Iuro ad euangelia sancta n
ra ego Nicolaus marcello
qui sum procurator ecclesie
sancti maria. quod omia bo
na comunis que sunt in ma
nibus meas. et ad manus n

ACKNOWLEDGMENTS

This book began as a joint project with Sylvie Merian, and benefitted from her meticulous study of bindings and codicology even after she turned to other studies. Over the course of research and writing I have accrued many treasured friends, and debts to scholars and institutions, without whom this book never would have been completed. There are so many that I ask to be forgiven if I inadvertently miss expressing my gratitude here. I also hope this book adequately honors those whose ideas and assistance provided a foundation for this study, but who passed away before seeing its fruition.

The initial primary research on manuscripts in the Biblioteca Marciana was made possible by a Gladys Krieble Delmas Foundation travel grant. A grant from the American Philosophical Society allowed for study of relevant manuscripts in a number of North American collections. The University of South Florida's Office of Sponsored Research and the College of The Arts generously awarded funds over a number of years to examine the manuscripts in European collections and to purchase images. A visiting fellowship at the Huntington Library, where I benefitted from discussion with David S. Zeidberg and Mary Robertson, allowed me to study the materials in that collection. A fellowship at the Houghton Library of Harvard University, where Hope Mayo and William Stoneman offered advice and assistance, facilitated my research there. Valuable research and writing leave was provided by a Getty Postdoctoral Fellowship and an American Council of Learned Societies Fellowship. A Visiting Scientist Fellowship sponsored by the Dipartimento dei Beni Culturali (Archeologia, Storia dell'Arte, del Cinema e della Musica) of the University of Padua, chaired by Giovanna Valenzano, provided the ideal setting and resources for revising the manuscript and for research on a new project.

The inspiration for the topic began with an article by Giordana Mariani Canova, and she has been magnanimous in guidance and advice throughout.

David Chambers and Martin Lowry generously advised early on, and their work has provided an important foundation.

Numerous librarians, curators, and dealers have gone out of their way to facilitate my research. Many years ago in Venice, Attilia Dorigato, then Assistant Director of the Museo Correr, oriented me to that great collection. The subsequent enthusiastic and invaluable support, advice, and friendship of Piero Lucchi of the Biblioteca del Museo Correr, and eventual aid also by Andrea Pavanello and Monica Viero, were essential at various stages. I cannot thank Dr. Lucchi enough.

At the Archivio di Stato di Venezia, Claudia Salmini's kind generosity and profound knowledge of the archives equally were critical to this study. In addition to those already named earlier, I owe thanks especially to: Teréz Gerszi and Andrea Czére of the Museum of Fine Arts, Budapest; The Newberry Library, Chicago, and Paul F. Gehl; Bernard Deprez of the Library of the Katholieke Universiteit Leuven; Harriet West of Christie's, London; the Victoria and Albert Museum, London, and Rowan Watson; Eliot Rowlands and Wildenstein & Co., New York; William Voelkle and Roger Wieck of the Pierpont Morgan Library and Museum, New York; the Biblioteca del Seminario Vescovile of Padua and Giovanna Bergantino; at the Schoenberg Institute for Manuscript Studies, University of Pennsylvania Libraries, Philadelphia, William Noel and Lynn Ransom; the University of South Florida Library, Tampa, and Todd Chavez, Audrey Powers, Melanie Griffin, and Sandra Law; Jacopo Scarpa of Antichità Scarpa, Venice; the Archivio di Stato di Venezia and Giovanni Caniato, Michele Dal Borgo, Edoardo Giuffreda, Alessandra Schiavon, and Alessandra Sambo; Susy Marcon of the Biblioteca Nazionale Marciana di Venezia and also Piero Falchetta, Elisabetta Lugato, Tiziana Plebani, and Orfea Granzotto; the Fondazione Giorgio Cini and curators of the Fototeca; and Daniel De Simone of the Folger Shakespeare Library, Washington, D.C.

It has been a privilege to correspond with private collectors and often to be granted access to examine their *ducali*. I warmly thank T. Kimball Brooker

Detail of fig. 3.16

of Chicago; Cattanea Adorno, Genoa; Lawrence J. Schoenberg and Barbara Brizdle Schoenberg of Lido Key, FL; the Ford family, London; and Alberto Falck, Cecilia Collalto Giustiniani Recanati Falck, and Elisabetta Boetti, Venice.

For their generosity, and helping me feel at home while researching in Venice, I am grateful to Sally Spector, Marina Vitturi and her family, and especially Neda Furlan (who also assisted my research at the Fondazione Querini Stampalia) and her family. The extended hospitality, friendship, and erudition of Nicolas and Joanna Barker, and their daughter Emma, made research in London not just possible, but a joy. It has been my great fortune that study of manuscripts led me to meet friend and colleague Federica Toniolo, from whom I have learned so much. Her unflagging assistance, sponsorship, and hospitality, and that of her family in Padua, have been invaluable.

I have benefitted through conversation and assistance from so many, including Diane Ahl, François Avril, Meryl Bailey, William Barcham, Louise Bourdua, Chris Carlsmith, Matteo Casini, Monica Chojnacka, Stanley Chojnacki, Heather Cockburn, Brian A. Curran, Thomas and Maria Saffiotti Dale, Julia DeLancey, Angela Dillon Bussi, François Dupuigrenet-Desroussilles, Eric Dursteller, Consuelo Dutschke, Robert Echols, Silvia Fumian, John Garton, Diana Gisolfi, James S. Grubb, Cristina Guarnieri, Peter Humfrey, Lyle Humphrey, Frederick Ilchman, Michael Knapton, Benjamin Kohl, Gabriele Köster, Roland Krischel, Francesca Manzari, James H. Marrow, Alex Marshall, Andrew John Martin, Daniel Wallace Maze, Anna Melograni, Marta Minazzato, Yudit Naage, Laura Nuvoloni, Monique O'Connell, April Oettinger, Debra Pincus, Judith Pollmann and her Early Modern Memory team, Lisa Pon, Chiara Ponchia, Abigail Quandt, Dorit Raines, Sheryl Reiss, Martin Roland and Georg Vogeler with their *Illuminierte Urkunden* team, Vittoria Romani, Susannah Rutherglen, Ivano Sartor, Monica Schmitter, Anne Markham Schulz, Salvatore Settis, Allison Sherman, Silvia Spiandore, Elena Svalduz, Giorgio Tagliaferro, Gennaro Toscano, Deborah Walberg, Bronwen Wilson, and Wolfgang Wolters.

A number of people truly went out of their way to assist this project, especially Ilaria Andreoli, David D'Andrea, Blake de Maria, Anne-Marie Eze, Peter Fergusson, Guido Galesso, Holly Hurlburt, Andrea Nante, Jason Nethercut, Gary M. Radke, Dennis Romano, William J. Sibley, Maartje van Gelder, and Ekaterina Zolotova. It is impossible for me to adequately express my gratitude to Lilian Armstrong, whose innovative studies on painting in books led me to enter this field of inquiry. She has been overwhelmingly generous in her support and ceaselessly inspiring as a scholar and dear friend.

I also owe a particular debt of gratitude to others who took valuable time from their own research to read components of this project, or the entire manuscript, and to offer encouragement and assistance at various stages: Jonathan J. G. Alexander, Giovanna Benadusi, Tracy E. Cooper, Karin Krause, and Sarah Blake McHam. Patricia Fortini Brown read a section early on and provided great insight, generous advice, and encouragement, all critical to the completion of the book. I am especially grateful to Gillian Malpass for her initial interest and unflagging support, and to the anonymous readers she selected for their careful reading of the manuscript and invaluable suggestions. I owe special thanks to Christine Considine, Charlotte Grievson, and Jennifer Morris for their initial expert editing, and to the astute and patient Sophie Oliver, as Editor, and Mark Eastment, as Editorial Director, for guiding the book to publication.

In the School of Art and Art History, University of South Florida, I owe thanks to my colleagues Elisabeth Fraser, Riccardo Marchi, and especially Director Wallace Wilson, for their support, and to my students for their inspiring enthusiasm. Rodney Paul Mayton offered expert aid as Curator of the Visual Resources Center. The friendship of Sarah Apple, Susan Edelist, Jennifer Hardin, Mernet Larsen, and Dorion Wiley Loy sustained me throughout. My parents instilled in me an interest in books and archives and they have provided lifelong encouragement. My special thanks go to my husband Robert Clark for his expertise on the database, his acumen and insight, and for his motivating faith in the author and the project.

ABBREVIATIONS

ASVe Archivio di Stato di Venezia

ASVe *Guida generale* "Archivio di Stato di Venezia." Maria Francesca Tiepolo, Giustiniana Migliardi O'Riordan, Pia Pedani, Piero Scarpa, eds. *Guida Generale degli Archivi di Stato Italiani*, IV (Rome: Ministero per i Beni Culturale e Ambientali, 1994): 859–1148

b. busta (box file)

Barbaro *Arbori* Marco Barbaro, *Arbori de' patritii Veneti*. Recopied with additions by Antonio Tasca in 1743. 7 vols. ASVe, Miscellanea Codici Serie 1, Storia Veneta, 17–23

Barbaro Cicogna Marco Barbaro, *Genealogie e origini di famiglie venete patrizie*. Recopied with additions by Lorenzo Antonio da Ponte and Emmanuele Antonio Cicogna. 7 vols. BMCVe, MSS Cicogna 2498–2504

Barbaro GD Marco Barbaro, *Genealogie e origini di famiglie venete patrizie*. Recopied with numerous additions by Emmanuele Antonio Cicogna. 7 vols. BMCVe, MSS Gradenigo Dolfin 81.1–7

Barbaro *Genealogie* Marco Barbaro, *Genealogie delle famiglie patrizie venete*. BMVe Cod. It. VII, 924–928 (=8594–8597)

BFQS Biblioteca della Fondazione Querini Stampalia, Venice

BL British Library, London

BMCVe Biblioteca del Museo Correr, Venice

BMVe Biblioteca Nazionale Marciana, Venice

BnF Bibliothèque Nationale de France, Paris

Collezionismo 2007 *Il collezionismo d'arte a Venezia. Il Seicento*. Linda Borean and Stefania Mason, eds. (Venice: Marsilio, 2007)

Collezionismo 2008 *Il collezionismo d'arte a Venezia. Dalle origini al Cinquecento*. Michel Hochmann, Rosella Lauber, Stefania Mason, eds. (Venice: Marsilio, 2008)

DBI *Dizionario biografico degli italiani*. Albert M. Ghisalberti, ed. (Rome: Istituto della Enciclopedia italiana, 1960–). (Page numbers are not given because all the entries are available online)

DBMI *Dizionario biografico dei miniatori italiani*. Milvia Bollati, ed. (Milan: Silvestre Bonnard, 2004)

fol. folio (sheet number)

HLSM Huntington Library, San Marino, CA

ISGM Isabella Stewart Gardner Museum of Art, Boston

K. Knight

NYPL New York Public Library

ÖNB Österreichische Nationalbibliothek, Vienna

PML Pierpont Morgan Museum and Library, New York

Pr. Procurator

PRO Public Records Office, The National Archives, Kew, Richmond, Surrey, UK

PSM Procuratori di San Marco

r. recto (front of leaf)

reg. registro (register, or bound volume)

SAV *Segretario alle voci*, Archivio di Stato di Venezia

SDV *Storia di Venezia dalle origini alla caduta della Serenissima*. Alberto Tenenti and Ugo Tucci, eds. (Rome: Istituto della Enciclopedia italiana, 1991–2002)

Ser.mo Serenissimo (Doge)

v. verso (back of leaf)

V&A Victoria and Albert Museum, London

WAM Walters Art Museum, Baltimore

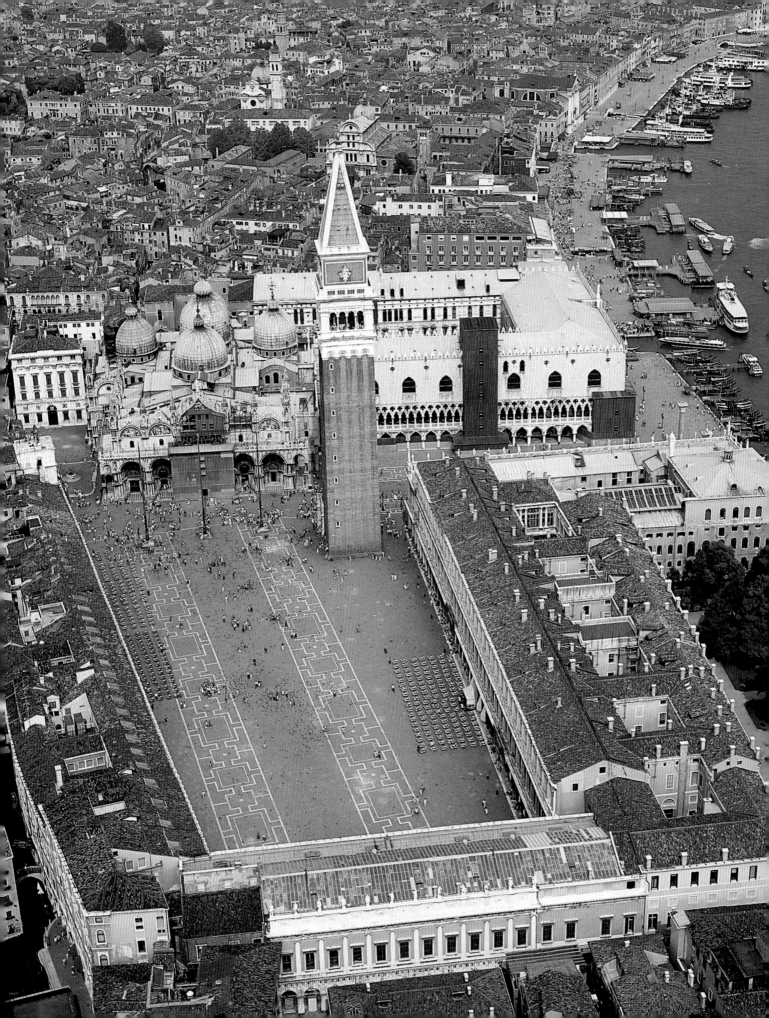

INTRODUCTION

FROM THE LATE Middle Ages through the eighteenth century, the impressive complex of the Doge's Palace in Venice housed large meeting halls, administrative offices, chanceries, law courts, and prisons in addition to the apartments of the elected prince, the doge (fig. 0.1). The palace and the adjacent Basilica of Saint Mark were the governmental and spiritual heart of an oligarchic republic, with an empire that at its height extended west into Lombardy and southeast to Cyprus. The dynamic of debate and negotiation among commissioning bodies through which these buildings were conceived, constructed, and furnished created monumental yet graceful manifestations of the power and ideals of the ruling collective, the patriciate of Venice.[1] But in May of 1523 a personal drama was unfolding in the palace that signals an important role also of painted official documents in expressing and preserving civic identity. The small paintings within these documents, however, especially highlighted the ideals and status of individual patricians, rather than the body politic, in relation to the state.

The great diaries of the patrician Marin Sanudo tell us that as Doge Antonio Grimani (1434–1523) lay dying in his apartments on May 7 he became preoccupied with the fate of certain relics of his ducal status and singular political career. Antonio was the patriarch of the Santa Maria Formosa branch of a family that was one of the most influential and powerful of the sixteenth century (fig. 0.2).[2] On his deathbed he called for his son Vincenzo (c.1464–1535) to tell him that he was leaving him everything, and to ask that Vincenzo maintain a peaceful relationship with nephews Marco and Vettor, sons of Vincenzo's deceased brother Girolamo. In addition to this concern for family cohesion, Antonio asked that his son sell his *restagno d'oro*, the ducal robe of gold-threaded brocade, a magnificent and costly signifier of princely status that the doge was required to purchase at his own expense shortly after his election. By contrast, Antonio requested that Vincenzo retain his "*Promissioni*" as procurator and doge. All this Vincenzo was to do "for the honor of our *casa*."[3]

What were these *Promissioni*, the preservation of which concerned the doge especially at the end of his life? They were manuscript documents in codex form (that of modern books, as opposed to single leaves or scrolls) containing the oaths and regulations by which Antonio swore when elected procurator and doge, the highest offices a patrician in Venice could attain. Vincenzo must have obeyed his father's wishes and kept the documents in the family, for they were appreciated for their miniatures five generations later in the inventory of the effects of Vincenzo di Pietro Grimani (1588–1647) held in the magnificent Palazzo Grimani Calergi.[4] But eventually they came to be dispersed and now rest in public collections, where one can see that they were handsomely scripted, illuminated (painted),

0.1 The center of Venetian administration and empire. Aerial view of the Piazza San Marco and Piazzetta, with the Basilica of Saint Mark and Doge's Palace, Venice

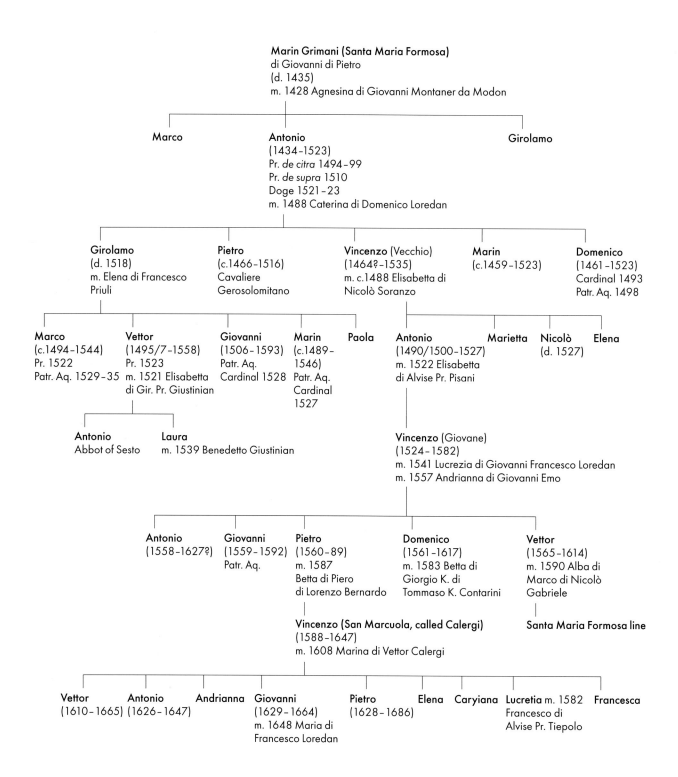

0.2 The Grimani of Santa Maria Formosa and San Marcuola (Grimani Calergi)

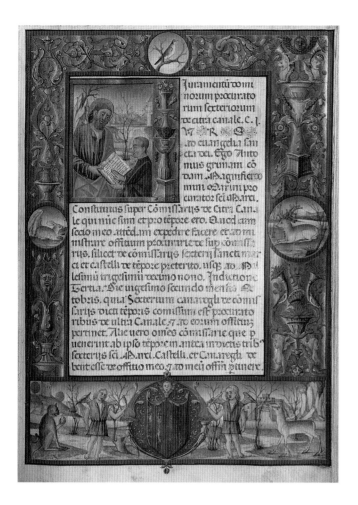

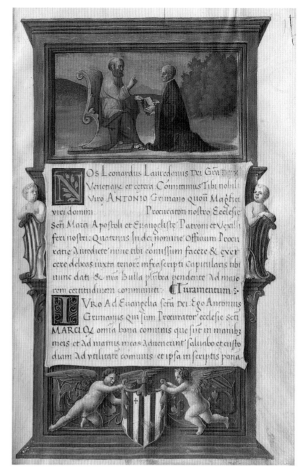

0.3 Ferrarese Master, Commission/Oath of Antonio di Marin Grimani as procurator *de citra*, elected 1494. 25.4 x 17.9 cm. Biblioteca del Museo Civico Correr, Venice, Cl. III, 158, fol. 5r. The opening text on this leaf is the *Giuramento*, or Oath of office

0.4 Benedetto Bordon (attrib.), Commission/Oath of Antonio di Marin Grimani as procurator *de supra*, elected 1510. 24 x 15.7 cm. Biblioteca del Museo Civico Correr, Venice, Cl. III, 906, fol. 5r. Opens with Commission of the office, followed by the Oath

and bound (figs. 0.3–0.5).[5] Perhaps of less value on the market than the gold cloth of Antonio's ducal *restagno*, the manuscripts were the clearest material proof of the doge's top achievements in government, and of the social and political status that he hoped to bequeath, along with his substantial wealth, to his family.[6]

Portraits within each of Antonio Grimani's manuscripts enhanced their value as documents.

A likeness of him at the age he obtained each office was joined to the relevant text commissioning and regulating his power and status. Antonio's maturation over sixteen years can be gauged by the obvious diminishing of the hair on his head from the first to the second of the portraits. They are therefore visual documents enhancing the textual ones. In the third manuscript, the *Promissione*, Antonio is represented wearing the gold *restagno* and other attributes of his ducal status. Viewed in sequence, the images convey the transience of life by recording the changes in his career and appearance. At the same time, they immortalized him as a divinely chosen and devout leader.

Antonio's documents are important examples of a general development in the fifteenth and sixteenth centuries in Venice, when such

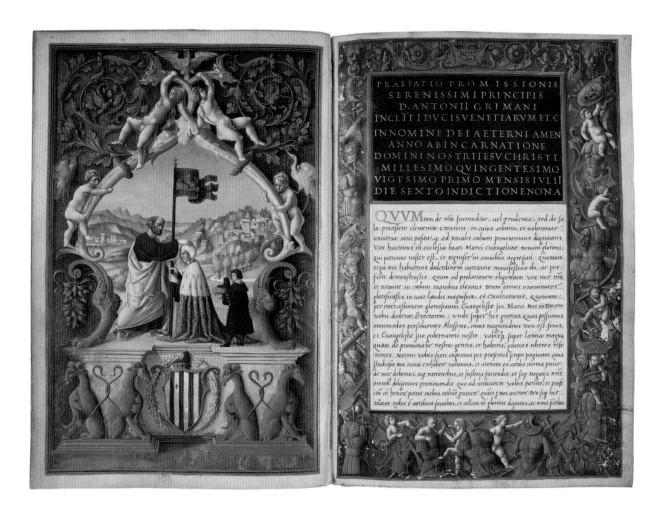

0.5 Benedetto Bordon and/or Second Grifo Master (attrib.), *Promissione* of Antonio di Marin Grimani, 1521. Each fol. 31.5 x 21.1 cm. British Library, London, Add. MS 18000, fols. 6v–7r. The opening text is the prologue, which emphasizes that the doge is elected not through his own fortitude or prudence, but by the grace of God. Grimani is dressed in his gold *restagno*

manuscripts with texts confirming and defining political office increasingly were embellished with fine bindings and paintings. The painting seems to have been initiated by patrician and citizen administrators who oversaw their production. But to a great degree, depending upon the relevant office, it was the recipients of the documents who determined the extent of painting and the nature of the imagery. While in use, the documents enhanced the authoritative image of the patrician and articulated his ideals of service. As will be argued,

stored in the family archives, paintings in these documents not only augmented, but could shape broader strategies of the patronage of architecture, painting, and sculpture, whose goal was to preserve individual and family patrician status.

PAINTING IN BOOKS AND MANUSCRIPTS

The miniatures under focus in this study were produced within documents, but their evolution to convey distinction and an ethos of service was stimulated by wide cultural and economic trends in the making and collecting of texts.

First, by the early fifteenth century, many of the Venetian patricians and secretaries in charge of the production of such documents were inspired by the ideals of humanist education

and the recovery of lost texts from antiquity. The corresponding cultivation of refined writing scripts and textual production at times nurtured a high quality in the creation and embellishment of these documents as well as of the literary texts avidly commissioned and collected in Venice.[7]

Second, print was introduced to Venice in 1469, and the emergence of the city as the world center of the printed book industry by the end of the fifteenth century also accelerated development of these documents as spaces for patrician self-imaging. Increased book production and trade attracted talented artisans to the city.[8] In the early period of print, manuscript books continued to be produced, volumes were still bound by hand, and some copies of printed books were embellished with hand-painted images to personalize them. The boundaries between print and script were extremely fluid, and most artisans of the book participated in the production of manuscript books and documents, as well as print. In the late fifteenth and sixteenth centuries, therefore, Venetian patricians could choose from an expanded pool of talented craftsmen to embellish their manuscripts. Elaborate painting and binding also highlighted that these documents in book form were accessible only to an elite among Venetian nobles.

A third general impetus for the development in Venice of fine documents with more elaborate painting was the intensified patronage of luxury manuscripts throughout Europe, and their important role as diplomatic gifts. In the fifteenth and sixteenth centuries a number of rulers commissioned and collected illuminated manuscripts not only as components of a passion for texts, but also as displays of piety, sophistication, and wealth. Emphasis could be placed on single and inordinately expensive projects as signs of prestige, as in the commission by Borso d'Este of an immense and copiously illustrated two-volume Bible (created 1455–61), or in the formation of extensive libraries of luxuriously produced manuscripts, as in the case of Federigo da Montefeltro, Duke of Urbino.[9]

A prince, duke, or even pope could invoke Aristotle's praise of wealth and the display of magnificence as a virtue in order to justify great expenditures on such luxury goods as illuminated manuscripts.[10] But in the Republic of Venice there had long reigned an ethos of *mediocritas*, of the equality of members of the patriciate, as articulated by the patrician Nicolò di Cattarin Zen (1515–1565) in 1539. Zen voiced a long-held ambivalence towards the "courtier's arts" as distracting from commerce and having the

0.6 Giovanni Bellini (attrib.), *Jacopo Antonio Marcello Presents the Manuscript as a Gift to René of Anjou.* Strabo, *Geography*, translated by Guarino of Verona, 1459. 37 × 24 cm. Réseau des médiathèques de l'Albigeois (médiathèque Pierre-Amalric d'Albi), MS 77, fol. 4r

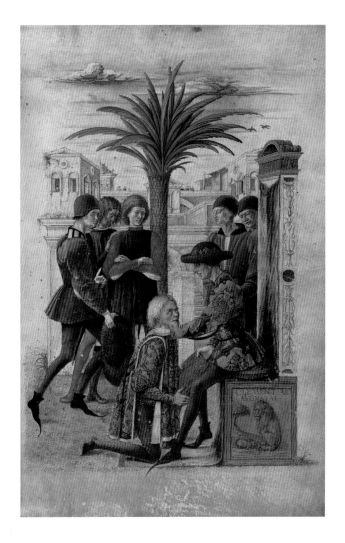

potential to disrupt the equilibrium of the ruling class.[11] And indeed, in fifteenth-century Venice, patronage of manuscript painting was relatively modest by comparison to that of princely and royal courts, perhaps in part because in the context of patrician ideals such conspicuous consumption would have been viewed by many as inappropriate.

Nevertheless, in the mid-fifteenth century the patrician Jacopo Antonio di Francesco Marcello (1388–1463/4) commissioned some of the finest manuscripts of the Renaissance as gifts to King René of Anjou and to Jean Cossa, councillor to the King. The books have paintings, including portraits of Marcello, which have been attributed to Mantegna, Jacopo Bellini, and Giovanni Bellini (fig. 0.6). These expensive gifts portrayed the patron as a cultivated intellectual, as a member of the distinguished chivalric Order of the Crescent, and as sympathizer and friend to the King.[12] The elevated status and sophistication of the recipients required a gift of appropriate refinement from Marcello.

And despite Venetian rhetoric of patrician harmony and equality, of course there were always differences of wealth, power, and opinion among nobles within the Republic. The desire by some to delight themselves and assert status through lavish spending on costume, entertainment, the building of great palaces, and patronage of art invited repeated attempts at regulation through sumptuary laws of what was regarded as wasteful consumption.[13] Manfredo Tafuri has analyzed an emerging advocacy for magnificence in the presentation of self and of the arts in the sixteenth century in Venice, as some patricians and their families also strove boldly to concentrate power in their own hands.[14] Tafuri also discerned different cultural tendencies, particularly in the patronage of architecture, from the late 1570s until the end of the 1620s along political factions in Venice identified as the *giovani* and the *vecchi*. To simplify greatly his complex and subtle analysis of a shifting set

of alliances and beliefs, the *giovani* were more politically radical but tended to adhere to older traditions of architecture, while the *vecchi*, among whom the Grimani were prominent, were strongly implicated with Rome and the Holy See, and more progressive in their patronage of the arts in the manner of the clients of artists and architects in Rome. Some historians, while still acknowledging that the terms *vecchi* and *giovani* were established in political language, have argued against clear divisions and even against the existence of such factions.[15] Nevertheless, Tafuri's analysis of different mentalities regarding the patronage of the arts as following along lines of family ties, friendships, and political outlook remains compelling.[16] It is no surprise then that, as with the other arts, some patricians and their associates with strong connections to courtly circles abroad were aware of the high standards of the luxury patronage of manuscripts and wished to emulate them as signs of cultural currency, wealth, and status.

Indeed, the Grimani of Santa Maria Formosa fashioned themselves to be as much ancient Roman as Venetian in the sixteenth century, and various descendants of Antonio were some of the most progressive and important patrons of the arts in Venice. The Roman Senate even confirmed the Grimani claim of Roman patrician origins with two illuminated documents (called privileges), thereby also granting citizenship in 1529. These were highlighted next to Doge Antonio's documents in Vincenzo di Pietro's inventory of 1647.[17] Certain ecclesiastical members of Doge Antonio's family, in addition to commissioning innovative architecture in a triumphant Roman style, and assiduously acquiring antiquities, became some of the most important collectors of painted manuscripts and patrons of miniaturists in sixteenth-century Europe.

In 1516, Doge Antonio Grimani's son Cardinal Domenico (1461–1523) took the young immigrant artist Giulio Clovio into his household in Venice. Clovio emulated the

0.7 Giulio Clovio, *Conversion of Saul*. Marin Grimani, *Commentary on the Epistles of Saint Paul to the Romans*, 1530–40. 42.9 x 32.7 cm. Sir John Soane's Museum, London, MS 143, fol. 7r

0.8 Gerard Horenbout (attrib.), *Feasting* (January calendar page), Breviary of Cardinal Domenico Grimani, c.1515–20. 28 x 21.5 cm. Biblioteca Nazionale Marciana, Venice, Lat. I, 99 (=2138), fol. 1v

compositions and effects of monumental artists, especially of Raphael and Michelangelo, and became exalted by Giorgio Vasari as the greatest miniaturist of all time and a "new, if smaller Michelangelo."[18] Domenico's nephew, Marin di Girolamo (*c*.1489–1546), the Doge's grandson, was also created Cardinal in 1527, and became a great patron of Clovio. The miniaturist's greatest work for Marin comprised the illuminations of a manuscript of the Cardinal's *Commentary on the Epistles of Saint Paul to the Romans*, with an opening miniature inspired by the Raphael cartoon owned by Marin of the *Conversion of Saul*, made for the Sistine tapestries (fig. 0.7). Marin's *Commentary* manuscript continued to

be treasured by the Grimani, and it was also listed next to Doge Antonio's documents and the two illuminated privileges from the Roman Senate in the inventory of Vincenzo Grimani Calergi's effects of 1647.[19] Clovio went on to become court painter to Cardinal Alessandro Farnese in the 1530s and 1540s, and Cosimo de' Medici in the 1550s. Largely through Clovio's art, there evolved an interest in Italy in miniature painting as a tour de force of technique on a small scale, and many were produced as independent pieces to be collected or presented as gifts of friendship or diplomacy.[20]

Domenico Grimani, in addition to supporting Clovio and his elevation in status as an artist transcending craft, also collected finished

0.9 "Bequeathed to his *patria* by Cardinal Domenico Grimani as a token of his devotion to her." Upper cover of the Grimani Breviary, c.1592. 29 x 22.5 cm. Biblioteca Nazionale Marciana, Venice, Lat. I, 99 (=2138)

manuscripts. In 1520, he purchased in Rome a large breviary that has been called the "most elaborate, and arguably the greatest work in the history of Flemish manuscript illumination."[21] Many of the paintings in this manuscript, especially those of the Calendar, convey the leisurely activities and fine fashions of courtly life, for the Calendar compositions are based on those of the Very Rich Hours of Jean, the Duke of Berry (1340–1416) (fig. 0.8). As will be discussed further, the eventual donation of the Grimani Breviary to the state and its public display demonstrate the high value placed on the arts of the book in Venice, and their perceived usefulness in negotiating state identity (fig. 0.9). The importance to Antonio Grimani of his

documents, and the celebrated patronage and collecting of manuscript illumination by his heirs, seem to have incited a greater interest among some patricians for having their documents painted as memorials. This can be observed especially in the last quarter of the sixteenth century among those who were allied with the Grimani, ideologically or through family ties.

PAINTED DOCUMENTS FOR THE DOGE, PROCURATORS OF SAINT MARK, AND RECTORS

Venetians were not always consistent in how they referred to the ornamented documents that are the subject of this book, so clarification of the nature and terminology of these manuscripts is needed (fig. 0.10). According to Sanudo, Antonio Grimani used the term *Promissione* for his documents as doge and as procurator of Saint Mark, but generally this was used solely for the manuscripts made for the doge upon his election. Only in the document of the doge is written a *Promissio*, the standard promise made by a newly elected doge to the citizens of Venice in his inauguration ceremonies.[22]

The documents for the procurators of Saint Mark typically were not called *Promissioni*, rather *Commissioni* (but also *Giuramenti* or *Capitolari* to denote the two additional textual components within them). The paintings in these books often respond to the specific opening text of these sections. For example, the illuminated page of Grimani's second manuscript as procurator opens with the Commission, and that leaf is thus illustrated with the image of him receiving the document from Mark, who blesses him (fig. 0.4). The painting of the opening leaf to Grimani's first manuscript as procurator correlates with the first text on that page, which opens instead directly with the Oath of office, or *Giuramento* (fig. 0.3). Theoretically, here Mark holds a copy of the Gospels instead of a Commission document, for Grimani places his hand upon it to take the very oath written

in the text adjoining the illustration. This is an idealized image of the actual ceremony of the inauguration of the procurator, in which he took his oath on a Gospel Book in the Church of Saint Mark.

In addition to the *Promissione* of the doge and the *Giuramento* of the procurator, *Commissioni* were a third major class of manuscript documents that came to be elaborately illuminated and bound. These were given to patricians appointed as captains of merchant galley convoys, as governors and captains of Venetian territories abroad, and the *Provveditori generali* who oversaw broader regions under Venetian dominion (Appendix 4).[23] *Commissioni* comprise the largest category of the documents under consideration here, and they open with the commission to office phrased as if coming directly from the reigning doge (fig. 5.13).

The three main classes of illuminated documents, which all contain rules and statutes, are named after the varying opening texts of a promise, an oath, or commission of office. They will be referred to throughout as the *Promissione* of the doge, the Commission/Oath (*Commissione/Giuramento*) of the procurator, and the Commissions (*Commissioni*) to the captains of galleys and to rectors (*rettori*, or rulers abroad). Because each of these classes were produced under different auspices and funding, they developed somewhat independently in format and as fields for decoration. Their separate standardized texts evolved over time, with additions or deletions made according to relevant legislation and reviews by boards of correctors.

Various other categories of Commission documents that were typically received by patricians never were illuminated. For example, one of Antonio Grimani's manuscripts

0.10 Illuminated manuscripts for Venetian patricians (*ducali*)

Office	No. of officers	Term	Document name	Contents (variable)	Payment for document made by
Doge	1	Life	Promise of the doge (*Promissione ducale*)	Table of contents Prologue *Promissio* Rules and statutes Oath	*Rason vecchie*
Procurators of Saint Mark (after 1443) *de supra* *de citra* *de ultra*	3 * 3 3	Life	Commission/Oath/Rulebook (*Commissione/Giuramento/Capitolare*)	Table of contents Commission *Giuramento* Rules and statutes	Relevant branch of the *Procuratia*, sometimes subsidized by recipient
Rectors (*rettori*) Captains of commercial galley convoys	See Appendix 4	1–3 years	Commission (*Commissione ducale*)	Commission Rules and statutes Eschatocol with monogram and/or signature of the *segretario alle voci*, sometimes also of the Grand Chancellor Salaries and allowed expenses signed by a notary of the *Governatori delle entrate* Table of contents	Ducal chancery, embellishment sometimes subsidized by recipient
The documents for the following office were to be returned upon completion of office, but came to be retained and illuminated					
Ducal councillors	6 (one for each *sestiere*)	8 months	Oath/Rulebook (*Giuramento/Capitolare*)	Oath Rules and statutes	Ducal chancery(?), eventually subsidized by recipient (?)

* After 1516 supernumerary offices could be won through pledges of cash or loans

commissioning him as captain general of the sea survives, but, as was usual for documents of this kind of post, it was not painted.[24] In addition, there were many prestigious offices for which patrician office holders did not receive a document that could be retained in the family. The desire for embellished documents is evident in that even though the six ducal councillors were supposed to return their *Capitolari* manuscripts upon completion of their brief terms, by the early sixteenth century these came to bear the recipients' coat of arms; in the second half of the century these could be personalized further with extensive imagery. Finally, the documents containing the texts of the oath and capitulary of many different kinds of rotating magistracies were not given to individual patricians, rather the manuscripts were maintained in the office where they exercised their duties.[25] Again, to reference Antonio Grimani's career as an example, he was elected as an *avogador di comun* (state attorney) in 1484, a prestigious position for which, nevertheless, it seems he would not have received a commission document.[26]

What defines these classes of manuscripts for the doge, ducal councillors, procurators, and rectors as documents? They were official copies of the legislated texts given to individuals upon their election to office. Commissions for rectors and captains of merchant galleys constituted the only class of such manuscripts regularly formalized as charters with the eschatocol, or concluding formula recording the date, place, and signature of a chancery secretary, but almost all these documents were supposed to be affixed with the official ducal seal, or *bolla,* even if now usually these have become detached and lost.

The commissioning and payment of the scripting and decorating of the different classes of documents varied, and certain themes specific to each office evolved. Because of the separate evolution and different coordination for payment and production of each of the three main document types, they will be examined in more detail in separate chapters. But for ease of discussion, these categories of documents that came to be increasingly illuminated will be referred to as a group under the umbrella term *ducale* (plural *ducali,* or in Venetian *dogali*).[27] This label has been used for such manuscripts since the eighteenth century, but it is imprecise and can be misleading unless carefully delineated within an historical and art historical context.[28] This is because historians of diplomacy employ the term differently, and more in line with how it was used in the early modern era. In diplomatic terms, a *ducale* is any document written in a doge's name, or signed by the doge, and typically directed to another official; it could be a letter, privilege, or mandate.[29] The documents focused on here comprise a small subset of Venetian documents, and were destined only for individual patricians. Some had texts addressed to the recipient in the name of the doge, but this category also includes the *Promissione* created *for* the doge.

These documents, granted to recipients of three different kinds of offices, were grouped together under the term *ducali* by scholars and collectors of illuminated manuscripts in the mid-nineteenth century, when, after the fall of the Republic in 1797, the documents came to be treasured on the market for their illumination and binding.[30] Retrospectively, scholars and collectors recognized that distinct kinds of documents granted to patricians who served in public offices had been the special focus of material enhancement and decoration. So it is proposed here that we accept the interchangeable historiographical terms *ducali* and *dogali,* which have come down to us through the filters of collecting and art historical scholarship, to group these classes of documents created for individual patricians.[31]

Large numbers of these manuscripts were produced in Venice, and they usually record the date of their production. For these reasons, as Giordana Mariani Canova has pointed out, the study of *ducali* is central to understanding the development of manuscript painting in Venice.

She also has indicated the importance of these manuscripts for a history of portraiture because many of them include likenesses of the recipients of the documents. Staale Sinding-Larsen and Wolfgang Wolters subsequently demonstrated that the paintings in these manuscripts operated in the broader visual culture of patrician ideological and political representation. David S. Chambers has clarified the relationship of the illuminated documents of the procurators of Saint Mark to the nature of their office, and analysis of them here is greatly indebted to his study. The recent exhibition of documents from the great collection in the Correr Museum Library, curated by Piero Lucchi, celebrated the completion of the catalogue online and presented valuable new research.[32] For the purposes of art historical study, the term *ducale* can serve to identify a category of Venetian documents that were specially embellished, collected in family archives, and later privileged on the market for their illuminations and bindings. We are extracting a group of documents to study according to the effort taken in their decoration, their display as attributes of power, and their intended archival destinations in patrician homes.

PRIVILEGE AND DUTY

For centuries, until its fall in 1797, the Republic of Venice was renowned for longevity and freedom from outside rule, allowing it to adopt and retain the title *la Serenissima Repubblica*, or the Most Serene Republic. Already in the fourteenth century, Petrarch attributed the strength of the city to invisible foundations of civic harmony, as maintained by virtuous rulers, an idea that was repeated and expanded in a constellation of literature, art and architecture, ritual, and music, which has come to be called the myth of Venice. The legendary dedication of Venetian nobles in selfless service to the state became a central theme of the famous myth of an ideal political and social order, ruled by an aristocracy of merit.[33] The importance of the myth in transmitting central values of Renaissance republican thought to modern Europe and America has occupied a privileged position in historical research.[34] Studies of its evolution in political and historical literature have encouraged analyses of the role of the arts and ritual in its creation. It bears repeating that the arts did not merely illustrate the myth; they participated in its creation, and perpetuated it. The patronage of art also was a fundamental practice of the politics of individual patricians; of projecting qualification to rule, and thereby influencing ascent through offices by election.[35] But as Tafuri has shown, a political message could be conveyed in Venice by restraint and conservatism in the patronage of the arts, as well as through magnificence and innovation.

The special embellishment of some categories of *ducali*, especially of the *Promissione* of the doge and *Giuramento* of the procurators, was encouraged by the state through subsidization of the cost. Overall, the paintings of *ducali* promoted the group ethos of patrician dedication in selfless service to the Republic. A central function of the myth of Venice was to promote faith in, and allegiance to, the government, and to affirm its ruling class.[36] It stressed the equality of all patricians. But as discussed, in the fifteenth and sixteenth centuries, patrons increasingly used their own funds to embellish the documents to distinguish themselves. In addition to the natural tendency to wish to mark one's achievements, trends of self-promotion in *ducali* also may have been in response to increasing stratification and surveillance of patrician status in the sixteenth century. It is important, therefore, to review here in more detail the evolution of how Venetian patrician identity was legislated and negotiated in the late Middle Ages and the Renaissance.

The creation of a Venetian nobility developed out of the conditions of membership (established in a law passed in 1297) in the late medieval main legislative body of Venice called the

Maggior consiglio, or Great Council. This so-called *serrata*, or closure, of the Great Council does not seem to have been intended initially to limit, but rather to affirm membership of the governing council. Nevertheless, the effect over the course of three decades was to define the ruling class based on family membership and hereditary succession. Eventually only legitimate male offspring of a fixed group of families were allowed to vote and to be elected to office (see fig. 0.11). Membership in the Great Council, thereby, became the marker of nobility and access to certain kinds of power in Venice.

The government was structured so that ideally all male patricians, upon attaining the age of twenty-five, participated in government if only to attend the weekly meetings of the Great Council. In theory, patricians were not to strive for governing posts, or to turn one down when elected. Participation in government was a privilege but also a duty. In practice, however, patricians often vied, sometimes aided by their pledges of financial aid to the state, for prestigious positions that could lead one up the political hierarchy and avoided, even refused, those duties that were inconvenient. Because being a patrician entailed the duty as well as the privilege to govern, we can imagine that at the heart of masculine Venetian patrician identity was a particularly insistent tension between collective and individual interest; between selfless service to the state and personal ambition, with a keen recognition that to a certain extent the collective interest was his own. This duty to serve required weekly attendance at the meetings of the Great Council, and also could demand leadership, and even sacrifice, in battle. In addition, election and influence depended not only upon family name and

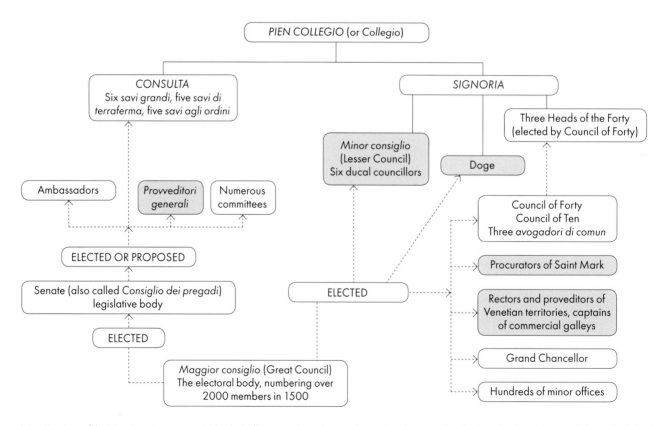

0.11 Structure of the Venetian Government. Shaded offices are those for which an official received or had made *ducali* that might be embellished

individual merit, but also continual politicking and image management.

There were two successive periods in the fifteenth and sixteenth centuries of intensified further regulation of the requirements for membership of the Great Council. From 1414 to 1430 legislation was enacted to more systematically document eligibility and membership, with more attention to the integrity of the women whom male nobles married. This has been called the second *serrata*.[37] The competition for membership of the Council was exacerbated in the latter years of the fifteenth century, when the noble population increased to the point that membership more than doubled. With greater numbers of nobles, families that were truly influential and powerful in government sought to visibly distinguish themselves from those more numerous poor patricians, who seemed noble only in name.

The government sought to control this membership boom, and Stanley Chojnacki has characterized certain laws enacted in the early sixteenth century as a third *serrata*. One of the elements of this was the *Libro d'oro* law of August 1506, which required fathers to notify the *avogadori di comun* within eight days of the birth of a son, in order to document the son's eventual eligibility for the Great Council – this was to weed out extramarital offspring. Chojnacki has emphasized that this shifted entry into political life, as the checkpoint for determining noble status, to an earlier moment – to actual birth to a member of the Great Council – an officially recorded continuity of the status of nobility from father to son. In addition, reforms of April 1526 further scrutinized the noble status of the marriage *before* the birth.[38] One effect of this continuing legislation was an eventual shift in the rhetoric of nobility from emphasizing virtue to purity of blood.

In addition to the closing of the patrician class to a fixed group of families, and increasing surveillance of hereditary status, a hierarchy within this class that could claim membership of the Great Council developed according to wealth, influence, and power. Whereas some offices of state provided employment to patricians, but were not highly thought of, others required substantial personal financial outlay by the holder of office. Consequently, some families eventually came to be regarded as of the senatorial class, or *le Senatorie*. They were distinguished especially by their wealth, which allowed members to take on the great offices of state that required it, and that thereby assured them greater power among purported equals. By contrast, especially by the late fifteenth century, some patrician families came to depend on a growing number of offices which, instead of requiring an outlay of expenses, were remunerated (*le Giudiziarie*). Many patricians who voted in the Great Council hall were actually poor – they were from families called *le Barnabotte*, after the area of Venice around Campo San Barnaba, where many of them lived. A number of scholars have identified individuals from the small group of families in the sixteenth century who had great wealth and influence, who were repeatedly elected to the highest offices, and who by then constituted an unofficial oligarchy within the legislated one, the real center of power in the Republic.[39]

Not all male patricians were drawn to politics, of course, and the structure of noble families often allowed for the distribution of careers according to talent and inclination. The predominant form of business organization among Venetian patricians was the *fraterna*, or family partnership. This encouraged a high degree of coordination among members towards the communal goals of fellowship, wealth, and influence.[40] And being a successful merchant did not preclude a civic career. In fact, although they were not supposed to do so, many patricians advanced their business interests while governing abroad. In addition, the respect and wealth obtained through successful trade advanced careers in government.

If a political career was pursued, there were a number of routes a patrician could take through the maze of councils, committees, magistracies, and posts abroad. As we have seen, however, not all positions resulted in a commission manuscript. Thus, a distinguished path focused on ambassadorships or committees of the *Collegio* would not produce a body of illuminated documents.[41] Instead, governorships invited the main visual trail of painted commission documents. Typically a young patrician would begin with election to the minor and less complicated towns to govern. These generally were granted for sixteen months to three years, and when he returned he might be elected to an office that allowed him to attend senate meetings. The highest places on committees of the *Collegio* to strive for were those of *savi grandi*, ducal councillors and members of the Council of Ten. Places on such committees, and governorship of Candia (Venetian Crete) in the fifteenth century, but then later of Brescia and Padua, were considered stepping stones to the highest offices as procurators of Saint Mark and as doge.[42]

Patrician identity was signaled by the family name, but not all lateral branches, or *rami*, of families were equally prestigious. Patricians with the same last name could be of very different economic and political levels, and different branches developed distinct identities. For example, the Grimani of Santa Maria Formosa, of which Antonio Grimani was the head, was one of the most important branches of the family, but there were several others, some with separate *case da statio* or main palaces, the locations of which provided geographical and architectural anchors of identity. Genealogy was critical to trace prestigious origins of the family, and to highlight a line of illustrious men, whose deeds added further dignity to the *casa*.

First or Christian names were important also to patrician identity, and in two ways. Typically one's most important patron saint was the onomastic saint, after whom one was named.

But the Christian name also referenced recent ancestors, for names typically were repeated over generations. Because so many patricians had the same names, they often are further identified in documents by the names of their fathers, or additionally even by their grandfathers, while the family name can be specified by branch. Whenever possible, patricians will be identified here by their father's name in addition to their own, and the branch of the family. It is not always possible, however, to fully distinguish the recipient of a given *ducale* from his homonyms.[43]

IMAGING THE PATRICIAN SELF

The possibility of discerning patterns of patronage in *ducali*, and of linking them to broader programs of commissioning in the arts, is dependent upon the survival and accessibility of relevant examples. This study is grounded in examination of over 1000 pertinent manuscripts or fragments that were made and illuminated during the period under focus, from 1382 to 1624.[44] This rather arbitrary time period was chosen because 1382 is the date of the first known surviving illuminated *Promissione* presumed to have been given to an individual doge, and because the quality of illumination in *ducali* generally declined in the early seventeenth century. The year 1624 marks the end of the dogeship of Francesco Contarini, one of the last patricians whose documents are discussed here. The documents under study presently are in over seventy private and public collections throughout Europe and the United States. *Ducali* were produced and illuminated until the end of the Republic in 1797, but as one might expect, the surviving and accessible documents are a fraction of all that were made and illuminated. Depending especially upon the waxing and waning of the empire and creation of governing positions abroad, an average of perhaps fifty patricians were elected to offices per year in the fifteenth and sixteenth centuries for which they would have

received a Commission that potentially would have been illuminated (see fig. 0.11).[45] Thus my database of 1000 full and fragmentary documents from 1382 to 1624 provided a large collection for study, but represents less than ten percent of the documents produced that potentially would have been painted.

From this group it is clear that to a great degree the decision to have one's *ducali* illuminated, especially with a portrait, was a personal one. There survive documents with extensive programs of painting for some patricians whose careers were not especially distinguished beyond election to a few lower-level governorships, and for whom there does not seem to survive much information, documentation, or other examples of their patronage of the arts. Many extremely ambitious patricians with successful careers in government, and who even were important patrons of art and architecture, were not concerned with having their documents illuminated with portraits, or had their documents illuminated only when they reached the highest levels of their service and when the expense was subsidized. For many extremely successful patricians who would have owned *ducali* manuscripts, simply none have been located or remain. The gaps in survival or availability of documents naturally prevent a complete mapping of attitudes towards embellishment of these documents and themes of their decoration. Where, for example, are the documents as procurator for Antonio Grimani's grandsons Marco and Vettor di Girolamo? Vettor especially was an important and innovative patron of art and architecture, and one might expect an interest in the special preparation of his manuscripts. But if one is disappointed not to find documents for many of the most influential patricians and patrons of art made familiar to us through historical and art historical studies, we may be content still to learn more about some famous protagonists, and to be introduced to the likenesses and self-presentation of numerous lesser-known patrician office holders.[46]

These lacunae also remind us that the three illuminated *ducali* of such a distinguished patrician as Antonio Grimani form an especially valuable record of a patrician and how he personally wished to be imaged. In fact, although there survive a number of monumental painted and sculpted portraits of Grimani, none seem to have been commissioned by him. Within each of his three *ducali*, Grimani is depicted as interacting with Mark, the patron saint of Venice, but he could have requested imagery from a wide range of possibilities. Groups of embellished documents made for individual patricians allow us to discern themes important to them as they progressed in their civic careers. In fact, by comparison to the *ducali* of other patricians, it is striking that Grimani's documents do not represent his onomastic saint, Anthony, or other common focuses of personal devotion such as Christ and the Virgin Mary, and such omissions must have been his choice.

Antonio's *Promissione* as doge, with its full-page illustration facing the opening text, is the most magnificent of his *ducali*. Because it draws on complex imagery specific to the office and the *Promissione* manuscript tradition, more detailed discussion of it will follow in Chapter 3. Most important here is to note that by the mid-sixteenth century, many rectors who never achieved the distinction of being elected procurator or doge also began to have their Commissions painted with full-page, and more loquacious, images.

This general development of greater elaboration and detail in *ducali* for lesser offices and more obscure individuals can be observed, for example, in a group of three Commissions as rector for Girolamo di Giovanni Andrea Venier (1525–1598) (figs. 0.12–0.14).[47] Girolamo was from one of the great families, and married into another one, the Pisani, but his immediate relatives did not circulate at the center of power and he had a substantial but not stratospheric career. In his documents, full-page illuminations with portraits of Girolamo each indicate the landscape of the region he was appointed to

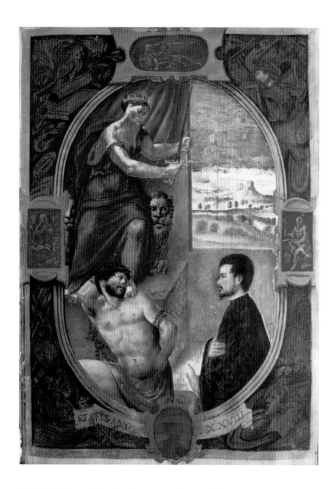

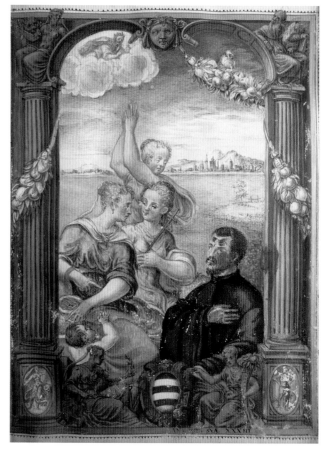

0.12 *Girolamo Venier Envisions Justice*, Commission to Girolamo di Giovanni Andrea Venier as *Podestà* and Captain of Sacile, 1555. 23.5 x 16.6 cm. Biblioteca Nazionale Marciana, Venice, It. VII, 1364 (=8122), fol. 1r

0.13 Giorgio Colonna (attrib.), *Girolamo Venier with Faith, Hope, and Charity*, Commission to Girolamo di Giovanni Andrea Venier as Captain of Brescia and Riviera di Salò, 1559. 23.5 x 16.5 cm. Biblioteca Nazionale Marciana, Venice, It. VII, 1352 (=8087), fol. 1r

govern. Female personifications emphasize his piety and devotion to key cardinal and theological virtues of good rulership. In the first document he calmly envisions Justice presiding over bound Vice, illustrating his dedication to rule as prescribed in the document.[48]

Each leaf displays Girolamo's relatively young age at the time of his appointment as a governor to a *reggimento* of the *terraferma*, the Venetian territories on the Italian mainland, from the ages of twenty-eight to thirty-eight. Girolamo's early ascent through the *cursus honorum*, or course of honors, the term

Venetians and other republics borrowed from ancient Roman use to describe an established hierarchy of government offices through which a patrician could advance, is effectively visualized in these manuscripts. The inscription of the sitter's age at the time a portrait was made was a practice well established by Northern European painters earlier in the century, and already adopted in Venetian portraiture. In the *ducale* context, the statement of Girolamo's age may also address and emulate ancient Roman interest in holding office at the youngest possible age, or *"in suo anno,"* which augured future success. More powerful

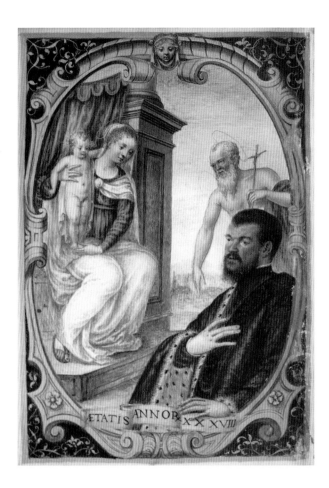

0.14 *Girolamo Venier in Adoration of the Madonna and Child,* Commission to Girolamo di Giovanni Andrea Venier as *Podestà* and Captain of Capodistria, 1564. 22.2 x 15.4 cm. Biblioteca Nazionale Marciana, Venice, It. VII, 1355 (=8116), fol. 1v

Despite Girolamo's success at a relatively young age, examples of his patronage of the arts, beyond commissioning images in his *ducali* and a modest tomb, are not known. By contrast in terms of the vicissitudes of survival, the illuminations of three *ducali* for Michele di Alvise Bon (1527–1586) are missing, having been spoliated already by the early seventeenth century, but the bindings, and components of a broader program of his self-imaging in the city, do survive (fig. 0.15).[51] To understand what the missing illuminated frontispieces of Bon's manuscripts may have looked like in relation to the surviving program of monumental portraits commissioned by him, one can examine manuscripts of the same period for similar posts to those held by Bon. Many of these are presented even more explicitly as if framed miniature versions of oil paintings. For example, Michele Bon was *Podestà* of Brescia in 1586. A full manuscript with two facing illuminated leaves for Sebastiano di Fantin Marcello (d. 1576), elected *Podestà* of Brescia in 1565, might suggest the nature of the missing illuminations for Bon's documents (fig. 0.16).[52]

The images in Sebastiano Marcello's manuscript have fictive heavy gilt wood frames, and the compositions, coloring, and motifs are indebted to the contemporary sculptors and painters Jacopo Sansovino, Titian, and especially Veronese. As in the Commissions for Girolamo di Giovanni Antonio Venier, these "paintings" show Sebastiano in devotion to the Madonna and Child, and female personifications of three virtues pertinent to his role in governing Brescia: Justice, Charity, and Temperance. Possession of the cardinal and theological virtues by patricians was deemed necessary for good governance, and justified rulership by the hereditary aristocracy.[53] Venice came to be personified herself as Justice, first in a roundel on the west façade of the Ducal Palace in the mid-fourteenth century, and later in

positions in Venice as ambassador to important rulers, as ducal councillor, or as a member of the Council of Ten, were typically not arrived at until one was at least in one's forties. In fact, Venice was known as a gerontocracy. Between 1400 and 1600, the average age of a doge upon election was seventy-two.[49] Girolamo Venier's precocious elections as a rector in his twenties and thirties, then, truly merited being celebrated with paintings in his documents and they may indicate great ambition for higher office, which culminated in his election as lieutenant of Udine.[50]

0.15 (Left) The Mendoza Binder (Andrea di Lorenzo da Verona?), lower cover, Commission to Michele di Alvise Bon as *Podestà* of Montagnana, 1552. Gold-tooled leather, 24.5 x 17.5 cm. Bodleian Library, Oxford, Laud misc. 710

0.16 (Below) Morgan Master (attrib.), Commission to Sebastiano di Fantin Marcello as Proveditor and Captain of Salò and the Riviera del Garda, 1565. 22.6 x 16.6 cm. Bibliothèque de l'Arsenal, Paris, MS 8596, fols. Av–1r

numerous multivalent images. Thus the figure of Justice can also be read as Venice herself.[54]

In the facing leaf of the Marcello *ducale*, Mary leans over to allow the Christ Child to bless Sebastiano. This specific motif of Christ blessing the patron is found in Venice already in the early fourteenth century, and came to be common not only in the so-called votive paintings of Doges destined for the Ducal Palace, but also in smaller paintings for other patrician patrons.[55] Marcello's onomastic saint, Sebastian, is depicted in a

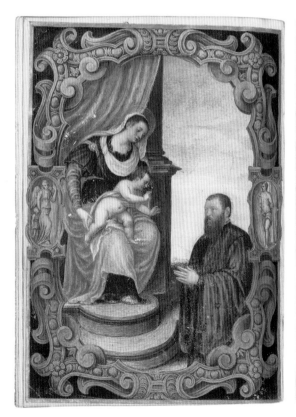

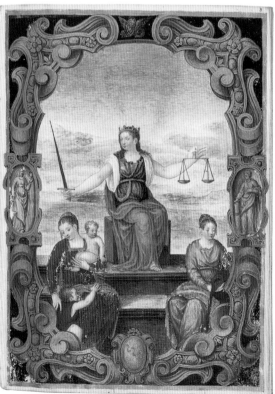

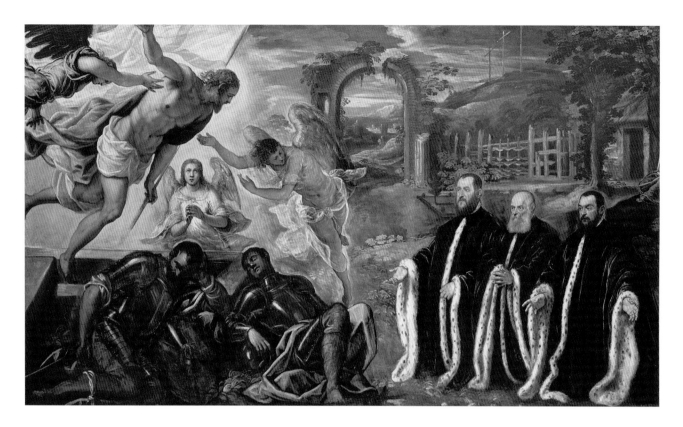

0.17 Jacopo Tintoretto and studio, *Three Avogadori di Comun and the Resurrection of Christ*, c.1571. Oil on canvas, 268 x 460 cm. Hall of the Avogaria di Comun, Doge's Palace, Venice. Michele di Alvise Bon is shown third from right

monochrome cameo in the faux elaborately carved frame to his right. In sum, the diptych of opening leaves to Marcello's Commission draws on themes found in panel painting and in sculpture in both public and domestic contexts. These implicated individual patricians and their families in the ethically, indeed divinely, inspired administration of the state. The patrician is represented as sent to preside over Venetian territories, blessed by Christ, and qualified to rule by his many virtues.

Although Michele Bon's portraits are missing from his Commissions, his likeness is recorded with those of his fellow state attorneys (*avogadori di comun*) in a painting by Tintoretto for the office of that magistracy in the Ducal Palace sometime after he took office in 1570 (fig. 0.17).[56] We can recall here that this was the office in charge of keeping track of the legitimacy of members of the Great Council, as well as overseeing and executing laws and regulations in a great number of other areas of state. Bon, third from right, gestures in reverence and astonishment with his fellow

magistrates, as they witness Christ's resurrection. This painting is just one of a number of similar canvases of magistrates, all in the red robes, or "toga" of their office, that now dominate the upper walls of the hall, and which were generally commissioned and paid for by the magistrates during their tenure (fig. 0.18).[57] These images embed Bon in a lineage of wise patricians of this office. The message conveyed is that they are inspired and authorized to lead by virtue of their great religious devotion, and that they are thereby also honest and honorable. The lawyers embody the office, but the magistracy and its authority lives beyond them.[58]

Prominent nobles participated in commissioning and determining the visual programs of the public spaces of their family altars and chapels, as well

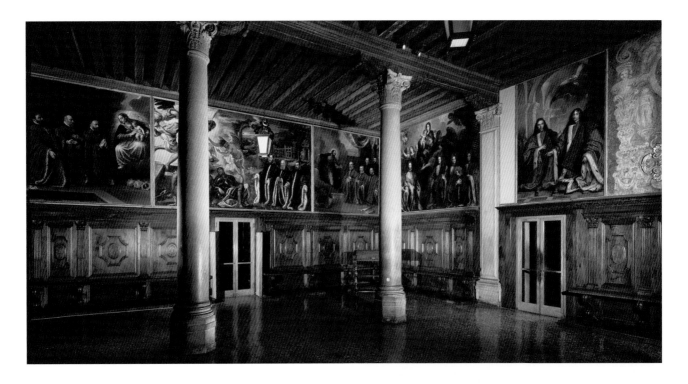

0.18 Hall of the Avogaria di Comun, Doge's Palace, Venice. The pictures originally may have been shown in a somewhat different order

0.19 Jacopo and Domenico Tintoretto (attrib.), *Michele Bon and his Wife Envision Saint Michael the Archangel Battling Lucifer*, altarpiece of Michele di Alvise Bon, c.1581. Oil on canvas, 380 x 180 cm. San Giuseppe di Castello, Venice

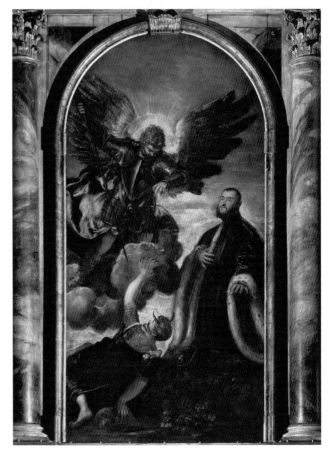

as in the offices of various magistracies, and in the Ducal Palace. Bon had himself portrayed in a painting that has been attributed to Jacopo and Domenico Tintoretto, for his altar in the Church of San Giuseppe (Sant'Iseppo) di Castello, where he and his wife were entombed. Here he witnesses his onomastic saint, Michael, battling Lucifer (fig. 0.19).[59] The iconography and compositions of the lost miniatures of Bon's manuscripts were, most likely, related in imagery to those in the large-scale paintings he commissioned, to create a consistent, but nuanced and layered, visual presentation of Bon as a pious patrician dedicated to serving the Republic. The manuscripts kept in Bon's home probably held domestic, miniature versions of his image displayed in public spaces.

THE DOCUMENT AS ATTRIBUTE AND SYMBOL

While holding office, patricians were to maintain and regularly consult the regulations of their relevant *ducali* documents. When they arrived at their posts abroad, rectors could present the texts and images of their Commissions as proof of their identity and authority to govern. But the manuscripts also functioned as signifiers when closed. Their bindings encompass a variety of styles and techniques, including gold-tooled leather as in Bon's documents, painted, varnished and layered leather, expensive brocades and velvets, and silver, according to the fashions of the era and tastes of the recipient. Such material sumptuousness caused the documents to command greater attention visually when in use, and to stand out among the scores of documents maintained and consulted in private family archives. They became instruments, along with architectural settings, costume, and ritual, in the "spectacle of power" of the Venetian state as well as in the memorialization of patrician individuals and their achievements.[60] In independent portraits, the image of such manuscripts with fine bindings and the ducal seal could be employed as attributes of an individual and his office.[61]

In a portrait of Gianfrancesco di Nicolò Sagredo (1571–1620) as consul of Syria, the patrician proudly displays his Commission document, identifiable by the ducal seal and tassel, bound in crimson velvet with silver fixtures (fig. 0.20).[62] Nicolò di Alessandro Contarini (1658–1725), elected as *Podestà* of Padua in 1704, shows his Commission for that post, which was bound more ostentatiously in silver *repoussé* (fig. 0.21).[63] In a posthumous portrait of the Procurator Antonio di Giovanni Grimani (1554–

0.20 Leandro Bassano (attrib.), *Portrait of Gianfrancesco di Nicolò Sagredo*, 1619. Oil on canvas, 113.9 × 101 cm. Ashmolean Museum, Oxford, WA1935.97

0.21 Antonio Balestra (attrib.), *Portrait of Nicolò di Alessandro Contarini as Podestà of Padua*, elected 1704. Oil on canvas, dimensions unknown. Antichità Pietro Scarpa, Venice

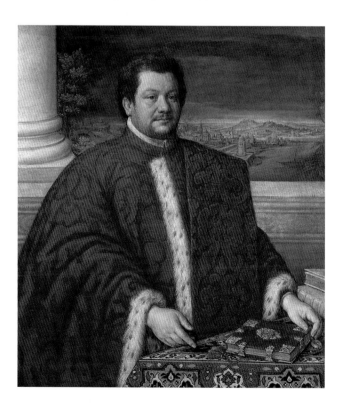

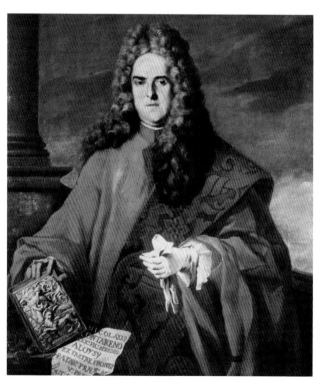

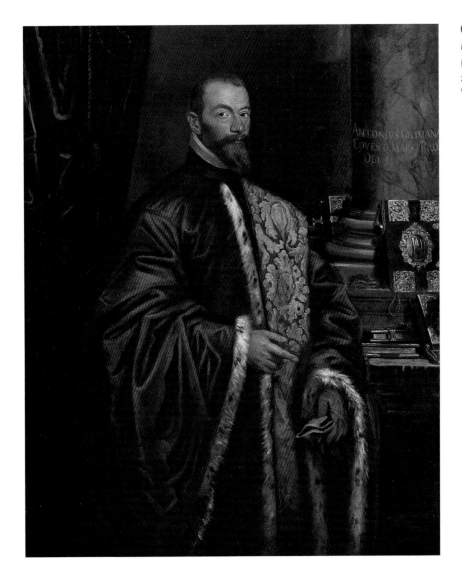

0.22 Domenico Tintoretto (attrib.), *Portrait of Antonio di Giovanni Grimani (dai Servi)*, 1624. Oil on canvas, 113.9 x 101 cm. Collezione Banca Popolare di Vicenza, Inv. 29630

1625), of a different branch (called "dai Servi") from the family of Doge Antonio Grimani, he is surrounded by a number of manuscripts identifiable as Commissions by their size, elaborate bindings, and seals (fig. 0.22).[64] The group evokes his entire successful governmental career, culminating in his election as a procurator of the branch called *de ultra*.[65]

THE USES OF A DOCUMENTARY IMAGE

Doge Antonio Grimani's concern for the preservation of his "*Promissioni*" at his death confirms that although these manuscripts were authored and written out under state auspices, they were destined for preservation in the family. Nevertheless, Grimani's special consideration of them in his last days was unusual, and can be linked to two challenges to his legitimacy as doge, and by extension to the reputation of the entire *casa* Grimani. We may recall that the doge had appealed for harmony among his male heirs. It was common for Venetian patricians to do so in their last testaments, but Antonio would have been particularly concerned about restoring cooperation between his son Vincenzo and grandsons Marco and Vettor, for they had been arguing for some months over the

incapacitated doge's right to stay in office. The *Collegio*, the major executive council of Venice, had been pressuring the doge to resign from the highest office of the Republic, to which he had been elected for life two years earlier. Whereas Vincenzo wanted his eighty-nine-year-old father to capitulate to the inducements offered by the *Collegio* to leave office, the nephews desired that their grandfather remain in power because otherwise they would have to move out of the Ducal Palace and lose associated privileges. On the nephews' placement of their personal interest above that of the state, despite patrician rhetoric of selfless service, Sanudo sardonically commented "that's how things go here."[66] In the end, the doge remained in office, but one can imagine that he must have experienced the call for his resignation as a threat to his dignity, and to his legacy.

The second reason the doge may have been particularly concerned with the preservation of the documents of his official achievements is linked to the fact that not one but *two* documents had been made for him as procurator.[67] Since election as a procurator of Saint Mark was for life, normally one would not be created a procurator a second time. But Antonio Grimani had lost his first title and had even been condemned to exile to the Adriatic island of Cherso (now Cres, Croatia) almost twenty-five years earlier. Indeed, he narrowly escaped execution for failing, while captain general, to engage his forces in sea battles against the Ottomans along the western coast of the Morea, in August 1499. This lack of leadership, which some interpreted as betrayal, contributed to Venice's loss of the town of Lepanto (Naupactus), a key foothold in the Mediterranean. Through the intensive efforts of his sons and nephews, and a changed political climate in the 1520s, Antonio Grimani eventually was able to return to Venice, become elected again as procurator of Saint Mark, and ascend to the ducal throne. Nevertheless, at the height of his career there

were still those who perceived Antonio primarily not as doge but as a cowardly captain, the "ruin of Christians."[68] Antonio must have wanted the manuscripts kept in the family to document the fact that his honor, and that of his family, had been restored; that his enemies had judged, and perhaps still remembered, his actions wrongly. He wanted to fix a felicitous memory of himself through the preservation of key documents of his honor and service to the state.

Antonio Grimani's wildly oscillating fortunes reveal the often precarious status of even wealthy and powerful patricians, and how much could be at stake in negotiating and preserving a positive image of one's actions and career. His was a particularly dramatic version of the position faced by all men legitimately born to noble families in the Venetian oligarchic and hereditary Republic. They were expected to participate in government when they came of age, but had to be elected to positions of real power. In addition, they could lose everything, including their lives, in military service, or if their political enemies judged that they did not perform their duties as rulers adequately. In fact, by the thirteenth century there was already a pattern of placing blame on a top leader in times of crisis to avoid it being borne by the patriciate as a whole.[69] Despite the ideology of equality among patricians, the willingness of the body politic to find an individual culpable in complex situations reveals tensions between factions of powerful patricians, and resentments of poor patricians against the wealthy.[70] Antonio Grimani's enemies seized on his subpar performance as captain general to accuse him of sedition and betrayal, making him a scapegoat for a loss felt keenly by the Republic. His *ducali* were valuable in officially recording only the high points of his career, and his dedication to serving Venice.

We shall return to the collecting and commissioning strategies of the Grimani of Santa Maria Formosa in relation to *ducali*. For almost a

century after Antonio's death, his heirs patronized the arts to shape the memory of his life and career. As will be argued, towards this end, the painting in his ducal *Promissione* even came to be utilized as a compositional model for a major public monument. Grimani's manuscripts, and *ducali* generally, were hybrids of documentary record and artistic patronage. They could be consulted, appreciated for their craftsmanship, and referenced by future generations as historical evidence of distinguished service to the state by illustrious forebears.

<center>* * * * *</center>

The self-presentation in *ducali* by a number of patricians, some with controversial careers and others not, will be examined throughout this book. A word about organization will serve to further introduce the material. Part I, entitled *Material and Symbol*, examines *ducali* from the broader perspective of the special symbolic and practical roles of material books and documents in Renaissance Venice, for it is in this cultural context that *ducali* were produced, embellished, and perceived. Chapter 1 considers how the famed ensign of Venice, the lion of Mark holding an open book, enhanced perception of *ducali* as symbols of authority in Venice. Chapter 2 briefly outlines the key roles of *cittadino* (non-patrician citizen) chancery officials, patrician administrators, and artisans of the book in the creation of these documents as monuments. The storage of *ducali* in private family archives is compared to documentation of patricians in the state archives. Part II, entitled *Evolution*, examines the development of each of the three main kinds of illuminated *ducali* in relation to the relevant patrician offices. The funding and production for each of these was different, and special imagery evolved for each type in relation to the nature of the office. Consideration of the three main classes of *ducali* begins in Chapter 3 with the earliest, rarest, and highest form, the

Promissione of the doge. Chapter 4 investigates the development of the Commission/Oaths of the procurators. Legislation of the late sixteenth century restricting the rapidly rising funding for these documents reveals that by then they had become a prized arena for expression of a civic self. Chapter 5 is concerned with the last but largest class of these documents that came to be painted, the Commissions of the rectors. These especially express patrician identity in relation to the Venetian sense of its territories and international security. To convey the historical evolution of the decoration of these documents, and a general shift from state to individual agency in painting in them, discussion of the main categories of *ducali* is in reverse order to that in which a patrician would have obtained such documents over the course of his career. For this reason, Part III, entitled *Themes and Programs*, shifts to a thematic approach and examines groups of manuscripts for individual patricians for whom such sets of documents can be reconstructed. Where possible, the imagery of *ducali* are analyzed in the context of broader programs of patronage, to show that such illuminated documents could be essential components of patrician self-imaging. Chapter 6 considers the documents of several Venetian rectors in relation to their commissioning of portraits and memorials abroad, to show how they took advantage of service in subject territories to patronize the arts and to broadcast their name in ways they could not at home. Chapter 7 investigates paintings in *ducali* of the second half of the sixteenth century that memorialized patricians in relation to the Holy League and the Battle of Lepanto. It highlights the importance of the ceilings and walls of the Ducal Palace as fields for paintings proclaiming Venetian civic ideals in order to suggest that *ducali* offered analogous but smaller and more personal spaces for expression, available to more patricians. Throughout the book it is argued that *ducali* evolved in the Renaissance

as hybrid objects, significant to many of the original owners both as documents and as artworks. In the Conclusion the collecting strategies of the Grimani are examined further for broader consideration of how painting transformed documents of temporary value into memory objects, which authenticated and preserved individual and family status, in relation to the state. The transformation of *ducali* into memorials of individuals through their embellishment reflected the broader symbolic resonance invested in certain key manuscripts by the patriciate as a whole, in part as led by the Grimani. The Epilogue discusses the dispersion and collecting of *ducali* because various trends in the collecting and appreciation of these documents have determined to a great degree which ones have survived, and in what state. Many of the most impressive *ducali* miniatures are now detached from their manuscripts because, by the nineteenth century, they had come to be appreciated as small-scale examples of painting by Venetian Renaissance masters. Paradoxically, this fragmented state of many of the most appreciated *ducali* miniatures has caused them to be the most difficult to identify and study. Early admiration of these miniatures

by collectors, then, has contributed to their being relatively neglected in art historical study.

Because of the many documents, artists, and patrons discussed, an index of patricians cited, a glossary, and a list of document manuscripts by current location are included to aid the reader. It is hoped that the bibliography of printed editions of *ducali* texts will aid those who wish to read full examples of these documents.

A note on terminology: The artists most consistently dedicated to painting in documents and books in Venice were defined legally as *miniatori,* or miniaturists, within the guild of painters. The term originated in the Middle Ages with the common use of minium, or red sulphide of lead, in the painting of manuscripts.[71] By the sixteenth century, "miniaturist" had become associated with a "painter of small things" to quote Vasari, and eventually with a category of diminutive portraits.[72] But miniaturists in Venice painted not only in manuscripts and books, and not only on a small scale, and artists who worked primarily in other media also painted in *ducali*. For these reasons, at times the terms painter, illuminator, and miniaturist will be used interchangeably, as will the terms painting, illumination, and miniature.

PART I
MATERIAL AND SYMBOL

"*With God the creator governing our duchy* [because of] *the prayers of Saint Mark* [...] *and bestowed to us through the authority of heavenly grace, we complete wars successfully and adorning peace with laws, we uphold the state of our fatherland more honorably.*"

PROLOGUE TO THE *STATUTA VENETA*
OF DOGE JACOPO TIEPOLO, 1242[1]

PAX
TIBI
MAR
CE E

VAN
GELI
STA
MEVS

CHAPTER 1

THE BOOK IN THE LION'S CLAWS

ANTONIO GRIMANI'S DOCUMENTS as procurator portray him taking the oath of office on a Gospel Book, and receiving a commission directly from Saint Mark (figs. 0.3, 0.4). Both the government document and the Gospel manuscript are represented in these images as material bridges illustrating the reciprocal relationship between the patrician and the divine: Grimani receives the law and executive authority from Mark, and in return swears to serve him. Certain procurators especially served Mark as custodians of his relics and his Basilica, the state church. But images of the saint conveying privilege and duty through a codex came to be one of the most popular themes in the Commissions to the rectors as well (fig. 1.1). Because Mark was one of the four Evangelists, and therefore a messenger of the Word of God in writing his Gospel, the laws of Venice visualized as transmitted by Mark through rulebooks granted to patricians are represented as having a status similar to that of the Divine Word. By extension, the patricians who authored and executed these laws are shown to hold sanctioned authority. In fact, Venice's key emblem, the winged lion of Mark with an open book, proclaimed Venetian law and power as divinely authorized, and was the only civic symbol of a major Italian city in which a book features prominently (fig. 1.2).

The imagery that emphasized the authority of patricians as directly from Mark acquired greater resonance in the early fifteenth century, when Venice procured a section of Mark's Gospel believed to have been written in his own hand.

(Opposite) Detail of fig. 1.2

1.1 (Right) Giovanni Maria Bodovino (attrib.), *Saint Mark Gives Andrea Contarini his Commission Manuscript*, leaf detached from the Commission to Andrea di Pandolfo Contarini as *Podestà* of Bergamo, 1583. 21.9 x 14.9 cm. Fitzwilliam Museum, Cambridge, Marlay Cutting It. 52

The maintenance of this relic-document in the Basilica, where many chancery documents and records of the procurators also were archived, and its presentation in church ritual, literally substantiated the message of divine favor portrayed in images of Mark granting patricians their document. This chapter examines the symbolism of books and documents in codex form as transmitting law and sanction in Renaissance Venice, for this is the cultural field within which patricians had their *ducali* produced and embellished, and in which the documents were perceived. Representation of Venetian laws as divinely authorized was central to the myth of Venice as an ideal Republic. Codices were important symbols of authority in general in the Middle Ages and Renaissance, but found special formulation and significance in Venice.[1]

MYTH AND LAW

Gasparo Contarini's *Commonwealth and Government of Venice*, first published in 1543, was a central text in which the myth of Venice was codified and transmitted abroad, and he especially extolled the excellence and wisdom of the Venetian form of government and its laws, as well as the virtues of its rulers.[2] The status of an individual within Venice, and the prescribed

1.2 Carpaccio, *Lion of Mark*, 1516. Canvas, 139 x 368 cm. Formerly over a doorway in the Camerlenghi di Comun, now Doge's Palace, Venice

conduct and image of the state within the world, were formed and mediated not through one single text or document, but by a large variety of statutes and legislation (*ordini*), which we can call collectively the constitution.[3] Some of these, such as the civil law statutes (*Statuta Veneta*), were general guidelines applicable to all residents of Venice, and these are the governmental texts most typically found in Venetian book inventories across social classes (fig. 1.3).[4] Other statutes regulated a particular bureau or council (*consilia/organo*), and generally were retained only in the relevant chancery.[5] As discussed earlier, the *ducali* manuscripts that are the focus of this study were rulebooks given only to individual patricians elected to certain offices.

The texts of Venetian laws and statutes accumulated and expanded over centuries, and came to regulate almost every aspect of the city and the life of its citizens, from the construction of the pilings that underlay the physical foundation of the city to the administration of its empire. The manuscripts examined here constitute a tiny fraction of the extensive and ever-increasing creation and copying of texts that

structured the legal and administrative core of the state – the material products of a remarkable bureaucracy. Venice came to be particularly prolific in the creation and preservation of rulebooks and documents, which may have contributed not only to its mythic perfection and actual longevity, but, some would argue, also to an eventual stasis.[6] Such documents encoded the rules of power relationships that could then be conformed to, or subverted. They are the physical manifestations of what has been called "pragmatic literacy," as opposed to that which produces literary texts. Indexical markers such as signatures and seals (collectively called *emblems*

by Richard H. Britnell and Roy Harris), like those on *ducali*, link a document to specific persons in an official capacity, confirming the document's authority. They are, therefore, often critical to this sort of manuscript.[7] The collecting of such documents in state and patrician family archives affirmed a web of power relationships and projected the continuity of authority for centuries.[8]

CODEX AND AUTHORITY

The symbolism of the book as attribute of authority in Venice originated in long-standing church traditions. Like all great temporal powers

1.3 Opening initial "D" with Saint Mark, Prologue to the *Statuta Veneta* (1242), c.1346. 30 x 22.2 cm. Law Library, Library of Congress, Washington, D.C., KKH8501. A17 V46 1346, fol. 1r

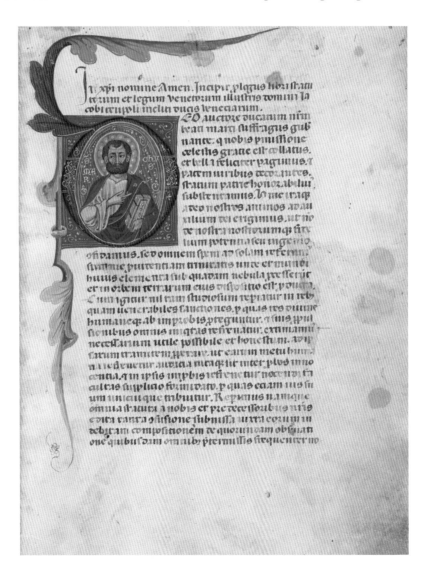

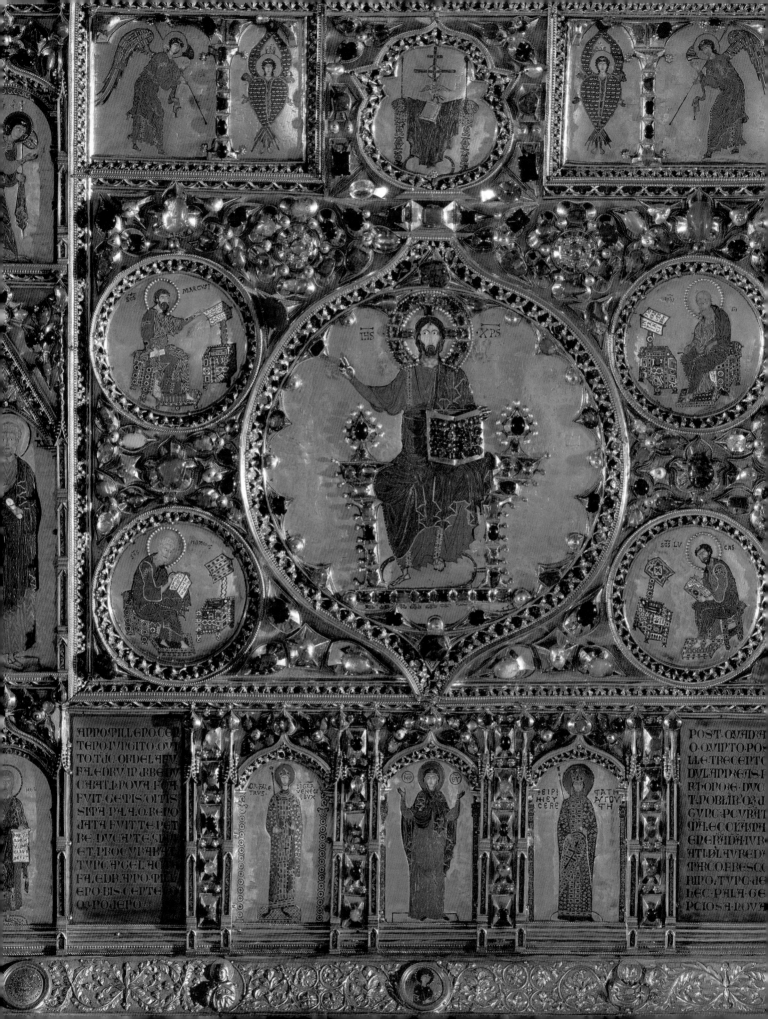

of Europe in the medieval and early modern era, Venice considered its laws and legitimacy as granted by God, and believed that the state served Christ. Patrician service and devotion to the Republic were inseparable from religious faith and action.[9] The very fate of Venice was seen to depend upon God's favor. As Christianity developed in the early Middle Ages, it increasingly evolved as a religion intertwined with the technology of writing, its central texts chosen and translated through custody of the church, mediating between God and believers. The image of a scroll or codex could represent the Word of God and divine authority.[10] The codex form, as opposed to the scroll, was associated particularly with the Christian faith, and became one of the most common identifying attributes in images of the Evangelists.[11] The books they held symbolized their role as transmitters of the Word and the New Law of the Gospels, while the Hebrew Bible prophets typically retained the scroll as an attribute. Images of Christ with a book generally symbolize him as the Word, God and the Word being one according to the Gospel of John (1:1).[12] A prominent example in Venice is the jeweled cloisonné enamel of Christ as Pantokrator (All-Powerful) and as Logos (the Word) at the center of the Pala d'Oro, the main altarpiece of the Basilica of Saint Mark (fig. 1.4).[13]

Christ himself could be referenced in literature and art simply as a book, as the Word incarnate. Material Gospel Books, especially, were understood as inanimate intermediaries embodying Christ, invested with transitive power to convey the living Word to believers.[14] In response to such weighted metaphors of books as embodying the sacred, keen attention was directed to the material presentation of texts. Church leaders and Christian rulers patronized the arts of manuscript production, commissioning

1.4 Byzantine Master, *Christ Pantokrator*, Pala d'Oro (detail), 11th century. Cloisonné enamel, central roundel diameter 37 cm. Basilica of Saint Mark, Venice

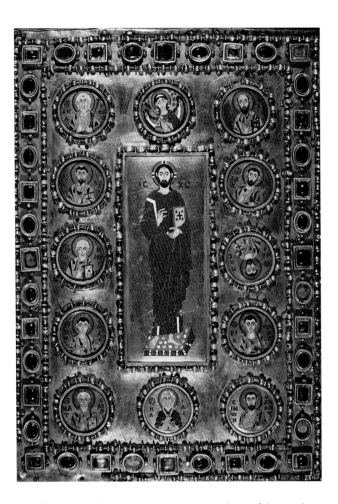

1.5 *Christ Pantokrator*, upper cover, Evangeliary of the Basilica of Saint Mark, Byzantine, late 10th to early 11th century. 29 x 21 cm. Biblioteca Nazionale Marciana, Venice, Cod. Lat I, 100 (=2089). The mid-14th-century liturgical manuscript that was inside this cover contains sections of the Gospels in the order they were read during Mass, and public offices of the Basilica of Saint Mark

sumptuous volumes to declare themselves as intercessors of divine authority in presenting the Word.[15] Thus, around the same time that the Pala d'Oro was refurbished in the mid-fourteenth century, a splendid new set of liturgical books was produced for use on this same altar (fig. 1.5). The texts of these guided the participation of the doge and the *primicerio*, the head priest of the Basilica, in the liturgy of the state church.[16] The oaths of the procurator and doge were taken on these manuscripts in their inauguration ceremonies. The sumptuousness of the volumes

highlighted the sacred nature of the texts, their role in bridging the oaths of the top officials of Venice, and the privileged status of the clergy and patricians who handled them.

The sculpture on the northwest corner of the façade of the Ducal Palace complement the symbolism within the Basilica of books as representing and disseminating the New Law of Christ, by illustrating the role of material texts in transmitting the Hebrew Bible and secular legal traditions (fig. 1.6). The large corner relief by Bartolomeo Bon depicts the Judgment of Solomon, to highlight the king as the biblical exemplar of the wise ruler and judge.[17] Several reliefs on the capital below Solomon illustrate the critical role of material texts in transmitting law and justice. Among these sculptures is one that shows Moses receiving the first written laws of God, the tablets of the Ten Commandments (fig. 1.7).[18] Thus, the sculptures of this column highlight the centrality of the medium of writing in transmitting law, and claim that the justice meted out in Venetian legal courts, which were located in this wing of the palace, followed divine and venerable historical precedent. The laws and documents of Venice were conceived of as authored by Venetian rulers and administrators through divine guidance, and Venetian rulers were promoted and exhorted to remain as just and wise as Solomon. The Venetian government and its rulers extensively employed images of codices to further emphasize their authority and laws as divinely sanctioned. Indeed, the most common symbol of Venetian authority was the lion of Mark holding a book.

1.6 (Left) Porta della Carta and northwest corner of the Doge's Palace, Venice, 1422–43

1.7 (Below) *Moses Receives the Ten Commandments*. Detail of capital, northwest corner of the Doge's Palace, Venice, 1422–38

1.8 *Lion of Mark* with its paws on an open book, Piazzetta, Venice, composite from before 1293. Lion: 260 x 440 cm. Cornell University Library, Ithaca, NY. Rare & Manuscript Collections, A.D. White Collection, 15/5/3090.01429

THE LION OF MARK

Wherever one goes in Venice and its former territories, one is greeted and accompanied by the lion of the Evangelist Mark with a volume in its claws, the apocalyptic sign of Venice's patron saint and the standard symbol of the state and its authority achieved by means of his favor and protection.[19] Just as the saint presided in the city, he oversaw the territories Venice ruled.[20] While serving in office, a patrician holding his document thus was echoed and reinforced visually by this symbol of the higher power that authorized him and whom he was to obey. During the period of the Republic the lion, with or without a book, was ubiquitous, appearing on the ephemera and tools of everyday life, including coins, official seals, and the banners of festivals and processions, as well as on public and private monuments and within government documents.[21] Most of these lions were created in Venice, but some of those sited in the city were felines appropriated from elsewhere. The lions of the phalanx that guards the Arsenal gate were brought from Greece in the seventeenth and early eighteenth centuries. Their placement in front of the main entrance to the naval yards,

where war ships were constructed, reminds us of the fierce aspect conveyed by the Evangelist's symbol.[22] By contrast to the Arsenal lions, the official lion symbol of Venice is no natural animal – in addition to grasping a book, he is winged.

The most famous of these winged lions, and the first to greet visitors arriving by water to the Piazzetta of Venice, is perched atop one of the two columns of the *molo*, or jetty (fig. 1.8). This bronze creature is a hybrid made from elements taken from Byzantium. Wings were added, and an open book placed beneath his front paws.[23] The winged lion as symbol of Mark originated in Christian interpretation of the lion among the tetramorphs around God's throne in Ezekiel's vision of the Old Testament, and of the four creatures around the throne in Revelation.[24] The authors of the Gospels became associated with the creatures of Revelation, and these winged figures usually show that they symbolize the Evangelists by carrying their books with the Word of God, written in their hand (fig. 1.9). The lion of Venice thereby represents not just the authority of Venice and its protection by Mark, but ultimately by God, who inspired the Evangelist to write, and by Christ as the Word of the New Law of the Gospels.

This winged lion with a book took many forms after Venice stole Mark's body from Alexandria in 829, and claimed the cult of, and special protection by, the Evangelist away from Aquileia and Grado, which were contesting seats of the patriarchate, as will be explained further.[25] The book was originally closed, but often came to be shown open with inscriptions.[26] The most common text in Mark's book became "*Pax tibi Marce Evangelista meus*," or "Peace be with you, Mark my Evangelist" (fig. 1.2). The inscription on Mark's book references the *praedestinatio* or predestination legend, according to which an angel announced to Mark in a dream, "Peace be with you, Mark – Rest here," when he was sleeping on the island of the *rivolatina civitatis* or future Venice.[27] This phrase, which simultaneously emphasizes Mark's destiny as protected by and as protector of Venice, had entered the *praedestinatio* script already under Andrea Dandolo (doge 1343–54).[28]

But the first known example of the *praedestinatio* phrase imaged on the lion's book accompanies a portrait of Doge Francesco Foscari (doge 1423–57) above the main, ceremonial entrance to the Ducal Palace courtyard, the Porta della Carta, sculpted in the early fifteenth century (fig. 1.6).[29] What was to become the standard text written on Mark's book alludes to Venice's protection of the saint in his tomb in the Basilica, as well as his favor for and protection of the city. That the inscription is not from the Gospels is significant – it is this text in an open book, ultimately, that distinguishes a feline with a book as the lion of Venice from generic representations as one unit of the tetramorph (fig. 1.9).[30] But there were other texts in the lion's book that confronted the visitor to diverse magistracies of Venice, in large painted or sculpted images hung over the entrance doors, or which could be read on the books of various lions in other settings. The lion and his book that originally graced the entrance to the law offices of the *avogadori di comun*, or the state prosecutors, emphasizes that good

laws restrain the passions of men.[31] The book of Mark's lion, therefore, is not a casual accessory or attribute, but a potent symbol of the claimed apostolic foundation of the Venetian state, of Venice's protection of Mark, and of its laws and administrators as mediating the will of God through Mark to the people of the city and its territories.

In addition to the open or closed book as a static sign of authority, images of the giving of books and scrolls became important for conveying the transfer of divine power in the Middle Ages, and these are the precedents to images of Mark

1.9 Plaque with *Agnus Dei* on a cross between emblems of the four Evangelists (clockwise from the upper left: Matthew, Mark, John, Luke), South Italian (perhaps Benevento), 974–1000. Ivory, 23.5 x 13.7 cm. Metropolitan Museum of Art, New York. Gift of J. Pierpont Morgan, 1917, 17.190.38

1.10 *Christ and the Apostles*, relief panel, modified in the mid-13th century (?). 111 x 300 cm. Reliquaries Chapel (Sanctuary) of the Basilica of Saint Mark, Venice

granting a book to patricians. The iconographic theme of the *traditio legis* or "giving of the law" had developed in Rome by the fourth century. In such imagery Christ hands Peter a scroll or book, in the presence of Paul, to illustrate the transmission of the Word and divine authority through the apostles, and the establishment of the New Law to supplant that of the Old Testament. This theme was revived in the thirteenth century in Rome, and it has been argued that around the mid-thirteenth century Venetian artists modified a sarcophagus front to create a variation on it, in a relief now set in the north wall of the Reliquaries Chapel in the Treasury of San Marco (fig. 1.10). Christ stands in an aedicule in the middle of the relief amid his apostles, and blesses one who advances towards him, holding a book carefully balanced on voluminous drapery. Otto Demus and Debra Pincus have argued that Venetian artists subtly transformed previous compositional models of the *traditio legis*.[32] In earlier sarcophagi, the advancing apostle typically

holds out an empty cloth in which to receive a scroll from Christ. In the Venetian relief it seems that Mark, instead of Peter, already has a codex manuscript, which he appears to present instead to Christ, who blesses him. The codex, by contrast to the scrolls that the other apostles hold, may be meant to represent Mark's Gospel.[33] In this way, emphasis on Mark's role in transmitting the Word through the writing of his Gospel seems intended.

This mid-thirteenth-century Venetian sculpture portrayed transmission of the Word, and perhaps Mark's important role in its transcription, around the same time that Doge Jacopo Tiepolo ordered that a new and definitive edition of the civil and criminal statutes of Venice be compiled.[34] In the prologue to these revised *Statuta Veneta* (completed in 1242), in a paraphrase of the opening to Emperor Justinian's *Digest*, or code of law, Tiepolo declared that he governs under God's rule through Mark's prayers (fig. 1.3).[35] A century later, Venetian officials could be figured as taking their oaths on manuscripts offered by the lion of Mark, and the oath-taking or acceptance of office by Venetian officials from Mark became a standard image in *ducali* (fig. 2.2).

WRITTEN BY THE HAND OF MARK

On June 24, 1420, the vigil of the feast of the apparition of Saint Mark (*apparitio Sancti Marci*), Doge Tommaso Mocenigo (doge 1414–23) and members of the *Signoria*, a supreme governmental authority that included the ducal councillors, collected a manuscript fragment from the island of Murano, where it had been sent from Cividale del Friuli in the foothills of the Dolomites. The Venetian officials carried the book in solemn procession around Piazza San Marco and into the Basilica, to deposit it finally in the church treasury.[36] It will be referred to here as the *Vangelo* to distinguish it from other Gospel Books. The leaves of this fragment in Venice have deteriorated badly, but the better preserved parts of the manuscript, now in Prague and Cividale, display a Latin uncial script that has been dated by modern paleographers to the sixth century of the Common Era.[37] At the time, however, it was believed to be the Gospel of Mark written by the saint's own hand.[38] It was, therefore, simultaneously precious as a relic of the Word of God as transmitted by Mark, and as a contact relic of the trace of the hand of Venice's patron saint. The Gospel fragment has an impressive gilded silver binding as its reliquary (fig. 1.11), which iconographic and stylistic evidence suggests was made in Aquileia in the fourteenth century, before the manuscript's transfer to Venice.[39] It is the reliquary binding that identifies the importance of the substantially decomposed fragment as a relic.

The imagery of the binding highlights the further significance of Venice's triumphant acquisition of the leaves written by Mark. The front shows an enthroned Saint Peter, who charges Mark to write, and according to one popular tradition Mark wrote the words of his Gospel from Peter's dictation. On the back cover, below a crucifixion scene, Mark writes his Gospel, and presents his disciple Hermagoras to Peter, who concedes him the pastoral staff, sign of Hermagoras' accession as first bishop of the Roman province of Venetia and Istria. The coats of arms support Aquileia's patriarchal title and jurisdiction as allegedly founded by Mark, with simultaneous allegiance to Peter and the papacy.

The cities of Grado and Venice had challenged the authority of Aquileian apostolicity and Mark's favor since the eighth century, Venice most decisively with the acquisition of Mark's body from Alexandria in 827. Upon acquiring the body, Venice forged a new identity independent of Byzantium and Rome, and underscored its lucrative trade with Egypt and the Middle East.[40] After Venice conquered Cividale in 1419 and Udine in 1420, the temporal rule of the Patriarch of Aquileia, whose residence by that time was in Udine, was secularized to become the Patria of Friuli, overseen by the Venetian lieutenant of Udine. The Aquileian Cathedral chapter

1.11 *Saint Peter Directs Mark to Write his Gospel*, upper cover of the Gospel of Mark (*Vangelo*), 1319–32. 32.2 x 26.7 cm. Basilica of Saint Mark, Venice, Tesoro n. 98

1.12 (Above) **Reliquary of Mark's ring, c.1336.** 23.2 x 9.1 cm. Basilica of Saint Mark, Venice, Santuario n. 48

1.13 (Right) **Reliquary of Mark's thumb, c.1420–30.** 35.8 x 13 cm. Basilica of Saint Mark, Venice, Santuario n. 106

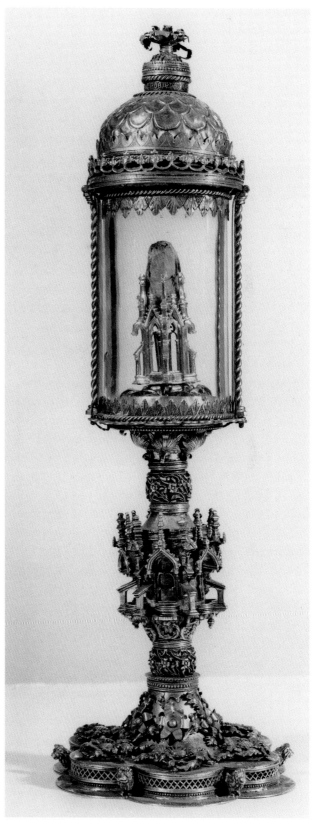

was required to consign a part of the Gospel manuscript to Venice. Hence the importance of the acquisition of this manuscript to Venice and the ceremony granted it: The "return" of this relic to Mark's body in the church dedicated to him was a material sign of new Venetian dominion over territories formerly under the Patriarchate of Aquileia after several years of battle. This was a victory that advanced the expansion of Venice's territory on the mainland, and affirmed Venetian claim to Mark's favor.[41]

After the initial deposit of the *Vangelo* in the Basilica Treasury in 1420, it was displayed annually on the main altar, above Mark's body, on the feast day of Mark's apparition. Along with the manuscript, ostensory reliquaries

containing the thumb of Mark and his ring were also displayed (figs. 1.12, 1.13). On the vigils of this feast these items were carried in a procession around the Piazza, recalling the *andata* celebrating the arrival of the manuscript in 1420.[42] Ritual placement of the manuscript reliquary of Mark's own Gospel on the altar every year reiterated the message of God's favor of Venice through Mark, clearly stated in the jeweled enamels of the altarpiece and in the mosaics of the apse above (fig. 1.14).

Presiding over the ritual of the church in the conch of the apse is the Enthroned Christ (fig. 1.15).[43] He holds the book to show his role as ruler and as the Word, as repeated on the Pala d'Oro below. Beneath Christ, also in mosaic, are Saints Peter and Mark, who carry gem-encrusted books, as bearers of his message. Hermagoras holds out his hands to Saint Mark to the far right. Saints Peter, Mark, and Hermagoras gesture towards each other, which can be interpreted as enacting the same basic scene of Peter instructing Mark to write the Gospel as depicted on the *Vangelo* cover.[44] These mosaics illustrate the foundation of the Church of Aquileia and thereby of the Venetian patriarchate. Mark also presents the Gospel to the viewer and to the world, underscoring Mark as conveyor of the New Law, just as Hermagoras symbolizes Venice's claim to apostolic foundation.[45] Acquisition of the Gospel fragment written by Mark was a material fulfillment of this mosaic scene, for his Gospel, which Peter exhorts him to write and which is presented to us, now rejoined Mark's body below in the Basilica.

The procession of the manuscript and its deposit in the Treasury on the vigil of the feast of the apparition of Mark was critical to a message of Mark's favor of Venice. The feast is one of four specific to Mark and was unique to the city. It celebrated the discovery (*inventio*) averred to have happened on June 25, 1094, while the church was being rebuilt, as depicted in mosaics of the second half of the thirteenth century, on the west walls of the south transept of the Basilica. According to legend, during rebuilding the location of the saint's body had been forgotten. The predominant version recounts further that while the Patriarch of Grado was reciting Mass, Mark miraculously reached out his arm to call attention to where he was buried, and gave his ring to the patrician Domenico Dolfin.[46] The *Vangelo* manuscript does not figure in the legend of the apparition, but was included in this feast day celebration because it was "returned" to the body of Mark on the vigil of that day. In this way, dominion over Aquileia was celebrated yearly in connection with the reiteration of Mark's favor of Venice.[47]

The relics of the thumb and ring affirmed the presence of the rediscovered but not visible body resting under the altar.[48] But another detached piece of the saint, a tooth, was edited out on this feast day.[49] It seems significant that the *Vangelo* manuscript, supposed to have been written by Mark himself, was displayed on the altar only with his thumb and ring, or other relics related to his hands. Although written in Latin, not Greek, the *Vangelo* was popularly believed for centuries to have been written, as Giovanni Stringa phrased it, "*di suo proprio pugno*," or by Mark's own hand.[50] Focus on elements of Mark's hand not only emphasized that he was rediscovered by his own gesture, but also reinforced the importance of the hand of the saint as scribe, as channel of the Word, in writing the manuscript.

RELIC AND DOCUMENT

As a relic of the Word of God and of the saint's script, Mark's Gospel fragment in Venice was just one example in a broader medieval tradition of Bible manuscripts considered as sacred objects.[51] But because this manuscript, while inspired by the Divine Spirit, was written in Mark's own hand, it also could be perceived as having the same qualities as signature documents, which became essential to legal authority in the Middle Ages.[52]

1.14 (Above) *Pala d'Oro, general view.* Basilica of Saint Mark, Venice

1.15 (Right) *Piero di Zorzi, Mosaic of Christ in Majesty, Saints Nicholas, Peter, Mark, and Hermagoras,* restored 1506. Central apse of the Basilica of Saint Mark, Venice

The reliquary binding of the manuscript fragment was the marker, like the metal seals of *ducali*, of legitimacy. The treatment of the *Vangelo* fragment as a relic may remind us of the reverence we still pay to original signature documents, and of the authority granted to them. When dated, they are also considered as records in time. As a relic that recorded the trace of Mark's hand in writing the New Law of the Gospels, the *Vangelo* perhaps was the ultimate authoritative document of God's Word and of his favor of Venice. Above all, the presence of this relic-document in the Treasury must have created greater immediacy to the sense of divine investiture and authority to officials, especially to those who participated in the procession of book, ring, and thumb on every vigil of the feast of the apparition of Mark.[53]

The *ducali* manuscripts outlining the authority and oaths of Venetian officials were related to this primary document. They were purported to have been divinely authorized and were written by hand. Whereas Mark was considered the scribe of the *Vangelo*, the manufacturers of documents for patricians in Venice were, of course, not saints but professional notaries, secretaries, scribes, and artisans. Indeed, at the time of the increasing embellishment of *ducali*, there grew a special concern for handwriting in the ducal chancery. In the next chapter we shift from consideration of the broader symbolic field of documents and books in Venice to consider briefly the ways in which manuscripts were transformed into monuments through care in their execution, and to examine the producers of the documents for patricians. These producers included Venetian state secretaries, and their training and expertise were essential to the pervasive image of the manuscript document in Venice as embodying and transmitting divinely sanctioned law.

ELENCHVS
SIVE
INDEX
EORVM · QVAE IX ·
HISCE PACTORVM
CONTINENTVR LIBRIS ·
QVAE QVIDEM OLIM
ALTISSIMIS OBSITA TENEBRIS
SITVQ DIVTVRNO SEPVLTA ·
LONGIS POST SECVLIS
NVNC PRIMVM
IN LVCEM EDITA SYNT ·
IN VSVM
REIP. SENATVSQ VENETI
ANDREAE GRITI
PRINCIPIS SAPIENTISS.
AVTHORITATE ET AVSPICIIS
ANDREAE FRANCISCII.
MAGNI CANCELLARII OPE
ET PETRI BRIXIANI
A SECRETIS
OPERA
ANNO SALVTIS
M·D·XXXVIII·

CHAPTER 2

DOCUMENTS AS MONUMENTS

THE ILLUMINATED DOCUMENTS that are the focus of this study were produced and utilized in a culture in which the book form was associated especially with legal and spiritual authority conceptualized as transmitted from God through Venice's patron Saint Mark. *Ducali* were made for use by individual Venetian patricians elected to certain high offices of state, and typically were stored among important papers in family archives, or separately, as treasured objects. Collections of documents in private hands complemented the massive accumulation of materials in the archives of the state and were critical to more precise definition and defense of individual and family patrician status. Attention to the quality of the scripts, painting, and binding in texts destined for both state and private archives more obviously transformed them into *monuments* in the sense deriving from the Latin verb *moneo,* the primary meaning of which is, as Andrew Butterfield has pointed out in his discussion of Florentine tombs, "to bring to the notice of, to remind, to tell of."[1]

The motivation to increasingly embellish *ducali* in the fifteenth and sixteenth centuries arose from the desire of individual patricians to distinguish themselves, but they were encouraged by the example of the paintings and documents produced in the state chanceries for consultation in the various state archives and public offices, or as components of diplomacy. The erudition, training, and talents of various non-patrician

bureaucrats and artisans were vital in creating the appearance of all of these materials. For this reason, the relative roles of patrician officials, *cittadino* chancery secretaries, and independent artisans in the production and decoration of *ducali,* within the broader context of other illuminated document and book production in Renaissance Italy, will be surveyed briefly in this chapter. The continuing power of handwritten materials to grant distinction in the early era of print also will be explored.

CITTADINI AND THE STATE CHANCERIES

The patrician class was defined initially in the laws of the *serrata* of 1297, which closed membership of the Great Council to a fixed group of families. From the mid-fifteenth to the late sixteenth century, the status of a secondary, hereditary elite class became more codified. Whereas only Venetian nobles could vote, after 1478 men of the legally defined class directly below them, the *cittadini originarii,* were granted exclusive access to posts in the state chanceries. While *cittadini* never could become elected to such positions as rector or doge, they still could aspire to various positions of substantial influence within the bureaucracy of the Republic. The general policy of privilege for *cittadini* in terms of access to various governmental positions added to their prestige in relation to the lowest class, the *popolani,* who constituted the bulk of the residents of Venice.[2] In fact, the head of the chancery, the Grand Chancellor, was elected from

Detail of fig. 2.5

the *cittadini originarii* and held an honorary and symbolic position comparable to the doge. It was the highest state position a *cittadino* could attain, and was held for life.[3] In a law passed in 1569, the majority of bureaucratic jobs outside of the chancery also were reserved for *cittadini originarii*. Whereas patricians cycled briefly through most magistracies and posts, sometimes serving for as short a term as three months, many *cittadino* functionaries retained bureaucratic positions over many years. In this way *cittadini* formed the backbone of the government.[4] In addition, already by the sixteenth century, such distribution of influence to *cittadini* in the bureaucracies, as well as in the confraternities called *scuole*, was perceived as encouraging contentment with, and therefore relative stability of, the class structure and hence of Venetian society.[5]

The Grand Chancellor and many of the secretaries were highly educated and cultivated men of letters who socialized with influential patricians, scholars, and artists, and many were collectors of art.[6] From the mid-fifteenth century onwards, their training was arranged by the state, which hired masters to prepare select *cittadino* boys for their future careers. These masters, usually competent in both Latin and Greek, were given salaries to teach grammar, rhetoric, poetry, oratory, and history.[7] The first years of the sixteenth century marked an especially high cultural era of the chancery, when secretaries such as Giovanni Battista Ramusio and Benedetto Ramberti, and later Aldus Manutius the Younger and Celio Magno, all respected authors, worked there. The training and cultivation of *cittadini* as notaries, scribes, and secretaries were critical to the quality and appearance of the production of documents in Venice, as well as to the functioning of the state. Patricians entrusted them with carrying out the mechanics of government, its documentation and record-keeping. The humanist education of secretaries, with its focus on the recuperation and appreciation of classical texts, made many of them especially sensitive to the cultivation of the arts of the manuscript document.

ELECTION AND THE *SEGRETARIO ALLE VOCI*

The minimal involvement in governance expected of all male patricians of legal maturity was participation in weekly meetings held on Sundays in the large, magnificent hall of the Great Council (fig. 2.1).[8] Membership of the Great Council has been calculated to have been around 1000 patricians after the first *serrata* of 1297, and as ranging from 1200 to 1500 at the turn of the fourteenth to fifteenth centuries. Sanudo, writing in 1493, at the height of the empire and also of membership of the Great Council, stated that there were approximately 2600 eligible nobles, but that due to service or business abroad only some 50–70 percent, or up to 1800, were present on any given Sunday.[9] It was during these meetings that patricians were elected to the committee that began the process of electing the doge, that the procurators were elected, and in which patricians generally were elected to other posts within the city (*de intus*) and overseeing the empire (*de extus*).[10]

The rules and procedures for elections varied according to the office, and were complex in the attempt to ensure fairness and avoid nepotism. Nevertheless, contemporary sources indicate that intrigues and lobbying, called *broglio*, had defenders as well as detractors.[11] The procedural norms for elections varied somewhat until the third decade of the Cinquecento, when rules were solidified in a form lasting until the fall of the Republic.[12] The Grand Chancellor and the secretaries oversaw the complex balloting procedures. Important magistrates, including the *avogadori di comun*, the Heads of the Ten, the Censors, and the *auditori vecchi* and *nuovi* also observed the proceedings, and the *avogadori di comun* gave the final approval (called the *cedula*).[13] The final stage of an election is

2.1 Paolo Forlani, *Sala del Gran Consiglio* (Hall of the Great Council), 1566. Engraving, 56.2 x 43.3 cm. Newberry Library, Chicago, Novacco Map 4F290

IL GRAN CONSEGLIO DI VENETIA.

L'amor che molte gia l'eterno padre
Per figlia hauer di sua deità trina
Chiese che fu del suo figliuol poi madre
Del'universo qui ha fa Regina.

Ex cuneis formis Bolognini Zalterij

NICOLAO BANDÆ IV. CONS. EX.
Paulus Furlanus Veronensis.

illustrated, with some discrepancies in the titles of personnel, in Paolo Forlani's large etching of the Great Council of 1566 (fig. 2.1). Around 700 patricians are shown voting on a particular candidate. About forty young boys collect the ballots as secretaries on the dais count them.[14]

The main official who oversaw the details of elections in the Great Council and the Senate, and sometimes in the Council of Ten, was the *segretario alle voci*, a member of the ducal chancery.[15] The title *alle voci* refers to the fact that this secretary had to call out (*stridere*) the names of the candidates elected in the main councils, so that all those in the hall, especially the vast Great Council, could hear. Claudia Salmini has clarified the wide range of duties, immense responsibility, brilliance, and labor required of the holders of this position.[16] After election results were announced by the Grand Chancellor, the *segretario alle voci* recorded, among other important details about the election, the winners' names, along with those of the men who had vouched for them (*plezii*, or pledgers) and who were responsible for filling the office if the elected man became ineligible.[17] The *segretario alle voci* kept track of the length of term of each post, general eligibility for taking part in voting and for election, and the period of *contumacia*, or statutory ineligibility for re-election of each person, and scheduled each election at the proper time.[18] Some patrician families and individuals kept track of election results at home in manuscript lists called *consegi*. These not only recorded family achievements in the broader context of all elections, they also helped in strategizing for advancement.[19]

DOCUMENTS IN STATE OFFICES AND ARCHIVES

Of great importance in the chanceries was not just the production of documents but making sure that records remained accessible and identifiable according to relative importance. Offices of various arms of the government, in addition to the main ducal chanceries, maintained their own collections of documents.[20] Materials were organized by location but also by document form, for example large or small, scrolled or codex, and by containers such as bindings, shelves, and cabinets.[21] In addition, script and decoration announced the care in production of a text, and suggested relative importance.[22] Entrances to spaces in the Ducal Palace and other official buildings were embellished with decorative frames and signs, and interiors were furnished with paintings and sculpture to alert patricians and visitors to the function and importance of these rooms (fig. 1.2). So too, texts were written out with care, and bound and decorated, to enhance their visibility and to frame their reception. If we think of texts as spaces the mind enters as one reads, frontispieces are the doorways, and they were marked by decoration to aid and condition comprehension.

An example of an illuminated manuscript that was produced and maintained in relevant offices for reference, rather than given to an individual patrician, contains the oath of office and statutes of the officers *al cattaver* (fig. 2.2).[23] This volume perhaps marked a new and complete edition recording the oath and defining the regulations of officers of this arm of the Venetian bureaucracy. It is fairly large (31 x 21.5 cm) and is prefaced with a table of contents to create a useful working instrument. The office of the *cattaveri*, founded in 1280, generally oversaw incoming and outgoing trade, and the control of contraband.[24] The leaf opening the *Giuramento* text, or Oath of office of the three patrician officers, shows them placing their right hands on a book proffered to them by the lion of Mark, as they hold with their left the standard of Mark. They are taking the oath of office on a Gospel Book, the manuscript bridging their sacred contract to serve. Below, a notary

2.2 *Capitolare of the cattaveri*, late 14th century. 31 x 21.5 cm. Law Library, Library of Congress, Washington, D.C., MS V. 42, fol. 4r

Incipit Capitulare officialum de octabanis
qui apellantur Catauere. Capitulum. J.

Vivo ro Euangelia sancta dei proficuum
et honorem uenecianum in hoc officio salue
capitulis in hoc capitulari specificatis. Et
simul cum socijs meis ul' eorum altero iq
ram et arctabo de omnibz contrabannis q
sicint contra dominium ducem et comune
uenecianum Et de hijs que facta sunt et
iam intromissa pro dominium. Et de plega
nijs que date sunt occasione contrabanno
num et contra ordinamenta domini ducis
et comunis uenecianum. Et cum dictis so
cijs meis ul' eorum altero puniam speciales
psonas que portabunt seu portauerit ul' fe
caunt aut facient portari contrabannia sicut
nobis omnibz ul' maiori parti nostrum uide
bitur. Et mittam litteras ex parte domini du
cis comunibz et omnibz rectoribz et speciali buc
psonis ubi expedirit uidebimus in ponendo pe
nam et penas pro hijs contrabannis inquireci
dis et puniendis sicut nobis uel maiori parti
nostrum uidebitur. Et imponam psonas ro sacra
mentum cum expediat et imponam penam et pe
nas pro hijs contrabannis inquirendis et puniendis
Et si aliquod comune ul' comunia seu rectores no obe

maintains the accounts over which they preside, and a man with a sword and helmet is ready to use force to uphold the regulations. The oath and responsibilities of the personnel of the office are reinforced by images in the manuscript guiding their duties. The example of such a document produced for groups of officials to use in their office probably encouraged the eventual interest by patricians in having the documents created solely for them to be embellished.

THE TRIUMPHANT RENEWAL OF THE CITY AND ITS LAWS UNDER DOGE ANDREA GRITTI

In the wake of defeat to the French in 1509 at Agnadello, Venice temporarily lost almost all its *terraferma* territories. Venetians consequently became profoundly aware of the dissatisfaction of many of its subjects, who readily capitulated to the French, and began to reconsider their laws and administration of justice at home and abroad. After Venice reacquired most of the territories it had lost, several attempts were made by the Senate and other bodies of officials to initiate a review and streamlining of Venetian laws. But the project did not always find consensus. Partial progress was made only under the reign of Doge Andrea Gritti (doge 1523–38), who expressed special interest in the administration of justice, and whose ambitious vision of the renewal of Venice's power and its revived image as the "new Rome," encouraged by Pietro di Bernardo Bembo (1470–1547) and the procurator Vettor Grimani, would initiate the transformation of the Piazza San Marco in a Romanizing style.[25] In the summer of 1528 three prominent patricians were elected as *savi sopra le leggi* to review and organize all legislation. Daniele di Costantino Renier (1476–1535), Francesco di Alvise Pr. Bragadin (1458–1530), and Giovanni di Renier Badoer (*c.*1465–1535) reported to the *Collegio* less than a year later, saying they had seen all the books of the chancery, a remarkable claim given the amount of material, and had already systematized legislation of the Great Council.[26]

Rulings concerning the Great Council had accumulated since the *serrata* of the late thirteenth century. These regulated who could have access to vote, participate in government, be elected to office, and the procedures for elections. The three *savi* examined 128 registers to prune decrees, legislations, and resolutions that they felt were no longer necessary, and to highlight those that were to be maintained in force. The resulting *Capitolare del Maggior consiglio* was published initially as two large and elegant manuscripts, one on membrane and one on paper, in September of 1529 (fig. 2.3).[27] The new organization and clarity of the regulations were matched by beautiful and very legible chancery scripts, as well as by a table of contents and other editorial apparatus to aid access to and comprehension of the materials.

Although the editing of the legislation was done by the three *savi*, the preface to the *Capitolare* is phrased as an address from Gritti, and emphasizes that laws emanate from God as eternal and perpetual like the movements of the sun and planets, but that eventually over time men need to organize them.[28] The text is illustrated in both manuscripts with paintings of Mark granting the document directly to Gritti, to show the doge, like Moses, as mediating personally between God and his people. As Gaetano Cozzi has pointed out, the images in these manuscripts assert ducal authority after, by contrast, various attempts had been made to reign in Gritti's actions and to restrict the scope of the doge's visibility in the city.[29] At least one of the three *savi* overseeing the new edition of the *Capitolare*, Giovanni Badoer, eventually had his own Commission especially illuminated (fig. 5.29).[30] He may have participated in the choice of artists and subject of painting for the *Capitolare del Maggior consiglio*, or was at least inspired in the highlighting of important documents through painting by his experience in this earlier project.

While the editorial work of pruning and clarifying the statutes of the Great Council was entrusted to three patricians, the writing

VMMVS ILLE OPIFEX DEVS, Qui vni-
uerſum mundum, eternaſq intelligentias creauit, primus omnium
mirabilj prouidentia leges tulit. Ea scilicet ratione ut quæ diu per-
petuo ue eſsent duratura, ceu globorū conuerſiones, Solis meatus, et

2.3 *Capitolare* of the Great Council, also called the *Libro d'oro*, copy on paper (detail), 1529. 44 x 30 cm. Archivio di Stato, Venice, *Capitolare del Maggior consiglio, Libro d'oro vecchio, fol. 21r*

and embellishment of the resulting edition was overseen most directly by one of the greatest and most cultivated Grand Chancellors, Andrea de' Franceschi (1473–1552).[31] De' Franceschi attained this highest public dignity accessible to a *cittadino* in 1529, after serving in various positions as a secretary in the chanceries and to ambassadors, and independently as an envoy abroad. In addition,

he was a distinguished connoisseur and collector. He had his portrait painted by Titian at least twice, and owned over sixty silver and two gold portrait medallions.[32] The documents produced under his reign are exceptionally elegant and finely produced. Some of the same artists were rehired for other projects under his care, and it seems likely that he and his assistants chose the scribes and miniaturists for this project.[33]

The text of the new *Capitolare* of the Great Council, because it regulated the rules of admission to the patrician class, was called the Golden Book, or *Libro d'oro*. It should not be

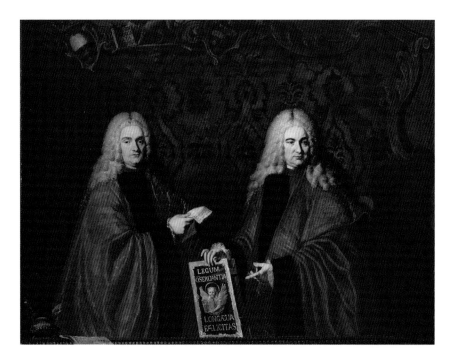

2.4 (Left) Pietro Uberti (attrib.), *Two Avogadori di Comun and a Book Inscribed "Legum observantia longaeva felicitas,"* 18th century. Oil on canvas, 173 x 203 cm. Sala dello Scrigno, Doge's Palace, Venice

2.5 (Below) T.º Ve Master (attrib.), Title page of the Index of the Treaties (*Pacta*) ..., 1538. 32 x 21.5 cm. Archivio di Stato, Venice, *Pacta e aggregati*, reg. 7, fol. 3r

confused with the registers of legitimate patrician births and marriages, also called Golden Books, and maintained by the *avogaria di comun*.[34] The latter were preserved with the Silver Book (*Libro d'argento*), which registered *cittadino* status, in coffers within a cabinet that held other relevant documents authenticating patrician and citizen identity. The cabinet, or *scrigno*, containing these gave the relevant room in the Ducal Palace the name Sala dello Scrigno. One of the eighteenth-century paintings of this suite of rooms shows two *avogadori* holding up a book with the inscription: "Long-lived happiness by observance of the laws," to reinforce the notion that the regulations they maintained and enforced, preserved as material texts, provided the foundation for social stability (fig. 2.4).[35]

Another phase of the reorganization of Venetian law under Doge Andrea Gritti and conducted under the purview of Andrea de' Franceschi was the transcription of the treaties made between Venice and other governing bodies, the records of relations with outside entities, and a new index of both. This project was undertaken by the secretary Pietro Bressan (d. 1546) under

de' Franceschi's supervision.[36] A magnificent title page to the index of the nine volumes of the completed project in 1538 dramatically announces that the pacts had been neglected for centuries, indeed had long been buried, and now were redrafted to bring them to light (fig. 2.5).[37] The text is written in Roman capitals as if incised on a monument, and the illuminator painted sculptures, which we recognize today as representing Diana of Ephesus, to frame the fictive stone slab, or *stele*. In the Renaissance, these were interpreted as representing Idea, or the goddess of Nature. Lorenzo Lotto had some ten years earlier portrayed the Venetian *cittadino* and collector Andrea Odoni with a statuette similar to these figures in his hand. Odoni was a civil servant in Venice, whose service collecting taxes on wine was even commemorated with a carved marble plaque in 1534 at the tax offices, so his portrait would have been known to some patricians and to secretaries of the chancery.

2.6 Giovanni Maria Bodovino (attrib.), Donation by Venice of the Palazzo Gritti (Venice) to Pope Sixtus V, in the name of Doge Pasquale Cicogna, Venice, March 19–23, 1586. 48.5 × 69 cm. Archivio Segreto, Vatican, AA. Arm. I–XVIII, 1302 (CI)

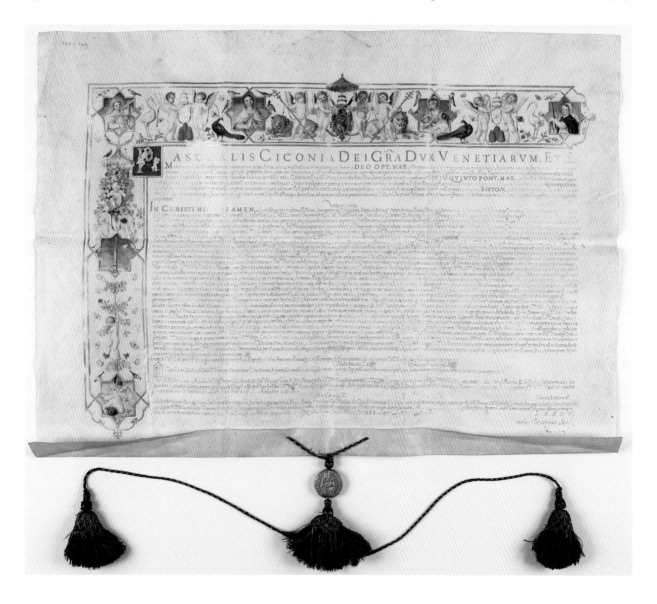

But perhaps a more direct reference in the miniature was to the painting by Raphael in which two such statues frame the throne of the "Knowledge of Causes," or Philosophy, in the Library (now Stanza della Segnatura) ceiling frescoes (1508–11) in the Vatican.[38] Although the precise meaning of these figures in the context of the manuscript is yet to be elucidated, clearly the authority of the pacts is emphasized through their framing as antique. A parallel was made between the unearthing and collecting of antiquities and the recuperation of historical documents buried through the entropy of time. The renewal of Venetian law is framed in antiquarian terms parallel to the revision of the Piazza and Piazzetta as a Roman forum.[39]

Decades later, in 1586, special care and expense went into the creation of the document of a donation to Pope Sixtus V of an enormous palace facing the Church of San Francesco della Vigna to house the papal *nuncio* (fig. 2.6).[40] The choice by the Venetian government to purchase this palace to donate to the Holy See clearly was due in part to its size, but as Tracy Cooper has pointed out, also may have been because it faced the magnificent façade of the church by Palladio clad in marble.[41] Recognition of the pope's grand patronage of architectural and urban planning schemes in Rome also is made in the central vignette in the left border of the document. It shows the obelisk that was just about to be relocated by Pope Sixtus V (from April to September of that year) to Piazzo San Pietro. This was the first monumental obelisk raised in the modern period and the method used to move it was devised by Domenico Fontana, as described in his publication about it.[42] The importance of this document as a diplomatic record is highlighted by the gilding of the lead seal. The magnitude of the gift of the palace and, as with Jacopo Antonio Marcello's manuscripts to René of Anjou, King of Naples, the acknowledgment of the eminence of the recipient, required special attention to the crafting of the document.[43]

PATRICIAN FAMILY ARCHIVES

As discussed in the Introduction, Antonio Grimani asked that his son Vincenzo keep his documents as doge and procurator in the family. The maintenance of *ducali* at home had a singular tradition. Whereas early modern Florentines kept particularly detailed family memoirs, called *ricordanze*, Venetians generally did not keep an equivalent of the separate family chronicle. More common are chronicles and heraldic books recording abbreviated information on all of the noble families. To account for this, James Grubb has pointed to the group ethos of the patriciate, and suggested that Venetians created and relied more on a collective and public record; *public* registration of family identity was ample.[44] Although usually Venetian patricians did not note family details in *ricordanze*, Dorit Raines has shown how they did keep important records, including *ducali*, in private family archives as instruments in maintaining and extending their power.[45] After receipt and use by a patrician in performing the duties of his office, therefore, *ducali* manuscripts were stored in family archives as records of service to the *patria* that complemented, and intersected with, materials in the State Archives or stored separately as precious objects, as will be discussed later. Such manuscripts were maintained with other textual materials not just as memorials, but also for the instruction and moral direction of subsequent generations. The documents of former office holders provided biographical records of model ancestors for patricians to emulate, and helped family members to strategize their careers in government. This practice had an ancient Roman precedent, which was described by Pliny the Elder in his *Natural History*, following his famous discussion of the practice of collecting wax

2.7 Giovanni Vitali, Commission/Oath of Lorenzo di Angelo Correr as procurator *de supra*, elected 1573. 28.8 x 20 cm. Biblioteca del Museo Civico Correr, Venice, CL III 1017, fol. 1r

NEL
NOME DI DIO.

Incomincia la Tauola della
Commißione del Clarißimo Signor
Lorenzo Correro fù del Cl.mo M.
Anzolo Procurator di San Marco sopra
le cômeßarie di Seßieri di San Marco, Ca
ßello, et Canareglio di quà dal Canale.

GIVRAMENTO

d' eßo Clarißimo Signor Procu-
rator, d' eßer per lui tolto cerca
l' oßeruanza dell'infraßcritti Capitoli.
Capitolo primo.
Di moßrar, et conßegnar al
mio Compagno, che sara eletto dà
per se tutte le Commeßarie.
Capit.
.ij.

portraits – "true portraits," or *imagines* – of ancestors in the *atria* of patrician homes. Pliny emphasized the importance of the *tablina*, or archive rooms filled with ledgers of records and accounts of deeds done by office holders, as a supplement to *imagines*, and to portraits that were painted in family trees.[46]

The *Natural History* never lost favor in the Middle Ages, but Pliny's text received broader and heightened attention from humanists in the fourteenth to sixteenth centuries.[47] Although much humanist commentary on Pliny in Venice focused on correcting the texts on natural history more strictly, Pliny's descriptions of Rome and ancient art in this book were mined for models of art and architectural patronage throughout the Renaissance.[48] Venetian humanists self-consciously aligned notions about the institutions and patrician class of Venice with those of ancient Rome.[49] The revival of the portrait bust in fifteenth-century Florence, and in the latter half of the sixteenth century in Venice, has been directly linked to the precedent of *imagines* described in ancient literature.[50] In addition, Venetians avidly collected and commissioned painted portraits of family members and ancestors already by the end of the fifteenth century. Giorgio Vasari, in attributing the custom of portraiture in Venice to Giovanni Bellini, famously noted that "the houses of Venice are full of portraits, showing family members going back four generations."[51] The creation of portraits in *ducali*, and the maintenance of these manuscripts in patrician family archives, can be seen as a new hybrid merging of *imagines* (as painted miniatures) with the *tablina* of documents. Exemplary ancestors were in this way recorded in deed, directly with their likeness, in the household.

That illuminated ducal documents were kept for the glory of the family and *patria* for instruction is materially apparent today in a few surviving sections of patrician archives still relatively intact in private and public collections.

Archival materials of the Marcello family are still conserved within the Andrighetti Zon Marcello Library in Venice.[52] Many important family archives were donated to public collections. The importance, extensiveness, and long survival of one *ramo*, or branch, of the Tiepolo family, that of Sant'Aponal, is evidenced by the thousands of documents on membrane from 1199 to 1788, donated in two installments – in 1914 and 1964 – to the State Archives.[53] The archives of families related through marriage also flowed into these collections, creating valuable resources for the study of intersecting patrician families. The richest public deposits of these patrician archives are still in Venice; in the State Archives, the Biblioteca Nazionale Marciana, Biblioteca Querini Stampalia, and Biblioteca Correr.

The documents extracted from dispersed family archives most commonly survive today in library collections. *Ducali*, however, do not appear frequently in Renaissance Venetian book inventories. Although usually in codex form and bound, these manuscripts generally were kept not among literary or devotional books, but among *carta*, or documents, together with other archival materials.[54] But sometimes the preciousness of the miniatures or binding of a *ducale*, and its importance as a record of a high office held, led such manuscripts to be grouped with valuable treasures. We have seen that the miniatures of Doge Antonio Grimani's documents were highly esteemed in the inventory of Vincenzo Grimani Calergi of 1647. They were listed with the magnificent manuscript of the *Commentary on the Epistles of Paul* illuminated by Giulio Clovio, and with independent miniatures.[55] The inventory of the belongings of the procurator Lorenzo di Angelo Correr (1530–1584), made in 1584, records books and documents in various areas throughout the palace, but begins with a general list of highly valued items without mention of their location. Among diamonds, coinage, and silver table settings is noted Lorenzo Correr's Commission/Oath document as procurator,

described as bound in velvet with silver fixtures. This manuscript of 1573 has no miniatures but a beautiful and very expensive script by the scribe Giovanni Vitali (fig. 2.7).[56] Unfortunately it has lost its binding, which probably was very similar in appearance to the Commission of Gianfrancesco Sagredo (fig. 0.20). In the inventory of Correr's household, the manuscript was singled out from other documents as a special, precious object, probably both for its materials and for its importance for family status.[57]

SCRIPTS IN THE ERA OF PRINT

The ducal chancery was defined as the "heart of the state" in mid-fifteenth-century legislation, and in recognition of the importance of the training of its functionaries a master was hired to teach grammar and rhetoric to select *cittadino* boys to groom them for work there. A separate writing master also eventually was hired to teach them the scripts in which to write documents and letters so that these would be elegant and legible.[58] These writing masters and their students were, for the most part, the scribes

of Commissions. The earliest known writing master in the chancery was the enterprising *cittadino originario* Giovanni Antonio Tagliente (*c.*1465–*c.*1527), who took on the position in 1492. He probably retained it until his death, or for some thirty-five years. There had been earlier teachers of scripts, but Tagliente essentially created a newly stipendiary position for himself. In 1491, he wrote a supplication addressed directly to Doge Agostino Barbarigo in his own best *cancellaresca*, or chancery, hand (fig. 2.8).

Tagliente's job application allows us to see the master's craft, and his penchant for exuberant ligatures and flourishes. His initial request for the job as writing master seems to have been carried enthusiastically by Doge Barbarigo himself to the meeting of the Council of Ten, where he made a motion that Tagliente be given an appointment at a yearly salary of 50 ducats. Barbarigo's motion was turned down, but Tagliente's second try, in which he offered to succeed his uncle Priamo del Biondo as *sensale*, a stipendiary position in the Fondaco de' Tedeschi, and in addition teach writing in the chancery school for free, was approved.[59] The influence of his teaching

2.8 Giovanni Antonio Tagliente, Supplication to Doge Agostino Barbarigo that he be hired as writing master, 1491. Archivio di Stato, Venice, Consiglio di dieci, Misti, filza 5, doc. 127

of chancery cursive can be seen in the script of such manuscript documents as a Commission to Marcantonio di Alvise Contarini of 1504 (fig. 2.9). In fact, the similarity of the hand to Tagliente's supplication suggests to some that it was written by the master himself.[60]

Subsequent calligraphers who taught in the chancery were not *cittadini*, or indeed native Venetians, but Tagliente's long-term post as a writing master had set a precedent. Nicolas Barker has shown that Francesco Alunno (*c.*1484–*c.*1556),

2.9 Benedetto Bordon (illuminator, attrib.), Tagliente (scribe, attrib.), Commission to Marcantonio di Alvise Contarini as Captain of the Galleys to Flanders, 1504. 24 x 15 cm. Free Library of Philadelphia, MS Lewis E. 143, fol. 1r

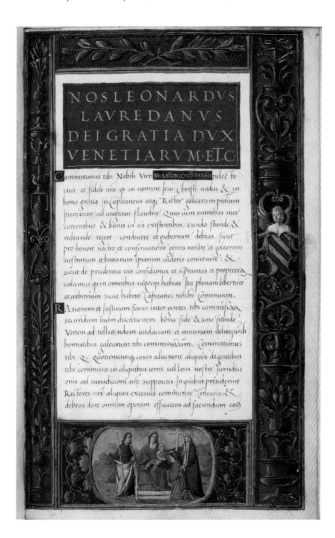

a priest from Ferrara who had worked in Udine, was hired in 1533, a few years after the death of Tagliente, with a stipend now strictly for teaching writing in the chancery. Alunno's application, like that of Tagliente, was written out in a beautiful chancery script that advertised his proficiency in both word and example. The minutes of the Council of Ten's decision to hire Alunno emphasized the need for scribes of the highest quality in the chancery, and that the stipend would allow him to continue to practice his art and to teach writing to members of the nobility as well.[61]

After Alunno died, Giovanni Vitali (1521–1581), a priest from Brescia, was hired in 1556 to come in every day to teach writing to the youths of the chancery.[62] Vitali aggressively pursued commissions to script documents outside of his salaried post in the chancery. He drew up careful accounts for payment of his work on commission, which, as will be detailed later, allow insight into the funding of the documents of the procurators of Saint Mark in the sixteenth century. The scribe negotiated high prices for his handiwork, and sought and thanked patrons through gifts of his manuscripts.[63] In addition, Vitali came to be paid separately, and substantially, for writing and decorating manuscripts for various *scuole*, for liturgical manuscripts for use in the Basilica of Saint Mark, and for a large number of Commissions for procurators, as in the document for Lorenzo Correr (fig. 2.7).

Tagliente was a *cittadino*, and both Alunno and Vitali were clerics. Technically, as men of the cloth, Alunno and Vitali would have been prohibited from working for the government, but wrote out numerous manuscripts for the procurators anyway. Most other artisans of the book, including independent scribes, miniaturists, and binders, came from the largest class in Venice, that of the *popolani*, who comprised about 90 per cent of the inhabitants. This group could neither hold government office nor vote. In order to practice the crafts of painting and binding, both *cittadini* and *popolani* had to belong to and participate in guilds overseen by the state.[64]

THE PAINTERS OF *DUCALI*

Although Vitali sometimes claimed in his colophons to be a miniaturist, he did not paint portraits or figures of saints, rather he enhanced the appearance of pages through writing blocks of text in elaborate colored medallions, again as in the Commission/Oath for Lorenzo Correr. Strictly speaking, artists had to be members of the guild of painters to limn (illuminate manuscripts) in Venice, and *miniatori* had their own *colonello*, or branch, within the guild. Most manuscripts were painted by such professional miniaturists, but some artists who worked primarily in larger media also illuminated documents. For example, the hand of Giovanni de Mio, who designed mosaics for the Basilica of Saint Mark and painted roundels on the ceiling of Sansovino's Library, has been identified in Commissions (fig. 2.10).[65] Marco del Moro, best known for his prints and for stucco work in the Doge's Palace, is documented as having illuminated the Commission/Oath as procurator, now lost, of Marin di Girolamo Grimani.[66] And according to Giustiniano Martinioni, Marco Boschini, the important seventeeth-century artist, dealer, and writer on art, painted Commissions.[67] As will be discussed in Chapter 4, the painters of *ducali* not only emulated the compositions of larger state monuments in designing paintings in documents, but also at times were simultaneously the artists of these larger and more public projects.

Few illuminations in Venetian manuscripts are signed or documented, but from the scant evidence available it is possible still to attribute bodies of work to a number of artists and their workshops. Masters could employ family members, and they trained assistants to work in their style. Connoisseurship is an inexact science, but it allows us to assemble works in groups, which gives a useful sense of the careers of individual artists and their workshops.[68] As Giordana Mariani Canova has pointed out, the study of *ducali* is especially valuable for

2.10 Giovanni de Mio (attrib.), *Virtue Restraining Vice*, leaf detached from a Commission to a member of the Michiel family, 1554–56. Mounted on wood board, 23 × 16.2 cm. Museo Civico Correr, Venice, Cl. II, 728

constructing the history of painting in Venice, because when the manuscripts are still intact, their date of production is recorded within them, or the date of election of the recipient is accessible as recorded in the archives.[69] For the most part, the paintings in the manuscripts were created near the time of the writing of the manuscripts.

Even in the rare cases where miniatures were signed, one cannot necessarily further identify or construct a broader oeuvre for the master. So, for example, the hand of Gaspare of Verona is known only by his work in one signed Commission, to Marin Venier (1521–1593), son

of the illustrious collector Giovanni Antonio, as *Podestà* and Captain of Sacile (fig. 2.11).[70] In rare cases, records of payment allow one to associate an artist with the paintings in a specific document. This is the case of the Commission/Oath of Giovanni da Lezze as procurator *de supra*, documented as painted by the miniaturist Jacopo del Giallo (fig. 4.18). For many bodies of work individuated through connoisseurship, the artists remain anonymous, and are given monikers. For example, the prolific Master of the Pico Pliny (Pico Master) was named after

a copy of Pliny's work written out for Giovanni Pico della Mirandola.[71] There are a number of miniaturists listed in such archival documents as the *Accordi* ledgers, which recorded the contracts of apprentices with masters, many of whom we cannot link to any paintings.[72]

The patrons and craftsmen of the decoration of *ducali* participated in the consumption and production of manuscripts and books in general in Venice. The number of *ducali* embellished with paintings, and the extent of their illumination, increased dramatically in the period of the introduction of print to the city. To understand, therefore, the development of *ducali* as spaces for imaging patrician identity, it is useful to examine briefly the broader context of the expansion of book and manuscript production in Renaissance Venice with the introduction of print.

2.11 Gaspare Veronensis (signed), *Prudence and Marin Venier Praying to the Madonna and Child*, Commission to Marin di Giovanni Antonio Venier as *Podestà* and Captain of Sacile, 1551. Each fol. 23.5 x 16.5 cm. Pierpont Morgan Library, New York, M.353, fols. 1v–2r

PERSONALIZED COPIES IN THE ERA OF PRINT

Venice was an important center of manuscripts before the arrival of print, but it did not compete with Florence, Bruges, and Ghent in the rapid and voluminous production of luxury illuminated manuscripts for such prominent rulers and voracious collectors as Lorenzo de' Medici, Federigo da Montefeltro, Duke of Urbino, and Matthias Corvinus, King of Hungary.[73] As a center of commerce and intellectual life, and a crossroads of trade and travel, however, Venice had fertile soil for the further development and broader distribution of the products of the new book technology of print in the last quarter of the fifteenth century. The necessary materials of paper and metals, and the expertise and manual skill of scholars and artisans, were easily sourced. Printing was imported to the Serene Republic in 1469, and the city quickly became one of the most important centers of the new medium up to the end of the sixteenth century. A key factor in the development of the nascent press industry in Venice was available financing, with the encouragement of and patronage by both locals and foreigners, and some protection by the state in privileges, an early form of copyright.[74]

One of the initial consequences of the advent of print in Venice was that it offered some intellectuals and craftsmen new opportunities for work as writers, editors, printers, publishers, designers, and binders.[75] The scribe Filippo de Strata lamented in the 1470s that the introduction of print to Venice ruined his profession. But as we have seen, calligraphers such as Tagliente not only continued to find employment as scribes and writing masters for the state, but also capitalized on the new medium by producing profitable editions, reprinted several times, which illustrated examples of scripts, and purported to teach writing to the masses.[76] In fact, miniaturists found greater employment than before in illuminating copies of print editions, and in designing woodcuts as illustrations for printed books. These opportunities,

in turn, attracted more artisans of the book to the city.[77] The print industry went through various booms and busts, and Venetian primacy was eventually ceded to other cities. But it has been estimated that at its peak from 1550 to 1574, some 500–600 men were employed by the press, and there were up to fifty publishers producing at least one title a year, in a city with an estimated population of about 120,000. These numbers do not take into account the employment afforded to masters of the subsidiary crafts of book binding and illustration.[78]

In Venice at the turn of the fifteenth century, too, readers and collectors of books had exponentially greater access to, and choice of, volumes to acquire, and to read or consult, than just thirty years earlier. It is difficult to estimate fully how many editions and copies of books were printed, but by 1500 at least 233 printing shops turned out some 3500 editions, about 25 per cent more than the output of Venice's main printing rival, Paris.[79] It has been suggested that Venice produced three-quarters of the books published in Italy between 1526 and 1550.[80] It was not just the quantity of print that was transformative, of course. Printing in Venice was distinguished by the attention to a high quality of production, and the editorial programs of publishers including Nicholas Jenson and Aldus Manutius. As scholars such as Martin Lowry have shown, the culture of humanism found fellowship with commercial enterprise both in manuscript and in print in the Renaissance.[81] Many patricians, some of whom earned *ducali* manuscripts, financed editions, profited from investments in the book industry and associated manufacturing, especially of paper, and enthusiastically supported print through protective legislation. Authors, editors, and printers worked directly with various types of craftsmen.[82] Standard texts formerly common in manuscript form came to be printed, and new genres emerged in response to an expanding market. Many books were furnished with woodcut or engraved prints. In addition to providing livelihoods for various

professions associated with the new industry, print brought greatly expanded production of, and access to, images as well as texts, in number and kind, to early modern Venice.

Bronwen Wilson has argued that the very sense of self and identity of Venetians both formed and responded to the flood of images representing the world and one's place in it, in maps, costume, and portrait books.[83] By contrast to the uniform class identity projected in costume books, where "generic" patricians were represented in characteristic dress, hierarchically arranged according to government post, the portraits of patricians in manuscript documents particularized their image, while also affirming their membership of an elite class.[84] The intensified interest in portraying the individual in *ducali* may have been one response to their generalized characterization in print.

The influx of volumes in printed multiples was dramatic, but various elements of the manuscript book, and kinds of manuscript production, lingered until the beginning of the sixteenth century.[85] For instance, the practice of rubricating opening initials by hand remained widespread in early printed editions, and coats of arms and other decorations often were added to the opening text pages of individual copies. In many printing houses it was common practice to print the first few copies of an edition on membrane rather than paper, and to have these luxury volumes at times sumptuously illuminated for patrons. There are, for example, two membrane copies of the first official history of Venice, the *Decades rerum Venetarum* by Marcantonio Sabellico, which bear the Barbarigo coat of arms and the ducal *corno* (fig. 2.12). It was under the reigns of Doges Marco and Agostino Barbarigo that the monumental project was commissioned by the government and printed. These, then, were copies of such presentation volumes given to Doge Agostino Barbarigo and perhaps members of his family in recognition of the exclusive privilege granted to Andrea Torresani to print the work.[86]

2.12 Master of the Pico Pliny (attrib.), Marcus Antonius Sabellicus, *Decades rerum Venetarum* (Venice: Andreas Torresanus de Asulo, 1487). Approx. 41 x 27 cm. Giustiniani Recanati Falck Library, Venice, fol. a3

In addition, a prejudice in favor of manuscript books remained in some quarters. Vespasiano da Bisticci famously claimed in his *Memoirs* that the manuscripts in the collection of his client Federigo da Montefeltro were so beautifully written and illuminated that a printed volume would have been embarrassed in such company.[87] Federigo did own a number of printed books that he prized, and he personalized them with sumptuous bindings and illumination.[88] It was probably not so much the aesthetic of print that a dealer like Vespasiano

found offensive, or threatening to his livelihood as a merchant of manuscripts, but that many people could have a similar copy, making the mere ownership of a book less prestigious.

The high quality and proliferation of illuminated copies of printed books on membrane up to the early sixteenth century indicate that attributes of manuscript books that were hard for producers and consumers to relinquish were uniqueness, personalization, and luxury – the ability to confer distinction upon the owner.[89] In fact, one could say that the coming of the printed book placed the relative uniqueness of each manuscript volume in relief, even if methods of standardization and mass production had already been in place in manuscript production for certain markets. The painting of printed books was one way of reclaiming qualities of a unique copy from a multiple. For this reason, for centuries, collectors like Federigo continued to commission and collect splendid manuscripts for their personal enjoyment, as status symbols and statements of power.[90] Although thousands of editions of printed books were produced in the early era of print, various kinds of texts, such as ledgers and documents, for which only a single or a few copies of text were needed, continued to be written out by hand.

As we have seen in the case of key documents recording major legislation and organization produced under Doge Andrea Gritti and the Grand Chancellor Andrea de' Franceschi, documents could be variously emphasized in collections through enhancement of their material value and visual appearance. In this way, bound and illustrated texts stood out among other documents, to operate simultaneously as monuments. Their increasing illumination reflects intensified strategies of display and memorialization.

The evolution of the increased decoration in *ducali* documents points also to what is perhaps the most distinct benefit of manuscripts over print and digital media: They more naturally integrate markers indexical of authority, such as signatures and seals, and their uniqueness grants the owner distinction. In the case of *ducali*, it seems that the increasingly archaic nature of manuscripts as unique copies became emphasized in part by paintings, to underscore that these were documents in book form still available to only a select few, in an era that saw the general expansion of access to texts. We can call this enhanced value of the mark *indexical*. In semiotic terms, an index establishes meaning along the axis of a physical relationship to a referent, and indexicals are retained in some printed books through inscriptions, signatures, or hand-decoration.[91] The link of the scripted *Vangelo* to Mark's hand was promoted in the images on the reliquary binding. Manuscripts record not just the intellectual communication of a writer in the form of text, but also the physical effort and trace of the scribe, of a miniaturist if illuminated, and of an author and/or owner if inscribed and dedicated to someone. In contemporary book culture, a strong desire to possess books indexical of an author is evident in the phenomenon of book signings, which create unique copies out of multiples, and which establish a direct link between the author and a particular copy. If the signature includes an address to the reader, the book is enhanced by the trace of a relationship of the author with the collector.[92] In sum, to mark or illuminate a document or printed book always alters some aspect of its value as a commodity, its nature as symbol, and how it potentially works as an object mediating reception of a text.

In this chapter, the broader contexts of document production for the archives, and the evolution of the print industry in Renaissance Venice have been examined. Embellishment of *ducali* was valuable to patricians in highlighting that these documents granted them individual authority and recorded their service to the state. We now can examine more specifically the messages conveyed by the paintings in them.

PART II
EVOLUTION

IMAGES OF THE lion of Mark with his book, proclaiming the Saint's favor of the Republic and Venetian laws as divinely sanctioned, reigned throughout the city and its territories. In addition to this pervasive image of a book as symbol of divine right and power, various traditions of painted imagery evolved within the actual documents held and read by patricians to guide them in executing their sovereignty under Mark. These miniatures in *ducali* expressed the ideals of the relevant offices and of the state as delineated in the document texts, but over time embellishment also came to convey how individual recipients wished to be perceived and remembered. Standardized imagery was adapted and transformed to create personalized memorials to patricians. Study of the development of *ducali* as fields for painting in relation to the nature of each office allows insight into how patricians conceptualized their identity with regard to particular kinds of governmental service, in the very spaces where the nature and duties of office were defined.

Vm
nō de
nostra
fortitu
dine ul'
prudē
tia sed
ō sola
procef
ferit
Cleme
tia Cre
atoris,
In cui'
Arbi
trio et
uoluntate uniuerfa funt posita q
ad culmen ducalis dignitatis per
uenerimus. vos hactenus i Ecclia
beati Marci Euageliste din Glosi
qui patronus noster est 7 signifer
in oibus aggregati quantaz erga
nos habueritis dulcedine caritatis

p pntis scripti paginam quia stu
diosos nos tanto exhibere uolum
ampli et attentos ex cordis itimo
put de iure debemus super ratoib7
et iusticys faciendis et sup nego
tys nostris oibus diligentius
promouendis que ad utilitatem
uobis pariter et profectum cuz ho
noze patrie meli'ualeat puenire
quanto p nos auctoze deo sup hys
maioz nobis est attributa facultac
et collata tam glozosa dignitas
ac nimis precella

De bono regimine, et osuatio
ne boni status dnij Venetiaz. i

Volentes igitur quod i uo
luntate gerimus sup hys
in opere appertius declarare Nos
Christophozus Mauro dei gra
Dur Venetiaz et cet' promitte
tes promittimus vobis vniuso
pplo Venetiaz maiozibus 7 mi
nozibus et uris hzdib7 q' imodo
i antea cunctis diebus quibus

THE PROMISE OF THE DOGE

"We arrive at the summit of ducal dignity not through our own strength or prudence, but only through the clemency which emanates from the Creator …"
Prologue, The Promise of the Doge[1]

THE DOGE WAS the principal mortal representative of Venice, and copies of the *Promissione,* the primary document regulating his actions and appearance, seem to have been the first *ducali* to become illuminated. This chapter will examine the evolution of the miniatures in these manuscripts in relation to the ducal office, and to how doges were represented in other media. Subsequent chapters will focus on the paintings in documents for the procurators, the next class to become embellished, and then in the Commissions of the rectors, the last but largest category of documents transformed into fields for painting. Illuminated *Promissioni* made to be kept by the doge are the rarest of surviving *ducali,* in part because the position was held by the fewest. The production of these documents was the most carefully regulated, as were the doge's image and conduct, for on both practical and symbolic levels the doge was the person of reference for Venice. Coins were minted in his name, letters and privileges of state were sent with his signature.[2] He came to be considered, as stated in a document produced by the Council of Ten in 1447, the very "likeness of Venice," and the *Promissione* specified many details of his actions and appearance as such.[3]

Detail of fig. 3.6

Because of the symbolic weight and intensive scrutiny of the office of the doge, the image of the individual was most constrained by his governmental role in both the texts and images within *Promissioni,* by comparison with the documents for other officers. The earliest illustrations in them, in fact, merely identify the reigning doge with the written promise and regulations. Nevertheless, the miniatures in a series of *Promissioni* surviving from the fifteenth to the mid-sixteenth century convey increasingly more expansive and personalized messages about successive doges, presumably at their request. The paintings in these documents enhance interpretation of the prologue, the opening text of the *Promissione,* which declares that the doge was elected not through personal merit or politicking, but by divine will.

Whereas early miniatures encourage a reading of the prologue with an emphasis on the humility of the doge submitting to the will of God, the miniatures in later documents shifted to proclaim the election of a doge as a triumph over human intervention and scrutiny. In fact, discomfort with a growing emphasis on depicting the doge as triumphant and sacred in documents kept by him and by his family eventually may have put an end to all representational miniatures in *Promissioni.* While documents for the procurators and rectors continued to become ever more elaborate and specific to the recipient into the seventeenth century, the last known *Promissione* with a portrait is from the first quarter of the sixteenth century (Appendix 1). In essence, then, study

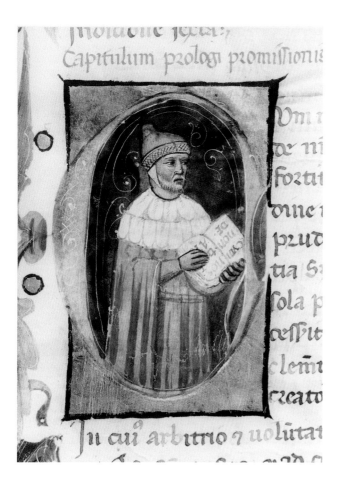

† moldcione iccai:
Capitulm piologi promiſſioni
Om i
or ni
foztu
onc i
pzuc
tia ſ
ola p
eſſit
lenn
zcato
Jn cui arbitrio 7 uolutat

3.1 *Doge Antonio Venier Takes the Oath of Office,* opening leaf of a copy of the *Promissione* of Doge Antonio di Nicolò Venier, elected 1382 (detail). 35.5 x 24.5 cm. Archivio di Stato, Venice, *Collegio, Promissioni ducali,* reg. 3, fol. 7r. The doge wears the *camauro, biretum,* and *bavero* as he takes the oath on the prologue to the *Promissione*

of the image of the doge in *Promissioni* reveals the dynamic between the desires of the sitting officer for elevated self-presentation and the demands upon him to represent the ideals of the collective.

As texts, *Promissioni* provided the oaths that these elected officials swore by the Gospels upon inauguration. In addition, the *capitoli,* or rules and statutes, of the documents laid out the key duties and restrictions defining the nature of the doge's office. These were meant to promote, indeed compel, the behavior and image of the office holder, and provided a record of his

agreement to follow the statutes in the taking of his oath. The term *Promissione* stems from the formula (*promittentes promittimus*) in the opening chapter after the prologue, which distinguishes this oath as a promise (*promissio*) to the people of Venice by the doge, to rule to the best of his ability and in good faith (fig. 3.1). This direct promise to the Venetians was in addition to the second oath, made by the Gospels, at the end of the document.[4] An oath on its own, separate from constitutional clauses, may go back to the beginnings of the institution of the dukedom. But the form of an oath as a promise *with statutes* has been considered a foundational document of Venice's passage from a monarchy to a commune, in which the ruler came to be emphasized as beholden to the people with specific conditions. The doge's promise still was the basis of Venice's governmental form as a mixed or aristocratic republic in the Renaissance, with the doge as chief administrator and figure-head.[5] Indeed, the *Promissione* document was one of five central official compilations of laws and measures, and therefore one of the fundamental pillars of the constitution of Venice.[6]

During his tenure, the doge was supposed to read, or have read to him, his entire *Promissione* text at least every two months. After he passed away, a *Promissione* document would have been the most precious of *ducali* to have in a family archive, for it was material proof of the high status of the *casa* within Venice, and even suggested standing at a level competitive with hereditary royalty abroad. The image of the doge in these documents, while informed by his wishes for self-presentation, was constrained in part because illumination was paid for by the state. Nevertheless, because such a likeness was made early in a doge's tenure, it could represent more precisely how he wished to be shown, certainly more so than in the many representations of him made posthumously. Since these highest officials typically were elderly when elected, most portraits of many of them as doge were made after their deaths.

Because the paintings in *Promissioni* generally would have been made at the outset of their tenure, they comprised an early component of broader programs of imaging and memorializing a doge by himself, his family, and the state. In fact, portraits in many of the documents can be viewed as early essays into a patrician's cultivation of his legacy as the highest representative of the Republic. Some illuminations in *Promissioni* even may have been referenced as prototypes for later portraits in larger monuments. For example, the illumination of Doge Antonio Grimani's *Promissione*, the preservation of which so concerned him at his death, had innovative imagery emphasizing that he ascended to the office through divine, rather than human, election (fig. 0.5). As will be shown, decades after his death, unique compositional elements in this document were incorporated in the commemorative oil painting of him by Titian, made for the Doge's Palace.

Before examining in more detail the illumination of *Promissioni* manuscripts in the context of the other arts, it is important to survey briefly the parameters within which the doge was created, presented, and portrayed. The office and figure of the doge formed a singular category of ruler, largely defined by the evolving *Promissione* text. Reading of the paintings in the manuscripts is best informed by study of the office and its representation. In particular, the doge's crown and vestments, along with other material attributes to some extent mandated by the *Promissione* text, had specific meanings associated with them that were manipulated variously in portraits to emphasize him as powerful on the world stage, and as sacred.

THE DOGE: PERSON AND OFFICE

The sovereignty of the doge changed greatly in nature and extent from the eighth to the twelfth century, as the Venetian government evolved into a city-state or commune. The first doges were military officials of the Byzantine Empire, but from the ninth to the eleventh century they became independent monarchs with unlimited power. Ducal election then became an extremely complicated series of steps to safeguard against nepotism and influence, and officers and committees were instituted to oversee and control the actions of the doge.[7] After the revolution that overthrew the Orseolo family dynasty in 1032, a move to check the authority of the doge within Venice was begun with the election of two ducal councillors to assist, and also to oversee, his actions.[8] A more complete transformation of the office from monarch towards what Edward Muir aptly termed a paradoxical prince – an official who maintained the splendid appearance and some of the prerogatives of a ruler, but whose actual power became increasingly circumscribed – developed when Venice became a commune under the dogeship of Pietro Polani (doge 1141–48).[9] Some kind of oath of office probably had been taken by the incoming doges in the earliest years of the dukedom, as was a common practice by rulers throughout Europe in the Middle Ages. However, the formation of an autonomous Council of Sages (*Consilium sapientes*) in the early years of the commune created a political body that may have overseen the oath and more specifically delineated ducal powers.[10]

This Council of Sages of the early commune was eventually transformed into the Lesser Council, or *Minor consiglio* (fig. 0.11). After 1178, the ducal councillors of the Lesser Council were six in number, one for each of the six districts of Venice called *sestieri*. Each councillor held office for the relatively brief time of eight months, but could be re-elected after a waiting period called the *contumacia*. In essence, the doge with his councillors constituted an integrated unit of administration; the senior councillor even acted as interim head of state after a doge died. Councillors were, like the doge, required to keep a copy of his *Promissione* and to read it regularly. The Lesser Council advised the doge but was also charged with seeing that he did not overstep his

authority. The ducal councillors have been called "the conscience of the Doge," for they could find him and force him to begin work as head of state, which they were called upon to do with Renier Zen (elected 1253). They even could force him to abdicate, a role in which they participated in the case of Francesco Foscari in 1457.[11]

In addition to scrutiny by the councillors, probably some time in the thirteenth century the committee of the Correctors of the Ducal *Promissione* (*Correttori della promissione ducale*) was instituted to evaluate the text after the death of a doge, and to edit and extend it. In the fifteenth century a new committee, the Inquisitors of the Deceased Doge (*Inquisitori del doge defunto*), was charged to investigate whether the previous doge had followed the statutes. The family of the deceased doge was to be fined if there were serious infractions, adding another layer of oversight.[12] The *Promissione* text most closely spelled out the qualified political role of the doge, whose actual powers were increasingly circumscribed while his symbolic role as personifying the state became ever more accentuated.

The doge's status as symbol was expressed through regulation of his movements, regalia and attributes, as codified by statutes in the *Promissione*, and by ceremonial protocol. Portraits of the doge and his role in the patronage of the arts similarly were both prescribed and circumscribed. On the one hand, portraits were required to convey the dignity of the office, and a sense of the longevity of the Republic, by showing an extensive sequence of successive heads of state. On the other, the nature and location of such representation in public spaces were restricted, to prevent individual doges from establishing hereditary or autocratic identification with the state. They represented Venice, but could not embody it as absolute rulers.[13]

In procession, the doge was accompanied by a set of material attributes, including a parasol and eight silk standards, which symbolized papal favor and recognition of Venetian dominion over the Adriatic.[14] These were among a number of gifts purported to have been made by Pope Alexander III to Doge Sebastiano Ziani in recognition of his role in protecting the pope, and in mediating in a dispute with Emperor Frederick Barbarossa in 1177, resulting in the "Venetian peace." Through these ducal attributes, and in paintings in the Palace of the relevant events, the doge was shown as Defender of the Christian Faith, and intermediary between pope and emperor, and was therefore presented as a leader of similar standing.[15] So for Venetian political order as an oligarchic Republic, the doge had to retain his status and image as an elected magistrate, as *primus inter pares*, or first among equals. But for Venetian diplomacy, it was critical that he also conveyed the majesty of divinely authorized power; of a great ruler equal to other heads of state.[16] In addition, as the primary and most direct representative of the people of Venice to Mark, he was to present himself with appropriate dignity. Although not portrayed consistently as holy on the level of a king or Byzantine emperor, the ceremonies of his investiture, and his participation in the Mass next to the *primicerio* in the Basilica of Saint Mark, invested the doge with an aura of sacredness. His sacred and worldly aspects were emphasized separately in the staging of the oaths of his inauguration, the first taken in the Basilica of Saint Mark and the second in the Doge's Palace.

INAUGURATION AND DISTINGUISHING ATTRIBUTES

The inauguration and coronation ceremonies comprised a series of events over the course of one day, in which the doge took two oaths.[17] Coronation protocol became most strictly defined by a decree instituted by the Great Council in 1485, and was refined under the dogeship of Leonardo Loredan (elected 1501).[18] We will focus on just the few elements of the ceremony that

3.2 Antonio Rizzo, Scala dei Giganti. Courtyard of the Doge's Palace, Venice, c.1486-90. The giant figures of Mars and Neptune by Jacopo Sansovino were installed in 1567, giving the staircase its name

became important iconographically in *ducali* portraiture. After being presented to the Venetian people, the new doge elect took an oath at the main altar of the Basilica of Saint Mark, while placing his hand upon a book that contained the Gospels. The volume was probably either one of the great service books of the church produced in the fourteenth century, or eventually perhaps even the manuscript fragment thought to have been written by Mark (all discussed in Chapter 1, figs. 1.5, 1.11).[19] Next, the doge ritually accepted the responsibilities of office by taking a banner called a *vexillum*, offered to him by the admiral of the Arsenal, which then was reconsigned to the admiral. Afterwards, the doge was transported on a platform with two of his closest relatives and the admiral (still holding the *vexillum*)

outside into the crowds in the Piazza, where he distributed money to the people. He then was carried into the courtyard of the Ducal Palace.

During the fifteenth century some doges and Venetian officials sought to increase the splendor of the ducal office in competition with that of rulers on the Italian mainland. This probably is why the second oath and the coronation were moved from inside the Ducal Palace to the public venue of the courtyard with the election of Doge Marco Barbarigo in 1485.[20] A magnificent staircase by Antonio Rizzo was designed to create an effective stage for this climax of the coronation (fig. 3.2). It probably was not finished in time for the inauguration of Marco's brother and successor Agostino Barbarigo in 1486, but most likely was the platform for that

3.3 *Doge Marin Grimani Presented to the Virgin by Saint Mark, with Saints Joseph and Jerome, 1595.* Altar frontal, 114 x 345 cm. Manufactured by Jacopo di Gilillo of the Medici Tapestry Works after a design by Domenico Tintoretto and cartoon by Alessandro di Cristofano Allori. Basilica of Saint Mark, Museo Marciano, Venice, Inv. 30. The doge wears only the linen *camauro* on his head, while Christ blesses his *biretum*

3.4 Giovanni Grevembroch, "Preziosa Corona Ducale," *Varie Venete Cose* (detail), c.1776. 28.3 x 20 cm. Biblioteca del Museo Civico Correr, Venice, MS Gradenigo Dolfin 65, 1, fol. 76

of Leonardo Loredan in 1501, and certainly for Antonio Grimani in 1521.[21] During the ceremony, awaiting the doge on the steps were the Grand Chancellor and members of the *Signoria*. The Grand Chancellor handed the *Promissione* text to the most senior councillor, who then administered the oath of the doge. The most junior councillor then placed the *camauro*, a white linen skullcap, on the doge's head (fig. 3.3), which was followed by the *biretum*, also popularly called the *corno* for its characteristic horn-shape, or the *zoia*, a jeweled version of it (fig. 3.4), which was placed by the senior councillor. There usually was not enough time in between the death of one doge and the inauguration of the next for the correctors to finish their revision of the *Promissione*, so the doge would not have been given a definitive manuscript copy at the ceremony.[22] The next day, at an assembly of the Senate, he repeated the oath for a third time.

The doge's head coverings were charged with meaning, and images of him in his *Promissione* emphasized various aspects of his authority by showing him wearing the *camauro*, *biretum*, or *zoia*. The wearing of the translucent *camauro di rensa*, a skullcap made of fine linen "from Reims," was instituted sometime in the mid-thirteenth century, and symbolized the almost sacred status of the doge. While assisting the *primicerio* in the Mass, the doge took off the *biretum* but retained the *camauro*. Francesco

Sansovino, writing in 1581, claimed that the *rensa* of the doge recalled the memory of the holy oil with which Christian kings were anointed, "so that this Prince is as one of them."[23]

The *corno*, by contrast, was the principal marker of his worldly status. The decree of 1486, which ordered that the doge be crowned on the stairs in public, declared that the rite needed to be seen by all because the key distinguishing mark (*insigne*) of the doge was his *biretum*.[24] The *Promissione* of Bartolomeo Gradenigo in 1328 first specified the *zoia* to be provided by the state and maintained by the procurators of San Marco. The wearing of the *biretum* and *zoia* came to be highly circumscribed to emphasize that the doge did not personally own them. In 1401 a decree ordered that every time the doge was to wear the jeweled *biretum* it had to be presented by the head of the *Quarantia*, the supreme judicial authority of Venice, and a *gastaldo*, or functionary, of the procurators, and then returned to the *Procuratia*.[25] Great care was taken in the design and modification of the *zoia*.[26] At times it was deemed too plain, and further gems were added. In other periods the *zoia* became so heavily encrusted with stones, including emeralds, rubies, and diamonds, that it was difficult to wear with dignity and had to be altered, a task that the *Promissione* delegated to the procurators.[27]

The protocol of the coronation ceremony and other rituals, and the regalia of the doge, distinguished the office from the office holder. They also helped ensure continuity across the lifetimes of many individuals, while seeking to prevent dynastic succession, by contrast to the rituals of dynastic monarchies. Many of the rules laid out in the *Promissione* and in other regulations of the doge similarly were to balance the two bodies of the doge – the abstract, continuing office of rulership, with the specific person – and to maintain the doge as the link between the people of Venice and divine favor.[28] Individual doges could have themselves portrayed wearing various components of their vestments to emphasize different aspects of their ducal persona.

TRADITIONS OF PORTRAITURE

Doges actually were required by the *Promissione* to initiate, or even commission and pay for, certain material and visual records of their service, while other expected artistic commissions not mentioned in the *Promissione* were established by custom and paid for by the state. These included ducal portraits created in a variety of media, and conventions of depicting the doge in manuscript documents evolved in relation to his representation in such artifacts. Nevertheless, certain aspects of the imagery in *Promissioni* were specific to the document and came to reflect the different responses of each doge to the text, which asserted that the doge was elevated to his rank not by his own merits but by the grace of God. As memorials, illuminations in *Promissioni* are unique in that the doge's personal copy was paid for by the state, but unlike other kinds of works produced with public funds it remained with his family after his death.

One of the earliest duties spelled out in the *Promissione* was that the doge was to give gifts to Mark and to his church, following the generally established practice of donations made by a Christian ruler as expressions of wealth and status, but also supplication and piety.[29] Already in the text of the *Promissione* of Jacopo Tiepolo, who was elected in 1229, the doge was required to offer directly to Saint Mark a piece of cloth (*pannum*) worked in gold. With the *Promissione* of Marin Zorzi (elected 1311), the doge was required to fulfill this duty within a half year, rather than the full year formerly allowed.[30] The requirement of a gift of precious cloth by the doge to the patron saint was taken very seriously, but doges frequently died before they could fulfill this obligation.[31] Deliberations by the procurators in 1573 urged that if the gift of cloth (now specified as for the altar of the Basilica of Saint Mark) had not been completed while the doge was alive, his descendants should donate it within one month after his death.[32]

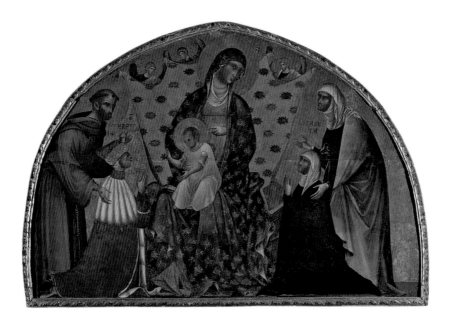

3.5 Paolo Veneziano, *Saint Francis and Saint Elizabeth of Hungary Present Doge Francesco Dandolo and Dogaressa Elisabetta Contarini to the Virgin and Child*, lunette of the tomb of Doge Francesco Dandolo, 1339. Panel, 145 x 223 cm. Chapter House of Santa Maria Gloriosa dei Frari, Venice

Few of these tapestries survive, but they could be substantially larger than a basic antependium, or altar frontal (in Italian, paliotto). They could cover all four sides of the main altar of the basilica during special ceremonies, especially the feasts of Saint Mark. An inventory of the altar tapestries in the church made in 1463 lists a series that went back to doges of the mid-fourteenth century, but the compositions were not described. In the early seventeenth century, Giovanni Stringa mentioned five from the sixteenth century as of particular richness. Of all of these, only two whole and one fragment survive, and these are of the sixteenth century.[33] They show a portrait of the donating doge kneeling in reverence to sacred personages, with Mark and other saints in attendance, similar in composition to the so-called votive portraits of the doge created to hang in the Ducal Palace (figs. 3.3, 3.21). The *Promissione* did not specify that the cloths were to feature portraits, so it is unknown when this tradition began, but likenesses clearly were key to the compositional model by the sixteenth century.[34] The altar frontals given by previous doges may have graced subsidiary altars in the church when the main altar was decorated with that of the reigning doge, so that a succession

of pious rulers could be viewed throughout the church. A tradition of portraying the doge in altar frontals may have been initiated as early as the thirteenth century, when the required gift was written into the *Promissione*, but again such altar cloths with portraits survive only from the sixteenth century onwards.

There were a number of other commissions paid for by the doge and the state that created a record of, and memorial to, each doge. Sansovino wrote that the doge was required to have a painting created for one of the council halls, but these conditions were not specified in the *Promissione*.[35] Instead, records show that by the sixteenth century at least some of the portraits destined to hang in the council halls of the Ducal Palace were commissioned posthumously by the Council of Ten and invariably all were paid for by the Salt Officers, who were responsible for the building and upkeep of the Ducal Palace.[36] Like the altar frontals, these images always show the doge in a devotional pose, and today are referred to as votive portraits. They were intended to display the piety of the doge and the state, and to invite divine favor.[37] The earliest of the independent votive portraits to survive still in situ in the Doge's Palace is a stone relief

with a portrait of Leonardo Loredan (doge 1501–21), kneeling in prayer to the Virgin and Child, but the tradition may have begun much earlier, and it certainly developed out of privately funded imagery of the doge that goes back to the lunette painted by Paolo Veneziano for the tomb of Francesco Dandolo (doge 1329–39) in the Frari (fig. 3.5).[38] In the context of state-funded portraiture, the earliest of such compositions to survive, however, are in neither the altar frontals, nor in palace portraits, but in *Promissioni* (fig. 3.6).

Complementing portraits of doges on the antependia in the Basilica and the votive portraits in the council halls were several series of simpler half-length portraits of doges in the Ducal Palace, which, in their accumulation, especially expressed the continuity, longevity, and antiquity of the office and the patriciate. The most important and public series runs around the top wall of the hall of the Great Council. Sanudo claims that the tradition of this cycle was begun by Marco Corner (doge 1365–68). These portraits were reproduced and continued after the first set was destroyed by the fire in the palace of 1577.[39] Patricians came to have similar series of their ancestors painted in their homes to emphasize the antiquity and status of their families. Some privately funded votive images featuring portraits of doges were intended for domestic or ecclesiastical settings, as may have been the case with Giovanni Bellini's portrait of Doge Agostino Barbarigo (fig. 3.19).[40] Numerous portraits also were made for the general market.[41]

In addition to the personal expenses of an altar frontal and other gifts to the Basilica with the doge's image, the *Promissione* required that the doge present a dignified household, specifying he was to employ a certain numbers of servants, and purchase "articles of silver for his own use" within a half year of being elected.[42] In general terms, the *Promissione* also came to regulate certain vestments that he was to wear, and on what occasions.[43] As well as the gold brocade

restagno that Doge Grimani mentioned at his death, the doge was required to own a fur-lined red mantle (*manto*) and a *bavarum* (*bavero*), or broad collar, in ermine. The doge was required by his *Promissione* to wear these at least ten times a year, on those days when he "was seen" according to a statute of 1320.[44] Ceremonial books maintained by the Ceremony Master of San Marco and the ducal chancery dictated such matters in greater detail.

Whereas the doge was required to wear certain garments and provide gifts ornamenting the interior of the palace and church, the image and heraldry of the doge progressively were forbidden to be installed during his lifetime in public spaces outside of the Ducal Palace.[45] This rule was largely followed, except for some limited inscriptions and coats of arms on other civic buildings. The most magnificent public images of the doges that came to be installed outside of the zone of the palace were the portraits on their tombs in churches. These were commissioned either by the doges themselves, or were commemoratives paid for by their descendants. Family tombs and altarpieces provided a spatial and visual context for the perpetual prayers funded for the souls of the deceased family members.[46] These public monuments celebrating an illustrative member of the family and his achievements also helped to elevate the status of the family as a whole. Comparison of imagery in *Promissioni* with that of relevant tomb monuments will show that, even within the strictures of the official context of the document, the illuminations tended to have more imagery personally relevant to the doge.

READING, WRITING, AND ILLUMINATING THE *PROMISSIONE*

To understand the miniatures in *Promissioni*, it is important to further clarify the legal nature of these documents and how they were produced. Again, the statutes section of the *Promissione* defined

Incipit prologus pmissionis Illustris domini Christophori Mauro dei gratia Ducis Incliti Venetiaz. Quam fecit Populo pro Ducatu.

In nomine dei Eterni Amen. Anno ab incarnatione dni nostri xpi Millo quadringentesimo sexagesimo secundo, Mense May die duodecimo intrante Indict. x.

Capitulum plogi pimissionis. I.

Cum no de nostra fortitudine ul prudentia sed dei sola processerit Clementia Creatoris, In cuius Arbitrio et uoluntate uniuersa sunt posita qd ad culmen ducalis dignitatis peruenerimus. uos hactenus in Ecclesia beati Marci Euangeliste dni Glosi qui patronus noster est et Signifer in omibus aggregati quantaz erga nos habueritis dulcedine caritatis

Ibi perfecte demostrastis cuz ad prolationem eligentium uos uice nra et noie in celum manibus eleuatis deum omnes unanimit glorificastis in uoce laudis magnifica et exultatois, Quoniam per intercessionem gloriosissimi Euangeliste sui Marci nos in ducem uobis dederat et rectorem. Inde super hys gratias quas possumus omnimodas psoluentes altissimo, cui magnitudinis non est finis et Euangeliste suo gubnatori nostro. Vobis quoqp super leticia magna quam de promotione nra geritis et habetis grates uberes refferentes Notum uobis fieri cupimus p pntis scripti paginam quia studiosos nos tanto exhibere uolum ampli et attentos ex cordis itimo put de iure debemus super ratoib et Justicys faciendis et sup negotys nostris omibus diligentiis promouendis que ad utilitatem uobis pariter et profectum cuz bonoze patrie meli ualeat puenire, quanto p nos auctore deo sup hys maior nobis est attributa facultac et collata tam gloriosa dignitas ac nimis precelsa.

De bono regimine, et psuatione boni status dnij Venetiaz. ij.

Volentes igitur quod in uoluntate gerimus sup hys in opere appertius declarare Nos Christophorus Mauro dei gra Dux Venetiaz et cet promittentes promittimus uobis uniuso pplo Venetiaz maioribus et minoribus et uris heredib q imodo i antea cunctis diebus quibus

some of the doge's powers and progressively outlined limitations upon him. Ongoing legislation attempted to make his actions conform to the letter of the document. From the thirteenth century, after the death of each doge the text of the *Promissione* was reviewed, and statutes were changed or added by correctors. The *Promissione* of Jacopo Contarini of 1275 is the first that compelled the doge to read his *Promissione*, or have it read to him, every two months, as was already required for his councillors.[47] A section of the *Promissione* added in 1289 had the doge vow to have two copies of the manuscript made within three months of his accession. He was to retain the copy given to him, one was to be made to be kept in the chancery, and the third was to rest with the procuracy of Saint Mark. All three were to have the lead ducal seal affixed.[48] Each of the six ducal councillors also needed to read the *Promissione* regularly, as well as their own rulebook. In addition, copies were required by other chanceries, such as that of the *Collegio*. The doge also eventually was required to read and observe the *Capitolari* of the councillors.[49]

The failure by some doges to regularly read and follow the *Promissione*, and the central purpose of the text to direct and circumscribe the behavior of the doge, is indicated by occasions when the doge was ordered to retake the oath of his inauguration on a missal, as was required of Andrea Gritti (doge 1523–38) in the presence of the Heads of the Council of Ten (*Capi del Consiglio di dieci*) in 1528.[50] A statute ordered by the Great Council in 1578 additionally required that the ducal councillors read the *Promissione* in its entirety to the doge at a specific time every year – the first week of the month of October, the start of the administrative year – and to remind him of his original oath to observe its statutes.[51] In 1585, after the death of Doge Nicolò da

Ponte, new legislation ordered that one of the *segretarii alle leggi* remind the ducal councillors to call the doge to observe the regulations of his *Promissione*.[52]

After the death of Doge Pasquale Cicogna in 1595, there again was consensus that the councillors needed to oversee the actions of the doge more carefully.[53] The council decreed that the doge would have to retake the actual oath with the Heads of the Council of Ten in the presence of the entire Great Council every year in October, in addition to rereading it then and every two months. That he had to retake his oath yearly suggests that belief in the efficacy of the original was diminishing, but that there was hope that repetition of it would make doges conform to the rules of the document.[54] So that members of the Great Council had better access to the document, and to assure their oversight, the *Promissione* of the doge, beginning with that of Doge Marin Grimani in 1595, was ordered to be printed under the auspices of the *Rason vecchie* and distributed to every noble member of the council.[55]

As discussed earlier, it may have taken some time for the doge to receive a definitive copy of his *Promissione* to allow for scribes to include changes made by the correctors. The doge had been responsible since 1278, according to his *Promissione*, for having copies made of his manuscript, but the doge did not necessarily involve himself directly with their production. Since at least 1316, a subdivision of the ducal chancery called the Lower Chancery (*Cancelleria inferiore*) maintained the *Promissioni*, the acts of correctors and of the Inquisitors of the Deceased Doge, as well as other relevant materials.[56] Scribes in the chancery, or sometimes specially hired calligraphers, would then have used the stored templates to create new editions and special copies.

Again, according to the *Promissione* text, the doge was given a personal copy of the document, and was to have two copies made of it. A record of the request of payment for the illumination of a *Promissione* for Doge Cristoforo Moro,

3.6 Leonardo Bellini, *Promissione of Doge Cristoforo di Lorenzo Moro, elected 1462.* 34 x 23.6 cm. British Library, London, Add. MS 15816, fol. 5r

elected in May of 1462, gives some insight into how the decoration of the document for the doge typically may have been commissioned, and the important role of cultivated secretaries in arranging it. In December of 1463, over a year and a half after Moro's election, the secretary Ulisse Aleotti (d. 1488) requested to be reimbursed the sum of four gold ducats by the office of the *Rason vecchie* for having paid Leonardo Bellini to create a *Promissione* for the doge.[57] This record of payment to the "painter, or actually miniaturist" Bellini allowed Lino Moretti to identify the illumination of Moro's only known surviving *Promissione*, now in the British Library, as by that artist (fig. 3.6). This attribution to Leonardo Bellini has made the manuscript the basis for the construction of his oeuvre, and his hand is found in *ducali* until 1483.[58]

By the time of the commission of Moro's *Promissione*, Leonardo Bellini already was working for many illustrious patricians. He had embellished a manuscript written in 1457 for Leonardo Sanudo, father of the diarist Marin Sanudo, and a nephew of the future Doge Moro.[59] In fact, Leonardo Sanudo had collected together and published the many orations written in celebration of the doge's election, and he may have recommended the miniaturist to Aleotti and Doge Moro.[60]

The *Rason vecchie*, from whom Aleotti requested reimbursement, generally paid the expenses for events and objects that honored the doge, as well as for other public festivals and ceremonies.[61] Aleotti stated that he wished to be repaid "according to the custom ... by this office," and we can therefore assume that most, if not all, of these *Promissioni* for the use of the doge were paid for by the *Rason vecchie*, at least around this period.[62] While Leonardo Bellini already was well patronized by patricians close to Doge Moro, the role of Aleotti in commissioning the *Promissione* may have included choice of artist, for the secretary seems to have known the Bellini family of painters well. He also was aware

of the patronage of art, book production, and manuscript illumination by courtly rulers on the mainland, especially the Este of Ferrara, to bolster their image. This commission may have been intended to extend to Venetian rulers the political and dynastic uses of portraiture so effectively employed at the Este court.[63]

The miniaturist Leonardo Bellini (*c*.1424–*c*.1490) was a nephew of the more famous painter Jacopo Bellini (*c*.1400–1470/71).[64] For at least twelve years, Leonardo had been trained and brought up in Jacopo's studio as if he had been his son. The Bellini family held the privileged status in the city of being *cittadini originari* like Aleotti, and the secretary wrote a sonnet celebrating Jacopo Bellini's victory over Pisanello in a competition to paint the best portrait of Lionello d'Este. This competition allegedly was sponsored by Lionello's father, the marquis Nicolò d'Este, at his court in Ferrara in 1441.[65] Some scholars doubt the competition ever took place, but what is important here is the championing of Leonardo Bellini's uncle and master Jacopo by Aleotti. Also relevant is that Aleotti participated in the growing interest in portraiture as aiming to capture a *vera effigie*, or true likeness, of the sitter.[66] The notion of a visual document recording the appearance of the doge may have been of particular interest to Aleotti, who was highly trained in the production of textual documents.

So Doge Moro did not himself pay for the illumination of his *Promissione* now in the British Library but, as will be discussed, the personalized imagery of the miniatures indicates he must have been consulted. He would have conveyed any wishes for the choice of artist and design to Aleotti. Such secretaries and administrators, who were part of cultivated social networks, may have thought it was in the interest of the state to promote an elevated and distinctive image of the doge in manuscripts, just as other rulers throughout Europe were promoted through luxury manuscripts embellished

with their portraits.[67] Many other copies of *Promissioni* were manufactured during the reign of each doge. Before the evolution of illumination in documents destined for the personal use of doges is further examined, these must be distinguished from those made for other readers.

DIFFERENT TYPES OF *PROMISSIONE* DOCUMENTS

It is generally agreed that Doge Moro's document in the British Library was made under the direction of the secretary Aleotti to be presented to the doge, and was designed with the input of Moro in terms of included saints and other personalized imagery. But many illuminated *Promissioni* were meant for readers other than the doge. Surviving original manuscript *Promissioni* can be divided under several categories by format and intended audience, and the destined recipient was critical to patterns of their illumination and

3.7 (Above left) Giustino del fu Gherardino da Forlì (attrib.), *Capitolare* of a ducal councillor, c.1368–82. 35.7 x 28.7 cm. J. Paul Leonard Library, San Francisco State University, De Bellis La. 12, fol. 1r

3.8 (Above right) Giustino del fu Gherardino da Forlì (attrib.), *Doge Andrea Contarini Receives the Standard from Mark*, *Promissione* of Doge Andrea di Nicolò Contarini, elected 1368. 35.7 x 28.7 cm. J. Paul Leonard Library, San Francisco State University, De Bellis La. 12, fol. 31r. Because this is preceded by the *Capitolare* of the ducal councillors, and does not have prominent heraldry, it probably was not made for consultation by the doge himself

3.9 (Below) Gold ducat of Doge Giovanni Dandolo (doge 1280–89). Each 2.1 cm diameter. Museo Bottacin, Padua, Serie Veneta, n. inv. 81n. ingr. 557

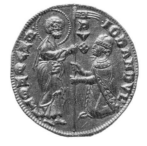
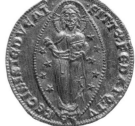

storage.[68] The first and earliest category is of *Promissioni* documents that were actually signed by the doge. These are in a notarial form that has been called an *"instrumentum publicum."*[69] Only two of these, for Jacopo Tiepolo (doge 1229–49) and Marin Morosini (doge 1249–53), exist.[70] They are brief, contained on one large piece of parchment to be scrolled in storage, and neither has illuminations. The form was no longer used after the thirteenth century. It seems that after this time the oaths taken during the coronation ceremony were considered sufficient, so a signature was not necessary.[71] We can recall here that the *Promissione* text itself required that the doge have two copies made of his document, one for the ducal chancery and the other for the procurators. These copies for use by secretaries and administrators comprise a second category, and some still survive in the State Archives of Venice. These were created sequentially, but a number of them came to be compiled and bound together in volumes. Some were embellished with portraits of the relevant doge.[72] A particularly fine example opens the *Promissione* of Antonio Venier (doge 1382–1400). The miniaturist has portrayed the doge with vigorous realism in the manner of Nicolò di Giacomo di Nascimbene, a prolific miniaturist from Bologna (fig. 3.1).[73]

A third category of surviving *Promissioni* manuscripts are those bound with the councillors' Oath and statute books (*Giuramenti* and *Capitolari*), and these often were illuminated. Such is the document of Andrea di Nicolò Contarini (*c*.1305–1382), elected doge in 1368. Its illumination can be associated with that in a manuscript signed by Giustino del fu Gherardino da Forlì, who may have been the miniaturist or the scribe (figs. 3.7, 3.8).[74] The oath of the councillor opens with an initial "I" (*"Iuro…"* on fol. 1r) representing an official who points to a quote from Psalm 92 inscribed on a banner sustained by an angel: "The righteous shall flourish like the palm tree, he shall grow like the cedars of Lebanon."[75] Every year on Palm

Sunday the doge and the *Signoria*, including the councillors, processed in Piazza San Marco with palm fronds covered in gold leaf to recall Christ's victorious entry into Jerusalem and Venetian triumph over its enemies. The quote simultaneously asserts patrician piety and exhorts Venetian officials to rule in an exemplary manner, a message that became common in miniatures within sixteenth-century Commissions of procurators and rectors.[76]

In the initial "C" (*"Cum…"* on fol. 31r) opening the prologue of the *Promissione* in this manuscript, the lion of Mark hands the kneeling doge a standard with his symbol, a variation on a standard scene on coins and seals culled from the inauguration rituals (fig. 3.9). His dress does not yet correspond with a new text in this *Promissione*, which is the first requiring the doge to obtain and regularly wear at least

one "beautiful cloth worked with gold" (the gold *restagno*), within the first six months of his tenancy, indicating the greater emphasis put upon him as grand symbol.[77] In fact, Contarini was a reluctant ruler – he initially refuted the dogeship, and was buried in a modest tomb in the monastic courtyard of Santo Stefano, near the family chapel.[78]

When *Promissioni* such as these do not prominently display the coat of arms of the doge, and especially if the councillor's manuscript is located before that for the doge, it seems safe to presume that these manuscripts were made not for the doge personally but as reference copies for another individual or office. Many would have been made for the ducal councillors, who were compelled in the statutes of their manuscript to read a copy of the *Promissione* as well as their own *Giuramento* on a regular basis, but were supposed to return the manuscripts upon completion of their turn of duty.[79]

3.10 (Opposite) *Giustino del fu Gherardino da Forlì* (attrib.), *Promissione of Doge Michele di Marin Morosini*, 1382. 27.3 x 26.6 cm. Biblioteca Nazionale Marciana, Venice, Lat. X 189 (=3590), fol. 6r

3.11 (Right) *Giustino del fu Gherardino da Forlì* (attrib.), *Promissione of Doge Antonio di Nicolò Venier*, elected 1382. 24.6 x 25 cm. Giustiniani Recanati Falck Library, Venice, cl. IV cod. 410, fol. 5r

To these *Promissioni* produced for the councillors and other officers we can add the numerous copies on paper or membrane, not as carefully made, created as reference copies or records for interested individuals, or for use in various offices. [80]

The fourth category, the subject of this chapter, is comprised of independent *Promissioni* manuscripts created for the doge and to be retained by him, and these are the manuscripts that came to be most extensively illuminated. The key identifier of such manuscripts is that they prominently display the doge's coat of arms as a mark of ownership on the opening page of text and/or binding, and many of them have more extensive imagery than those without conspicuous heraldry. The surviving series of these show a general progression from standardized imagery identifying the doge with the promise and rules of office, to portraying him as humble supplicant, to showing him as divinely elected and even triumphant.

MANUSCRIPTS FOR THE DOGE

The earliest surviving illuminated independent *Promissioni* manuscripts with relevant coats of arms are of two successive doges of the late fourteenth century, and they are similar enough in format and decoration as to suggest little input from the respective recipients, and scrutiny perhaps by the same secretary. The first document is that of Michele di Marin Morosini (1328–1382), elected in 1382, but he was doge only for a month because he died of the plague (fig. 3.10).[81] Like the illuminations in the manuscript for a ducal councillor who served under Contarini just discussed, the portrait of the doge in the *Promissione* can be associated with the artist who decorated the manuscript signed by Giustino del fu Gherardino da Forlì, but this *Promissione* created for the doge himself is more sumptuous and glitters with gold leaf.[82] If indeed the role of Ulisse Aleotti in overseeing the illumination of Cristoforo Moro's *Promissione* (fig. 3.6) was standard, this document would have been paid for by funds

from the *Rason vecchie*, under the supervision of a secretary. In this earlier case, however, there was little interest in creating a unique and personalized image of the doge. In this fairly large manuscript, the opening initial portrays the new doge Morosini with the *corno* on his head, and cloaked in the red ducal *manto* with the *bavero*, as required for his ceremonial appearances by the statutes of the *Promissione*. He is shown receiving the manuscript or taking an oath, a very common kind of image in manuscripts of the time. The office is identified by the book and by the regalia. At any rate, the portrait is not much individualized, rather it provides a general sense of historical record and reference, and emphasizes the doge as authorized by and conforming to the document.

The same decorative scheme is found in another *Promissione*, close in size, of the successive doge Antonio di Nicolò Venier (doge 1382–1400) (fig. 3.11).[83] There are a number of other *Promissione* manuscripts that were produced under Venier's reign, but this is the only one that displays his coat of arms and that has a scheme of border decoration in the style of Giustino, similar to the document for Morosini, the preceding doge.[84] These earliest surviving *Promissioni* destined for the doge himself merely emphasize his oath, and have a homogenous and impersonal stamp. Subsequent *Promissioni* with prominent heraldry of the doge, and therefore apparently made for his personal use, show him genuflecting and emphasize the sacred nature of the office and ducal election to amplify the meaning of the prologue text. At the same time they became more personalized to project the distinct character of each doge.

DOCUMENT AND MONUMENT

Francesco di Nicolò Foscari (c.1374–1457)

The first known *Promissione* transformed by embellishment into a monument to a doge was made for Francesco Foscari, elected in 1423 (fig. 3.12). The miniatures are attributed to Cristoforo

Cortese (active 1399–c.1443) through comparison with other illuminations signed by him. Cortese is the earliest illuminator in Venice known to have autographed some of his works, suggesting a certain self-consciousness, and emulation of the growing practice of signing panel paintings.[85] As discussed in Chapter 1, shortly before Foscari's election the previous doge, Tommaso Mocenigo, had triumphally processed the newly acquired fragment of a Gospel Book believed to have been written in Mark's own hand (fig. 1.11). It may be an accident of preservation, but Foscari's *Promissione* contains the only portrait in which Mark offers the doge a manuscript, either meant to represent the *Promissione* or the Gospels on which to take his oath. The manuscript was shown perhaps to highlight that the recent acquisition of Mark's autograph Gospel further confirmed his favor of Venetian laws and its administrators.[86] In this way, the doge's statutes appear to have an authority approaching that of the Gospels. Foscari's manuscript may have inaugurated a series of *Promissioni* that were more expansively decorated and personalized than documents up to that date.

The painting in Foscari's *Promissione* complements the sculptural group with his portrait created for the Porta della Carta (fig. 1.6), in that it adapts the imagery and meaning from the investiture ceremonies as portrayed on coins and seals, but emphasizes the codex rather than the vexillum as embodying the authority granted to him from Mark.[87] In the illumination, the divine sanction of the doge's election through Mark's intercession is emphasized, thus reinforcing and personalizing the text of the prologue that the figurated initial opens. This in turn emphasizes that a patrician arrives "at the ducal summit," not from his own fortitude or prudence, but by the will of God.[88] Foscari's also is the first *Promissione* in which the doge is shown wearing the gold *restagno* required to be purchased by the doge, as specified in the *Promissione* text by 1367. Whereas the gold cloth

projects a princely demeanor, it can be interpreted simultaneously as signifying Foscari's sacred status.

The illumination fuses inauguration imagery, where Mark invests the doge with the office, with a votive image composition. The doge's family lineage also is highlighted through the representation of patron saints. Foscari's namesake Saint Francis stands by while a bishop, presumably Saint Nicholas of Bari, presents Foscari to Mark.[89] Dennis Romano has suggested that Nicholas was included as the namesake of Francesco's father, noting that "Foscari is presented by his biological father (Nicholas) and his spiritual father (Francis) to the father of the state (Mark)."[90] Venetians tended to name progeny after their forbears, emphasizing the

3.12 Cristoforo Cortese (attrib.), *Promissione* of Doge Francesco di Nicolò Foscari, elected 1423 (detail). 34.8 x 24 cm. Giustiniani Recanati Falck Library, Venice, fol. 5v

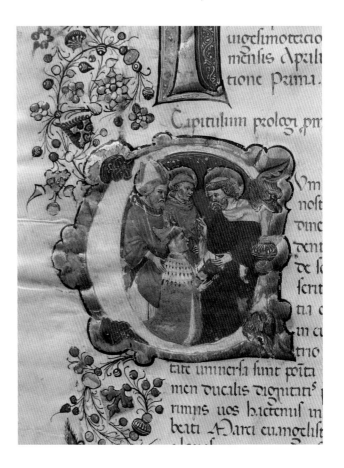

continuous line, and Francesco had a grandson named Nicolò, born in 1447, who became instrumental in the creation of the magnificent tomb for Francesco in the Frari, intended in part to restore the reputation of the doge.[91] He may have owned this copy of Foscari's *Promissione*, for it was in the Foscari family until 1797, when it was acquired by a French official.[92] The amplification of the role of illumination in the book to memorialize Foscari, with the inclusion of Nicholas as marker of patrilineal succession, presented an early model to those who would collect such manuscripts in family archives.

During his long tenure, Foscari oversaw the great expansion of Venice on the *terraferma*, and an overall aggrandizement of the office towards personal and princely rule. But he also faced bitter political struggles. Twice he was forced to banish his only surviving son Jacopo from Venice, and he even attempted to abdicate on two occasions, in 1433 and 1442, but was not allowed to do so. Then, in 1457, Foscari was forced to leave office against his will, the stated reasons being old age and decrepitude. In fact, he eventually invoked the oath and statutes of the *Promissione* to try to remain in office. The doge rebutted the initial urging for him to resign made by the Council of Ten by invoking the authority of the *Promissione* itself, stating that he did not wish to disobey the oath he took upon assumption to office, and that indeed he could not do so. Foscari challenged the Ten by referring them to the statute that stated the ducal councillors would need to make a proposal in the Great Council to depose him. Nevertheless, the Council of Ten was able to get the Great Council to approve its authority in deposing the doge, and Foscari died just two days after the election of Pasquale Malipiero in his place.[93]

In the rest of this chapter we will examine the other six surviving, more elaborately illuminated, *Promissioni*. These are what remain over the course of sixteen ducal reigns, ending with that of Francesco Venier, who was elected in 1554.

The illumination of these *Promissioni* carefully negotiated the personal image of the doge with the required protocol of his office, in the closest proximity to the words that upheld his election as by divine will, yet that also placed limitations upon his power. All of these doges for whom there survive *Promissione* manuscripts from the fifteenth century – Cristoforo Moro, Nicolò Tron, Nicolò Marcello and Agostino Barbarigo – came under scrutiny for behavior that pushed at the boundaries of ducal decorum. These manuscript paintings merit special consideration when examining ducal imagery, as many of them clearly were illuminated with consideration of the doge's instructions, and therefore represent relatively rare evidence of their own self-imaging after election as doge. All of these images emphasize divine election and the sacred nature of the office, but are personalized with distinct focuses of devotion.

Cristoforo di Lorenzo Moro (c.1390–1471)

The *Promissione* for Cristoforo Moro, elected in 1462 (fig. 3.6), shows the doge presented in such surviving manuscripts for the first time in a square, which fully displaces the space of the initial prepared by the scribe, an overall *mise-en-page* that was adapted in the *Promissioni* of the two successive doges. In a radical departure in terms of the representation of space in such manuscripts, the small *sacra conversazione* of Moro is set in a one-point perspective courtyard measured out by the tiled pavement, as if an independent votive painting. The filigree border with flowers and gold dots is filled with vignettes of a wide variety of identifiable birds and exotic animals, such as cheetahs, a monkey, and a lion mauling a doe. The clothed angel holding the coat of arms of the doge in Foscari's *Promissione* is replaced by winged young boys in the more classicizing mode of Paduan art of the period. Moro is shown kneeling before the Virgin and Child, attended by Saints Mark and Bernardino. Because this composition precedes surviving ducal votive portraits in the Doge's Palace, some scholars have proposed that

the illumination in *Promissioni* could have been the iconographical sources for such paintings. But such imagery also is closely linked to earlier images of doges on tombs, and the surviving, if later, cloth antependia required of them. Whether it preceded or followed such votive representations, this inclusion of Saint Bernardino of Siena in addition to Mark especially personalized the message of divinely ordinated election and characterized Moro as particularly humble.[94]

As discussed previously, illumination of Moro's manuscript has been attributed to Leonardo Bellini on the basis of the document of payment by the secretary Ulisse Aleotti, but the imagery is highly specific to this doge. Moro is dressed in the slightly more humble red ducal mantle, not the gold *restagno* worn by Foscari in his manuscript. Moro receives the blessing of the Christ Child and Mary

3.13 Pietro Lombardo, Tomb monument of Doge Nicolò di Giovanni Marcello (d. 1474) (detail), 1490s. Full monument approx. 600 x 300 cm. Santi Giovanni e Paolo, Venice

with Saint Bernardino behind him and Mark to his left. The hagiographical literature written after Bernardino's death claimed that he and Moro were close spiritual friends, and that while Moro was rector of Padua in 1442, Bernardino repeatedly prophesized that Moro would become doge. The claim that Bernardino was Moro's divine intercessor was also circulating by the time of Moro's death, and was certainly aided by the doge's inclusion of representations of him in works he patronized after Bernardino's canonization in 1450.[95]

The representation of Bernardino in the miniature especially reinforces the notion of divine election specified in the opening text. Indeed, Moro had the Church of San Giobbe rebuilt and dedicated to the memory of Bernardino, and had requested burial under the presbytery of the church, in front of the main altar dedicated to the saint.[96] Moro's tomb was probably planned during his lifetime and it presents a subtle yet majestic solution to the problem of self-commemoration. His tomb monument was a simple slab, yet by its location, as Debra Pincus aptly characterizes it, he "takes full possession of the choir."[97] The tomb is on the one hand self-effacing, yet also absorbed into the most sanctified part of the church. This corresponds with his representation in the *Promissione*. Moro wears on his head only the translucent *camauro di rensa*, symbol of ducal religious authority and sacred status, while his *corno*, the principal marker of his worldly status, crowns his coat of arms at the foot of the page. The depiction of doges with the head covered only by the *camauro* is rare in surviving monumental painting of the fifteenth century. But some doges are shown wearing it in tomb lunette reliefs of the second half of the fifteenth century, as in the portrait of Doge Nicolò Marcello (d. 1474) in the lunette of his tomb originally in the Church of Santa Marina, but now in that of Santi Giovanni and Paolo (fig. 3.13).[98] In such tomb sculptures, a representation of the doge fully in the round, wearing the *biretum* as sign of his worldly dignity as doge, reclines above his sarcophagus,

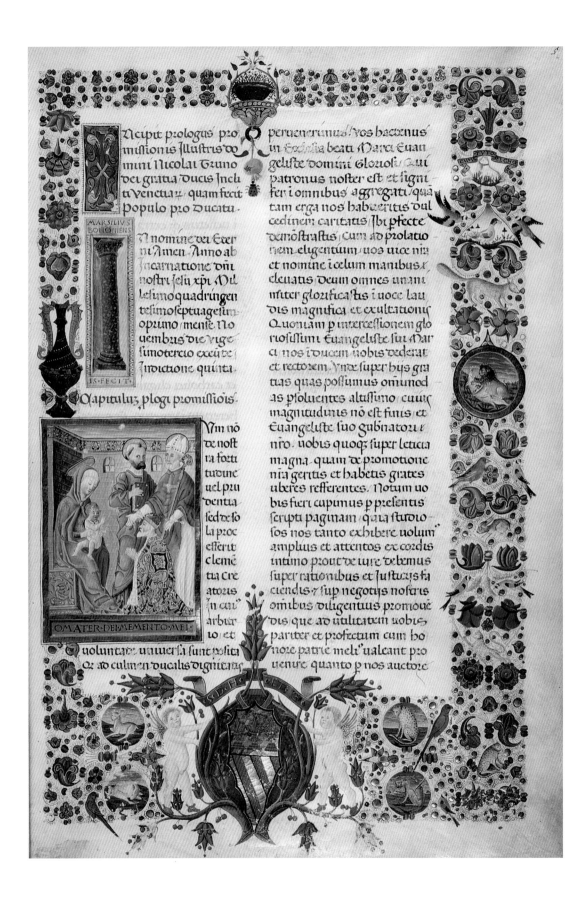

surrounded by personifications of Virtues and signs of his achievements. This approximates how he would have actually appeared while lying in state during the funeral (from the sixteenth century onwards as a wax effigy).[99] Above, in low relief, the doge's presence in a heavenly realm is indicated in that he wears only the *camauro*.

The precedents for such a devotional image of the doge in his *Promissione*, with patron saints and kneeling in front of the Virgin, are found earlier, in the fourteenth-century monumental tombs of doges, beginning with that of Francesco Dandolo (1328–1339) (fig. 3.5). The ritual surrounding the death of the doge and the gradual closure of space in the Basilica of Saint Mark as a site for tombs of doges, requiring that they be buried outside the zone of the Basilica, emphasized that the doge returned to being just another patrician while the office continued. Nevertheless, the privately funded tombs retained a civic character that boasted of ducal status.[100] The painting commissioned by Francesco Dandolo for his tomb is the first known to show the doge in prayer to the Virgin.[101]

Despite the humble persona represented in his *Promissione*, Moro was the first doge to issue coins showing his profile portrait in the style of ancient coins and contemporary portrait medallions.[102] The next doge, Nicolò Tron, issued a large number of coins with his profile portrait, ending with the decree that required coins to feature the doge only in the subservient posture of kneeling in front of Mark.[103]

Nicolò di Luca Tron (1399–1473)

There are surviving *Promissioni* for the two subsequent doges, Nicolò Tron (doge 1471–73) and Nicolò Marcello (doge 1473–74), and both closely follow Moro's in format and imagery in that they are linked to devotional portraits and

3.14 Marsilio da Bologna (signed), *Promissione* of Doge Nicolò di Luca Tron, elected 1471. 34.8 x 23.5 cm. New York Public Library, Spencer MS 40, fol. 6r

their respective personal devotional practices. The *Promissione* of Tron is the only one signed by a miniaturist (fig. 3.14).[104] Marsilio da Bologna signed his name in the frame of the opening "I," rendered as a classical column. Marsilio may have used Moro's *Promissione* as a template for the border because the general design and even the animals in the roundels are almost exactly the same. But now he set the scene indoors, pushing the figures towards the front of the picture frame for greater immediacy and illusionistic play. Marsilio added devices of Tron, including the inscription "with all my heart" above a dog, surely featured at the request of the doge, to create a more courtly and personalized effect.[105]

In the portrait miniature, Tron, dressed in his gold brocade mantle, is presented by Mark and his name saint Nicholas to the Christ Child, seated on the Virgin's lap. Beneath this scene in capitals is the plea, "Oh Mother (of God) remember me." The inclusion of a version of this supplication is not uncommon in portraits within Books of Hours, and in portraits of sitters in devotion to Mary and Christ from northern Europe.[106] It enhances the pious aspect of the doge, and contrasts with the unabashedly triumphal imagery of his tomb commissioned by his son Filippo from Antonio Rizzo and his workshop. This massive monument on the left wall of the choir of the Frari presents a complex program glorifying the doge's rule with imagery derived partly from ancient coins. The inscription states the tomb was financed by gains from Tron's wars with the Ottoman Empire.[107] Subsequent tombs by the Lombardo family of sculptors repeated the triumphal arch format, which was also popular in manuscript and book frontispiece design. The *Promissione* of Tron presents a more humble and pious, yet also courtly and personal, representation of him than in the tomb commissioned by his son. Within the constraints of the official context of the document, it may have respected his wishes for self-presentation more closely.

Nicolò di Giovanni Marcello (c.1399–1474)

Although the composition of the illuminated leaf for the *Promissione* of the subsequent doge, Nicolò Marcello, is similar in conception to that of Tron, the imagery emphasizes greater submission to God, to create a message that also undermined the ideal of human supervision of the doge embodied in the ducal councillors (fig. 3.15).[108] Marcello's Commission/Oath as procurator *de supra* (he was elected as such in 1466) survives and has a rich border of flowers with angels presenting the coat of arms. Like his *Promissione*, it is in the style of Leonardo Bellini but is almost purely decorative (fig. 3.16).[109] Marcello is portrayed regally but diminutively in his *Promissione*. Mark presents him to God the Father, who holds the orb and cross as ruler of the world, and whose throne is flanked by the Virgin and Child to the left.[110] There is the same kind of border of gold dots and filigree as in the *Promissioni* of Moro and Tron, in the tradition of Ferrarese illumination, but the more exotic animals and violent image of a lion

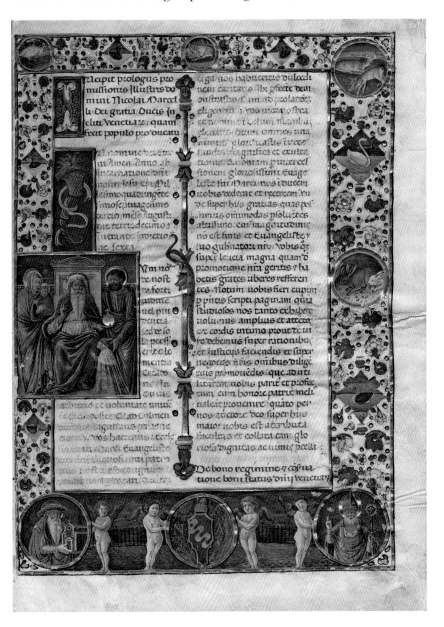

3.15 (Left) Leonardo Bellini and workshop (attrib.), *Promissione* of Doge Nicolò di Giovanni Marcello, elected 1473. 35 x 25 cm. Biblioteca del Museo Civico Correr, Venice, Cl. III, 322, fol. 6r

3.16 (Opposite) Leonardo Bellini (attrib.), Commission/Oath of Nicolò di Giovanni Marcello as procurator *de supra*, elected 1466. 27 x 19.2 cm. Biblioteca Nazionale Marciana, Venice, Lat. X, 238 (=3509), fol. 5r

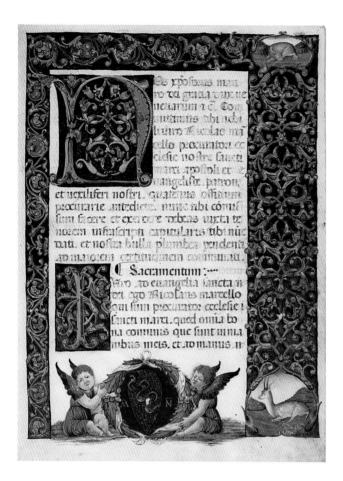

attacking his prey are replaced with rabbits, deer, a swan, and other indigenous mild creatures.

The figure of God the Father enthroned as the focus of a votive image is unusual, and must be meant to highlight the text that the miniature prefaces, which emphasizes Moro as elevated to the office by the Creator.[111] As in the *Promissioni* of Foscari and Tron, Marcello is dressed entirely in gold. Francesco Sansovino claims Marcello was the first to process completely gilded, with even a gold brocade umbrella and gloves, as a sign of Venice as imperial power over land and sea. Even the throne, which preceded him in procession, was of gold rather than the standard crimson (*cremesino*).[112] Yet other imagery of this leaf references Doge Marcello's admiration of an order of poor friars. Below, in the corners of the margins, are half-length images of Saint Nicholas, his namesake, and Jerome as Cardinal, holding a miniature church.

Jerome was featured probably because of Marcello's devotion to the *Gesuati* (Jesuates), who especially venerated the saint, and whose original oratory on the Zattere in Venice was dedicated to Jerome. A few *Gesuati* friars first came to Venice from Siena in 1392. They were named as such because of their repeated invocation of Christ, or "*Gesù.*" In this sense they can be considered forerunners of Saint Bernardino of Siena in their encouragement of the cult of the name of Jesus.[113] Like the Franciscans, and a number of other newer orders, they were devoted to living according to the precepts of humility, voluntary poverty, and bodily mortification.[114] Marcello donated large funds during his lifetime, and in his testament, to the *Gesuati* of the Zattere. Their oratory dedicated to Jerome was replaced in the early sixteenth century with a new one in honor of the Virgin Mary of the Visitation, and this church still stands.[115] But the order was abolished in 1668, when their land in Venice was given to the Dominicans, who eventually built the large church dedicated to Mary of the Rosary. This eighteenth-century church with glorious paintings by Giovanni Battista Tiepolo is still referred to by the old name of the *Gesuati*.

Flaminio Corner reported that Marcello was so devoted to the *Gesuati* that he requested to be crowned as doge by two of the friars of that order, instead of by the senior councillor, as protocol required. Thus Nicolò Marcello knelt to receive his jeweled *biretum* from the poor friars Girolamo Scardena and Giovanni Veronese, introducing an element specific to his personal devotional beliefs into state ceremony and emphasizing his divine election.[116] This tampering with the protocol granted the order public dignity after they had been denounced by Pope Eugenius IV. It can be read also as stating that Marcello was less beholden to the vigil of his councillors than to a higher authority.[117] The *Promissione* text of the opening leaf emphasizes complete submission to God. Marcello may have understood his practice of dressing completely in

gold as calling attention to the divinely ordained, as well as princely, status of his office.

Nicolò Marcello left substantial wealth to his wife Contarina and his daughter Marina, a nun, as well as to many pious and charitable institutions. He requested a modest burial at the Carthusian monastery of Sant'Andrea del Lido,

and gave especially large sums of money for the yearly Masses for his soul and those of his loved ones. The rest he left to the legitimate heirs of his deceased brother Bernardo Marcello.[118] These heirs also presumably inherited his *Promissione* and other documents, but the patrons of his tomb are unknown (fig. 3.13). Originally installed in

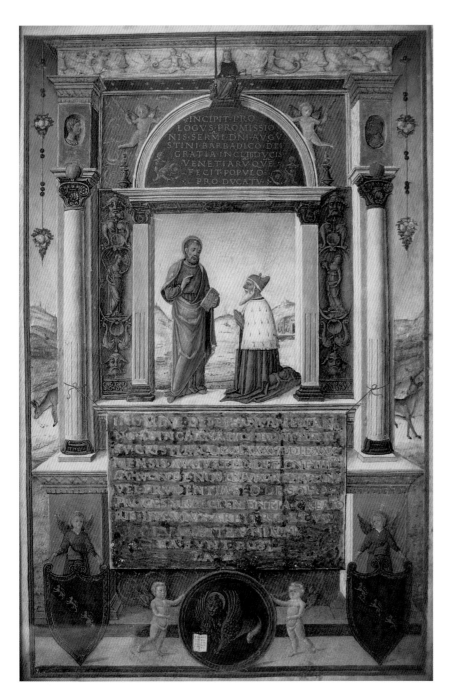

3.17 (Left) Master of the Pico Pliny (attrib.), Leaf detached from the *Promissione* of Doge Agostino di Francesco Barbarigo, elected 1486. 33.5 x 21.5 cm. Ford Collection, London

3.18 (Opposite) Master of the Seven Virtues (attrib.), Commission/Oath of Agostino di Francesco Barbarigo as procurator *de supra*, elected 1485. 24.2 x 16.4 cm. Biblioteca del Museo Civico Correr, Venice, Cl. III, 160, fol. 7r

the family chapel in the Church of Santa Marina in Castello, it was transferred to that of Santi Giovanni e Paolo sometime after 1808, when Santa Marina was deconsecrated, and before 1818, when that church was demolished.[119]

In the lunette of the tomb the doge is presented to the Virgin and Child again by Mark, as in his *Promissione*, but now, to the right, also is Saint Liberalis, to whom originally this church was dedicated.[120] There is no real relationship between the tomb and manuscript illumination. As with the case of Tron, and as highlighted by the neglect of Marcello's expressly desired burial site at Sant'Andrea del Lido in favor of the family tomb at Santa Marina, the *Promissione* may have been closer to Marcello's own wishes of self-presentation.

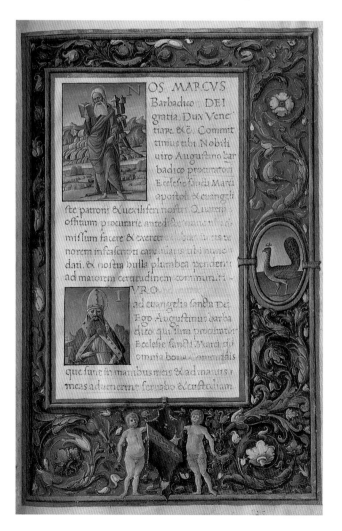

Agostino di Francesco Barbarigo (1420–1501)

Whereas the imagery in the documents of Marcello and Moro featured personalized elements of their piety and emphasized submission in the context of divine election, the *Promissione* of Agostino Barbarigo introduced the theme of princely triumph, which accorded with how he pushed the limits of acceptable ducal presentation and behavior and also unusually succeeded his brother Marco as doge. The miniature appears to be an early stage in the doge's development of his ducal persona. The fully illuminated opening leaf to what must have been Agostino Barbarigo's personal copy of his *Promissione* is the first surviving to largely dispense with text, displaying a short section written as if hanging in front of a tomb (fig. 3.17). In filling the entire large page, the illumination functions visually like Doge Tron's monumental tomb, which takes up the wall of the left presbytery of the Church of the Frari.[121] The focus on triumph in using the vocabulary of ancient monuments is also similar to Tron's tomb monument. Agostino was elected in 1486, and behaved in such an unusually imperious manner that after his death the new office of the Inquisitors of the Deceased Doge was instituted to reign in such impulses by future doges.[122]

Agostino's audacity was epitomized in his demand that those who addressed him kneel and kiss his hand. The new setting of Mark and the doge within an antique-style monument set against a deep landscape stresses the doge's accession as a triumph, while recapitulating elements of the traditional investiture composition carried over from coins, and intimated in the Foscari *Promissione*. By contrast, the Commission/Oath of Agostino as procurator *de supra* of San Marco in 1485 merely shows Mark with a book in the opening initial, and the doge's onomastic patron saint, Augustine, in the initial that opens the procurator's pledge (fig. 3.16).[123] Nevertheless, even with a halo Venice's patron saint looks suspiciously like Agostino himself, for while he usually is shown with brown hair and beard,

here he has a long white one. The illuminator of Agostino Barbarigo's *Promissione* is the so-called Pico Master, whose prolific output of miniatures and woodcut designs in Venice has been revealed by Lilian Armstrong. This master painted in all kinds of books, and already had embellished manuscripts produced in the civic chanceries. The manuscript composition reflects the pictorial habits of the Pico Master, who was already producing borders that imitated triumphal monuments in the 1470s, as well as Agostino's princely ambitions, and perhaps the designs for the ceremonial staircase by Antonio Rizzo, by then under construction.[124]

The triumphal staging of the doge with Mark in the open on a monument in the *Promissione* miniature may have referenced especially the fact that Agostino's predecessor and brother Marco (doge 1485–86) had been the first doge to be crowned outside in front of the public, on November 19. As discussed earlier, previously the coronation ceremonies had been set away from the *popolani* inside the Senate Hall, but in 1485, in the interval before the election of Marco, the Great Council decided that the ceremony should be presented to the public on stairs in the courtyard.[125] In this way, the ceremony assumed greater visibility, and could approach the magnificence of the coronation of absolute princes and kings. So it was probably under the dogeship of Marco, too, that the great ceremonial staircase by Antonio Rizzo, *protomaestro* of the Ducal Palace, was begun, creating an appropriately triumphal setting for the ceremony (fig. 3.2). It was for the most part completed under Agostino's term and bears the initials and a portrait of Agostino, as well as the Barbarigo arms. The rich sculptural decoration should be interpreted as a glorification of the office of the doge in general, but certain elements,

3.19 Giovanni Bellini, *Doge Agostino Barbarigo Presented by Mark to the Virgin and Child, with Saint Augustine and Angels*, 1488. Canvas, 200 x 320 cm. San Pietro Martire, Murano

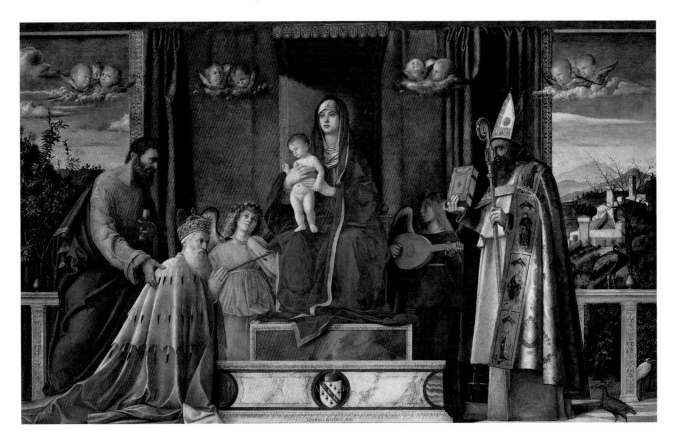

especially the symmetrical placement of two coats of Barbarigo arms over the ground floor arches framing the stairs, immortalize both doges personally.[126] The staircase was called the Scala dei Giganti after Jacopo Sansovino's statues of Mars and Neptune were installed in the mid-sixteenth century.[127] In the miniature, to either side of the base of the leaf, angels hold up two Barbarigo coats of arms, to emphasize Agostino's singular, and normally prohibited, succession of his brother.[128] The image can be viewed as an early stage in the development of his styling of himself as doge.

A portrait of Agostino Barbarigo by Giovanni Bellini, probably commissioned by the doge and completed shortly after his *Promissione* was painted, represents him as in his document, in the most magnificent manner possible (fig. 3.19). It generally follows the votive portrait format already well developed with the painted lunette of Francesco Dandolo's tomb, and emphasizes the piety of the doge by showing him in prayer to the Virgin and Child, as well as Mark's favor. Barbarigo is dressed both in his gold *restagno* and the *zoia*, the latter recognizable in both the painting and document by the jeweled element at the top. The doge seems to have preferred this manner of presentation, and the *Promissione* was the first image to feature it.[129]

According to custom, design of the Scala dei Giganti would not have been directly commissioned by the Barbarigo doges. But Agostino did commission a massive double tomb for himself and his brother in the Church of Santa Maria della Carità, unfortunately destroyed after the church was suppressed. The church, along with the associated greater complex of the Scuola della Carità and monastery of Canons Regular of the Lateran, became part of the new Accademia Galleries under

3.20 Isabella Piccini, Tomb of Doges Marco and Agostino Barbarigo in situ in the Church of Santa Maria della Carità, Venice, 1692. *42.9 x 59.2 cm. Vincenzo Coronelli, Isolario/ Descrittione/Geografico-Historica ..., fols. 17v–18r, Biblioteca Nazionale Marciana, 225.d.7*

Napoleonic decree.[130] Only fragments of the Barbarigo tomb, scattered in a number of places, remain and the portrait of Agostino is now in the ante-sacristy of the Salute.[131] A seventeenth-century engraving suggests how the full tomb looked before its destruction in the early nineteenth century (fig. 3.20).[132] In this monument, Agostino was shown in the same profile position as in his *Promissione* and in the painting by Giovanni Bellini. Also as in the *Promissione*, the two coats of arms emphasize the double success of the brothers. The similarity of the tone and image of the doge in the manuscript painting with that of the tomb commissioned directly by Agostino reinforce the probability that the doge was instrumental in determining the imagery of his manuscript, and that it even served as an early step in the evolution of his thinking about how he, as doge, wished to be memorialized.

IMAGE AS DOCUMENT

Antonio di Marin Grimani (1434–1523)

Doge Antonio Grimani's concern at his death about the preservation of his documents as doge and as procurator, discussed in the Introduction, suggests the commemorative value of these civic documents, which in his case recorded the most dramatic resurrection from patrician dishonor to distinction and power. The imagery of Grimani's *Promissione* (fig. 0.5) unites an emphasis on the sacrality of the doge, as in Moro's document, with the triumphalism of the painting in Agostino Barbarigo's, to create the most complete visual argument of the doge's election as divinely ordained.[133] And in fact, for several decades after Grimani's death, this imagery, which also emphasizes innocence from sedition, seems to have been consulted by his sons and grandsons as they pursued various projects and monuments to repair communal memory of him.

We can recall here that Antonio Grimani was the patriarch of the Santa Maria Formosa branch of one of the most influential and powerful families of the sixteenth century (fig. 0.2).[134] He was elected to one of the highest offices of state, for life, as procurator *de citra*, in 1494 (fig. 0.3).[135] Grimani initially tried to evade his subsequent election as Captain General of the Sea in 1499, at the beginning of the Ottoman-Venetian wars, but eventually he accepted this prestigious post. However, although this role was critical to the security of the state, selection of candidates was determined rarely by technical expertise and experience, rather by political factors, including wealth.[136] As captain, Grimani failed several times to engage the Turkish fleet off the southern coast of Greece, and Venice consequently lost territories around Lepanto. Grimani's cowardice was broadcast by his enemies as seditious, and he was exiled to the island of Cherso off the coast of Dalmatia. With the help of his four sons, Antonio eventually escaped to Rome. Ultimately he was pardoned, allowing him to return to Venice. In a remarkable comeback, in 1510 he was elected again as procurator, this time of the *de supra* branch (fig. 0.4). In the document for this second chance to serve, a subtle shift in composition, from showing Antonio taking the oath of office to accepting the commission from Mark, may have been intended also to highlight his election as by divine intervention.[137]

In the full-page miniature of Grimani's *Promissione*, which faces the opening text of the prologue emphasizing his election as not from his merits but by divine selection, the doge is portrayed in a symbolic re-enactment of his coronation. The miniature conflates two phases that took place in separate locations: the granting of the vexillum in the Basilica with the crowning at the top of the Scala dei Giganti in the palace courtyard. In the miniature, Saint Mark invests the doge with the banner, as the *primicerio* did in the actual ceremony, and the doge wears only the *camauro*, signifying his almost sacred status, as he would at this earlier point in the proceedings. A young boy, the ducal *ballottino*, holds the *biretum*, anticipating the final moments

of the coronation. Rachel Hostetter Smith has elucidated the symbolic importance of this young boy in emphasizing the role of divine providence rather than political machinations in the election of the doge. In the intricate electoral system of Venice, young boys counted the ballots, and not directly with their own hands but by a pair of artificial wooden ones. The collection and counting of the ballots, overseen by such youths perceived as incorruptible innocents, and uninfluenced by human hands in the counting, was seen to reflect only the will of God in the selection of the doge. The ballot boy who assisted in the electoral process of the doge then accompanied him throughout his tenure.[138] This is the first known representation of the *ballottino*. The inclusion of a *ballottino* surely highlights the meaning of the text of the prologue facing the image but also the vindication of Grimani's banishment, for the composition of this painting is completely original. The imagery seems to have subsequently been adopted in a concerted effort led by Antonio's progeny, and by the government itself, to reinforce through images the notion that Antonio Grimani's return to office and his rise in power were divinely ordained. This overall message and some details of the image would be reutilized in at least two monuments to the doge overseen by his progeny and created long after his death, as now will be explained.

Returning to Sanudo's account of Antonio Grimani's last words on May 7 of 1523, the doge called upon his son Vincenzo (hereafter called Vincenzo Vecchio, to distinguish him from his grandson, Vincenzo di Antonio Giovane), who was not living in the Ducal Palace, but in the Grimani palace at San Vio, and requested that his documents as procurator and doge, the most fundamental records of his honor restored, be kept in the family. Presumably, Antonio's son Vincenzo Vecchio maintained Antonio's documents in his family archives. Again, they are mentioned as still in the family five generations later, in the inventory of Vincenzo di Pietro's

effects (fig. 0.2).[139] Doge Grimani initially asked that the gold *restagno* be sold, but then ordered that it be exhibited once a year in San Nicolò al Lido, the church with the relics of that patron saint of sailors. It is in this church that the concluding thanksgiving ceremonies were, and still are, conducted for the festival of Venice's Wedding to the Sea (*Sposalizio del mare*). Ritual display of his ceremonial mantle in San Nicolò, the church embodying Venice's dominion over the sea, transformed it from an attribute emphasizing Grimani's wealth and status among princes, to reframe his reputation as positive and victorious in relation to Venetian maritime possessions.

Although there often was discord among the progeny of Antonio, they had worked during his lifetime, sometimes individually, sometimes together, on projects to commemorate him on the façades and interiors of the now-destroyed churches of Sant'Antonio in Castello and San Francesco della Vigna. The first projects were still incomplete when the doge died in 1523, after which the Great Council approved a new law prohibiting inscriptions and effigies of the doge in public places, perhaps with the Grimani project at Sant'Antonio in mind.[140]

Despite the new law, Antonio's descendants continued to plan public memorials to him after his death. And from Sanudo's accounts in his diaries, it is clear that the doge's reputation remained controversial, for during the procession of his body to the Church of Santi Giovanni e Paolo, young boys chanted in rhyme, "*L'è morto il carestia, viva la Signoria!*" ("The famine is dead, long live the *Signoria!*") Even the funeral oration emphasized Grimani's success at making money and praise of his son Cardinal Domenico, rather than focusing on his civic or military accomplishments.[141] But the plans for a major tomb honoring Antonio never materialized, and the doge remained buried in Sant'Antonio in Castello, in what apparently was a modest monument before it was destroyed in the nineteenth century.[142] However, two other

commemorative projects commissioned by
his descendants and the state eventually were
completed, which extended the messages
of vindication and innocence of the painting
in his *Promissione* to a broader audience.

These two commemorative projects were
the altar frontal required by the *Promissione*
document itself, and the customary votive portrait
for the Ducal Palace, in this case commissioned
of Titian. As discussed previously, if the
antependium was not completed before the doge
died, it was expected that his heirs would provide
for it. And in fact, Antonio's son Vincenzo
Vecchio deposited initial payments for the
tapestry in the Dolfin bank, but only eleven years
after the doge died, in July of 1534. After another
twenty years, in 1554, Antonio's grandson Vettor
Pr. K. di Girolamo (1495/97–1558) finally made
arrangements with Giovanni Rost of Brussels to
create the piece.[143] The cloth commissioned by
Vettor was described in a procuracy inventory
of May 1558, or not long after its completion,
as "with the figure of Saint Mark, the most Serene
Prince Grimani, and three women, that is to say,
three Virtues."[144] A cloth fragment featuring only
a profile of Grimani's head has been identified
as from this altar frontal (fig. 3.21).[145] Grimani
is represented with only the *camauro* on his head.
A hand to the left hovers with the *biretum* above
his head – he is shown just before being crowned,
as in his *Promissione*, and as in the representation
of him to be made by Titian. It seems that one
design for the tapestry also formed an additional
precedent for his portrayal in the painting by
Titian of him in armor, to reframe his reputation
more specifically as a military hero.

A drawing in the British Museum, now
generally agreed to be by Andrea Schiavone, has
been identified as the design for an altar frontal for
Doge Antonio Grimani, because of the inscription
"GRIMANUS" in the border and the general
format similar to such pieces (fig. 3.22).[146]
In fact there were two drawings for a cloth altar
frontal for Doge Antonio listed in the inventory

3.21 Fragment of the *paliotto* (altar frontal) of Doge Antonio
Grimani, c.1558. *25 x 27 cm. Museo Civico Correr, Venice*

of Vincenzo di Pietro Grimani Calergi's effects
of 1647.[147] But although the drawing also portrays
the coronation of the doge, otherwise it is quite
different from the surviving cloth fragment. It is
possible that it was one of several proposed models,
or a drawing for a tapestry destined for another
church.[148] Lozenges along the top right border
contain the inscriptions "Innocence," "Prudence,"
and "Faith." The representation of these as female
personifications below aligns it with the inventory
description of three Virtues in the cloth, but these
are joined by other figures. The woman holding
a chalice in the foreground may represent Faith.
Behind her, one who seems to hold a mirror must
be Prudence. This would leave the woman holding
up Grimani's *biretum*, thus taking the place of
the *ballottino* in the *Promissione* illustration, as
representing Innocence, and the labels are aligned
above these women in that order. In this way, the
imagery expands on the theme of inculpability
emphasized in the *Promissione* miniatures, and
contributes to the notion of military prowess
of the commemorative painting by Titian.

Schiavone's drawing shows the doge as a
Roman general, completely bare-headed, his

3.22 (Above) Andrea Schiavone (attrib.), *Allegorical Coronation of Doge Antonio Grimani*, design for a cloth antependium for Doge Antonio Grimani?, c.1540–45. Ink and gouache on paper, 21.5 x 54.8 cm. British Museum, London, 1938, 1210.2

3.23 (Right) Pietro Lombardo with sons Tullio and Antonio, *Tomb of Doge Pietro di Leonardo Mocenigo*, c.1476–80. 1500 x 300 cm. Santi Giovanni e Paolo, Venice

helmet at his feet, while a female personification of Venice places a mantle upon him with a fur collar, most likely the *restagno* designated as a relic for display at San Nicolò al Lido. The Roman-style armor follows a tradition of ducal portraiture in tomb monuments, as in that for Doge Pietro Mocenigo (d. 1476), who was figured in armor under his ducal *manto* in his tomb in the Church of Santi Giovanni e Paolo (fig. 3.23).[149] Grimani's actions in battle, characterized here as valiant, allow him to put aside the helmet of war and accept the dogeship. Instead of showing patron saints, the representation focuses on Grimani as a military man, whose victories garner him the ducal crown. The doge's dress of armor was an important new element in the evolving restoration of his image as a military exemplar. It would be adopted in the votive painting begun just a year later by Titian, and aligns with contemporaneous literary restoration of him as a

warrior in Paolo Giovio's *Eulogies of Illustrious Men of Arms* of 1551 and Giovanni Battista Egnazio's *The Exemplary Model of Illustrious Men*, published in 1554.[150] In fact, the doge's grandson Vettor may have been instrumental in these literary, as well as figural, portraits as he and the doge were friends with Giovio.[151]

There was also general concern in the Venetian government, as well as within the family, that Antonio Grimani's reputation should be restored. In March of 1555, or shortly after the completion of the altar frontal, and the publication of these encomiums to the former doge, the Council of Ten ordered that a painting by Titian be made "towards the happy/fortunate [*felice*] memory" of Doge Grimani "as has been done for the others." Four months later, in July, Titian received an advance of 50 ducats, also "*a far dil Serenissimo Grimani bona memoria*" from the Salt Officers.[152] These documents suggest that by this time state-funding of such portraits of each doge, to be hung in the council halls, was standard practice. Also significant are the terms "*felice memoria*" and "*bona memoria*," used by the Council of Ten in describing the purpose of the painting, which suggest a special concern for the collective memory of the previously disgraced Antonio. Nonetheless, no document survives in which the Salt Officers request the key compositional elements for the painting.[153] With the sitter deceased, and because of what appears a particularly indeterminate commission as recorded in the documents, it seems probable that Titian would have consulted with members of the Grimani family to decide the main elements of Antonio's votive painting.

One of these family members again could have been Vettor di Girolamo Grimani, Antonio's grandson (fig. 0.2). Vettor remained a procurator *de supra* until his death in 1558, and was particularly active in commissioning artwork to shape the memory of his grandfather, as we have seen with his commission of the altar frontal. He also convinced his nephew Vincenzo Giovane, and his brother Cardinal Marin, to transfer the project for a tomb and memorial to Doge Antonio from the façade of Sant'Antonio to that of San Francesco della Vigna in 1544, and remained a primary agent in the patronage of the Grimani family in that latter church.[154] Vettor's brothers Marin and Marco had died by 1555, when the Council of Ten ordered Titian's painting, but another brother, the patriarch Giovanni, and their nephew Vincenzo Giovane, who presumably held the *Promissione*, could have been instrumental also in determining the main elements of the composition. Nevertheless, the painting was only finished and installed in its current location in the Sala delle Quattro Porte (also called Sala dell'Antipregadi) of the Doge's Palace many years later (fig. 3.24).[155]

Titian was working on the painting in 1566 when Vasari saw it in the artist's home among other works in progress. The painting was still unfinished, and thus spared, when fires burned in the Ducal Palace in 1574 and 1577, and Sansovino does not mention it as installed in his description of the palace in 1580. The canvas was finished probably well after Titian died in 1576, by his nephew Marco, who left the main composition intact.[156] It was completed under the reign of Doge Marin di Girolamo Grimani, elected in 1595, a distant relative of Antonio from the San Luca branch of the family, but one who would have been motivated to assure the restored reputation of a former Grimani doge.[157] Stringa described the painting of Doge Antonio as in situ in 1604.[158] This, then, is the composition on which the procurator Vettor and his cousin Vincenzo Giovane, working together still in 1549 to get a tomb monument for Antonio built on the façade of San Francesco, would have counseled Titian. In fact Vincenzo Giovane lived until 1582, and could have been further consulted throughout this time.

Like the altar frontal designed by Schiavone and the praise written by Giovio, the imagery reframes Grimani's naval reputation. It depicts him in armor, as in the altar frontal drawing,

3.24 Titian and workshop, *Doge Antonio Grimani and "Faith,"* begun before 1566, completed before 1604. Oil on canvas, 365 x 500 cm. Sala delle Quattro Porte, Doge's Palace, Venice

and thereby allows him to participate in the imagery of victorious captains on ducal tombs of the fifteenth century, cancelling the mental image of him as cowardly and defeated. Instead of being enrobed by a female personification as in the drawing, Antonio holds out his hands in wonderment and devotion to a figure of Faith holding a chalice and cross, assisted by angels. His military service is emphasized in this image more directly as performed for the preservation of the Christian faith. Since the painting was only finished and installed after the allied Christian

victory at Lepanto, it can be read as participating in the same eschatological message as the votive painting of Doge Sebastiano Venier (doge 1577–78) by Veronese, in the *Collegio* of the Ducal Palace (fig. 3.25).[159] It was on Saint Justine's feast day that the Battle of Lepanto battle was won, and in Veronese's painting she acts as intercessor for Venier, who is blessed by Christ as Savior of the World. In the name of the Christian faith, allegorized by the chalice to his left, Venier has brought the world closer to the Paradise pictured above. In Titian's painting, the cloud of angels surrounding Faith intimate that Doge Antonio Grimani had also served honorably in this way.[160]

Although the manuscript painting (fig. 0.5) is very different in style from Grimani's votive

portrait in the Ducal Palace, some shared compositional peculiarities indicate that Grimani's *Promissione* was consulted. In Titian's painting, as in the manuscript, the doge is shown only with his *camauro* on his head and a young boy to the right of Grimani, identifiable as the ducal *ballottino*, holds the ducal crown. The fact that the *ballottino* is present in both the painting and the *Promissione* has been pointed out before, but the extreme closeness and uniqueness of the compositions have not been noticed.[161] As discussed previously, the ducal ballot boy was imaged in the Renaissance as "a manifestation of the virtue and rightful authority of the doge in Venetian life and art."[162] Young boys representing the *ballottino* are shown in a number of portraits of the doges in the Doge's Palace. Two young boys hold the helmet and train of Sebastiano Venier in his portrait.[163] But only in Grimani's painting, as in the manuscript, is the *ballottino* clothed in the ceremonial crimson damask robe of the ducal coronation. The *ballottino* holds up the *biretum*, and stands in the same position in relationship to the doge as pictured in the

Promissione, to emphasize the divine election of Antonio Grimani.

The representation of the doge in Titian's painting seems to have been the summation of decades of development by his sons and grandsons in various commemorative projects, and conveys a layered message with emphasis on innocence and divine election first articulated in the *Promissione*. The dressing of the doge in armor underneath the *restagno* followed the precedent of Schiavone's antependium. But the *Promissione* was the first step, formulated and approved by Doge Antonio and subsequently referenced by his heirs, in thinking about how to represent the doge's career and legacy. Like an artist's preliminary drawing, it was a key early phase in visual presentation. The preservation of the *Promissione* in the family archives, a manuscript that was a personal version of public record in the State Archives, textually, but also visually, reinforced the memory of Antonio's

3.25 Paolo Veronese, *Sebastiano Venier in an Allegory of the Battle of Lepanto*, 1577–82. Oil on canvas, 285 x 565 cm. Sala del Collegio, Doge's Palace, Venice

absolution through election as doge. Nevertheless, this is the last known ducal *Promissione* with a portrait. Portraiture in *Promissioni* appears to have been discouraged systematically after this, for by contrast, the creation of likenesses increased in number and in detail for all other kinds of painted documents.

Francesco di Giovanni Venier (1489–1556)

In a *Promissione* for Francesco Venier, who was elected in June of 1554, the artist reprised the motif of a classical tomb or memorial upon which the opening text is written (fig. 3.26).[164] The format is similar to the earlier illumination by the T.° Ve Master of the opening leaf to the Index of the Treaties (*Pacta*) destined for the State Archives (fig. 2.5). Above two magnificent herms, Saints Dominic and Francis guide our eyes to the opening inscription. A year after being elected, the doge obtained the concession from the brothers of San Salvatore to construct his tomb in their church. It is clear from the wording of his testament that after his election as doge Venier had changed his modest plans of burial at San Francesco della Vigna to conceive of a more magnificent tomb at the Church of San Salvatore, and it was built in a Roman manner not dissimilar in concept to the miniature in his *Promissione*.[165] Nevertheless, the lack of a portrait and more personal imagery is striking, especially in the context of evidence that he was intensely interested in the illumination of his earlier Commissions.

The importance to Venier's reputation of his service as a rector to various Venetian territories, as documented and once figured in his Commission manuscripts, is represented in the votive portrait of him by Jacopo Palma il Giovane (known as Palma Giovane), created in *c*.1593 for the Senate Hall (fig. 3.27). Female personifications of the territories Venier had previously governed as rector present their statute books, as identified by city heraldry on the bindings, to Venice enthroned. The statutes in such documents spelled out the conditions

3.26 T.° Ve Master (attrib.), *Promissione* of Doge Francesco di Giovanni Venier, elected 1554. 33.6 x 23.7 cm. Biblioteca del Museo Civico Correr, Venice, Cl. III, 324, fol. 1r

of the relationship of subject territories to their Venetian overlord, and as such complemented the Commission texts of the rectors.[166]

A number of Francesco Venier's previous *ducali* survive, but two are missing their opening leaves, presumably because they had miniatures that created a visual trail with portraits, now lost, of his service to the state. They would have conveyed how Venier had wished to be remembered in relation to his governing of Venetian territories, but the image conveyed by his *Promissione* is especially constrained. Perhaps for this reason the illuminated leaf never was detached from the manuscript.[167]

3.27 (Left) Palma Giovane, *Doge Francesco Venier Presents the Subject Cities to Venice Personified*, c.1593. Oil on canvas, 380 × 345 cm. Sala del Senato, Doge's Palace, Venice

3.28 (Opposite left) T.° Ve Master (attrib.), *Commission to Sebastiano di Moisè Venier as Duke of Candia*, elected 1548. 23 × 16.3 cm. Katholieke Universiteit Leuven, Maurits Sabbe Library, Berchmanianum Collection, MS 18 BK, fol. 1r

3.29 (Opposite right) Alessandro Merli (attrib.), Leaf detached from the *Capitolare* of Giovanni Battista di Pietro Vitturi as ducal councillor for the *sestiere* of Santa Croce, elected 1600. 20.4 × 14.2 cm. Victoria and Albert Museum, London, n. 3127 (MS 1214)

Most of the *Promissioni* created for personal use by other doges have been lost, but some of the documents from earlier in their careers survive. For example, the *Promissione* for Sebastiano di Moisè Venier, elected doge in 1577, has not been located, but a Commission for him as Duke of Candia (Crete) survives (fig. 3.28).[168] A beautifully scripted *Promissione* for Pasquale di Gabriele Cicogna, elected in 1585, carries his coat of arms on the binding but not within the document and has no portrait.[169] There are other later surviving manuscript copies of *Promissioni* for doges, but these are all minimally decorated or completely unilluminated, and do not seem to have been made for the ruler.[170]

In addition, the sacred and binding nature of the doge's promise and oath made at his inauguration had become less convincing. After Cicogna's death in 1595, the Great Council found it necessary to require the doge to repeat the oath yearly. The *Promissione* as symbol of authority and divine election had lost much of its power. The statute requiring the doge to have manuscript copies made of his *Promissione* remained until the end of the Republic, and more research is needed to find out if manuscripts for his personal use continued to be made.[171] By contrast, a longer and more elaborate tradition of illumination survived in the *Giuramenti* of the procurators, perhaps because these officials

were able to use public funds more directly to have the manuscripts made, and because the image of the procurator remained less controlled by other officials. Especially in the late sixteenth century, many procurators had increasingly elaborate Commission/Oath documents created for themselves, at times personally supplementing the cost provided by the state. Even the *Capitolari* of some ducal councillors, which previously never had even small portraits, came to have full-page images with likenesses, as in one for Giovanni Battista di Pietro Vitturi (1537–1614) (fig. 3.29).[172]

The creation of the doge's copy of his *Promissione* seems to have been paid for by the state, but embellished through consultation with the doge. The imagery of these documents augmented the opening text, which specified the sacred nature of the office and duty of the doge. The earliest known paintings in the doge's copy of his *Promissione* are of the late fourteenth century, and the imagery became more specific to the reigning doge through the fifteenth and early sixteenth centuries. The *Promissioni* of Agostino Barbarigo and Antonio Grimani shifted the emphasis of representations of the doge from humility to triumph, and this may be why the personalized miniatures with portraits ceased to be produced, even while the extensiveness of painting and the personalization of the imagery in documents for other offices increased. In fact, the most expensively produced and embellished documents became those of the procurators, who even attracted controversy for the amount of public money they spent on them. Their documents are the subject of the next chapter.

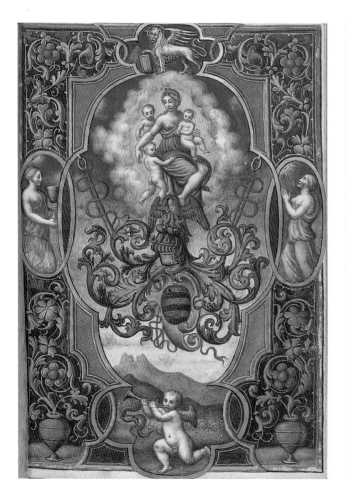

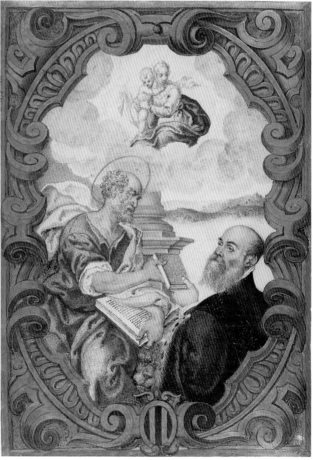

Incipit ordo commissionis nobilis
uiri. domini pauli belegno. procurato
ris sancti Marci super commissarijs 1
de ultra canale constituti.

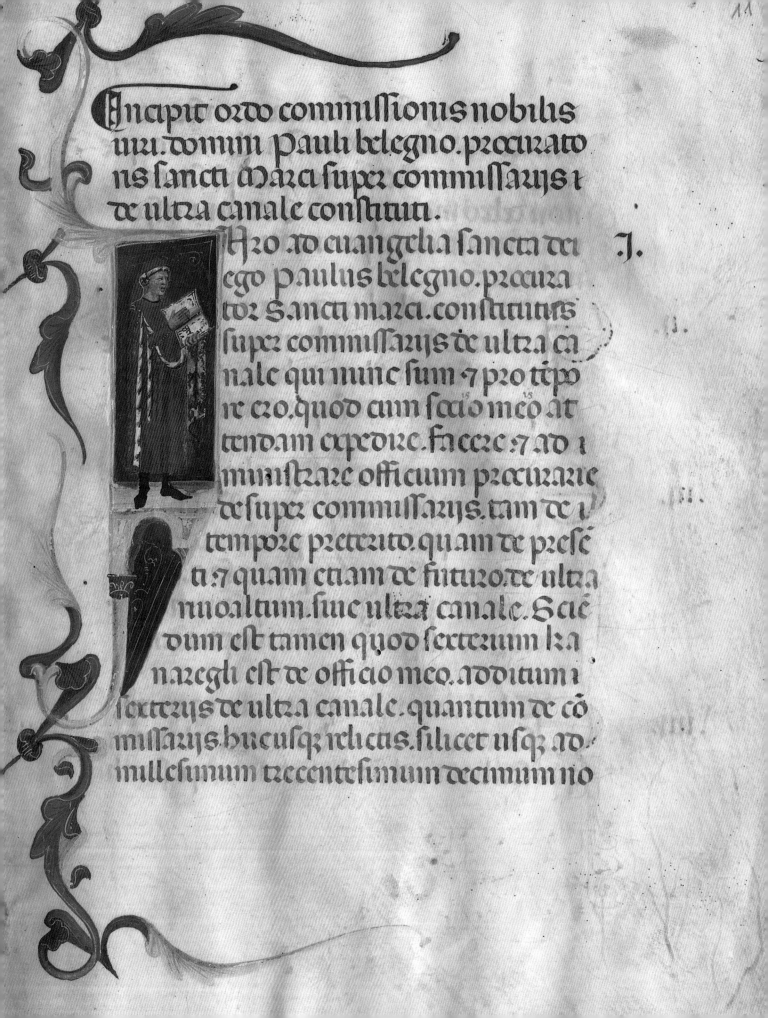

ᴘ᷒ro ad euangelia sancta dei
ego paulus belegno. procura
tor sancti marci. constitutus
super commissarijs de ultra ca
nale qui nunc sum 7 pro tempo
re ero. quod cum socio meo at
tendam expedire. facere 7 ad 1
ministrare officium procuratie
de super commissarijs. tam de 1
tempore preterito. quam de prese
ti 7 quam etiam de futuro.de ultra
nnoaltum.siue ultra canale. Sciē
dum est tamen quod sexterium ka
naregli est de officio meo. additum 1
sexterijs de ultra canale. quantum de co
missarijs hucusq; relictis. silicet usq; ad
millesimum trecentesimum decimum no

.J.

.ij.

.iij.

CHAPTER 4

THE OATH OF THE PROCURATORS

THE IMAGE AND actions of the doge were controlled to a great degree by the symbolic requirements of the office, as defined and prescribed largely in the *Promissione* texts. His representation in the paintings within these manuscripts likewise was constrained, and additionally so because production of the document destined for the doge's use apparently was paid for by state funds to which he did not have personal access. By contrast, records of payment show that the procurators, who also were elected for life, and whose status was second only to the doge, eventually could spend state funds directly for their own official document, which typically held the Commission (*Commissione*), the Oath (*Giuramento*) and Regulations of Office (*Capitolare*).[1] At times, the equality and unanimity of the procurators were conveyed through elegant, but modest and repeated, decorative schemes for all the documents of officials elected around the same time. But eventually the temptation to overspend public funds on commemorating one's appointment proved too great for some officials, and the documents became a medium for more detailed expression of individual identity.

In fact, a law passed by the Great Council in September of 1580 complained about the rapidly accelerating expense lavished on paintings for the offices of the procurators, and on the production of the Commission documents. But the Council only imposed spending limits for the Commission/Oath manuscripts, not on the oil paintings.[2] This limit may have been imposed because expenditure on the manuscripts had gotten more seriously out of hand. The paintings in the documents also tended to incorporate more personalized imagery. While the larger paintings were destined to be displayed in the public offices of the procurators in perpetuity, the manuscripts left state possession, and eventually entered the family archives of the office holder. The purposes of painting in some of these documents, therefore, came to differ from that of the publicly displayed portraits. Whereas those made for state buildings highlighted illustrious nobles ultimately to convey the dignity of the office overall, special decoration of the documents could skew this balance towards celebrating the individual and family over service to the state.

Despite the new restrictions, many procurators continued to want a luxury copy of their Commission. Confronted with a payment limit, some merely supplemented the cost with their own funds. Because both state and private monies could be spent to produce and embellish these later *Giuramenti*, and because the office was prestigious but the image of the procurator less controlled than that of the doge, some of the manuscripts made for the procurators are the most extensively and finely painted of all *ducali*.

As with *Promissioni*, early illumination reinforced the meaning of the opening texts,

4.1 *Paolo Belegno Takes the Oath of Office as Procurator*, Commission/Oath of Paolo di Stefano Belegno as procurator *de ultra*, 1368. 28.7 x 22 cm. Biblioteca del Museo Civico Correr, Venice, Cl. III, 315, fol. 1r. Belegno is shown taking his oath in the opening initial to the Oath text

in this case of the Commission and Oath, through illustration of the investiture and oath-taking (fig. 4.1). Eventually the most popular theme portrayed election and service as granted directly by Mark, as stressed earlier in Francesco Foscari's *Promissione* as doge. But again, procurators could control payment and production of their manuscripts, so the illumination of the *Giuramenti* of the procurators came to express the intersection of private with official identity more expansively. In the fifteenth century, imagery of doges in their *Promissioni* articulated the nature of their piety and reinforced the opening text, which claimed that they were not elected on merit but by divine will. By contrast, many of the Commissions of the procurators came to advertise humanist ideals of nobility, of privilege merited by civic virtues and pedigree. In the sixteenth century, the messages became more boastful, to extoll even individual wealth, perhaps reflecting the fact that after 1516 many procurators arrived at the office through pledging large amounts of cash. Military command by nobles to preserve the Republic, especially against the Ottomans, at times was referenced subtly in fifteenth-century documents of the procurators. In the later sixteenth century, such valor and personal sacrifice could become the focus of full-page paintings in Commissions. For such elaborate documents, some artists not primarily dedicated to miniature painting were hired. In fact, at least one of these, Marco del Moro, also worked as a painter and stuccoist in the buildings of the procurators and in the Ducal Palace. His work as a miniaturist, therefore, must be understood not merely as derivative of grander monuments, but as one component of his production of civic imagery for patricians. Such practice across media created even greater synergy between the imagery and style of the miniatures in the documents and public commemoratives.

Again, early illumination of these documents responded to the opening texts of the Commission of office, Oath, and statutes. A brief history of the procurators, their obligations, and associated ceremonies will aid reading of the subjects illustrated in these manuscripts, and clarify how some patricians interpolated portraits and personal imagery to create expansive memorials of their service to the Republic.

MEN OF MARK

The origins of the procurators lay in the need to oversee and maintain Mark's Basilica. Among elected officials, therefore, they shared with the doge an especially privileged and direct relationship to Venice's patron saint, as was emphasized often in the illuminations of their Commission manuscripts. Their office was the second highest one could obtain, and was considered a critical step toward ducal election. The position of procurator may have originated with the *translatio*, or translation of the body of Mark from Alexandria to Venice in around 829 under Doge Giustiniano Partecipazio, and the need for an administrator to oversee the design, construction, decoration, and maintenance of the new church to house the saint's remains.[3] But the earliest mention of the *opus* of San Marco and its procurator, or administrator of the structure and its operation, is found only in the twelfth century, or just after the transformation of Venice from dukedom to commune.[4] In the early years of the office, the doge personally nominated the procurators to oversee the expansion and embellishment of Mark's *martyrium*. They and their sub-committees in turn chose and oversaw the *proto* of the church, who was both their chief architect and supervisor of construction. The procurators often intervened personally in details of the decoration of the church, and the maintenance of its treasures, including, as we can recall here, the *Vangelo* and the ducal *zoia*.

By the twelfth century, the responsibilities of the procurators also expanded to encompass the guardianship of orphans and the mentally disabled, and fiduciary responsibilities such as

administering wills and trusts for those private individuals who nominated them in these capacities. These greater responsibilities and the handling of increasing sums prompted the Great Council to take over jurisdiction and election of the procurators from the doge in the thirteenth century, a move that can be understood to mark the shift of the church from being primarily the doge's private chapel to becoming the state church of Venice.[5]

From the thirteenth century onwards, the procurators also supervised the design and maintenance of the Piazza, where they had their offices, some apartments reserved for them to live in, and rental properties.[6] The Library by Jacopo Sansovino, despite its name, was at least equally the state palace of the procurators, as it was largely taken up with their offices (fig. 4.2). Indeed, it has been argued that the extensive rebuilding of the Piazza and its structures, and the styling of it as a Roman forum, expressed the dignity and power of the procurators as much as that of the city.[7]

The number and status of the procurators also grew with the weight of their responsibilities and the wealth entrusted to them to administer. Originally numbering one or two, in 1319 they were divided administratively into three branches, with two procurators in each.[8] Those *de supra Ecclesia* maintained supervision of the *opera* of San Marco and guardianship of minors and the insane. The two newer branches took over the maintenance of trusts and the execution of wills. The procurators *de citra canale* ("to this side of the canal") administered those from *sestieri* on the San Marco side of the Grand Canal (San Marco and Castello). The procurators

4.2 Jacopo Sansovino, Library of San Marco, Venice, begun 1537

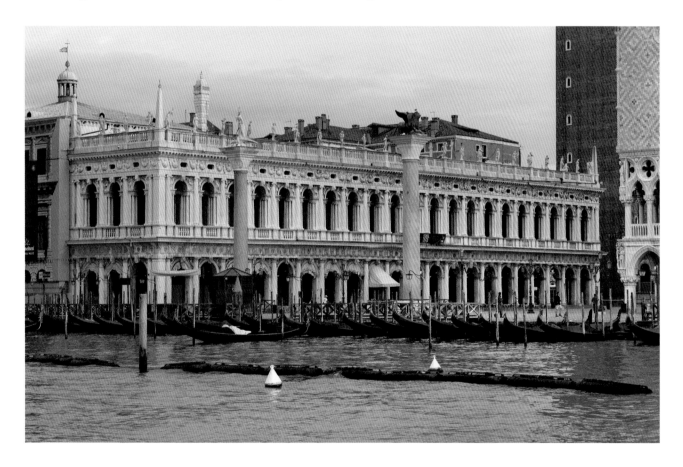

de ultra administered those from "the other side" of the Grand Canal (San Polo, Santa Croce, and Dorsoduro).[9] In addition, by this time they had a substantial staff of scribes, notaries, cashiers, *gastaldi*, and bursars with various roles. Their financial duties bestowed them with great importance in the Venetian economy.[10]

The duties and number of the procurators again expanded substantially in the fifteenth century. In 1443, they became nine, three for each branch. Election to a particular branch depended upon the vacancy, rather than any official hierarchy accorded to the offices. Nevertheless, the procurators *de supra Ecclesia* held the greatest privilege as patrons of art because they kept the original duty of overseeing the Basilica, and were responsible especially for the patronage of the arts in honor of Mark, including of the manuscripts for his church. These procurators also came to commission and maintain the structures framing the Piazza and Piazzetta, excepting the Doge's Palace. As patrons it is they who largely determined the appearance of this iconic heart of the city.[11] In the sixteenth century the procurators *de supra* also oversaw some of the most distinctive educational and cultural institutions of the city: the School of San Marco, which hired distinguished lecturers, the Public Statuary, and the Library of San Marco.[12] The large assets at the disposal of the procurators and their life-long terms of office were critical to their great importance as state patrons of the arts. Individual procurators could initiate complex architectural projects, for example, and might expect to see their completion. Like the doge, if elected at a relatively young age, they could build the influence of their office over time, by contrast to all other patrician administrators, whose tenure was limited typically to three years or less.[13]

The office of the procurators took on a somewhat different cast when, in 1516, candidates were allowed to outbid each other with gifts of cash or loans to the state, and then even to compete to buy a supernumerary office

through the pledge of large sums. In fact, some patricians were willing personally to borrow huge sums of money to buy these extra offices designated "*cum oblatione*" or "*per danari*," as opposed to "*per meriti*," giving us an impression of the prestige and opportunities the office could offer. There does not seem to have been any great stigma in paying for the office as opposed to being elected by merit. In fact, one's wealth and willingness to make a large financial sacrifice to the Republic, especially in times of war, was seen as laudable and patriotic. From 1516 to 1538, thirty-eight procurators were created *per danari* as opposed to only six by merit.[14]

Although procurators *per danari* bought their privilege of office, their duty to the Republic was not seen as discharged with their payment – some of the most dedicated and active procurators of the sixteenth century gained office in this way. In fact, it has been argued that the great transformation of the Piazza in the 1530s was indebted to the large new ranks of "wealthy and cosmopolitan" procurators *de supra* who paid for office.[15] Nevertheless, no sixteenth-century procurator *per danari* was ever elevated to the ducal throne, the highest office of the Republic.[16]

INAUGURATION

As with the election of the doge, there were great festivities upon the election of a procurator on the part of his family and friends, and by the institutions of the city, and these celebrations became more elaborate over the centuries. We can follow the broadest outlines of the feasts and ceremonies according to early modern sources. Upon election, the bells of churches were rung, there were fireworks, and music was played continuously for several days until three or four in the morning. As a sign of piety and generosity, the procurator distributed money, bread, and wine to the poor and to the hospitals, and bread and wine to the *traghetti* (men who ferried people across the canals). Some three days after his election, the

procurator processed to the Church of San Marco to hear Mass, dressed in crimson robes and a *stola* of the same color and fabric. Those who had been knighted could sport a *stola* of gold fabric, or even could wear a gold *restagno* robe, such as the doge wore on special occasions. Some of these events are commemorated on the left leaf of Girolamo Zane's document as procurator, discussed in more detail later (fig. 4.20).

The new procurator elect was accompanied by the other procurators, senators, invited friends, and his entire family. Like the doge, he then took his first oath on an open missal or Gospel Book at the altar, promising to observe the statutes of office and to provide for all things related to the religious cult and benefit of the Republic. Passing through the portal of San Clemente into the Basilica, the procurator went into the Ducal Palace and presented himself to the doge in the *Collegio*. He then received a key of office in a red velvet purse given to him by one of the *gastaldi*, or officials who executed criminal sentences in the name of the doge. The new procurator elect retook his oath on a book given to him by the Grand Chancellor, probably this time the Commission, and affirmed that he would be a true and just administrator.[17] The key and document were the material signs of his investiture.

After taking leave of the doge, the procurator went with his new colleagues, the other procurators, to the foyer (*ridotto*) of the offices of his procuracy, where he gave a feast in which elaborate sugar confections featured prominently, and which also were distributed to all the shopkeepers and merchants along the Merceria. In the evening there was a party in the Ducal Palace, and in the Piazza there were triumphal arches and spectacles. Inscriptions on paintings and temporary festival monuments carried mottos addressing the beliefs and virtues of the procurator, and sometimes these also were featured in their *Giuramenti* documents (figs. 4.6, 4.11, 4.12). The festivities continued for three days in the family palace. Elements of the celebration of the procurator came to be memorialized, especially in the eighteenth century, in elaborate festival books called *gratulatorie*.[18]

PORTRAITURE

Portraits in the documents of the procurators evolved in relation to likenesses in larger paintings, many now lost, displayed in their offices and other spaces of the *Procuratia* buildings. Study of these traditions together allows for broader understanding of the intended function of portraiture in conveying the dignity and longevity of the office as an institution, and in memorializing the roles of individual patricians in it. Today the portraits in the documents supplement, and at times might authenticate, the archive of likenesses of patricians painted in oil.

As in the case of the doge, official portraits of individual procurators survive earlier in manuscripts than in independent paintings, but this probably is an accident of preservation. Whereas the earliest individualized likeness of a procurator in a Commission/Oath can be dated to 1452, Marin Sanudo tells us that two procurators *de supra* – Leonardo di Pietro Mocenigo (elected in 1418) and Bartolomeo di Alvise Donato (Donà, elected in 1427) – were portrayed already in a painting of 1430, in the Chapel of Saint Catherine in the old *Procuratia*. They were the only two procurators of that branch when the paintings were made, for the number had not yet increased to three. The painting and chapel no longer exist, but Sanudo explained that the image showed both men receiving the key of office from Saint Mark, in a scene set in front of the Basilica.[19] This is an important clue indicating that although the earliest surviving official portraits of procurators are to be found in manuscripts, there were paintings of them in the spaces of the *Procuratie* already by 1430 that emphasized their unity in service to Mark. The theme of the procurator's investiture with the key in this painting would recur in the miniatures of their Commission manuscripts.

Portraits were hung in the offices of the procurators as well as in their chapel. The earliest known of these is a group portrait by Giovanni Bellini of three officials *de ultra*: Tommaso di Nicolò Pr. Mocenigo (d. 1517), Luca di Marco K. Zen, and Domenico K. di Zaccaria Trevisan, all elected within less than one year (August 1503– March 1504). They are presented by Peter and Mark to the enthroned Virgin and Child, much in the tradition of the votive portraits of the doges (fig. 4.3).[20] By contrast to these paintings, which convey all three office holders together, a tradition of individual likenesses predominated later in the sixteenth century.

It is not known when the tradition of portraits of individual procurators especially painted for their offices began but it was well established when Francesco Sansovino, son of the sculptor and architect Jacopo, gave a brief description of the old offices in 1581, before they were destroyed to make way for the new ones designed and begun by Vincenzo Scamozzi in 1588. Among those paintings Sansovino mentions as hanging in the *Procuratia de supra* survive the "*vivacissimo*" portrait of Antonio di Giovanni Battista Cappello (1494–1565), and that of Jacopo di Francesco Soranzo, il Vecchio (1467–1551), "of venerable and serious aspect," both painted by Tintoretto (fig. 4.4).[21] Such qualities as vivacity or gravity are personal attributes essential for men with great responsibilities and powers. In the offices of the procurators *de citra*, Sansovino singled out the painting of Girolamo di Bernardo Zane (1515–1572) by Parrasio Micheli as "most worthy of memory" (fig. 4.22).[22] Early seventeenth-century authors described the rooms

4.3 Giovanni Bellini (attrib.), *Saints Peter and Mark Present the Procurators "de Citra" Tommaso Mocenigo, Luca Zen, and Domenico Trevisan to the Virgin and Child*, c.1504. Tempera and oil on canvas, mounted on wood, 91.8 x 150.2 cm. Walters Art Museum, Baltimore, Acc. 27.446

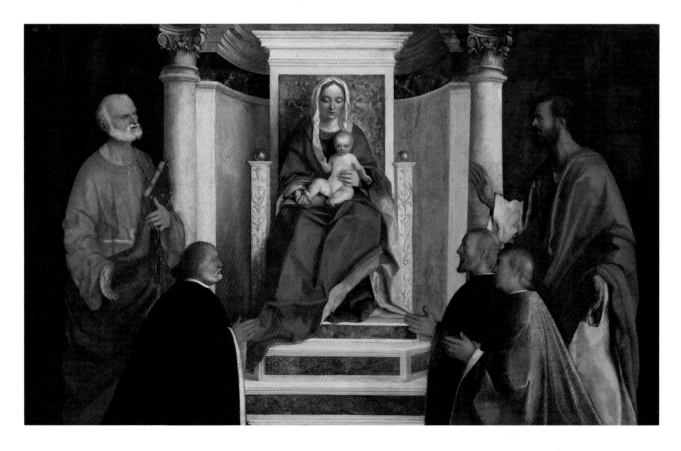

of the offices in the new *Procuratorie* as also filled with portraits, in somewhat different order, and much amplified.[23] The paintings were dispersed in the early nineteenth century. As yet there has been no full systematic reconstruction of the surviving portraits and their placement in the offices. But analysis of some of the paintings and surviving payment accounts of the *Procuratia de supra* gives insight into the purposes of such portraits.[24]

For conventions of the portraits and costume of individual procurators from later in the century we can return to examine Tintoretto's painting of Jacopo Soranzo. The slightly over life-size image was painted in oil on canvas perhaps around 1550, or almost thirty years after Soranzo's election in 1522 as procurator *de supra*.[25] The wealth of Jacopo, and his avid desire for prestige and power in government, is reflected in his purchase of election through the pledge of 12,000 ducats. Like the many other such sitters represented by Tintoretto, the unsmiling procurator is made to look imposing by the voluminous, heavy, red fur-lined velvet robe with large, open sleeves. This kind of sleeve was allowed only to various high-up officials, but is not a certain marker of a procurator, as it was allowed also to the state treasurers (*camerlenghi*) and the Grand Chancellor, as described in the costume book of Cesare Vecellio, and affirmed in portraits.[26] So, unlike the doge, the procurators did not wear special markers of their dignity, but as with other high officials were almost invariably shown "in color," in the crimson (*cremesino*) or variously hued *pavonazzo* robes (ranging from purple-red to blue) worn by Venetian nobles who were members of important magistracies.[27]

Soranzo is seated in an armchair, which encourages his drapery to form a pyramid, with his black *baréta a tozzo* at its apex.[28] The prominence and downward slope of his right hand in the forward center of the painting, as a corner of the pyramid base, further create a sense of weight and solidity, an effect that would have been enhanced by the placement of the portrait high up on a wall.

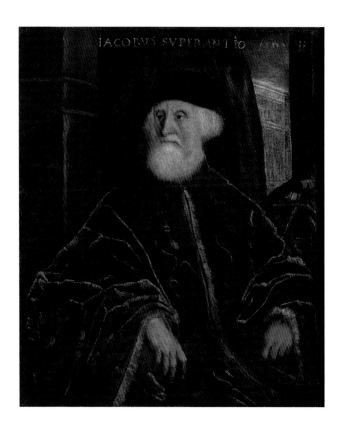

4.4 Jacopo Tintoretto, *Portrait of Jacopo di Francesco Soranzo, il Vecchio*, c.1550, from the offices of the *Procuratia de supra*. Oil on canvas, 106 x 90 cm. Gallerie dell'Accademia, Venice, Inv. 145

Soranzo is depicted perhaps in his office, with the red curtained window open enough to reveal what may be intended as Jacopo Sansovino's Library, a project with which the procurator was involved. A massive pier behind Soranzo adds to the impression of gravitas and solidity, as recognized in Francesco Sansovino's characterization of the painting. Many of the subsequent procurator portraits by Tintoretto maintain the imposing pyramidal structure, and expand the view of the sitter and size of the canvas.[29] The features of Soranzo's face are the only elements of the painting that truly individualize him. Otherwise, such paintings emphasize the official aspect of patrician identity through costume and "mask." The count of up to twenty of these somber portraits to a room in the procurators' offices indicates their purpose to evoke the administrative capabilities of particular

individuals, the solemnity and authority of the office in general, and the sense of a long and stable history of the Republic.

These paintings constitute, in essence, image archives promoting the officially recorded visages of administrators of the state as parallel and supplementary to those in the Ducal Palace across the Piazzetta. As with the series of the images of the doges in the palace, the accrual and display of these portraits in large numbers not only attested to the longevity and venerability of the Republic, arguably they may also have promoted such stability. The actual fragility of any government or institution, and the inevitable factions and debates among members of the ruling class, are masked by the monotonous succession of such likenesses.[30]

Numerous portraits of procurators were commissioned from a single artist at a time, and the relevant documents confirm that while the procurators were interested in memorializing individuals in paintings in their offices, the prime concern was their contribution to the reputation of the group. Some of these portraits were of living procurators, but just as there were campaigns to revive, organize, and restore key documents in the chancery archives, and to redecorate the palace after the fires of the later sixteenth century, there were comprehensive programs to restore paintings in the *Procuratie*, and to create series of paintings of former procurators for whom portraits were missing or severely damaged.[31] For example, in 1572 the procurators *de supra* lamented that their offices did not have portraits of many of their predecessors who had been made doge. They charged their fellow procurator Federico di Francesco Contarini (1538–1613), who was acting as *cassier* (cashier), to commission the portraits of these former doges, so that they could have "a worthy memory of their sublimity, for the honor of the *Procuratia*." Contarini was to have these portraits made from the "authentic ones" in possession of the descendants of the doges Loredan, Grimani, Gritti, and Lando.

So as in the case of Antonio Grimani's family-held *Promissione*, which was used as a visual source for the commemorative painting of Grimani by Titian in the Ducal Palace, images from patrician collections were used as documentary sources for publicly displayed portraits.[32]

The impulse to record a likeness in official documents was parallel to the project of documenting the visages of officers in such publicly displayed paintings, but the more private nature of the documents, and the fact that they remained in domestic collections, eventually encouraged greater expansiveness in conveying individuality. The recipients could exert more direct control on painting in the documents, which more often were made during their lifetime, than on the portraits in oil. In addition, at least by the Cinquecento, whereas the procurators *de supra* used their funds to commission paintings for the offices of other procuracies as well as for their own, the three divisions each commissioned and paid separately for their Commission/Oath manuscripts.

THE MANUSCRIPTS AND THEIR ILLUMINATION

The surviving known records of payment for the writing and illumination of procurator Commissions come from sixteenth-century sources: the account books of the procurators *de supra*, which survive in a fragmentary state from the 1530s on, the financial accounts of one of the scribes, Giovanni Vitali of Brescia, whose work will be discussed further later, and the personal financial accounts of the procurator *de supra* Marin di Girolamo Grimani (1532–1605), later doge. As mentioned earlier, eventually the procurators themselves were able to authorize payment for their preferred scribes, miniaturists, and binders, or pay them directly, for which they would be reimbursed.[33] In addition, the procurators *de supra* commissioned liturgical manuscripts for the Basilica, and often utilized the same artisans of the book for both sacred and secular texts.[34]

From the evidence of the manuscripts themselves, it seems that the earliest documents for individual procurators were made in the ducal chancery, but again, the procuracies began to commission their own documents in the early fifteenth century. The first known surviving illuminated Oath of a procurator is that of Paolo di Stefano Belegno (d. 1373) as procurator *de ultra*, elected in 1368 (fig. 4.1).[35] The manuscript is dated in the eschatocol as having been finished the day after his election, in a formula that suggests it was written out in the chancery of the Ducal Palace, rather than farmed out to a special scribe.[36] There is no inconsistency in the script recording Belegno's name with that of the rest of the text, so it may have been written in one campaign and made ready to hand to him during his inauguration. It has no coat of arms, but in the opening initial, a procurator is shown placing his hand on an open book as he takes his oath, as he would in the ceremony. The intent of the image seems less to show a likeness of an individual than to emphasize the efficacy of the oath. The next known Commission for a procurator is that of Pietro di Jacopo Corner, called "the Great" (il Grande), of San Samuele (d. 1407), elected *de supra* in 1375. This beautiful manuscript is decorated only with elaborate penwork, in which is tucked the Corner coat of arms.[37]

Bartolomeo di Alvise Donato (Donà) was one of two procurators portrayed in the painting described by Sanudo as in the lost Chapel of Saint Catherine, but his document as procurator *de supra* of 1427 shows Mark instead of Donato in the opening initial (fig. 4.5). He points to an open manuscript as if inviting the procurator to make his oath by the Gospel and to protect Mark's church. This is the earliest surviving Commission/Oath where the procurator's coat of arms is emphasized, at the bottom of the page.[38] It follows the practice already established in surviving *Promissioni*, and suggests that at this time some procurators began to consider these manuscripts as a place to celebrate their election and to promote themselves for

posterity. In this much more luxurious manuscript, sections of the opening text are written in gold alternating with brilliant blue and reddish-brown inks. There is no final protocol or notarial mark of the chancery secretaries, suggesting a private scribe was hired. The absence of an eschatocol became standard until, in the late sixteenth century, scribes for hire such as Giovanni Vitali advertised their expensive handiwork through inscriptions. In sum, in the fifteenth century the writing of these manuscripts seems to have moved out of the hands of notaries or secretaries with stipends in the ducal chancery to scribes hired by the procurators, who were paid by the piece.

Donato's is the earliest Commission/Oath that we can presume was created more specifically under the direction of the recipient. He had been one of the electors of the reigning Doge Foscari, and was even a co-father-in-law with Foscari, for his son Andrea had married the Doge's daughter Francesca in 1423. In fact, Donato may have been following the lead of his relative Doge Foscari, for whom survives the first extensively illuminated *Promissione*, in requesting a specially scripted and illuminated document made to commemorate his election.[39]

Despite the precedent of Donato's document, initially many patricians do not seem to have been overly concerned with the details of the production of their Commission manuscripts upon being elected procurator, and many of the fifteenth-century manuscripts are illuminated in a standard format of decorated opening initials and border, and a coat of arms, which essentially changed only in style over some fifty years. The Commission/Oath of Francesco di Pietro Barbarigo (d. 1448), "the Rich Man of San Trovaso," as procurator *de ultra*, of 1442, has a foliate border in the style of Cristoforo Cortese, as in the Commission/Oath of Bartolomeo Donato, personalized only with a coat of arms.[40] Francesco's success in government appointments was surpassed by that of his two sons, Marco and Agostino Barbarigo, who, we can recall, both became doge.[41] There are a number

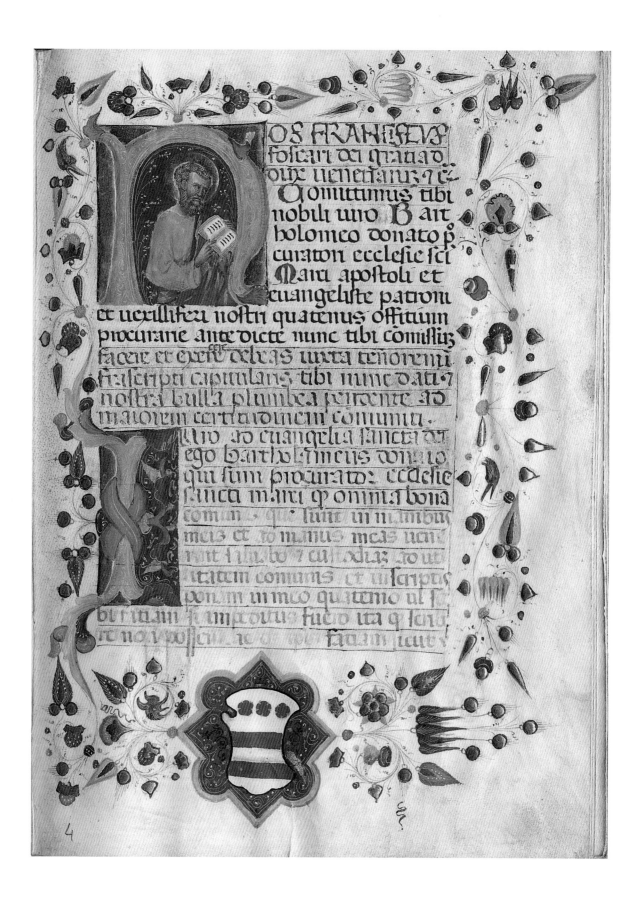

OS FRAHCISVS
foscari dei gratia d
oux uenetianum et c
Committimus tibi
nobili uiro Bar
tholomeo donato p
curatori ecclesie sci
Marci apostoli et
euangeliste patroni
et uexillifem nostri quatenus offitium
procurarie ante dicte nunc tibi comissum
facere et exerc̃ debeas iuxta tenorem̃
subscripta capitularis tibi nunc dati et
nostra bulla plumbea pertinente ad
maiorem certitudinem comunitatum
Iuro ad euangelia sancta dei
ego bartholomeus donato
qui sum procurator ecclesie
sancta marci q̃ omnia bona
comunis q̃ sunt in manibus
meis et ad manus meas uene
runt salua bo̅ et custodia͠ ad uti
litatem comunis et inscriptus
ponam in meo quaterno ul se
bic ritiam si impeditus fuero ita q̃ scri
et no u potero te c q̃ que faciam scire

of fifteenth-century procurator Commissions that were finely executed but without portraits.[42] Although there are no relevant records of payment from this period, we can presume that essentially duplicates were produced for the officials of particular branches. Most of these manuscripts were not personalized beyond a coat of arms, but they were produced with far greater care than everyday ledgers and documents.

The introduction of more customized illumination in these manuscripts in the later fifteenth century generally coincided with the expansion of the office of the procurators in 1443, growing aristocratic claims by patricians, and corresponding humanist laudatory rhetoric. By contrast to the *Promissione* of the doge, these Commissions employed classical imagery and literary allusions to convey notions of patrician virtue, and to advertise the role of wealth and pedigree in determining status and privilege.

ETHICS AND EXEMPLARS

Since the late Trecento, ideals of patrician masculinity in the Renaissance were conceived in part through contemporary interpretations of classical literature, united with Christian morality. Ethical guidelines could be formulated through reading, commentary, and writing. They could be shared informally through friendships, conversations, and correspondence, or in the more formal settings of lectures, academies, and publications. The interest in defining social virtues in the context of the study of classical literature encouraged not only the production of manuscripts dispersing these texts, and responses to them, but also new kinds of art objects and pictorial subjects, including portrait medallions and series of portraits of exemplary men and

women. In addition, the emulation of classical art in itself carried connotations of "wealth, nobility and discrimination."[43] A new style of writing and embellishing manuscripts also developed in imitation of what were considered ancient scripts and decoration.

In early Renaissance Florence, the study of classical literature was encouraged as a means of educating oneself to become an engaged citizen, considered key to maintaining the Republic.[44] By the fifteenth century Venetians also began to produce their own variant ethos of civic duty informed by classical study, which was adapted to promote their unique "mixed" Republic and its ruling class as fulfillments of Plato's ideal governmental structure.[45] In addition to the body of laws that defined the oligarchy of Venice, therefore, grew a literature informed by the study of classical texts, which further enhanced distinction, in part through emphasizing the obligation of the privileged class to serve the state. As the humanist and historian Sabellico advised in the late fifteenth century, Venetian patricians were to study the ancients: "So that you can as best as possible benefit the Republic in the Senate, and the citizens in the marketplace, both by advising and acting, in order that you not appear to be born for yourselves alone, but for your country … and your friends."[46] It is significant that Sabellico emphasized that patricians must at least *appear* to live to serve the broader collective. As scholars such as Robert Finlay and Donald Queller have shown, and as one might expect from human nature, a wide gap could exist between the ideals of Venetian service to the state and their execution.[47] What precisely those ideals should be also was open to the interpretation and emphasis of individual patricians.

PEDIGREE AND WEALTH

The imprint of classical study on the design of the documents of procurators is first found in the Commission/Oath of Francesco di Candiano

4.5 Master of the Donato Commission, Commission/Oath of Bartolomeo di Alvise Donato as procurator *de supra*, elected 1427. 27 x 19 cm. Biblioteca del Museo Civico Correr, Venice, Cl. III, 775, fol. 4r

Barbaro (1390–1454), elected procurator *de citra* in 1452 (fig. 4.6).[48] The opening leaf features a portrait of him, albeit presumably looking much younger than his sixty-one years upon election, receiving the keys of office directly from Mark, following iconography previously established in the lost Chapel of Saint Catherine. This, then, is the first known painting of a procurator parallel to monumental portraits of them made at the time, but now lost. Again, as will be shown, other portraits in these documents similarly fill in the image archive of likenesses of patricians, whose larger portraits in fresco or oil have disappeared. Such illumination extended the emphasis of divine investiture and authority to patricians besides the doge. Barbaro's interest in having his portrait painted in his document may have been stimulated by a self-consciousness of patrician virtue and exemplarity as newly framed by his study of classical texts, and as an extension of his collecting of manuscripts and ancient coins.

Francesco served in many and great offices of state, and his career exemplifies that of a Venetian civic humanist of the first half of the fifteenth century. In his youth, he was tutored by the prominent master of Ciceronian Latin, Gasparino Barzizza, whose writings greatly informed the Venetian sense of patrician identity. Applying study of Cicero's *De officiis* and Seneca's letters to contemporary life, Barzizza wrote that the ideal patrician needed to alternate between business, public service, and studies, an ideal that his student Francesco Barbaro practiced.[49] Barbaro went on to attend the University of Padua, where he received his doctorate in 1412. Upon returning to Venice, he took into his household Guarino of Verona, the eminent scholar of Greek language and literature, and studied with him. Through Guarino, Barbaro entered into social contact with the elite of Florentine humanism. Barbaro accompanied Guarino to Florence in the summer of 1415, where he was a guest of Cosimo and Lorenzo de' Medici (il Vecchio), and such illustrious humanists as Leonardo Bruni and Nicolò Niccoli.[50]

At the age of twenty-six, Francesco wrote what would become his most famous text, entitled *On Wifely Duties*. It was a gift to Lorenzo de' Medici, upon Lorenzo's marriage in 1416 to Ginevra Cavalcanti.[51] Although this was dedicated to a Florentine, Barbaro's text emerged from well-established Venetian patrician values, which were given a humanist bent. Barbaro promoted the increasing self-consciousness of patrician *virtù* as something to breed as well as to cultivate. Buttressed by classical sources, Barbaro exhorted nobles to select a wife of virtue because the object of marriage, he argued, was the preservation of the purity and privilege of noble families. The continuation of the patrician family was necessary to a successful Republic.[52] The continuing popularity of *On Wifely Duties* into the sixteenth century is attested to by its history of frequent reprints, including a translation from Latin into Italian published in 1548.[53]

Barbaro was especially active in the central humanist practices of buying, commissioning, and exchanging books. We are fortunate that a list of his manuscripts has come down to us, from which we can glean his interests, and which has allowed scholars to track some fifty-two of the still-existing volumes with his marks of ownership in libraries.[54] Among the manuscripts was one that contained the works of the ancient Roman historian Tacitus, and which Barbaro lent to Cardinal Bessarion, the Greek patriarch who would donate his outstanding collection of mainly Greek manuscripts to the Republic in 1469. Barbaro also owned a copy of Plato's *Laws*, given to him by George of Trebizond to show him how the Venetian constitutional system reflected ideal Platonic theories of government.[55]

Barbaro participated in the enthusiastic search for lost ancient texts in libraries. He hired scribes to copy books written by him and others,

4.6 Commission/Oath of Francesco di Candiano Barbaro as procurator *de citra*, elected 1452. 28.2 x 20 cm. Österreichische Nationalbibliothek, Vienna, Cod. 438*, fol. 4r

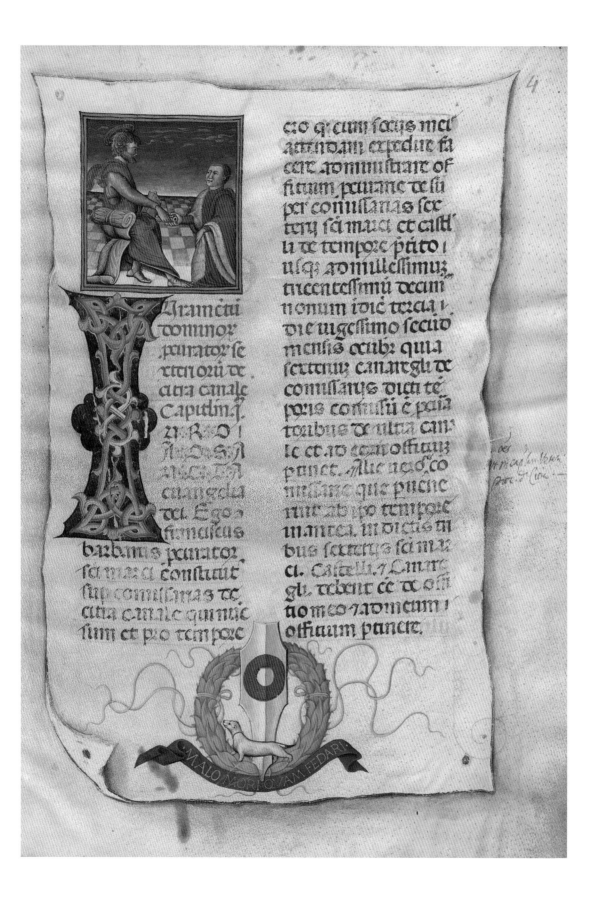

and he bought books already written out, many from the *librarii* in Venice.[56] Barbaro wrote comments in the borders of his manuscripts, for example in a copy of Aristotle's works, which then were annotated by his grandson Ermolao di Zaccaria (d. 1494).[57] In moments of time that he could spare from his patrician duties in the years 1447 to 1452, and especially in the winter after he had been elected procurator (1451–52), Francesco oversaw the compilation of a definitive manuscript edition of his correspondence, which included letters to the great humanists and rulers of his day, and to the populaces of the territories he governed.[58] Perhaps because Barbaro's passion for antiquity was primarily literary, he commissioned manuscripts with relatively simple ornamentation. The aesthetic is of script and letter ornament derived from sources believed to be antique.

When Francesco Barbaro was elected procurator in 1450, he had just served as *Podestà* of Padua. As such, he would, as a celebrated humanist, author, and collector of books, have become ever more familiar with the new classicizing style of art and manuscript painting that was emerging there, including the interest in the illusionistic play prominent in the illumination of his Commission. The opening text of his document is conceived as if upon a fictive piece of parchment attached to the page by pins, with the leaf curling up on the lower left-hand corner. This kind of trompe l'oeil play is of distinctly Paduan origin, influenced by the interests of Mantegna and the circle of artists around Squarcione. It became a major compositional device in manuscript painting in the later fifteenth century in the hands of such miniaturists as Girolamo da Cremona and Benedetto Bordon, among others.[59] As well as exhibiting the skill of the artist, this illusionism calls attention to the materiality of the actual page, and thereby, of the historical moment of the appointment written on it. The style of the large and bold multi-colored opening initial of interlaced and knotted vines

(*a cappio intrecciato*) had been introduced into the Veneto by the 1430s in manuscripts produced by Andrea Contrario and Michele Salvatico. These copyists were friends of Barbaro and worked regularly for him.[60] Such initials imitate those of the Carolingian manuscripts that humanists were newly appreciating and copying, many of which were considered more ancient.[61]

The portrait of Barbaro seems to aim for an actual, if very flattering, likeness as well as to symbolize the acceptance of office. Of all the surviving manuscripts made for Barbaro, his Commission as procurator is the only known one with his portrait. In fact, it is the only known surviving portrait of him made during his lifetime. It was made at a time when detailed Flemish portraits in oil, which focused on the head and shoulders from a three-quarters view, were beginning to be collected in Venice. Shortly before Francesco was elected procurator, the future doge Marco Barbarigo had his likeness painted by a Flemish master in that manner.[62] The inclusion of Barbaro's portrait only in his document, and not in other manuscripts commissioned and collected by him, suggests a particular pride in attaining the office, and a desire to memorialize his election. The likeness in the manuscript may have complemented one made for the *Procuratia*, but now lost.

Francesco's wish to leave a visual image of himself in the family archives also must reflect his enthusiastic participation in the culture of eulogy and biography, of exemplarity. He wrote several funeral orations, and translated Plutarch's lives of Aristides and Cato the Elder from the Greek into Latin. He collected ancient coins, and discussed the identity of portraits on coins with the Florentine patristic scholar Ambrogio Traversari.[63]

At the bottom of the page of Barbaro's document is the family coat of arms, and an emblem of an ermine and motto further personalize the document. The dramatic motto "Better death than dishonor" may have been

invented by Francesco and was adopted by later generations of the family.[64] The red ring on a white background of the Barbaro coat of arms, used by all the *rami* of the *casata*, had particularly heroic and gruesome origins, which the motto intensifies. According to legend, the coat of arms emerged from a mark made in the aftermath of a great victory during the crusade to the Holy Land of 1122–25, led by Doge Domenico Michiel. During a naval battle near Ascalon, the Barbaro ancestor Marco Magadesi cut off the hand of a Moor, and used the bleeding stump to imprint a circle on to a turban, which he flew as a pennant from the masthead of his ship.[65] Magadesi subsequently changed his name to Barbaro, to reference his vanquishing of the Islamic barbarians, or *barbari*. The red circle imprinted by the stump on white became the family coat of arms. The very name and heraldic symbol of the family perpetually referenced their ancestor Marco as an exemplary Christian soldier, willing to use force and risk his life to preserve Venice.

Despite the example of Barbaro's Commission/Oath, among surviving documents portraits of procurators are featured again only decades later. Instead, elaborate floral borders by Leonardo Bellini and his workshop predominate in procurator Commissions from just before Cristoforo Moro's election as doge in December of 1462 to the 1470s, with the last procurator's Commission attributable to Bellini being dated 1483. These manuscripts all have borders of flowers and gold dots in a style originating in Ferrara, with angels, winged putti, or hybrid creatures framing the coat of arms at the bottom of the page (fig. 4.7).[66] The convention of putti or other figures holding up the coat of arms, and the interlaced vines decorating the opening initial, emerged from the desire of humanists to have manuscripts decorated "in the ancient manner," as Leonardo Bruni requested when commissioning a manuscript of Cicero's works for Nicolò Niccoli in 1407.[67] Some of the documents in this period are so similar that it is as if they were made at the

same time, or one was copied from the other.[68] A functionary of the office may have overseen the production of a group of these documents, in which unanimity of the procurators was conveyed by the replicated designs of the illuminations. Nevertheless, Andrea di Nicolò Lion (d. 1478), elected procurator *de supra* in 1473, must have requested specifically that a portrait be fitted into the painting in his document, which otherwise maintains the standard *mise en page* (fig. 4.8).[69] Unlike Barbaro's unnaturally youthful portrait, Lion is shown with a head of white hair to create a truer likeness.

A new phase in the painting in documents for the procurators was stimulated by the introduction of print in 1469, which brought an influx of miniaturists looking to benefit from the new opportunities for work, creating an exceptionally rich pool of artisans of the book. There also was intense state interest, both financial and cultural, in book production. Some of the patricians who became procurators would play a direct role in the development of the industry. For instance, Bertuccio di Marin Contarini (d. 1490), whose magnificent document as procurator is discussed later (fig. 4.11), was one of five ducal councillors heading the Senate's creation of the first known European printing privilege, granted to Johannes of Speyer in 1469. This gave the German master printer a five-year monopoly to print in Venice and its territories (he died shortly after and the privilege was annulled). The privilege produced under Contarini cites with praise Johannes's editions of the letters of Cicero and the *Natural History* of Pliny, and confirms the interest of many patricians in these texts. Johannes made available "many, famous volumes, and for a low price …" The document continues, "such an innovation, unique and particular to our age and entirely unknown to those ancients, must be supported and nourished with all our goodwill and resources."[70]

Also in 1469, Cardinal Bessarion donated his precious collection, primarily of Greek

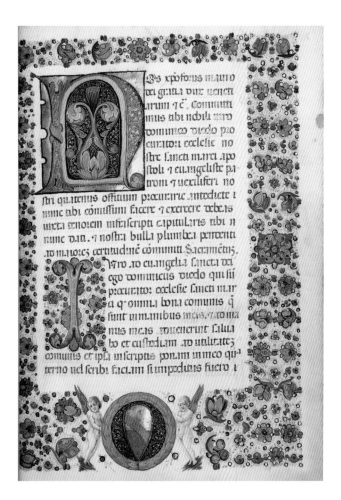

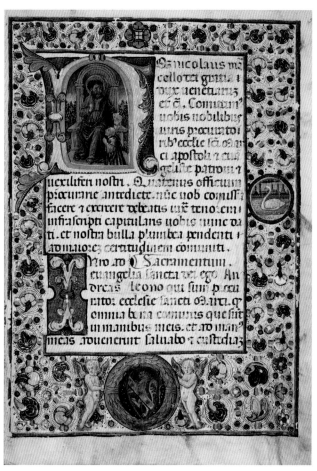

4.7 Workshop of Leonardo Bellini (attrib.), Commission/ Oath of Domenico di Giovanni Diedo as procurator *de supra*, elected 1464. 27.5 x 19.6 cm. Isabella Stewart Gardner Museum, Boston, 2.b.2.5, fol. 5r

4.8 Leonardo Bellini (attrib.), Commission/Oath of Andrea di Nicolò Lion as procurator *de supra*, elected 1473. 27 x 19.2 cm. Biblioteca Nazionale Marciana, Venice, Lat. X, 358 (=3517), fol. 5r

manuscripts, to the Church of San Marco. In this way these books, numbering over 1000, came under the care of the procurators *de supra* and were the foundation of the collection for which Sansovino's Library would be built. Although for the most part the collection remained in storage until Pietro Bembo was named librarian in 1530, surely the custody of this magnificent collection, with glittering masterpieces of Byzantine as well as contemporary Italian manuscript painting, helped to elevate interest in, and standards for, the production of the manuscript documents of the procurators.[71]

The most prominent illuminator in the earliest years of print in Venice was Girolamo da Cremona. He trained in Padua under Mantegna, and worked in many of the most important artistic centers of the Italian Renaissance, including Mantua, Ferrara, Padua, Siena, and Florence. Girolamo came to Venice by 1475, and he stayed there, for the most part, until 1483.[72] Under his example there grew a fashion for greater illusionism and trompe l'oeil effects in manuscripts. His miniatures feature close studies of flora and fauna, and of gems, coins, medallions, and other materials of antiquarianism

4.9 Girolamo da Cremona with assistants (attrib.), Commission/Oath of Antonio di Marco Erizzo as procurator *de citra*, elected 1476. 28.3 x 20 cm. Cambridge University Library, Add. MS 4121, fol. 5r

documents, with Erizzo's head shown balding, for he was in his seventies when elected. The precision of the portrait and the luminosity of the landscape perhaps reflect a study of Giovanni Bellini's portraits. Erizzo reaches out towards the opening text as if to take the oath written there. His portrait faces a bronze medal portrait, derived from coins of Septimius Severus, making the link between documenting his image and the current interest in portraits of exemplary men on ancient coins explicit. As a procurator *de citra*, Erizzo was not responsible for the Church of San Marco, and nothing is recorded about him as a collector, but a testament to him as a refined patron is that in 1480 he was involved in the construction of the exquisite Church of Santa Maria dei Miracoli.[74]

Girolamo da Cremona collaborated with other miniaturists on painting programs in luxury copies of early printed books, most notably in the large and magnificent presentation volumes of works printed by the publisher Nicolaus Jenson and given to his friend and financial backer Peter Ugelheimer of Frankfurt from 1477 to 1479. The fruits of such close fraternization among miniaturists are evident in the Commission of Antonio K. di Jacopo Loredan K. (1420–1482), elected procurator *de supra* in 1478, the illumination of which is attributed to the Master of the Seven Virtues, an artist subsequently favored by the procurators (fig. 4.10).[75] The opening miniature shows the influence of Girolamo da Cremona in the rich fictive-sculpture border decoration full of jewels and cameos, which now frames a humanist script, of a kind that informed the famed Roman type of Jenson. The cameo on the left is derived from ancient coins of Nero, whose *sestiere* was among the most coveted and valuable of coins in the fifteenth century.[76] A cross placed in the lower border and the use of the term *militi* in the opening text identifies him as a Christian soldier, and celebrates his lengthy and successful service in battles, including his time as Captain General of the Sea, against the Ottoman "infidel."

and collecting. A number of the procurators took advantage of Girolamo's art and that of his associates to bring greater preciousness to the manuscripts celebrating their accession to office.

An important example in Girolamo's style opens the Oath of Antonio di Marco Erizzo (1409–1483) elected procurator *de citra* in 1476 (fig. 4.9). The portrait fuses the long tradition of full-length images of men in the opening initials of manuscripts, which typically are not intended as likenesses (fig. 4.1), with the newer interest in verism in portraits.[73] It features one of the most convincing and detailed likeness in such

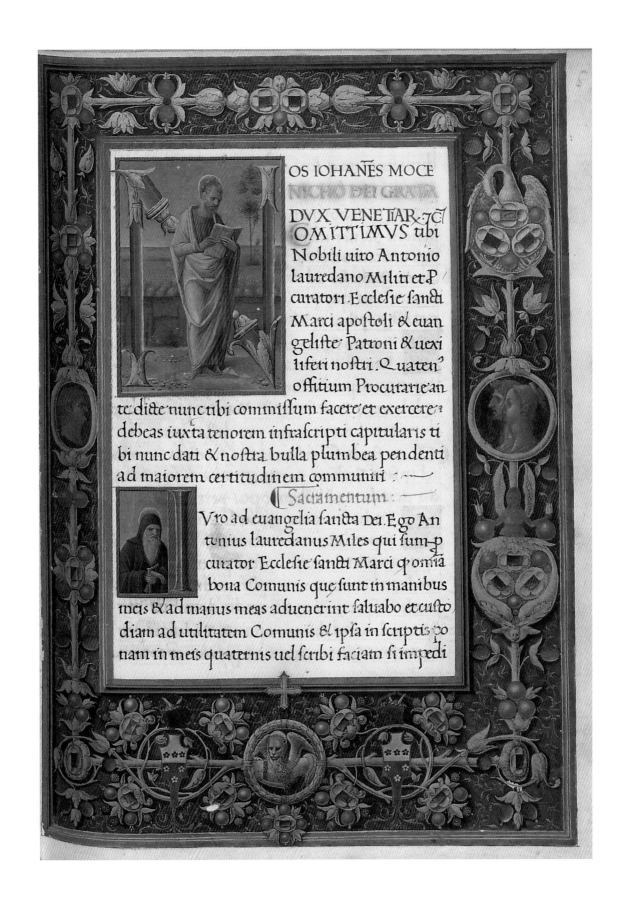

OS IOHANĒS MOCE
NICHŌ DEI GRATIA
DVX VENETIAR: 7C
OMITTIMVS tibi
Nobili uiro Antonio
lauredano Militi et P
curatori Ecclesie sancti
Marci apostoli & euan
geliste· Patroni & uexi
lifeti nostri. Quaten⁹
offitium Procurarie an
te difte nunc tibi commissum facere et exercere;
debeas iuxta tenorem infrascripti capitularis ti
bi nunc dati & nostra bulla plumbea pendenti
ad maiorem certitudinem communiti ; ⁓
 ¶ Sacramentum : ⁓
Vro ad euangelia sancta Dei. Ego An
tonius lauredanus Miles qui sum ṗ
curator Ecclesie sancti Marci ꝗ omia
bona Comunis que sunt in manibus
meis & ad manus meas aduenerint saluabo et custo
diam ad utilitatem Comunis & ipsa in scriptis po
nam in meis quaternis uel scribi faciam si imṗedi

The Master of the Seven Virtues may have initiated a fashion for creating full-page heraldry on the leaf facing the opening text in the documents for procurators. These pages at times included mottos that proclaimed the procurator's beliefs about the relative roles of pedigree, wealth, and virtuous deeds in relation to noble status, a topic that became hotly debated in the Renaissance. In his book *On Wifely Duties*, Francesco Barbaro had emphasized the importance of the virtue of one's wife in preserving the nobility of the family. Gasparo Contarini's book on the government of Venice, which was central to the myth of the ideal Republic, claimed that nobility came from blood rather than riches.[77] We can recall here that laws of the three *serrate* legislated increasing surveillance of the purity of noble blood. In the later sixteenth century, several authors, including Paolo Paruta and Girolamo Muzio, argued for the importance of virtuous actions over wealth and bloodline. The mottos in the documents of the procurators express their views in this ongoing debate.

For example, the Master of the Seven Virtues illuminated the Commission/Oath of Bertuccio

4.10 (Opposite) Master of the Seven Virtues (attrib.), Commission/Oath of Antonio K. di Jacopo Loredan K. as procurator *de supra*, elected 1478. 22.7 x 16.3 cm. Katholieke Universiteit Leuven, Maurits Sabbe Library, Berchmanianum Collection, MS 18 BK, fol. 5r

4.11 (Below) Master of the Seven Virtues (attrib.), Commission/ Oath of Bertuccio di Marin Contarini as procurator *de ultra*, elected 1485. Each fol. 27.5 x 19 cm. Biblioteca del Museo Civico Correr, Venice, Cl. III, 313, fols. 7v–8r

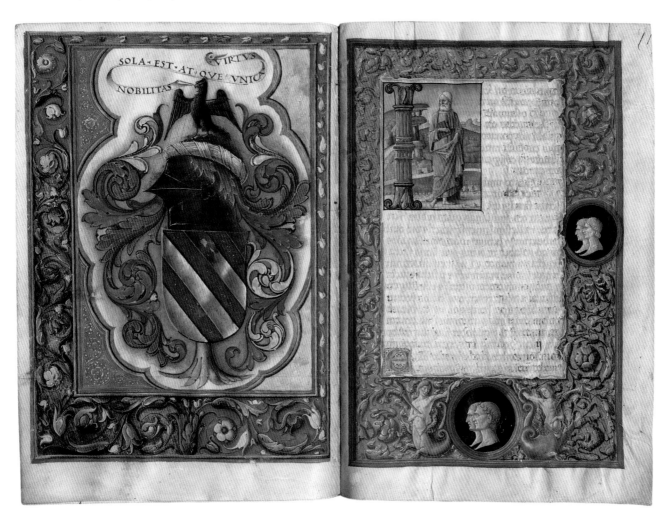

di Marin Contarini, one of the undersigned for the privilege to the printer Johannes of Speyer in 1469. Contarini was elected as procurator *de ultra* in 1485 (fig. 4.11). A banderole on the leaf facing the opening text quotes the ancient Roman satirist Juvenal (55–140): "*Nobilitas sola est atque unica virtus*," or "the one and only nobility is virtue."[78] This famous verse is from Juvenal's satire with the words "What's the use of pedigrees?" The satire is addressed to an aristocrat named Ponticus, and urges him to assure his worth through deeds rather than relying on the notion of nobility as preserved

through one's bloodline, and the monuments that exalt it. In context, the verses read:

> Though you adorn your entire atrium with ancient wax portraits in every direction, the one and only nobility is personal excellence [virtue]. So, be a Paulus or a Cossus or a Drusus – in morality. Rate that ahead of your ancestors' statues …[79]

Although some regarded Juvenal's satires generally as too racy to be included in school curricula, his work was highly esteemed and widely read in the Renaissance. Francesco Barbaro's teacher, Guarino, lectured on Juvenal extensively. Competing commentaries produced heated controversies, and editions of Juvenal's works were some of the first books to be printed in Venice.[80]

4.12 Benedetto Bordon (attrib.), Commission/Oath of Antonio di Alvise K. Mocenigo as procurator *de citra*, elected 1523. Each fol. 16 x 9.7 cm. Royal Library, Windsor, MS RCIN 1081196, fols. 1v–2r

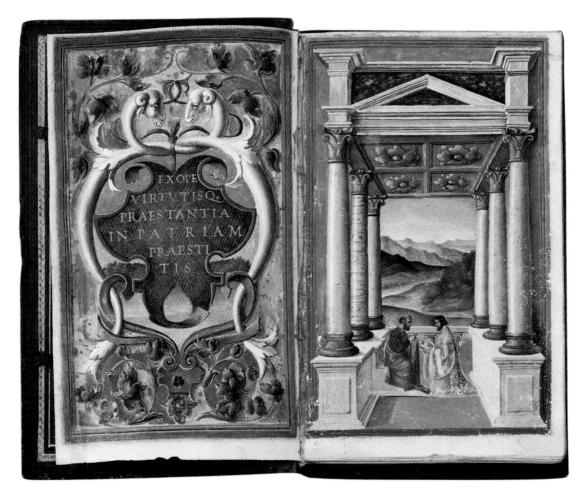

The moralizing motto culled from Juvenal, set in classically inspired decoration, allowed Contarini to project an identity founded in the study of classical antiquity, and to emphasize that as procurator he possessed nobility in achievement and service as well as in birth.

By contrast, the importance of wealth in determining social status was promoted blatantly in the Commission of Antonio di Alvise K. Mocenigo (d. 1557), who was elected procurator *de citra* in 1523 by payment (fig. 4.12).[81] In it the miniaturist Benedetto Bordon portrayed the procurator taking his oath of office on a book proffered by Mark in a classical loggia, innovatively set in a deep landscape with atmospheric perspective.[82] The inscription on the facing illuminated leaf proclaims: "You attain pre-eminence in your native land both from wealth and by means of notable virtue."[83] This special pride in riches seems to have been a family tradition. Antonio's father, Alvise, was the founder of the Mocenigo branch called "*dalle zogie*" or "*dalle perle*" ("of the jewels" or "pearls") because of their affluence and magnificence, and the family was further enriched through strategic marriages.[84]

Gasparo di Tommaso Molin (d. 1550) was elected procurator *de citra* in 1526, also by payment, but the motto of his Commission/Oath is more cautionary to the rulers of Venice: "Beware O Judge, in all things not to swerve from what is just." Again, such mottos as featured in these documents of the procurators were exhibited on banners in the festivities on the day of the procurator's inauguration.[85]

Although the work of Bordon and associated artists predominated in manuscript painting in general in the 1520s, a variety of miniaturists were employed by the procurators *de supra*. The portrait of Jacopo di Francesco Soranzo, il Vecchio, elected as such in 1522, was discussed as an example of the paintings that lined the walls of the *Procuratia*. His Commission for this position is relatively modest in that there is no full leaf reserved for a motto (fig. 4.13). The fine illuminated Flemish-

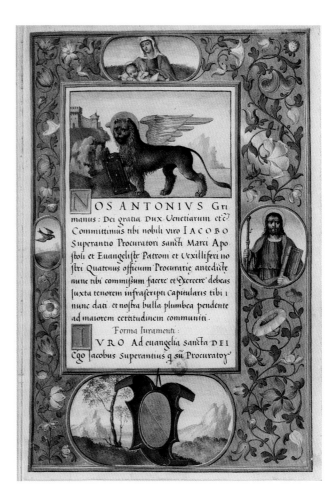

4.13 Trees Master (attrib.), Commission/Oath of Jacopo di Francesco Soranzo, il Vecchio, as procurator *de supra*, elected 1522. 24.8 × 17 cm. Bibliothèque national de France, Paris, MS Smith Lesouëf 17, fol. 2r

style border of scrolling vines with flowers on gold ground framing the opening text is by the Trees Master, a miniaturist who may have emerged around 1514, and trained in the Bordon workshop.[86] The only imaged references to Jacopo's identity are a portrait of his namesake Saint James with the attributes of a pilgrim's staff and a book, and the Soranzo coat of arms. The lack of a portrait suggests humility, but as will be discussed in a later chapter, Jacopo's grandsons Giovanni and Jacopo di Francesco made sure that their Commission documents for the lesser offices as rectors were more elaborate, and included portraits.[87]

UNITY AND DISTINCTION

At times the production of Commissions was fully standardized for a group of incoming procurators. In June of 1537, six patricians were elected procurator *de ultra* by payment, for sums ranging from 13,000 to 16,000 ducats.[88] For three of them the leaves illustrating their Oaths survive.[89] These leaves are remarkable because they all have portraits, but these are set in a repeated composition, differing only in their faces and patron saints (figs. 4.14–4.16). The portraits clearly were commissioned all together from one miniaturist, the T.° Ve Master, and as a group convey the equality of the three patricians. A votive portrait in oil of one of them, Girolamo di Andrea Marcello (d. 1553), made for the offices of the procurators *de ultra*, expands upon the themes of oath-taking and devotion illustrated in his document (fig. 4.17).

Here the visibly more aged procurator, with a beard now almost completely white, places his hand on the text of the oath in the Commission document that Mark and the Christ Child hold. Such could be the close interrelationship between the messages of a publicly displayed memorial and archived manuscript image.[90]

4.14 (Below left) T.° Ve Master (attrib.), Commission/Oath of Girolamo di Vettor Bragadin as procurator *de ultra*, elected 1537. 22.4 x 16.1 cm. Biblioteca Nazionale Marciana, Venice, Lat. X, 224 (=3798), fol. 1r

4.15 (Below centre) T.° Ve Master (attrib.), Leaf from the Oath of Giulio di Giorgio K. Contarini as procurator *de ultra*, elected 1537. 21.5 x 15 cm. British Library, London, Add. MS 20916, fol. 5r

4.16 (Opposite) T.° Ve Master (attrib.), Leaf from the Oath of Girolamo di Andrea Marcello as procurator *de ultra*, elected 1537. 21.5 x 15.3 cm. Musée Marmottan Monet, Paris. Wildenstein Collection

4.17 Jacopo Tintoretto, *Girolamo di Andrea Marcello Takes his Oath of Office as Procurator "de Ultra",* with the Madonna and Child and Saints Jerome and Mark, after 1537. Oil on canvas, 148 x 193 cm. Private collection, The Netherlands

In this context of standardized formats for portraits in the Commissions of the procurators *de ultra*, which focus on the commission and oath and ultimately project the unanimity of the officials, the lack of a portrait but hiring of a renowned artist painting in the Roman manner could convey prestige. Giovanni K. di Priamo da Lezze (1506–1580) was elected as a procurator *de supra* through payment in July 1537, a month after the elections of Bragadin, Contarini, and Marcello as *de ultra*.[91] He had his manuscript illuminated by the central Italian miniaturist Jacopo del Giallo, to memorialize his cosmopolitan tastes and international distinction rather than his visage (fig. 4.18). A year after his election, compensation of 8 ducats to Jacopo del Giallo for da Lezze's Commission was recorded in the *de supra* ledgers (Appendix 3).[92] Da Lezze may have directly requested del Giallo to paint his document, for he could have known the illuminator through their common acquaintance, the famous author Pietro Aretino. Aretino included both del Giallo and da Lezze in his literary works and correspondence from 1530 to 1553.[93]

Da Lezze also may have requested that del Giallo paint his document because of the public acclaim of the artist by Aretino, and the artist's illustrious and courtly clientele. In a letter published in 1538, Aretino thanked del Giallo for the illumination of a text that Aretino had sent to Empress Isabella of Portugal, and praised him as a miniaturist rivaling great painters. Aretino characterized Jacopo as an artist of *disegno* and *rilievo* to distinguish him from craftsmen who relied on the qualities of the materials they used, such as ultramarine and gold, for artistic effects.[94] Nevertheless, the visual sumptuousness of da Lezze's document also is due in no small part to the artist's liberal use of these materials.

While there is no portrait of Giovanni in his Commission manuscript as procurator, his name and knighthood are memorialized in gold Roman capital lettering on a solid lapis blue "tablet," framed by curling shredded parchment and crowned with laurel. Previously, in 1532, also aided by his father's wealth and influence, Giovanni da Lezze had been granted the title of Knight and Palatine Count of Santa Croce, an area in the Trevigiano, by Emperor Charles V. The crown of his elevation as count is included above the da Lezze coat of arms.[95] The border features classical motifs such as leaf men, sea creatures blowing conches and other music makers, and putti cavorting on festoons and on scrolling stems and leaves with flowers. Such motifs were already part of the classicizing visual vocabulary in the Veneto by the mid-fifteenth century.[96] Putti on festoons were available for an artist like Jacopo del Giallo to study on an ancient sarcophagus fragment (second century, with the Rape of Proserpina), in the palace of the Grimani of Santa Maria Formosa.[97] In sum, Giovanni's document memorialized him not through portraiture but by conveying sophistication and distinction through additional texts articulating his knighthood, paintings with antiquarian imagery, the quality of the materials, and the fame of the artist.

At 8 ducats, del Giallo commanded much more for his work than another miniaturist, Gasparo, who was paid 5 ducats for the Commission/Oath of Pietro di Francesco Grimani, elected procurator *de supra* one year after da Lezze, in 1538. Grimani, acting as *cassier*, authorized the payments for his manuscripts himself.[98] Unfortunately, that document does not seem to have survived. It would have allowed us to identify the name with a body of work. Because the T.° Ve Master was working regularly for the ducal chancery and for the procurators in these years, and he tended not to use expensive materials so extensively (one of the reasons he may have been paid less than del Giallo), one is tempted to link him with this "Gasparo."[99]

Records of payment for another lost Commission, that for Melchiorre (Marchiò) K. di Tommaso Michiel (d. 1572), elected procurator *de supra* in 1558, give a fuller picture of the expenses for the components of a Commission/Oath mid-century. The *cremesino* velvet for the binding cost just over 12 ducats, payments to a Zuane de la Speranza for the silver fixtures of the cover, 5. Giovanni Vitali earned 10 ducats for writing the text, and the miniaturist Giorgio Colonna a little over 7, making a total of 34 ducats. Colonna was paid less than the scribe, and substantially less than for the materials of the binding.[100]

Surviving miniatures for documents of the procurators *de citra* in the 1540s and 1550s have single illuminated leaves by the T.° Ve Master, but the procurators for this office subsequently allowed costs for the script, binding, and miniatures to spiral out of control (fig. 4.19).[101] A great deal of the expense may have been in payment to the scribe Giovanni Vitali. He became sought-after but charged highly for his work, as much as 36½ gold ducats for the materials and scripting of one Commission, more than what was paid to create Michiel's entire document of 1558 (Appendix 3).[102]

4.18 Jacopo del Giallo, Commission/Oath of Giovanni K. di Priamo da Lezze as procurator *de supra*, 1538. 25.6 x 18.3 cm. Biblioteca del Museo Civico Correr, Venice, Cl. III, 14, fol. 1r

COMMITTIMVS
TIBI NOBILI
VIRO IOANI
DALEGE COMITI
S CRVCIS ÆQVITI ET PROCV
RATORI S MARCI APOSTOLI ET
EVANGELISTÆ PATRONI ET VEXILL
IFERI NRI QVATTENVS OFFICIV
PROCVRATIÆ ANTE DICTÆ
NVNC TIBI COMISSVM FACE
RE ET EXERCERE DEBEAS IVSTA
TENOREM INFRASCRIPTI CA
PITVLARIS TIBI NVC DATI
ET NOSTRA BVLLA PLVMBEA
PENDETE AD MAIOREM CE
RTITVDINE COMVNITI

De Iuramento D procuratoris

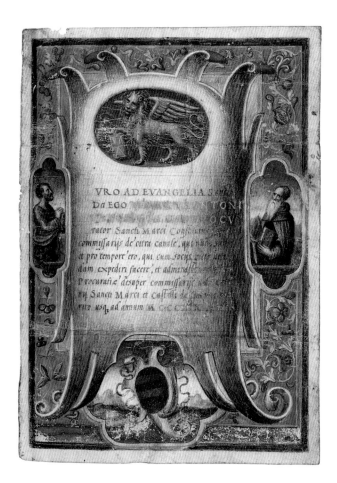

4.19 T.° Ve Master (attrib.), Leaf detached from the Oath of Marcantonio di Cristoforo Venier as procurator de citra, elected 1554. 23.5 x 17 cm. Biblioteca del Museo Civico Correr, Venice, Cl. III, 321, fol. 2r

CONTROVERSIES OVER FUNDING

In response to complaints about the expense lavished on the portraits and manuscripts for the procurators *de citra*, a law passed by the Great Council of Venice in September of 1580 imposed monetary limits but only on the manuscripts. The ruling states that expenditure on such portraits and manuscripts had increased so rapidly in recent years that the Great Council feared such excess spending might bring the office of the procurators into disrepute. Whereas these procurators used to spend 5 ducats, then 10 per manuscript, in the years leading up to

1578 over 696 ducats had been spent on fourteen manuscripts, at an average of almost 50 ducats a manuscript. With Vitali's escalating charges for writing the document out, it was not difficult to arrive at such expense. The new law decreed a limit of 15 ducats for the production of manuscripts for the procurators *de citra* and *de supra*, following a rule already in place created by the procurators *de ultra*, but did not set a specific limit on the independent paintings.[103] By comparison with 48 ducats for one procurator's Commission manuscript, records of payment suggest that Tintoretto received just 60 ducats in total for three portraits of the procurators *de supra* in 1576, or only 20 ducats each.[104] These specific oil paintings by Tintoretto are not identifiable today, but would have been the official kind that hung in the offices in the Procuratie Nuove of Piazza San Marco.[105]

So what did the illumination of these controversial manuscripts look like? In the two years previous to the ruling, Vincenzo K. di Barbon Morosini (1511–1588) and Nicolò di Agostino Venier (1525–1587) were elected as procurators *de citra*, but their Commissions are not known to have survived. The closest in date of the known surviving Commissions for the procurators *de citra* before the imposed expense limits of 1580 are those of Girolamo K. di Bernardo Zane (1515–1572), elected procurator by merit in 1568, and Alvise di Lorenzo Tiepolo (1528–1591), elected in 1571 through a pledge of 20,000 ducats (figs. 4.20 and 4.31).[106] Both of these manuscripts are prefaced with two full-page illuminations featuring portraits of the recipients of the office, by contrast to the single opening text page for Giovanni da Lezze. They create a memorial that extends well beyond dedication to the oath of office. We do not have payment records for these manuscripts, but they can serve as examples of what might have cost some 50 ducats for script, illuminations, and binding, before the price limit was put in place. The scribe of both manuscripts was Giovanni Vitali, and

again, we know that he charged up to 36½ gold ducats for writing out such manuscripts with limited illuminated decoration of major initials and text openings.[107] The Tiepolo manuscript is in its original velvet binding, with impressions from the metal fixtures that at some time were removed. The velvet and silver cost over 17 ducats for Michiel's *ducale* of 1563. Despite the increase in space dedicated to illuminations in these manuscripts, the actual expense for painting was probably less than a quarter of the total cost.

Nevertheless, the increase in expense coincided in some cases with more detailed representation of the procurator and his achievements, conveying not just a documentary sense of the appearance of the patrician at the time of his election, but also of the events

associated with it. The miniatures for the Commission/Oath of Girolamo Zane provide two such detailed images of his achievements simultaneously to the viewer – as procurator *de citra* and as Captain General of the Sea. Many procurators served previously or simultaneously as captain general, and this was indicated in some of the fifteenth-century documents of procurators by references added to the opening texts, as noted in relation to discussion of the manuscript for Antonio Loredan (fig. 4.10). The two offices were so closely tied that in the seventeenth century it became common

4.20 *Girolamo Zane as Procurator and as Captain General of the Sea*, Commission/Oath of Girolamo K. di Bernardo Zane as procurator *de citra*, 1568. Each fol. 29.5 x 21 cm. British Library, London, King's 156, fols. 11v–12r

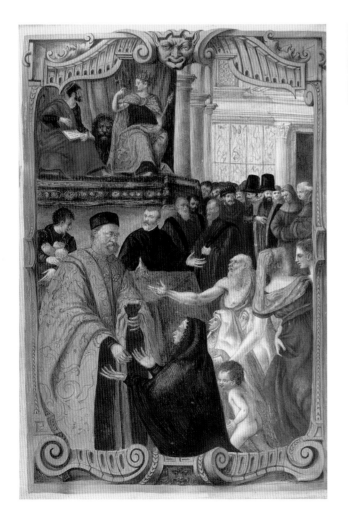
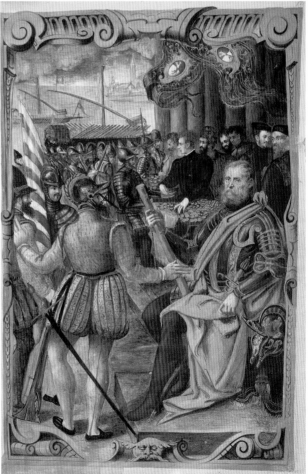

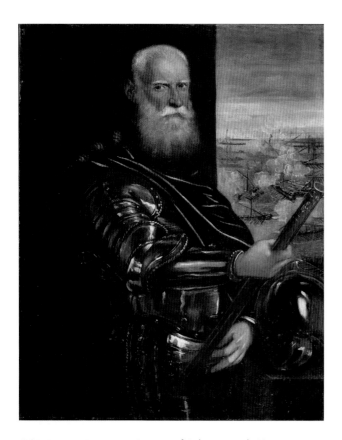

4.21 Jacopo Tintoretto, *Portrait of Sebastiano di Moisè Venier as Captain General of the Sea*, with the sea-battle of Lepanto in the background, c.1572. Oil on canvas, 104.5 x 83.5 cm. Kunsthistorisches Museum, Vienna, GG Inv. N. 32

The left illuminated leaf of the manuscript represents Zane dressed in the gold *restagno* mantle signifying his knighthood, typically worn only on ceremonial occasions. The scene incorporates elements of a procurator's inauguration set in Piazza San Marco, with the stone revetments of the Basilica in the background. On a podium, two actors portray Saint Mark and Venice personified to create a tableau vivant, a common feature of festive occasions in the Renaissance. Zane also performs some of his normal duties as procurator as set out in the manuscript text, such as paying a widow her allowance as a pauper asks for charity. To the right, the figures in the background with the tall black hats typically worn by Greeks in Venice may be the grammar masters whom the procurators were obliged to pay. The friars in their brown habits probably reference Zane's right to burial and construction of an altar in the Franciscan Church of Santa Maria Gloriosa dei Frari.[111]

The right-hand illumination shows Zane now seated across the Piazzetta in front of the Library, and dressed in armor as captain general. Behind him troops are being paid in preparation to set sail, the ships waiting in the Bacino. Zane's pose as captain general with his baston of command followed a tradition going back to Titian's portrait of Francesco Maria I della Rovere as Venetian Captain General of the Terraferma, of 1536–38, a model also adapted by Veronese and Tintoretto. The portraits by Tintoretto of Sebastiano Venier, Zane's successor as captain general, are especially similar (fig. 4.21). But whereas Zane's image shows him before departing Venice, Venier's commemorates his success in battle.[112] Unfortunately, like Antonio Grimani, Zane would not be honored for his final expedition as captain general.

Zane actually was elected Captain General of the Sea three times: in 1566, in 1568 shortly after his election as procurator, and in 1570. Although it is possible that this document could have been painted after 1570, it probably was illuminated

for successful captains to be automatically elected as procurator, and the miniatures in Zane's Commission balance the two dignities equally.[108] The costume and poses of Zane in these two roles as procurator and military leader conform to conventions of representing patricians in larger oil paintings, but the miniatures are much more descriptive. Indeed, they convey the sense that we are witnesses to specific historical moments in the life of Zane, expanding the notion of the documentary image and paralleling the journalistic accounts of the ceremonies in printed pamphlets.[109] They also are similar in intent to the large narrative paintings of the Great Council that show important episodes in Venetian history peopled with patrician protagonists.[110]

to honor his almost simultaneous election as procurator and as captain general before his third and disastrous service, for the scribe Giovanni Vitali signed the text as completed in 1568, and records of payment show that these documents typically were finished within a year or so of assumption of office.[113] Two years later, in March of 1570, Zane was chosen again to command the Venetian fleet in the war with the Ottomans, who had just officially claimed Cyprus. In his first two appointments as captain general, it had been unnecessary to engage in battle, granting Zane a reputation, enhanced by his wealth, of having supremely good fortune, which in the popular imagination promised success in this new venture. But like Antonio Grimani, who as procurator also was sent into battle as Captain General of the Sea in 1498, Zane's mission ended disastrously.[114] After the fall of Nicosia that September, discussions among the three Christian fleets at Crete delayed action as the Ottomans advanced, fueling reports of Zane's poor command. That December, he was arrested on various charges of ineptitude and corruption, returned to Venice from Corfu, and was imprisoned. Like Grimani, he was dismissed from office and put on trial. Whereas Antonio Grimani was able to return to Venice after exile, ultimately winning the dogeship, Zane's trial came when he was already advanced in age. In 1572, at the age of seventy-seven, still incarcerated in the Ducal Palace and awaiting a verdict, Zane died. Sebastiano Venier was elected as captain general in his place, and through his heroism and success in battle was elected doge in 1577.[115]

The two aspects of Zane as a Venetian official presented in the document were portrayed also in a larger painting executed in oil. The portrait of him for the offices of the procurator *de citra* by Parrasio Micheli shows him dressed in gold brocade robes, but in this case with the distinctive gold "large bells" or *campanoni d'oro* buttons on the shoulder, which were worn by the doges and captains on the capes over their armor (fig. 4.22).[116] Zane's costume in Parrasio's image is,

therefore, a composite of that of a procurator and a captain, and other procurators were also portrayed in this way.[117] The painting may have been made shortly after Zane's entry into office to celebrate both recent elections, for a payment is recorded to Parrasio for five portraits of procurators that year.[118] The oil painting focuses on Zane's likeness and fierce character, rather than representing the events associated with his elections.[119] The miniaturist represented two distinct events of Zane's career, so leaving a more comprehensive visual record of the achievements of this patrician for his descendants than was displayed in the halls of the *Procuratia*.

4.22 Parrasio Micheli, *Portrait of Girolamo K. di Bernardo Zane*, from the offices of the *Procuratia*. Oil on canvas, 116 x 87 cm. Gallerie dell'Accademia, Venice, Inv. 1028

4.23 (Above left) Marco del Moro? (attrib.), *The Garden of Love*, c.1570. Etching, 35 x 24.7 cm. Fitzwilliam Museum, Cambridge, 31. K12-61

4.24 (Above right) T.° Ve Master (attrib.), *Leaf from the Commission to Girolamo K. di Bernardo Zane as Captain of Padua, elected 1544*. 22.9 x 15.4 cm. Chester Beatty Library, Dublin, W219

The hand of the painter of Zane's Commission as procurator is not found in many documents, but the figures, facial types, and composition can be compared to those in an etching of *The Garden of Love* (fig. 4.23). For example, the two women to the far right of the miniature have similar facial and body types, as well as positions, to the two women playing instruments with their backs turned to us in the etching. See, too, the overall disposition of gestures and movement in both the manuscript and etching to create implicit parallelograms working back into the picture plane at a steep angle. One copy of the print is inscribed with initials that have been interpreted as a monogram of the artist Marco del'Angolo, called del Moro.[120] This artist now is more famous as a painter and stuccoist, but he was documented two decades later as painting a Commission for Marin Grimani, now lost, which will be discussed later. The artistic personality of Marco del Moro remains to be defined, and as Alessandro Ballarin has pointed out, it is hard to reconcile the signed prints and drawings by him with surviving paintings. By comparison with paintings more clearly signed by Marco, the figure types and style of this print are quite distinctive. Nevertheless, they are similar to those in a drawing signed by the artist, as will also be discussed later.[121]

Also preserved in the family archives would have been the document for Zane's

much earlier service as Captain of Padua, to which he was elected in 1544 (fig. 4.24).[122] The miniature offered a different view of his service to Venice, emphasizing his piety. In fact, the imagery documents his devotion to the penitent Jerome and the Franciscans decades before he commissioned his altar featuring Jerome in the Frari Church. A central female personification embodies both Fame with her trumpet and Justice with her scales. Zane's name saint Jerome is shown as penitent with a book in the right border, and Saint Francis is featured in the left.[123] In his testament of 1569, Zane described the altar that he had commissioned from Alessandro Vittoria featuring the penitent Jerome (fig. 4.25).[124] The Commission provided a space for Zane to formulate his sense of service to the state and his piety, and the miniature documents the devotional focus that would find fruition in the altar some twenty-five years later.[125]

4.25 (Above) Alessandro Vittoria, *The Penitent Saint Jerome, c.1572.* Altar of Girolamo K. di Bernardo Zane, Santa Maria Gloriosa dei Frari, Venice

4.26 (Right) Upper cover of the painted and varnished leather binding, Commission/Oath of Girolamo di Cristoforo da Mula as procurator *de supra,* elected 1572. 28.2 x 20 cm. Newberry Library, Chicago, MS Wing ZW 1.575

Despite the interest of Zane in leaving a multi-faceted image of his service to the Republic in the miniatures of his documents, some procurators were content to have documents made that relied solely on magnificent script and bindings to honor their election. Two procurators *de supra* elected by payment in the early 1570s received such Commissions scripted by Giovanni Vitali, with painted and varnished leather bindings of Middle Eastern inspiration. These were for Francesco di Giovanni Francesco Priuli, elected in 1571, and Girolamo di Cristoforo da Mula, elected in 1572 (fig. 4.26).[126] Eclectic adoption of Islamicizing design was not shunned at this time despite the brief victory over the Ottomans. Such decorative motifs may or may not have been perceived as carrying a particular significance beyond an appreciation of fine design, and need further contextual study.[127]

Payments recorded by Marin di Girolamo Grimani (1532–1605) show that in the face of the new strictures on the funding of procurator Commissions after 1580, some patricians simply took the allowed disbursement of 15 gold ducats in cash and supplemented the amount with personal funds to have luxury Commissions made. The patronage strategies of the Santa Maria Formosa branch of the Grimani family were discussed in relation to Doge Antonio Grimani. Marin was of a different but equally prominent *ramo* of the Grimani family, that of San Luca (fig. 4.27). His father commissioned Michele Sanmicheli to design and construct the great *casa di statio* on the Grand Canal, and Marin focused on the interior decoration of the palace after his father died in 1570 (fig. 4.28).[128] Marin was elected as procurator *de citra* on April 1, 1588, and doge in 1595. It is not known if Marin's Commission as procurator or his *Promissione* as doge survive, but

4.27 (Above) Alessandro Vittoria, *Portrait of Marin Grimani (di San Luca) as Procurator*, c.1593. Terracotta, 84 x 65.6 cm. Ca' d'Oro, Venice

4.28 (Right) Michele Sanmicheli and Gian Giacomo de' Grigi, Palazzo Grimani of San Luca, Venice, begun 1556

several of his earlier Commissions do: as *Podestà* of Brescia (1571), as ducal councillor, and as Captain of Padua (1587). These are in the Correr and have sumptuous bindings, but none were ever illuminated (fig. 4.29).[129] But in December of 1589, over a year and a half after election as procurator, he recorded the expenses, including the painting, for this Commission. Perhaps the greater dignity of the office of procurator, combined with the fact that instead of receiving a manuscript commissioned by a secretary, funds were available to him to have one made, compelled him to hire an artist also to illuminate it.

Grimani chose Marco del Moro, an artist by then publicly praised as a miniaturist, but who worked also in a variety of media, to paint the now-lost manuscript. We can recall here that the limit for state-funding of these documents had been set at no more than 15 ducats in 1580. We already have encountered the question of attribution of works to this artist in relation to Zane's document as procurator. For Grimani's document, del Moro was paid over 12 ducats, by now the same as the scribe Lorenzo of San Moisè. The total cost of the manuscript was 205 lire, 16 soldi, or a little over 33 ducats, of which Marin was paid 93 lire from the *Procuratia*, which translated into ducats amounts to exactly the 15 allowed by the legislation. He paid the rest out of his own pocket.[130]

Knowing that Marco del Moro illuminated Grimani's document tells us that at least one of the miniaturists of these documents also participated in the design and execution of the decorative programs in the more public spaces of official buildings and monuments of the Republic. As discussed earlier, however, linking the hand of Marco to actual miniatures is difficult because his signed and documented works exhibit such a wide range of quality and styles, and many of them are damaged and overpainted. For example, the figures and their poses in Zane's Commission as procurator are similar to those in the etching signed "M.A" and attributed to Marco del Moro (fig. 4.23), but dissimilarities between the figures in

4.29 Upper cover of the painted and varnished leather binding, Commission to Marin di Girolamo Grimani as Captain of Padua, 1587. 23 x 17 cm. Biblioteca del Museo Civico Correr, Venice, Cl. III, 740

the etching and those in more fully signed paintings by him lead one to consider that the monogram could be that of a different artist, or even of the publisher (fig. 4.30).[131] The evidence that Marco del Moro and members of his family were active as miniaturists in Venice will be explored in more depth here, but further study of Marco del Moro's entire oeuvre is necessary before attribution of specific illuminations to him can be confirmed.

Marco del Moro was the eldest son of Battista d'Angolo (1515–1573), called Battista del Moro. The del Moro was an important family of artists from Verona, who were involved in numerous state and private projects in Venice. Marco may

have learned to illuminate from his father, whose talent as a miniaturist was lauded by Vasari in the second edition of the *Lives* in 1568.[132] Four years later, in 1572, the physician and author Leonardo Fioravanti praised Marco rather than his father as the best miniaturist in Venice, and claimed the artist delighted in mathematics and perspective.[133] Most of Marco's paintings are now lost or heavily overpainted, but there are a few signed drawings and etchings by him. Some of his documented stucco work in the Ducal Palace also survives.

Marco's work for official spaces of the Republic began shortly after his arrival in Venice. He created two paintings, now lost, for the courtyard of the *Procuratia de supra* in 1564–65, and monochrome allegories and stuccoes for the *Anticollegio* in the Doge's Palace in 1577.[134] His much younger brother Giulio (1555–1616) was involved in

numerous projects for Marin Grimani in his family palace at San Luca. Grimani may have chosen Marco as painter of his document in part because Giulio already was working extensively for him, in part because Marco was renowned as a miniature painter. Unless Marin's Commission/ Oath document is found, certain attribution of miniatures to Marco may not be possible.

But comparison of Marco del Moro's signed work with the miniatures of the Commission/Oath of Alvise Tiepolo, elected procurator *de citra* in 1571, also suggests he, or even perhaps his father, could have been the miniaturist of this document (fig. 4.31). If Marco was the miniaturist of Tiepolo's document, the subsequent choice of the same miniaturist by Grimani could reflect tradition and family ties. Tiepolo was elected to the same branch of procurators *de citra* as Marin Grimani, and the procurators of a particular branch often rehired miniaturists. Marriages created especially close family relations between Alvise and Girolamo before Girolamo's election as procurator. They became co-fathers-in-law when Alvise Tiepolo's only son Francesco married Marin's daughter Donada in 1579. In addition, one of Marin Grimani's cousins, Girolamo di Ermolao, married Alvise Tiepolo's daughter Lucrezia in 1591.[135]

The miniatures in Tiepolo's document were created with fine lead underdrawings colored in wash, except for the procurator's mantle, which is painted opaquely. The figures and the wash technique can be compared with the drawing signed by Marco del Moro of *Christ and the Samaritan Woman at the Well* (fig. 4.30).[136] Besides similarities in the stances of the figures, such details as the toes of the figures in the drawing and those of Justice in the miniature are very close. One may never be able to identify definitively the artists of the Commissions of either Girolamo Zane

4.30 Marco del Moro (signed), *Christ and the Samaritan Woman at the Well*, undated. Ink wash, gouache, and chalk on paper, 42 x 29 cm. Département des arts graphiques, Musée du Louvre, Paris, Fonds des dessins et miniatures, Inv. 2799, recto

or Alvise Tiepolo, but examination of Tiepolo's document reveals this artist had profound knowledge of Veronese's work in the Doge's Palace, which again encourages consideration of Marco del Moro as miniaturist, for he worked in close proximity to Veronese.

In the left-hand leaf of Alvise Tiepolo's Commission as procurator, he is presented by Charity and Faith to his patron saint Alvise, or Louis of Toulouse. The prominent placement of Charity must reflect the fact that one of the chief responsibilities of Alvise as procurator would have been the care of orphans and the poor. In the right-hand leaf, Justice puts down her sword and scales to embrace Peace, referencing Psalm 85. The image is a variation on the theme of Justice and Peace kissing, versions of which were visible on the walls

4.31 Marco del Moro?, Commission/Oath of Alvise di Lorenzo Tiepolo (Dalla Misericordia) as procurator *de citra*, 1571. Each fol. 28.3 x 19.7 cm. Archivio di Stato, Venice, Archivio Tiepolo, consegna II, b. 5, fasc. 10, fols. 11v–12r

of public offices in Venice.[137] Alvise seeks favor, and is embedded, in an allegory of piety and civic virtue that represents his place within the Venetian ideal, in a mode, as we will see, directly in keeping with Veronese's paintings in the Doge's Palace.

Members of the del Moro family worked alongside and sometimes in competition with Veronese on a number of projects throughout their careers. In fact, while Veronese was creating paintings for the ceiling of the *Collegio* in the Doge's Palace, Marco was creating in stucco and paint the setting for Paolo's central painting

of *Venetia* (1576–77) in the adjoining *Anticollegio* (fig. 4.32).[138] In this relatively small room, guests, including ambassadors, waited to gain audience with the doge in the *Collegio*. The collaboration, or at least awareness, by Veronese and Marco del Moro of each other's work in the creation of this ceiling, can be inferred by their working proximity. In turn, to highlight just a few concordances between the miniatures of Tiepolo's Commission and Marco's stuccos for the ceiling of the *Anticollegio*, Marco employed egg-and-dart motifs in gold and white strapwork to frame images similar to those in the manuscript. The figures inhabiting the spaces between frames have similar proportions for stock postures, including the arm-over-head gestures, as do the putti in the lower corners of the fictive frames of the Commission miniatures. The signed but undated altarpiece of the *Circumcision of Christ* by Marco has a quite different color palette from the

4.32 (Above left) Vault of the *Anticollegio*, Doge's Palace, Venice (detail), 1576–78. The painted and gilded stucco work is by Marco del Moro

4.33 (Above right) Marco del Moro (signed), *Circumcision of Christ*, undated. Oil on canvas, 276 x 153 cm. Originally Santa Maria dell'Umiltà, now Gallerie dell'Accademia, Venice, Inv. 1041

manuscript, but the female facial types are very similar, with elongated oval faces, high foreheads, and long "ski-jump" noses (fig. 4.33).[139]

Let's now look at the close relationship of the imagery of Grimani's Commission to Veronese's paintings in the Ducal Palace. Payment records show that Commissions for procurators typically were painted within the first year of a patrician's accession to office. The paintings of the ceiling of the *Collegio* in the Doge's Palace were all painted by Veronese and were begun sometime around late 1575, or several years after Tiepolo's election.[140] But sections of the miniatures in Tiepolo's

manuscript parallel details in Veronese's paintings in the *Collegio*. For example, Justice and Peace in the right-hand leaf of the manuscript seem to be moving around the same axis as the figures of Justice and Peace approaching the enthroned *Venetia* in Veronese's ceiling painting (fig. 4.34).

Veronese's *Allegory of the Victory at Lepanto*, situated below this scene of *Venetia* on the ceiling, was begun after the election of Sebastiano Venier as doge in 1577 and features a portrait of him (fig. 3.25). Because Francesco Sansovino's description of the work, printed in 1581, corresponds to the earlier *modello*, discussed later, and not this painting, it is thought it may have been finished in c.1582–84. In this painting and in Tiepolo's Commission, the patricians Venier and Tiepolo kneel and hold out their hands in prayer, in both cases mediated by a personification of Faith, who holds a chalice, but her position differs. Saint Justine at the center, rather than Faith, mediates directly in Veronese's allegory. The similarity of the positions of the central characters Venier and Tiepolo is even more marked in Veronese's preparatory drawing for the painting, which emphasizes the coronation of Venier as doge as the result of his heroic military service at Lepanto (fig. 4.35).[141] Perhaps Tiepolo's Commission, contrary to usual

practice as documented in the records of payment in the *de supra* ledgers, was painted several years after he was elected, and the procurator may have requested imagery referencing or deriving from Veronese's paintings in the *Collegio*. It is possible also that the miniaturist found visual solutions through his interactions with Veronese prior to completion of Venier's portrait. In any case, the portrait of Tiepolo in his document linked him closely to imagery celebrating patricians in the Doge's Palace. The miniatures more specifically transform the document into a monument to Tiepolo in the family archives.

In sum, Marin Grimani's accounts record that he paid Marco del Moro to paint his Commission. The cost indicates that it would have been of a luxury format similar to Tiepolo's. But Grimani would have requested or devised a program for his manuscript that expressed his own sense of patrician service and identity. The paintings

4.34 (Below left) Paolo Veronese, *Preservers of Liberty*, begun c.23 January 1576–April 1578. Oil on canvas, 250 × 180 cm. Sala del Collegio, Doge's Palace, Venice

4.35 (Below right) Paolo Veronese, Preparatory drawing for the votive painting of Sebastiano Venier, after 1577. Grey and white oil on paper with red preparation, 29.9 × 47 cm. British Museum, London, 1861,0810.4

would have extended or complemented the image of him created by the projects he commissioned for his palace, and his chapel in the Church of San Giuseppe, which anticipated his magnificence as doge.[142] Because the procurators had ample funds available to have their documents painted, and could supplement them, and because they could oversee their production, these documents became ever more elaborate in the late sixteenth century, by contrast to the cessation of portraiture in *Promissioni*.[143] But the last Commission for a procurator to be discussed returned to the votive imagery found more usually in fifteenth-century *Promissioni* of the doges, or Commissions of the rectors, to create a humble and pious memory of the procurator.

Francesco di Bertuccio di Francesco Contarini (1556–1624), of the branch "dalla Porta di Ferro," was elected procurator *de citra* in 1615 and in his document he is shown in adoration of the Virgin and Child, to whom he is presented by his name saint, Francis of Assisi (fig. 4.36). Francesco wears the gold *stola* of knighthood. He was elected doge in 1623, but no illuminated *Promissione* for him is known.[144] Francesco's emphasis on his piety in his document as procurator may have been instilled in him by his father Bertuccio, for whom two documents survive that intertwine piety and devotion to the state. The surviving Commissions for his father Bertuccio di Francesco (1523–1576) as *Podestà* of Cittadella, 1548, and as *Podestà* of Sacile, 1556, both visualize the theme of fame achieved for the sake of God and the *patria* (fig. 4.37).[145] The first has the patriotic inscription "I owe all to God and Country," the second "To only God, honor and glory" (1 Timothy 1:17).[146] Francesco became doge in 1623, and died the following year. The location of his *Promissione*, if a manuscript version was made for him, is not known.[147] As with the *Promissioni* of the doge in the sixteenth century, the commissioning of portraits for these documents of the procurators eventually diminished greatly, and seems to have ceased by the mid-seventeenth century.

Nevertheless, Commissions for procurators continued to be created as deluxe manuscripts and to figure as props in portraiture. While it seems that these manuscripts ceased to be repositories for likenesses, they continued to memorialize service through impressive illumination, scripts, and bindings. For example, the opening text of the manuscript of Antonio K. di Giovanni K. Pr. Grimani (ai Servi, b. 1622), elected procurator *de ultra* in 1673, is written out in gold ink and lists his lineage over three generations.[148] Alessandro Longhi's portrait of Ludovico di Ludovico Manin (1725–1802) as procurator (he would become the last doge) shows the patrician displaying his Commission with a silver binding.[149] Giambattista Tiepolo's portrait of Daniele IV Dolfin (1656–1729) prominently features his manuscripts and regalia as both procurator and *provveditore generale da mar*.[150] But the arts of the books were even more exuberantly employed in the printed *gratulatorie* of the procurators of the eighteenth century.[151] Patronage of the arts of the book to memorialize procurators was transferred in this way more completely from script to print, in a medium that could be distributed as multiples.

To summarize, in the fifteenth century it became standard for procurators to receive a fine copy of their Commission, the early paintings of which emphasized their prestigious service to Mark and their sacred oath. Whereas the design of these documents could be quite uniform, some patricians, such as Francesco Barbaro, requested or commissioned imagery that distinguished them and documented their ideals of service in more detail. They eventually could use state funds to hire artists of the book directly to produce their documents. Spending on the manuscripts climbed rapidly in the sixteenth century, until a limit was imposed. Some patricians, such as Marin Grimani, responded to the expense limits by augmenting the allowed cost with their own cash. In hiring artists including Marco del Moro, who also painted in the Doge's Palace, procurators

4.36 (Above left) Commission/Oath of Francesco di Bertuccio di Francesco Contarini as procurator *de citra*, 1615. 29 x 21 cm. Isabella Stewart Gardner Museum, Boston. 2.c.1.2., fol. 1v

4.37 (Above right) T.° Ve Master (attrib.), Commission to Bertuccio di Francesco Contarini as *Podestà* of Cittadella, 1548. 23.4 x 16.4 cm. The National Archives, Kew, Public Records Office 30/25: 104/7, fol. 1r

could have their service memorialized in imagery directly complementing the figuration of patricians and ideals of service in state buildings.

The positions of doge and procurator were attainable typically only by the highest-achieving, wealthiest, and well-connected patricians. Many of those who did not attain the post of doge or procurator, but who were elected as an administrator of Venetian territories, eventually also wanted to leave memorials to themselves in their documents called *Commissioni ducali*. These evolved as spaces for patrician self-presentation as the dominion of Venice itself expanded in the fifteenth century. Images in them adapt themes found in the Commissions of the procurators, but also portray notions of empire and rulership. No documentation on payment for the painting and binding of these manuscripts has been discovered, and governmental scrutiny of their decoration seems to have been minimal. These documents were not always made to the same high standards of script, binding and illumination as those made for the doge or procurators, but their imagery was more expansive and offers insight into how a broader population of patricians conceptualized their identities in relation to service to the state and to the vicissitudes of the empire.

CHAPTER 5

THE CHARGE TO THE RULERS OF EMPIRE

T HE SPACES FOR images within *Promissioni* and Commission/Oath documents were small, yet could become significant as documentary components in self-presentation and memorialization by individual patricians. Nevertheless, such manuscripts were granted only to the minuscule top percentage of nobles elected as doge or as a procurator of Mark. With Venetian territorial expansion in the fifteenth century numerous new administrative positions for nobles as rectors (*rettori*), or rulers in lands under Venetian dominion, were created. Before departing for such posts abroad on the mainland or in overseas territories, these rectors, and also captains of Venetian commercial galley convoys, received manuscripts containing their charge and guidelines. These documents are called *Commissioni ducali* because although rectors typically were elected in the Great Council, the commission of office is phrased as from the reigning doge.[1] Following the precedent of the illumination of documents for procurators and doges, in the second half of the fifteenth century some patricians came to have the opening leaves of their manuscripts as rectors painted with simple decorations featuring their coats of arms. By the mid-1500s some documents were painted with full-page portraits, and at the end of that century a few recipients had their documents embellished with a sequence of up to five illuminated pages, completing a general evolution from decoration towards detailed memorialization.

Detail of fig. 5.40

This chapter examines the development of painting in Commissions and how patricians came to be represented, both in terms of their external appearance and internal governing virtues and ideals, in their documents. While it is clear that the Commissions to the rectors generally were written out in the ducal chancery, for they contain the relevant signatures confirming official scrutiny, it still is not known who coordinated and paid for the subsequent binding and illumination of these manuscripts. But to some extent the chancery collaborated with and even encouraged recipients to transform these documents into monuments, for the scribes left increasingly large areas open for the benefit of miniaturists, and the painters sometimes added folia to augment the spaces for illustration. The extent and wide range of illumination, and the consistency of themes for individual patricians, suggest that it was mainly those who received the documents who oversaw their embellishment.[2] This allowed for relative freedom in the scope and nature of painting in these documents, especially by comparison to the *Promissioni* of the doge. Particularly in the late sixteenth century, some patricians ordered unique and highly original images of themselves and their ideals of service. Because assumption of office through election was inherently political, many of the miniatures can be read as negotiating one's reputation, sometimes in the face of controversy. Service abroad could be extremely challenging and even dangerous, and the invocations of blessings in the miniatures probably often were

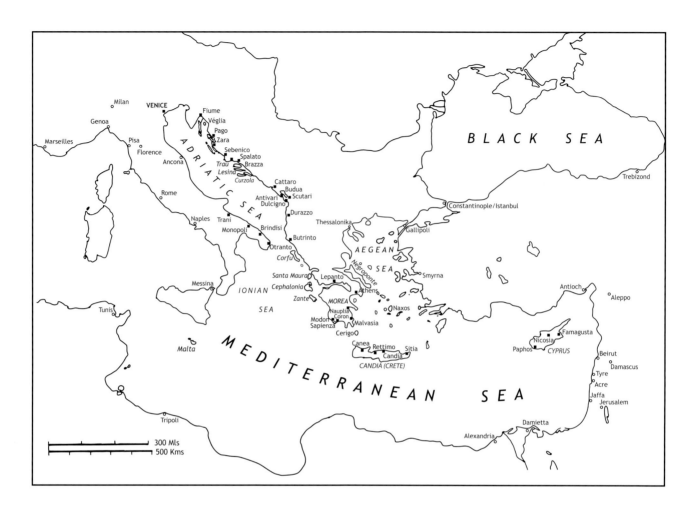

5.1 The Venetian *stato da mar*. ° indicates non-Venetian towns

DOMINIUM AND THE IDEAL RECTOR

The rich material and artistic culture of the city of Venice was nourished by wealth and goods from international trade, and from tax revenues and products of territories held on the mainland and across the Mediterranean Sea.[3] Venice reigned over ports and lands to protect and further her mercantile and agricultural interests

not merely routine. Each painter contributed his skills, interests, and habits of working to coordinate with the wishes of his patrons. Therefore, the roles of both painters and patrons in the development of the documents as spaces for figuration of patricians will be explored.

by the eleventh century, but can be recognized as an empire after the rapid accumulation of territories from 1380 to 1420, which coincided with a definitive shift from the use of the term *commune* to *Dominium* in describing the state (figs. 5.1, 5.2, Appendix 4).[4] Venice had focused initially on acquisitions overseas, constituting the *stato da mar*. But with the outset of the First Ottoman-Venetian War in 1463, Venice shifted primarily into a defensive military position in regards to maritime possessions. As discussed in the cases of Doge Antonio Grimani and the procurator Girolamo Zane, a critical arena in which reputations could be made or broken was in naval command in the recurrent wars against the Ottomans. During the fifteenth and sixteenth centuries, the time period focused upon in this study, Venetians began to shift attention

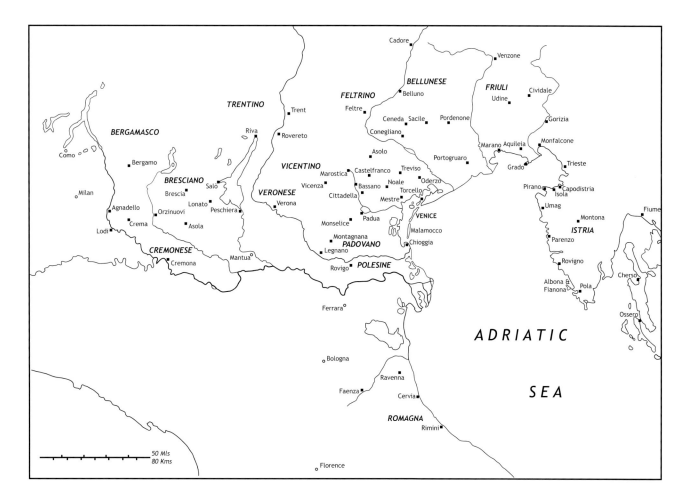

5.2 The Venetian *terraferma*. ° indicates non-Venetian towns

to augmenting the *stato da terra*, or the mainland state, and reached the greatest expanse of their territories.[5]

By the end of the sixteenth century, the Venetian *stato* had suffered definitive losses, especially in the Mediterranean. Pivotal campaigns and battles, such as the temporary but harsh setback of the Battle of Agnadello on the mainland in 1509, and the celebrated but short-lived victory over the Ottomans at the Battle of Lepanto of 1571, emerged as symbolic points of reference for notions of state, and of patrician service. While Venetian territories abroad actually diminished, ever greater dominion and power were claimed in the rhetoric of the arts, and in the illumination of Commissions. The paintings

in the documents allow for insight into individual responses to the vicissitudes of the empire.

Because Venice was not a monarchy, unlike most other early modern empires, the challenges to governing Venetian territories were unique. The most general term for the patrician officials sent by Venice to oversee her cities and provinces was *rettore* (rector), but the specific terms and categories of rule varied by city and territory, depending upon the treaties that had been established with subject cities and provinces, and the statutes of these areas.[6] The title of *conte* (count) commonly was used for Venetians governing in cities along the east coast of the Adriatic; in Istria and Dalmatia, and in the Peloponnese. *Provveditore* (provedior) was a title also granted to rectors of certain areas in Istria and of Ionian islands such as Zante (Zakynthos).

The most common titles of Venetian rulers on the Italian peninsula were *podestà* and captain.[7] The *podestà* generally oversaw political and judicial affairs, and maintained public order and general peace, while the captain prevailed over economic and military administration. The work of the *podestà* and captain were assigned to two different men in the most complex or important cities and regions, such as Padua and Verona, or a patrician could be elected as both for less problematic posts, such as Treviso. Those serving in the important positions as *provveditori generali* oversaw broader regions, and these patricians also received Commissions, as did captains of convoys of commercial galleys.[8]

Unlike the process of appointment to govern in an empire under a prince or monarch, the rectors generally were elected in the Great Council, and the varying degrees of their success in administration depended greatly upon the relative experience, networking skills, and talent of the elected official, whose official term did not exceed three years.[9] The Commission texts for these officials attempt to clarify the role of the ruler as impersonal representative of the state, whose financial interests and personal relations were not to intermingle with his office as overlord. Sansovino claimed that the rector's position of governing abroad was comparable to the doge's in Venice, which suggests an outwardly princely mien, but power that actually was reined in.[10] A number of the prohibitions outlined in the documents were developed already by the thirteenth century to prevent rectors from becoming partial to their subjects, or to overly profit personally from the assignment. For example, they were not to act as merchants, receive donations, or assume other offices during their rule. In the fifteenth century new regulations were added that, for example, prohibited sojourns away from their district overnight, and entertainment of locals in their home.[11]

Venice naturally and invariably portrayed lordship over its territories as benevolent and beneficial to subjects, and some territories did prosper through the range of local arrangements. But overall, Venetians were, of course, most interested in assuring their own economic, political, and military profit. Their rule could be detrimental to local economies and populations, to the ultimate disadvantage of even Venice proper.[12] Some patricians conducted themselves in a princely and corrupt manner, provoking violent reactions among the inhabitants.[13] Despite the regulations in Commissions, individual patricians, as merchants and landowners as well as lords, commingled loyalty to the collective needs of the state and its subjects with their own, to enrich personal wealth through trade and agriculture, or even embezzlement.[14] Some patricians not only had extensive property in the territories they governed, but also continued family bonds through ancestral origins or marriage. In addition, Venetian patricians supervised the ecclesiastical administration of its territories, for Venice claimed relative independence from Rome through apostolic foundation by Mark.[15]

The response, in turn, of territorial subjects to Venetian domination varied enormously – from the generally harmonious relations epitomized by the city of Treviso, which was conquered in 1339, to the long-held and strong antipathy of many Paduan nobles, due to the relative strength and autonomy of the patrician class at the time Venice took over in 1405, and to differences in the ways economic relations unfolded.[16] Such strains were visible especially in times of crisis, as during the wars against Venice of the League of Cambrai, when many cities under Venetian rule were seen to capitulate all too readily to the armies of the League. In a variety of media, patrician rectors employed portraiture and symbolic representation of ideals of their rule to formulate what Giovanni Tatio, an author born in the subject town of Capodistria, would codify in writing in the late sixteenth century as a proposed *immagine*, or image, of the rectors. The Commission statutes encouraged ideal behavior. Tatio's image was a

model to emulate, but perhaps also was intended to distract attention from sometimes painful deviations from the ideal.[17] An ideal image, of course, is presented to us in *ducali*.

The inventive and personalized fusion of Christian and classical republican virtues that a patrician could use to frame his image as a rector is encapsulated in the opening miniature to the Commission to Agostino di Benedetto Bembo (1518–1585) as *comes* (count), the title of the Venetian rector of Trau (now Trogir, in Dalmatia), of 1560 by the T.° Ve Master (fig. 5.3).[18] God the Father presides over Justice embracing Peace; the subject is identified for us by the inscription below. The text on the lower pedestals additionally claims that Justice and Peace are the benefits of a leader with virtue.[19] Justice is shown unusually not as a female personification, but as a Roman soldier, perhaps referencing Agostino Bembo as *comes*, for the term originated in the ancient Roman *comes rei militaris*, or military supervisor of a region of the empire. This figure of Justice is remarkably similar to that of a military general in the woodcut image of *Concordia* in a number of French editions of Andrea Alciato's emblems, published by Guillaume Rouillé beginning in 1548, suggesting the illuminator drew inspiration for his painting from the woodcut.[20] Pseudo-hieroglyphics of a hand and an eye perhaps reference a personal emblem of Agostino, and an eye appears superimposed on a hand also in that edition of Alciato's emblem book to signify the injunction to live soberly.[21] Although Agostino's facial features were not illustrated in his document, the miniature portrays him allegorically as a virtuous and dignified leader. The ethics of rule illustrated in the document would have been passed through such images and in personal advice to Agostino's five sons, one of whom, Giovanni (1543–1618), was elected doge in 1615.[22]

How individual patricians had themselves figured as rectors in their documents will be explored in more detail from various perspectives throughout this chapter and the next. In addition to the allegorical mode of portraying the qualities

5.3 T.° Ve Master (attrib.), Detached leaf, Commission to Agostino di Benedetto Bembo as *Comes* of Trau, elected 1560. 22.5 × 16 cm. Huntington Library, San Marino, EL 9 H 13, 33

of a particular rector, as exemplified in the Commission of Agostino Bembo, artists created likenesses of patricians that drew on antique sources, including coins and medals, and various traditions of monumental art, including tomb sculpture and votive paintings.

PRODUCTION OF COMMISSIONS

The earliest surviving Commission manuscript is of the mid-thirteenth century. It is a vertical scroll with no illumination, and a ducal seal was once attached.[23] Many Commissions survive as single pieces of parchment up to the fifteenth century, but some were produced in codex form already

by 1357.[24] In the later fifteenth century, the texts of Commissions still were short enough so they could be written on some 10 folia nested within a single folded membrane sheet, or wrapper. Because of the additional statutes added as time went on, by the end of the sixteenth century the Commission for a post could run to some 300 folia, or 600 pages.[25] Of all *ducali*, the appearance and physical structure of the Commissions of rectors especially came to emphasize authenticity and extensive official scrutiny, perhaps because the manuscripts had to represent the authority of Venice abroad, not just at home. Embellishment, signatures, and seals created sites where various identities could be inscribed. These include the state as divinely inspired author of the documents, personified by the doge through his commission of office and marked in his seal; members of the ducal chancery and notaries of the Public Revenue Office (*Governatori delle entrate*) as producers and controllers, by their signatures; and the patrician charged with the office, through personalized illumination and binding.

As the bureaucracy at home and territories of the Republic abroad increased, so too did the numbers of officers that oversaw them. By the late fifteenth century up to eleven positions were up for election in the hall every week. But only the highest officials of posts abroad generally received Commission manuscripts, for these rectors would need to consult them while away from home. The magistrates of offices *de intus*, or within the confines of the city, such as the various *advocatores*, generally did not receive such documents. They could refer to the general statutes or any other relevant texts of the office in situ, in manuscripts that also often came to be illuminated but were for general use (fig. 2.2). Patricians elected as support staff abroad, as in the role of *camerlengo* (treasurer), also did not receive Commissions, nor did *cittadini* staff.[26] I have calculated that, in the last decade of the fifteenth century, at the height of the empire, patricians were elected to just over 100 offices a year for

which they could have received a Commission document that potentially was illuminated. This number varied greatly according to the extent of Venetian territories. Overall, during the fifteenth and sixteenth centuries, an average of roughly fifty Commission manuscripts that potentially would have been painted were produced and presented to patricians each year.[27] Whether they were painted or not, and to what extent, seems to have depended upon the desires of the patrician, and perhaps the time he had between election and departure from Venice for his post.

The patricians of the *Collegio* authored the Commission texts, which were written out in ledgers (*registri*) in the *Cancelleria secreta* by the *segretario alle voci* and maintained there.[28] In each document, following the commission of office as phrased by the doge, were listed the basic regulations, followed by additional statutes recorded with the date of their institution. The central role of the *segretario alle voci* in elections was discussed in Chapter 2. He may have written out some Commissions distributed to patricians, but I believe that other notaries or secretaries also must have had a role in the actual copying of the Commission manuscripts because of the sheer amount of labor involved, and because the manuscripts show a number of scribal hands in any given year. The important point here is that by contrast to the Commission/Oath documents of the procurators, which were made by outside scribes paid by the piece, the Commissions for rectors seem to have been written out by personnel of the ducal chancery and they carry the official marks of chancery scrutiny.[29] The eschatocol, or formulaic ending of the document, typically was added after the statutes, and if complete, typically includes a record of the oath of the patrician, the date, and signatures and/or notarial signs or monograms of the Grand Chancellor and/or *segretario alle voci*.[30]

Once the Commission was completed in the chancery, a notary of the *Governatori delle entrate* added the salaries and revenues granted

to the holder of office at the end of the document, typically in a looser mercantile (*mercantesca*) script, and signed it.[31] The *Governatori delle entrate* bureau was instituted in 1433, and charged with controlling offices that levied taxes on the *reggimenti* of both land and sea.[32] The *Governatori* were patricians, but the *cittadino* notaries of this office recorded the salaries of the rector and other relevant officers. Because this notary would have had to consult his records to write in these details, it is possible that the Commission manuscripts were sent over to his offices in the Rialto. These rooms eventually were sited on the second floor of the Palazzo dei Camerlenghi, or State Treasurers' Building, completed by 1525.[33]

When the Commission manuscript arrived in the hands of the secretaries of the *entrate*, it probably still was a set of unbound gatherings in a membrane wrapper, otherwise it would have been difficult to write in. At this point the manuscript was either sent directly to the rector, or to a miniaturist, where it could be illuminated under the supervision of the recipient, with artists perhaps chosen at times on the recommendation of the *segretario alle voci*. The workshops of miniaturists were scattered all over the city, but those of some of the most productive miniaturists of *ducali*, such as Giovanni Maria Bodovino, were located conveniently along the main walkways from the Camerlenghi towards the Ducal Palace.[34]

The last step would have been the binding of the document by a *ligador da libri*.[35] Although their earlier organization is not known, these bookbinders formed a *colonello*, or branch, of the *Università dei stampadori e libreri* when it was formed in 1549.[36] There is such consistency in materials and designs for many *ducali* that a bindery dedicated to government documents was once hypothesized. It now generally is agreed that the manuscripts were sent out to independent binders, because the same tools and binding techniques were used for other kinds of books. Binders of Commissions, like miniaturists, were involved

in many aspects of the manuscript and printed book trade.[37] We can assume the manuscript was sent to the binder with the official lead seal of the doge already affixed to the membrane wrapper, as some *ducali* that were never bound have the seal.

It seems, then, that the collaborative nature of funding and production of Commissions was analogous to that for the decoration of the Camerlenghi interior and the offices of magistrates in the Doge's Palace. In these cases the support for paintings, that is the walls, were provided by the state but the paintings themselves were paid for by elected patricians. The *Governatori delle entrate* or *avogadori di comun* (fig. 0.18), for example, could celebrate their period of service by commissioning works from painters chosen by the state, and they pooled their own funds to pay for these monuments.[38] Such private funding for these paintings differed from the sole use of state funds for the portraits of doges in the Ducal Palace and of the procurators in their offices. These latter cases, in turn, accord with the primarily state financing of the painting of the documents for the doge and procurators.

The date of election (*remansit/electus*) as recorded in the *segretario alle voci* registers, compared with the date subsequently recorded in the eschatocol in the Commission manuscript, as well as the time for the rector to leave on the journey to the post (*expeditio*) and date of entry into office (*intravit*), also as recorded in the registers, are valuable for suggesting how much time an illuminator and binder had to finish decoration of the manuscript before it left the city in the hands of the rector. Although a statute of the fourteenth century directed patricians to take office within one month of election, the period between the date written in the eschatocol of the manuscript and travel to the post ranges considerably, from one day to a year.[39] This may be one reason why some documents were left unilluminated – there may not have been enough time before departure for the post. Theoretically an official could have his document illuminated

abroad or on his return to Venice.[40] Nevertheless, Commissions are almost always illuminated by miniaturists working in Venice, rather than in the town where patricians were sent to serve. The manuscript would need to have been illuminated before being bound, so that the leaves would lie completely flat for the painter. For ease of reading and reference, the gatherings then were at least sewn within a membrane wrapper before the patrician left for his post.

Of course, the evolution of Commissions as decorated documents depended upon the development of Venice's maritime and *terraferma* holdings as well as of the arts of the book in Venice. In its early history, Venice established a fragmented empire along the east Adriatic to the east Mediterranean, and documents for the most important rectors in the *stato da mar* are the earliest to survive. In the earliest period of decoration of Commissions, from the mid-fifteenth century to around 1470, the paintings generally follow the conventions of the embellishment of contemporary manuscripts of classical and vernacular literature.

EARLY PAINTINGS IN COMMISSIONS

The first surviving decorations in Commissions are in manuscripts for the highest positions of the most important overseas holdings, especially the island of Crete, which was called by the Venetians Candia, or in Latin, Creta. Candia was purchased by Venice in 1210 and remained under Venetian dominion until the Ottoman conquest in 1669.[41] One of the earliest illuminated Commissions is that of Leone di Pietro Duodo (b. 1415), elected Duke of Candia in 1459, several decades after the first-known illuminated *Promissioni* of the doge and Commissions of procurators. It has a foliate initial with gold, and the Duodo coat of arms (fig. 5.4).[42] The Commission to the subsequent duke, Lorenzo di Giovanni Moro, nephew of Doge Moro, is painted much more extensively, with *spiritelli*, or winged putti, holding up the

5.4 Commission to Leone di Pietro Duodo as Duke of Candia, 1459. 25.5 x 17.5 cm. British Library, London, Add. MS 41659, fol. 4r

arms of Moro, following an antiquarian fashion in humanist manuscripts (fig. 5.5). The miniatures are in the style of Leonardo Bellini, who painted the *Promissione* of the doge and the documents for some procurators, but the illumination is not as extensive as that for those higher officials.[43] The document has a limp membrane binding painted again with the arms of Moro on front and back (fig. 5.6).[44] These are among the earliest known Commissions that would have accentuated the image of authority of the rector while abroad, and stood out among the numerous documents within his family archive.

The early evolution of illumination in manuscripts for dukes of Venetian Crete in the

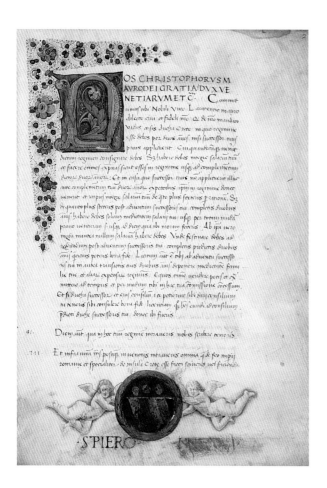

5.5 (Above left) Leonardo Bellini?, Commission to Lorenzo di Giovanni Moro as Duke of Candia, 1462. 25 x 17.6 cm. New York Public Library, Spencer MS 126, fol. 2r

5.6 (Above right) Lower cover (membrane wrapper), Commission to Lorenzo di Giovanni Moro as Duke of Candia, 1462. 25.5 x 18 cm. New York Public Library, Spencer MS 126

mid-fifteenth century probably was linked to the long-standing fiscal and cultural importance of the island to Venice and the prestige of the position, a distinction that would shift to Padua in the sixteenth century.[45] Both the Duodo and Moro families had trade networks in the *stato da mar*. In addition, certain patrician families held extensive territories there, and in contrast to many other posts there were financial profits to be gained as duke. The value of this Venetian stronghold also was felt more keenly with the fall of Constantinople to the Ottomans in 1453.[46]

EXPANSION ON THE MAINLAND: TERRITORY AND ABUNDANCE

With the outbreak of the First Ottoman-Venetian War in 1463, the stance of Venice in the Mediterranean would shift irrevocably to the defensive. Treviso, Venice's first holding on the *terraferma*, had been acquired first in 1339 and by 1400, under Doge Michele Steno, Venice began to focus on expanding holdings on the mainland, inciting debate within the patriciate and criticism in Italy. These territories held many levels of meaning for the patricians of a city built on salt marshes, with no visible ancient Roman remains. Through extension on the *terraferma*, Venetians could benefit financially from agriculture, trade, and industry, and could levy substantial tax revenues. Many individual patricians and their families held increasingly

large and valuable properties on the mainland. In addition, patricians were able to appropriate ancient history and its material relics more directly through possession of the *terraferma*. Such cultural currents as the revival of pastoral poetry, made more accessible in the early sixteenth century with the publication of Jacopo Sannazaro's *Arcadia*, written in the vernacular, and the development of idyllic landscape painting in Venice, reflect the intense interest in and engagement with the mainland.[47]

An account by Marin Sanudo of a tour through Venice's mainland territories in 1483 is highly suggestive of Venetian understanding of, and attitudes toward, the *terraferma* during the years when Commissions began to be increasingly decorated. Marin was just seventeen years old when he accompanied his cousin Marco, who was traveling with two other patricians as *auditori nuovi*. These officials were in charge of an aspect of the Venetian judicial system on the *terraferma* through which locals could register formal complaints and appeals.[48] With attention to detail that would expand to become a life's work in his famous diaries, Marin recounted the formal welcome of the *auditori* into each town, and named the relevant rectors in charge. He described and even made some drawings of the fortifications that marked

5.7 (Below left) Leonardo Bellini (attrib.), Commission to Giovanni di Cresio da Molin as *Podestà* of Montagnana, 1474. 25.3 x 17.3 cm. Biblioteca Nazionale Marciana, Venice, Lat. X, 272 (=3373), fol. 1r

5.8 (Below right) Pico Master (attrib.), Commission to Nicolò Muazzo as Captain of the Galleys to Aigues-Mortes, 1478. 25.7 x 18 cm. Biblioteca del Museo Civico Correr, Venice, Cl. III, 59, 1r

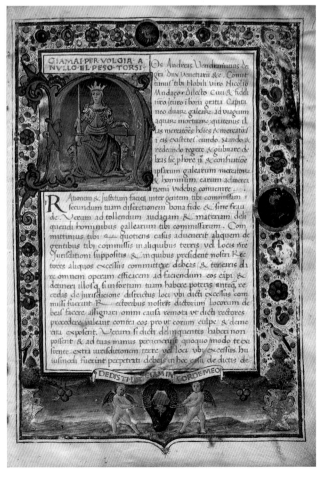

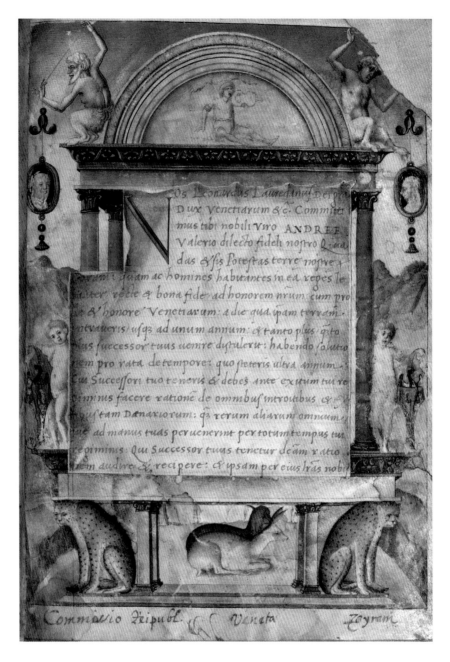

5.9 First Pisani Master (attrib.), Commission to Andrea di Giorgio Valier as *Podestà* of Piran, 1501. 23.9 × 16 cm. Special Collections, Lehigh University, Bethlehem, PA, 234252, fol. 1r

and maintained the territories as Venetian. Marin also reported on the structures and monuments, and coats of arms and inscriptions, left by Venetian rectors to memorialize their service.[49] In this way, he conveys a strong sense of possession of the mainland and pride in Venetian rule.[50] His quotes of relevant passages by ancient authors, for example of Virgil on Mantua and Livy on the foundation of Padua,

give glimpses of the classical veil through which many educated Venetians perceived the *terraferma*. Put simply, Sanudo's *Itinerary* conveys the extent to which Venetians saw the mainland territories as extensions of their city and its heritage in a period when the illumination of the Commissions of the rectors to these areas substantially increased. The paintings in these documents often depict the

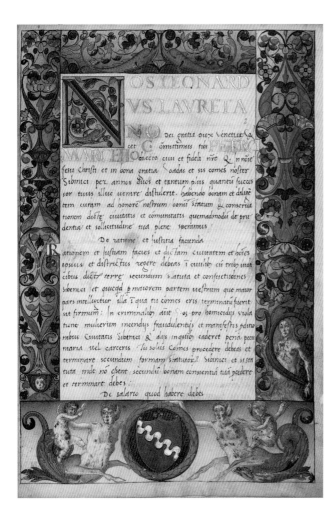

5.10 Antonio Maria da Villafora (attrib.), Commission to Pietro di Jacopo Marcello as Count of Sebenico, 1501. 24.2 x 16.4 cm. British Library, London, Add. MS 24897, fol. 2r

extensive landscapes absent from the islands of Venice proper.

We might read, then, a celebration of the fertility of Venetian territory in the illuminations for such Commissions as one to Giovanni di Cresio da Molin (d. 1484) as *Podestà* of Montagnana of 1474 (fig. 5.7). The miniatures by Leonardo Bellini depict putti playing instruments in a landscape with rabbits, and such allusions to abundance as a putto holding a cornucopia.[51] The imagery is more specific to the official nature of the document in the miniatures by the Pico Master in the Commission to Nicolò di Pietro

Muazzo, appointed as captain of a merchant galley convoy (fig. 5.8). The opening initial features Justice personified, equated with Venice personified as *Venetia*.[52] In the *bas de page*, two putti pull on a chain wrapped around a coat of arms embedded in a heart, with the personal motto "You have put more joy in my heart …" derived from Psalm 4:7.[53] Through the motto and imagery the identity of the official, indeed his heart, is united with that of the state and with his diligent service.

The Pico Master became the most important illuminator of Commissions in the 1480s, and eventually also designed woodcuts in printed books. His work, in such Commissions as that for Nicolò Muazzo, may have recommended him for more extensive painting in documents for the higher offices of the procurators and doge, as in the *Promissione* of Agostino Barbarigo, 1486 (fig. 3.17).[54] Whatever the precise arrangements were between chancery and illuminator, it is clear that the patrician recipients guided the subjects for illumination, but the propensities of the painters also were decisive in the final composition.

The painter of the Commission to Andrea di Giorgio Valier as *Podestà* of Piran (in Slovenia, on the Istrian coast) (fig. 5.9) dispensed with the lion of Mark that the Pico Master had by then made standard in the tympana of such fictive monuments (fig. 5.15). He replaced the civic symbol with a man playing a stringed instrument, evoking the imagery of bucolic poetry featured in manuscripts of Theocritus and Virgil in this period. In fact, this Master painted at least two copies of classical texts printed by Aldus Manutius, one of which is of the works of Virgil, for a member of the patrician Pisani family.[55]

In tandem with such evocations of idyllic landscapes, the borders of many Commissions allude to the importance of coastal territories for Venetian maritime power through miniatures of fantastic sea creatures, as in the Commission to Pietro di Jacopo Marcello (b. 1473) as

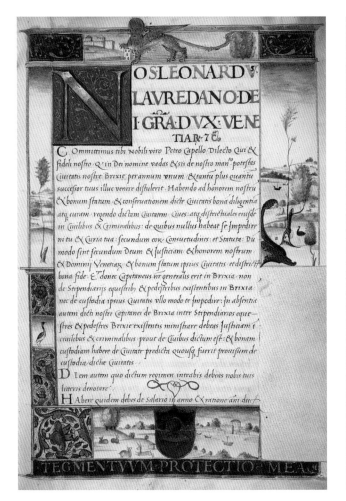

5.11 Alberto Maffei (attrib.), Commission to Pietro di Giovanni Pr. Cappello as *Podestà* of Brescia, 1501. 24.5 x 17.5 cm. Deutsche Staatsbibliothek, Berlin, MS. Hamilton 224, fol. 1r

5.12 Nicolò di Giovanni Fiorentino (attrib.), Portal monument to Vettor di Giorgio Cappello, c.1467. Sant'Elena, Venice

Count of Sebenico (Šibenik, Croatia) of 1501 (fig. 5.10). Such playful transformation of ancient imagery by miniaturists and sculptors was a distinctive feature of current art in the Veneto.[56] The painter of Marcello's document was Antonio Maria da Villafora, and his brother-in-law Benedetto Bordon already was a prolific painter of Commissions.[57] Alongside these artists worked craftsmen who employed much simpler schemes. One of these can be called the Gold Dots Master, because of his profuse use of gold dots and spray.[58] Another is the Venetian scribe and miniaturist Alberto Maffei, who illuminated

a Commission to Pietro di Giovanni Pr. Cappello (d. 1524) as *Podestà* of Brescia, 1501, in which is included the motto of Cappello: "protect me with your armor" (fig. 5.11).[59] Aside from the lion of Mark or image of *Venetia*, nothing differentiates these illuminations from those in manuscripts and printed editions of classical texts these patricians also may have collected. The format for illumination of Commissions would become more distinctive with the introduction of portraiture, which initially emerged from the models of portraits in tomb monuments on the exteriors and interiors of Venetian churches.

COMMISSIONS AND TOMB MONUMENTS IN THE LATE FIFTEENTH CENTURY

Free-standing public monuments to individual patricians were not allowed by Venetian law and custom. Nevertheless, there were monuments to individuals within churches, and by the thirteenth century even on their exteriors, beginning with the tomb monuments of doges on the façade of Santi Giovanni e Paolo.[60] In the second half of the fifteenth century, the fronts of some churches came to be transformed into monuments even to patricians who did not obtain the highest offices of doge or procurator. The right to affix one's coat of arms, inscriptions, and sepulchral monuments on a church or monastery was allowable under the legal concept of *Jus*

5.13 (Above left) Commission to Jacopo di Cristoforo Marcello as Captain of Padua, 1480. 24 × 17 cm. Deutsche Staatsbibliothek, Berlin, MS Hamilton 222, fol. 1r

5.14 (Above right) Giovanni Buora (attrib.), Tomb monument of Jacopo di Cristoforo Marcello, c.1485. 600 × 300 cm. Santa Maria Gloriosa dei Frari, Venice

patronatus. These rights could be obtained by granting land, providing funds to construct a building, or providing for the relics or liturgical furnishings of an existing building.[61]

The tradition in Venice of a monument on a façade with a portrait began with the monument to Vettor di Giorgio Cappello (1400–1467), on the Church of Sant'Elena (fig. 5.12). Cappello was a Captain General of the Sea who died after battling the Ottomans in 1467.[62] Cappello kneels

in reverence and supplication to Saint Helena in the lunette above the classicizing doorway. The portal was commissioned by his three sons Andrea, Alvise, and Paolo. As we have observed in relation to the efforts of the sons of Doge Antonio Grimani to memorialize him on the façades of Sant'Antonio and San Francesco della Vigna, this kind of filial commemoration became a unique and important form of patronage in Venice.[63] The Sant'Elena monument also participated in a new fashion in

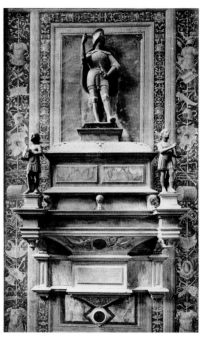

5.15 (Left) Pico Master (attrib.), Commission to Melchiorre di Paolo Trevisan as *Podestà* of Padua, 1488. 25.5 x 16 cm. Biblioteca del Museo Civico Correr, Venice, Cl. III, 85, fol.1r

5.16 (Above) Venetian School, Tomb of Melchiorre Trevisan, c.1500. 575 x 290 cm. Santa Maria Gloriosia dei Frari, Venice

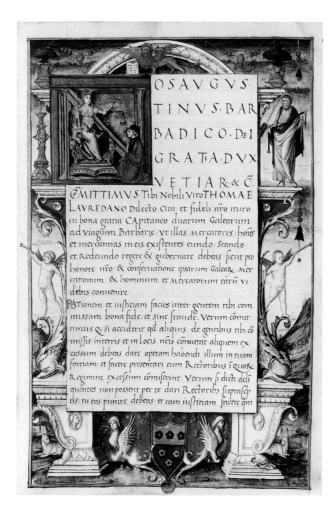

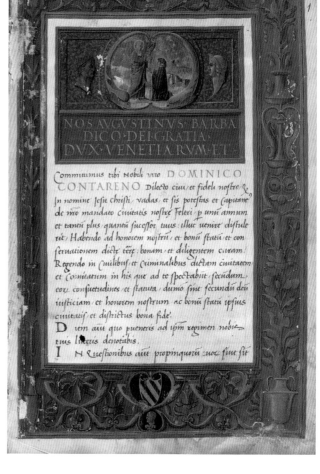

5.17 (Above left) Pico Master (attrib.), *Commission to Tommaso di Alvise Loredan as Captain of the Galleys to the Barbary Coast*, 1490. 24 × 7.5 cm. Bibliothèque national de France, Paris, Lat 4730, fol. 1r

5.18 (Above right) Benedetto Bordon?, *Commission to Domenico di Maffei Contarini, Podestà and Captain of Feltre*, 1492. 24 × 16.5 cm. Russian State Library, Moscow, Fund 183 (Foreign Autographs Collection) No. 456, fol. 1r

the second half of the fifteenth century for creating monuments to fallen Venetian war heroes.[64] As these monuments to patricians began to increase in form and visibility, so too the illuminations of Commissions granted to the lesser offices emulated these arts to transform manuscripts into monuments calling attention to the power of the patrician while he was in office, and memorializing him within the family archive after his service.

We can compare some Commissions with tomb monuments to show how the miniatures came to emulate them in the later fifteenth century. The Commission for Jacopo di Cristoforo Marcello (of San Tomà, *c.*1415–1484), elected as Captain of Padua in 1480, opens with a magnificent interlaced Roman capital on gold ground (fig. 5.13). Harpies frame the coat of arms in the lower border, to create a simple but dignified opening leaf.[65] Jacopo died heroically, while admiral of the Venetian fleet in the capture of Gallipoli, in 1484. He was honored as admiral in a magnificent tomb in the Frari, where his standing effigy, dressed in Roman armor, is framed by frescoes of a triumphal procession above, and friezes of armor with the spoils of war on the sides, in imitation of the sculpted

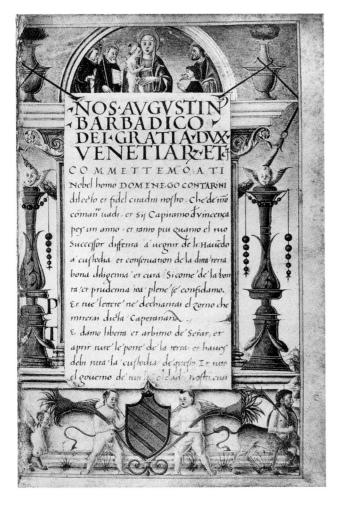

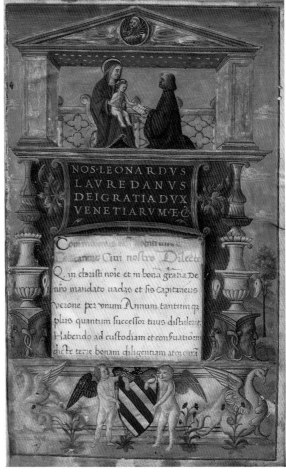

5.19 (Above left) *Commission to Domenico di Maffei Contarini as Captain of Vicenza,* 1499. 19.5 x 13 cm. Hoepli Catalogues 5/3/1928, lot 180 and 10/29/1937, lot 77

5.20 (Above right) Workshop of Benedetto Bordon (attrib.), *Commission to Domenico di Maffei Contarini as Captain of Verona,* 1508. 19 x 11.7 cm. Biblioteca del Museo Civico Correr, Venice, Cl. III, 308, fol. 1r

decoration on ancient monuments (fig. 5.14).[66] The scheme of a portrait set within a border of trophies and armor eventually developed also in Commission paintings (fig. 5.26).

In the Commission to Melchiorre di Paolo Trevisan (d. 1501), elected *Podestà* of Padua in 1488 (fig. 5.15), the Pico Master transformed the border of the opening text page into a faux stone monument similar to that in the miniature he painted for the *Promissione* of Doge Agostino

Barbarigo (fig. 3.17), but this monument is particularly Venetian – it straddles a canal. Putti blow trumpets to announce the fame of Trevisan. The Pico Master's success as an illuminator of *ducali,* as evidenced by the great number he painted, may in fact be due to his emulation of stone monuments, transferring the concept of the commemorative tomb to Commission pages.[67]

Trevisan replaced the disgraced Antonio Grimani as Captain General of the Sea after Grimani failed to engage the Ottoman fleet. As discussed earlier, through Grimani's perceived incompetence, Venice lost Lepanto, which had been in Venetian hands since 1405, to the Ottomans on August 29, 1499.[68] After Trevisan's death in 1500, his sons, like those of Cappello, had a monumental memorial tomb built for

their father, this one inside the Frari (fig. 5.16).[69] As in the monument to Jacopo Marcello, the stone plinth of the miniature is framed with painted trophies and armor. In the standing, armored effigy, Trevisan's military service to Venice is emphasized.[70] The instruments and spoils of war are painted in the frescoes surrounding the sculpture, as if illuminated borders to the central text of his monument.

In this case, a fictive stone memorialization of Trevisan in his Commission manuscript as Captain of Padua precedes the actual one.[71]

Portraits appear in *Promissioni* and in the Commissions of procurators by the mid-fifteenth century, but the first portrait I know of in a Commission to a rector is of decades later, within a monumental construct. In the document of Tommaso di Alvise Loredan as captain of a

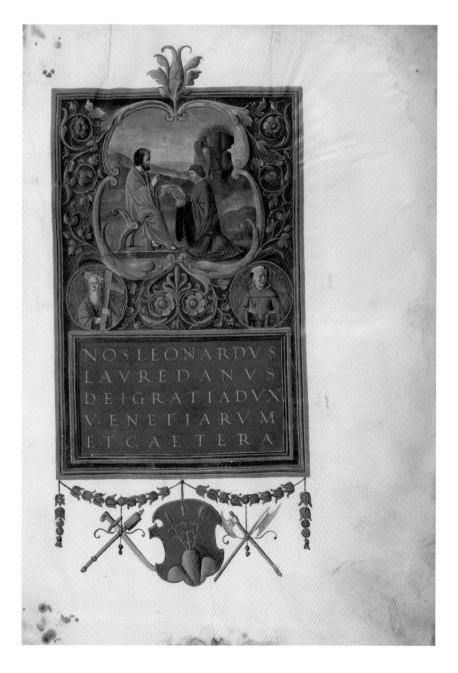

5.21 Benedetto Bordon (attrib.), Commission to Francesco di Marin Pr. de Garzoni as *Podestà* of Verona, 1508. 24.3 x 17.5 cm. Kupferstichkabinett, Berlin. 78.C.30., fol. 1r

convoy of two galleys to the Barbary Coast of Africa, of 1490, the Pico Master shows Loredan kneeling in the opening initial to an enthroned figure of Venice as Justice, in a space analogous to that occupied by Cappello some two decades earlier, on the façade of Sant'Elena (fig. 5.17). This was the first, and from the records of his elected offices, the only position for which Tommaso would have received a Commission manuscript. To either side of the monument, putti trumpet his fame.[72] Such new compositions in opening initials were only possible if the scribes in the chancery left an open block for the miniatures when writing out the document. In other words, by this time patricians were encouraged by the layout of the documents to request expanded decoration. In addition, the standard opening text is absent from some documents, indicating that also it was to be filled in under orders of the patrician by the miniaturist or an outside professional scribe.

The illuminator Benedetto Bordon, with his workshop and followers, continued to develop the expanded areas of the top register of the opening leaf to fit in more fully conceived portraits. In the Commission to Domenico di Maffei Contarini (1451–1533), elected *Podestà* and Captain of Feltre in 1492, the patrician is given a standard by Mark in front of a deep landscape. Contarini is presented as in the line of rulers of antiquity, for his portrait is framed by a stone slab sculpted with classical profiles (fig. 5.18).[73] Domenico is one of the earliest patrons for whom survives a series of portraits in *ducali*. Viewed in sequence they reveal a layered program of self-commemoration that draws on conventions of tomb monuments and votive paintings, and combats a controversial reputation.

The Commission to Domenico Contarini of 1492, as rector of Feltre, was an early one in an extensive career of service to the state, crowned by positions as Captain of Padua in 1513 and membership of the Council of Ten, as well as several rounds as *provveditore generale* of the *terraferma*.[74] He requested portraits in

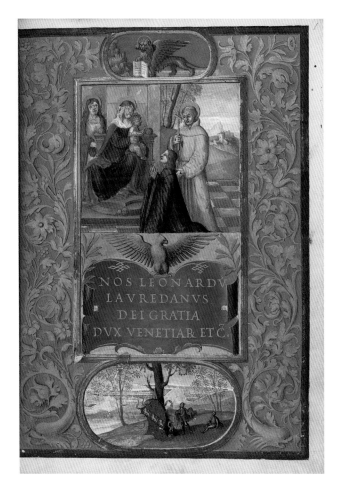

5.22 Commission to Francesco di Nicolò Barbarigo as *Podestà* of Feltre, 1515. 23 x 16.4 cm. British Library, London, Harley 3403, fol. 1r

at least two other surviving Commissions: as Captain of Vicenza in 1499 (fig. 5.19), and as Captain of Verona in 1508 (fig. 5.20).[75] In the Vicenza document, Domenico prays to the Madonna and Child in a loggia above the text, approximating the placement of Cappello in the sculptured portal at Sant'Elena. In the last Commission, the miniaturist, working in the conventions established by Benedetto Bordon, shows Domenico accepting his manuscript and a blessing directly from the Christ Child in an open loggia on a free-standing monument.

This rare image of the charge of office from the baby Jesus himself especially emphasizes

divine election, and may have been a response to serious accusations against Contarini. The Council of Ten initially refused to allow him to leave for Verona because he was accused of having obtained his election through bribery. The accusations eventually lapsed and Contarini assumed his post. This did not end the controversy surrounding his service, for he did not coordinate his leadership well with Venetian troops after the formation of the League of Cambrai. When Verona capitulated to the French after the Battle of Agnadello in 1509, Contarini, like many Venetian administrators and citizens on the mainland, fled back to Venice for safety. Sanudo recounts derisively how, of all the rectors returning to Venice, Domenico's carts were the most heavily laden with stuff, causing comment.[76] It is likely that intermingled with a sincere desire to serve as an exemplum for future generations, vanity and love for fine material goods underlay the further development of the Commission as a medium for portraiture.

COMMISSIONS AND VOTIVE PAINTINGS

In Contarini's last document, the opening text on the first leaf has diminished to a few lines to privilege the painting. Francesco di Marin Pr. de Garzoni (d. 1535) was Contarini's co-ruler in Verona as *podestà*, and for his Commission, produced in the same year as Contarini's, the opening text is even shorter (fig. 5.21). In the expanded space left for the painting, the artist Benedetto Bordon adapted the portrait formula of Mark handing the new office holder the Commission from the motif commonly found in documents for the procurators. Bordon may have become the most requested miniaturist of Commissions in these years, and eventually of documents for the procurators and doge, because of his ability to translate the saturated colors and rich landscapes of contemporary paintings by Giovanni Bellini, Cima da Conegliano, Giorgione, and the very young Titian into miniature.[77]

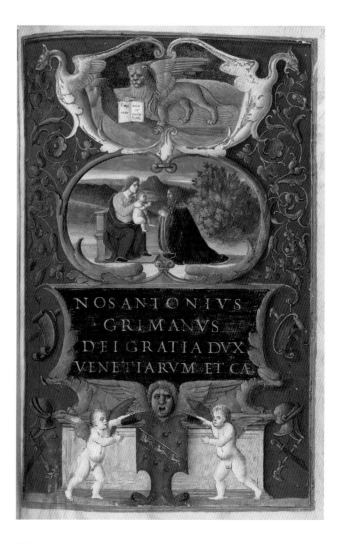

5.23 Benedetto Bordon (attrib.), Commission to Francesco di Nicolò Barbarigo as Captain of Vicenza, 1522. 22.7 x 14.8 cm. Fitzwilliam Museum, Cambridge, MS 188, 4, fol. 1r

Indeed, the de Garzoni family palace eventually housed a portrait by Titian of Francesco's father Marin, so that the likeness in the document complemented the portrait hung on the walls in style as well as in commemorative intent.[78]

Members of Bordon's workshop, or his followers, advanced the imitation of monumental painting in Commissions to Francesco di Nicolò Barbarigo as *Podestà* of Feltre, of 1515 (fig. 5.22), and as Captain of Vicenza in 1522 (fig. 5.23).[79] The miniaturist of the 1515 Commission may have been aware of Titian's most recent

5.24 Titian, *Madonna and Child with Saints Catherine and Dominic, and a Donor*, c.1513–14. Oil on canvas, 137 x 184 cm. Fondazione Magnani Rocca, Mamiano di Traversetelo, Parma, Inv. N. 3

paintings, for his composition, if not figural style, is close to that of the *Madonna and Child with Saints Catherine and Dominic, and a Donor*, of around 1513–14 (fig. 5.24). In the miniature, Saint Francis presents Barbarigo to the Virgin and Child, and a saint, perhaps Mary Magdalen, hovers behind and to the left of the Virgin. As in Titian's painting, the right-hand side of the picture opens up to a broad landscape. The miniaturist even imitates the juggling of the child on the Virgin's lap.[80] The cartouche with the coat of arms in the lower border includes a pastoral

landscape with shepherds, a representation of the *terraferma* as the *locus amoenus* of Venetian patricians. Although the portraits are small, the miniaturists apparently were painting Barbarigo from life or successive *ricordi*, for in the second painting he sports a beard.

The request by patrons for the visualization of a blessing by Christ and Mary in their manuscripts before embarking on such assignments, if somewhat routine, was probably often heartfelt. The paintings in a Commission to Filippo di Alvise Basadonna of 1523 as a captain of the convoy of galleys to Beirut are by the Trees Master (fig. 5.25).[81] This was Filippo's first state appointment that would have given him a Commission document, and in it he

5.25 (Above left) Trees Master (attrib.), Commission to Filippo di Alvise Basadonna as *Podestà* of the Galleys to Beirut, 1523. 22.7 x 14.8 cm. Fitzwilliam Museum, Cambridge, MS 188, 3, fol. 1r

5.26 (Above right) Commission to Jacopo di Girolamo Celsi as Captain of the Galleys to Alexandria, 1550. 17.5 x 12 cm. Bibliothèque Nationale de France, Paris, Dupuy 955, fol. 2r

had himself shown as presented to the Virgin and Child by his patron saint, Philip, and the patron saint of his father Alvise.[82] The accounts of Filippo's later appointment as Captain of the Galleys to Flanders in 1529 remind us that these assignments often involved truly arduous and dangerous journeys. Sanudo recorded a series of letters that convey the various travails of Captain Basadonna over this later journey, which extended to three years due to continual problems. Stuck in Southampton since October of 1531 and awaiting enough cargo of wool while

litigating with the galleymen (*galioti*) and owners of the galleys (*patroni*), Basadonna barely made it out alive after being stoned by a mob of galleymen who mutinied over pay in mid-February of 1532.[83] In May he was still sending letters to Venice, explaining the delay in Southampton due to the loss of men who died from the plague. Later letters from both him and Giovanni Battista di Domenico Grimani (d. 1550), one of the *patroni*, bitterly blame each other for subsequent delays, prompting an investigation by the Senate. Indeed, it was to be one of the last voyages of a Venetian merchant galley convoy to Flanders and England.[84]

The wish for benediction upon assumption of such voyages eventually produced extremely original paintings in Commissions, as in that to Jacopo di Girolamo Celsi (1520–1571) as Captain of the Galleys to Alexandria, in 1550 (fig. 5.26).[85] In a remarkably detailed cityscape, Celsi, before

boarding his ship, takes his cap off to request the blessings of God the Father, figured as a high relief sculpture in the lintel of the doorway to a church. This probably is a representation of the façade of the Church of San Ternità, dedicated to the Holy Trinity, for God with a triangular halo is a common representation of the Trinity. San Ternità, now completely destroyed, was near the Celsi family palace, and in fact his family branch was named after it. The medieval church had been rebuilt

around 1505–7, but was renovated again in the late sixteenth century, probably after the fire of the nearby Arsenale in 1569.[86] The façade as painted in the miniature, therefore, must reflect the church's appearance before the 1569 conflagration. Jacopo Celsi survived the journey to Alexandria, and pursued a successful career as a naval commander, culminating in his election as *provveditore dell'armata*, in which position he served until he was killed in battle with the Ottomans in 1571.[87]

5.27 Giorgio Colonna (attrib.), Commission to Benedetto di Nicolò Semitecolo as Captain of the Galleys to Alexandria, 1564. 24.2 x 17.4 cm. British Library, London, Add. MS 18846, fol. 1r

The illumination for the Commission to Benedetto di Nicolò Semitecolo (1523–1562) as Captain of the Galleys to Alexandria, of 1564, also unique in composition, expresses the wish for blessings allegorically (fig. 5.27). In the miniature by Giorgio Colonna, the sun appears to be rising on a seascape with the three galleys in the background, to indicate the beginning of the voyage. God the Father, with Saints Benedict and Nicholas, patron saints for Benedetto and his father, bless the ships from clouds in the sky, while a wind god blows the sails. In the foreground, Neptune with his trident rides a shell-boat drawn by sea horses.[88] Neptune was one of the pagan gods frequently shown to represent Venetian dominion over the sea. The creation of the miniature preceded the installation of the monumental "giant" Neptune at the top of the Scala dei Giganti in 1567, but Colonna and his patron Semitecolo may have been inspired by that project, which was commissioned already in 1554 (fig. 3.2).[89]

ANTIQUARIAN PORTRAITS

The portraits we are concerned with here are within official documents, as opposed to devotional or literary manuscripts. As such the drive to include a likeness in them was linked primarily to trends in portraiture emphasizing the public face, civic duty, religious and patriotic devotion, and exemplary achievement, as opposed to the rapidly developing vein of portraiture that sought to visualize private or fleeting sentiments, as in portraits by Giorgione and Lorenzo Lotto.[90] One aspect of portraiture in Commissions can be viewed as an extension of the *uomini famosi* tradition, or the literature on, and portraiture of, famous personages as exemplaries for moral instruction and legitimization of rule. Such portraiture is linked to the collecting of ancient statue busts and coins with portraits that were seen also to inspire imitation of the laudable deeds of ancient rulers.[91] Examination of the antiquarian and literary references in the Commissions to

Giovanni Dr. K. di Renier Badoer (*c.*1465–1535) and Giovanni Antonio K. di Jacopo Alvise Venier (1477–1550) reveals how patricians of the Republic could imagine themselves as leaders of an empire through allusions to ancient rulers, and how imagery in Commissions evolved through humanist discourse and ties of friendship.

Cameos and coins were central to the *all'antica* vocabulary of artists and recur often in miniatures in Venice by the third quarter of the fifteenth century. Such depictions often are only vaguely referential, and usually do not copy specific coins or cameos. This makes all the more remarkable the references to identifiable ancient rulers and antique sculpture in the illumination of the Commission to Giovanni Badoer as *Podestà* of Padua, of 1531 (fig. 5.29).[92] Badoer's Commission has no likeness of him, but several cameo-style and sculptural portraits stand in for his image.

The beautiful chancery scripted text for this highly prestigious post strays a little from the usual opening formula to distinguish Badoer as doctor and knight. Indeed, Badoer had sojourned in Padua many years before as a student at the university, where he studied philosophy and obtained a doctorate in theology. In Padua he became friends with the poets Filippo Galli and Francesco Pitti. The three of them created a literary society and wrote pastoral poetry, in which they used assumed names as protagonists. Badoer entered the sacred groves of gods and nymphs in his poetry as Phylareto, a goat-herder in the Euganean hills just south of Padua.[93] In his verse, the pastoral landscape is transferred to the actual *terraferma* from Sannazaro's indeterminate Arcadia. Like other bucolic poetry of the early 1500s, it is a literary mirror of the paintings in the pastoral mode of Giorgione and Titian.[94] Surviving copies of the *Phylareto* indicate the personal bonds of Badoer with other cultivated patricians and collectors of art.

It is probable that the notable collector of books and paintings Giovanni Antonio Venier owned the manuscript of Badoer's work bound

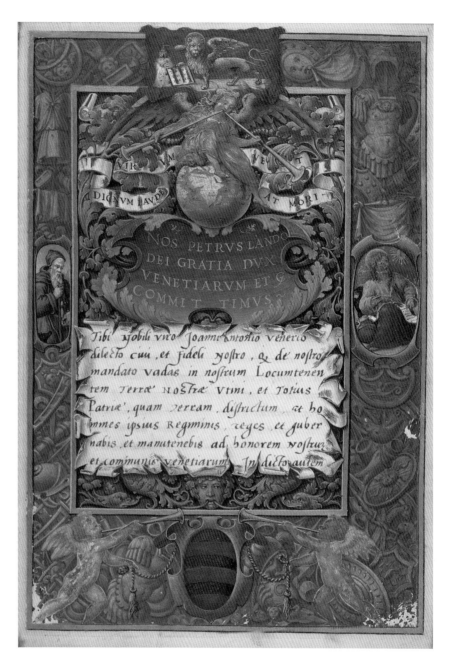

5.28 Jacopo del Giallo (attrib.), Commission to Giovanni Antonio di Jacopo Alvise Venier as Lieutenant of Udine, 1539. 24 x 16.2 cm. Pierpont Morgan Library, New York. M.354, fol. 1r

with the *Arcadia* of Sannazaro, now in the Marciana Library.[95] The modest manuscript, written in a fine hand on paper with pen and ink decorations, may have even been written out by Venier himself, perhaps as an expression of friendship with Badoer. Venier owned paintings by Raphael and two Sistine Chapel tapestries, acquired in the 1520s. He also possessed works by Giovanni Bellini, Giorgione, and Titian.

In 1524 Venier was accused of factionalism and banned from office, but by 1530 had returned to favor and service to Venice.[96] Venier's Commission as Lieutenant of Udine of 1539 complements Badoer's document and celebrates the restoration of his honor in emphasizing the immortality of fame through service to the state (fig. 5.28).[97] The miniatures are by Jacopo del Giallo, who this same year

painted the Commission/Oath of Giovanni da Lezze as procurator (fig. 4.18).[98] As an art collector, it is natural that Venier would have been anxious to seek out for his Commission the miniaturist praised by Aretino and employed by the procurators. Besides the typical patron saints in the border cartouches, the center features Fame personified, straddling the globe with an up-to-date representation of the Americas. A banner with a phrase culled from Horace announces that "(the muse) does not allow the praiseworthy to die (she enthrones him in the heavens)."[99] The word *musa* is absent, but the figure of Fame effectively takes her place. One can imagine that some patricians, such as da Lezze, Venier, and Badoer, would have shown each other their Commissions and discussed the classical mottoes, imagery, and artistry of the paintings within them, as extensions of their conversations about poetry, ancient history, and art.

Returning to Badoer, he subsequently began a long career of service to the state, including election as *Podestà* of Brescia and Captain of Verona, and ambassador to France and Spain, after which he was knighted.[100] He was one of the three *savi sopra le leggi* elected in 1528 to streamline Venetian laws, resulting in the beautifully illuminated manuscripts of the revised *Capitolare* of the Great Council (fig. 2.3). Badoer was personally complimented for his work on this project in a letter from his friend, the great poet Pietro Bembo.[101] In the Commission manuscript recording his return to Padua, not as a student or poet, but as a Venetian overlord, the opening text is framed with illuminated cameos and a portrait bust of ancient Roman rulers. These were copied, not from actual ancient objects but from woodcuts in Andrea Fulvio's *Illustrium imagines* – the printed book of portraits with eulogies to famous men and women, first published in 1517 in Rome (fig. 5.30).[102] The portraits in Fulvio, in turn, are inventions mainly derived from ancient coins and statues. The cameo at the top depicts Gaius Marius (157–86 BCE), renowned for having been elected as Roman consul seven

times. The right-hand border shows Julius Caesar (100–44 BCE) and the left-hand border features a copy of the woodcut representing Octavian-Augustus (63 BCE–14 CE) in Fulvio.[103]

The portrait in the bottom margin of the manuscript leaf also was copied, but from an ancient bust, believed by at least the mid-sixteenth century to be ancient and a likeness of the Roman emperor Vitellius (15–69 CE) (fig. 5.31). This celebrated sculpture was donated by Cardinal Domenico, son of Doge Antonio Grimani, to the Republic in 1523 and exhibited on the second floor of the Ducal Palace in 1525 along with ten other portrait busts, in a room that became known as the Hall of the Heads (Sala delle Teste).[104] The Vitellius came to be one of the most copied of busts believed to be ancient, and was reproduced in media ranging from stucco, bronze, and marble to painting and engraving, so that versions of it eventually could be found all over Europe. In Venice, Jacopo di Pietro Contarini (1536–1595) owned a bronze copy, and Marco Mantova Benavides (1489–1582) had a plaster copy in his great collection in Padua.[105] The miniaturist, therefore, could have seen the actual bust on display in the Ducal Palace, but did not need to do so in order to create his careful, if augmented rendition, in which he has rounded the termination after the fashion of other ancient busts known at the time, and of some contemporary busts that re-created the format.[106] In the bucolic poetry written in his youth, Badoer assumed the idyllic identity of an ancient goat-herder. In this unusual Commission, the replication of portraits culled from a printed book and an ancient sculpture bust portray his service to Venice as *podestà* in the ancient city of Padua as in the line of illustrious ancient Roman overlords.[107]

FULL-PAGE PORTRAITS

Full-page portraits seem to have emerged first in the work of the T.° Ve Master, whose work predominated in Commissions from around

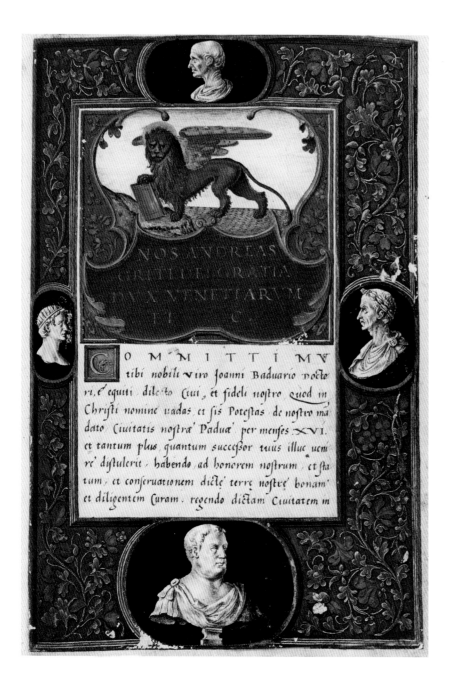

1533 to the 1550s. At least eighty surviving Commissions can be attributed to this artist and his workshop. One can see in his early works an adaptation from Bordon's format and style in imitation of contemporary monumental painting. In the illumination of the Commission to Nicolò di Zaccaria Morosini as Captain of Vicenza, of 1531, the master included cameo heads with a donor portrait, again aligning a Venetian rector

Clockwise from left:

5.29 Commission to Giovanni Dr. K. di Renier Badoer as *Podestà* of Padua, 1531. 23.6 × 16.4 cm. Raccolta Durazzo, Genoa. A V 13

5.30 *Julius Caesar*, from Andrea Fulvio, *Illustrium imagines*, 1517, fol. 16r. 15.2 × 10.5 cm. Biblioteca del Seminario di Padova, 500. ROSSA.SUP.APP-6.1.–22

5.31 Grimani "Vitellius," 2nd century CE or early 16th century. Marble, H. 48 cm. Museo Archeologico Nazionale, Venice, Inv. 20

with ancient rulers (fig. 5.32).[108] The overall
conception of the leaf as a solid sculpted block,
with spaces through which to see beyond into the
landscape, is so similar to some of the Bordon-style
illuminations of *ducali*, such as the *Promissione*
of Antonio Grimani of 1521 (fig. 0.5), that it seems
likely the master began his career in Bordon's
workshop, or at least copied his formulae.

The T.° Ve Master then began to enlarge the
portrait and lessen the plasticity of the borders
in his miniatures.[109] By the mid-1530s the Master
shifted to half-length portraits to create more
detailed, and therefore specific and identifiable
likenesses, as in that of Alvise di Francesco
Contarini, first as *Podestà* of Oderzo in 1541, and
then as *Podestà* of Bassano in 1550 (figs. 5.33,
5.34). In the later miniature Alvise appears to have
gained some weight and has a heavier beard.[110]
The quality of the portraits is highly variable,
but the T.° Ve Master and other artists usually
seem to have attempted a true likeness within the
constraints of the official portrait formula.

That a portrait in a *ducale* could be produced
separately from the rest of the composition,
perhaps by the master of the workshop completing
the rote work done by his assistants, is most
obvious when it does not conform spatially or
stylistically, as in a Commission to a member of
the Pasqualigo (fig. 5.35).[111] This division of labor
in some miniatures also was common practice in
the workshops of painters in the sixteenth century,
especially in that of Tintoretto.[112]

In some Commissions only patron saints
are shown, whether out of modesty, lack of
a *ricordo* or portrait model, or of time on
the part of the patrician to sit for a portrait.
Sometimes the recipient is dressed as a patron
saint, comparable to the common practice
whereby patricians requested to be buried in
the habit of a monk or friar, according to their
devotional focus (fig. 9.11).[113] In one miniature
attributable to Giovanni Maria Bodovino, both
the rector and his wife may have been portrayed
as their omonymous saints, for their faces seem

5.32 T.° Ve Master?, Commission to Nicolò di Zaccaria
Morosini as Captain of Vicenza, 1531. 23.7 x 16.5 cm.
British Library, London, Add. MS 15518, fol. 1r

less conventionalized than the saints in other
miniatures (fig. 5.36).[114] In this leaf detached
from the Commission to Alessandro di Nicolò
Contarini (1540–1604) as *Podestà* of Bergamo
(elected 1586), Saint Alexander, patron saint
both of Contarini and of the city of Bergamo,
looks up to the dove of the Holy Ghost. Ursula
was the name saint of Alessandro's wife, Orsetta
di Alessandro di Andrea Foscarini, and it seems
she is portrayed to the right as the saint, holding
the arrow as instrument of her martyrdom.
Her companions, the 11,000 martyred virgins,
are indicated in the background.

The T.° Ve Master may have been the first miniaturist to add full-page illuminations beyond the opening text page, either by inserting extra leaves that are blank on the reverse, or in collusion with the scribes, who began to leave the recto of the opening leaf blank as a space for a full-page image.[115] Inserted leaves allowed for a new format of an opening sequence of illuminated leaves, as in two Commissions for Melchiorre di Gasparo Salamon (1527–1576), as *Podestà*

of Castello di Motta di Livenza (province of Treviso) of 1557, and as *Podestà* of Este of 1561 (figs. 5.37, 6.2).[116] The larger spaces allowed the Master to more substantially represent the different locations to be governed. The Master also may have been the first miniaturist to add the age of the recipient, imitating a convention already well established in Flemish oil portraits by the early fifteenth century.[117] Inclusion of the age of the sitter with his portrait in a document that was dated in the eschatocol further enhances the sense of the portrait as a record in time.

THE ALLEGORICAL SELF

Portraits of actual women, the wives of rectors, exist in Commissions, but are extremely rare. More common were female figures that, in their sexual difference from men, could embody

5.33 (Below left) T.° Ve Master (attrib.), Commission to Alvise di Francesco Contarini as *Podestà* of Oderzo, 1541. 23.5 x 16.5 cm. National Archives, Kew, Public Records Office 30/25: 104/5, fol. 1r

5.34 (Below right) T.° Ve Master (attrib.), *Saint Louis of Toulouse Guides Alvise Contarini as Podestà*, Commission to Alvise di Francesco Contarini as *Podestà* of Bassano, 1550. 23.5 x 16.7 cm. National Archives, Kew, Public Records Office 30/25: 104/8, fol. 1r

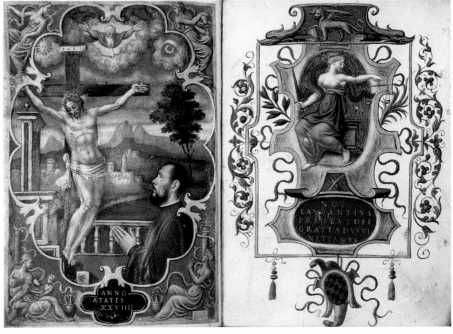

5.35 (Above left) Leaf detached from a Commission to a member of the Pasqualigo family, late 16th century. 21 x 13.2 cm. British Library, London, Add. MS 20916, fol. 16

5.36 (Above right) Giovanni Maria Bodovino (attrib.), *Saint Alexander and Saint Ursula (Alessandro Contarini and his Wife Orsetta?)*, leaf from the Commission to Alessandro di Nicolò Contarini as *Podestà* of Bergamo, 1586. 20.6 x 14.4 cm. British Library, London, Add. MS 20916, fol. 20

5.37 (Right) T.° Ve Master (attrib.), Commission to Melchiorre di Gasparo Salamon as *Podestà* of Castello di Motta di Livenza, 1557. Each fol. 23.5 x 16.5 cm. T. Kimball Brooker Collection, Chicago, fols. 1v–2r

invisible and various aspects of masculinity, including external influences, internal motivations, and actions over time.[118] These personifications could be imaged separately or in conjunction with the likenesses of men to convey their interior governing ideals. The most common female personifications were of the virtues and of *Venetia*, or Venice personified.

In late antiquity, a hierarchy of four cardinal virtues, the term stemming from the Latin *cardo*, or hinge, from which all other virtues arose, was adopted from the writings of Cicero, and more broadly diffused through Macrobius' *Commentary on the Dream of Scipio*.[119] The female personification of these virtues as Justice, Prudence (or Wisdom), Fortitude, and Temperance became ubiquitous in Italian art by the fourteenth century. These were joined by the Christian virtues of Hope, Faith, and Charity, whether to show the virtues of a body of administrators, as in Lorenzetti's famous fourteenth-century frescoes in Siena, or to suggest and exhort individual virtue, as in Commissions. As in the emergence of portraiture in Commissions, the early impulse to illustrate female personifications seems to have emerged from the example of tomb sculpture. In the document for Marco di Pietro Lando (d. 1531) as Captain of Candia (elected 1516 and 1518) (fig. 5.38), the overall format of three niches to each side with half-shell termination is similar to that of the magnificent tomb of Doge Pietro Mocenigo (1406–1476) in Santi Giovanni e Paolo by Pietro Lombardo (fig. 3.23).[120] But instead of the male warrior figures of the tomb, Benedetto Bordon displays female virtues, as included horizontally in the tomb of Doge Tommaso Mocenigo (1343–1423), also in Santi Giovanni e Paolo.[121]

In other miniatures the virtues to be enthroned are varied. Evidently a patron could pick those to be emphasized, as in the shuffling of Fortitude, Prudence, and Temperance around Justice in a leaf for Vettor di Marcantonio Michiel (1529–1576) as *Podestà* and Captain of Mestre, of 1552 or 1555,

attributed to Giovanni de Mio (fig. 5.39).[122] The interest of Vettor in the artistry of his Commission would have been encouraged by his upbringing, for his father Marcantonio di Vettor (1484–1522) was a notable collector and author of a now-famous inventory of artworks in private collections in Venice and the Veneto.[123]

Among the most renowned images of *Venetia* are the large canvases by Paolo Veronese, Giovani Battista Zelotti, and Tintoretto in the Doge's Palace. Largely through their art, *Venetia* evolved from being primarily identified with Justice and the Virgin Mary, as she is represented in the Commission to Tommaso Loredan as Captain of the Galleys in 1490 (fig. 5.17),

5.38 Benedetto Bordon (attrib.), Commission to Marco di Pietro Lando as Captain of Candia, elected 1516 and 1518. 24.4 x 17.5 cm. Österreichische Nationalbibliothek, Vienna, Cod. 5884, fol. 1r

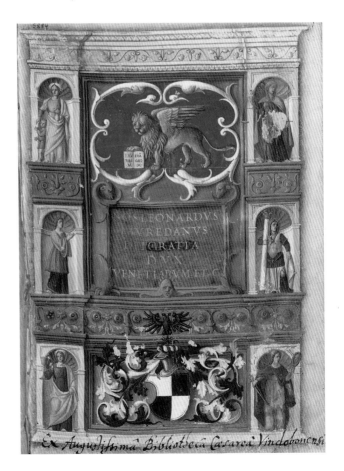

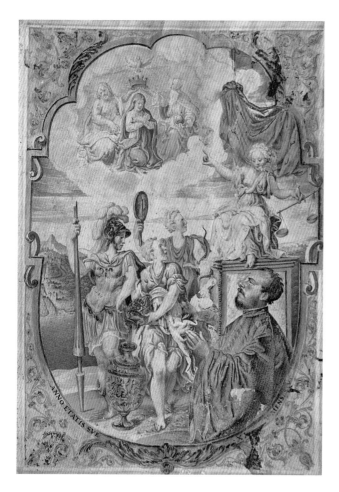

5.39 Giovanni de Mio (attrib.), Leaf detached from a Commission to Vettor di Marcantonio Michiel as *Podestà* and Captain of Mestre, 1552 or 1555. 23.1 x 16.3 cm. Museo Civico, Cremona, D88

the transcendent air of the ceiling paintings by Veronese, Ponchino, and Zelotti, as in their earliest paintings of her, for the ceiling of the Audience Hall of the Council of Ten (fig. 5.41). The iconographic program for the ceiling was written by the patrician Daniele di Francesco Barbaro (1514–1570).[126] The miniaturist has captured the porcelain beauty of the figures of Venice by these artists, but has shifted the perspective from a worm's eye view to accommodate viewing of it in the hand, in manuscript form.

Bragadin described his two years of service in Brescia, during which he oversaw civil and judicial affairs in the city and its surrounds, as "long and laborious" in his report to the Senate upon return to Venice.[127] In the illumination, Justice/*Venetia* is in a cloud above a view of Brescia. A *spiritello* equips her with her sword, as Faith, Temperance, Fortitude, and Prudence prevail in the corners of the leaf. The painting can be seen to signify that Bragadin's election, and his service guided by the virtues illustrated, will equip *Venetia* to execute justice in her territory of Brescia. As Tracy Cooper has shown, some ten years later, in 1579, Bragadin became one of the three superintendents overseeing the construction of the Doge's Palace (*provveditori sopra la fabbrica del palazzo*), a role in which he would have participated in directing architects and artists, including Veronese, in the ongoing reconstructions after the devastating fires of 1574 and 1577.[128] Bragadin perhaps first pondered a visual program that expressed his ideals of service to the state, preliminary to his consideration of the more monumental programs in the palace, in his Commission document.

The inventiveness of new themes derived from monumental painting can be seen in a leaf detached from a Commission to a member of the Corner family (fig. 5.42). The miniaturist may have been inspired by the triptych by Bonifacio de' Pitati in the offices of the *Imprestidi*, or state bonds, in which God the Father hovers over the Piazza and Piazzetta in a role similar to Christ in the miniature.[129] In the manuscript painting, Christ guides *Venetia*

to assimilate a wide range of personas, including those of pagan goddesses, to convey the political ideals of the oligarchic Republic.[124] These images of *Venetia* were created as monumental paintings placed high above one's head in the Doge's Palace, and for offices in other state buildings. A leaf detached from a Commission to Antonio di Andrea Bragadin (1511–1591) as *Podestà* of Brescia, in 1567, depicts *Venetia* with the lion of Mark, receiving the sword of Justice in a heavy gilt frame much like the sculpted examples surrounding the ceiling paintings in the Ducal Palace (fig. 5.40).[125] The Morgan Master successfully evokes the high altitude setting and

in her creation, or protection, of the city on the sea as she is crowned by a cherub, linking her to Mary as Queen of Heaven. In devising themes with miniaturists, patricians did not directly copy the imagery of larger monuments. The spaces in the documents allowed them to participate directly in the evolution of the rich visual language representing Venice and her ideal governance.

That the miniatures of Commissions to rectors became spaces in which patricians could freely express new themes through likeness and inventive allegory is demonstrated also in a detached leaf that Anne-Marie Eze has identified as having been made for Tommaso di Francesco Morosini dalla Sbarra as *Podestà* and Captain of Crema, to which he was elected in 1587 (fig. 5.43).[130] An inscription at the top of the leaf quotes from Psalm 84: "Truth is sprung out of the earth: and justice hath looked down from heaven."[131] *Veritas* is interpreted in the miniature as Venus, perhaps here also meant

5.40 (Left) Morgan Master, Venice as Justice and as Venus, leaf detached from a Commission to Antonio di Andrea Bragadin as *Podestà* of Brescia, 1567. 22.7 x 16.2 cm. Pierpont Morgan Library, New York, M.1082

5.41 (Below) Giovanni Battista Zelotti, *Venice Seated on a Globe*, c.1553–55. 286 x 150 cm. Audience Hall, Council of Ten, Doge's Palace, Venice

to represent Venice, handing her heart to Justice. The pairing of a "white" European woman and a "black" African nobleman or ruler was made in several famous cameos of the second half of the sixteenth century, such as that on the Drake Jewel given by Sir Francis Drake to Queen Elizabeth I in 1588. A candleholder given by the state of Venice to Henry IV of France and Marie de' Medici when they were married in 1600 also has a prominent cameo of a black man and white woman.[132] There have been various interpretations as to the identities and meanings of these figures. Karen C. C. Dalton has interpreted such images in the light of alchemical thought then current, whereby the male figure is meant to be Saturn and his female companion the Virgin Astraea, signifying a return of the Golden Age through the rule of the respective recipients of these gifts.[133] Astraea was depicted on the great steps in the courtyard of the Ducal Palace under the Barbarigo ducal reigns, and it is possible that the Commission image also alludes in this way to ideal patrician leadership as ushering in a golden age.[134] Nevertheless, Anne-Marie Eze has pointed out that the image of the well-dressed young black African man is so particularized and sensitively realized that it may be the likeness of a man known to the Morosini, rather than an abstraction.[135]

The line in Psalm 84 before "Truth is sprung out of earth" is "Justice and peace have kissed."[136] The theme of Justice and Peace kissing, alluding to the benefits of Venetian rule, is one of the most popular in late sixteenth-century Commissions. It was to be found in public offices, as in the painting of *Saint Mark Uniting Justice and Peace* of 1552, by Bonifacio de' Pitati, which hung in the Palazzo dei Camerlenghi, and appeared in the votive portrait of Doge Pasquale Cicogna (doge 1585–95) by Jacopo Palma Giovane, in the Senate Hall of the Doge's Palace. It also was reprised in many paintings in Commissions (fig. 5.44).[137] The borders of some of these later miniatures are transformed into oval, faux gilded wooden frames with strapwork, here in imitation of those by Cristoforo Sorte in the Senate Hall (after 1578) of the Ducal

5.42 Giovanni Maria Bodovino (attrib.), Leaf detached from a Commission to a member of the Corner family. 21 x 15 cm. Huntington Library, San Marino, EL 9, H13, 16

Palace.[138] Other frames more clearly imitate the gilded and painted frames with stucco decoration and faux mosaic by Giovanni Battista Cambi in the ceiling of the Sala delle Quattro Porte.[139]

THE CULMINATION OF PAINTING IN COMMISSIONS

The expansion of illumination and inclusion of portraits often accompanied the increasing prestige of a particular office within the overall success of any given patrician. But some extremely successful patricians did not bother to have their Commissions illuminated, while

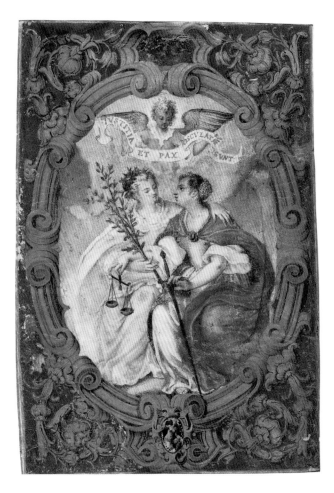

5.43 (Above left) Giovanni Maria Bodovino (attrib.), Leaf detached from a Commission to Tommaso di Francesco Morosini dalla Sbarra as *Podestà* and Captain of Crema, 1587. 22.2 x 14.8 cm. British Library, London, Add. MS 20916, fol. 22

5.44 (Above right) *Justice and Peace*, Leaf detached from a Commission. 20.5 x 14 cm. British Library, London, Add. MS 20916, fol. 27

others with respectable but not meteoric careers took great care in the programs of painting for their documents.[140] This latter approach was the case especially with Francesco di Alvise Pr. Tiepolo (d. 1614). Francesco never achieved the office of procurator that was celebrated in his father Alvise's document, discussed in Chapter 4 (fig. 4.31), but he was a more passionate patron of the arts when memorializing his career and family. His Commissions are the

most elaborate surviving for any patrician, and still are preserved in the Tiepolo archives now deposited in the State Archives of Venice. They constitute a valuable example of the collections of papers and documents by patrician families intended to serve as resources in governance, and in trans-generational family education and memorialization.[141] His Commissions bring together many of the elements variously emphasized in sixteenth-century documents, including portraiture, illustration of territory, and allegory, to memorialize his dedication to serve Venice and the monk Saint Sabba.

Francesco's instruction in the commissioning of art to memorialize himself and his family may have been enhanced by his associations through marriage with illustrious families of art patrons and collectors. In 1579 he married Donada, the

daughter of the eventual doge Marin Grimani, of the San Luca branch, whose patronage of the arts and payment to Marco del Moro for his document as procurator in 1589 has been discussed. In 1582, after Donada's early death, Francesco married Lucrezia Grimani, daughter of Vincenzo di Antonio Giovane (1524–1582), in this way becoming intimately related to the great family of Santa Maria Formosa (fig. 0.2). We can recall here the importance of the patronage of manuscript painting of this branch of the Grimani family, and the great efforts of Francesco's father-in-law, Vincenzo, and his uncles in commemorating Doge Antonio. Meanwhile Francesco's close association also with the San Luca branch of the Grimani continued, for from 1595 to 1597 he rented a floor in the San Luca palace, where his landlord and former father-in-law Marin Grimani also resided.[142]

5.45 (Below left) Giovanni Maria Bodovino (attrib.), *View of Vicenza*, Commission to Francesco di Alvise Tiepolo as Captain of Vicenza, 1597. 23 x 16.2 cm. Archivio di Stato, Venice, Archivio Tiepolo, consegna II, b. 170, fasc. 853, fol. 1r

5.46 (Below right) Giovanni Maria Bodovino (attrib.), Commission to Francesco di Alvise Tiepolo as Captain of Vicenza, 1597. Each fol. 23 x 16.2 cm. Archivio di Stato, Venice, Archivio Tiepolo, consegna II, b. 170, fasc. 853, fols. 2v–3r

The miniatures of Francesco's documents clearly were produced by two different workshops, yet they have similar and unique sequences of five full-page prefacing illuminations, indicating his special wishes. Both manuscripts open with a view of the respective town Tiepolo was to govern, followed by leaves featuring patron saints, Venice personified, and portraits of Francesco (figs. 5.45–5.47, 5.49–5.51).[143] Francesco well may have admired Marin Grimani's document as procurator of 1589, painted by Marco del Moro, as well as his father's fine Commission, still preserved in the same archive as his own documents. Also preserved in these archives are the original contracts and account book of Francesco's lavish patronage of the family chapel in the church of Sant'Antonin in Castello. His refurbishment of this chapel was intended to honor the relics of Saint Sabbas and to memorialize his father the procurator Alvise, who had been buried there in 1591 (fig. 5.48).[144] As Stefania Mason Rinaldi and Victoria Avery have shown, Francesco meticulously oversaw every detail of construction of the chapel, which features statues of Saints Louis of Toulouse and Francis, the patrons of father and son, flanking an altarpiece of Saint Sabbas ascending to heaven with his

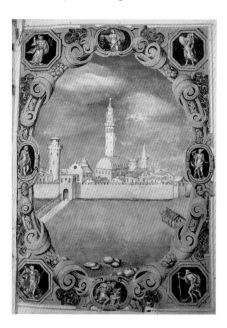
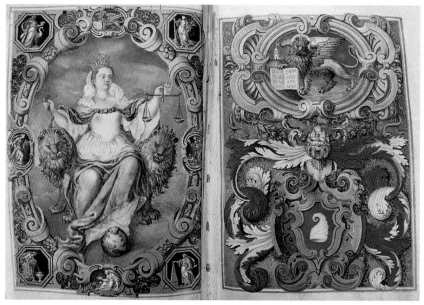

5.47 Giovanni Maria Bodovino (attrib.), Commission to Francesco di Alvise Tiepolo as Captain of Vicenza, 1597. Each fol. 23 x 16.2 cm. Archivio di Stato, Venice, Archivio Tiepolo, consegna II, b. 170, fasc. 853, fols. 1v–2r

double-barred cross.[145] The body of the saint was laid under the altar after the chapel's consecration in 1594, and the cross of Sabbas was one of the most important relics of the chapel, believed to have healing powers into the eighteenth century.[146]

A portrait bust by Alessandro Vittoria of Alvise was placed on the east wall with a plaque stating that Francesco had renovated the chapel so as to carry out his father's wishes. But devotion by Alvise to Sabbas is not reflected in the elder procurator's Commission/Oath. In the miniatures of this manuscript only Louis, his namesake saint,

is featured. By contrast, Francesco's Commissions promote his devotion to Saint Sabbas and intensive engagement with the creation of the chapel within a highly original and layered expression of his piety and service. In the Commission for Francesco's first governorship, as *Podestà* of Vicenza, a full-page miniature is devoted to Sabbas, who crosses his arms over his chest in a gesture of humility before the Virgin and Child (fig. 5.47). Saint Francis repeats the gesture of Sabbas in the facing miniature, behind a portrait of Francesco receiving his Commission manuscript from Mark. Painted cameos in the border depict scenes from the life of Sabbas to parallel the narratives painted by Palma Giovane in the chapel. The prominence of Sabbas in Francesco's first Commission is balanced by a full-page miniature of his namesake, Francis, in his subsequent

Commission as *Podestà* and Captain of Treviso, where in a separate miniature Sabbas stands behind Francesco, so that equal prominence of both saints is calibrated across the two manuscripts (figs. 5.50, 5.51). In both manuscripts Francesco is represented with a vision of the crucified Christ (figs. 5.47, 5.51) to affirm his devotion to the Sacrament, as also witnessed in his last testament by his donation to a *scuola* of the Sacrament.[147]

The opening sequences of miniatures transform Francesco's Commissions into monuments simultaneously celebrating the divinely authorized rule of Venice over its territories and Francesco's piety and career of service to Venice. The paintings expand on themes initiated in his patronage of the Tiepolo Chapel to honor his father and Saint Sabbas, but allow for a focus on memorializing Francesco himself. The illumination of such documents continued until the fall of the Venetian Republic in 1797, with the same themes repeated throughout the seventeenth and eighteenth centuries. Some of the miniatures

5.48 Tiepolo Chapel, dedicated to Saint Sabbas. Sant'Antonin, Venice, consecrated 1594

elevated patricians even further, in the manner of paintings by Giovanni Battista Tiepolo, but the extensive program of illumination in Francesco's Commissions does not seem to have been repeated.

Among the distinctive features of Francesco Tiepolo's Commissions are the full-page views of the towns he was sent to govern. Commissions became a medium for conveying not only personal responses to ideals of service and power, but also of governing in the context of geo-historical events. In this way they broadened the visual culture of the territorial imagination. Having examined the general evolution of these manuscripts as spaces for patrician self-imaging, we now turn to emphasize a more thematic approach, to examine common themes of painting in relation to the agency and actions of rectors while abroad, and the vicissitudes of the empire, and to further contextualize

series of documents for individual patricians within broader programs of patronage. The next chapter shifts to consider the paintings in Commissions in relation to the celebration, commemoration, and comportment of rectors while they served abroad.

5.49 (Below left) Alessandro Merli (attrib.), *View of Treviso*, Commission to Francesco di Alvise Tiepolo as Captain and *Podestà* of Treviso, 1605. 23 x 16 cm. Archivio di Stato, Venice, Archivio Tiepolo, consegna II, b. 170, fasc. 852, fols. 1r

5.50 (Below) Alessandro Merli (attrib.), Commission to Francesco di Alvise Tiepolo as Captain and *Podestà* of Treviso, 1605. Each fol. 23 x 16 cm. Archivio di Stato, Venice, Archivio Tiepolo, consegna II, b. 170, fasc. 852, fols. 1v–2r

5.51 (Beneath) Alessandro Merli (attrib.), *Francesco Tiepolo presented by Saint Sabbas*, Commission to Francesco di Alvise Tiepolo as Captain and *Podestà* of Treviso, 1605. Each fol. 23 x 16 cm. Archivio di Stato, Venice, Archivio Tiepolo, consegna II, b. 170, fasc. 852, fols. 2v–3r

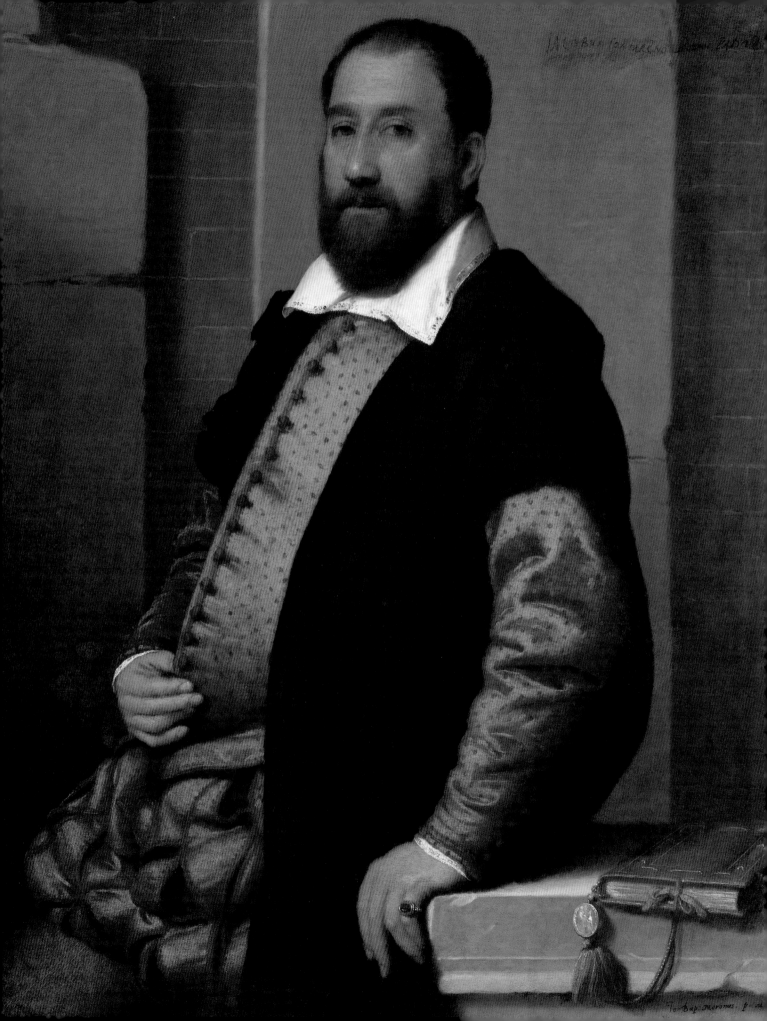

PART III
THEMES AND PROGRAMS

"always remember that you were born neither signorial

rulers nor dukes, but gentlemen of Venice ..."

MARIN K. DI SIGISMONDO CAVALLI TO HIS SONS IN HIS TESTAMENT,
FEBRUARY 15, 1570[1]

THE ORDER OF discussion so far has privileged analysis of how illumination evolved in each major category of *ducali*. We began with *Promissioni*, because these were the first to be painted. But this is the reverse order of that in which an individual patrician actually would have obtained such documents over the course of his career, and does not allow for more in-depth analysis of broader strategies of self-imaging in *ducali* in the context of the changing course of the Republic. The next two chapters, therefore, shift to a more thematic approach. Chapter 6 examines the imagery of Commissions of the rectors in relation to the sometimes conflicting ideals and realities of service and memorialization abroad. Away from

the center of administration in Venice, patricians increasingly tried to memorialize themselves on state monuments in ways not countenanced at home. These projects to memorialize service in territories abroad were paralleled by increasing regulation precisely against such personal exaltation, as transcribed within the Commission documents, so that the manuscripts provided less contested spaces for commemoration of election and service. Chapter 7 examines more specifically the strategies of patricians to commemorate themselves in relation to their involvement in the formation of the Holy League and Battle of Lepanto, and to create portable and more accessible memorials, in dialogue with the grand schemes of painting in the Doge's Palace.

PAX CE
TIBI EVA
MAR GEI

NOS LEONARDVS
LAVREDANVS
DEI GRATIA DVX
VENETIARVM ET CAET

CHAPTER 6

CELEBRATION AND COMMEMORATION OF THE RECTOR

"the rector should leave memory of himself to posterity through his virtuous and beneficial works for the city…"
Giovanni Tatio, 1573[1]

JUST AS THE doge continually had to calibrate his image and actions to satisfy the paradoxical yet also vague job description that he be first among equals, the rector sent abroad was to embody Venetian sovereignty without overly elevating himself personally. His term of service was short, typically no longer than three years, not only to assure emphasis on the power of the office over that of the individual, but also to maintain the identity of the rector as Venetian, and his loyalties to the heart of the empire. The regulations within Commissions guided patricians on how to govern in concert with the relevant statutes of each city or region. A number of the rules attempted to temper his behavior and to limit the personal mark he left on the region he administered. For as the patrician Marin Cavalli advised his sons in his last testament, they were to behave not as dukes, but as gentlemen of Venice. Nevertheless, the behavior of ruling patricians abroad was much less regulated than at home. There were many opportunities for rectors to celebrate and memorialize their temporary status in ways not countenanced in Venice. Indeed, they often were encouraged to do so, and even were flattered and celebrated, by those whom they governed. This chapter examines some cases where

Detail of fig. 6.12

surviving Commissions can be correlated with events, monuments, and literature celebrating a rector's service. The paintings in Commissions at times anticipated typical inauguration and departure ceremonies, or were precedents for the imagery of monuments financed while abroad. Paintings in these documents could be integral to programs commemorating a specific term of service and an overall civic career.[2] They document shifting patrician negotiation of the possibilities for and constraints upon self-promotion and memorialization as a rector.

THE JOURNEY, ENTRANCE, AND DEPARTURE OF THE RECTOR

Many patricians seized even upon the very moment of their election as rector to increase their visibility and reputation. Around 1485, they began formally to accept or refuse the office with a verbal statement and by signing in a ledger held by the *segretario alle voci*.[3] A sixteenth-century clause in Commissions warned that in accepting, one was not allowed to give long speeches – *arenghe* or *sermoni* – revealing that such time-consuming events had become commonplace. The newly elected were to state acceptance in a few prescribed words, under penalty of a fine.[4]

The official entrance of a rector to the subject city and transfer of power to him could be spectacular, so much so that deliberations in the Council of Ten in 1533 attempted to regulate the expense and display of these entries. They legislated that no more than six noblemen could

197

accompany the new rector to his assignment, and that no games, *commedie*, or parties could be made at his expense.[5] Nevertheless, there was little scrutiny of these regulations and the journey of a rector to his post could offer occasions for splendor, transmitting the message that he possessed the entire territory he traversed, as is conveyed by the account of the trip from Venice to Verona of Paolo di Zaccaria K. Contarini ("di San Trovaso," 1510–1566), elected *Podestà* of Verona in 1562.

Contarini's trip to Verona took four days, punctuated with an overnight stay in his family palace in Padua, where he visited his sons studying at the university. Numerous splendid meals featuring local delicacies were consumed, and Paolo met ceremonially with regional authorities and illustrious personages throughout his trip. As he neared Verona with his retinue, he was met and accompanied at various stages by many Venetian and local officials, including his co-ruler (the reigning captain), soldiers, and officials carrying

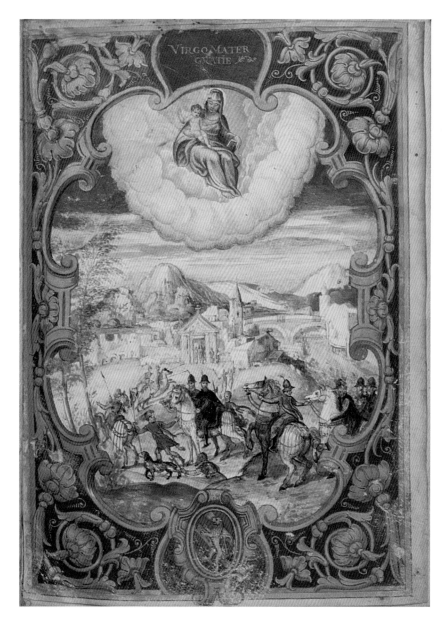

6.1 Giorgio Colonna (attrib.), *The Approach of Giovanni Badoer to Cividale*, Commission to Giovanni di Sebastiano Badoer as Proveditor of Cividale in Friuli, 1580. 22 × 16 cm. Walters Art Museum, Baltimore, W.487, fol. 1r

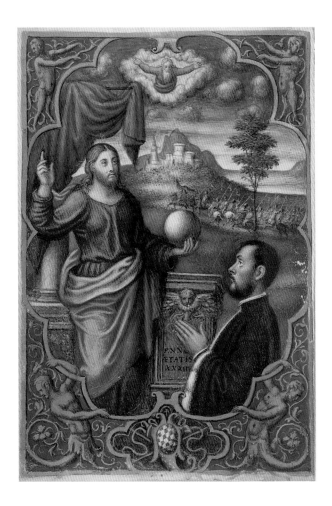

6.2 T.° Ve Master (attrib.), Commission to Melchiorre di Gasparo Salamon as *Podestà* of Este, 1561. Each fol. 21.8 × 15 cm. Cini Foundation, Venice, Inv. 22507, fols. 1v–2r

ensigns of Verona, five trumpeters, twenty-four halberdiers, and twelve members of the *podestà*'s court. When they entered the city at the Porta del Vescovo they were greeted by the outgoing *podestà* Francesco di Marcantonio Bernardo (1514–1580) and together they visited various churches. Finally, in a ceremony in the Piazza del Podestà, Bernardo relinquished the baston of command to Contarini.[6]

The entrance of the new rector into the city sometimes was commemorated in a painting installed in the local Venetian government offices.[7] His approach into the town also could be anticipated in Commission paintings.

The most detailed of these entry scenes, complete with greeting dogs and children, is in the opening page to the Commission of Giovanni di Sebastiano Badoer (1571–1604) as Proveditor of Cividale in Friuli, of 1580 (fig. 6.1), with Badoer presumably portrayed as the man on the white horse to the far right. In the Commission to Melchiorre di Gasparo Salamon as *Podestà* of Este, the background shows the rector with his large entourage moving towards the *castello* of the town (fig. 6.2).[8] The leaf detached from the Commission of Lorenzo di Jacopo Moro "da San Fantin" (1521–1568), elected in 1558 as *Provveditore generale* of Dalmatia, portrays Moro in procession on a magnificent white steed accompanied by a large retinue, perhaps as a representation of his imminent entry into the region (fig. 6.3).[9] The choice to show him on a horse may have been

6.3 Giorgio Colonna (attrib.), Leaf detached from the Commission to Lorenzo di Jacopo Moro as Proveditor General of Dalmatia, 1558. 22.3 x 16.2 cm. Wildenstein & Co., New York

inspired by Titian's great equestrian painting of Charles V at Mühlberg, of 1548, and now in the Prado. As described in the account of Paolo Contarini's journey to Verona, in many cities the official commencement of a rector's reign was a ceremony in which he was handed a staff, or baston, of command from the outgoing official.[10] This event was depicted symbolically in some Commissions, as in a detached leaf from a document for a member of the Belegno family (fig. 6.4).[11]

The ceremonies for the departure of a rector were even more elaborate than those for his inauguration, and these occasioned publicly delivered panegyrics, and ephemeral

and permanently installed works of art, often commissioned under a decree of the communal council of the subject city. A copy of the text of the encomium to the rector typically was given to him as a finely scripted manuscript, or in copies of a small-run printed edition.[12] Such ceremonies gradually became splendid events, depending on the region or city. A pamphlet commemorating the inauguration of the bust by Giulio del Moro of Vincenzo di Domenico Cappello (1522–1604), upon his departure as Rector of Belluno in 1599, describes the many tributes to him, including numerous triumphal arches, paintings, and coats of arms on house façades.[13] Vincenzo's Commission for this post, by contrast, is elegant but simple, with border roundels of Justice and Peace.[14] On returning to Venice, each rector gave an assessment of the region and his work there in a formal address, called a *relazione*, presented to the Senate.[15]

PORTRAITS AND MEMORIALS OF RECTORS ABROAD

In his book on the ideal image of the rector, Giovanni Tatio urged regional rulers to leave memory of themselves to posterity by acting with magnificence, and by creating virtuous works. Most likely in part to promote his profession as a writer, he counseled that the best way to "keep the memory of the rector alive" lay in written eulogies, rather than coats of arms painted or sculpted on monuments. In the latter case, Tatio was referring to the common practice of rectors leaving memorials with their arms or ensigns in painting or sculpture, in public locations of the cities they governed.[16] Through supervision of public works and the commissioning of art, Venetian rectors left their mark on the subject cities of Venice visually, as well as through governance and trade. They oversaw the building

6.4 *A Rector (probably Alvise Belegno) Receives the Baston of Command*, leaf detached from a Commission, late 16th century. 21 x 15 cm. British Library, London, Add. MS 20916, 25

of fortifications, as well as the construction and decoration of government buildings, and sought to leave at least a plaque or coat of arms to commemorate their service.[17]

For example, while Giovanni Badoer, whose Commission was discussed in the last chapter (fig. 5.29), was *Podestà* of Padua, he and Giovanni di Damiano Moro (1493–1539), his co-ruler as captain, oversaw completion of the new entryway to the Palazzo del Capitanio (figs. 6.5, 6.6).[18] After the War of the League of Cambrai (1508–16), as part of the effort to re-establish Venetian authority in Padua, the appearance of this building and the entire Piazza dei Signori had been transformed. The Palazzo del Capitanio, newly restored as the seat of the Venetian captain, originally had been the seat of the former ruling Carrara family, which remained a referent of identity for rebel noble Paduans in the sixteenth century. The entry was rebuilt to the design of Giovanni Maria Falconetto as a triumphal arch, and Badoer and Moro were allowed to have their coats of arms held up by two heralds framing the base of the future

6.5 (Above) Commission to Giovanni di Damiano Moro as Captain of Padua, 1531. 22.5 x 15.6 cm. British Library, London, Add. MS 21414, fol. 1r

6.6 (Right) Entry gate to the Palazzo del Capitanio, Padua, with pages holding coats of arms of *Podestà* Badoer and Captain Moro, c.1532

clock.[19] The entrance thus was recast through the classical language of the triumphal arch into a sign of Venetian sovereignty, in the space next to the Loggia del Consiglio, where the local Paduan assembly met. The individual patricians Badoer and Moro were encouraged to leave their mark as rulers on the city in the context of the larger imprint of the state.

Through administrating such public works, rectors thus were afforded a public space to display individual and family prominence in relation to the state in ways they could not in Venice. In fact, in 1479, the *savi di terraferma* stated that the desire to have one's name attached to a building or restoration work was so great that rectors were creating unnecessary projects just so they could have their heraldry attached. They legislated that only the simplest of coats of arms, costing less than 2 ducats, whether painted or sculpted, could be affixed to buildings and constructions. A new law of 1489, passed by the Council of Ten, created greater restrictions that now only allowed the rector to attach his coat of arms to the interior of his residence abroad, and specified that it could only be painted and not sculpted. The prescribed penalties for displaying one's heraldry publicly were harsh: a fine of 500 gold ducats and a ban on taking office for five years.[20] Nevertheless, despite the passage of time and degradation of many exterior surfaces, numerous patrician coats of arms with inscriptions throughout Venetian territories attest to the fact that this law generally was ignored.

In 1533 a resolution by the *Pregadi* (the Senate) then complained that rectors were spending state funds to construct unauthorized adornment of palaces and public works, to the extent that locals employed by Venice were not receiving their salaries.[21] Further resolutions restricting the self-presentation and memorialization of rectors were passed by the *Pregadi* many times during the sixteenth and seventeenth centuries.[22] The inefficacy of these restrictions is suggested by the fact that in 1592 the *provveditori alle pompe* began to require newly elected rectors to verbally take a vow to observe the sumptuary regulations, and in 1609 rectors had to record their vow in writing in a register maintained by the *segretario alle voci*.[23] New legislation "against the pomp of rectors" was issued again in 1691, which even encouraged locals to remove previous inscriptions and coats of arms.[24] But many of these still remain, for over time there was indeed a massive accumulation of projects sanctioned by Venice and the marks of individual rectors show that these sumptuary laws generally were not enforced, or patricians were happy, even proud, to pay the sumptuary penalty, a process known in Venice as to *"pagar le pompe."*[25]

TESTING THE LIMITS OF PRIVILEGE AND REPRESENTATION

Projects that overly glorified an individual patrician at state expense sometimes were symptoms of a particular rector's general sense of entitlement, which eventually could cause him personal ruin. Nevertheless, the collection of illuminated Commissions documenting only the glories of a patrician's career could maintain a patrician's positive reputation, at least within his family. Such was the case of Paolo q. Giorgio Nani "dalla Bavola" (*c.*1478–1551). He was born to wealth and connections, for his mother Elena was a daughter of Doge Agostino Barbarigo. Nani perhaps was instructed in the projection of princely rule by the example of his grandfather, the doge, whose regal behavior was discussed in Chapter 3.[26] But in his early career he practiced some acts of apparent selflessness. In the summer of 1513, he burned down the palace in Padua that he had inherited from his grandfather, so that it could not become a stronghold for the enemy during the War of the League of Cambrai.[27] Nani's expertise in military operations was highly valued, gaining him elections to numerous

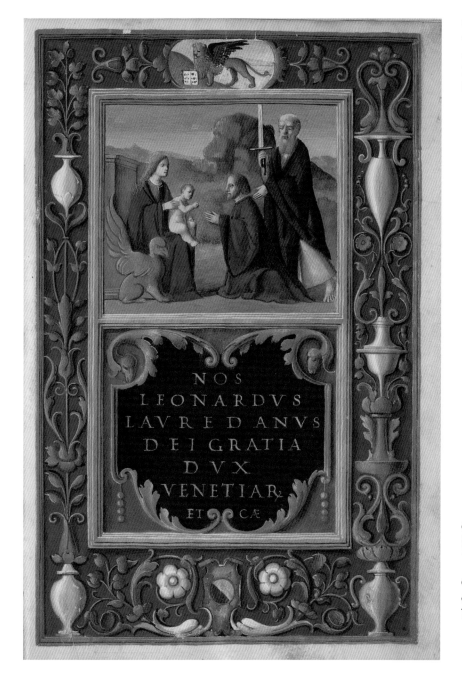

important posts in various capacities early in his career. Marin Sanudo clearly was impressed with reports of Nani's entry into Treviso as captain and *podestà* on Sunday, July 28, 1517, which the author described as "most dignified" and "at great expense."[28] The new rector made the journey to the city, before the regulations limiting the magnificence of such entries were legislated,

with fifteen carriages, and his entourage was greeted by citizens and officials on 400 horses and in twenty-four carriages. A sumptuous dinner followed in the Palazzo della Ragione, the building where the local Great Council of Treviso met regularly with the rector.[29] The next day all of the *cittadini* of Treviso were served food in silver settings, and were entertained with music

"so that it was a most excellent entrance," wrote Sanudo.[30] The opening leaf of Nani's Commission for this post has a miniature votive painting of him in which his patron saint, Paul, presents him to the enthroned Virgin and the Christ Child (fig. 6.7).[31]

Nani took office in Treviso shortly after the conclusion of the War of the League of Cambrai. At the beginning of this war, Venice temporarily lost almost all of its territories on the *terraferma*. In addition to the restructuring of such symbolic loci of powers as the main piazza and public palaces of cities, repair and fortification of *terraferma* holdings became foremost among Venetian concerns and major construction projects were initiated. The revived construction of city walls and magnificent gates emulating ancient Roman fortifications were intended for both practical defense and as visual markers of territory, meant to claim Venice as heir to imperial Rome.[32] Nani participated in overseeing the completion of the great walls of Treviso from the bastion of Santa Sofia to the Porta San Tommaso. But Nani and his immediate predecessor as rector, Nicolò di Paolo Vendramin (d. 1518), tried to immortalize their names by changing the titles of two portals of the Treviso walls after themselves, from Porta San Tommaso and Santa Quaranta to Porta Nani and Porta Vendramin.[33] In doing so, they blatantly overstepped the Council of Ten's regulations of 1479 meant to minimize the over-representation of individual Venetian patricians in subject cities.

Nani's successor as *Podestà* and Captain of Treviso, Francesco di Pietro Mocenigo (d. 1534), was charged in 1518 to investigate the name change of the portals. He confirmed it, stating that a title in bronze relief atop the Tommaso portal announced: "Paolo Nani, son of Giorgio, relative of Doge Agostino, Praetor and Prefect, made this."[34] In addition, Mocenigo found that outside the city, down the road that passed through the gate, there was a large marble pillar with the inscription "here terminates Via Nani." In other words, Nani even had a main road into the city renamed after himself.[35] A statue of Thomas à Becket was ordered atop the gate, and the name was changed back to San Tommaso, which it is called today. The statue crowning the gate, however, remains one of Saint Paul with his sword and book. In fact, the saint's name still is inscribed on the base in capital letters, and Nani's coat of arms remains embedded in many of the sculptural decorations (figs. 6.8, 6.9). In addition,

6.10 (Left) Votive relief of Paolo di Giorgio Nani, Porta San Tommaso, Treviso, 1518

6.11 (Below) Francesco Lignamine, *Ad Illustris. P. Ven. Paulum Nanum Tarvisii Praetorem Praefectum Q. Liber ...* 21.9 x 15.1 cm. Harvard, Houghton Library, Cambridge, MA, MS Typ 168, fol. 1r

a votive relief sculpture featuring Nani, a kind of monument on an outdoor public structure that was strictly prohibited, has survived inside the arch under the vault (fig. 6.10). In this relief, as in his Commission, Nani is presented to the Virgin and Child, but here by Liberale, the patron saint of Treviso, identifiable by his attributes of a wreath of roses and the Treviso flag. On the right, Nani's only son Agostino (1508–1585) is presented by Mary Magdalen and Saint George, the patron saint of his grandfather. By promoting all three generations in inscriptions and images, Nani claimed the state-funded gate as a family memorial similar in dynastic glorification to the tomb monuments of Venetian churches.

Locals seeking favor or patronage could encourage or praise such vanity projects by patricians. It is not known who created the sculptures of the Porta Nani, but a "Petrus" is named as carving the lion in a lengthy laudation of the patrician by the Trevisan Francesco Lignamine.[36] A manuscript of this text survives, which must have been a copy presented to Nani because it bears his coat of arms (fig. 6.11).[37] The illuminator placed the Nani coat of arms in front of a view of Treviso at the base of the page.

At the top, a lion's head visually links the text to the gate, making the manuscript a kind of souvenir for Nani of the monument in Treviso.

The penalty meted out to Nani for overstepping the boundaries of representation and memorialization, an order to erase references to him on the gate, was minimal and never executed fully. But the temptation to aggrandize himself and take advantage of his positions of power eventually would have graver consequences. Despite his overweening promotion of himself in Treviso, Nani was elected Captain of Bergamo in 1521. In the document for that mission Nani again chose to be depicted in prayer to the Virgin and Child as he is presented by his homonymic saint (fig. 6.12).[38] The grotesque of a male harpy, a winged serpent with a man's head, emerging from the helmet over the coat of arms, imitates that sculpted on the Treviso portal beneath Nani's coat of arms (fig. 6.9), and must have been an element of his device.[39] He subsequently was elected Captain of Verona in 1523, and finally *provveditore generale* of the *terraferma* in 1529–30.[40]

But in 1531 Nani was tried, tortured, and condemned for grave abuses of his power during his governorships at Bergamo and Verona, and as *provveditore generale*. Offences mainly involved financial graft. Sanudo recounted forty-one charges, down to Nani's alleged maintenance of six musicians of the *piffaro* instrument at the expense of the state.[41] He was eventually condemned to permanent exile in Capodistria. His son Agostino also was tried and condemned for destroying the evidence contained in his father's accounts, but eventually was exonerated when he produced the relevant ledgers. Agostino's presentation of the evidence, however, did not exculpate his father.[42] After Paolo Nani died in 1551, Agostino created a tomb for his father and for his paternal grandfather Giorgio in the now destroyed Carthusian monastic church of Sant'Andrea del Lido.[43] Although nothing is known to have survived of this tomb and chapel, Sansovino described the Nani chapel

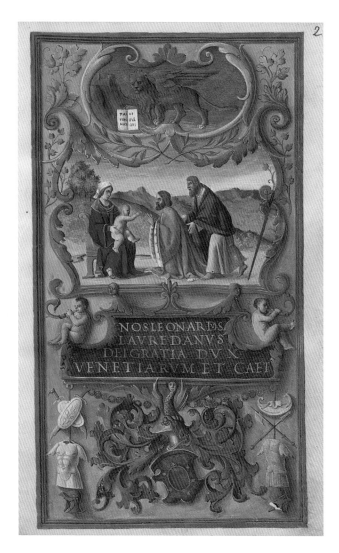

6.12 Benedetto Bordon (attrib.), Commission to Paolo di Giorgio Nani as Captain of Bergamo, 1521. 21.5 × 14.3 cm. Österreichische Nationalbibliothek, Vienna, Cod. Ser. N. 1778, fol. 2r

as "truly regal."[44] A history of the family written by Bernardo di Antonio Nani (b. 1712) in 1734 provides only the highlights of Paolo Nani's career, with no mention of his exile. Bernardo included a drawing of the San Tommaso gate of Treviso, which he labeled with the prohibited term "Porta Nana [sic]."[45] The illuminated documents and narratives in the family archives preserved an immaculate image of service to God and the state, belying a state record of corruption and disgrace.

6.13 Jacopo Bassano, *Matteo Soranzo's Votive Painting as "Podestà" and Captain of Bassano,* c.1537. Oil on canvas, 153 x 249 cm. Museo Civico di Bassano, inv. 7

COMMISSIONS AND PATRONAGE BY RECTORS WHILE IN OFFICE

Ultimately, Paolo Nani was punished only for consistent and extensive financial graft and corruption. The transformation of the Treviso gate into a memorial to him, probably at state expense, remains mainly intact, as do numerous other similar projects by patricians. But rectors also legitimately could commission works of art at their own expense as memorials to adorn the interiors of state buildings, similar to the process by which magistrates in Venice commissioned paintings in their offices of the Ducal and Camerlenghi Palaces. In addition, rectors could have works created for the interiors of sanctuaries and churches upon obtaining the relevant *jus patronatus.* Local artists, including Jacopo dal Ponte, called Bassano, and his family workshop in Bassano, often benefited greatly from such patronage by rectors. They executed paintings for the Palazzo Pretorio in the city, and for works that patricians also brought home to Venice. One important example is the painting by Jacopo of *Podestà* Matteo di Zaccaria Soranzo (1504–?1551), intended for the Palazzo Pretorio, which celebrates him and other members of his family,

and demonstrates how much more casual the public presentation of a Venetian official could be in the subject territories (fig. 6.13). Soranzo is shown in the traditional pose and official dress of a Venetian patrician in devotion to the Madonna and Child, but it has been proposed that in this highly original painting, his brother Francesco and daughter Lucia also are represented. The *podestà* and captain Matteo is presented by Saint Matthew, while the angel, an attribute of Matthew, holds a book. Matteo's daughter Lucia is shown playing with her dog as her patron saint, Lucy, offers her palm of martyrdom to the Christ Child, as if to distract him.[46] Such informal representation of a patrician with family members was not countenanced in state buildings in Venice in this period, but reflects study of family portraits for churches in Venice, especially Titian's Pesaro altarpiece in the Frari of 1519–26.

The location of Matteo Soranzo's Commission as *Podestà* and Captain of Bassano is not known, but the way that paintings in these documents could anticipate the themes of public monuments commissioned abroad is exemplified in the miniature of the document of Lorenzo di Pietro Cappello (1543–1612), elected *Podestà* and Captain of Bassano in October of 1588

(fig. 6.14).[47] The miniature easily could have been painted in Venice sometime before Lorenzo left for his post, for he was scheduled to arrive in Bassano only four months after election, in February of 1589. Lorenzo is portrayed in the miniature in devotion to the Madonna and Child with his two young sons Giovanni and Pietro. Giovanni was born in 1581, and is clearly the elder of the two boys shown. The younger Pietro was born in 1584, and would have been about five at the time this portrait was made.

Sometime during Lorenzo's tenure as *podestà* in Bassano, he also commissioned a large votive painting from Leandro Bassano, Jacopo's third son (fig. 6.15). It was completed the day before

6.14 (Left) *Lorenzo di Pietro Cappello, with Sons Pietro and Giovanni,* leaf detached from his Commission as *"Podestà"* and Captain of Bassano, elected 1588. 20 x 11.8 cm. Biblioteca Laurenziana, Florence, Ashb. 1096

6.15 (Below) Leandro Bassano, *Lorenzo di Pietro Cappello's Votive Painting as "Podestà" and Captain of Bassano,* c.1589. Oil on canvas, 176 x 298 cm. Museo Civico di Bassano, inv. 27

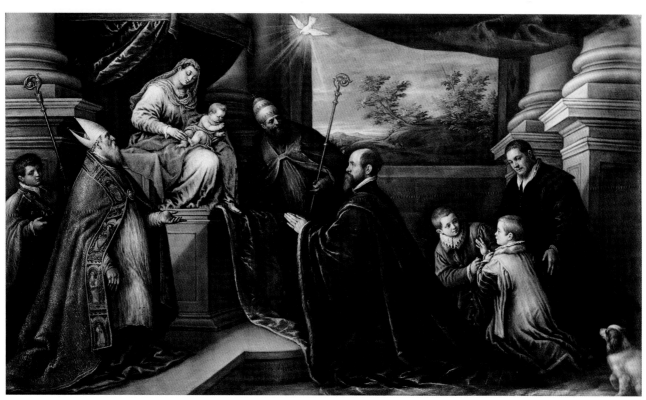

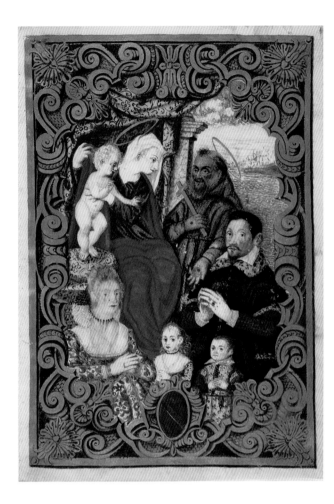

6.16 Commission to Francesco di Francesco Gradenigo as Proveditor of Peschiera, 1610. 23.1 x 17.1 cm. Biblioteca Nazionale Marciana, Venice, It. VII, 741 (=7507), fol. 1r

quiet as they play behind their father, or perhaps begin to pray, while a small dog looks on with one paw raised, as if pleading to join in.[50] The children wear the same colored garments in the miniature and the oil painting. The face of the younger son is almost identically conceived in both works.[51] The painting within the document recording assent to office, then, was a relatively private version, archived at home, of the public monument abroad.

Such family portraits in Commissions are rare, and can be interpreted as commemorating the entire family and the request for divine protection before setting out on the journey to the foreign post. One important example is in the opening miniature to the Commission to Francesco di Francesco Gradenigo (1576–1614) as Proveditor of Peschiera, in which he is shown with his wife Francesca di Bernardin Loredan, his first daughter, and his two-year old son Leonardo (fig. 6.16).[52]

Service in outlying cities also offered patricians the opportunity to patronize local artists for works not intended for public display abroad, but to bring back to Venice, and these can display continuity of themes with paintings in Commissions. Pietro di Giovanni Andrea Pizzamano (1512–1571) took advantage of his tenure governing Bassano to commission a painting of *The Miraculous Draught of Fishes* from Jacopo Bassano, and subsequently it probably hung in the family palace on the Giudecca (fig. 6.18).[53] In his Commission for the Bassano post, Pietro is shown in prayer to the Virgin and Child (fig. 6.17). The scene is set with a view in the far distance of Bassano. His name saint, Peter, holds a book in the right-hand cartouche. Themes of the opening leaf of his subsequent Commission as Rector of Sitia (on Candia, or Crete) (1544) (fig. 6.19) more closely

6.17 T.° Ve Master (attrib.), Leaf from the Commission to Pietro di Giovanni Andrea Pizzamano as *Podestà* and Captain of Bassano, 1544. 22.5 x 15 cm. British Library, London, Add. MS 20916, fol. 6r

Cappello left his post on June 7, 1590.[48] This painting was hung in the Palazzo Pretorio to join the portrait of Matteo Soranzo with his family members. As a votive portrait featuring children at play, Cappello's painting is indebted conceptually to the earlier one of Soranzo.[49] Lorenzo Cappello is blessed by the Christ Child as he is presented by two patron saints of the city, Bassiano to his right, and to his left Clement. A few years later, the church census of 1593 recorded the widower Lorenzo living with his family in Venice, in the parish of Santa Maria Formosa, with a M. Giovanni as "*maestro di scuola*," and it seems that such a teacher is trying to keep the two boys

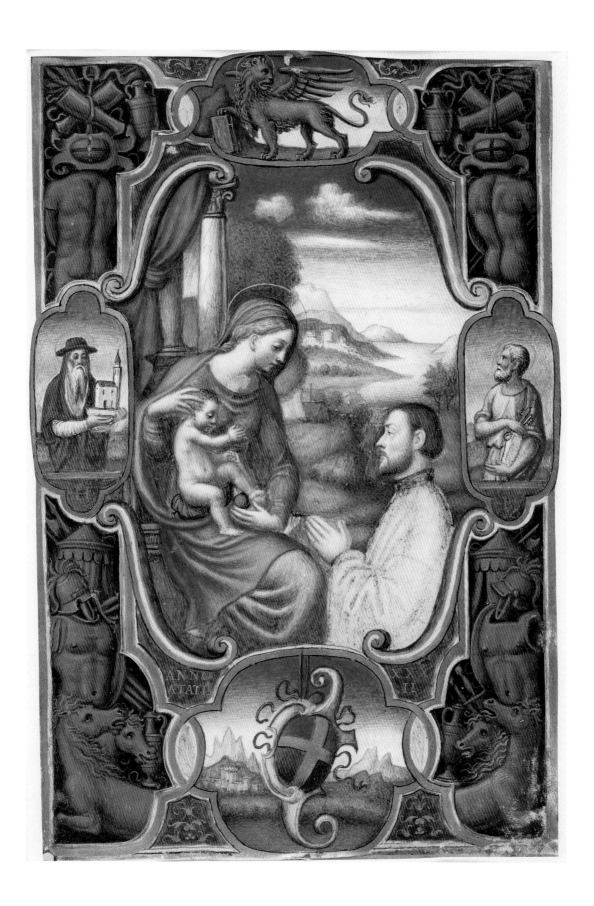

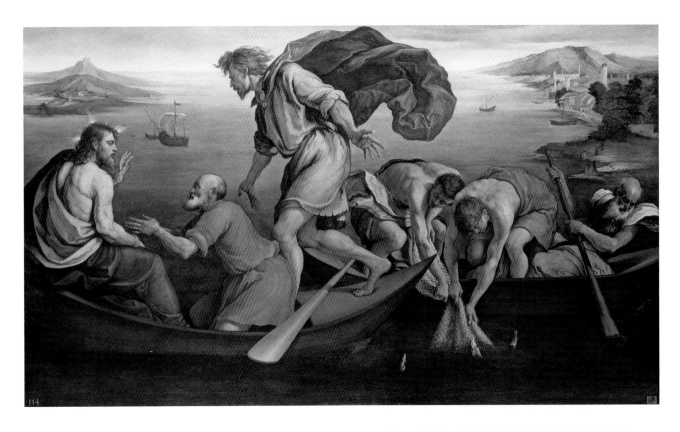

6.18 (Above) Jacopo Bassano, *The Miraculous Draught of Fishes*, 1545. Oil on canvas, 143 x 243 cm. National Gallery, Washington, D.C., Patrons' Permanent Fund 1997.21.1

6.19 (Right) T.° Ve Master (attrib.), Leaf from the Commission to Pietro di Giovanni Andrea Pizzamano as *Rettore* of Sitia (on Candia, or Crete), 1544. 23 x 16.7 cm. Private collection

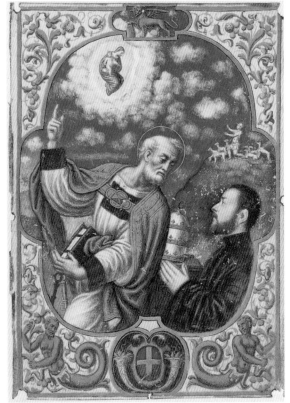

correspond with the interests shown in his purchase of the painting from Jacopo.[54] In the painting – as in the composition model for it, a chiaroscuro print by Ugo da Carpi after Raphael's composition for a Sistine Chapel tapestry of the same subject – Andrew is the most prominent figure, set in the middle of the composition with his cloak blown out by the wind. But Pizzamano's onomastic saint, Peter, is shown closest to Christ, and their exchange of glances illustrates the highlight of the narrative, when Christ responds to Peter's astonishment and self-recrimination, "Do not be afraid; henceforth you will be catching men."[55] Francesca Montuori

has argued that Jacopo's painting can be read as "suggesting that the Church could avoid schisms and return to guide all of Christianity by assuming the same attitude of faith and humility as that of Peter." The Pizzamano family owned much land in the region, and Pietro's brother Francesco (1507–1579) was an ecclesiastic in Bassano during Pietro's tenure there. While *podestà*, Pietro advocated that Rome restore attention to the parish.[56] Montuori's reading of the painting as reflecting Pietro's direct appeal to Rome and sympathy with the papacy is reinforced if we observe that in his subsequent Commission as Rector of Sitia, Pietro is guided by and seeks direction from Saint Peter, now vested as pope (fig. 6.19). One can consider the paintings in *ducali* not only as a component of self-presentation, but also as a stage in thinking visually over time about one's religious and political identity.

THE CUSTOMS AND COSTUME OF THE RECTOR

The conflicting goal of the patriciate as a collective to rein in the splendor of a rector, with the desires of some Venetians to live lavishly and as lords, is encapsulated by a resolution of 1549 in the Great Council that repeated many earlier ones concerning the image and presentation of the rector while in office. These included that he not accept gifts or create public festivals, that he not adorn his house with gold, silver, and velvet, and that he not retain more than a few horses.[57] Such regulations indicate that patricians indeed were doing all of these things. But some portraits of them in Commissions and in larger scale paintings suggest that there were regional conventions of the costume and comportment of rectors, and that they could adopt more informal attire abroad while still projecting an air of power and privilege.

Patricians usually were portrayed in their Commissions dressed in the heavy gown with voluminous sleeves called the *vesta* or toga. But in the second half of the sixteenth century, especially

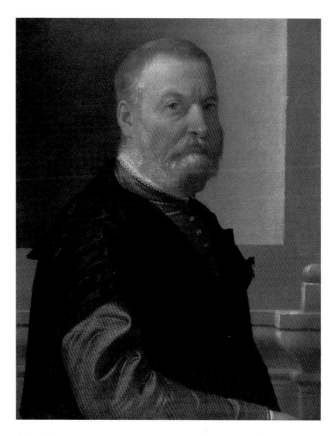

6.20 Giovanni Battista Moroni, *Portrait of Vettor di Marcantonio Michiel as "Podestà" of Clusone*, 1561. Oil on canvas, 66 x 51.5 cm. Kunsthaus, Zurich, Betty and David Koetsen Stiftung, inv. N. KS-44

in the Bergamasque territory, the status of rectors could be conveyed by more casual attire, both in independent oil portraits of them, and in their Commissions. An early example in oil is the portrait by Giovanni Battista Moroni of Vettor Michiel of 1561, as *Podestà* of Clusone, near Moroni's home in Albona (fig. 6.20).[58] We already have examined Michiel's Commission as *Podestà* and Captain of Mestre of some ten years earlier (fig. 5.39). Again, as son of the prominent chronicler of art Marcantonio Michiel, Vettor would have been well-informed about artists to seek out while serving abroad. Moroni was the pre-eminent painter of the region at the time. In fact, according to Carlo Ridolfi, Titian suggested that Venetian rectors sent to Bergamo, while there, "have themselves portrayed by Moroni

because he will paint them true to nature."[59] Vettor wears what Vecellio illustrated in his 1590 costume book and described as the clothes of a "patrician at home": A doublet in a luxurious red and a black open *zimarra* robe over it (fig. 6.21).[60] Such casual wear, similar to that worn by locals, was apparently acceptable for officials on post outside the city. A number of Commissions of the second half of the sixteenth century show them in the same costume, as for example in a detached leaf for a member of the Tron family (fig. 6.22).[61] An illustration of the general category of a Venetian *podestà* was painted into a copy of Doglioni's *La città di Venetia* of 1614. It depicts a man in the same dress, waving his Commission as a more determinant signifier (fig. 6.23).[62]

Another important portrait by Moroni of a rector in such attire is that of Antonio di Francesco Navagero (1532–1587) as *Podestà* of Bergamo, painted sometime during Navagero's tenure from 1564 to 1565 (fig. 6.24).[63]

6.21 (Above) Cesare Vecellio, *A Venetian Noble at Home*, from *Habiti antichi et moderni di tutto il mondo* (Venice: Sessa, 1598), fol. 85v. Woodcut. University of South Florida, Tampa, Special Collections, GT509.V43 1598

6.22 (Right) *A Patrician Prays to the Virgin and Child (with Saint Christopher?)*, leaf detached from a Commission to a member of the Tron Family. 21.5 x 15.5 cm. Huntington Library, San Marino, EL 9, H13, 6

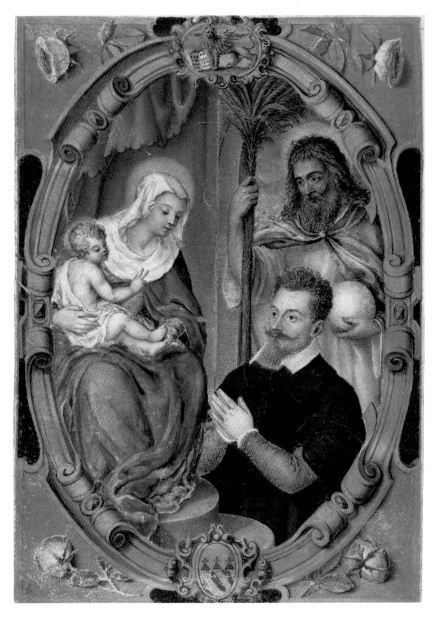

The inscription in the lower right of the painting claims that as *podestà* Navagero sustained the subject city.[64] This probably refers to his overseeing of the building of walls around the upper part of Bergamo, begun in 1561 under Venetian direction in response to French and Spanish invasions, and to his efforts to rebuild the economy and social structure, as he outlined in his *relazione* upon return to Venice. In Moroni's portrait of Navagero, a sense of the sitter's confidence, vitality, and power is accentuated by the codpiece revealed by his open fur-lined *zimarra*. The informal dress reveals anatomy completely hidden under the toga of office worn in Venice.[65] The virility emphasized by his costume supports visually the sense of the inscription emphasizing his revitalization of the city.

Another portrait by Moroni of a rector of 1575 has a confusing later inscription identifying the sitter as Jacopo Contarini, *Podestà* of Padua (fig. 6.25). Jacopo Contarini never was *Podestà* of Padua. The portrait could portray Jacopo Foscarini, who was *podestà* of the city in 1578, but more likely it represents Jacopo di Pietro Contarini (1536–1595) of the San Samuele branch (called delle Figure), who was elected *Podestà* of Bergamo in 1577.[66] Whereas Navagero was identified as a rector through an inscription in the lower right of the painting, here Contarini's status is proclaimed by the Commission manuscript, with its prominent tassel and ducal seal, projecting out towards the viewer on a ledge in the lower right field.

Unfortunately, the location of Contarini's document is not known. It would be extremely interesting to know the nature and extent of the painting in it, for Contarini was one of the great collectors and patrons of art, architecture, the sciences, and books of the second half of the sixteenth century in Venice.[67] It was he who owned a bronze copy of the Grimani Vitellius bust, discussed in relation to Giovanni Badoer's Commission as *Podestà* of Padua in Chapter 5. His Commission document, with its fine

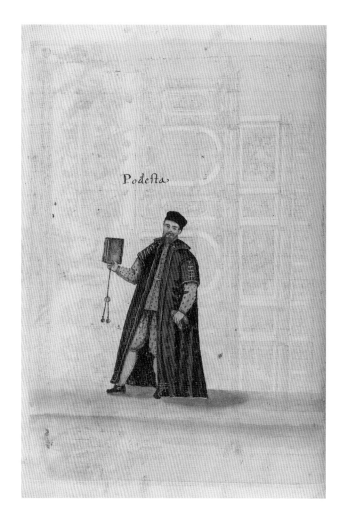

6.23 *A podestà*, miniature in G. N. Doglioni, *La città di Venetia con l'origine e governo di quella* (Venice: Antonio Turini for Giacomo Franco, 1614), fol. 15v. Pierpont Morgan Library, New York, PML 76228

binding and perhaps a portrait, would have found company among the books, antiquities, manuscripts, and scientific instruments of what constituted in essence a private museum in his home. With Jacopo di Antonio Marcello (1540–1603), under the guidance of Girolamo Bardi, Contarini also wrote the program for the redecoration of the Sala del Scrutinio and Great Council after the fire of 1577 in the Ducal Palace.[68] In addition, he oversaw the decoration of certain rooms in his palace at San Samuele, the Palazzo Contarini delle Figure, where Contarini

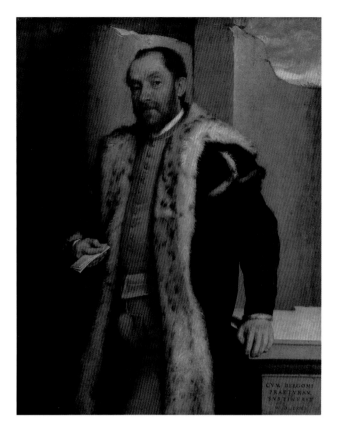

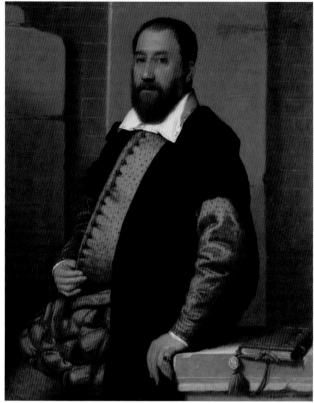

6.24 (Above left) Giovanni Battista Moroni, *Antonio Navagero as "Podestà" of Bergamo*, c.1564-65. Oil on canvas, 115 x 90 cm. Pinacoteca di Brera, Milan, inv. 334

6.25 (Above right) Giovanni Battista Moroni, *Jacopo Contarini (?) as "Podestà" of Bergamo with his Commission*, c.1578. Oil on canvas, 105 x 84 cm. Museum of Fine Arts, Budapest, inv. 53.501

probably intended this portrait to hang.[69]
If Contarini had his Commission as *Podestà* of Bergamo illuminated, the paintings would have been a component of his thinking visually about the ideals of the Republic, exercised also in the formulation of the program to redecorate the Ducal Palace. Whereas the program for the palace was to represent the patriciate as a group in relation to ideals of state, paintings in Commissions expressed personal responses to these concepts.

In Contarini's long *relazione* of 1579, he highlighted the poverty of the people of Bergamo and the general disorder in the region. Contarini

emphasized that he rewrote the statutes of the city in part to expand his power by giving the *podestà* the same larger scope of authority as a judge, as was already in effect in Brescia.[70] The painting by Moroni of Contarini effectively conveys a man at ease, but also one of power and authority vested in him by the state, and certified by the ducal seal so clearly shown on his document. By contrast to such informal wear worn by patricians on the *terraferma*, Vincenzo di Leonardo Dandolo (1548–1632) had himself portrayed magnificently as Consul of Alexandria in gold brocade with lynx fur, reflecting the different conventions of costume for that office and region (fig. 6.26).[71]

It seems that along with more casual dress, a closer relationship to Venice personified could be imagined in Commissions than that suggested by the remote and imperious figure typically portrayed in public monuments. *Venetia* is figured, even as if a patron saint, in two detached leaves for Alvise di Giovanni Maria Muazzo (1540–1616) as *Podestà*

of Albona and Fianona in 1587, and probably as Proveditor of Almissa in 1598 (figs. 6.27, 6.28).[72] In the first image *Venetia* is posed so casually and dressed so similarly to a wealthy Venetian matron, complete with the fashionable *corno* coiffure with hair pulled up into horns on either side of the top of the head, imitating a half moon, that it is difficult to completely discount that she could represent his wife Camilla di Marcantonio Malipiero, whom he married in 1574.[73] Additional metaphors of *Venetia* as a family member were invoked in testaments such as that of Marin K. di Sigismondo Cavalli (1500–1573). He advised his sons that until one's death, one could not hope to spend one's life in a more dignified way than in sacrifice to Venice, mother and protector.[74]

TRANS-GENERATIONAL SUCCESS: FAMILY ADVICE AND COMPORTMENT

Marin Cavalli's patronage of the arts and his Commissions, and personal advice to his sons, reveal some of the strategies of patricians to leverage their posts abroad in order to memorialize themselves, and to train their offspring to follow their lead in distinguishing themselves. Marin

greatly increased the wealth of the family, investing in lands especially near Verona and Padua. This, in part, would lead him to a particular concern for the adequate sustenance of the citizens of these cities and their surroundings, and interest in the general economic revitalization of urban centers of the *terraferma*. Like Pizzamano, he was one of many patricians who not only served in the *terraferma*, but whose wealth and identity were greatly vested in it. He was awarded more diplomatic and governing posts than almost any other patrician of his generation.[75]

In his surviving Commissions, as Captain of Vicenza in 1535 and as Captain of Brescia of 1552, the advancement of Marin's status can

6.26 (Below left) Commission to Vincenzo di Leonardo Dandolo as Consul of Alexandria, 1590. 22.4 x 15.5 cm. British Library, London, Add. MS 16996, fol. 1r

6.27 (Below centre) Leaf detached from the Commission to Alvise di Giovanni Maria Muazzo as *Podestà* of Albona and Fianona, 1587. 21.5 x 15 cm. Huntington Library, San Marino, EL 9 H 13, 15

6.28 (Below right) Leaf detached from a Commission to Alvise di Giovanni Maria Muazzo (probably as Proveditor of Almissa, 1598). 21.5 x 14 cm. Huntington Library, San Marino, EL 9 H 13, 13

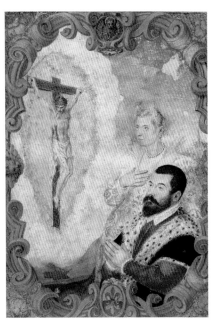
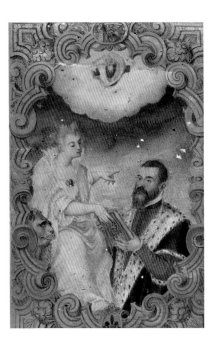

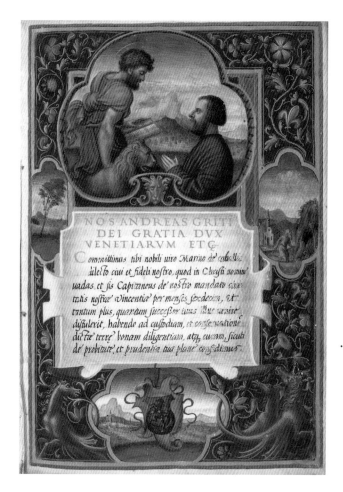

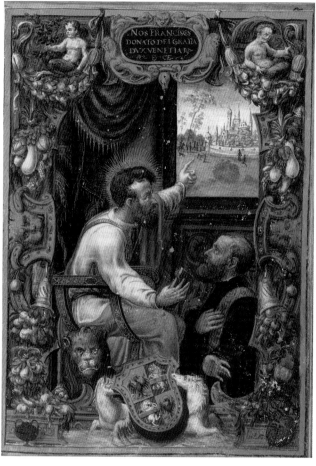

6.29 (Above left) T.° Ve Master (attrib.), Commission to Marin K. di Sigismondo Cavalli as Captain of Vicenza, 1535. 23.8 × 16.6 cm. Collection Médiathèque de Roanne, Boullier 14, fol. 1r

6.30 (Above right) Commission to Marin K. di Sigismondo Cavalli as Captain of Brescia, 1552. 24 × 16.8 cm. Collection Médiathèque de Roanne, Boullier 16, fol. 1r

be observed in his coats of arms.[76] While in both documents he is shown with Saint Mark, the second now shows his coat of arms quartered with the imperial eagle of knighthood granted to him by Emperor Charles V when he was ambassador to the Holy Roman Empire, and he also wears the golden stola of a knight (figs. 6.29, 6.30). Both *ducali* are decorated in the lower registers with cavorting hippocamps, the sea horses of ancient mythology that have fins, and instead of hind legs, terminate in fish tails. Hippocamps had been

incorporated in the classicizing visual vocabulary of Italian artists since the late fifteenth century, most notably in Mantegna's engraving the *Battle of the Sea Gods*. But in Marin's Commissions they were part of his personal emblem, reversing the order of his name to *cavallo marino*, or sea horse. Sea horses do not appear in the *ducali* for other Cavalli family members, and are featured prominently on either side of a cross, on his tomb, which as his testament of 1571 asserts, he commissioned himself.[77]

In his *relazione* as ambassador to France of 1543, Marin recommended further actualization of the economic potential of the cities of the *terraferma*.[78] In 1562 he was elected *Podestà* of Padua, but left his post less than a year later on a mission to define the boundaries between Germany and the Carnia, a region in the western

mountains of the Friuli. A tradition grew in the seventeenth century that claimed the citizens of Padua were so sad about Marin's departure that they commissioned a celebratory portrait of him from Domenico Campagnola to hang in the Palazzo del Podestà (fig. 6.31).[79] But recent scholarship has uncovered records of payment by Marin himself to Campagnola for such a painting. It too, then, was intended as part of a tapestry of self-glorification, both at home and abroad.[80] As in the miniatures of Marin's Commission manuscripts, in the painting for the Palazzo del Podestà Mark plays the critical role as intercessor, in this case presenting him to Christ as savior of the world. In the distance are also depicted the walled city he governed and the territory of which he owned a substantial part.

In his testament, Marin asked his descendants to "always remember that you were born neither signorial rulers nor dukes, but gentlemen of Venice, and to consequently maintain the habits and customs which are praised and approved by the good and prudent of Venice (*sua patria*) ..."[81] In addition to this admonition, he wrote a letter of counsel on how to present oneself and prepare

for the post of ambassador, addressed to one of his sons, probably to Sigismondo (1530–1579) on the occasion of his first turn as a diplomat.[82] This letter was copied and conserved in patrician family archives until the fall of the Republic. From Marin's text, one can get a sense of the personnel, clothing, and household items a rector ideally brought with him when he travelled to his post, and of the general image of himself that Marin, and probably many Venetian patricians abroad on duty, wished to convey. Although the conditions of service and reception of a Venetian ambassador abroad were quite different from those of a rector, the basic needs in order to function effectively were similar, as was the necessity to be organized and to present oneself in a dignified manner in order to carry out one's mission. Preparation of the service staff was especially important "because one cannot emphasize enough how great a source of contentment and consolation to an Ambassador is a well-organized, united, costumed and decorous family [staff], ready to serve and not displease ..."[83] Marin emphasized that the most important praise of an ambassador should be of his humanity, splendor, and prudence. But his manual accords significantly more space to the matters that he stressed were of secondary importance, including a copious table, dignified attire, table settings, and means of transport.[84]

6.31 Domenico Campagnola, *Votive Portrait of Marin Cavalli* (detail), 1572. Oil on canvas, 246 x 715 cm. Originally destined for the Palazzo del Podestà, Padua, now Monastery of Santa Giustina, Padua. Musei Civici di Padova, Inv. 1576-D

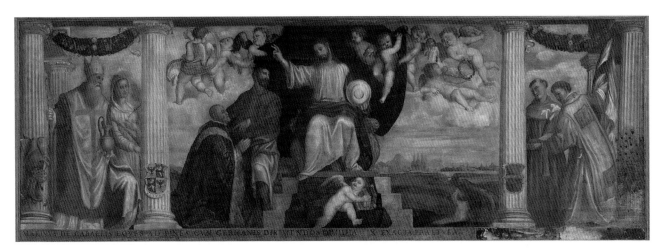

Marin wrote to his son that there were lots of options for clothing and that he, personally, liked to appear well-dressed but not loud. He suggested that one's costume should not cause children and the common people to follow and exclaim as if they were seeing a bear or giraffe.[85] He liked to wear rings, but only one or two, with diamonds or rubies notable more for their quality than size. He recommended that the staff should present a unified front by all wearing the same colors and fabric.[86] In discussing the carriages of the ambassador, Marin suggested they be decorated with various *imprese*, or mottos, and that these looked best if in a foreign language, especially French or Greek.

6.32 Commission to Nicolò "il Grande" di Marco Marcello as *Podestà* of Bergamo, 1557. Each fol. 23.3 x 17 cm. Sächsische Landesbibliothek, Staats- und Universitätsbibliothek, Dresden. Mscr. Dresden. F 169, fols. 1v–2r

Following current theory on emblems, he stressed that the *impresa* should be somewhat difficult to understand. He explained the meaning of his relatively straightforward Latin motto "*Matura*" in the manual. This command to ripen or mature complemented the horse (*cavallo*) in the family coat of arms, which shows speed and pride tempered with reins: impetuousness restrained by prudence and maturity.[87] The *imprese* in the Commission of Nicolò di Marco Marcello (1508–1561), elected *Podestà* of Bergamo in 1557, better follow Marin's advice for opacity (fig. 6.32). These are displayed on a pedestal around Saint Mark, and include such mottos as "*iesper en haut aler*," in a variant of French, on a banderole around a raptor foot with wings. The Latin for "*Now and Forever*," with entwined rings, perhaps more straightforwardly alludes to love and commitment, but the overall significance

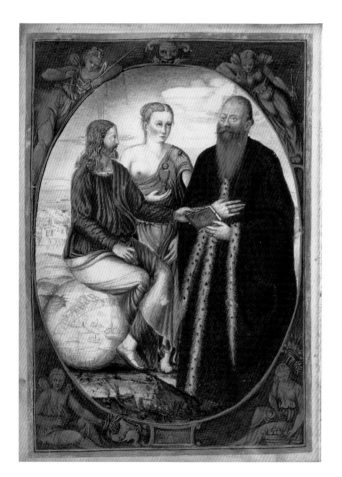

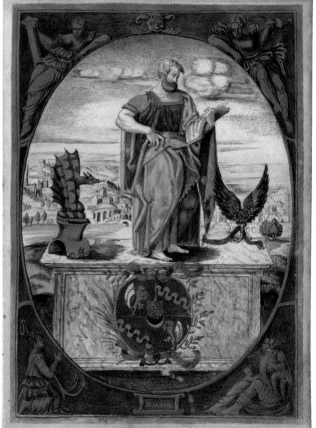

has been lost.[88] Returning to Marin, he ended his discourse by counseling his son that with this advice, he could hope to serve Venice to the honor of himself, his birth, and his elders. In such service one could recompense the dear and most beloved *patria*, to which, Marin admonished his son, they were both in debt.[89]

The general compositional format of Moroni's portrait of Jacopo Contarini (fig. 6.25), including its frank and direct connection with the viewer, and the display of a Commission manuscript as a marker of office, is emulated in the portrait of Marin's son Antonio di Marin K. Cavalli (1538–1601) in his Commission as Lieutenant of Udine of 1582 (fig. 6.33).[90] This and other similar Commission portraits are further examples of the interplay between media in the representation of patricians.[91] Antonio Cavalli's wife, Franceschina di Zorzi Corner, accompanied him to Friuli, but before she departed Venice she dictated her last testament, in which she requested her eventual burial in the Cavalli family chapel, in the northern transept of Santi Giovanni e Paolo.[92] Such careful preparation tacitly acknowledged the dangers of travel and Friuli's reputation for violence.[93]

Marin Cavalli memorialized himself in his portraits in his Commission documents and in works financed while he was abroad. He attempted to train his sons in a patrician ethos and in practical matters of comportment in letters of advice and in his testament, documents maintained in family archives with the Commissions. Whether or not one had one's portrait painted in a Commission may well have been encouraged by family tradition. It may also have evolved through consultation with siblings. In addition to vertical transmission from fathers to sons, brothers also at times worked together to enhance their standing in Venice and its territories. Jacopo Soranzo il Vecchio's simple document as procurator was examined in Chapter 4 (fig. 4.13), but two of his grandsons, Giovanni K. (1520–1603) and Jacopo K. Pr. di

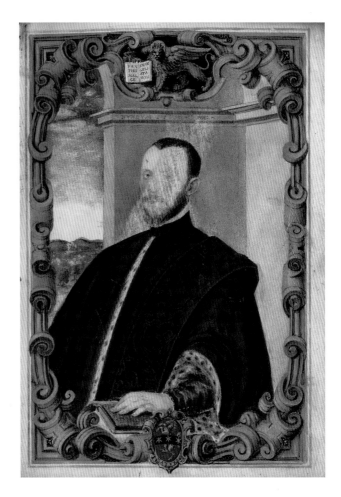

6.33 Giovanni Maria Bodovino (attrib.), Commission to Antonio di Marin Cavalli as Lieutenant of Udine, 1582. 22.8 x 16.5 cm. Biblioteca del Museo Civico Correr, Venice, Cl. III, 868, fol. 1r

Francesco il Giovane (1518–1599), had at least some of their Commissions illuminated with full-page portraits in the 1560s, and eventually were portrayed together on a larger scale, in part to rehabilitate Jacopo il Giovane's reputation (figs. 6.34, 6.37).[94] They especially left a number of images of themselves that negotiated the sometimes treacherous terrain of patrician service.

In Jacopo il Giovane's earliest known Commission, he is shown in prayer to the Virgin and Child, dressed in his gold robe signifying his knighthood (fig. 6.34). The ideals of civic service

and achievement are more clearly highlighted in an oil painting of Jacopo il Giovane as *Podestà* of Padua, a post to which he was elected in 1569 (fig. 6.35). Here he is presented by his name saint, James, to a parade of personified virtues, similar in disposition to those represented in other Commissions of this era, and as actually performed by actors in festival processions, as will be discussed in the next chapter (fig. 6.36).[95]

In 1562, Jacopo's younger brother, Giovanni, was sent as ambassador to Philip of Spain, who knighted him. This honor is emphasized by the golden cloth, the *stola*, which he wears in the portrait of his Commission as *Podestà* of Bergamo of 1567 (fig. 6.37).[96] Two years later, Giovanni was elected councillor to the doge, representing his home *sestiere* of San Polo (fig. 6.38).[97] On the verso of the leaf Giovanni is specified not only as knight

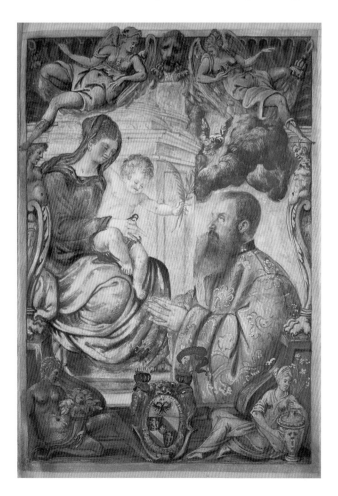

and son of Francesco, but also as relative of the procurator Jacopo di Francesco Soranzo, il Vecchio, his grandfather. These textual precisions suggest that Giovanni was particularly interested in leaving a clear record of his service in the family archives. In fact, there is a distinctive pattern of subject matter in the illumination of the manuscripts recording service as ducal councillor by the Soranzo brothers, in that the miniature of each document only features their respective name saints.[98]

The highlight of Giovanni's political career must have been as ambassador to Rome and his central role in forming the Holy League against the Ottomans.[99] But after a number of other prestigious posts, in 1584 Giovanni found himself and his brother Jacopo accused of being traitors to the Republic. Giovanni was found not guilty, but Jacopo was condemned to exile in Capodistria. Jacopo eventually was pardoned in 1586, but his political career was over.[100] In 1589, Giovanni, as *Podestà* of Padua, commissioned a double portrait from Palma Giovane for the Palazzo del Podestà (fig. 6.39). The risen Christ is framed by personifications of War and Peace, and the text at the base of the painting mentions the plague that afflicted Padua during each of their reigns, and besides memorializing the notion of them as benevolent protectors of the city it seems an attempt to rehabilitate the reputation of Jacopo.[101]

Giovanni continued to have a successful civic career, and was elected procurator *de citra* by merit in 1596, and one of the several other oil paintings of him may have been created for the walls of the *Procuratia*.[102] By contrast to his projects of memorializing himself on the mainland while serving as rector, Giovanni expressed in his last testament of 1599 that he be buried in the Church of Sant'Andrea del

6.34 Mannerist Master (attrib.), Commission to Jacopo K. di Francesco Soranzo il Giovane as *Podestà* of Brescia, 1562. 21.3 x 14.1 cm. Historic-Scientific Archive of the Institute of History at the Academy of Sciences of Russia, St. Petersburg, Coll. 46, carton 56, n. 5

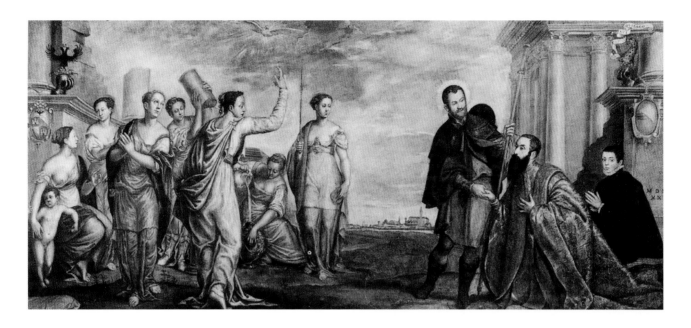

6.35 Francesco Apollodoro (attrib.), *Jacopo K. di Francesco Soranzo il Giovane as "Podestà" of Padua, elected 1569* (painting inscribed 1570). Oil on canvas. Private collection

Lido della Certosa without much pomp, and only a simple inscription.[103] Despite this wish, Giovanni's son, Girolamo, had him memorialized with a portrait bust, cenotaph, and inscription on the façade of the Augustinian Church of Santa Giustina, in a design by Baldassare Longhena (fig. 6.40).[104] This church had become the focus of the annual procession celebrating the victory at Lepanto after 1573, and Giovanni's success in the formation of the League is celebrated in the inscription.[105] The bust and monument to Giovanni was placed in the center, with a similar monument to his son Girolamo, and another to his brother Francesco, with flanking statues of War and Peace, following the precedent of the painting by Palma Giovane commissioned by Giovanni to hang in Padua. The busts and tombs have been destroyed, but the façade was once a magnificent monument to illustrious members of the Soranzo family, with Giovanni as its focal point, created by his son, who would have retained his father's portrait in his Commission at home.[106]

6.36 *The Triumph of Faith and a Parade of Virtues*, leaf detached from a Commission. 22 x 16 cm. Huntington Library, San Marino, EL 9 H 13, 11

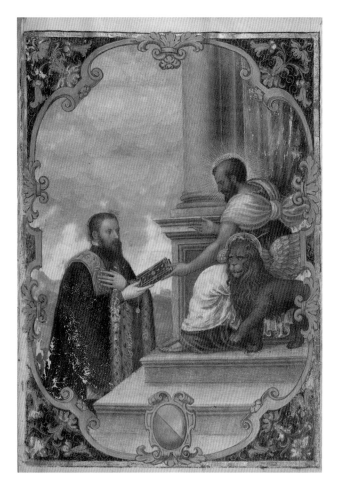

6.37 (Above) Morgan Master (attrib.), Commission to Giovanni K. di Francesco Soranzo as *Podestà* of Bergamo, 1567. 23 x 16 cm. Walters Art Museum, Baltimore, W.493, fol. 1r

6.38 (Right) Giovanni Battista Clario da Udine (attrib.), Commission to Giovanni K. di Francesco Soranzo as ducal councillor, 1569. 24 x 17.2 cm. Yale University, New Haven. Lillian Goldman Law Library, Rare Book Collection, MssJ V55 n. 2, fol. 1v

The ceremonies and duties of service abroad as rectors could be anticipated in the miniatures of their Commission documents. In these small paintings themes often were initiated, providing models for subsequent more expensive and public monuments at home and abroad. The greater range of representation of patricians in these documents by comparison with those for the procurator and doge reflects lesser regulation of the office and of the presentation of the rector.

In the late sixteenth century, the short-lived victory of Venice at Lepanto was critical to patrician identity. Some nobles came to emphasize their willingness to mirror Christ in making the ultimate sacrifice of their life in service to the state, which in the context of wars with the "Turks" was understood as a fight for eternal salvation, not only of Venice but of the world. The next chapter examines the role of *ducali* in such memorialization.

6.39 (Opposite above) Palma Giovane, *Giovanni and Jacopo Soranzo*, c.1591. Oil on canvas, 232 x 555 cm. Formerly in the Palazzo del Podestà, Padua, now Museo d'arte medioevale e moderna, Padua

6.40 (Opposite) Luca Carlevaris, *View of the Church of Santa Giustina* (with Soranzo monument on the façade), *Le fabriche e vedute di Venezia* (Venice: Giovanni Battista Finazzi, 1703), plate 16. Etching. Getty Research Institute, 88-B6282

POST ILLVSTRISS LEGATIONES SVPERANTII FRATRER B PRAETORES TACOBVS ET IOANNES
DEI FRVMENTARIÆ HIC ANNO M D XC RE D P FE

CHIESA DI S. GIUSTINA MONACHE AGOSTINIANE
Architettura di Baldissera Longena

Luca Carlevarijs del: et inc.

16

SERVICE, STATE, AND EMPIRE

VENETIAN POWER IN the Mediterranean and Levant began to decline in 1463 with the onset of the first extended war with the Ottomans. In the second half of the sixteenth century, Venetian dominion overseas increasingly was threatened by Ottoman forces, checked only briefly by the victory of Venice with the Holy League at the famous Battle of Lepanto in 1571. This triumph now generally is considered as having been a momentary upturn in the overall decline of Venetian maritime power, confirmed by the definitive loss of Cyprus by treaty with the Ottomans in 1573. Nevertheless, Christian response at the time was euphoric and the victory was celebrated to an unprecedented degree.[1] The miniatures in Commissions sometimes fixed in more permanent fashion the ephemeral imagery of such festivals and personalized the messages of larger and more public media. In this chapter, the ways in which individual patricians expressed their service to the state in the context of the Ottoman wars of the late sixteenth century will be explored. Some imagery in Commissions of this era responded to the vicissitudes of the empire, and paralleled the increasingly extravagant celebratory rhetoric in festivals and in monumental painting. The figuring of the patrician as a warrior defending not only Venice but also Christendom itself took on increased importance. At the same time that the large walls and high ceilings of the Ducal Palace became renewed fields for such expression of Venetian

civic identity, the leaves within *ducali* allowed for analogous but smaller and more personal imaging, available to more patricians.

THE IDEA OF EMPIRE ON THE EVE OF LEPANTO

The lion of Venice, with paws on both land and sea, symbolized Venice's broader dominion through trade, negotiation, diplomacy, and conquest. More specific messages about the nature of Venice's empire and foreign relations were relayed through a variety of media. In addition to the rituals and festivities for the inauguration of doges and procurators, processions and performances were created for myriad historical occasions, including special diplomatic visits, promulgations of political alliances, or the celebrations of battle victories. Performance, spectacle, and theatre were key components of Venetian life and experience.[2] The programs for recurring rituals and festivities, such as Carnival, incorporated themes and messages reflecting concerns of the moment. Venetians processed for religious festivals throughout the year, and created special celebrations and processions for important state visits and for political statements, as in the *andata* publicizing the anti-French Holy League in Venice of 1495, or of 1511, the celebration of the formation of the Holy League of 1571, and especially the celebrations of the victory of the Battle of Lepanto from October of 1571 to spring of 1572.[3]

A proposal to the patrician officials of the *Rason vecchie* for *Giovedì grasso* (Fat Thursday)

Detail of fig. 7.14

festivities to be held in the Piazzetta in 1570 dramatized the roles of both maritime and mainland territories that played in the Venetian imagination at a moment of extreme vulnerability of the empire.[4] The proposal for fireworks, performance, dance, and theater by a man named Zamaria dalla Schrimia catered to the intense significance to patricians of the empire of Venice and of its governance and preservation, on a day that traditionally celebrated a centuries-old victory over the patriarch of Aquilea.[5] Whereas many of the popular festivities of Carnival celebrated the inversion of the social

order, the proposal to the *Rason vecchie*, meant to please patrician officials and impress the general populace, elaborated on the myth of Venice as guided by infallible leaders under divine protection.

Giovedì grasso festivities came towards the end of a season packed with entertainments for Carnival, which began on the feast day of Saint Stephen (December 26) and ended on the moveable day of *Martedì grasso* (Mardi Gras, or Fat Tuesday), which varies from February 3 to March 9, and marks the beginning of Lent. The central performances and rituals for *Giovedì grasso*, also called *Zuoba di la caza*, or Thursday of the Chase, marked Venice's defeat of the patriarch of Aquilea in the conflict over ecclesiastical jurisdiction of western Dalmatia in the twelfth century.[6] The rituals progressively became more comic and aggressive in the fifteenth and early sixteenth centuries,

7.1 Giovanni Antonio Canaletto, *Performance of the "Labours of Hercules" in Front of the "Soler," or Carnival Stage, During "Giovedì Grasso" Festival before the Ducal Palace*, 1765/66. Ink and gouache on paper, 38.6 x 55.5 cm. National Gallery of Art, Washington, D.C., Wolfgang Ratjen Collection, Paul Mellon Fund, 2007.111.55

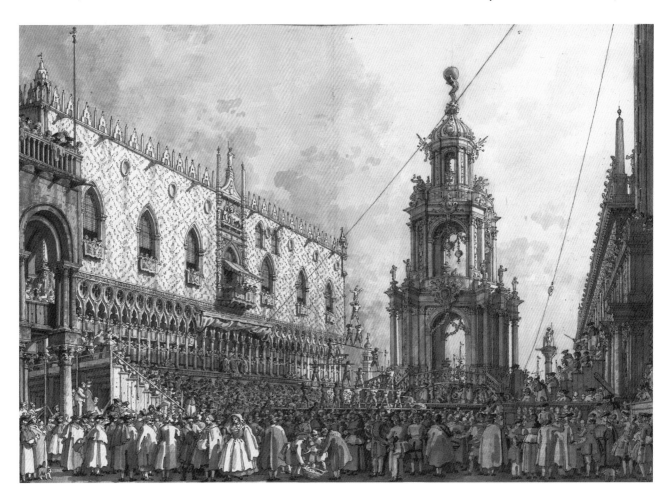

concluding with the slaughter of pigs and a bull, to symbolize the conquest of the patriarch and his allies. Reforms in the early sixteenth century put supervision of the festival in the hands of officials of the *Rason vecchie*, who, nevertheless, did not dispense fully with the slaughter.[7] The proposal to these officials for additional festivities on *Giovedì grasso*, which will be described here in relation to imagery in Commissions, was made at the time of the escalating Ottoman threat to Venetian territories in the Mediterranean, just before the War of Cyprus fought between 1570 and 1573 (the Fourth Ottoman-Venetian War). It was in the battles at sea during this war that the procurator and naval captain Girolamo Zane lost his reputation and status, that Agostino di Giovanni Barbarigo (1518–1571) and Marcantonio di Marco Bragadin (1523–1571) were killed and achieved martyr-like status, while other patricians such as Sebastiano Venier and Francesco Duodo, whose career will be further discussed, would survive and crystallize their careers as devout statesmen and warriors. It is not clear if the program of the spectacle proposed by dalla Schrimia actually took place. It may not have done so, due to the increasing presentiments of war and the insecurity of the overseas territories central to the themes of the entertainment. Nevertheless, the document attests to the rich fount of symbols and allegory of Venetian rule circulating in various media from which artists and patrons could create new themes and compositions.

In the proposal of December 1569, dalla Schrimia envisioned opening the festival with repeated enactments of "most beautiful" assaults by a great battalion of armed men led by Attila the Hun upon Altino, the ancient coastal town of the Veneti. Altino was to magically burn up and disappear completely in the enactment. This was a dramatization of Venice's fragile origins, when in 452 refugees escaping the invading "barbarians" fled the mainland for the lagoon islands.[8] Then an image of the world, in the form of a large globe, was to be set in the middle of the *solaro* (or *soler*), the stage.

7.2 Bodovino and workshop (attrib.), *Venice as Justice with a Globe at her Feet, with Prudence and Fortitude*, leaf detached from the Commission to Daniele di Sebastiano Foscarini as Lieutenant of Udine, 1578. 21.8 × 15.7 cm. Huntington Library, San Marino, EL 9 H 13, 19

This stage, which itself could be elaborate, typically was set up in the Piazzetta or Piazza San Marco for such performances (fig. 7.1). The globe of the world was to open into two parts to reveal a beautifully adorned woman personifying Venice with a unicorn on her lap (fig. 5.50), seated on a triumphal chariot accompanied by a lion and pulled by two "beautifully dressed" women personifying Fame and Peace. This representation of Venice emerging from a globe essentially conflates elements typical of illustrations of Petrarch's sonnets of the Triumph of Love and of Fame, the latter often including a globe and figure of *Fama*, with a general Triumph of Venice.

Triumphal processions were performed throughout Italy in the Renaissance, and were popular themes of paintings and prints.[9] In addition, the image of Venice emerging from the globe was a variation on the theme of Venice ruling the world while seated on a globe, as depicted in the Ducal Palace in the mid-1550s, in the painting by Giovanni Battista Zelotti for the Audience Hall of the Council of Ten, and as reprised in Veronese's image of Venice reigning with Justice and Peace

on the ceiling of the *Collegio*, of the late 1570s (figs. 5.41 and 4.34).[10] A number of Commission miniatures of the 1560s and 1570s also show Venice with a globe at her feet, in addition to portraying her as Justice on a triumphal chariot, accompanied by Virtues, and other variations on these themes (figs. 7.2, 7.3).[11] The miniatures do not illustrate events of such festivals; rather, they were invented from a common language of literary, performed, and monumental sources.

Returning to the proposal, then a figure of Charity, "always queen in this blessed republic," was to exit the globe, followed by the other six Christian and cardinal Virtues of Faith, Hope, Justice, Temperance, Fortitude, and Prudence. As imaged also in *ducali* of the time, these Virtues, in varying order, were to be performed by seven adorned women "who were to present themselves and make reverence to Venice," and then "there will be a

7.3 (Below left) Bodovino and workshop (attrib.), *Venice as Justice Seated on a Lion*, leaf detached from a Commission, date unknown. 21 x 15.4 cm. Huntington Library, San Marino, EL 9 H 13, 18

7.4 (Below right) Morgan Master (attrib.), *Venice as Justice Seated on a Chariot, Attended by Virtues*, leaf detached from a Commission to Nicolò Malipiero granted during the reign of Doge Girolamo Priuli, 1559–67. 22.5 x 16.5 cm. British Library, London, Add. MS 20916, fol. 12

7.5 Bodovino workshop (attrib.), *God the Father Presiding over Charity and Other Virtues*, leaf detached from a Commission to a member of the Venier family, c.1575. 21 × 15 cm. Huntington Library, San Marino, EL 9 H 13, 14

beautiful dance never seen before which will be most pleasing and make all content …" (figs. 7.4, 7.5).

The first part of the performance illustrated Venice as emerging from and triumphing over the world, in peace, by means of the Virtues animating her rulers. The personified Virtues that guided patrician leaders were mutable, living, indeed sometimes dancing, concepts figured across media. The second and third parts of the proposed performance more specifically addressed Venice's concern with her maritime territories.

Neptune and his shell were to appear next, pulled by two old mariners with tridents in hand (fig. 5.27). They were to be presented to Venice:

which will demonstrate her as Queen of the Sea, and a galley will appear with three kings and a man in white armor. The three kings will show themselves to be the King of Cyprus, Crete, and Dalmatia, the armed man will be Corfu. Then artillery and rockets will be fired in sign of happiness

and then these will dismount the galley and come before you [high representatives of the Republic] to present the crowns of the said reigns, making themselves subjects.

Then, in imagery borrowed from Revelation, with Venice standing for the Virgin:

an ugly serpent [fig. 9.13] spewing fire will exit from the sea and will come towards Venice to devour her, and will come against the armed man of Corfu. There will be a good combat and at the end the serpent will be shown to be the infidels who seek to continue to disturb this holy Republic which God conserves in peace.

The concluding section advances the more aggressive image of Venice protected by her *terraferma* holdings:

Then out of a feigned cloud will appear Mars with a shield and sword, and will give these to you, and then many men clothed in various ways will demonstrate themselves to be Padua, Vicenza, Verona, Brescia, Bergamo, Crema, Treviso, Udine, and many other places which will represent themselves to Venice as subject allies.

The performance was to conclude with Mars taking the shield and sword and combating a terrible bear that tries to attack Venice, ending with another splendid dance performance.

The image of Venice conveyed by this proposal was of a virtuous empire whose maritime holdings were attacked by the infidel, yet which was buttressed by the subject but faithful allies on the mainland, and backed by the gods. Artists and their patrons drew from a large repertoire of such often ephemeral imagery across media to invent the compositions of Commissions.

THE HOLY LEAGUE AND VICTORY

After the allied Christian victory at the Battle of Lepanto on October 7, 1571, many paintings in Commissions diverged from standard themes to incorporate responses to the sense of triumph and renewal. Earlier that year, on July 6 of 1571, the Ottomans had raided the island of Zante (Zacynthos), an important Venetian colony in the Ionian Sea. The miniature of the Commission to Leonardo di Girolamo Emo (1524–1579), as Proveditor of Zante, of 1573, transformed the timeless image of Mark charging the rector with his office to create a historical document (fig. 7.6). Doge Alvise I Mocenigo, rather than the saint,

7.6 Walters Master (attrib.), Commission to Leonardo di Girolamo Emo as Proveditor of Zante, 1573. 23.2 x 17 cm. Österreichische Nationalbibliothek, Vienna, Cod. 5890, fol. 1v

hands Emo the Commission document as he points to the crumbling city of Zante on the island, with the text above urging him to restore what had been destroyed by the Ottomans.[12]

The same miniaturist, called the Walters Master, seemed to have been appreciated by patricians for his interpretations of current historical events. Among a number of inventive compositions related to the victory is a leaf for the Commission of Girolamo di Andrea Mocenigo

7.7 (Below left) Walters Master (attrib.), Leaf detached from a Commission to Girolamo di Andrea Mocenigo as Lieutenant of Udine, 1573. 22.2 x 16.7 cm. Huntington Library, San Marino, EL 9 H 13, 26

7.8 (Below right) Giacomo Franco after Jacopo or Domenico Tintoretto, *The Holy League*, from Giovanni Nicolò Doglioni, *La città di Venetia con l'origine e governo di quella* ... (Venice: Antonio Turini, printer, and Giacomo Franco, publisher, 1614). 28.7 x 20 cm. Newberry Library, Chicago, Wing folio ZP635.F85

(1523–1584), elected Lieutenant of Udine in 1573 (fig. 7.7).[13] He receives the document from Doge Mocenigo (they were from different branches of the family), who here is shown with two of the other heads of the Holy League: Pope Pius V and King Philip II of Spain. Their alignment together in a celebratory allegory was first recorded in a description of the triumphal procession made in Venice for the announcement of the League, printed in 1571. In the fifth tableau vivant described, three young boys, clothed in official dress, represented the leaders of the League: Pope Pius in his *habito pontificale*, King Philip in *habito regale*, and Doge Mocenigo in *habito dogale*.[14] In the miniature, the three leaders of the Holy League are aligned just as they were in a painting for the chapel of the Rosary in the Church of Santi Giovanni e Paolo, by Jacopo or Domenico Tintoretto.[15] The painting is lost, but

the composition was copied by Giacomo Franco in an engraving (fig. 7.8). In this print, the head coverings of the leaders, which signify their authority – imperial crown, papal tiara, and ducal *corno* – are on the ground in front of them. They are bare-headed and kneel to emphasize their humility and devotion. In the Commission leaf, the leaders are arranged in the same order but now with heads covered. The pope is enthroned and the two leaders stand. The miniaturist has shifted the emphasis away from the gratitude of these great

Christian powers for divine grace and victory, to highlight a patrician receiving his Commission from a power unified with, and roughly on the same level as, papal and regal authority.

Another leaf detached from the Commission to Girolamo Mocenigo extends the reference to victory at Lepanto by showing Venice crowned by Mark with a cherub who carries the attributes of victory, a palm frond and laurel crown (fig. 7.9).[16] This figure of Venice can be simultaneously interpreted as Venus because the cherub resembles

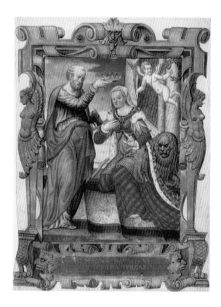

7.9 (Above) Walters Master (attrib.), Leaf detached from a Commission to Girolamo di Andrea Mocenigo as Lieutenant of Udine, 1573.
21.7 x 15 cm. Huntington Library, San Marino, EL 9 H 13, 25

7.10 (Right) Leaf detached from the Commission of Luca di Salvador Michiel as procurator *de citra*, elected 1587.
26.5 x 19 cm. Private collection

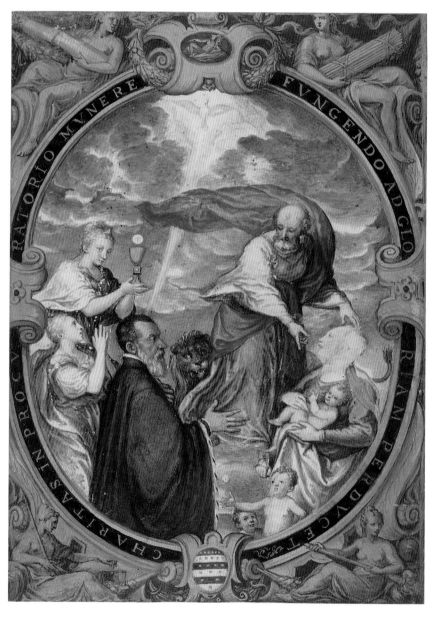

Cupid, son of Venus. *Venetia*, shown here, echoes the Virgin Mary as painted in the great fresco by Guariento, where she is crowned by Christ. This fresco was at that time still at the head of the Hall of the Great Council (fig. 2.1), before it was greatly damaged by fire and replaced by the canvas of *Paradise* by Tintoretto.[17]

Service in the wars against the Ottomans while rector abroad could be highlighted in the paintings of Commissions decades after the fact. The detached leaves from a document for Luca di Salvador Michiel (1520–1596), elected procurator *de citra* in 1587, follows the model of that for Girolamo Zane, elected to the same post in 1568, in showing him as military commander and charitable procurator (figs. 4.20, 7.9, 7.11).[18] But by contrast to Zane, whose document was created before his disgrace in the events leading up to the Battle of Lepanto, the paintings of this later document celebrate Michiel's success in fending off Ottoman attempts to take Venetian Crete in the same period, when he served as

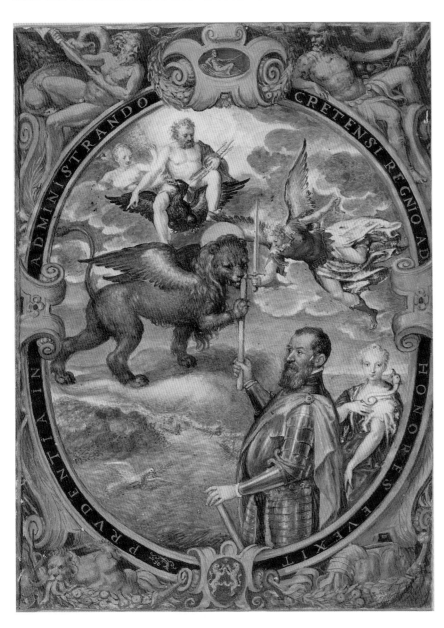

7.11 Leaf detached from the Commission of Luca di Salvador Michiel as procurator *de citra*, elected 1587. 26.5 x 19 cm. Private collection

Proveditor of Canea (the western region of the island). In what must originally have been the right-hand leaf of two facing images of the same man, two figures associated with the island, Jupiter and a woman holding a serpent, watch as Michiel, in armor, receives the baton of command as proveditor from the lion of Mark, and the sword of Justice from Saint Michael (fig. 7.11). The inscription circling the fictive frame claims that good judgment in governing Crete has brought Michiel honors, highlighting the importance of such achievement in his eventual election as procurator.[19]

Francesco di Pietro Duodo

A layered promotion of civic honor can be observed in the illumination programs of four surviving manuscript leaves from Commissions that appointed Francesco di Pietro Duodo (1518–1592) to various offices of the Venetian Republic. Together they emphasize his service in governing key Venetian territories, and eventually celebrate his substantial role as commander of the large war ships called galleasses (*capitano delle gallere grosse*) in the victory at Lepanto in 1571. When the documents still were intact and collected as a group in the family archive, the Commissions provided a visual as well as a documentary biography highlighting his highest achievements and the evolution of the image he wished to convey of himself.[20]

The Commission for one of Francesco Duodo's earliest state assignments, as captain of a convoy of merchant galleys to Beirut (elected in 1545), survives but the opening leaf is missing, probably because it was illuminated. The upper cover of the gold tooled leather binding is impressed with Duodo's name. Instead of the usual coat of arms of the recipient on the lower cover, the Greek motto "ΕΥΔΑΙΜΩΝΑΕΙ" ("Prosperity, blessedness, or happiness") is inscribed, evidence that Duodo took unusual interest in how his documents would appear while in use. The inscription reflects also his

interest in classical literature and antiquities.[21] According to Francesco Sansovino, Duodo and his brother Domenico assembled an important collection of medals and small antiquities. Unfortunately, there are no inventories of the Duodo collections until the later seventeenth century, making it difficult to distinguish Francesco's particular acquisitions.[22] Nevertheless, the perusal of such a Commission, originally with paintings as well as a binding with a personalized inscription, would have complemented the passing around and discussion of ancient coins and portrait medallions of illustrious men with friends.

The first known surviving Commission leaf to Francesco Duodo exhorts him to administer justice, and was detached from his document as *Bailo* and Proveditor of Corfu of 1559 (fig. 7.12).[23] The composition by the T.° Ve Master was reprised almost exactly in a Commission to Melchiorre Salamon two years later, in 1561, so it may have been a stock invention offered by the artist to patrician clients (fig. 6.2). Venice personified is represented as queen with her crown and as Justice with a sword and scales, reprising her ubiquitous image inside and on the exterior of the Ducal Palace.[24] She also represents the wisdom of Solomon, for she is seated on his lion throne. Inscribed on the column bases of the framing triumphal arch is the opening to the apocryphal book of Wisdom, also known as the Wisdom of Solomon (1:1): "Love righteousness, you rulers of the earth…"[25] The arch is embellished with ancient-style armor and the heraldry and initials of Duodo. Venice is blessed from above by God the Father, who is flanked by putti holding trumpets to proclaim Duodo's fame, won by service.

Duodo was subsequently elected *Podestà* of Bergamo in 1568, and the leaf from that Commission, also detached, is by the Mannerist Master (fig. 7.13).[26] By contrast to the miniature for Duodo as a rector of Corfu, this composition is unique in manuscript painting. Venice as queen and as Justice now embraces Duodo, as represented by his escutcheon. Personifications

of Bergamo, and of the territories governed previously by Duodo – Udine and Corfu – offer their coats of arms to Venice. The landscape in the background and Poseidon representing Corfu underscore the fact that Duodo served both Venetian territories on the mainland and in the Ionian Sea. The painting in this Commission preceded the votive work by Palma Giovane of Doge Francesco Venier (d. 1556) in the Ducal Palace, which has a similar theme, by some twenty-five years (fig. 3.27). In Venier's portrait, personifications of territories that Venier had been elected to oversee, indicated by the coats of arms on the statute books they carry, present themselves to Venice. In contrast to Duodo's Commission, Venier himself is portrayed, rather than just his coat of arms.[27]

The inscription in the upper corners of the leaf of Duodo's Commission quotes from Psalm 115: "Not to us, O Lord, not to us, but to thy name give glory ..."[28] This assertion of pious humility had been inscribed earlier on the palace of Andrea di Nicolò Loredan (da Santa Maria Formosa; d. 1513), begun in the 1480s by Mauro Codussi, and eventually the home of the Grimani Calergi (Palazzo Loredan-Vendramin-Calergi). The same sentiment had also been common to various editions of Venetian coins since the fourteenth century.[29] Whereas the regions Duodo governed are represented in his *ducali* as trophies of his career of service to Venice, his achievements and Venetian power are won through the grace, and for the glory, of God.

Like many other rectors, Duodo left memorials of his service in the *terraferma*. He had an inscription made in stone recording his rule as Lieutenant of Udine in 1566. To reinforce the sculpted archive of the service as rectors by members of his family in Udine, he also had an inscription made retrospectively for his fifteenth-century ancestor Tommaso di Pietro, who had served there in 1441.[30] In his next Commission, of 1578, as Captain of Brescia, the coats of arms of Padua (the location of Duodo's Commission

for this post is not known) and Brescia supplement those of his previous posts on Corfu, and in Udine and Bergamo. The arms are set within a border, framing his portrait within references to his accumulating political achievements (fig. 7.14). But instead of being represented as a rector, Duodo's important role as commander of the galleasses in the victory at Lepanto is celebrated. He is shown against a seascape with a galleass in the background, now in armor receiving the victory palm, probably from Saint Justine because it was on her feast day that the Holy League won the battle in 1571.[31] The spoils of the war – a turban, shield, and the arrows of a "Turk" – are poking out from beneath her skirt.

It was standard for Justine to be shown with the palm of martyrdom and victory. But here she holds an attribute she is not associated with elsewhere – a pine cone.[32] This attribute could be a reference to the colossal ancient bronze pine cone in Rome, known as the *Pigna*. The sculpture had been enclosed in a tabernacle in the forecourt of Saint Peter's from the late fifth century to around 1605.[33] The forecourt was commonly called the Paradise, and the pine cone with its tabernacle was associated with Rome as the center of Christianity and with rebirth. In Justine's hand, the pine cone may be intended to be associated with the promise of eternal life to Duodo for the sacrifice he had been willing to make in battle of his earthly body. In a book on the antiquities in Rome, printed in Venice in various editions in the 1550s and 1560s, Ulisse Aldrovandi wrote that the *Pigna* was believed to have been taken from the sepulcher of the great ancient Roman general Scipio.[34] If this interpretation of the monument in Rome was meant to be interpolated in reading the painting, the pine cone enhanced the image of Duodo in armor as a military leader in line with the greatest of antiquity. Rome as a reference also is fitting because it was in the alliance of Venice with the pope in the Holy League that victory was achieved, and like the Grimani and the Tiepolo families, the Duodo was one of a powerful group of patricians with papalist sympathies.

Francesco Duodo's presentation in armor is a significant deviation from the standard imagery of rectors and conveys his wish to be commemorated here as a naval victor. As in Girolamo Zane's portrait in his Commission as Captain of the Sea, Duodo's likeness is indebted to the compositional model by Titian of Francesco Maria I della Rovere (1490–1538) and it references the tomb memorials of the fifteenth century, but here more certainly also the contemporary portraits of the Venetian

martyrs of Lepanto. Duodo's image especially can be compared to Veronese's famous portrait of Agostino Barbarigo, the captain at Lepanto who was killed by an arrow that struck his eye. Veronese portrayed Barbarigo as if a saint, calmly holding the arrow as an attribute of his martyrdom.[35] In the miniature, Duodo clutches Justine's palm so that here he, although still alive, also is aligned with the famous martyr Barbarigo, exemplar of the sacrifice of all the patricians who fell at Lepanto. His presentation in this way may demonstrate a campaign eventually to become elected doge, as this image probably was made just months after the election of Sebastiano Venier as doge in June 1577, who also had been portrayed as a victorious captain (fig. 4.21). Captain Barbarigo as martyr, victorious in heaven, and Captain Venier as victorious in battle, became new models for ideal Venetian patrician service to the *patria*.[36] Duodo

7.12 (Below left) T.° Ve Master (attrib.), Leaf detached from the Commission to Francesco di Pietro Duodo as *Bailo* and Proveditor of Corfu, 1559. 22.4 x 16.8 cm. Edinburgh University Library, MS La. III. 795/1

7.13 (Below right) Mannerist Master (attrib.), Leaf detached from the Commission to Francesco di Pietro Duodo as *Podestà* of Bergamo, 1568. 22.2 x 15.5 cm. Huntington Library, San Marino, EL 9 H 13, 22

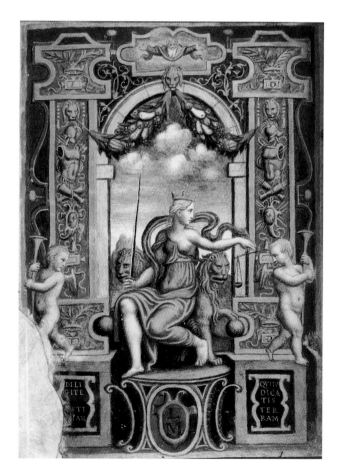

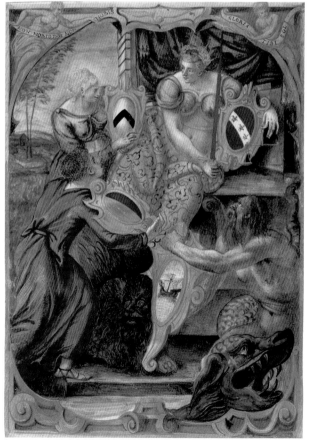

wished to be presented similarly as an exemplary warrior patrician, and his family furthered that desire. After his death, his armor, a key relic of his service and valor, was donated by his descendants to the Hall of Armor in the Arsenale.[37]

The highest office that Duodo held was as procurator *de ultra*, to which he was elected by merit in 1587. In the leaf detached from the relevant Commission/Oath manuscript, the representation of the battle of Lepanto as religious victory gained through patrician sacrifice is enhanced by

means of an image of the Resurrected Christ, with Duodo's galleass in the background, set within a fictive gilded frame filled with armor and weapons (fig. 7.15).[38] The captured and bound Ottomans framing Duodo's coat of arms at the base of the frame and the sleeping Roman centurions within the main picture cannot access Francesco's triumphant vision.[39] Complementing his image as warrior in his previous Commission, Duodo is represented in the toga worn by procurators in their large-scale portraits in the *Procuratie* offices.[40] The miniature in Duodo's Commission marks a departure from the tradition of portraying the oath of adherence to the regulations of the office spelled out in such manuscripts. It is a more expansive memorial, encompassing his service over his entire career as rector, commander, and warrior, emphasizing his willingness to follow Christ in making the ultimate sacrifice of his life for God and *patria*.

7.14 (Below left) Giovanni Maria Bodovino (attrib.), Leaf detached from the Commission to Francesco di Pietro Duodo as Captain of Brescia, 1578. 22.5 × 16.5 cm. Huntington Library, San Marino, EL 9 H 13, 10

7.15 (Below right) Leaf detached from the Commission to Francesco di Pietro Duodo as procurator *de ultra*, 1587. 28.5 × 20.5 cm. Huntington Library, San Marino, EL 9 H 13, 20

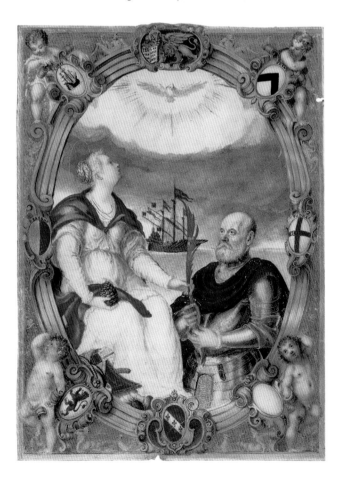

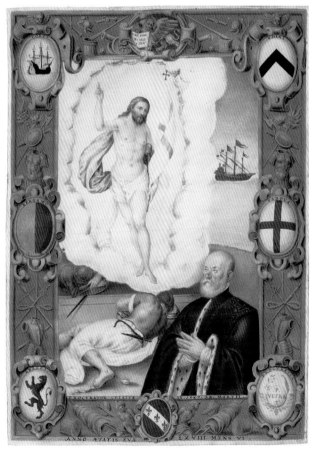

The representation of the coats of arms of territories Duodo governed, as "trophies" of service, is found in all of the last three of his Commissions. The last two feature a galleass in the background to represent his service as captain at Lepanto. Nevertheless, all of his Commissions were painted by different artists. Duodo, therefore, must have specified the imagery to the artists of his documents. The ship also appears on the leather binding of a manuscript collection of transcribed documents and laudatory text recording his participation at Lepanto. This manuscript is not a Commission but supplemented them in transmitting a collection of written narratives and additional evidence of his exceptional fulfillment of service to the state.[41]

Duodo funded a number of other portraits of himself.[42] He probably commissioned his portrait for the Arsenale while *patrono* from 1546 to 1550.[43] Two busts of him by Alessandro Vittoria, one in terracotta and one in marble, also survive.[44] In Duodo's will, written sometime after his election in 1587 as procurator, the marble version of the bust was mentioned as being in his house (fig. 7.16). He requested that it be installed in the Church of Santa Maria del Giglio (also Santa Maria Zobenigo) on his altar, and that six of his gilded square banners and a square standard be hung in the middle of the church. He wished that these, with an epitaph, be installed "in memory of my labors in honor of Majestic God; and for our *patria*."[45] Giovanni Stringa's description of the church affirms that the standards hung there at least until the early seventeenth century.[46] Later sources interpreted them as spoils from the battle, but the six banners probably were not relics of the enemy ships, rather the flags of the six galleasses that he commanded and that preceded the Christian fleet at Lepanto.[47] The largest banner may have been from the galleon named *il Fausto*, from which Duodo commanded the galleasses. Don John of Austria, naval commander of the entire operation, praised Duodo's command of these ships as a major cause of the final victory.[48]

Vittoria's bust of Duodo reprises the image of him as a victorious captain at Lepanto, for he is dressed in the armor and cape of naval captains.[49] But despite the wishes expressed in his testament, Duodo's marble portrait bust remained in the family palace until it was eventually installed at the Duodo estate on the *terraferma*, in Monselice.[50] Nonetheless, his altar of marble in Santa Maria del Giglio survives with its painting from the Tintoretto workshop, probably of 1581–82 (fig. 7.17).[51] Here Duodo is dressed not as a statesman or warrior, but as his onomastic saint, Francis of Assisi, and holds his hands up to show his stigmata. The galleass that figured in his last two Commissions, however, reappears in the seascape behind him. Saint Justine and the Resurrected Christ remain as clear allusions to his role at Lepanto. He emulates Francis and Christ in his willingness to sacrifice himself for the Christian Faith, as would have been emphasized further by his portrait bust as captain, if it had been installed as he requested in his will, together with the banners of his ships hung in front of the altar.

The special care with which Duodo cultivated his memory in Commission manuscripts and at his altar at Santa Maria del Giglio may have emerged from his ideological and family ties with the prominent papalist families of the Grimani and Tiepolo. His commemorative strategies, in turn, apparently influenced the painting of documents for younger men of these families. His eldest surviving son Francesco (1563–1613) married Isabetta Tiepolo, daughter of the procurator Alvise and sister of Francesco Tiepolo, in 1588. As discussed in Chapter 5, Francesco Tiepolo would commission an especially elaborate sequence of paintings for his Commissions beginning in 1597, and a chapel dedicated to Saint Sabbas in which his father Alvise also was commemorated with a sculpted portrait bust by Alessandro Vittoria (figs. 5.45–5.51). Through this marriage, close ties were created also between the families of the Duodo and the Grimani of both Santa Maria Formosa and San Luca, for

7.16 (Above) Alessandro Vittoria and workshop, *Bust of Francesco di Pietro Duodo*, before 1592. Marble, 84 x 61 cm. Originally in the Duodo Palace, now Galleria Giorgio Franchetti at the Ca' d'Oro, Venice

7.17 (Right) Jacopo Tintoretto and studio, *Francesco di Pietro Duodo as Saint Francis of Assisi, with Saint Justine and the Risen Christ*, c.1580–82. Oil on canvas, 275 x 138 cm. Santa Maria del Giglio, Venice

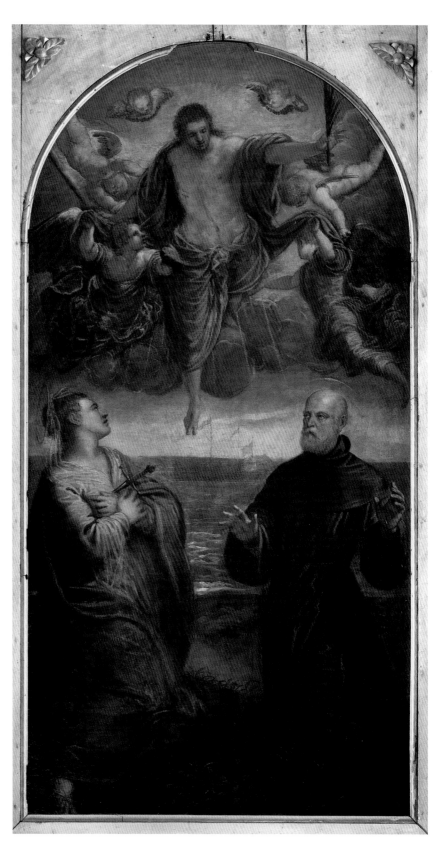

Francesco Tiepolo had married women from both branches (Donada di Doge Marin in 1579 and Lucretia di Vincenzo di Antonio in 1582).

In his last testament, Francesco Duodo emphasized his wish that his sons Pietro and Alvise, "of good and tranquil nature and always inclined towards virtue," remain in accord and harmony with each other.[52] Duodo seems to have transmitted his care for the decoration of books, evident in his Commissions, to Pietro, who was an avid collector and patron of beautiful bindings. Pietro, like his father, was a prominent statesman who eventually was elected procurator.[53] Duodo's portrait bust eventually was placed in a family memorial with sculptures of his brother Domenico and son Pietro, as commissioned by his great-grandson Alvise Pr. di Girolamo (1624–1674) in 1663. Pietro had worked with Vincenzo Scamozzi

to initially develop the stepped itinerary of seven chapels at Monselice, as a model of the seven pilgrimage churches of Rome. This Romanizing architect had been hired by the procurators to complete the Libreria begun by Sansovino, to design its famous *antisala* (or vestibule), and to initiate the Procuratie Nuove. Scamozzi was also favored for domestic projects by Jacopo Contarini and Marcantonio Barbaro. With the chapels at Monselice, Pietro continued the work of his father in affirming the importance of Rome and the role of the papacy in developing and affirming faith.[54]

Although Francesco had an altar constructed for himself in Santa Maria del Giglio, he stated in his testament that he wished to be buried in the family funerary monument (*arca*) in the Church of Sant'Angelo. This church was in the same square (*campo*) as the family palace, but was demolished

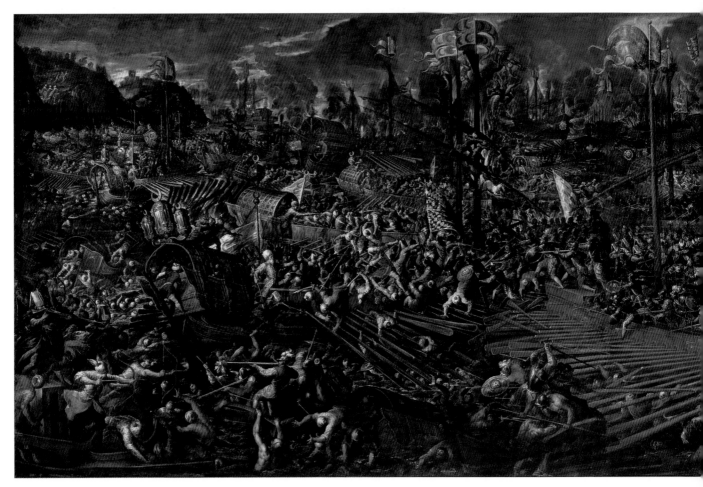

in 1837. Just a few years before it was destroyed, Emmanuele Antonio Cicogna transcribed the simple inscription honoring the ancestors of Duodo and his brother Domenico on the steps to the main chapel.[55] In the same *campo*, in the palace, was a particularly large and sumptuous library, in which Duodo's Commissions probably were stored.[56]

The representation of Duodo as naval victor by means of the sign of his ship in his manuscripts at home was paralleled by the image of his galleon, the *Fausto*, identifiable by his coat of arms, in a huge painting of the Battle of Lepanto on the east wall of the Sala del Scrutinio in the Doge's Palace (fig. 7.18). Executed in the early 1570s by Tintoretto, the original was replaced after it was destroyed by the fires of 1577 by a canvas by Andrea Vicentino, and was but one of many public and grand images celebrating the patriotic heroes of Venice.

VENICE AS SOVEREIGN, AND THE SUBMISSION AND GRATITUDE OF SUBJECT TERRITORIES

"These are the actions, the examples, and the allegories of the walls and ceilings of the [Great Council and Scrutinio] … invented by the diligence of Jacopo Contarini, son of Signor Pietro, and Jacopo Marcello, son of Signore Antonio … they were explained by me … so that anyone could know all about each painting; so that one could more easily imitate these featured Heroes; to leave honored memory of their proper actions to posterity, who will be born in the future age of this Serene Republic."

Girolamo Bardi, 1584[57]

7.18 Andrea Michieli (called Vicentino), *The Battle of Lepanto*, 1595–1605. Oil on canvas, 520 x 1390 cm. Sala del Scrutinio, Doge's Palace, replacing the painting by Jacopo Tintoretto destroyed by fire in 1577. Duodo's ship, recognizable by the banner bearing his coat of arms, is in the background, just right of the center of the canvas

Allegories idealizing Venice's relationship to her subject territories were performed and displayed throughout the city and empire, and eventually broadcast in the grandest manner in the massive paintings of the Great Council and Sala del Scrutinio, created after the fire in the palace of 1577, at a time when Venice's empire was actually diminishing (figs. 7.18–7.22).[58] It was, after all, in these two halls that patricians cast votes and were elected to their posts as rectors and rulers abroad. The complex program of the ceiling of the Great Council Hall survives in both its visual formulation in situ, and in textual editions disseminated in manuscript and print, by the Florentine Girolamo Bardi, a monk of the Camaldolese Order, who collaborated on its creation. Bardi's text often diverges from the actual painted imagery, and therefore cannot be read as a simple description or guide. But reading the texts in conjunction with viewing the images, something that Bardi certainly hoped many would be able to do, creates an awesome onslaught of Venetian propaganda. The massive scale and staggering effects in the ceiling of various uses of *di sotto in su* perspective – literally "from below to above," a term used to describe extreme foreshortening of figures, giving the impression that they are suspended in air – creates a distinctly imperial image of Venice, directed primarily at the Venetians who sat weekly in the Hall of the Great Council, as well as to visitors.

Bardi credited the program to the patricians Jacopo di Antonio Marcello and Jacopo di Pietro Contarini, whose portrait with a Commission document, as *Podestà* of Bergamo, was examined in Chapter 6 (fig. 6.25).[59] According to the program text, these triumphant allegorical scenes show the power and glory of Venice, the result of *imprese*, or battles and deeds, and the examples of *virtù* of patricians as depicted in the history scenes on the walls below.[60] The miniatures in Commissions of the second half of the sixteenth century complemented these dramatic canvases,

which commemorated battles and allegorized Venetian power. But in the miniatures, patricians were drawn out of such crowd scenes to be more easily scrutinized, and memorialized individually.

The subjects of the wall scenes were in large part copied from what had been there before the 1577 fire. However, Giorgio Tagliaferro also has shown how the new program can be read in the context of post-Lepanto millenarianism. Here Venetian patricians are understood as not just conquering for the glorification of the state, but also for the consecration of Venice as central mediator of the path of man towards eternal salvation, culminating in the canvas by Tintoretto entitled *Paradise* on the east wall of the Great Council Hall.[61] Bardi emphasized

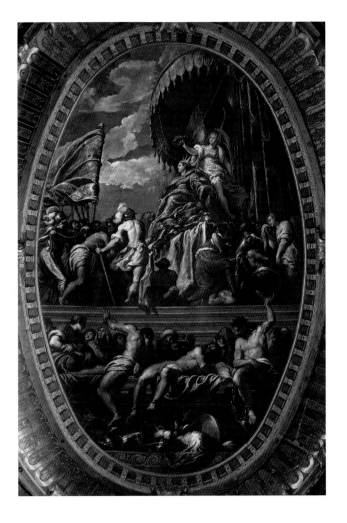

7.19 (Opposite) Palma Giovane, *Venetian Sovereignty (Subjugation of Cities and Regions)*, Great Council Hall ceiling, 1582–84. Oil on canvas, 904 x 580 cm. Doge's Palace, Venice

7.20 (Right) Jacopo Tintoretto and studio, *Voluntary Submission of Cities and Regions*, Great Council Hall ceiling, 1584. Oil on canvas, 1030 x 650 cm. Doge's Palace, Venice

that the three central allegories on the ceiling of this room, to be read from the back of the room towards the tribunal where the doge and *Signoria* sat, represent how the peoples dominated by the Republic, all without their own liberty, nevertheless at least "live secure from the cruelty and avarice of tyrants." The program, as Bardi wrote it, is a clear attempt to justify domination.

According to Bardi, Venetian sovereignty was represented as through force and armor in the first painting, by Palma Giovane, of 1582–84 (fig. 7.19). Although Venice had long been figured as Justice, in no other place are triumph and subjugation by force so explicitly stated. Bardi himself notes that the iconography is largely based on ancient imperial medals or coins.[62] A haughty

enthroned Venice reigns over the submission by force of half-nude male personifications of cities and territories – here they are bound and chained, their armor as spoils on the lowest step.[63] As Wolfgang Wolters has pointed out, this representation of Venice crowned as military victor, and the emphasis on battle scenes on the walls, contrast with the more common Venetian message up to that date that her territories submitted voluntarily. Even the mock battles proposed to be performed on *Giovedì grasso* in 1570 were defensive rather than aggressive.[64]

Bardi wrote that the square second painting, in the middle, shows Venetian rule through the love and voluntary dedication of her subjects, of willful submission (fig. 7.20). In this painting of 1584, by Jacopo Tintoretto and studio, Venice personified consigns an olive branch to the reigning Doge Nicolò da Ponte (doge 1578–85) and members of the *Signoria* at the top of a steep staircase of a stage set in Piazza San Marco. Below, the representatives of cities and provinces submit voluntarily to Venetian rule, by bringing the relevant keys, standards, and charters with seals. These representatives are described in the program texts for the ceiling as "Greeks, Dalmations, Istrians, and Italians."[65] As discussed in relation to Francesco Duodo's Commissions, such representations of formal, yet voluntary submission through the offering of coats of arms or statute books can be found elsewhere in the Ducal Palace, as in the votive portrait of Doge Francesco Venier (doge 1554–56) by Palma Giovane in the Senate Hall, and that for Doge Marcantonio Memmo (doge 1612–15) in the votive painting of him also by Palma in the Great Council (fig. 3.27).[66] The official, legal, and ceremonial confirmation of subject status are shown here as akin to the rituals of the actual ceremonies of conferring symbolic keys and standards, and statute books.[67]

In the last and most famous painting in this sequence, by Veronese, Venetian rule is shown through the happiness and universal jubilation

7.21 Paolo Veronese, *Venetian Peace ("Pax Veneta")*, Great Council Hall ceiling, c.1582. Oil on canvas, 904 x 580 cm. Doge's Palace, Venice

of the subject peoples, the *Pax Veneta* or Venetian Peace; the composition and idea are borrowed from coins of the *Pax Romana* (fig. 7.21).[68] The paintings of the ceiling show a progression of rule from initial force to subjugation, legal and ceremonial confirmation, and finally the recognition by perhaps initially recalcitrant subjects of their more blessed state under Venetian dominion – a possible entry to a higher grace.

Venice personified is thus shown in the same room as military victor, granter of peace, and ultimately, queen and goddess, whose people rejoice in the peace she bestows. The allegorical Venice in female form transcends the transient life-spans and physical efforts of individual male patricians, who labor and fight to create the state.

7.22 Giovanni Battista Brustolon, after a drawing by Canaletto, *The Doge Giving Thanks for his Election in the Sala del Maggior Consiglio, c.1765*. Etching, 44.2 x 55.7 cm. Getty Research Institute, Los Angeles, DG678.478.B91 1766, plate 4

There is no division between, or privileging of, land or sea holdings, indeed the concept of Venetian rule encompasses the entire world and the afterlife. Venetian patricians encouraged artists to convey eschatological significance and employ ancient templates of imperial expression, such as Roman coins, to figure Venetian rule and power on the ceiling. Bardi concluded his tract by stating that his overall intention in describing the decoration program was to facilitate imitation of the highlighted heroes, and to leave honored memories of their actions to future generations of the Serene Republic.[69] The service of virtuous individuals allowed the collective of Venice to rule through both diplomacy and military might.

Only a few patricians actually guided the programs of the great paintings of the Ducal Palace or were imaged in them, but many more bequeathed records of their service to the state and patrician ethos at home in *ducali* manuscripts. Study of these documents shows us that the image of *Venetia*, the notion of empire, and the ideals of the patriciate as displayed on greater scale within the Doge's Palace and performed in front of it were pondered and developed by more artists working with a greater number of patricians than considered previously. The themes found on the walls of the palace, such as that of Francesco Venier presenting subject cities where he had served as rector to Venice, may even have been formulated earlier in manuscript documents. The small spaces of *ducali* allowed a larger percentage of artists and patrons to engage in imaging the myth of Venice, in dialogue with the grand and public paintings of the state (fig. 7.22).

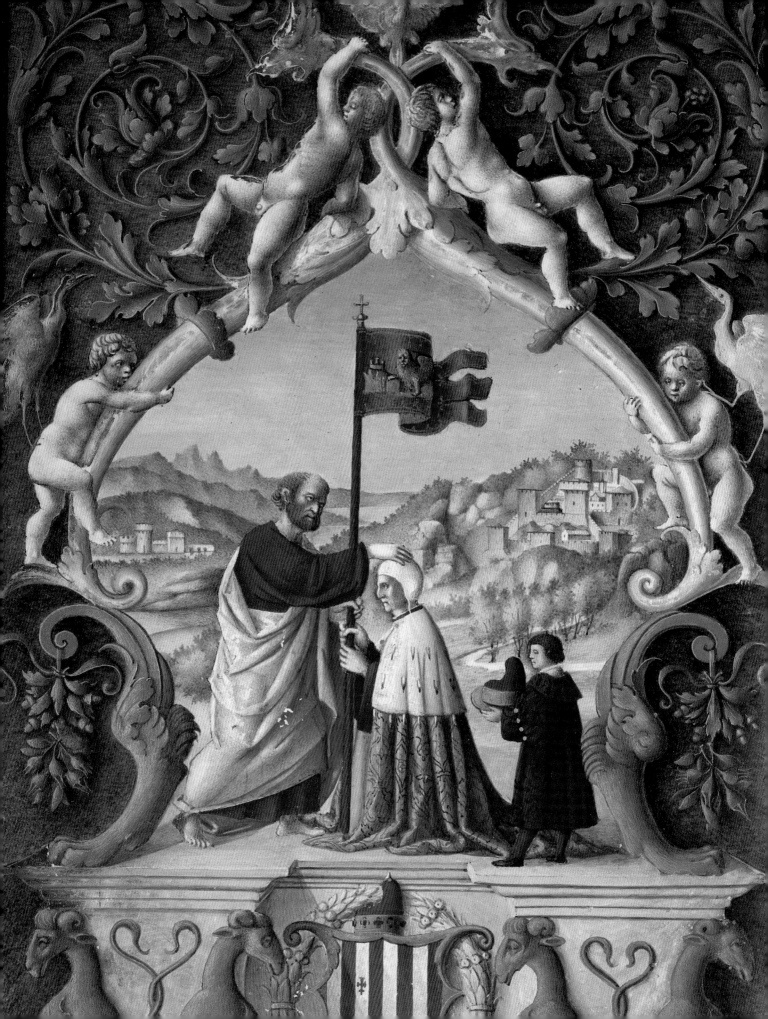

CONCLUSION

MANUSCRIPTS AND MYTHS OF STATE

W E BEGAN WITH Doge Antonio Grimani's concern on his deathbed that the manuscripts documenting the restoration of his honor through election to the highest offices of state remain in the family. And, in fact, inventories record that the documents were kept and appreciated by his descendants many generations later. The fine quality of the miniatures, scripts, and bindings of his documents called attention to them as important among the scores of papers and objects collected by his family, and they were prized in the seventeenth century for the value of their paintings. So, through embellishment, *ducali* evolved as hybrids of textual documents and art, with painting often adding documentary value in recording the appearance of a patrician at the age at which he assumed office. *Ducali* thereby occupied a region in between what Aleida Assmann has defined as the *canon* and *archive*, or actively referenced and passively stored forms of cultural remembrance.[1] Documentary evidence and painted imagery were fused together, and maintained in the family to keep an honorable and celebratory version of service perpetually and literally in sight. Indeed, visual analysis suggests that at least one of Doge Grimani's manuscripts, his *Promissione*, was consulted for the composition of the monumental portrait of him by Titian, commissioned posthumously and destined for the very public space of the Salle delle Quattro Porte of the Ducal Palace (figs. 0.5

Detail of fig. 0.5

and 3.24). The imagery in both the document and the oil painting asserted the doge's innocence and divine election in the face of lingering disgrace.

Antonio Grimani's anxiety during the last hours of his life that his *ducali* be preserved probably was unusual, but interest in transforming documents into luxury manuscripts and memorials grew among many patricians and their families in the fifteenth and sixteenth centuries. The evolution of *ducali* into symbols of status and as memory objects will now be compared further with the meaning invested by the state in two manuscripts, the *Vangelo* and the Grimani Breviary, discussed initially at the outset of this book (figs. 0.8, 0.9, 1.11, 8.1, 8.2). The acquisition, storage, and display of these manuscripts claimed the former as a relic of the hand of Mark, documenting divine favor for Venice, and the latter as the handiwork of artists manifesting the wealth and sophistication of its leaders. This was the culture of manuscripts as symbols of state within which individual patricians had their *ducali* embellished to assert their status in Venice. Procurement of the Breviary by the state, and the creation of a special binding for it, also even further repaired the reputation of Doge Antonio Grimani.

The introduction of painting in *ducali* appears to have been stimulated by the engagement of patrician office holders and *cittadino* secretaries in the culture of humanism. This was accompanied by interest in the arts of the book, with recognition of the value of painting in manuscripts to promote distinction,

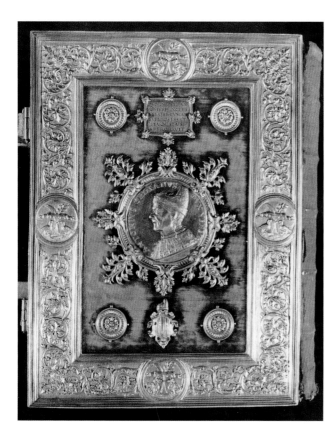

8.1 "The gift was approved by Antonio, prince and father, on his deathbed." Lower cover of the Grimani Breviary, with portrait of Doge Antonio Grimani, c.1574 (or 1592?). 29 x 22.5 cm. Biblioteca Nazionale Marciana, Venice, Lat. I, 99 (=2138)

amount of outside scrutiny of the paintings of these documents differed according to the offices they bestowed. Freedom of expression of an individualized patrician self correspondingly correlated to document type. Payment for the doge's *Promissione* seems to have come entirely from the office of the *Rason vecchie*, and the image of patricians in these documents was most constrained. Paintings in *Promissioni* evolved from small portraits in opening initials conveying adherence to the statutes to full-page paintings of the doge emphasizing divine election.

Funding of the documents for the procurators came from the coffers of each of the three branches of the office. Spending on them spiraled upward in the mid-sixteenth century, and eventually provoked a limit on state-funding for their production. In response, some procurators personally directed the entire creation of their documents and supplemented the allowed amounts with their own funds, as evidenced by the expense accounts of Marin Grimani, of the San Luca branch of the family, and the lavish illustration of some of the later documents, such as that for Luca Michiel as procurator (figs. 7.10, 7.11). Such augmented payment encouraged more expansive representation of the self at the interstices of the public and the private, and the nature of the imagery strayed greatly from the original focus on affirming the oath of office. Sometimes the very artists hired to paint in these documents bridged the domestic and public spheres of image production. Marin Grimani's financial accounts are instructive here. They reveal that when elected procurator in 1588, he hired Marco del Moro to paint his relevant Commission/Oath document. This artist was a renowned miniaturist, but he also produced important paintings and stuccoes for private palaces, as well as for the public spaces of the Doge's Palace and the Procuratie Nuove.

Production of the third category of these manuscript documents, those for rectors and captains of trade convoys, was overseen by the

as practiced more ostentatiously in princely courts. Special initiatives to organize and edit Venetian laws, especially the program under the reign of Doge Andrea Gritti, produced exceptionally fine documents under the direction of the Grand Chancellor. These provided models to individual patricians of the highlighting of documents through attention to script, painting, and binding.

The predominant themes of painting in *ducali* varied according to the nature of the relevant office to which a patrician was elected, but all focused generally on conveying not only the privilege, power, and divine favor of the patrician elect but also his duty to serve wisely and justly, following the regulations within the manuscripts. The sources of payment and

segretario alle voci working under the Grand Chancellor in the ducal chancery. But it seems that the financing and direction of painting within them was left to the recipients, whose actions and appearance while in office abroad also bore less official control. The invention of themes became most expansive in the late sixteenth century to convey the divine charge of office, record one's appearance and ideals of service, invoke divine blessing before departure, and respond to the trials and victories of the empire.

Ducali, especially for procurators and rectors, provided a space in which one could call attention to and memorialize one's dispensation of duty, when doing so in public spaces was more circumscribed by custom and legislation. Patricians serving abroad were to temporarily represent sovereignty in a dignified manner, but had to be careful not to overly celebrate and memorialize themselves personally as rulers and especially not to use public funds to do so. Although actual scrutiny regarding compliance by rectors to their regulations was lax, as seen in the case of Paolo Nani, the opening leaves to the texts of Commissions, painted at the discretion of the recipient, provided self-financed and less-contested, if more private, outlets for remembrance of governance abroad. Back at home in Venice, only relatively few high-ranking patricians were represented in the paintings and sculptures of such public buildings as the Doge's Palace, the *Procuratie*, and the Camerlenghi Palace. Even fewer were allowed to dictate the design and messages of the largest gathering spaces, the Great Council Hall and Sala del Scrutinio. The spaces in *ducali* thus provided the opportunity for many more (but still not all) patricians to participate in representing themselves in relation to ideals of state.

Ducali provided a medium within which patricians elected to certain kinds of office could evolve an image of themselves and their service to the state over time, as they advanced in their career, complementing or even anticipating their more public representation in altarpieces, tomb monuments, and palace decoration. Collectively, the paintings were important visual components of the myth of Venice, which emphasized the piety, dedication, and talents of individual patricians in governing the Serene Republic. When stored in the archives or among precious objects of a family, *ducali* bolstered claims of status based on election and service at the highest levels.

No Venetian patrician of the fifteenth century or his family rivaled the intense patronage of luxury manuscripts practiced by individual rulers or dynasties, such as the Visconti and Sforza of Milan, the Este of Ferrara, the Angevin Kings of Naples, or Federigo da Montefeltro of Urbino. If a patrician had been so inclined, such magnificence would have breached the constraints of the prevailing ethos of *mediocritas* of the fifteenth- and early sixteenth-century Republic. But Venetians already embraced the *Vangelo* manuscript, housed in its gilded reliquary, and presented regularly on the main altar of the Church of Saint Mark, as a sign of divine favor, and regarded the magnificent liturgical manuscripts of the Basilica as representative of their piety (figs. 1.5, 1.11, 9.1). In the sixteenth century some descendants of Antonio Grimani became extremely important collectors and patrons of manuscript painting, a component of their assiduous collecting and commissioning of art and architecture, and departure from earlier patrician ideals of restraint and equality. They eventually also would convince the state to memorialize their family and honor the Republic by accepting, embellishing, and displaying the magnificently illuminated Breviary of Cardinal Domenico Grimani.

COLLECTING PAINTED MANUSCRIPTS TO GLORIFY FAMILY AND STATE

The patronage and collecting practices of the Grimani encouraged a higher valuation of the art of miniature painting in Venice and abroad, and probably stimulated interest in its usefulness

for memorialization in manuscript documents. Grimani patronage of the miniaturist Giulio Clovio launched his illustrious career. Clovio subsequently served as court artist to King Louis II of Hungary, Cardinal Alessandro Farnese, and Duke Cosimo I de' Medici with his spouse Eleanora of Toledo. King Philip II of Spain even tried to entice Clovio to work for him at El Escorial.[2] Venetian patricians from many different families, of varying levels of influence and political affiliation, had their *ducali* painted extensively. But particular attention to their decoration in the late sixteenth century can be discerned among certain nobles such as Francesco Duodo and Francesco Tiepolo, who were closely affiliated with the Grimani through marriages, political outlook, and usually papalist sympathies.

The gift by the Grimani of this renowned and sumptuous Flemish breviary to the state is emblematic of their promotion of luxury painted manuscripts to distinguish the family in the sixteenth century. Analysis of how it came to be accepted by the state and displayed publicly also reveals the social and political process through which such a symbol of family distinction could become integrated as a sign of the oligarchic state (figs. 0.8, 0.9, 8.1, 8.2). The gift of the breviary, and investments of some Grimani members in the arts of the book, in turn, may have been inspired, at least subliminally, by the *Vangelo* fragment, which symbolized Mark's favor for Venice (fig. 1.11).

THE TRACE OF A SAINT, THE TRACE OF ARTISTS

Saint Mark was considered to be the first bishop of Aquileia, and from 1445 to the eighteenth century, Venice zealously guarded the right to choose his successors in that office, who held the title of patriarch.[3] For almost 100 years, the powerful Grimani of Santa Maria Formosa had a virtual lock on the title, with its attendant benefices, shared in that time period only with members of the Barbaro and Giustiniani families.[4] In fact, the Grimani custodians of the famous breviary all were at some time patriarchs of

Aquileia: Domenico 1498–1517, Marin 1517–29 and 1533–45, and Giovanni 1545–50, and from 1585 until his death in 1593. They transferred the manuscript to each other in a manner not unlike their reservation of the title of patriarch, also for each other, in a process called *renuncia cum regressu*.[5] They would have been especially aware, therefore, of the significance of the Gospel fragment in the Basilica of Saint Mark as simultaneously a relic of the saint and sign of Venetian dominion over Aquileia. Perhaps all the more so given that Aquileia itself had returned to Austrian control shortly after the conquest by Venice of Friuli, and that the Venetians retained the right to elect the patriarch but continually had to contest it with the Holy See.[6] Indeed, Grimani promotion of the breviary as a sign of the wealth, cultivation, and generosity of the family can be considered as an emergent modern mirror to the ritual display of the *Vangelo* relic as symbol of the divine favor and power of the Republic. And whereas belief in the value of the *Vangelo* as a relic eventually ceased, interest in the value of the Grimani Breviary as an artistic monument, as a relic of the handiwork of important artists, has continued to increase.

To reiterate the importance of the *Vangelo* to Venice, the Gospel fragment came to the city in the early fifteenth century when ceded by the Cathedral of Aquileia, in the context of the Venetian conquest of the region and patriarchate.[7] The "return" of this relic to Mark's body in Venice in the fifteenth century was an important symbol of Venice's new dominion over the territories formerly held by the patriarchate of Aquileia, and after 1445 Venice appointed all such patriarchs. After the initial deposit of the *Vangelo* fragment in the Basilica in 1420, it was displayed on the main altar, which held Mark's body, every June 25, the feast day of Mark's apparition, along with reliquaries containing the thumb of Mark and his ring (figs. 1.13, 1.12). The reliquaries containing elements of, or objects in contact with, his hand enhanced the claim that

the manuscript relic was written in Mark's own hand. It was a document of Mark's favor.

The Flemish breviary first came into the Grimani family when Domenico purchased it in Rome or Venice in 1520.[8] Domenico stipulated in his first will of 1520 that the breviary was to remain in the family initially in the care of his brother Vincenzo Vecchio and then in perpetuity. Because it was "so noble and beautiful," Domenico wanted it to be shown to people of note or honor whenever possible and he even demanded that an inventory of every page be made.[9] But in his second testament, he instead willed the breviary to his nephew Marin di Girolamo, whom he also had placed as his proxy as Patriarch of Aquileia in 1517.[10] In Domenico's will of August 1523, he stipulated that his nephew Marin should not part with the breviary for any reason, and he ordered that after Marin's death it should be left to the Venetian government and kept (like the *Vangelo*) with the treasures of the Basilica.[11]

In 1545, Marin in turn designated his younger brother Giovanni di Girolamo Grimani (1506–1593) as Patriarch of Aquileia in exchange for the title of Bishop of Ceneda.[12] Upon Marin's death in 1546, the breviary was amongst his possessions in Rome, but his estate was much in debt, requiring release of the manuscript to creditors. A letter from Giovanni Antonio Venier, Venetian Orator in Rome at the time, explained the situation to the *Signoria*, and emphasized the significance of the "*famosissimo*" book that was "singular, without compare."[13] We can recall that Venier was himself an important collector of books and paintings. He also had been Lieutenant of Udine, a post that included governance of all of Friuli, including Aquileia, the annexation of which had been marked by the acquisition of the *Vangelo,* and celebrated every year through its display on the feast day of the apparition of Mark. The painting in Venier's Commission as lieutenant emphasized the immortality of fame through service to the state (fig. 5.28).[14] But the *Signoria* only recovered the breviary from creditors with funds from Domenico's nephew, Giovanni Grimani. The recouped gift was first placed in the sanctuary of San Marco, but then given to Giovanni on loan in recognition of his aid in recovering it. Giovanni was an extremely controversial figure with a troubled relationship both with Venice and Rome. He came to be accused of heresy twice, first in 1546–47 and again in 1560–61, to be acquitted finally in Trent in 1563. He began to litigate with the Venetian *Signoria* over possession of the feudal lands of San Vito al Tagliamento in 1576 and then was accused of espionage for the Holy See in 1581.[15] Giovanni eventually used the breviary as a negotiating tool.

When Giovanni had become ill in 1574 he sent the breviary to the reigning doge, Alvise I Mocenigo, who consigned it to the procurators. After his recovery soon after, Giovanni took the breviary back.[16] Gravely ill again in 1592, he this time enlisted the aid of Procurator *de supra* Marcantonio di Francesco Barbaro in presenting the manuscript to the doge and the *Collegio* again in bestowing it as a gift to the state.[17] Sometime before 1593, whether during the first consignment of the manuscript in 1574 or the second in 1592, the procurators *de supra* commissioned the special red velvet binding mounted with gilded silver portrait medallions and inscriptions, definitively transforming this devotional book with Flemish paintings into a memorial to illustrious Grimani family members and their donation to the state, perhaps in part because the procurators suspected Giovanni or a Grimani relative might yet again reclaim ownership of it.[18]

On the front cover is a profile effigy of Domenico as the original donor of the manuscript to Venice with an inscription emphasizing his devotion to his *patria* (fig. 0.9). The bottom cover has a similar profile image of Domenico's father, Doge Antonio Grimani, with an inscription stating that on his deathbed he had approved the gift (fig. 8.1).[19] In Marin

Sanudo's account of Antonio Grimani's last words, Antonio's approbation of Domenico's gift is not mentioned, but the new binding and its inscriptions transformed the breviary into a sign of the magnanimity and dedication not only of Domenico, but also of the formerly disgraced doge. The object was elevated as a family monument at a time when the painting of Doge Antonio for the Ducal Palace was still unfinished, and the reputation of his grandson Giovanni also was in need of repair. In essence, through state acceptance of the gift of this manuscript and the rest of Giovanni's extensive and valuable collections, the overweening wealth and magnificence of the family was assimilated by the collective, and any lingering dishonor mended.

Meanwhile, the paintings inside the breviary had acquired increasing fame over the course of the sixteenth century. The Venetian patrician Marcantonio Michiel examined it at the Grimani Palace in Santa Maria Formosa sometime soon after 1520, and recorded it in his list of collections. He marveled at its enormous purchase price of 800 gold ducats, as well as its artistry. Michiel particularly admired the naturalism of the miniature for February, set in an icy winter landscape, in which a urinating child turns the snow yellow (fig. 8.2).[20] He noted that many masters illuminated the manuscript over a number of years, and identified, as he actually phrased it, the "hand" of Memling, of a Girardo da Guant, and of a Livieno da Anversa, citing specific folio numbers.[21] This process of distinguishing the hands of artists is an example of early connoisseurship. In the context of this manuscript, understood as important for containing the trace of talented artists, it made the breviary a particularly valuable gift.

The breviary had traveled often with Marin, Domenico, and also probably Giovanni between Rome and Venice from 1523 to 1592, and its miniatures were avidly examined by prominent artists. The paintings inspired new compositions and motifs in the work of such artists as Clovio, Titian, and Federico Zuccari.[22] The secular display of the Grimani Breviary first promoted by Domenico in Venice even may have encouraged the development of a competing Roman "signature" manuscript by Clovio, the renowned Farnese Hours, for his other cardinal patron, Alessandro Farnese.[23] Vasari's description of the Farnese Hours as an important sight in Rome, and his claim that Clovio's miniatures rivaled the hands of monumental masters such as Michelangelo, in turn must have further encouraged Giovanni Grimani to leave the great breviary to Venice as a rival to the Roman Farnese manuscript for public display.[24]

By the end of the sixteenth century, the Vangelo and breviary were kept in the sacred and civic heart of the city. The Gospel Book remained in the Treasury of the Basilica of San Marco, and the breviary was installed instead across the Piazza in the new secular treasury for books and antiquities, the Library of Saint Mark's, designed by Sansovino. Descriptions of the Vangelo and breviary by contemporaries, and the ways these manuscripts were stored and displayed, indicate that their primary importance was symbolic, material, and visual rather than textual. These had become books to be shown and perceived, rather than read. And through at least the early seventeenth century, the symbolic capital ascribed to the Vangelo and breviary was balanced, before the rise of positivist historical study eventually diminished the perceived value of the Vangelo.

Giovanni Stringa, in his additions of 1604 to Sansovino's famous guide to Venice, devoted an entire section to the Mark fragment within his description of the Treasury of the Basilica of San Marco.[25] Whereas Stringa highlighted the Vangelo fragment as a relic of the hand of the Evangelist Mark, he echoed sixteenth-century sources in valuing the breviary for its craftsmanship and beauty, or the hands of artists.[26] As Stringa tells us, the Grimani Breviary was held at that time in the vestibule (antisala) of the Library. This vestibule was especially designed by Vincenzo Scamozzi,

after Sansovino's death, under the direction of Giovanni Grimani, as heir to Domenico's collection and donor. Within this magnificent room, the breviary was stored in a *studiolo*, a large and magnificent collector's cabinet made for Giovanni, now lost.[27] The *studiolo* also held his cameos, bronzes, and precious gems, which he had donated to the Republic along with his collection of antique statuary and other works of art.

Giovanni had first approached the *Collegio* with his proposition to donate his collection of antique statues to the state in February of 1587,

a time in between the two instances in 1574 and 1592 when he separately offered the breviary. In this proposal he asked that a place for their display be chosen "proportionate to the effect that foreigners after having seen the Arsenale and other marvels of the city could also see as a notable thing these antiquities collected in a public place." The *studiolo* and its contents, including the breviary, thus were placed in the Library with the statuary and became available for view there.[28] Indeed, the Englishman Fynes Moryson (1566–1630) recorded seeing the Mark

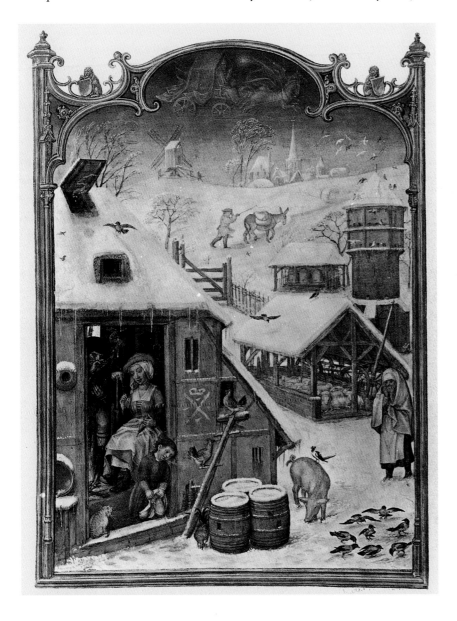

8.2 Gerard Horenbout (attrib.), *February* calendar page, Breviary of Cardinal Domenico Grimani, c.1515-20. 28 x 21.5 cm. Biblioteca Nazionale Marciana, Venice, Lat. I, 99 (=2138), fol. 3v

fragment in the upper vestry of the Basilica and the breviary in the vestibule of the Library in 1594, before the vestibule was fully completed.[29] Eventually the breviary was returned to the Treasury of the Basilica, but still was shown to important visitors.[30]

As late as 1758, Flaminio di Giovanni Battista Corner (1693–1778) described Mark's Gospel fragment as the most remarkable item in the Treasury of the Basilica, but left room for doubt about its authenticity.[31] Rational inquiry had diminished the power of this object as a true relic. The loss of the patriarchate of Aquileia in 1751 and Venice's general political and economic decline perhaps also had diminished belief in Mark's favor. The fall of the Republic in 1797 further rendered the symbolism of the document anachronistic. The *Vangelo* is no longer displayed every June 25, nor valued as a relic of Mark's trace.[32]

By contrast to the relative obscurity of the Gospel fragment, the fame of the Grimani Breviary has increased. After persistent urging by the librarian Jacopo Morelli (1745–1819), it was transferred back to the Marciana Library along with some other manuscripts under the presiding Austrian government in November of 1801, and an elaborate new display pedestal was completed for it in 1905. The imagery on this book-stand projects nostalgia for the former glory and independence of the Republic and its patricians through reproductions of the Grimani portrait medals on the breviary cover. These are presided over by the lion of Mark brandishing a sword, which still is the insignia of the Marciana Library.[33]

Whereas scientific analysis discounts the value of the Gospel fragment as a true relic of the hand of Mark, photography and digital imaging have aided study of, and intensified interest in, the breviary as a key relic of the hands of several important Flemish manuscript painters. A magnificent and expensive full-color facsimile has been published.[34] Furthermore, Erik Drigsdahl has claimed that he found a signature, that most definitive and reflexive of indexes,

of the noted miniaturist Simon Bening in the breviary.[35]

In sum, in Renaissance and early modern Venice, power could be symbolized by the preservation and display of manuscripts recording the unique trace of human hands. The Gospel fragment was employed on the stage of liturgical performance, where the contact-relic of traces of the saint's hand consigned authenticity and sacred authority to the state, its law, and its rulers. The Grimani Breviary was appreciated in the realm of connoisseurship and collecting, where costly and miraculous artistry bestowed status and prestige to a patrician family and its city. The production, use, and storage of Venetian *ducali* operated in both modes of signification of these publicly displayed manuscripts. In the handwritten texts of *ducali* were traced the divinely authorized laws of Venice. Some of these manuscripts were notarized with seals and signatures from the chancery. Sumptuous decoration of *ducali*, and their maintenance and use in family archives, or storage with precious objects, linked them to the broader magnificence of individual patrician and state artistic patronage. Painting and binding transformed these documents, originally of temporary value, into memory objects, which authenticated and preserved individual and family status, in relation to the state.

Ducali continued to be painted until the end of the Republic. But no *Promissioni* with portraits of the doge are known after that of Antonio Grimani of 1521, perhaps because the officials of the *Rason vecchie* no longer wanted to fund triumphal images of the doge that would remain in family archives. After the death of Doge Grimani, the Correctors of the *Promissione* especially limited the commemoration and visibility of doges outside the sphere of the palace through new regulations. In addition, legislations of 1578, 1585, and 1595 required ever greater surveillance of the doge's cognizance of and adherence to the statutes of the *Promissione*.

He eventually was required to retake his oath to uphold the statutes every year, which suggests that belief in the sincerity and efficacy of the original promise and oath had been lost. Correspondingly, the notion of the material document as bridging a contract with the divine also diminished, to be replaced by that of a rule book to be carefully enforced and grudgingly followed.

In the seventeenth century, the magnificence of the Commissions of the procurators generally was overtaken by printed editions of festival books celebrating their election and inauguration festivities. Commissions for rectors continued to be painted with portraits and extensive imagery relevant to the recipient and his duties of office, and a number produced in the seventeenth and eighteenth centuries are extremely interesting in terms of iconography.[36] They offer a rich field for future research. But overall, the quality of painting declined as Venice ceded eminence in the book industry to other cities, perhaps also because the very sense of the privilege and exclusivity of the patriciate diminished with the entrance of numerous families after 1646 to finance the costly wars to defend Crete and the Morea. And whereas the highest offices of doge and procurator continued to remain competitive, by the mid-eighteenth century fewer patricians felt the sense of duty to govern in the lower but often expensive and arduous positions, such as rector.[37] The ethic promoting selfless patrician service had diminished.

The texts of *ducali* authorized individual patricians to govern in various offices. These manuscripts came to be illustrated to commemorate service to the state, to convey ideals of patrician service, and prospectively to shape family memory. Study of them allows us to appreciate more fully the extent to which patricians striving for both corporate and individual distinction fashioned the city and its territories as a memorial landscape. The archives of many families can be conceptualized as having contained miniature portrait galleries of patricians within documents, and Venice itself can be viewed as an archive of memorials held in its governmental buildings, churches, and palaces. Because of the desire by patricians to promote themselves both individually and as a collective, and the longevity of the Republic, these archives, one on vellum and parchment, the other expressed or housed in brick and stone, became particularly extensive, and remain unusually compelling.

NOS ANDREAS
GRITI DEI
GRATIA DVX
VENETIAR ETC.

COMMITTIMVS

tibi Nobili viro Dilecto ciui, et fideli Nostro Petro Dechataiapetra &
in Christi Nomine vadas, et sis De nostro mandato POTESTAS ciuitatis
nostræ VINCENTIÆ per menses
XVI . et Tantum plus quantum
successor tuus Illuc venire distulerit

AFTERLIFE: THE DISPERSION AND COLLECTING OF *DUCALI*

THIS BOOK HAS examined how certain Venetian documents were painted and elaborately bound to transform them into trophies of patrician achievement and service to the state. *Ducali* exemplify the power of the arts of the book not just to embellish but also to augment, even transform the function and meaning of a text. As discussed in relation to the Grimani patronage of manuscripts, symbolic meaning was further enhanced, transformed, and revealed by collecting, preservation, and display. Indeed, as is to be expected, the overall pool of material available for study of these documents has been determined by the filters of collecting. Thus, this epilogue explores how *ducali* eventually came to be dispersed and how many were fragmented, and what significance collectors and scholars have seen, or sought, in them after they left patrician family possession. In fact, these manuscripts, which were visually and materially enhanced to celebrate patrician rulership and rank, lost utility in upholding patrician status after the Republic ceased to be in 1797. They were collected in museums and libraries to preserve the memory of the former glory of Venice, but became most valued on the market in the nineteenth century for their illuminations and binding, rather than as records of service to the Republic, and this often led to their dismemberment.

The miniatures in late sixteenth-century *ducali* manuscripts particularly emulated large-

Detail of fig. 9.7

scale painting. Their similarity in style and format to monuments by recognized masters such as Titian, Veronese, and Tintoretto led to these illuminations being the most assiduously stripped from their books and avidly collected in the nineteenth century. Paradoxically, this fragmented state of many of the most appreciated *ducali* miniatures has caused them to be the most difficult to identify and study. Early admiration of these miniatures by collectors has contributed to their being relatively neglected in art historical study. Fragmentation shows us that in as much as *ducali* are documents that were transformed into memory objects through paintings, the attractiveness of the images caused them to be treated in ways that could subsequently obscure the identity of the patrician to be remembered.

SPOILS: A LONG TRADITION

"beyond those troops of ordered arches there rises a vision out of the earth, and all the great square seems to have opened from it in a kind of awe, that we may see it far away;-a multitude of pillars and white domes, clustered into a long low pyramid of coloured light; a treasure-heap, it seems, partly of gold, and partly of opal and mother-of-pearl, hollowed beneath into five great vaulted porches ..." John Ruskin[1]

The urban fabric of Venice itself exemplifies the historical practices of appropriating and re-using ancient and foreign building materials and

sculptures, and seizing relics and treasures from abroad, to formulate civic identity. Venetians of the Empire had masterfully employed a visual language of collecting and display to express alliances and dominion, and to convey the city's intertwining political and religious ideals. Even Venice's most prized relic, the body of Mark, was a *furtum sacrum*, or sacred theft, from Alexandria in 828. But the greatest enrichment of precious objects arrived in the years following the sack of Constantinople of 1204, the culmination of the Fourth Crusade. The relics and treasures taken from the Byzantine capital were placed mostly in and around the Church of Saint Mark.[2] As discussed in Chapter 1 and the Conclusion, the message of Mark's favor through his physical presence was reinforced by the early fifteenth-century acquisition of a book relic: the Gospel fragment believed to have been written in the Evangelist's own hand (fig. 1.11). Venice was instructed in the raiding of monuments and the reuse of their elements by the very example of the metropolis Venetians had looted – according to Saint Jerome, in the early years of its founding in the fourth century, "Constantinople was dedicated by the virtual denuding of every city."[3] It is, therefore, a concise lesson in history to observe that when, in the mid-nineteenth century, Ruskin famously described the Basilica of Mark as like a "treasure-heap," Venice was itself being systematically divested of artistic and cultural jewels. As Venetians despoiled Byzantine monuments from the twelfth to the fourteenth century, and collected antiquities from the fifteenth to the seventeenth century, so too much of its patrimony was displaced in the late eighteenth, nineteenth, and early twentieth centuries – a process that began even before the Republic ceded to foreign rule, and before the eventual impoverishment of many of the city's inhabitants. Marino Zorzi has movingly described the despondency and disillusionment that induced some patricians to discard their rich material heritage, even if not forced to for economic reasons, after the cataclysmic events of the late eighteenth century ended their privileged status as rulers, and thereby the potency of these objects to reinforce political capital.[4]

Today, museums around the world exhibit numerous well-heads, reliefs, and other stones from Venice.[5] Objects from the interiors of the city also have been much sought after by collectors, including the manuscripts that are the subject of this study.[6] There are thousands of *ducali* manuscripts, and fragments of them, in collections around the world. Many of these materials remain in private collections, out of access by the general public. But some Venetians, most notably Teodoro di Jacopo Correr (1750–1830), who will be discussed further, collected what they could to preserve in Venice "many honored memories of the *patria*" after the fall of the Republic, so that the city still holds the largest number of these manuscripts, albeit mostly in public collections rather than in the patrician archives for which they were originally destined.[7]

EARLY DISPERSION: ENGLISH ADMIRATION FOR THE REPUBLIC

The earliest known surviving collection of *ducali* purchased by a foreigner is that of the English archbishop William Laud (1573–1644/5). He acquired a set of six Commissions, among which were the four of Michele Bon discussed in the Introduction. These were donated along with hundreds of other manuscripts to the Bodleian Library, Oxford, on May 22, 1635 (fig. 0.5).[8] Laud's general collection was vast, and donated items included curiosities such as a magic wand. Despite the omnivorous nature of Laud's collecting, it is still intriguing to consider how he might have found the set of *ducali* and why he would have wanted to obtain it. The *ducali* were donated by Laud in a grouping in which the majority of manuscripts were connected with Venice, and Richard William Hunt has

suggested they may all have been bought for Laud by an English bookseller who had purchased them in Italy.[9] Laud's acquisition is all the more interesting when one considers that the illuminated frontispieces, which commonly featured portraits in the sixteenth century, had already been removed before they reached the Bodleian Library, and presumably therefore the collector.[10] Why would someone have cut out the miniatures, and why would Laud have wanted to purchase and preserve such damaged manuscripts?

There have been a number of fascinating cultural studies on the cutting up of manuscripts for their miniatures or other parts, and the reasons for such dismemberment.[11] Laud's collection of Bon Commissions is the earliest case of which I know of someone detaching the leaves of a Venetian manuscript for its miniatures. As we have seen, as the records of the higher offices to which patricians were elected, this type of *ducale* was typically kept in family archives in perpetuity, as evidence of the glory of the patrician line, and yet Antonio Grimani's comment to his sons to preserve them may suggest that a market for them already existed. Why they were sold to Laud at such an early date, without illuminations, is difficult to determine; it may well be that the estate was dispersed after Bon's death – it is not clear whether he had heirs.[12] Perhaps a separate market for the illuminated leaves of these manuscripts already existed in Venice, or the family may have saved the opening leaves, which presumably included portraits, while discarding the manuscripts. For his part, despite the lack of miniatures, Laud may have appreciated the spoliated books for their gold-tooled leather bindings, which he left intact, and/or for the historical interest of their texts.[13] In the rest of this epilogue, we will explore to what extent interest in Venice as an ideal republic is reflected through collecting of Venetian manuscripts from the early modern period to the twentieth century. And, prompted by the case of Laud's curiously spoliated books, one can ask, to what extent is it possible to gauge the nature of such interest not only by the collecting of *ducali* manuscripts but also by the condition in which they were obtained or maintained?

Laud's purchase of Bon's Commissions in the early seventeenth century came at a time when the political system of Venice had become the subject of great English admiration for its longevity, stability, and independence, and such *ducali* texts, although deprived of their pictures, may have appealed to Laud for detailed insight into the actual content of the constitution that directed individual Venetian patricians in governance.[14] English interest in Venice's government is most cogently signaled by the success of an augmented English translation of Gasparo Contarini's panegyric and description of the Venetian Republic and its magistrates, written by Lewis Lewkenor (c.1556–1626).[15] Lewkenor's English edition was first printed in London in 1599, and seems to have been standard reading for the seventeenth-century British traveler to Venice.[16] In his preface, he claimed that Venice contained the fruits of all great governments throughout the world.[17] Lewkenor's Contarini translation became one of the central texts through which the famous myth of Venice as an ideal aristocratic republic, governed by selfless and enlightened patricians, was transmitted to England. A number of scholars have argued that it was in fact in England that these Venetian governmental ideals had their most profound effect.[18]

Although dedicated to the exposition of the exemplary Venetian government and her magistrates, Lewkenor also pointed out a different reputation of Venice than that of the ideal republic, whose admirers were less mature. The group he calls "the youthfuller sort" would "extol to the skies their humanitie towards strangers, the delicacie of [Venetian] entertainments, the beauty, pomp, and daintines of their women, and finally the infinite superfluities of all pleasure and delightes." Here we find some of the elements of another

side to the myth of Venice, in this case as the "gallant city," which opened up room for detractors.[19] To Lewkenor, only those whom he characterized as of "graver humor … dilate of the greatnes of their Empire, the gravitie of their prince, the maiesty of their Senate, the venerablenes of their lawes, their zeale in religion, and lastly their moderation and equitie …"[20] Since Lewkenor's edition of Contarini concentrates on describing and praising the Venetian government and its patricians, we can assume that both Lewkenor and Contarini belonged to this latter camp of "a graver humor."

Diplomatic relations between England and Venice almost ceased during the reign of Queen Elizabeth I because of religious differences, but were renewed in 1603. Admiration of Venice by the "youthfuller sort" is demonstrated in some early seventeenth-century English travel accounts. These bolstered Venice's political reputation, and added lengthy accounts of the city's beauty, its art, and the available curiosities and entertainment, including particular fascination with the courtesans, crystallizing the two-sided metaphor of Venice as both Virgin and Venus.[21] Thomas Coryat (c.1577–1617), in the dedication to his *Crudities* of 1611, which distilled tongue-in-cheek descriptions and experiences from his travel to Venice in 1608, boasts that his book was the first in English to focus on the visual splendor and infinite entertainments of Venice.[22] The engraved images relevant to Venice in Coryat's book depict her notoriously carnal beauties; the frontispiece shows a courtesan pelting a man in a gondola with eggs, and Coryat himself is portrayed as visiting a celebrated Venetian courtesan in a full-page illustration. Claiming himself not fit to discourse at length on Venice's government, and having already noted that one could glean that information by reading Contarini, Coryat does provide a brief synopsis of Venice's government near the end, before lamenting the high price of wine in the city.[23]

The accounts by Coryat and other English writers benefited from a number of books printed in Italian praising the sights of Venice, and its government and people, which were already circulating in numerous editions; in particular, the guidebooks by Francesco Sansovino, and the "costume books" by Cesare Vecellio and Giacomo Franco.[24] The *Itinerary* of Fynes Moryson, published in 1617 and based on his travels in the 1590s, repeated Coryat's emphasis on the curiosities and beauty of Venice, but omitted mention of the courtesans, and his was followed by a series of English books praising Venice for the structure of her government.[25] Although a counter-myth of Venice as decadent, decaying, and authoritarian also developed abroad, this only served to heighten the city's status as "an important ideological reference point and a potent symbol" for the English.[26]

The reputation of Venice's visual splendor was augmented by the increasing value placed on sixteenth-century Venetian painting abroad, beginning with the liberal and extensive patronage of Titian by Emperors Charles V and Philip II at their courts in Spain and Central Europe. Venice became one of the principal centers for the commerce of art in the seventeenth century, offering opportunities to visiting collectors, and forming a node for international distribution. Collectors in England began to enthusiastically acquire Cinquecento Venetian paintings in the seventeenth century through agents and travel.[27] This is not the place to summarize the rich history of the collecting and influence of Venetian painting abroad, but rather to emphasize that besides the fascination with Venice's government and its culture of physical beauty and pleasures evident from literary sources, a long tradition of valuing and collecting Venetian painting in England and on the Continent set the groundwork for appreciation of the miniatures of Venetian manuscripts, and a separate market for them in the eighteenth and nineteenth centuries.

COLLECTORS IN FRANCE

Contarini's text on Venice's government was actually first published in Paris in 1543. But a keen interest in the government and rulers of Venice by the French is evident already in the late fifteenth to early sixteenth centuries, from the appearance of an anonymous panegyric of Venice in French. A copy of this early but fully developed version of the myth of Venice was splendidly illuminated by a French miniaturist for Admiral Louis Malet de Graville, who conducted negotiations with the *Signoria* of Venice in 1485. The manuscript opens with a painting of the seat of Venice's power in an impressive aerial evocation of Piazza San Marco facing the Basilica and Ducal Palace, which imposes early Renaissance characteristics on the façade of the Basilica. The opening text page shows the doge presiding in the Senate, with chancery scribes below, writing.[28] The author prefaces his subject by extolling the long freedom of the city from subjection and tyranny because of the perfection of her good institutions and laws. As the opening images signal to the reader, the text first discusses the most notable buildings and sights of the city, before settling into a description of the administrative organs of government, which is so detailed as to include the lower orders of servants. The actual ballot boxes are illustrated, demonstrating interest even in the mechanical details of Venetian elections.

In France, as in England, Venetian paintings were acquired eagerly by influential collectors, and this tradition began at an even earlier date. Some important Venetian paintings arrived in important French collections as diplomatic gifts. In 1515 Giovanni Bellini was ordered to paint a Madonna for the sister of the new king of France.[29] Francis I, although he preferred paintings from artists of Tuscan origins, himself acquired three more Venetian paintings sometime after 1530, probably through Pietro Aretino.

Above all, once again, the burgeoning art market in Venice itself provided the hub from which to acquire Cinquecento Venetian art.[30] It is in the mid-seventeenth century, especially under Louis XIV (1643–1715), that the French royal collection was again greatly enriched with Venetian paintings, when, in 1661 and 1662, some fifty paintings by Titian and Veronese, as well as other Venetian painters, were acquired from other French collectors. The king even received three Venetian paintings as diplomatic gifts, including Veronese's great *Supper at the House of Simon*, in 1664 and 1665.[31] The majority of Venetian paintings acquired at this time in France were by Titian, Veronese, and Tintoretto. The interest and healthy market for Venetian painting in France, especially of the works of Titian and Veronese, continued into the eighteenth and nineteenth centuries.

In this context of the high international valuation of Cinquecento Venetian painting, it is still remarkable that a Venetian manuscript was one of the most expensive to be sold at auction in France in the eighteenth century. This was the elaborately illuminated, late sixteenth-century account of the missions in service to the state of the Venetian *cittadino* and secretary Carlo Maggi (d. *c.*1587), produced in manuscript form sometime after his return to Venice in 1573.[32] A number of earlier magnificently illuminated manuscripts were listed in the sales catalogue of J. B. Denis Guyon de Sardière of 1759, but the Maggi manuscript was the most carefully described.[33] Louis-César de la Baume le Blanc, Duc de Vallière (1708–1780), the great bibliophile and collector, attributed the miniatures of this manuscript to Titian and Veronese in 1761, after which it sold at auction for 2000 francs, a very high price for the time.[34] The illuminations have been most recently attributed to Lodewijk Toeput, called "il Pozzoserrato," the Flemish artist who may have joined Tintoretto's workshop after 1573, and this is not a hand found in *ducali* manuscript illumination.[35] Although

not a *ducale*, the manuscript offers a dramatic *cittadino* counterpoint to a *ducale*'s significance in documenting a patrician's distinguished service to the state. Full-page illuminations depict the Maggi family tree, chivalric arms, portraits of Maggi and of his purported son, and views of the lands to which he traveled on his missions for the Republic, culminating in an image of him recounting the success of his service to the doge. Indeed, with its key messages of service to the Republic and Maggi's distinguished genealogy, the manuscript can be read as a plea for the equivalent of patrician status by a Venetian *cittadino*. In the eighteenth-century French market, Maggi's illuminated book was especially valued as a specimen of the style of Cinquecento Venetian painting and illumination most prized by critics and collectors.

VENICE IN THE EIGHTEENTH CENTURY

The fall of the Republic in 1797 was the definitive end of the production of ducal documents, but the dispersal of Venetian manuscripts, and of the Venetian patrimony in general, had already accelerated in the seventeenth and early eighteenth centuries. Venice became even more of an important market for both new and old works of art in the eighteenth century. Travelers to Venice on the Grand Tour were able to buy objects from less financially sound nobles and clergy, prompting recurring, sometimes sardonic, comment by the prominent *cittadino* man of letters Apostolo Zeno (1668–1750), as in a letter of 1731: "Little by little Italy is losing its best (treasures) ... but one shouldn't be stupefied, because we are losing money, taste and learning."[36]

Consul Joseph Smith (1675–1770) was the most significant English collector of *ducali* in the eighteenth century; not for the number of these manuscripts that he acquired, but for their aesthetic worth, and as records of the highest offices. He does not seem to have collected *ducali*

manuscripts from later than the sixteenth century, probably because the quality of the miniatures declined generally after around 1610. The high caliber of Smith's collection can be traced not only to his long residence in Venice and involvement in various aspects of Venetian society, which would have given him greater access to such acquisitions, but also to his stated aim to draw together a collection worthy of a king.[37]

Smith resided in Venice from the early years of the eighteenth century until his death, and was English consul of Venice mainly from 1744 to 1762. Although he is more famous for his patronage of Canaletto and for his collection of paintings and drawings, Smith actually seems to have begun his collecting career by focusing on the acquisition of manuscripts and early printed books. In 1762, he sold most of his art collection to George III, and in 1765, his books. From the king, the books and manuscripts eventually entered the British Library.[38] The manuscripts Smith sold to George III included the Commission of Girolamo Zane as procurator of 1568, with miniatures of the highest quality (fig. 4.20).[39] In 1850 the British Library purchased from Smith's collection the magnificent *Promissione* of Doge Antonio Grimani of 1521 (fig. 0.5).[40] This manuscript is one of those that Doge Grimani, on his deathbed, requested his sons retain in the family. Grimani was a famous Venetian doge, but English collectors also must have appreciated the miniatures in High Renaissance style. Whereas Laud acquired only partial texts and preserved them in their original bindings, Smith followed the fashion of the time and discarded the original binding of Grimani's *Promissione*. Smith had it rebound with his own heraldry to emphasize his possession of it.[41] Such continued illustrious provenance would only increase the value of such books for collectors and institutions.

On July 12, 1773, increasing sales of the Venetian patrimony prompted the Council of Ten to assign Anton Maria Zanetti the Younger

to produce an inventory of the art treasures of Venice, in part to prevent their being bought and taken away by wealthy foreigners.[42] But losses accelerated in the 1790s, when artworks from Venice, and Italy in general, were carted away for sale.[43] One of the most famous Venetian collectors of books in this period of the late eighteenth century was Matteo Luigi Canonici (1727–1805), who acquired the extensive collection of Jacopo di Sebastiano Pr. Soranzo (1686–1761) around 1780.[44] The Bodleian Library purchased 2045 of these manuscripts in 1817. Incidentally, the collection transferred to the Bodleian included only one *ducale*.[45] Canonici's most important *ducale*, the *Promissione* of Doge Nicolò Tron (doge 1471–73), one of very few signed by a miniaturist (Marsilio da Bologna) was retained by Canonici's heirs, and acquired separately by the collector Walter Sneyd (1809–1888) in 1834. It is now one of the most significant illuminated manuscripts in the New York Public Library (fig. 3.14).[46]

THE FALL OF THE REPUBLIC: APPROPRIATION AND DESTRUCTION

In May of 1797 the oligarchic Republic of Venice abdicated to the French. On May 12, 1797, the Great Council approved a motion to hand power over to a "provisional representative government," and Doge Lodovico Manin left the Ducal Palace on May 14, the day before French troops entered the city. The new Venetian municipal government maintained the symbol of the lion with his book, but the inscription "*Pax tibi …*" was replaced with "*Diritti e doveri dell'uomo and del Cittadino*" ("Rights and duties of man and citizen").[47] The phrase that had emphasized the promise of peace through Venetian patrician rule under Mark's favor was replaced with one stressing the new secular and egalitarian ideals.

On May 16, Bonaparte signed a secret treaty in Milan with envoys from Venice, which included an agreement that Venice send twenty paintings and 500 manuscripts to Paris, a small part of the bounty that would be despatched from elsewhere in Italy and indeed from all over Europe.[48] Among the first objects confiscated by the French were the winged lion in the Piazzetta, and the great bronze quadriga (carriage) and horses on the façade of Saint Mark's that the Venetians had brought home from Constantinople during the Fourth Crusade.[49] The choice of books and manuscripts seems to have been made in Paris, according to the papers left by Keeper of Printed Books at the Bibliothèque Nationale, Jean-Basile-Bernard Van Praet.[50] Private collections were not to be raided, so no full *ducali* were chosen.[51] But in these turbulent times many manuscripts and books were simply stolen from both public and private collections.[52]

After 1797, symbols of the aristocracy and the Republic, including the *Libro d'oro* and ducal insignia, were publicly burned in Piazza San Marco to ritually emphasize, through destruction in addition to despoliation, that the patriciate no longer had special status or privileges in the eyes of the new law. Sculptures of the lion of Mark were smashed.[53] Venice was delivered to Austria according to the Treaty of Campo Formio in October of 1797.[54] Under the first Austrian regime, the manuscripts consigned to Paris were returned to Venice, to the repositories from which they had been taken. Some manuscripts in the Treasury of the Basilica of San Marco, including the three liturgical books created in the fourteenth century for use in the Basilica, were also moved to the Marciana Library in 1801 and 1803 for protection from damp.[55] Much of the liturgical content of these manuscripts – a missal, an evangeliary and an epistolary – was already obsolete with the abdication of the doge, who had been a key protagonist in the ritual of the Basilica. The manuscripts also were no longer useful in bridging the promise and oaths of the doge and procurators, since no more were to be inaugurated. Around this time some of these manuscripts lost leaves, most notably the evangeliary. Five cuttings were acquired by Georges Wildenstein (1892–1963) and

placed in a Gothic-style frame, as if they were in fact small panels of a private portable altarpiece (fig. 9.1).[56]

The evangeliary, like the accompanying epistolary and missal made at the same time, was rebound in leather after its relocation to the Marciana Library. Its original covers are now stored separately. These covers are spectacular, fit for their intended central role in the performance of the unique liturgy of the Venetian State Church of Saint Mark. That of the evangeliary, made of gilt silver on wood with gold cloisonné enamel, stones and pearls sometime in the late tenth to early eleventh century, was most likely originally made to cover a Byzantine Gospel manuscript (fig. 1.5). It may have arrived in Venice as a diplomatic gift, or as one of the objects taken during the Fourth Crusade.[57] When Saint Mark's became a cathedral in 1807, the Roman rite was adopted, and the content of these manuscripts, with special feast days highlighting God's favor of Venice, definitively became no longer of use in the liturgy. Separated from each other, these bindings and manuscripts are now only "used" by researchers and displayed in museum exhibitions.[58]

Some manuscripts were given away to pay off state debts after the fall of the Republic. The Commission of Francesco Barbaro as procurator of 1452 (fig. 4.6), the earliest surviving procurator's *ducale* with significant illumination and a portrait of the recipient, was part of the large and illustrious collection of books and documents owned by Doge Marco di Nicolò Foscarini (doge 1762–63). It was one of almost 500 manuscripts from the Foscarini collection sent to Vienna at the beginning of the nineteenth century to help pay off the debts of the Republic, and remains there, in the Austrian National Library.[59] Venice was under the Hapsburg Empire until January 18, 1806, when it was placed under French rule again following the victory at Austerlitz. The Congress of Vienna of 1815 consigned Venice once again to Austria, at which time the San Marco horses were returned to Venice from Paris. Venice remained under Austrian rule excepting the brief insurrection period led by Daniele Manin (1848–49), until 1866, when it became part of the Kingdom of Italy.[60] Although it had fallen, admiration for the long-lived and illustrious Republic continued, and actually encouraged theft from the archives.

A collection of state archival manuscripts was sent from the Venice Archives to the Pinacoteca di Brera in Milan under Italian government requisitions in 1837, and then in 1842 to the Imperial Library in Vienna.[61] Some of these manuscripts originally produced for use in the state chanceries had adventurous modern itineraries before returning to Venice. The two earliest surviving compilations of *Promissioni* with illuminations (for Francesco Dandolo, doge 1329–39, and for Andrea Dandolo, doge 1343–54) were returned from Vienna to the Brera in 1866, when Venice became part of Italy. They were then eventually placed in the new Venice State Archives, which were now housed in the former convent of the Frari, so returning them to their original context among archival materials of the former Republic. Here they were displayed among other treasures in the Sala Diplomatica Regina Margherita. During World War II the installation was dismantled and, sometime from 1946 to 1949, the folia with miniatures of the *Promissione* were stolen, along with a number of entire illuminated manuscripts and detached leaves, eventually to enter the international market.[62] We have seen that there was some sort of market for detached leaves by the sixteenth century, but demand for these had accelerated in the nineteenth century.

9.1 Master of the San Marco Evangeliary, Five cuttings from the 13th-century evangeliary of the Basilica of Saint Mark, as previously displayed in a gothic-style frame. Top scene 9.3 x 9.3 cm; others 6.7 x 7.7 cm. Musée Marmottan Monet, Paris. Wildenstein Collection

DETACHED LEAVES AS INDEPENDENT PAINTINGS

"The opportunities for the purchase of books which confronted an English visitor on the continent at the end of the Napoleonic Wars had no previous parallels, and have never been equaled again."
John Pemble[63]

While Venice was occupied by Austria, severe economic recession in the 1820s and 1830s prompted sales of Venetian residential property as well as valuables, creating a virtual colonization of Venice particularly by the English and the French. The accelerated sales of Venetian possessions coincided with a new interest in illuminated manuscripts as works of art and models for artisanship, to such an extent that manuscripts were cut up and their individual illuminations sold in large numbers. Abbé Luigi Celotti (c.1768–c.1846) became the most important intermediary in the sale of artworks from churches suppressed during the French occupation, and from private collections sold out of financial need, or to avoid their being sacked. As secretary and librarian to Count Giovanni Barbarigo in Venice from 1801, Celotti lived in the Casa Barbarigo on the Grand Canal in San Polo, from where he had privileged access to Venetian collections, buying manuscripts from illustrious patrician families including the Nani, Gradenigo, and Mocenigo.

Celotti is most famous for having the first sale solely comprised of manuscript cuttings, in London at Christie's on May 26, 1825.[64] This auction has been singled out as a watershed in promoting the value of individual miniatures and leaves as works of art. This and the subsequent Celotti sales elevated the single leaf extracted from books to a new valuable collecting category aimed at an audience of connoisseurs of painting rather than bibliophiles, and set high prices.[65] The early nineteenth-century general craze for book collecting, the "bibliomania" described and abetted by Thomas Frognall Dibdin, died down in the 1830s.[66] During this depressed trade for books, Celotti effected a successful transition of market interest to "specimens" of artistic merit. Although comprised mainly of leaves cut out of manuscripts claimed to have been looted from the papal chapel by Napoleon's troops in February of 1798, the first sale also featured the framed, detached leaf from the *Promissione* to Doge Agostino Barbarigo of 1486, perhaps acquired directly from Celotti's employer, the Count Barbarigo. In the catalogue, the illuminations were attributed to Giovanni Bellini.[67] The extensive description of the leaf and annotations in a copy of the catalogue allow us to identify it as one purchased from that sale by Richard Ford (1796–1858). The leaf remains in the frame described in the auction catalogue, on a wall in a Ford family residence (fig. 3.17).[68]

Today, with more extensive understanding of manuscript painting in fifteenth-century Venice, we can safely shift attribution of this *Promissione* leaf from Giovanni Bellini to a professional and prolific miniaturist, the so-called Pico Master.[69] But in the Celotti catalogue, the value of the leaf as index of both a ducal election and of the hand of Giovanni Bellini was maintained.

Roger Wieck has emphasized that Celotti's motives in cutting pictures out of codices were aesthetic, as Celotti often reconfigured fragments to create pastiche pages.[70] To give a sense of the volume in which Celotti traded, he sold nearly 4000 lots of individual leaves and full manuscripts in 1825 in four sales at Christie's and Sotheby's in London.[71] William Young Ottley (1771–1836) was the author of the Celotti catalogue, and his own collection of over 1000 leaves, probably the largest at the time, was sold in 1838.[72] The Ottley sale stimulated an interest in cuttings even further, and they became souvenirs that could easily be transported home for English travelers to the Continent. Many *ducali* manuscripts with illuminations intended for storage in patrician family archives were stripped of their miniatures, and therefore of much of their original signifying context.

THE PRECEDENT OF SINGLE MINIATURES IN THE RENAISSANCE

Although a keen market for detached miniatures in England only developed fully in the nineteenth century, manuscripts are known to have been broken up for their paintings well before 1700. Full-page miniatures by the French Renaissance miniaturist Jean Bourdichon were detached from a Book of Hours in England in the sixteenth century, so that they could be better appreciated.[73] And as noted above, it is unclear when the miniatures of *ducali* in Laud's seventeenth-century collection were excised – whether in Venice or abroad. In Venice there also had long been a craft of creating and framing individual miniatures, which may have encouraged the detachment of leaves from manuscripts – of conceptualizing them as separate from a book. The extensive production and export of illuminations set under crystal in Venice of the late thirteenth to mid-fourteenth centuries can be seen as the industry and practice precursor.[74] Such individual miniatures typically were set in reliquaries, liturgical objects, and materials for private devotion, but were also to be found in objects made for recreation, such as chessboards.[75] A Byzantine mosaic icon donated to the Church of Santa Maria della Salute by Matteo Bon in the seventeenth century is framed by sixteenth-century miniatures protected under glass in this tradition (fig. 9.2).[76] This broader use of miniatures in devotional and domestic products continued, and their placement and function is most often gleaned from testaments and inventories. Carlo Maggi, whose magnificent manuscript was discussed earlier, listed a "small illumination of the Pietà, which I keep next to my bed" in his testament. This leaf, too, was presumably set in some kind of frame, and the testament conveys how miniatures played a critical role in the private, intimate contemplation of images.[77] By virtue of their small size, they can be kept by the bedside, or, in the case of portrait miniatures, carried next to the heart.[78]

9.2 Byzantine mosaic icon, late 13th to early 14th century, with painted frame of 16th-century Venetian miniatures under crystal/glass. 21.6 x 17.1 cm. Seminario Patriarcale, Venice

Marcantonio Michiel's famous inventory of private art collections in Venice and its territories in the years 1521–43 mentions a number of independent miniatures in private collections. Michiel noted two female nudes painted by Giulio Campagnola on membrane in the collection of Pietro di Bernardo Bembo in Padua, one after a painting by Giorgione, the other after a painting by "Diana" (Benedetto Rusconi, called Diana).[79] These reflect the growing desire for miniature copies of famous paintings, which joined the fashion already well developed for collecting small art objects, antique and modern gems, coins, medallions, and bronzes, some of which were copies of famous, larger sculptures. There was also a growing interest in collecting miniature portraits both painted and in wax, and Michiel records that

Bembo owned a miniature portrait of himself as a young man by Raphael, as well as gems and small bronzes, antique and modern.[80]

Such miniatures were displayed on desks or on walls, or stored in specially made cabinets with the other collectibles in the new spaces of the *studiolo* and Wunderkammer. Within these small rooms or cabinets, collectors could possess a microcosm of a world of wonders from antiquity, from nature, and of inspired craftsmanship.[81] The artists of these miniatures could be painters who also worked in oil on a grander scale, such as Raphael. They could, alternatively, be artists who were devoted mostly to miniature painting on membrane or paper, or, like Giulio Campagnola, artists who

were renowned for miniature painting but who also worked in other media, such as engraving. A number of single leaves produced in the Veneto sometime later in the sixteenth century copied the compositions of larger works. Such is a miniature, *Christ and the Adulteress*, with a composition after Jacopo Bassano's painting of the same theme (fig. 9.3). The original painting was commissioned by a Venetian *podestà* of Bassano in 1536, and hung in the Palazzo Pretorio, to be joined eventually by the paintings for Matteo Soranzo and Lorenzo Cappello (figs. 6.13, 6.14).[82]

9.3 *Christ and the Adulteress*, miniature after painting by Jacopo Bassano of 1536. 19 x 24 cm. Free Library of Philadelphia, E M. 47: 10

Besides producing independent illuminations, miniaturists increasingly created full-page miniatures for extra-foliation – for adding to a manuscript as a full leaf after the text had been written out. Four miniatures in the Morgan Library attributable to the Venetian miniaturist Benedetto Bordon, or the Master of the Triumph of Venus, have been pasted on board, and follow common imagery for illustrating Books of Hours, including an *Annunciation* for the Hours of the Virgin (fig. 9.4).[83] They may have been planned for a manuscript but were never attached, or else were detached from a finished Book of Hours.[84] Their current state as independent miniatures highlights their status today as art rather than as devotional aides. Marcantonio Michiel's appreciation and high monetary valuation of miniatures still in intact books in the sixteenth century might be considered a precursor to the eventual common desire to detach illuminations to appreciate them better. Michiel described four illuminated miniatures by the late fifteenth-century miniaturist Jacometto Veneziano in a Book of Hours in the house of Francesco Zio, and later in the possession of Andrea Odoni; and an opening miniature of David in a Book of Hours by Benedetto Bordon owned by Odoni.[85] Michiel's inventory attests to the estimation of Venetian miniatures separate from their devotional function and book context by art connoisseurs in the Veneto in the sixteenth century. The testaments and inventories of miniaturists in Venice also mention caskets of independent illuminated leaves and drawings among their possessions.[86]

The growing interest in collecting single leaves of miniatures can, furthermore, be linked to the collecting of drawings, which developed from changing artist workshop practices and production. In the late Middle Ages, artist workshops often maintained collections of drawings as exemplars, gathered into model-books.[87] In the mid-fifteenth century, Jacopo Bellini developed collections of drawings with

9.4 Benedetto Bordon or Second Grifo Master (attrib.), *Annunciation*, c.1515. 14.6 x 9.5 cm. Pierpont Morgan Library, New York, M.369, no. 1

studies, which have the unfinished, exploratory sense of a sketchbook, apparently more records of inspiration rather than strictly models for others to follow. Collectors increasingly appreciated drawings as examples of an artist's style, and, as Vasari relates, as records of the flashes of inspiration, which could flag during the execution of a finished work.[88]

It was therefore a simple step for collectors to compile drawings by various artists in albums. The first known collection of drawings by various artists attached to leaves in a volume

by a collector is from the Veneto – the so-called Antonio II Badile Album, probably initially gathered together in the early sixteenth century.[89] This album is distinguishable from earlier albums of drawings, such as the famous Jacopo Bellini sketchbooks, in that it is not by an individual artist as a record or exploratory volume, and it does not seem to have been intended as a collection of exemplars for a workshop. Although no true miniatures are found in the collection, the Badile Album signals the growing interest in collecting single leaves and fragments of drawings arranged in albums, a distant precedent of the nineteenth-century craze of collecting manuscript fragments. The most famous Renaissance collection of drawings by various artists is that of Giorgio Vasari, who included some illuminations by Trecento artists and drawings by the miniaturist Giulio Clovio in his *Libro de' disegni*.[90] By delineating elaborate frames around the drawings he pasted in his volumes, Vasari visually elevated works on paper and membrane to a status approaching finished paintings.

Nevertheless, writers on art in the Renaissance generally regarded the status of miniature painting in gouache or tempera as being lower than painting on larger surfaces in any medium. In the fifteenth century, Leon Battista Alberti cautioned painters against learning to draw on small tablets (*in picciole tavollele*) because it was easier to hide faults in execution when painting in miniature; artists should draw large figures to develop their skill.[91] Vasari championed Clovio as "the most excellent miniaturist who ever lived," by claiming that he, in essence, overcame the limitations of the craft. Vasari regarded Clovio as a "painter of small things" and as "a small and new Michelangelo" more than as a professional miniaturist.[92] The nature of this praise of Clovio must have encouraged ambitious miniaturists to imitate monumental painting, to create monuments in miniature, whereas traditionally they had looked to other media for inspiration.

Miniaturists of the late sixteenth century were further encouraged to paint in the monumental manner of Clovio by the extensive production of prints after his work.[93]

As discussed in previous chapters, in the mid-sixteenth century, patrons of *ducali* apparently began to demand more full-leaf illuminations, and scribes of the Venetian chancery actually designed the layout of text to accommodate such images by beginning the text on the verso of the first leaf, rather than beginning on the recto, which had formerly been standard procedure. This left the opening leaf blank and ready for full-page illumination as if for an independent painting. Miniaturists also added additional illuminated leaves to *ducali*. These full-page miniatures especially were excised by collectors and assembled in a manner akin to drawings.

It is difficult to reconstruct the particulars of the growing interest in collecting drawings and miniatures in the sixteenth and seventeenth centuries in Venice because leaves gathered in albums often were kept in collections of books and papers, and their details usually were not specified in inventories or sales.[94] One wonders, for example, what happened to the sixty individual miniatures counted in the inventory of the deceased miniaturist Giovanni Maria Bodovino in 1617. If not destroyed, did they enter the collection of a professional miniaturist as exempla, or did they get sold on the art market, to be collected with leaves of drawings and prints in boxes, rolled in protective tubes, or pasted into volumes?[95]

The largest known early collection of miniatures detached from *ducali*, numbering eighty-one leaves, was taken by the French in 1797 from the Library of the Clerics Regular of Somasca of Santa Maria della Salute. The subsequent fortune of the leaves is unknown, but the collection is presumed to have been assembled by the patrician Giorgio Bergonzi (1646–1709) some 100 years earlier, and donated to the Salute along with many books and his famous collection of over 6000 engravings and 3000 drawings. In his testament, Bergonzi had

9.5 Giovanni Maria Bodovino or Valerio Mariani (attrib.), *A Member of the Nani Family Presented to Saint Mark,* 1570s–90s. 21.5 x 33 cm. National Gallery of Ireland, Dublin, Drawings, 2328

requested that the prints and drawings all be bound in volumes, each with a frontispiece recording his name.[96] A volume of seven *ducali* leaves, bound in velvet, was one of the items sold at the Samuel Rogers sale of 1856.[97] Although perhaps detached from their books only in the nineteenth century, this is another example of how such miniatures could be stored like drawings in an album.

One of the most curious illuminations today stored in a drawings collection is a large membrane leaf, probably painted by Giovanni Maria Bodovino in the 1570s–1590s (fig. 9.5). It exhibits the general imagery found in *ducali*, with a portrait of a member of the Nani family,

probably Francesco or Vincenzo, as he is presented to Mark by Saint Vincent Ferrer, dressed in Dominican habit, while Saint Francis receives the stigmata in the background. In the middle ground is a pelican feeding her young, symbol of Christ's sacrifice, and a model of Christian charity, with the motto *semper idem*. The format is too large and oblong for a *ducale* leaf, so the general imagery of *ducali* may have been used to preface a different kind of manuscript text in album format, or to create an independent miniature.[98]

APPRECIATION FOR RENAISSANCE MINIATURES IN THE NINETEENTH CENTURY

Sometime before 1792, the illuminations of the great fourteenth-century service books for San Marco were described as "richly illuminated, but in a poor manner" by Jacopo Morelli, then

custodian of the Marciana Library.[99] As we have seen, his opinion did not prevent miniatures from being cut out of these manuscripts in the early nineteenth century (fig. 9.1). Intensified collecting of single leaves in that century came at a time when Italian "primitives" were just beginning to become appreciated. But prejudice for High Renaissance painting lingered. Shortly after Morelli's disparaging assessment of Trecento miniatures, the character of Philemon, in Dibdin's *Bibliographical Decameron* of 1817, gushes upon spying a High Renaissance manuscript: "My scepter almost drops from my hand … yes Immortal Clovio!"[100] Ottley himself, in his book of 1823 that outlines the highlights of Italian painting, reiterated Vasari's notion of the degeneration of painting in Italy in the Middle Ages, and the light to be found in sixteenth-century painting.[101]

Just as the Maggi manuscript was admired and valued in eighteenth-century France through appreciation of Cinquecento Venetian painting by well-known masters, eighteenth- and nineteenth-century dealers and collectors also tried to link *ducali* illuminations to painters such as Giovanni Bellini, Titian, and Veronese. The scholar Antonio Marsand, writing in 1835, claimed to have seen some *ducali* leaves painted by Veronese and Tintoretto. He surmised that the opening leaves were missing from one document probably because it had been illuminated, and that its beauty "nurtured the temptation of a lover of free beautiful things" to cut the leaves out.[102] If not attributed to artists of large-scale paintings, assignment to the miniaturist Giulio Clovio was most common.

The early nineteenth-century taste for Venetian art of the sixteenth century is reflected in sales catalogue selections and the prices set at auction, and in the surviving collections of single leaves. At the de Rothesay sale of 1855, the highest price for *ducali* went to the latest sixteenth-century Commission leaf, of 1565, and prices decline with date, the lowest price going to a *ducale* of 1507.[103] With the climbing valuation of individual miniatures, we find many over-optimistic attributions of *ducali* illuminations to artists actually inscribed onto leaves, such as in a miniature detached from a Commission of 1512 in the Huntington Library (fig. 9.6). It is in the manner of the miniaturist Benedetto Bordon, but someone, perhaps a dealer, has written "Johannes Bellinus" at the bottom, imitating the text but not the handwriting of Bellini's signature in paintings.[104] On the leaf facing the opening miniature to Giovanni Moro's Commission as Captain of Padua, discussed in Chapter 6 (fig. 6.5), was pasted a miniature, attributable to the miniaturist Giorgio Colonna, detached from a later Commission. A paper sheet, attached sometime in the nineteenth century to the manuscript by an English collector or dealer, claims that "It was always in Venice esteemed by the family as an undoubted work of Titian … The other page is by a painter of lesser note but would of itself be beautiful if seen apart from such a perfect chef d'oeuvre. There is a Painting of Titian in the Louvre but little differing from it."[105]

The inscription "T.° Vec'¹ Dep 1578" on a detached miniature in the Fitzwilliam Museum, Cambridge, was clearly inscribed at the very bottom of the leaf at a late date to suggest that the miniature was painted by Tiziano Vecellio, or Titian (fig. 9.7). The scrawling execution and marginal placement indicate a dealer's, or owner's, hopeful designation rather than an artist's signature.[106] One can compare it, for example, to a very rare actual signature and date integrated into the painting by the otherwise unknown miniaturist Gaspare Veronensis, in the *ducale* to Marin Venier discussed in Chapter 2 (fig. 2.11).[107] Paradoxically, the inscription in the Cambridge leaf led to an unintended attribution. Some scholars, rather than assigning it to Titian, have assumed that there was a miniaturist who used these initials as his signature, and an oeuvre for this now so-called "T.° Ve Master" has become established.[108]

It was John Ruskin, writing in the 1850s, who began to invert the hierarchy of manuscript illumination, valorized by Vasari and echoed by later scholars, which put the work of Giulio Clovio at its height. Ruskin instead claimed that gothic illumination from 1250 to 1350 should be most prized, and that Clovio epitomized the decline of that art. At the same time, he encouraged new appreciation of Tintoretto.[109] Still, in his article of 1867 on Venetian illumination, the English collector Edward Cheney (1802–1884) explicitly stated his bias for miniature painting of the fifteenth and sixteenth centuries in his opening sentence: "The art of illuminating, though the word, according to Dante, was adopted from the French, had always been much practiced in Italy, where it was carried to the highest perfection in the fifteenth and sixteenth centuries."[110] In 1891, John W. Bradley (1830–1916) published the first monograph on Clovio, followed by an extended article on Commissions in 1896, which similarly prized later works. Bradley utilized recently published archival research to cite the names and careers of some of the Venetian miniaturists who actually painted these manuscripts.[111]

9.6 (Below left) Benedetto Bordon (attrib.), *Leaf detached from a Commission to Vincenzo Donato as Count and Proveditor of Lesina (Hvar)*, 1512. 20.9 x 13.2 cm. Huntington Library, San Marino, EL 9 H 13, 1

9.7 (Below right) T.° Ve Master (attrib.), *Leaf detached from a Commission to Pietro di Bernardino Tagliapietra as Podestà of Vicenza*, 1535. 23 x 15.8 cm. Fitzwilliam Museum, Cambridge, Marlay Cutting, It. 43

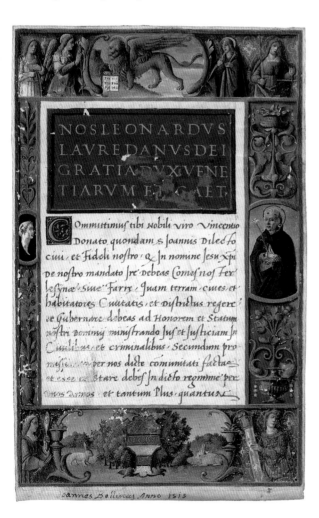

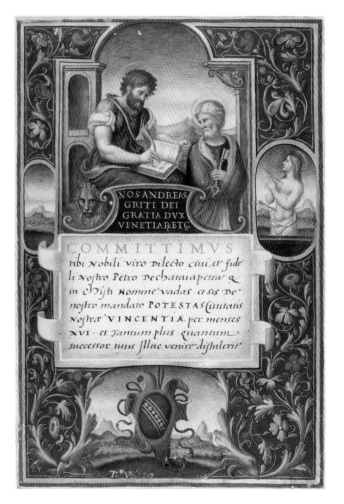

THE NEW ARCHIVES OF VENICE

A different stimulus to interest in *ducali* manuscripts was the collection of archival materials and their reorganization under the directorship of Jacopo Chiodo, and the subsequent opening to the public of the newly organized State Archives in the former Franciscan convent of the Frari in 1823.[112] The vastness of the materials drew great international appreciation. Leopold von Ranke is generally credited with elevating the status of archival research as a means to arrive at historical truth, and he was greatly inspired by his discovery of the extensive reports by Venetian ambassadors at the Berlin Royal Library. He subsequently examined materials in the archives in Venice as well, and came to vaunt the documents produced by the magistracies of the Venetian Republic as a model of archival richness.[113] Researchers still rely on the scholarship of Cesare Foucard (1825–1892) and Emmanuele Antonio Cicogna (1789–1868), who utilized the archives in the 1840s and 1850s, and of the Brits Horatio Brown (1854–1926) and Rawdon Brown (1803–1883; they were not related), who combed the archives through the 1880s. Indeed, the French historian Armand Baschet wrote in 1870 that "in the last few years the Archives of Venice have acquired the greatest vogue."[114]

Before the archival research of the nineteenth century, information on miniaturists and other artists generally came from more anecdotally received information repeated in artist biographies. And despite Vasari's praise of Giulio Clovio and a few other artists who worked in miniature, the status of painting in books, as with all "applied" painting, declined further and these artists were rarely written about. Carlo Ridolfi (1594–1658) and Marco Boschini (1602–1681), Venetian writers on art in the seventeenth century, did not mention miniatures, despite the fact that Boschini himself, according to Francesco Sansovino, illuminated Commissions and *mariegole*, the statute books of the guilds and religious confraternities.[115] In a rare example of writing about Italian miniaturists in the seventeenth century, an Olivetan abbot of Friuli, Secondo Lancellotti, praised the now obscure Venetian miniaturists Giovanni Maria Bodovino and Valerio Mariani, in a polemic attempting to prove that the best times had not passed, and that there existed artists of a recent generation who were outstanding.[116] When Pietro Zani of Parma published his encyclopedia of art in 1820, he repeated the names of sixteenth- and seventeenth-century miniaturists lauded by Vasari and Lancellotti, including Giulio Clovio, Bodovino, and Mariani.[117] The works especially of Bodovino have been generally unknown since the nineteenth century, but through the study of *ducali* I have been able to outline the career of this artist who was one of very few Venetian miniaturists appreciated in art historical literature from the sixteenth to the nineteenth century.[118]

VENETIANS STRIVE TO PRESERVE THEIR PATRIMONY

Some patricians, such as Angelo Lorenzo di Giacomo Giustinian Recanati (b. 1715), had been able to take advantage of the dispersal of Venetian collections in the late eighteenth century to acquire *ducali*, along with other papers "pertaining to the erudition of patrician matters," for their libraries. His heirs maintained and expanded the collection at the family palace on the Zattere, where it was catalogued in the nineteenth century.[119] Scholars and admirers of Venice are indebted to the patrician Teodoro di Jacopo Correr (1750–1830), who donated his extensive collections to the city upon his death, along with his house and funds to keep the collections open to the public. The Museo Correr opened in 1836, and the first scholars of *ducali* benefited from studying its collections.[120] Correr had begun to collect after an illustrious career of service to the Republic, although, at times, he seems to have tried to escape the very duties of governing celebrated in the *ducali* manuscripts he acquired.[121] Correr was a remarkable collector for the broad

range of his interests. Not just aesthetic, but historic considerations were important in his acquisitions of objects.[122] Also fortunately for Venice, the great bibliophile, historian, and bibliographer Emmanuele Cicogna granted his great collection of manuscripts to the city in 1865, and these are also preserved in the Correr. Some of these are among the most important *ducali* in the collection, including the *Capitolare* of Giovanni da Lezze as procurator *de supra* of 1538, documented as by the artist Jacopo del Giallo (fig. 4.18).[123] The Correr has since

purchased and attracted the gifts of a great number of other collections, so creating the largest holding of *ducali* in the world.[124] Stored in a patriotic museum, and no longer of active service to patrician families, *ducali* joined the material effects of all classes of Venetian society as remnants of what was in many senses a completed history.

Because *ducali* were collected by Correr and Cicogna for their historical as well as artistic value, most of those in the Correr collection are still intact. Nevertheless, many excised examples eventually also were acquired and framed, and at one time some were displayed on the walls.[125] Several leaves detached from Commissions to members of the Michiel family were mounted on board, probably all at the same time, but ended up both in the Correr (figs. 2.10, 9.8, 9.9), through the acquisition of the Donà dalle Rose Collection,

9.8 (Below left) Giovanni de Mio (attrib.), Leaf from a Commission to a member of the Michiel family (born c.1530–33), 1556–59. 23 x 16.6 cm. Museo Civico Correr, Venice, Cl. II, 727

9.9 (Below right) Giovanni de Mio (attrib.), Leaf from a Commission to a member of the Michiel family (born c.1530–33), 1556–59. 23.2 x 16.4 cm. Museo Civico Correr, Venice, Cl. II, 729

and in Cremona (fig. 9.13).[126] An album of twenty-one leaves, mostly Commissions from the sixteenth to the eighteenth century, but also including prints, forms a veritable portrait gallery of Venetian patricians. It was donated by Domenico Zoppetti (1792–1849) to the Correr in 1856, along with other albums of drawings and prints.[127] Sometime in the nineteenth century all of these detached leaves were grouped among art objects rather than among the books of the library of the Correr. They remain stored in the museum along with portrait miniatures, large independent illuminations, and miniatures on ivory and metal. A number of important private collections rich in ducal documents also entered the Marciana Library in the nineteenth and twentieth centuries.[128]

Scholarly publication focused on ducal documents began with the 1851 study of *Commissioni ducali* as a class of manuscripts with miniatures, by the indefatigable Emmanuele Cicogna.[129] He noted that the miniatures of *Commissioni ducali* had been, and were still,

9.10 T.° Ve Master (attrib.), Commission leaf, second half of the 16th century. 22.5 x 15.8 cm. Free Library of Philadelphia, Lewis E M 47: 11

avidly collected as single leaves and graced some of the finest collections.[130] He perceptively suggested that sales catalogues were being over-optimistic in attributing such miniatures to the likes of Titian and Veronese, and that by the fifteenth century, illumination had become a separate painting specialty.[131] Cicogna attributed paintings in *ducali* to miniaturists such as Benedetto Bordon and Giorgio Colonna, whose names became known through signatures and archival documents.

A keen interest in *ducali* documents in England is recorded shortly thereafter in a list of these manuscripts begun by John Holmes (1800–1854), then Assistant Keeper of Manuscripts of the British Library. Holmes lists *ducali* in the British Library, the Bibliothèque Nationale, Paris, and various private collections, and his manuscript includes later annotations by Sir Frederic Madden (1801–1875), Holmes's supervisor as Keeper of Manuscripts (1837–66).[132] Recorded are a number of groups of *ducali* miniatures cut from their books, presumably by Italian dealers. Some of these collections are still intact; for example, a large group of thirty-one *ducali* leaves, plus two non-Venetian examples, was purchased by the British Library at the library sale of Lord Stuart de Rothesay (1779–1845) in 1855, in addition to the full Moro manuscripts discussed earlier.[133] The British Library acquired many more *ducali* from the 1840s to *c*.1863, during a period of particularly intensive growth of the national collections.[134]

The Holmes manuscript notes that at least six leaves were purchased by the prodigious collector Bertram, 4th Earl of Ashburnham (1797–1878), in 1856 – not from a book seller, but from the picture dealers Colnaghi of London. These were added to a set of *ducali* leaves already recorded in the first catalogue of Ashburnham's magnificent manuscript collection of 1853. Holmes himself compiled two of the volumes of the updated catalogue of the collection, published in 1861.[135] Upon Ashburnham's death, four large groups of the

9.11 T.° Ve Master and assistant (attrib.), *Pietro Bollani as Saint Anthony*, leaf detached from Commission to Pietro di Giovanni Bollani as *Podestà* of Umag (Istria/Croatia), 1547 (the Bollani coat of arms has been painted over). 21.6 x 15.3 cm. Fitzwilliam Museum, Cambridge, Marlay cutting, It. 44

manuscripts he collected were preserved in blocks in national collections, but the *ducali* leaves were dispersed.[136] Two leaves ended up in Philadelphia; one is now in the library of Temple University, and the other, which in the Holmes manuscript was attributed to the seventeenth-century painter Alessandro Varotari (called il Padovanino), is now in the Free Library (fig. 9.10). Both can be assigned to the T.° Ve Master, the miniaturist presumed to be, or at least promoted as, Titian.[137]

The Fitzwilliam Museum also has an important collection of twenty-two *ducali* leaves, seventeen of which are from the 245 illuminations

bequeathed by Charles Brinsley Marlay (1831–1921) in 1912. One of these had been framed and exhibited at the Burlington Fine Arts Club, London, in 1886, along with other choice leaves from the Marlay Collection. It shows Pietro di Giovanni Bollani (d. 1555) as Saint Anthony of Padua in his Commission as *Podestà* of Umag (Istria/Croatia), and it too is by the T.° Ve Master (fig. 9.11).[138] All these collections clearly illustrate the nineteenth-century taste for Venetian Cinquecento painting, with the miniaturists Benedetto Bordon, the T.° Ve Master, Giorgio Colonna, Giovanni Maria Bodovino, and Alessandro Merli being most favored because of the similarity of their style and coloring to that of the larger paintings by well-known artists from Giovanni Bellini to Palma Giovane.

The art education movement of the nineteenth century additionally encouraged the collecting of single leaves as examples of medieval and

9.12 (Opposite) Leaf from a Commission to a member of the Contarini family, second half of the 16th century. 24.1 x 17.2 cm. Free Library of Philadelphia, Lewis E M 27:11

9.13 (Right) "I came, I saw, and God conquered." *Seven-headed Dragon of the Apocalypse,* leaf detached from a Commission to a member of the Michiel family, c.1555. Mounted on wood board, 22 x 16 cm. Museo Civico di Cremona, D87

Renaissance design for artists and artisans, as a higher status of the applied arts was being promoted. John Charles Robinson (1824–1913), the curator of the South Kensington Museum, London, began to collect "illuminations" for the museum in 1855, as part of such a mission. Many of these were then mounted in frames to circulate in art schools outside London for this purpose, until eventually deposited in the library of the museum, renamed the Victoria and Albert, in 1899. One of the first detached miniatures Robinson purchased is the *ducale* leaf for the patrician Giovanni Battista di Vitturi as ducal councillor, elected in 1600 (fig. 3.29). This illumination is now attributable to the Venetian painter Alessandro Merli.[139] It was one of only four illuminated pieces described individually in the first catalogue of the museum of 1860, along with a Giulio Clovio-style altar card and a montage of scraps from Sistine Chapel manuscripts, again attesting to Robinson's taste for later Renaissance illuminations.[140]

For the scholar of manuscripts, such collections of leaves are both pleasing and frustrating. They are aesthetically gratifying because dealers or collectors clearly have weeded out inferior illuminations to highlight the more splendid miniatures. In some cases, the miniatures retain information about the doge, recipient, and/or the post, from which one can date and historically contextualize the leaf. But as Gustav Friedrich Waagen (1794–1868) pointed out after examining Ottley's collection of miniatures, around 1838, "By being thus detached from the documents to which they originally belonged, they are unfortunately deprived of the principal means of ascertaining the place and time of their origin."[141] The careers of late sixteenth-century patricians and illuminators are especially obscured because of the fashion for excising the full-page miniatures, many of which were on inserted leaves with no text by the late sixteenth century. For example, a leaf detached from a document to a Contarini has miniatures in a

fine hand near to that of Giuseppe Porta, called Salviati (1520–1575), who was active in Venice (fig. 9.12). Salviati designed woodcuts for books and had extensive and varied interrelationships with the Contarini, including the great patron and collector Jacopo di Pietro, but the miniature cannot be securely dated, nor the patron identified, because of the loss of the rest of the manuscript.[142]

Sometimes the significance of more unusual iconography also is lost particularly because the miniature cannot be related to a patron. This is for instance the case with a miniature of the seven-headed beast of the Apocalypse, with the arms of the Michiel family, now in Cremona (fig. 9.13).[143] The iris featured at the top of the leaf suggests that it was made for the same Michiel whose leaves are now in the Correr, in which an iris takes center stage (fig. 9.8).

To further complicate the situation, miniatures sometimes were manipulated to enhance their appearance as independent paintings. The coat of arms and text sometimes are rubbed out and sometimes appear to have been varnished.[144] Collectors or dealers sometimes doctored the manuscripts that had lost leaves, or that never had miniatures, by pasting in illuminated leaves taken from other manuscripts.[145]

For all of these eighteenth- and nineteenth-century collectors of *ducali* leaves, interest was concentrated in the miniatures as specimens of Venetian Cinquecento painting. By contrast, the acquisitions of the collectors Rawdon Brown and Auguste Boullier most reflect English and French admiration for the history of the former Republic and its constitution. Brown was the first English historian to consult the Venetian archives, and he lived in Venice for fifty years (1833–83).[146] From 1862 until his death, he was hired by the Public Record Office in England to collect information on relations between Venice and England. Cesare Foucard, in a lecture of 1857, described Brown's collection of Commissions as

one of the three most notable in the city, rivaled only by those in the Correr, in Cicogna's collection, and in the family archive of the Contarini branch called "dalle Statue" (also "delle Figure").[147] This great Contarini collection was also soon dispersed – one of the manuscripts, for Paolo Contarini as Captain of Candia (Crete), ended up in the Walters Museum, Baltimore (fig. 9.14).[148]

Rawdon Brown eventually willed his collection to the Public Records Office, now at Kew, where it remains today.[149] The desire to identify England with Venetian imperial power during the Renaissance seems indicated in a gift he made of one of his manuscripts. An illuminated Commission to a Venetian – Giovanni Contarini – as Captain of Cyprus of 1538 was taken out of the Public Records Office collection, presumably by Brown himself, and presented to the Earl of Beaconsfield in 1878, on the occasion

of the government's decision to take over Cyprus by agreement with the Ottoman government, and the appointment of Sir Garnet as captain general.[150] This manuscript, now in the British Library, has a relatively simple opening border with the lion of Mark and the Contarini coat of arms in front of an evocation of Cyprus, in the style of the Trees Master (fig. 9.15), and so its presentation largely was for its historical rather than artistic value.

Auguste Boullier of Roanne (1839–1898) spent a large part of his life and fortune collecting manuscripts and books on Venice. These served his research projects, including a first volume

9.14 Walters Master (attrib.), *Portrait of Paolo Contarini, Map of Candia (Crete)*, Commission to Paolo di Dionisio Contarini as Captain of Candia (Crete), 1575. Each fol. 25 × 18 cm. Walters Art Museum, Baltimore, W.484, fols. 1v–2r

9.15 Commission to Giovanni di Alvise Contarini as Captain of Cyprus (Famagusta), 1538. 23.5 x 16 cm. British Library, London, Add. MS 45539, fol. 1r

of a projected series on the history of Italy, and a work on the art of Venice, published in 1870. His rich collection, which includes a number of intact *ducali*, was left to the Municipal Library of Roanne, France, where it remains today.[151] Smaller groups of intact *ducali* similarly collected specifically to augment the study of history and law can be found in the library of the Senate in Rome, established after the unification of Italy in the nineteenth century, in the Law Library of the US Congress, Washington D.C., and the Law Libraries of Yale University, New Haven.[152]

The collector and writer Edward Cheney was the first to write a scholarly article in English that discussed *ducali*. In this publication of 1867, he noted that the most modest class of *ducali*, that of Commissions to the rectors, had not been expensive until recently, but had risen to a value that actually induced Venetians to sell their collections.[153] He records that *ducali* were usually dismembered to achieve greater profit; that most of the illuminated frontispieces of Commissions had been taken out, as well as the cord, seal, and metal clasps from the binding. As we have seen, this accords with the condition in which Commissions are usually found today.[154] This kind of dismemberment could only be countenanced if the original symbolism and usefulness of these books had been, for most people, lost. Cesare Foucard, archivist and professor of paleography in Venice, made the loudest cry against the destruction and dispersal of Commissions. He recognized their original purpose as exempla for future generations of patricians, but re-imagined that ideal for a larger public.

In a general lecture on Venetian manuscript illumination of 1857, while Venice was still occupied by the Austrians, Foucard extolled *Commissioni ducali* above all other Venetian manuscripts for the quality of their miniatures. He concluded by singling out *ducali* for Pietro and Paolo Contarini, one being the manuscript now in the Walters (fig. 9.14). Paolo had defended the island of Zante while he was proveditor in 1570. Like the great collector and patron Jacopo di Pietro Contarini, he was of the branch called "delle Figure" but lived in the area of Sant'Antonino, "*al ponte d'arco.*"[155] The illumination by the Walters Master shows Paolo presented by his name saint Paul to a female personification of Venice and to Mark. A young man, perhaps an heir, or a *ballottino*, is behind him and a figure of Victory hovers in the background with a laurel wreath and trumpet.[156]

Foucard praised the miniatures for showing "the semblances of two ancient citizens, valorous in war, wise in public administration, expert in diplomatic affairs," precisely the

impression patricians and the miniaturists of *ducali* had aimed for. Foucard argued that collecting together a series of *ducali* would form a gallery of illustrious families. In a passionate plea, he urged legislation against the dispersion of such "patriotic monuments" because *ducali* contained "the sacred heredity of a people, the memories and works left by the men who were great in intelligence of state and in craft." He argued that the loss of such monuments would leave Venetian citizens bereft of worthy men to emulate.[157] The memory-objects of patrician families were preserved and appropriated for the advancement of the general populace in such Venetian museums as the Correr, and soon after, in the house-museum of Count Giovanni Querini Stampalia.[158]

COLLECTING IN AMERICA – THE FILTER OF ENGLISH COLLECTIONS

As with art collecting in general, the acquisition of *ducali* shifted to the United States in the early twentieth century. American collecting of ducal documents must be understood in the overall context of the vast new wealth of nineteenth-century industrialists and their desire to create a link with the European past and artistic patrimony – a European aristocratic peerage, on American soil. But by this time many *ducali* were locked in public European collections, and the massive sell-off of Venetian collections had slowed, so that finding high-quality manuscript illuminations became more difficult. Isabella Stewart Gardner (1840–1924), in fact, is the only American collector who seems to have gone out of her way to collect Venetian manuscripts. She and her husband Jack Gardner first visited Venice in 1884, and returned for many extended stays. Out of thirty-one manuscripts listed in her self-published catalogues of 1906 and 1922, nineteen are Venetian.[159] She was already being encouraged to collect such manuscripts in the 1870s by the first professor of art history in America, Charles

Eliot Norton (1827–1908).[160] Norton, in turn, was clearly influenced by his friendships with the English Venetophiles John Ruskin and Rawdon Brown, but especially by his close association with Edward Cheney. All of these friends were members of the Philobiblon Society, a group of book collectors founded in 1853 in London, and all were collectors of *ducali*. In fact, the Gardner Museum has a signed copy of Cheney's article on *ducali* with an inscription to Norton. Gardner purchased the bulk of her illuminated Venetian manuscripts from Norton himself in 1903. Some of these were formerly in the collections of Cheney, Ruskin, and possibly Brown.[161]

Gardner was also inspired in her collecting by her extensive stays at Palazzo Barbaro, the patrician *casa* of gothic origin, rented and then owned by Ariana and Daniel Curtis of Boston after 1881. Gardner's own residence, Fenway Court, Boston, work on which was begun in 1901 and which was opened to the public in 1903, is the most sustained re-creation of the courtyard and interiors of a private Venetian palace. It incorporates numerous important fragments from the fabric of the city acquired there during 1897, in addition to the remarkable collection of paintings, many Venetian, obtained through Bernard Berenson.[162] In fact, Gardner's seemingly capricious arrangement of pieces from a variety of sources itself imitates the Venetian use of *spolia* (or repurposed sculpture and masonry), and walking through her courtyard especially replicates the rich experience of coming upon inserted (and unlabeled) fragments of sculpture and stone as one moves through Venice. Despite her penchant for collecting architectural and interior fragments, her *ducali* are for the most part complete, with text and bindings generally intact. But she owned two detached *ducali* leaves; one is mounted on board and framed, and still on display, if much faded, in a glass cabinet, as if a small devotional painting – literally a "cabinet miniature" (fig. 9.16).[163]

9.16 Giovanni Maria Bodovino (attrib.), Leaf detached from a Commission to a Girolamo (?) Valier. 22.5 × 16 cm. Isabella Stewart Gardner Museum, Boston, P27e49

Venetian manuscripts otherwise accrued in American collections through the purchase of entire collections from Europe, or as just a few of a vast number of steadily acquired manuscripts by voracious collectors. Henry Edwards Huntington (1850–1927) acquired the largest single grouping of detached *ducali* leaves – thirty-nine in all, from a private collection – when he purchased the Bridgewater Library of the Earls of Ellesmere in 1917.[164] J. Pierpont Morgan (1837–1913) and his son J. P. Morgan (1867–1943) of New York, Henry Walters (1848–1931) of Baltimore, and J. F. Lewis (1878–1932) of Philadelphia acquired *ducali* as part of broader acquisitions of manuscripts over time.

J. Pierpont Morgan began collecting around 1890. His great wealth allowed him to collect whole manuscripts, but he did not disdain single leaves.[165] Echoing the concerns of Zanetti over the potential loss of the Venetian patrimony some 100 years earlier, Léopold Delisle, *administrateur général* at the Bibliothèque Nationale in Paris, noted the threat to European collections of a new American taste for manuscripts backed by substantial funds in a review of the 1906 catalogue of the Morgan Collection.[166] For his part, J. Pierpont Morgan may have found *ducali* interesting primarily for their bindings. He purchased two in 1908 from Giovanni Dotti of Florence, on the recommendation of the art critic Roger Fry. One of these has magnificent illuminations signed by Gaspare Veronensis (fig. 2.11), as well as a fine gold-tooled leather binding. Of eight purchased in 1912 from Ferdinando Ongania in Venice, seven were already missing their illuminated leaves and one has only mediocre painted decoration but, again, fine bindings.[167] Henry Walters, son of the railroad magnate William T. Walters (1819–1894), developed a collection to almost rival that of Morgan, and his acquisition of Venetian *ducali* was, like Morgan, related to a particular interest in bindings.[168] Out of the eleven *ducali* that he acquired, three are missing illumination, and another three were never illuminated.[169]

John Frederick Lewis of Philadelphia began collecting manuscripts around 1907, but it was not until the enthusiasm caused by the sale of the Robert Hoe Collection in 1911 and 1912 that he "became intent upon securing the finest examples of the illuminator's art."[170] Lewis collected single leaves in part because he wanted a broad collection and felt that leaves sustained an affordable option. Most of the fourteen *ducali* leaves that entered his collection came through English sources, by way of the dealer A. S. W. Rosenbach, who had purchased them from the Lord Northwick Collection sale at Sotheby's in 1926.[171]

Today, the few Venetian manuscripts and leaves still in private hands, out of the many that entered the market in the nineteenth century, continue to be exchanged in sales and at auction, and some make their way back to Venetian public collections. But Italy now leads the world in protection of its cultural heritage, so Cesare Foucard's entreaties for legislation to protect Venetian material culture, and to keep it in Venice, have been answered to some extent. Despite recent cases of the illegal despoiling of manuscripts and books in public collections, and the fact that some manuscripts continue to be cut up for pleasure and for greater profit, it is a practice that at least has come to be more generally frowned upon.[172]

Although *ducali* originally were collected and maintained in Venetian patrician archives, they flooded the art and book markets when the fall of the Republic impoverished many patrician families, and made the manuscripts essentially anachronistic as implements in the documentation of family status and power. Collecting of Venetian *ducali* reflects more general, changing, historical trends in attitudes towards manuscripts as being valuable for their paintings, bindings, and texts, or as intact objects. Collectors such as Auguste Boullier and Rawdon Brown acquired fully intact manuscripts when they could, because of specific interest in, and admiration for, the mythic Venetian aristocratic democracy and empire. Some Venetians, like Correr, collected *ducali* and other relics of the past in museums that memorialized the Republic and its leaders, and thereby preserved a sense, if fossilized, of civic and cultural identity. Nevertheless, the sixteenth-century fashion for commissioning full-page illuminations with portraits in *ducali* encouraged their dismemberment and collection as independent paintings. Many nineteenth-century collectors were most interested in the detached leaves of the sixteenth century as presumed miniature versions of paintings by the great Venetian painters of the period: Bellini,

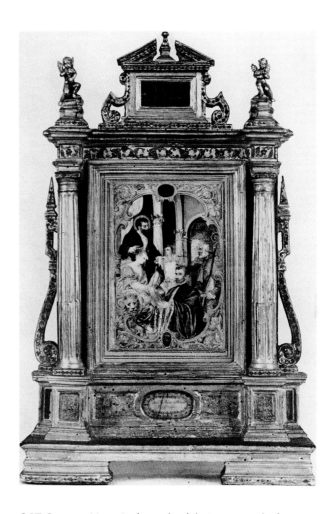

9.17 Giovanni Maria Bodovino (attrib.), Commission leaf in a gilded wooden frame. Formerly Palazzo Soranzo-Van Axel, Venice

Titian, Veronese, and Tintoretto. Such fracturing of the original context of these images inevitably caused displacement of the original intentions of their creators. *Ducali* leaves could, therefore, be framed as devotional paintings, as in the case of a late sixteenth-century miniature by Bodovino for a member of the Michiel family, which was inserted into a gilded wooden frame. The label on the frame refers only to Saint Augustine, who was clearly not the intended focus of the representation (fig. 9.17).[173] The identity, and therefore the memory, of the patrician who is portrayed was lost when the leaf was cut out of the document, vitiating the purpose for which these manuscripts were painted.

APPENDIX 1

Doges and their Illuminated *Promissioni*

This table lists the documents apparently made for the personal use of the doge, as identifiable by the prominent inclusion of the coat of arms, and extensive decoration. Doges for whom no *Promissione* with their personal heraldry is known are indicated in parentheses.

Doge	Election year	Current location of *Promissione*	Attributed miniaturist
Michele Morosini	1382	BMVe	Giustino del fu Gherardino da Forlì
Antonio Venier	1382	Giustiniani	Giustino del fu Gherardino da Forlì
(Michele Steno)	1400		
(Tommaso Mocenigo)	1414		
Francesco Foscari	1423	Giustiniani	Cristoforo Cortese
(Pasquale Malipiero)	1457		
Cristoforo Moro	1462	BL	Leonardo Bellini (documented)
Nicolò Tron	1471	NYPL	Marsilio da Bologna (signed)
Nicolò Marcello	1473	BMCVe	Leonardo Bellini or follower
(Pietro Mocenigo)	1474		
(Andrea Vendramin)	1476		
(Giovanni Mocenigo)	1478		
(Marco Barbarigo)	1485		
Agostino Barbarigo	1486	Ford Collection, London	Master of the Pico Pliny
(Leonardo Loredan)	1501		
Antonio Grimani	1521	BL	B. Bordon or Second Grifo Master
(Andrea Gritti)	1523		
(Pietro Lando)	1539	BMCVe	Missing opening leaves, perhaps was for the doge
(Francesco Donà)	1545		
(Marcantonio Trevisan)	1553		
Francesco Venier	1554	BMCVe	T.° Ve Master
(Lorenzo Priuli)	1556		
(Girolamo Priuli)	1559		
(Pietro Loredan)	1567		
(Alvise I Mocenigo)	1570		
(Sebastiano Venier)	1577		
(Nicolò da Ponte)	1578		
Pasquale Cicogna	1585	Giustiniani	Decorative imagery only, attributed to Giovanni Maria Bodovino
(Marin Grimani)	1595	First printed edition	

Supplement and Updates to David Chambers's List of Commission/Oath Documents of the Procurators (Chambers 1997, 83–88)

Initial dates are those of election and not necessarily the date the manuscript was produced.

1368 BELEGNO, Paolo Pr. di Stefano (d. 1373). BMCVe, Cl. III, 315.

1375 CORNER, Pietro Pr. di Jacopo (d. 1407), *de supra.* BnF, lat. 4727.

1427 DONATO, Bartolomeo Pr. di Alvise (d. 1431), *de supra.* BMCVe, Cl. III, 775.

1481 SORANZO, Vettor K. Pr. di Nicolò (1410–1488), *de supra.* Miniatures attributed here to the Master of the Pico Pliny. Sections of the border, including the image of Vettor's patron saint, Victor Maurus, appear to have been touched up extensively by a restorer. Venice, Biblioteca Giustinian Recanati, Cl. IV, Cod. 13. Chambers 1997, 34, 84, fig. 10.

1491 DUODO, Cristoforo Pr. di Luca (d. 1499), *de ultra.* The full-page miniature of this fragment shows God the Father blessing Christopher, the patron saint of Duodo, and an unidentified saint. Zurich, Schweizerisches Nationalmuseum, LM 25893. http://www.e-codices.unifr.ch/en/searchresult/list/one/snm/LM025893 [Accessed January 7, 2017].

1522 PRIULI, Francesco Pr. di Giovanni Francesco (d. 1542), *de supra per denari.* Miniature attributed to the T.° Ve Master. Detached leaf, Cleveland Museum of Art, Jeanne Miles Blackburn Collection, 2011.69.

This leaf is puzzling because on the recto the name of Francesco Priuli has been added over a crossed-out name, and the figure of Saint Anthony Abbot in the right margin, with his attribute, the pig, in the left, does not correspond with the recipient's name or with close members of his family. The hand of the miniaturist and composition are closest to the miniatures of the *Libro d'oro* manuscript on vellum, dated 1529. ASVe, Capitolare del Maggior consiglio (Libro d'oro vecchio), esemplare pergamena, fol. 24r. The text on the reverse also names Francesco Priuli as recipient with no deletions. Chambers 1997, 40, 86, n. 319. Stephen N. Fliegel, *The Jeanne Miles Blackburn Collection of Manuscript Illuminations* (Cleveland, OH: Cleveland Museum of Art, 1999): 84, cat. 82.

1522 GIUSTINIAN, Andrea di Onofrio, *de citra.* Christie's London, Valuable Books and Manuscripts, July 12, 2017 (sale 14299), lot 29. The miniature prefacing the text of the oath shows Giustinian with Saint Mark.

1526 DA MOLIN, Gasparo Pr. di Tommaso (d. 1550), *de citra.* Miniatures attributed to Benedetto Bordon. Now Cambridge, MA, Houghton Library, Harvard College Library, MS Typ 543. Chambers 1997, 40, n. 321.

1587 MICHIEL, Luca Pr. di Salvador di Luca Dr. (1519–1596), *de citra.* Two detached leaves:
Luca Michiel as Provveditore Generale. Christie's London, King Street, Old Master & British Drawings & Watercolours, July 10, 2014 (sale 1538), lot 107.
Luca Michiel as Procurator "de citra." Christie's London, South Kensington, Old Master & British Drawings & Watercolours, December 2, 2014 (sale 5877), lot 11.

APPENDIX 3

Payments to Miniaturists for the Documents of Doges and Procurators

Payment date	Amount	Election date
December 1463	4 gold ducats to Leonardo Bellini for the *Promissione* of Doge Cristoforo Moro	May 1462
April 1539	8 ducats to Jacopo del Giallo for the Commission of Giovanni K. da Lezze as procurator *de supra*	July 1537
June 1539 and February 1540	Two payments for a total of 5 ducats to a Gasparo, "*miniador*," for the Commission of Pietro Grimani as procurator *de supra*	April 1538
September 1560	Over 8 ducats to Giorgio Colonna for the Commission of Marchiò K. Michiel as procurator *de supra*	March 1558
December 1589	Over 12 ducats (74 lire, 8 soldi) to Marco del Moro, "*pitor*," for the Commission of Marin Grimani as procurator *de citra*	April 1588

1 gold ducat = 6 lire and 4 soldi. 1 lira = 20 soldi. 1 gold ducat = 124 soldi.

APPENDIX 4

Reggimenti and Commissions by Region (1420–1797)

The Commissions of the rectors of the territories of Venice were the most numerous documents to be embellished. Their number and kind varied according to the vicissitudes of the empire. The offices for patricians for which manuscript documents were regularly granted and often painted are given below. These are not all the offices to which patricians were elected, rather the ones for which they received a Commission that could be embellished and maintained at home. *Reggimenti* possessed by Venice for one year or less, or only for a period before 1420 or after 1620, have been omitted. The title of the rector given is that which predominated in the period under study.

In some less important or contested *reggimenti*, a patrician covered two offices at once, and these are indicated below where conjoined with "and."

Towns and regions are given in Italian, with alternative place names in parentheses, followed by dates of the office. Tenure of office typically was of sixteen months on the *terraferma* and twenty–four to thirty–two months in the *stato da mar*.

Some rectors were elected by local subjects and their *reggimenti* are not listed here. For these see Da Mosto 1940, vol. 2, 3–24.

ELECTED IN THE GREAT COUNCIL

DOGADO

This was the territory contiguous to Venice, corresponding to the ancient Venetian state.

Cavarzere (13th century–1797) ~ *podestà*
Caorle (1261–1797) ~ *podestà*
Chioggia (1208–1797) ~ *podestà*
Cologna (1404–1797) ~ *podestà*
Gambarare (13th century–1797) ~ proveditor
Grado (1261–1797) ~ count
Loreo (13th century–1797) ~ *podestà*
Malamocco (1261–1797) ~ *podestà*
Murano (1271–1797) ~ *podestà*
Torcello (with Burano, Mazzorbo, and Lido Maggiore, 13th century–1797) ~ *podestà*
Torre delle Bebbe (13th century–1607) ~ *podestà*

DOMINION OF THE TERRAFERMA

This territory comprised the lands between the Bergamasco in Lombardy and the region of Friuli.

Bergamasco

Bergamo (1428–1797) ~ *podestà*, captain
Martinengo (1428–1797) ~ *podestà* and proveditor

Cremasco

Crema (1449–1797) ~ *podestà* and captain

Cremonese

Cremona (1499–1509) ~ *podestà*, captain

Bresciano

Brescia (1426–1797) ~ *podestà*, captain
Asola (1485–1797) ~ proveditor
Orzinuovi (1428–1797) ~ *podestà*
Salò (Riviera del Garda) (1349 and 1426–1797) ~ captain and proveditor
Lonato (1426–1797) ~ proveditor

Trentino

Rovereto (1420–1509) ~ *podestà*
Riva (1444–1509) ~ proveditor

Veronese

Verona (1405–1797) ~ *podestà*, captain
Soave (1404–1797) ~ captain
Peschiera (1440–1797) ~ proveditor
Legnago (1400–1797) ~ proveditor and captain

Vicentino

Vicenza (1404–1797) ~ *podestà*, captain
Bassano (1404–1797) ~ *podestà*, captain
Marostica (1404–1797) ~ *podestà*
Lonigo (1404–1797) ~ *podestà*

Padovano

Padua (1405–1797) ~ *podestà*, captain
Montagnana (1405–1797) ~ *podestà*
Este (1405–1797) ~ *podestà*
Monselice (1405–1797) ~ *podestà*
Castelbaldo (1405–1797) ~ *podestà*
Cittadella (1405–1797) ~ *podestà*
Piove di Sacco (1405–1797) ~ *podestà*
Camposampiero (1405–1797) ~ *podestà*

Trevigiano

Treviso (1338–1797) ~ *podestà* and captain
Asolo (1338–1797) ~ proveditor
Castelfranco (1338–1797) ~ *podestà*
Portobuffolè (1338–1797) ~ *podestà*
Oderzo (1338–1797) ~ *podestà*
Motta (1338–1797) ~ *podestà*
Noale (1338–1797) ~ *podestà*
Serravalle (1337–1797) ~ *podestà*
Mestre (1338–1797) ~ *podestà* and captain
Conegliano (1338–1797) ~ *podestà* and captain

Feltrino

Feltre (1404–1797) ~ *podestà* and captain

Bellunese

Belluno (1404–1797) ~ *podestà* and captain

Friuli

Udine (1420–1797) ~ lieutenant
Gradisca (1480–1511) ~ proveditor
Cividale (1508–1797) ~ proveditor
Monfalcone (1420–1797) ~ *podestà*
Pordenone (1537–1797) ~ proveditor and captain
Caneva (1420–1797) ~ *podestà*
Sacile (1420–1797) ~ *podestà* and captain
Portogruaro (1420–1797) ~ *podestà*
Marano (1420–1513, 1544–1797) ~ *podestà*, then proveditor

Polesine

Rovigo (1404–38, 1482–1797) ~ *podestà* and captain
Lendinara (1483–1797) ~ *podestà*

Badia (1482–1797) ~ *podestà*
Adria (1482–1797) ~ *podestà*

Romagna

Ravenna (1441–1509, 1527–30) ~ *podestà* and captain, subsequently *podestà*, captain, and later, proveditor
Rimini (1503–09) ~ *podestà* and captain, proveditor
Cervia (1463–1509, 1527–30) ~ *podestà*, then proveditor
Faenza (1503–09) ~ proveditor, then *podestà*
Comacchio (1482–84) ~ proveditor
Meldola (1504–09) ~ proveditor
Brisighella and Val d'Amone (1503–09) ~ proveditor and captain

STATO DA MAR

The Adriatic and Ionian Seas

Puglia

Monopoli (1484–1509, 1528–30) ~ *governatore*, then proveditor
Trani (1490–1509) ~ *governatore*
Brindisi (1496–1509, 1528–30) ~ *governatore*, then proveditor
Otranto (1496–1509, 1528–30) ~ *governatore*, then proveditor
Mola (1497–1509, 1528–30) ~ proveditor
Polignano (1495–1509, 1528–30) ~ *governatore*, then proveditor

Istria

Capodistria (Koper) (1278–1797) ~ *podestà*
Raspo (Raspor) (1394–1797) ~ captain
Pinguente (Buzet) (1420–1511) ~ *podestà*
Albona e Fianona (Labin and Piomin) (1420–1797) ~ *podestà*
Pola (Pula) (1297–1797) ~ count and proveditor
Parenzo (Poreč) (1266–1797) ~ *podestà*
Cittanova (Novigrad) (1270–1797) ~ *podestà*
Muggia (1420–1797) ~ *podestà*
Pirano (Piran) (1283–1797) ~ *podestà*
Pisino (Pazin) (1508–09) ~ proveditor
Isola (Izola; Latin: Insula) (1281–1797) ~ *podestà*
Umago (Umag) (1269–1797) ~ *podestà*
Rovigno (Rovinj) (1330–1797) ~ *podestà*
San Lorenzo (1271–1797) ~ *podestà*
Dignano (Vodnjan) (1330–1797) ~ *podestà*
Valle (Bale) (1331–1797) ~ *podestà*
Grisignana (Grožnjan) (1420–1797) ~ *podestà*
Buie (Buje) (1420–1797) ~ *podestà*
Montona (Motovun) (1276–1797) ~ *podestà*
Portole (Oprtalj) (1420–1797) ~ *podestà*
Arbe (Rab) (1118–1797) ~ count and captain
Cherso (Cres, Kerso) and Aussero (Oser, Latin: Ossero) (1097–1797) ~ count and proveditor
Veglia (Krk) (1481–1797) ~ proveditor
Pago (Pag) (1115–1797) ~ count

Dalmatia

Zara (Zadar; Latin: Iadras) (1409–1797) ~ count and
 captain
Nona (Nin) (1409–1797) ~ count
Sebenico (Šibenik) (1413–1797) ~ count and captain
Traù (Trogir) (1420–1797) ~ count
Spalato (Split) (1420–1797) ~ count
Almissa (Omiš) (1444–1797) ~ proveditor
Brazza (Brač) (1420–1797) ~ count
Lesina (Hvar) (1420–1797) ~ count, or *rettore* and proveditor
Curzola (Korčula) (1420–1797) ~ count

Albania

Cattaro (Kotor) (1420–1797) ~ count, then *rettore* and
 proveditor
Budua (1420–1797) ~ *podestà*
Alessio (Ljesh) (1403–76) ~ proveditor
Salinario (1500–06) ~ proveditor
Antivari (1405–11 and 1444–1571) ~ *podestà*
Scutari (Shkodër) (1404–77) ~ count and captain
Drivasto (Drisht) (1405–78) ~ *podestà*, then *rettore* and
 proveditor
Dulcigno (Ulcinj) (1405–12 and 1425–1571) ~ count and
 captain
Durazzo (Durrës) (1403–1500) ~ *bailo* and captain
Croia (Krujë) (1469–77) ~ proveditor
Dagno (1445–73) ~ proveditor

Venice in the Aegean

Ionian Islands

Corfu (1386–1797) ~ *bailo*, proveditor and captain
City of Corfu ~ captain
Zante (Zakynthos) (1484–1797) ~ proveditor
Cefalonia (Cephalonia) (1499–1797) ~ proveditor
Santa Maura (Lefkada) (1502–04) ~ proveditor *ordinario*,
 proveditor *straordinario*

Morea

Napoli di Romania (Nafplio) ~ proveditor, also called
 rettore, *bailo*, *podestà*, and captain
Malvasia (Monemvasia) (13th century–1540) ~ *podestà*,
 proveditor
Modon and Coron (Methoni) (13th century–1499) ~
 proveditor
Corone (Koroni) (13th century–1499) ~ proveditor
Argo (1442–63) ~ *rettore*
Lepanto (Navpaktos) (1415–1500) ~ *rettore* and proveditor
Braccio della Maina (1487–99) ~ *rettore*

Negroponte

Negroponte (Euboea; Latin: Nigropons) (1208–1470) ~ *bailo*
Fetelea (Pheteleon) (1209–1470) ~ *rettore*

Greek Archipelago

Egina (Aegina) (1451–1537) ~ *rettore*
Tine and Micone (1439–1718) ~ *rettore*
Lemnos (Limnos) (1464–77) ~ *bailo* and captain
Schiati (Schietto, Skiathos) (1455–1538) ~ *rettore*
Sciro (Schiro, Skyros) (1455–1538) ~ *rettore*
Andros (1511–14) ~ *rettore*
Cerigo (Kithira) (1363–1797) ~ proveditor and *castellano*
Naxos (1404–1500) ~ *governatore*

Candia (Venetian Crete, or Iraklion)

Candia (Crete or Iraklion) (1204–1669) ~ *duca*
Canea (Khania, Chania) (1204–1669) ~ *rettore*, proveditor
Rettimo (Rethymno) (1204–1669) ~ *rettore*, proveditor
Sitia (Sythias) (1204–1669) ~ *rettore*
Suda (Souda) ~ proveditor
Spinalunga (Kalydon) ~ proveditor
Grabusa (Gramvousa) (1584–1692) ~ proveditor

Cyprus (1489–1571)

Nicosia ~ lieutenant
Famagosta (Famagusta) ~ captain
Baffo (Paphos) ~ captain

Resident ambassadors and consuls

Constantinople (Istanbul) ~ *bailo*
Alexandria ~ consul
Damascus ~ consul

CAPTAINS OF MERCHANT GALLEY CONVOYS

For a map of routes and list of captains elected from 1495
to 1569, see Judde de Larivière 2008, xiii, 311–19.

To:

Romania (area of the former Byzantine Empire and
 islands including Crete, in the Aegean and eastern
 Mediterranean)
Cyprus
Alexandria
Beirut
Flanders
Barbary Coast
Aiges-Mortes

PROVEDITORS ELECTED IN THE SENATE

Proveditor General of Dalmatia
Proveditor General of Corfu
Proveditor General of Candia
Proveditor General of Cyprus

Notes

INTRODUCTION

1 Tafuri 1989; Howard 2002; Cooper 2005; Deborah Howard, "The State," in Humfrey, ed. 2007, 33–91; Howard 2008; Howard 2011.

2 On the Grimani of Santa Maria Formosa, see Michel Hochmann, "La famiglia Grimani," in *Collezionismo 2008*, 207–49.

3 "*Tutto vi lasso ben vi priego per honor de casa nostra a conservar la pace tra lui et nepoti suoi fatti Procuratori et conservar la sua Promission Ducale et dila Procuratia et di revender il suo manto di restagno d'oro ...*" (May 7, 1523), Sanudo 1879–1903, vol. 34, col. 127; published in Cheney 1867–68, 92–93. Sanudo added a note that Grimani later asked that the *restagno* be kept and displayed once a year in the Church of San Nicolò al Lido. David S. Chambers considers at length Grimani's career, this passage by Sanudo, and its significance in Chambers 1997, 34–37.

4 "*miniature in doi libri de commissioni del doge Antonio Grimani*," ASVe, Giudici del proprio, Mobili, reg. 209, fols. 95v–98v: *Collezionismo 2007*, 278–79, 338–40. The term *Commissione* would refer most correctly only to Grimani's documents as procurator, but Venetians were not always consistent in the relevant terminology, as discussed later in more detail. The manuscripts probably then continued in the possession of the family through the line of Vincenzo's only son to marry, Giovanni (1629–1664). Consul Joseph Smith (1675–1770) purchased the *Promissione* probably sometime during his residence in Venice, 1744–62. On the subsequent fortunes of Antonio Grimani's *Promissione*, see the Epilogue.

5 Commission/Oath of Antonio Grimani, procurator *de citra* of San Marco, elected August 1494, BMCVe, Cl. III, 158. From the collection of Teodoro Correr. Commission/Oath of Antonio Grimani as procurator *de supra*, 1510, BMCVe, Cl. III, 906. Acquired after Correr's gift of his collection to Venice. *Promissione* of Antonio Grimani, 1521, BL, Add. MS 18000. Rebound.

6 On the second-hand market for such fabric, see Patricia Anne Allerston, "The Market in Second-Hand Clothes and Furnishings in Venice, c.1500–c.1650," PhD thesis,

Florence, European University Institute, 1996; Jack Hinton, "By Sale, by Gift: Aspects of the Resale and Bequest of Goods in Late Sixteenth-Century Venice," *Journal of Design History* 15, no. 4 (2002): 245–62; Evelyn Welch, "From Retail to Resale: The Second-Hand Market in Renaissance Italy," in *The Art Market in Italy 1400–1600*, Sara Matthews Grieco and Louis Matthew, eds. (Florence: Olschki, 2002): 261–77.

7 Alexander, ed. 1994, 11–20; Alexander 2016, 251–62.

8 Lilian Armstrong, "The Impact of Printing on Miniaturists in Venice after 1469," in Hindman, ed. 1991, 174–204.

9 Alexander, ed. 1994, 11–20; Alexander 2016, 208–11. Borso d'Este's Bible cost approximately 2000 ducats, or about twice what Ghirlandaio was paid around the same time for the frescoes of the Tornabuoni Chapel in Santa Maria Novella, Florence, completed in 1490. Anna Melograni, "Quanto costa la magnificenza? Il caso della *Bibbia Bella* di Borso d'Este," *Bollettino d'Arte* 144 (2008): 7–24.

10 On the conflicted relationship involved in the revival of the classical concept of magnificence in the Republic, see Tracy E. Cooper, "Palladio and his Patrons: The Performance of *Magnificenza*," *Annali di architettura* 22 (2010): 89–100.

11 On the concept of *mediocritas* as articulated by the patrician Nicolò Zen, see Tafuri 1989, 1–18; Brown 2004, 23–52.

12 *Life and Passion of Saint Maurice* (gift to Jean Cossa), Paris, Bibliothèque de l'Arsenal, MS 940, and the *Geography* of Strabo (gift to René of Anjou), Albi, Bibliothèque Municipale, MS 77. Marc-Édouard Gautier, ed. *Splendeur de l'enluminure. Le roi René et les livres* (Angers: Villes d'Angers, 2010).

13 Diane Owen Hughes, "Sumptuary Law and Social Relations in Renaissance Italy," in John Bossy, ed. *Disputes and Settlements: Law and Human Relations in the West* (Cambridge: Cambridge University Press, 1983): 69–99; Tafuri 1989, 6–7.

14 Tafuri 1989, 1–13. General knowledge and acceptance of the concept of magnificence in Venice can be discerned from a pedagogical table that maps out the appropriate categories of expenditure by which

to display it, in a book by Orazio Toscanella on the principles of rhetoric published by the Venetian *Accademia della fama*. Reproduced in Lina Bolzoni, "Rendere visibile il sapere: L'Accademia Venezia fra modernità e utopia," *Italian Academies of the Sixteenth Century*, eds. David S. Chambers and François Quiviger (London: Warburg Institute, 1995): 61–77 (77). On the balancing act between equality and distinction, see Raines 2006, 18–20.

15 Fassina 2007.

16 Cooper 2005, xi; Howard 2011, 11, 84.

17 The granting of the privilege in 1529 is discussed by Giovanni Fiorini, writing in 1761, as transmitted by Bruno de Donà, "*I fasti della famiglia Grimani con riferimento al ramo di S. Maria Formosa*: Un frammento manoscritto e inedito," *Atti e memorie dell'Ateneo di Treviso* 14 (1996–97): 167–75 (172); Marcella De Paoli, *Opera fatta diligentissimamente: restauri di sculture classiche a Venezia tra Quattro e Cinquecento* (Rome: L'Erma di Bretschneider, 2004): 25. Two such privileges are recorded in the inventory of Vincenzo Grimani Calergi's collection in 1647: "miniature de doi privileggi del Populo Romano alla casa Grimani," *Collezionismo 2007*, 339.

The current whereabouts of the illuminated privileges are unknown, but the concession by the city council is recorded in the Archivio Storico Capitolino, Camera Capitolina, Cred. VI 49, 450, fol. 350r (March 12, 1529). The later re-registration of the privilege of citizenship of 1670 is recorded in Archivio Storico Capitolino, Camera Capitolina, Cred. I 35, 35, fol. 72. From the not yet published manuscript "Francesco Magni e continuatori, Repertorio delle creazioni di cittadinanza romana (secoli XIV-XIX)," ed. Claudio De Dominicis (Rome, 2007). I am grateful to Andreas Rehberg for this information. On such concessions of the privilege of Roman citizenship in this period, see Andreas Rehberg, "L'*élite* municipale romana e i nuovi cittadini fra gli habitatores di Roma del primo Cinquecento," in Anna Esposito and Maria Luisa Lombardo, eds. *Vivere a Roma. Uomini e case nel primo Cinquecento* (Rome: Il centro di ricerca, 2007): 27–57.

On the importance of the Grimani collection of antiquities in Rome, see Kathleen Wren Christian, *Empire Without End: Antiquities Collections in Renaissance Rome, c.1350–1527* (New Haven and London: Yale University Press, 2010): 322–26.

18 Vasari 1568, vol. 2, 852; Calvillo 2000, 280.

19 London, Sir John Soane's Museum, MS 143. *Collezionismo 2007*, 339. On the *Commentaries* illuminated by Clovio, now in the Soane Museum, see Calvillo 2000. Vettor di Giovanni Grimani Calergi (1652–1738) left the manuscript to Vincenzo di Giancarlo Grimani (1676–1746, Santa Maria Formosa) in his testament of 1738. Cicogna 1824–53, vol. 4, 632.

20 Alexander, ed. 2008; Bauman 2001.

21 BMVe, Lat. I, 99 (=2138). Kren and McKendrick, eds. 2003, 420–24 (420).

22 In addition to the promise opening the text and an oath at the end, a *Capitolare*, or set of regulations governing ducal conduct was transcribed in the *Promissione*.

23 These were the *Provveditore generale da mar*, who resided in Corfu, the *Provveditore generale* or Lieutenant of Friuli, who served in Udine, and the *Provveditore generale* of Dalmatia, who resided in Zara.

24 July 29, 1494. BL, Add. MS 15145. The manuscript has been rebound.

25 Such documents will be discussed further in Chapter 2.

26 The offices to which patricians were elected 1332–1524 are now easily found in the database *The Rulers of Venice*: O'Connell, ed. *c.*2009.

27 Literally, "ducal," or "of the doge." The adjective becomes here a noun. The *Promissione* and Commissions for individual procurators and rectors were all to have the *bolla* affixed. It is not clear if the Commission/Oath manuscripts for the ducal councillors were also supposed to have the ducal seal.

28 For example, the term *ducali* clearly seems to reference Commissions in the inventory of the effects of Giovanni di Antonio Pr. Nani (1665–1748) in his palace at Sant'Eufemia on the Giudecca, at the request of his wife Lucretia Querini, in December of 1748. Eight "*libri ducali*" are listed in a study above the garden, along with Books of Hours, medallions, paintings, miniatures, eyeglasses, and other items typically found in such a room. A membrane *Promissione* is listed with genealogies (*Nomi de patrizi*) and *Capitolari* of ducal councillors on top of a small table in another room. ASVe, Giudici de petizion, Inventari di eredità, tutele, curatele, oppure richiesti in causa, b. 446, pezzo 7. The scholar Antonio Marsand, a native of Venice, explained in his early nineteenth-century catalogue of Italian manuscripts in the French Royal Library that Venetians called Commission documents *lettere ducali*, and a list of the leaves taken by the French from the Somascan Library of Santa Maria della Salute in 1797 refers to them simply as "*Miniature di Ducali*." Marsand 1835–38, vol. 1, 489–92; Samuele Romanin, *Storia documentata di Venezia* (Venice: P. Natarovich, 1861): X, 411.

29 Chambers 1997, 25. I am thankful also to Dieter Girgensohn for discussing the term with me as it is used in diplomacy.

30 Antonio Marsand was the first scholar to write about *ducali*, and the appreciation of their miniatures as art, in 1835. The Italian scholar and collector Emmanuele Antonio Cicogna, in an article of 1851 primarily on Commissions, was the first to call more extensive attention to their historical and artistic interest, and noted that they were already in great demand on the market. Around the same time, the librarian of the British Library J. H. Holmes may have been the first to apply the blanket term *ducali* in discussing these

three types of manuscript, but did so in a manuscript for a limited audience. In 1857 the paleographer Cesare Foucard argued further that such manuscripts constituted Venice's distinctive contribution to the art of manuscript illumination. With primary interest in the painting in manuscripts, the English scholar John W. Bradley applied the term *ducali* to include an even broader range of documents, including *mariegole*, the statute books of Venetian *scuole* and guilds. After that, many scholars of manuscript illumination have utilized the Venetian dialect of the term, *dogale*, to distinguish this class of manuscripts, usually leaving out the *mariegole*. Marsand 1835–38, vol. 1, 489–92; Cicogna 1851; [J. H. Holmes]; Foucard 1857; Cheney 1867–68; J. W. Bradley 1896.

31 In so doing, we follow the tradition of accepting the term *cassoni* to discuss the chests that were more commonly called *forzieri* in the Renaissance, indeed to use the terms Renaissance or Early Modern for periods in history, among many other anachronistic but useful terms. Baskins 2008. See also a discussion of the term *sacra conversazione*. Humfrey 1993, 12–13.

32 Mariani Canova 1968, "La decorazione dei documenti ufficiali in Venezia dal 1460 al 1530;" Sinding-Larsen 1974; Wolters 1987; Meyer zur Capellen 1985; Chambers 1997. Giulia Maria Zuccolo Padrono did the major groundwork on identifying the oeuvre of various sixteenth-century masters of these documents in Zuccolo Padrono 1969; Zuccolo Padrono 1971; Zuccolo Padrono 1972. Di Luzio 1985–86; Dorigato 1986; Nuvoloni 2000; Szépe 2001; Szépe 2005; Lucchi, ed. 2013. A detailed online catalogue of *ducali* in the Correr is available at http://www.nuovabibliotecamanoscritta.it/BMCVe.html.

33 "Venice – rich in gold but richer in fame, mighty in her resources but mightier in virtue, solidly built on marble but standing more solid on a foundation of civic concord …" Written by Petrarch in a letter to Pietro da Muglio, 1364. *Epist. Seniles* 4.3. Translation by Craig Kallendorf, with discussion of the quotation of this phrase since the sixteenth century in relation to the myth of Venice. Kallendorf 1999, 14–17; 14, n. 40. There is an enormous literature on the myth. For analysis of its history and development, see Martin and Romano, "Introduction," in Martin and Romano, eds. 2000, 1–35.

34 Pocock 1975; Pocock 1979; Hankins 2000.

35 Rosand 1984; Wolfgang Wolters, "L'autocelebrazione della Repubblica," *SDV* 6 (1994), *Dal rinascimento al barocco*: 469–513; Deborah Howard, "The State," in Humfrey, ed. 2007, 33–91. Adrian Randolph discusses representation in the arts of Renaissance Florence as a fundamental practice
of politics, vital to the formulation of civic identity, in Randolph 2002.

36 Dorit Raines has analyzed extensively the form and transformation of the Venetian patriciate's cohesion and self-identification from the sixteenth to the eighteenth century, and the mechanisms of its operation and duration in political and sociological terms. Raines 2006.

37 Gerhard Rösch, "The *Serrata* of the Great Council and Venetian Society, 1286–1323," in Martin and Romano, eds. 2000, 67–82; Chojnacki 1994; Crescenzi 1996.

38 Stanley Chojnacki, "Identity and Ideology in Renaissance Venice. The Third *Serrata*," in Martin and Romano, eds. 2000, 263–94. Crescenzi 1996.

39 Lowry 1971; Grendler 1979; Cozzi 1980 and 1983; Cowan 1986, Grendler 1990; Burke 1994; Raines 2006; Monique O'Connell, "Class History: Officials of the Venetian State, 1380–1420," in O'Connell, ed. c.2009, paragraphs 182–202.

40 Davis 1962, 26–28.

41 Dorit Raines describes the nature and evolution of the private patrician "political" family archive, and outlines the kinds of documents that were on membrane and often illuminated, in Raines 2011, 138.

42 Davis 1962, 26–31; Raines 2006.

43 The most important source for distinguishing a patrician elected to office from contemporaries with the same name is the records of elections of the *Segretario alle voci*, which usually do identify the name of the father. These records from 1332 to 1524 are consultable online in the database *The Rulers of Venice*: O'Connell, ed. c.2009. For later election records, it still is necessary to consult the registers in the archives, ASVe, *SAV*, Elezioni in Maggior consiglio, registri, 1524–1797. Some of the gaps in these can be filled through consultation of ASVe, *SAV*, Accettazioni, 1540–1797, and ASVe, Capi del Consiglio di dieci, Giuramenti.

44 My database has a total of 2000 entries of manuscripts dating from the fourteenth century to 1797.

45 This is a very rough estimate. Publication and analysis of the *Segretario alle voci* (SAV) database covering elections from 1524 to 1595, in conjunction with more precise analysis of the data in the *Rulers of Venice* database, would provide a more exact figure. On the *SAV* database, see Salmini c.2009, paragraphs 176–81.

46 I have found manuscripts and fragments for twenty-one of the seventy-seven "great office holders" from the 1540s to the 1590s compiled by Paul F. Grendler (Grendler 1990). Miniatures survive as in the original manuscripts or as detached leaves for at least thirteen of these patricians. Stefano di Paolo Tiepolo (d. 1557) (Commission as Lieutenant of Cyprus, 1532, missing opening leaf; Commission as Proveditor General of Cyprus and Famagusta, 1532, never illuminated; Commission as Proveditor of the Island of Corfu, 1537, missing first leaf; *Capitolare* as ducal councillor, 1542, missing opening leaf, all in ASVe, Archivio privato Tiepolo; Commission as Captain General of the Sea, 1551, never illuminated, ASVe, Commissioni rettori e altre cariche); Filippo Pr. di Priamo Tron

(d. 1556) (Commission as Captain of Padua in 1542 with miniatures by the T.° Ve Master, BMCVe, Cl. III, 1097); Francesco di Giovanni Venier (see Chapter 3); Pietro Ser.mo di Alvise Loredan (1482–1570) (*Promissione* as doge, elected 1567, BnF, Lat. 10144, rebound and never illuminated); Francesco di Jacopo Pr. Soranzo (c.1493–1563) (?) (Commission as Proveditor of Zante, 1561) BMCVe, Cl. III, 862); Girolamo di Bernardo Zane (see Chapter 4); Marin di Sigismondo Cavalli (see Chapter 6); Giovanni di Michiel da Lezze (see Chapter 4); Sebastiano Ser.mo di Moisè Venier (c.1496–1578) (Commission as Captain of Brescia, 1561, never illuminated, BnF, Lat. 4746A); Leonardo di Girolamo Dandolo (1512–1582) (*Capitolare* as ducal councillor, 1577, full-page coat of arms, BMCVe, Cl. III, 741); Alvise di Antonio Grimani (see Helena Katalin Szépe, "Painters and Patrons in Venetian Documents," in Lucchi, ed. 2013, 26–27); Girolamo di Antonio Pr. Priuli (d. 1583) (Commission as *Podestà* of Brescia, 1575, never illuminated, University of Pennsylvania, Schoenberg LJS 304); Jacopo di Francesco Soranzo (see Chapter 6); Paolo di Santo Tron (1509–1580) (perhaps Commission as ducal councillor, Budapest, National Széchényi Library, Codex 313); Alberto di Angelo Badoer (1542–1592) (leaf detached from his Commission as *Podestà* of Verona, 1584, Cambridge, Fitzwilliam, Marlay Cutting It. 51; Morgan, Panayotova, Reynolds, eds. 2011, vol. 1, 178); Francesco di Pietro Duodo (see Chapter 7); Marin di Girolamo Grimani (see Chapter 4); Luca di Salvador Michiel (see Chapter 7); Girolamo di Agostino Surian (Helena Katalin Szépe, "Painters and Patrons in Venetian Documents," in Lucchi, ed. 2013, 34); Marco di Giovanni Antonio Giustinian (1539–1601) (Commission as *Podestà* of Bergamo, 1583, never illuminated, Paris, BnF, Smith Lesouëf 44); Bernardo di Stefano Pr. Tiepolo (1526–1607) (*Capitolare* as ducal councillor of 1590, formerly BMCVe, Cl. III, 860, now missing).

47 Commission to Girolamo Venier as *Podestà* and Captain of Sacile, 1555, BMVe, It. VII, 1364 (=8122) (with miniature attributed to Jacopo del Giallo by M. Levi D'Ancona 1962, 17); Commission to Venier as Captain of Brescia and Riviera di Salò, 1559, BMVe, It. VII, 1352 (=8087); Commission to Venier as *Podestà* and Captain of Capodistria, 1564, BMVe, It. VII, 1355 (=8116). The Commission to Venier as *Podestà* and Captain of Rovigo of 1565 lacks the first leaf, suggesting that it too was illuminated: BMVe, It. VII, 1363 (=8121). His highest office was that of Lieutenant of Udine, to which he was elected in 1581, but I have not found the relevant Commission. For his testament of 6 April 1598, written in his own hand, in which he requests burial in his modest tomb in Santa Maria Zobenigo: ASVe, Notarile, Atti Galeazzo Secco, 1191.331 and 1194.V.921. His mother Foscarina was the daughter of Andrea di Bernardo Foscari of Rovigo, and was educated in poetry. Barbaro GD, fol. 294r. Girolamo married Elena Pisani,

daughter of Nicolò di Giovanni (S. Vidal), in 1551. Girolamo's son Giovanni Andrea, in his turn, became Captain of Bergamo in 1602. Raines 2006, vol. 1, 220, n. 118. His Commission, illuminated by Alessandro Merli, is BMVe, It. VII, 1350 (=8085).

48 The theme of Justice presiding over Vice is similar to that in a painting by Giovanni Battista Ponchino of the *Allegory of Justice* of c.1554 in the Stanza dei Tre Capi del Consiglio di Dieci in the Doge's Palace, from which the miniaturist may have derived inspiration. Schulz 1968, 24, plate 42.

49 Grendler 1990, 82; Finlay 1978, 157. In recounting his trip to Venice in the spring of 1594, the Englishman Fynes Moryson commented, "I never in any place observed more old men, or so many Senators venerable for their grey haires and aged gravity." Moryson 1617, 71.

50 See note 47.

51 Commission to Michele Bon as *Podestà* of Montagnana, 1552 (election and oath recorded in the *Segretario alle voci* and *Capi del Consiglio di dieci* registers), Oxford, Bodleian Library, Laud misc. 710; Commission of Michele Bon as Proveditor of Cividale del Friuli, 1564, Laud misc. 711; Commission of Michele Bon as *Podestà* of Bergamo, 1572, Laud misc. 713; Commission of Michele Bon as *Podestà* of Brescia, 1586, Laud misc. 714. I. G. Philip, *Gold-Tooled Bookbindings* (Oxford: Bodleian Library, 1951): figs. 12 and 13.

52 Paris, Bibliothèque de l'Arsenal, MS 8596. Marsand 1835–38, vol. 2, 323. Henry Martin, *Catalogue des manuscrits de la Bibliothèque de l'Arsenal* (Paris: Librairie Plon, 1885): vol. 6, 509. The Commission for Marcello as *Podestà* and Captain of Capodistria (elected 1568) is in the British Library (Add. MS 41154), but is missing its first leaf. Sebastiano Marcello had married Paola di Alvise di Rigo Badoer in 1539, and was buried in the Church of Sant'Angelo. Cicogna 1830, vol. 3, 126.

53 Personified virtues were commonly portrayed on the tombs of the doges throughout the fifteenth century but were depicted on domestic interior walls as early as the fourteenth century. As just one example of a sixteenth-century domestic context, Vasari painted independent figures of the Virtues of Charity, Patience, Justice, Hope, and Faith in oil, as ceiling paintings for Giovanni Corner's palace sometime after 1542. Brown 2004, 32, 83–85. Anne Dunlop, *Painted Palaces: The Rise of Secular Art in Early Renaissance Italy* (University Park, PA: Pennsylvania State University Press, 2009); Schulz 1968, 120; Elena Bassi, *Admiranda Urbis Venetae. Palazzi di Venezia* (Venice: La Stamperia di Venezia, 1976): 387.

54 Lermer 2005, 229–34; Rosand 2001, 18–46; Rosand 1984, 177–96.

55 See especially the painting by Paolo Veneziano for the tomb of Doge Francesco Dandolo, of c.1339. Pincus 2000, 105–15. On further development of the theme see Wolters 1987, 93–149.

56 *Three Avogadori di Comun and the Resurrection of Christ*, Venice, Doge's Palace, Avogaria, *c*.1571. Von Hadeln identified the *avogadori*, including Bon, who took office July 9, 1570. Von Hadeln 1911, "Beiträge zur Geschichte des Dogenpalastes," 4–5; Pallucchini and Rossi 2 (1982): cat. 315, 196; 3: fig. 410; Wolters 1987, 140–42.

57 Vecellio describes the red overgarment of the *Avogadori* in Vecellio 1598, 105. The organization of the paintings in this room has gone through extensive changes since 1797; see Wolters 2010, 178–80.

58 This kind of corporate image of Venetian magistrates was essentially invented by Tintoretto some fifteen years before for a portrait of the sitting treasurers for their offices. Patricia Fortini Brown, "Where the Money Flows: Art Patronage in Sixteenth-Century Venice," in Ilchman, ed. 2009, 46.

59 *Saint Michael the Archangel Battling Lucifer*, attributed to Jacopo and Domenico Tintoretto, Venice, Church of San Giuseppe di Castello. Raffaello Borghini already described the painting and patron in *Il Riposo, in cui della pittura e della scultura si favella ...* (Florence: Giorgio Marescotti, 1584): 554; Pallucchini and Rossi 1982, vol. 2, 220, cat. 417; Pallucchini and Rossi 1982, vol. 3, fig. 531; Paul 2005, 182.

60 Stollberg-Rilinger, Puhle, Götzmann, Althoff, eds. 2008. On civic ritual in Venice see especially Edward Muir 1981. Watson 2007.

61 On the ducal seal, or *bolla*, see Rosado 1985, 119–41.

62 Oxford, Ashmolean Museum. Leandro Bassano, *Portrait of Gianfrancesco Sagredo*. On the identification of the sitter, see Nick Wilding, "Galileo's Idol: Gianfrancesco Sagredo Unveiled," *Gallilaeana: Journal of Galilean Studies* 3, 2006: 229–45. For an example of this kind of binding, see the Commission to Andrea di Pietro Badoer (1515–1575) as Captain of Crema, 1562, Cambridge, Trinity College, 0.2.17. Another portrait with the sitter shown with a Commission in this kind of binding is Giovanni Bernardo Carbone, *Portrait of a Member of the Dolfin Family*, Museo d'Arte Medievale e Moderna, Padua, Inv. 1694.

63 Antonio Balestra, *Portrait of Nicolò Contarini* (1666–1740), Venice, Antichità Pietro Scarpa. Adriana Augusti, *Il ritratto nella pittura veneziana* (Trieste: Assicurazione Generali, 1998): 30. An example of such a binding is the Commission of Domenico di Pietro Condulmer as *Podestà* of Padua, 1772, BMCVe, Cl. III, 1050. Granzotto 1999.

64 Collezione Banca Popolare di Vicenza. Giuseppe Maria Pilo, "Un ritratto inedito di Domenico Tintoretto," *Arte Veneta* 28 (1974), 258–60.

65 The document as procurator probably is depicted as that directly below the inscription on the column identifying him, for it is of the larger format typical for the Commissions of procurators in that era, and was the highest office he held.

66 "*E cussi va le nostre cosse.*" Sanudo 1879–1903, vol. 34, col. 116.

67 While Antonio Grimani probably kept both documents as procurator, they arrived in the Correr collection at different dates, so it is not known if they were sold from the family collection at the same time.

68 Viggiano 2007.

69 Viggiano 2007.

70 Fassina 2007.

71 Alexander 1992, 40; Jennifer Marie Bauman, "Miniature Painting and Its Role at the Medici Court in Florence, 1537–1627," PhD thesis, The Johns Hopkins University, 1998: 11–126; Szépe 2009.

72 Vasari 1906, vol. 7, 557.

PART I OPENER

1 "*Deo auctore Ducatum nostrum Beati Marci suffragus gubernante, qui nobis permissione celestis gratie est collatus, & bella feliciter peragimus, & pacem iuribus decorantes statum patrie honorabilius sustentamus.*" Roberto Cessi, *Gli statuti veneziani di Jacopo Tiepolo del 1242 e le loro glosse* (Venice: Carlo Ferrari, 1938): 3. English translation by Jason Nethercut.

CHAPTER 1: THE BOOK IN THE LION'S CLAWS

1 James W. Watts, ed. *Iconic Books and Texts* (Sheffield: Equinox, 2013).

2 Contarini and Lewkinor 1599, 10–12. The first edition of Contarini's text was published in Latin in Paris in 1543. Contarini 1543. It was first translated into Italian and published in Venice in 1545, and in many subsequent editions in Venice and abroad.

3 Zordan 2005, 148–52; Silvano 1993, 17 n. 25. See for example Washington, D.C., Library of Congress, Law Library, KKH8501.A17 V46 1346, fol. 1. Helena Katalin Szépe, "Doge Andrea Dandolo and Manuscript Illumination of the Fourteenth Century," in Toniolo and Toscano, eds. 2012, 152–56.

4 Fremmer 2001; Helena Katalin Szépe, "Doge Andrea Dandolo and Manuscript Illumination of the Fourteenth Century," in Toniolo and Toscano 2012, 152–56.

5 Silvano 1993, 17.

6 Brown 1907, vol. 1, 293–334; De Vivo 2010. On the development and importance of legal and documentary culture in Italy in general, see Ronald Witt, *The Two Latin Cultures and the Foundation of Renaissance Humanism in Medieval Italy* (Cambridge: Cambridge University Press, 2012).

7 Historically, in expanding and preserving memory, such literacy allowed for the development of administration on a greater scale. Keller 1992, 1; Clanchy 1993. Britnell argues that written records do not actually create

political, economic, or religious authority, but can better safeguard or expand such authority. Richard Britnell, "Pragmatic Literacy in Latin Christendom," in Britnell, ed. 1997, 3–24; Thomas Behrmann, "The Development of Pragmatic Literacy in the Lombard City Communes," in Britnell, ed. 1997, 25–42; Harris 1995, 71–73.

8 Derrida 1995.

9 Paolo Prodi, "The Structure and Organization of the Church in Renaissance Venice: Suggestions for Research," in Hale, ed. 1973, 409–30. Caroline A. Wamsler provides a nuanced inquiry into the merging of the secular and sacred in Venice in her discussion of the Trecento program of the Hall of the Great Council. "Merging Heavenly Court and Earthly Council in Trecento Venice," in Alicia Walker and Amanda Luyster, eds. *Negotiating Secular and Sacred in Medieval Art: Christian, Islamic, and Buddhist* (Aldershot: Ashgate, 2009): 55–74.

10 On the evolution of this iconography, see Armando Petrucci, "The Christian Conception of the Book in the Sixth and Seventh Centuries," in Armando Petrucci, *Writers and Readers in Medieval Italy: Studies in the History of Written Culture*, trans. and ed. Charles M. Radding (New Haven: Yale University Press, 1995): 19–42. On images of books and what they symbolize, see David Pearson, *Books in History* (London: British Library, 2nd ed., 2011); Watson 2007.

11 Kearney 2009, 10–11, with relevant bibliography.

12 *Logos* in the original Greek and *Verbum* in the vulgate: "In principio erat Verbum. Et Verbum erat apud Deum, Et Deus erat Verbum," *Biblia Sacra Vulgata*, 1042. "In the beginning was the Word, and the Word was with God, and the Word was God ... and the Word was made flesh, and dwelt among us ..."

13 Above Christ with his book, which is encrusted with precious stones, is a throne with a closed book, surmounted by the dove of the Holy Spirit; this represents the *Hetoimasia*, signifying preparation for the Last Judgment. W. F. Volbach, "Gli smalti della Pala d'oro," in Hahnloser, ed. 1965–72, vol. 1, 3–13.

14 Jerome and Origen discussed the Word as incarnate in Christ, and made flesh in scripture. According to Marsilio Ficino, Jesus was a living book of moral and divine philosophy. Andrew Louth, "The Theology of the Word Made Flesh," in John L. Sharpe III and Kimberly van Kampen, eds. *The Bible as Book: The Manuscript Tradition* (London and New Castle, DE: The British Library and Oak Knoll Press, 1998): 223–28; Kearney 2009.

15 On the patronage of books by rulers and church leaders in the Middle Ages, see Pächt 1989, 9–12; de Hamel 1994.

16 Helena Katalin Szépe, "Doge Andrea Dandolo and Manuscript Illumination of the Fourteenth Century," in Toniolo and Toscano 2012, 152–56, with previous bibliography.

17 Wolters 1976; Sinding Larsen 1974, 167–75; Tagliaferro 2005, 134 n. 9.

18 Exodus 32:15, 34. Other reliefs show Aristotle as giver of law, in which he gives out books; the pact of God with the Israelites (Exodus 24:7), in which Moses reads a book while people place their hand on it to take an oath. On the sculptural program of this side of the palace, see Lermer 2005, with specific discussion of the Capital of Justice, 192–97.

19 Rizzi 1990; Rizzi 2012.

20 Daniele Rando has shown how Mark assumed a personal place in the language of pacts and other documents in the twelfth century. Concessions were made to Mark, the doge and the commune, not just to an indeterminate collective. Rando 1996, 78–79.

21 Aldrighetti 2002.

22 Rizzi 2012.

23 Scarfi, ed. 1990, 33.

24 Ezekiel 1:4–10 and Revelation 4:6–7.

25 Giorgio Cracco, "La cultura giuridico-politica nella Venezia della 'serrata,'" in *Storia della cultura veneta*, vol. 2: *Il Trecento* (Vicenza: Neri Pozza, 1976): 238–71; Rando 1996.

26 Rudt de Collenberg 1989, 57–84.

27 *"Pax tibi Marce. Hic requiescet corpus tuum."* The *praedestinatio* or *vaticinatio legend* was definitively recounted in Doge Andrea Dandolo's fourteenth-century *Chronica veneta*. Tramontin 1965, 51–52.

28 Debra Pincus has argued that the dogate of Andrea Dandolo in particular began to emphasize "the concept of the Venetian ruler as a transmission agent bringing divine revelation into the deliberations of state." Debra Pincus, "Hard Times and Ducal Radiance," in Martin and Romano, eds. 2000, 89–136 (115–17, 122–23).

29 *"Pax tibi Marce Evangelista meus."* The current sculptural complex has been heavily restored after it was vandalized following the fall of the Republic. Romano 2007, 147–53. The new head of Foscari was mistakenly made after a head representing the later doge Cristoforo Moro. Matteo Ceriani in Christiansen and Weppelmann, eds. 2011, 329.

30 There were earlier versions of this kind of sculptural complex but it is not known what, if any, inscriptions were on the lion's book. Pincus 1976; Wolters 1976.

31 Donato Bragadin, *Lion of Mark*, created to hang over a door leading to the *Avogaria di comun*, now in the fifteenth century, Venice, Doge's Palace. Wolters 2012, 64–65, fig. 44.

32 Demus 1960, 171–72; Pincus 2000, 47–51. Armin F. Bergmeier, "The *Traditio Legis* in Late Antiquity and its Afterlives in the Middles Ages," *Gesta* 56, 1 (2017): 27–52.

33 See for example a sarcophagus with the *Traditio legis*, Ravenna, fifth century, Sant'Appolinare in Classe.

34 Andrea Padovani, "La politica del diritto," *SDV* 2 (1995), *L'eta del comune*: 303–30 (315).

35 See quote on p. 39 of the present book.

36 Uwe Ludwig, "L'Evangeliario di Cividale e il Vangelo di san Marco. Per la storia di una reliquia marciana," in Niero, ed. 1996, 179–204 (180).

37 On the early deterioration of the fragment in Venice, see Sansovino 1604, fol. 71v. Two quires of the manuscript were given to Charles IV of Bohemia in October of 1354, at his request, and remain in Prague, in the Metropolitan Chapter Library MS Cim. no. 1. Several quires remain in Cividale del Friuli as the "Codex Forojuliensis," Museo Archeologico Nazionale, Biblioteca Capitolare, cod. CXXXVIII. On the importance of the manuscript as a relic of Mark, see Demus 1960, 16. The fragments in their binding in Venice are described by Hans R. Hahnloser in "Opere occidentali dei secoli XII–XIV," Hahnloser, ed. 1965–72, vol. 2, 151–52, plate CXL. The entire original manuscript, and its script, bindings, and history are described and illustrated in Scalon, ed. 1999; Brunettin 2001; Marek Suchý and Jiří Vnouček, "The Story of the Prague Fragment of S. Mark's Gospel through Fourteen Centuries," in Gillian Fellows-Jenson and Peter Springborg, eds. *Care and Conservation of Manuscripts* 9 (Copenhagen: Museum Tusculanum Press, 2006): 83–112.

The origins of this particular inscription also may be more generally from the "*passiones*" tradition ascribed to Mark's disciple Hermagoras, according to which Christ addressed the saint with these words while Mark was prisoner in Alexandria. This moment was illustrated in narrative scenes on the two sides of the main altarpiece of the Basilica of Saint Mark, the Pala d'Oro shown on major feast days, and the Pala Feriale shown at other times.

38 Stringa in Sansovino 1604, fols. 71v–72r (misfoliated as 76r): *In sacrestia ... Del Libro de gli Evangelij di S. Marco di proprio pugno. Cap. CXXXIII*

"*Vi si custodisce parimente in detto luogo un Libro, che contiene il Vangelo scritto da S. Marco di suo proprio pugno in lingua latina, che apporta senza dubbio non poca maraviglia a chiunq; lo vede: conciosa cosa che a pena discerner si possono le lettere non che le parole, per la molta antichità sua, che le ha quasi del tutto consumate, essendo horamai quasi passati 1550 anni, che furono da esso glorioso Vangelista scritte; pur in alcuni luoghi si legge, ma difficilmente, qualche parola, Trovasi egli coperto d'argento, con lavori, figurine, e altri ornamenti vaghissimi adornato, et si hebbe l'anno 1422. sotto il Principato di Tomaso Mocenigo, il quale operò sì con gli Oratori Forlani, che vennero all'hora alla divotione della Republica, che havendolo con lettere instantemente dimandato, hebbe gratia di haverlo. Trovavasi prima egli presso le Monache di S. Benedetto in Aquilea, poscia fu portato in Cividale in Friuli, e di quindi Venetia da quei cittadini per l'istanza fatta dal predetto Doge, mandato; onde*

si tiene per una bellissima e notabile reliqua.

"*Questo viene il di 25 Giugno, giorno della sacra Apparitione di San Marco, posto insieme col soprascritto Anello, & con uno dito grosso di San Marco, sù l'altar grande; & dopo la Messa maggiore si fà con dette reliquie una solenne processione attorno la Chiesa con l'intervento pur del Doge, et Signoria, come pur anco in altro luogo scoperto habbiamo.*"

Stringa 1610, 63; described as "*di suo mano*" or "by his own hand" by Giustiniano Martinioni in Sansovino 1663, 102.

39 Gallo 1967, 204–6; Hahnloser, ed. 1965–72, vol. 2, 151–52, plate CXL; Susy Marcon, "Il reliquiario del Vangelo di San Marco," in Scalon, ed. 1999, 13–20.

40 Uwe Ludwig, "L'Evangeliario di Cividale e il Vangelo di san Marco. Per la storia di una reliquia marciana," in Niero, ed. 1996, 179–204 (184–85). According to Papias, an early Father of the Church quoted by Eusebius, Mark was "interpreter of Saint Peter," from which arose the popular tradition that Mark wrote down the words of his Gospel from Peter's dictation.

41 Uwe Ludwig, "L'Evangeliario di Cividale e il Vangelo di san Marco. Per la storia di una reliquia marciana," in Niero, ed. 1996, 179–204. On the medieval rivalry of Aquileia and Venice for patriarchal authority, see Dale 1997, 7–9. On acquisition of the ecclesiastical province of Aquileia, see Laven 1966–67.

42 As described by Marin Sanudo in Sanudo 1879–1903, vol. 18, col. 296; vol. 24, col. 405–6; vol. 58, col. 372; and by Stringa in Stringa 1680, 85–89; Stringa in Sansovino 1604, fol. 76v; Martinioni in Sansovino 1663, 515; Renier Michiel 1817, vol. 3, 136–37; Muir 1981, 88–90. Prescribed in the Basilica *Cerimoniale* by Bartolomeo Bonifacio, before 1564, BMVe, Lat. 111, 172 (=2276), 47r. Transcribed in Cattin and Di Pasquale, eds. 1990–92, vol. 3, 126–27. The thumb and ring reliquaries have remained in the Basilica (Santuario nos. 106 and 48). On the ring, see Gallo 1967, 101–2; Hahnloser, ed. 1965–72, vol. 2, 161–62, cat. 158. On the thumb (the oldest inventory reference to it locates it in the sacristy, September 30, 1463): Gallo 1967, 118–19; Hahnloser, ed. 1965–72, vol. 2, 181–82, cat. 174.

43 Although some of these mosaics above the main altar of the Basilica were damaged by fire in the fifteenth century, they were restored, perhaps for a second time, in 1506 by the artist Piero di Zorzi, presumably according to their original composition of the eleventh or twelfth century. Signed as by "Magister Petrus." Demus 1984, 31, n. 1; Merkel 1987, 25; Merkel 1994.

44 To the left of Peter, somewhat isolated, is Nicholas, patron of the Venetian fleets, his hand directed toward the viewer in blessing.

45 Demus 1984, 32–35.

46 Demus 1960, 12–15; Dale 1994, 85–89. As written in some manuscripts of the *Chronica brevis* by Andrea

Dandolo: "*Et sic evangelista pius de una columna antiquae ecclesie manum extendens se propalavit.*" Monticolo 1895, 128. This scene is represented on the Pala Feriale painted by Paolo Veneziano. The Pala Feriale was shown in place of the Pala d'Oro above the main altar of the Basilica on non-feast days throughout the liturgical year. The scene of Mark calling attention to his presence is even more clearly represented in the early fourteenth-century missal made for use in the Basilica, on the page with the text used to celebrate the apparition. *Missale ad usum ecclesiae Sancti Marci*, BMVe, Lat. III, 111 (=2116), fol. 148r. Also illustrated in a late fourteenth-century manuscript of the narrative, made for a member of the Dolfin family. *Vita, translatio et apparitio Sancti Marci*, BMCVe, Cod. Correr 1498, fol. 75. Partially transcribed in Manno 1995, *San Marco Evangelista*, 235–36. Illustrations of the ring and the event are on folios 1r and 25r. Description of the manuscript and its illustrations in Marcon 1995, 124–26; Marcon 2009, 159–60; Enrico Maria Dal Pozzolo, Rosella Dorigo, Maria Pia Pedani Fabris, eds. *Venezia e l'Egitto* (Milan: Skira, 2011). The ring eventually was acquired by the Scuola of San Marco, but sources differ as to whether it was this ring or the more famous one given by Mark to a fisherman that was displayed on the altar on the apparition feast day. Gallo further discusses the rings possessed by the Scuola of San Marco and in the Treasury of Saint Mark in Gallo 1934, 201–4; Hahnloser, ed. 1965–72, vol. 2, 161–62.

47 Museo Correr, Cl. II, 24. This version of the legend illustrates how individual Venetian patricians and their families, like the Dolfin, could promote themselves as protagonists in Venetian religious and political history. Such stories were carefully advanced by the art patronage of these families, as in the Correr manuscript created for the Dolfin family. A narrative image of the granting of the ring by Mark to Domenico Dolfin also was painted on a large piece of parchment, together with the text of the legend, sometime in the mid-sixteenth century. This significant but unfortunately greatly damaged painting affirms that, centuries later, members of the Dolfin family continued to promote the version of the narrative celebrating their family's role in Mark's reaffirmation of his patronage of the Venetians in view. Andrea Bellieri in Enrico Maria Dal Pozzolo, Rosella Dorigo, Maria Pia Pedani Fabris, eds. *Venezia e l'Egitto* (Milan: Skira, 2011): 284–85.

48 Authenticity of a relic is often disputed, and Stringa takes care to assert that the body of Mark was actually present under the altar; Stringa 1680, 90. In 1807, a patriarch assigned under Napoleon wanted to find the body. When the mensa was opened, nothing except an illegible piece of parchment was found. Excavation of the crypt beneath the altar in 1809 uncovered a body, which was officially declared to be that of Mark in 1835. Giovanni Venni asserts the body is that of Mark

in Venni 1928. On reliquaries that are in the form of arms, and their relation to gesture, see Cynthia Hahn, "The Spectacle of the Charismatic Body: Patrons, Artists, and Body-Part Reliquaries," in Martina Bagnoli, Holger A. Klein, C. Griffith Mann, and James Robinson, eds. *Treasures of Heaven: Saints, Relics, and Devotion in Medieval Europe* (Baltimore: Walters Art Museum, 2010): 163–72.

49 The tooth and its reliquary are still in the Basilica of San Marco, Santuario no. 106. They are described in Hahnloser, ed. 1965–72, vol. 2, 160–61, cat. 157, plate CL.

50 Stringa 1610, 63; Sansovino 1663, 102.

51 The Gospels separated out from the rest of the Bible as Gospel Books, in particular, could be held in special regard. Especially if copied by a saint, manuscripts of the Gospels could come to be considered relics or reliquaries, especially in the British Isles. Throughout the Middle Ages, all Gospel Book manuscripts generally were conceptualized as preserving the Word Incarnate, and therefore simultaneously as relics and reliquaries. Lucas 1986, 9; O'Floinn 1994. In addition, simply tracing the Word of God could make a hand attain miraculous powers. The *De Abbatabis* relates a story of an Irish monk, Ultan, whose hand "once used to write the Lord's word" and subsequently performed a miraculous cure when raised from its resting place. Backhouse 1981, 14. The Treasury of the Basilica of Saint Mark also held a manuscript believed to have been written by the hand of Saint John Chrysostom, but the Mark fragment had a more important and distinctive tradition as relic and symbol in Venice. On books as amulets and relics, see Jean Vezin, "Les livres utilizes comme amulettes et comme reliques," in Ganz, ed. 1992, 101–15.

52 Britnell 1997.

53 Salmini 1998, 94.

CHAPTER 2: DOCUMENTS AS MONUMENTS

1 Andrew Butterfield, "Monument and Memory in Early Renaissance Florence," in Ciappelli and Rubin, eds. 2000, 135–60 (135). Eric Ketelaar has shown that by the seventeenth century, antiquaries in Holland were using the term *monumentum* to describe archival sources of historical value. Eric Ketelaar, "Muniments and Monuments: The Dawn of Archives and Cultural Patrimony," *Archival Science* 7, 4 (2007): 343–57.

2 On *cittadini*, see Schmitter 2004; De Maria 2010.

3 Casini 1991; Weigel 2002.

4 On the secretaries of the Chancery, see Trebbi 1980; Neff 1985; Trebbi 1986; Zannini 1993.

5 Pullan 1971, 103; Bellavitis 2001; Crouzet-Pavan 2002, 226–28; De Maria 2010, x. On the actually more fragile status and finances of Chancery staff, see De Vivo 2013.

6 Mann 1976; Deborah Howard, "Contextualizing Titian's *Sacred and Profane Love*: The Cultural World of the Venetian Chancery in the Early Sixteenth Century," *Artibus et historiae* 67, 34 (2013): 185–200.

7 Ross 1976; Pedani Fabris 1996; Zannini 1993, 119.

8 Young nobles with all the appropriate credentials normally could assume their place in the Great Council at the age of twenty-five. A lottery called the Barbarella, named for its annual occasion on the feast of Saint Barbara (December 4), was open to those who reached the age of eighteen. Winners could join the Great Council five years earlier, at the age of twenty. Those who did not win could try again the next year. Chojnacki 2000, 235–38.

9 Todesco 1989; Andrea Mozzato, "Problems and Possibilities of Constructing a Research Database: The Venetian Case," in O'Connell, ed. *c.*2009, paragraphs 104–48.

10 Neff 1985, 45. What follows is indebted to Salmini *c.*2009.

11 Girolamo Priuli discusses defenders and detractors in his Diary, BMCVe, MS Prov. Div. 252c, vol. 5, fols. 89v–90r, translated by David Chambers in Chambers and Pullan, eds. 1992, 77; Raines 1991.

12 By the late fifteenth century, nominees for each office would be chosen by between two and four nine-man committees, depending on the importance of the office. Each of the two to four committees of nine people nominated one person, then the whole Great Council voted on these nominees. To obtain a seat on a committee, a nobleman had to draw a gold ball from an urn stocked with gold and silver balls, although if a near relation also drew a gold ball, one of them would be eliminated. The office for which a nomination would be made was determined by another lottery. Once nominees were announced, balloting proceeded. The electoral rules were spelled out in the *Capitolare del Maggior consiglio*. The rules are summarized, with an anastatic reproduction of a *Capitolare* of 1577, in Ivone Cacciavillani, *La "bala d'oro." Elezioni e collegi della Serenissima* (Venice: Corbo e Fiore Editori, 2001).

13 Andrea Mozzato, "Problems and Possibilities of Constructing a Research Database: The Venetian Case," in O'Connell, ed. *c.*2009, paragraphs 104–48.

14 Woodward 1990, 38, cat. 65. Also on Forlani and this print, see D. S. Chambers in Martineau and Hope, eds. 1983, 304, cat. H3; Bury 2001, 226.

15 Also called the *Segretario sopre le voci*.

16 Salmini *c.*2009.

17 The *plezius* also assumed financial risks associated with the office, for example, in case of embezzlement.

18 Da Mosto 1937–40, vol. 1, 221; ASVe, *Guida generale*, 905–6. The ledgers that contained these are in ASVe, *SAV*, Elezioni in Maggior consiglio and Elezioni in Senato. Much of the material from 1332 to 1524 in

these manuscripts is accessible in the database *Rulers of Venice*: O'Connell, ed. *c.*2009.

19 Giovanni Netto, "Appunti su una singolare fonte veneziana: 'I consegieti'," *Archivio Veneto*, serie v, 179 (1995): 127–44; Raines 2006. See for example the series in 59 volumes in the Marciana, which was kept in the Tiepolo family. BMVe, It. VII, 813 (=8892) – It. VII, 836 (=8915).

20 On the locations of the three ducal chanceries, see Salmini 1998, 96.

21 Salmini 1998; De Vivo 2010.

22 Salmini 1998.

23 Washington, D.C., Library of Congress, Law Library, MS V 42. *Capitolare* of the officers of the *cattaveri*, after 1391. Faye and Bond 1962, 113. In the Venice State Archives there is an earlier manuscript of the *Capitolare*, with statutes from 1260 to 1374, apparently written in one campaign. It is bound in leather with metal bosses. The leaf with the opening text of the Oath has a flourished opening "I" in blue and red ink, of nineteen lines. ASVe, Ufficiali al cattaver, Atti, pezzo 1. In 1752 a new and streamlined edition of the statutes was written. ASVe, Ufficiali al cattaver, Atti, pezzo 2. For general information on the office and on an illuminated *Capitolare* manuscript of the office of 1744, see Tiepolo, ed. 1984, 62–64, cats. 109–14; ASVe, *Guida generale*, 937–38.

24 In the period after this manuscript was produced, the *cattaveri* came to oversee the comportment and trade of Jews in Venice, and the maintenance of their status as distinct from that of Christians. Pullan 1983, 79.

25 Andrea di Francesco Gritti is a prime example of a prominent patrician who served under many posts for which he would have received a Commission, including that of *Podestà* of Padua in 1505 and procurator *de supra* in 1509, and of course the *Promissione* as doge, but I have found no such documents for him.

 On Andrea Gritti, see Gino Benzoni, "Gritti, Andrea," *DBI* 59 (2003). See especially Gaetano Cozzi, "La politica del diritto," in Cozzi 1980, 122–52.

26 Angelo Ventura, "Bragadin, Francesco," *DBI* 13 (1971). On Badoer, see Chapter 5 here, the section "Antiquarian portraits." Daniele Renier served several times as rector and became procurator, but the only surviving *ducale* for him that I know of is his simple *Capitolare* as ducal councillor of 1520. It is beautifully scripted in chancery cursive and has his coat of arms, in the standard format for these documents of this period. BMCVe, Cl. III, 643.

27 The manuscript on membrane shows the wear of extensive consultation; additions were made to it until 1628. The other, on paper, was amended only to 1535. ASVe, Maggior consiglio, Libro d'oro vecchio, n. 1 (esemplare pergamena) (leaf size 41 × 29 cm) and ASVe, Maggior consiglio, Libro d'oro vecchio, n. 2 (esemplare cartaceo) (leaf size 48 × 27.3 cm). Tiepolo, ed. 1984, 18, cat. 3, and 21, cat. 11; Maria Francesca Tiepolo in Martineau and Hope 1983, 395–96, cat. H6.

28 *"Summus ille opifex Deus, Qui inversum mundum, eternasque intelligentias creavit, primus omnium mirabilis providentia leges tulit."*

29 See Chapter 3. While the copy on paper presents the scene in a verdant landscape with a large villa in the background, the setting in the copy on membrane is in a loggia in front of a dramatic seascape with mountains in the background. In this way Venetian rule over both the maritime and *terraferma* holdings is represented.

30 See Chapter 5, the section "Antiquarian portraits."

31 On Andrea de' Franceschi, see Neff 1985, 431–35; Sergio Zamperetti, "de Franceschi, Andrea," *DBI* 36 (1988); Hochmann 1992, *Peintres et Commanditaires á Venise (1540–1628)*, 356–58; Salmini 1998, 1–3.

32 Titian, *Portrait of Andrea de' Franceschi*, Detroit Institute of Arts. Another portrait of Andrea, thought to be by Titian's workshop, is in the National Gallery of Art, Washington, D.C. See Wethey 1969–75, vol. 2. Portraits, 100–1, plates 61 and 63.

33 For example, a sequence of miniaturists favored over several years by the chancery secretaries for less extensive work can be discerned in the opening leaves to the registers of secret deliberations of the Senate, especially from 1538 to 1570. ASVe, Senato, Deliberazioni, Secreti, registri 59–77. I would like to thank Claudia Salmini for calling my attention to these registers and discussing them with me.

34 ASVe, Avogaria di comun, *Libro d'oro nascite*, begun in 1506, and *Libro d'oro matrimoni*, begun 1526.

35 Attributed to Pietro Uberti (1671–c.1762). *Two Avogadori di Comun and a Book Inscribed "Legum observantia longaeva felicitas,"* Doge's Palace, Venice. On the portraits in the offices of the *Avogadori di comun*, see Nicola Ivanoff, "I ritratti del Avogaria," *Arte Veneta* 8 (1954): 272–83.

36 Neff 1985, 391–92.

37 ASVe, Pacta e aggregati, Indici, 1538. Index of the *Pacta*, the *Liber albus* (treaties and privileges in relation to entities in the east) and *Liber blancus* (treaties and privileges in relation to entities in the west). Tiepolo, ed. 1984, 25, cat. 18. On the role of Andrea Gritti in this general renovation of the archives, as part of his broader revision of Venetian identity, see Tafuri, ed. 1984; Tafuri 1989, 152–59; Salmini 1998. Illumination attributed to the T.° Ve Master in Zuccolo Padrono 1971, 60.

38 Royal Collection, RCIN 405776. On Odoni and interpretation of the image of Diana, see Schmitter 1997, 252–76; Schmitter 2004, 956. Lucy Whitaker, Martin Clayton, Aislinn Loconte, *The Art of Italy in the Royal Collection: Renaissance and Baroque* (London: Royal Collection, 2007): 206–7.

39 Tafuri, ed. 1984; Tafuri 1989.

40 Donation by Venice, in the name of Doge Pasquale Cicogna, of the Palazzo Gritti in Venice to Pope Sixtus V, Venice, March 19–23, 1586, Vatican, Archivio Segreto, AA. Arm. I–XVIII, 1302 (CI). The donation manuscript remains one of the treasures of the Vatican Secret Archives, and a facsimile has been made of it. *Archivio Segreto Vatican*, eds. Terzo Natalini, S. Pagano, A. Martini (Florence: Nardini, 1991): 194–95. The facsimile and commentary: *Exemplaria Praetiosa II, Munificentia Venetiarum* (Venice: Scrinium Trust Company of the Archivio Segreto Vaticano).

The palace, later known as Palazzo Gritti-Contarini-Morosini "della Nunziatura" because it was owned by members of these three families when it was purchased, had been built by Doge Andrea Gritti in 1525. Giuseppe Tassini, *Edifici di Venezia distrutti o volti ad uso diverso da quello a cui furono* (Venice: Giovanni Cecchini, 1885): 19. I attribute the miniatures to Giovanni Maria Bodovino.

41 Cooper 2005, 57–58, with relevant bibliography.

42 Domenico Fontana, *Della trasportatione dell'obelisco Vaticano et delle fabriche di Nostro Signore Papa Sisto V* (Rome: Domenico Basa, 1590).

43 Miniaturists also could be paid for creating diplomatic gifts. In 1573, Carlo di Mazi requested reimbursement for purchases he made under orders of Gabriel Corner, *savio* of the *terraferma*, for expenses of the ambassador to Constantinople. Besides purchasing twenty-four pairs of eyeglasses, he paid a Francesco, "*miniador*," in Calle delle Acque, Venice, 27 lire and 5 denari, or about 12 ducats, for unspecified work. ASVe, Ufficiali alle rason vecchie, Documenti della cassa grande, b. 379, June 12, 1573.

44 Grubb 1994; James S. Grubb, "Introduction," in James S. Grubb, ed. *Family Memoirs from Venice: 15th to 17th Centuries*, contribution by Anna Bellavitis (Rome: Viella, 2009): IX–XXIX.

45 Raines 1996; Raines 2011.

46 Pliny, *Historia Naturalis*, Book XXXV, sections 6–7, cited in Harriet I. Flower, *Ancestor Masks and Aristocratic Power in Roman Culture* (Oxford: Clarendon Press, 1996): 304.

47 The *editio princeps* was produced in Venice in 1469, making it one of the first books to be printed in Venice. Fourteen more editions were printed in Venice by the end of the fifteenth century, three of which were in the Italian translation by Cristoforo Landino, C. G. Nauert, Jr., "Ciaus Plinius Secundus," *Catalogus Translationum et Commentariorum: Medieval and Renaissance Latin Translations and Commentaries*, eds. F. E. Cranz, P. O. Kristeller, IV (Washington, D.C.: Catholic University of America Press, 1980): 297–420.

48 Blake McHam 2001, 89–105; Brian W. Ogilvie, *The Science of Describing: Natural History in Renaissance Europe* (Chicago: University of Chicago Press, 2006): 124–27; Blake McHam 2013.

49 Barbara Marx, "Venedig – *Altera Roma*. Transformationen eines Mythos," *Quellen und Forschungen aus italienischen Archiven und Bibliotheken* LX (1980): 324–73.

50 John Pope-Hennessy, *The Portrait in the Renaissance* (New York: Bollingen Foundation, 1966): 71–75; Luchs 1995, 18–19; Lewis 1997; Martin 1998. Martin Gaier has shown how Carlo Sigonio's interpretation of Roman history, specifically of a notion he called a "right to portraits," led him to argue that ownership of portraits proved membership in the noble class, and that this influenced the higher production of portrait busts in late sixteenth-century Venice. Gaier 2007; Jennifer Fletcher, "The Renaissance Portrait: Functions, Uses, Display," in Campbell, Falomir, Fletcher Syson, eds. 2008: 46–65.

51 Peter Humfrey, "The Portrait in Fifteenth-Century Venice," in Christiansen and Weppelmann, eds. 2011, 48–63 (48–49).

52 ASVe, Giuseppe Dalla Santa, Inventario della Biblioteca Andrighetti Zon Marcello, 1909 (manuscript).

53 Andrea Da Mosto, "Archivio Tiepolo," *Gli Archivi Italiani*, II (1915): 131–37; (1937): 4–5; ASVe, *Guida generale*, 1124–25.

54 This is evident from examining the book inventories collected by Anselm Fremmer. Fremmer 2001.

55 Introduction, see the section "Painting in books and manuscripts."

56 Pompeo Molmenti, *La storia di Venezia nella vita privata dalle origini alla caduta della Repubblica* II (1906): 633; Chambers 1997, 87. On the high price of velvet in the Renaissance, see Monnas 2009, 23–25.

On this scribe and what he charged for his work see Vio 1980, 193; Chambers 1997, 62, 69, 79–80 and Chapter 4 here, the section "Unity and distinction."

57 Lorenzo di Angelo Correr was elected procurator *de citra* in 1573. BMCVe, Cl. III, 1017. An earlier Commission for him with a portrait as *Podestà* of Vicenza, 1560, is in Dresden, Sächsische Landesbibliothek, Staats- und Universitätsbibliothek, Mscr. Dresden F. 150. Ekaterina Zolotova, "Il Maestro delle commissioni del doge Girolamo Priuli (1559–1567). Cenni sulla personalità artistica," in Lucchi, ed. 2013, 89–90.

58 Zannini 1993, 119; for a new contextual interpretation of the "heart of state," see De Vivo 2013.

59 Venice, ASVe, Consiglio di dieci, Deliberazioni, Misti, filza 5, fol. 127. On this document see Lazzarini 1930; Wardrop 1949; Wardrop 1963; Schutte 1986.

60 As Captain of the Galleys to Flanders, 1504. Philadelphia, Free Library, MS Lewis E. 143. Attributed to Tagliente by James Wardrop (note archived with the manuscript).

61 Barker 2009, 22–24.

62 For this he was paid 10 ducats a month. ASVe, Consiglio di dieci, Comuni, Registro 22, c. 180. Nov. 28, 1556, and ASVe, Capi del Consiglio di dieci, c. 180, Dec. 17, 1556. Vio 1980. On Vitali, see also Marcon 1990; Marcon 1995; Chambers 1997.

63 Not long after becoming a teacher in the chancery, he wrote out a *Promissione* of Doge Lorenzo Priuli (doge 1557–59). BL, Stowe 917. Sometime after Alvise Mocenigo I was elected doge (1570), Vitali presented him with a manuscript he scripted of the ceremonies relevant for the doge in the church, perhaps also to gain his favor and future commissions. *Libro de l'osservanza de le ceremonie de la chiesa di Santo Marco*, dedicated to Doge Alvise Mocenigo I (doge 1570–77) and written out by Giovanni Vitali, *c.*1570, Cambridge, MA, Harvard University Libraries, Houghton, MS Typ 336.

64 Romano 1987.

65 Marinelli 2008.

66 Hochmann 1992, "Le mécénat de Marino Grimani," 44, 51 n. 4. See Chapter 4 here, "Controversies over funding." Other examples of painters who worked as miniaturists and monumental painters include Pietro Mera, a painter in Venice of Flemish origin, who signed and dated a miniature in the *mariegola* of the Botteri in 1600. BMCVe, Cl. II, 116. Susy Marcon, "Mera, Pietro," *DBMI* 758. Alessandro Merli (*c.*1580–*c.*1608) was a miniaturist who painted a large *Washing of the Feet of Christ* in oil for the Church of San Lio. Helena Szépe, "Merli, Alessandro," *DBMI* 760–61. Roland Krischel, ed. *Tintoretto: A Star was Born* (Cologne and Paris: Wallraf-Richartz Museum and Fondation Corboud, 2017), 156, cat. 39.

67 "*Di miniature ancora lauora eccellentemente. Hauendo pur io ancora vedute, e Matricole, e Comissioni di sua mano.*" Sansovino 1663, vol. 2, *Quinto Catalogo de gli pittori di nome, che al presente viuono in Venetia …*, 22. Roland Krischel has identified the hand of Jacopo Tintoretto's assistant Giovanni Galizzi in a Commission manuscript of 1551.

68 For general studies of the careers of earlier Venetian miniaturists, see especially Mariani Canova 1969; Armstrong 2003. On miniaturist workshops and *ducali*, Szépe 2009; Helena Katalin Szépe, "Painters and Patrons in Venetian Documents," in Lucchi, ed. 2013, 25–61.

69 Mariani Canova 1968, "La decorazione:" 319.

70 Commission to Marin di Giovanni Antonio Venier as *Podestà* and Captain of Sacile, PML, M.353. The signature is on fol. 1v. A "Master Gasparo" is cited in payments for a Commission/Oath of the procurator Pietro di Francesco Grimani (d. 1553) in 1539 (elected *de supra* on April 24, 1538), and a Master Gaspare is recorded as dying in 1551 in Venice. Since this was a common first name, it is not clear whether or not these all refer to the artist from Verona who illuminated Venier's Commission. Chambers 1997, 46; Susy Marcon, "Gaspare da Verona," *DBMI* 258.

Marin Venier may have followed the precedent of his father Giovanni Antonio in paying special attention to the painting of his Commission. Giovanni Antonio was a prominent collector of art who had his Commission painted by the important miniaturist Jacopo del Giallo (see pp. 178–80). Shortly before his election as *Podestà* and Captain of Sacile, Marin

inherited with his brother his father's estate. R. Lauber in *Collezionismo 2008*, 320–23. See Chapter 5, the section "Antiquarian portraits." On the high regard of the miniatures of Marin's manuscript in the early twentieth century, see Eze 2016, 208–10.

71 Archival notices in Cecchetti 1887, "Nomi di pittori e lapicidi antichi"; Cecchetti 1887, "Saggio di cognomi ed autografi di artisti in Venezia, secoli XIV–XVI"; Bratti 1901; von Hadeln 1911, "Nachrichten über Miniaturmaler"; Mariani Canova 1969. For Padua, with notices of artists who also worked in Venice, see Sartori, "Pittori, miniatori, decoratori," in Baldissin Molli and Mariani Canova, eds. 1999. On the Pico Pliny Master, Armstrong 1990.

72 Some examples of such names of miniaturists for whom works have not been identified include Gasparo Segizzi, Giovanni Maria Verla, Rugier Arzentini, and Piero Cocco.

73 Kren, ed. 1983; Alexander, ed. 1994; Kren and McKendrick, eds. 2003; Alexander 2016. On Matthias Corvinus as patron, with assessments of the state of research, see Farbaky and Waldman, eds. 2011.

74 Lowry 1991; Marino Zorzi, "Dal manoscritto al libro," *SDV* 4 (1996), *Il Rinascimento. Politica e cultura*: 817–958; Witcombe 2004; Nuovo 2013; Harris 2013, 423–27.

75 Eisenstein 1983, 19.

76 De Strata's *Polemic against Printing* was addressed to Doge Nicolò Marcello, sometime between 1473 and 1474, when the print industry was faced with its first crisis of overproduction. Filippo de Strata, *Polemic against Printing*, edited with introduction by Martin Lowry, trans. Shelagh Grier (n.p.: Hayloft Press, 1986). On Tagliente's books on writing, see Schutte 1986; Becker 1997; Ogg, ed. 1953.

77 Armstrong 1991; Armstrong 2003; Alexander 2016, 177–97.

78 For an overview of the size and nature of the print industry in Venice see Grendler 1977, 3–20; Needham 1998; Nuovo 2013; Harris 2013.

79 These numbers have been calculated by Neil Harris through analysis of the *Incunabula Short Title Catalogue* (ISTC). Harris 2013, 423–24. For a more detailed but earlier study, see Needham 1997.

80 These figures are from Pastorello 1924, 56; Lowry 1979, 7; Bernstein 2001, 11, n. 10; Richardson 1994, 5. Current analysis of information from the ongoing *Census of Italian Sixteenth-Century Editions* (EDIT16) and Servizio Bibliotecario Nazionale database might reveal different numbers. See also Pettegree 2010, 254–55.

81 Lowry 1979; Lowry 1991; Nuovo 2013.

82 Salzberg 2011.

83 Wilson 2005.

84 See for example Vecellio 1590; Vecellio 1598.

85 Brian Richardson, "The Debates on Printing in Renaissance Italy," *La Bibliofilia* 100 (May–Dec. 1998): 135–55.

86 Marcus Antonius Sabellicus, *Decades rerum Venetarum* (Venice: Andreas Torresanus de Asulo, 1487). Venice, Giustiniani Recanati Falck Collection (on membrane and illuminated by the Master of the Pico Pliny) and Cambridge, MA, Harvard University, Houghton Library, WKR 11.1.9 (on membrane and illuminated in the style of Benedetto Bordon). Armstrong 2003, vol. 1: 264–66.

87 Vespasiano da Bisticci, *Renaissance Princes, Popes, and Prelates, the Vespasiano Memoirs: Lives of Illustrious Men of the Fifteenth Century*. Translated by William George and Emily Waters. Introduction by Myron P. Gilmore, reprint of 1963 (Toronto: University of Toronto Press, 1997): 104.

88 Martin Davies, "'Non ve n'é ignuno a stampa': The Printed Books of Federico da Montefeltro," *Federico da Montefeltro and his Library*, ed. Marcello Simonetta (New York: Pierpont Morgan Library, 2007): 63–78.

89 There has been much recent interest in emphasizing the uniqueness of each printed book in the early era of print, and in highlighting the variations between copies printed within any given edition. Nevertheless, printed exempla of any given text had more in common with each other than manuscripts produced on commission for different patrons.

90 On sixteenth-century manuscript illumination in Europe, see Kren, ed. 1983; Alexander, ed. 1994; Avril and Reynaud, eds. 1993; Kren and McKendrick, eds. 2003; Alexander 2016.

 In the Spanish Empire, documents that petitioned for legal noble status became elaborately illuminated and bound in the fifteenth and sixteenth centuries, to call attention to their importance. *El document pintado. Cinco siglos de arte in manuscritos* (exh. cat., Madrid: Ministerio de Educación y Cultura, Museo Nacional del Prado, Afeda, 2000). In fact, manuscripts continue to be produced even today if magnificent, unique volumes are desired to glorify a text and in order that the person or institution commissioning the work can insert themselves in an illustrious historical tradition, as is the case of the seven-volume illuminated Bible commissioned in 1998 by the Benedictine monastery of Saint John's Abbey in Collegeville, Minnesota. Calderhead 2005.

91 This characterization borrowed from Rosalind Krauss essentially derives from the work of Charles Sanders Pierce. Krauss 1985.

92 Although the early modern techniques of engraving and etching can be considered as recording the trace of a hand in a multiple edition, they are still not the original and direct trace upon a support. Modern printmakers and ateliers developed the signed "original" print to satisfy the desire for the unique trace, the index of the artist. Indeed, it is arguable that the increase in signing of works of art in the early modern era was encouraged by the development of printed multiples.

CHAPTER 3: THE PROMISE OF THE DOGE

1 *"Cum non de nostra fortitudine vel prudentia, sed de sola processerit clementia Creatoris, in cuius arbitrio et voluntate universa sunt posita, quod ad culmen ducalis dignitatis pervenerimus, vos hactenus in ecclesia Beati Marci evangeliste Domini gloriosi, qui patronus noster est et signifer in omnibus, aggregate, quantam erga nos habueritis dulcedinem caritatis ibi perfecte demonstrastis, cum ad prolationem eligentium vos vice nostra et nomine, in celum minibus elevates, Deum omnes unanimiter glorificastis in voce laudis magnifica et exultationis, quoniam per intercessionem gloriosissimi evangeliste sui Marci nos in ducem vobis dederat et rectorem*

 "... promittimus vobis universo populo Venetiarum ... Venetiarum regimen faciemus et statum patrie et totius ducatus conservabimus bona fide, verbo et opera ..." Prologue and Promise of the doge as transcribed in a *Promissione* of Doge Francesco Foscari. Girgensohn ed. 2004, 15.
2 Maranini 1931, 273.
3 Romano 2007. On illumination of *Promissioni* see Sinding Larsen 1974, 176–79; Jürg Meyer zur Capellen, *Gentile Bellini* (Stuttgart: Franz Steiner, 1985): 176–90.
4 *"ad sancta dei Evangelia ..."* For transcriptions of texts of the *Promissione*, see Graziato 1986; Girgensohn ed. 2004, or any of the editions printed from the sixteenth century to the fall of the Republic.
5 See the writings of Gasparo Contarini as noted by Cassandro 1963, 36; Zordan 2005, 148–65; Muraro 1975, 435.
6 The other fundamental compilations of law were the *Promissio maleficii*, which held the penal code, the two parts of the *Statuta Veneta* comprising maritime and communal law, and the *Capitolare* of the *Minor consiglio*, or the six councillors of the doge. Girgensohn ed. 2004, IX.
7 See for example Ugo Tucci, "I meccanismi dell'elezione dogale," in Benzoni, ed. 1982, 107–24. On the development of the election process, see Fasoli 1974, 495; Rösch 1989, 105–7; Benjamin Kohl, "Introduction," in O'Connell, ed. c.2009, paragraphs 52–85.
8 S. Gasparri, "Dagli Orseolo al commune," *SDV* 1 (1992), *Origini – Età ducale*: 816–21.
9 Muir 1981, 251–55. Andrea Castagnetti, "Il primo comune," *SDV* 2 (1995), *L'età del comune*: 81–130. Eugenio Musatti traces the additions and corrections to the *Promissione* in Musatti 1888.
10 On the early development of the investiture ceremonies of the doge, see Peyer 1955; Fasoli 1958; Pertusi 1965; Fasoli 1973; Giorgio Ravegnani, "Insegne del potere e titoli ducali," *SDV* 1 (1992), *Origini – Età ducale*: 829–46.
11 Romano 2007, 297–301.
12 The heirs of Agostino Barbarigo had to reimburse the state 7600 ducats upon the findings of the Inquisitors of the Deceased Doge. Chambers and Pullan, eds. 1992, 73–74. On the doge and his *Promissione*, see Da Mosto 1977, 15–20. A. Rossi, "Gli inquisitori sopra il doge defunto nella repubblica di Venezia," *Studi storici* (Bologna, 1906): 281–382. On the *Promissione*, with particular attention to its relation to the dogaressa, see Hurlburt 2006, 17–43.
13 Romano 2007, i–xxvi.
14 Sansovino claims that the standards signify *"Impero assoluto senza alcuna superiorita."* Sansovino 1663, 479. Wolters 1987, 162–78.
15 Pertusi analyzes the origins and references of specific early imagery and regalia of the doge, and examines the development of the legend of the donations of Alexander III. Pertusi 1965, 55–57; Muir 1981, 102–34; Giorgio Ravegnani, "Insegne del potere e titoli ducali," *SDV* 1 (1992), *Origini – Età ducale*: 829–46; Giorgio Ravegnani, "Tra I due imperi," *SDV* 2 (1995), *L'eta del comune*: 33–79.
16 Muir 1978. There is extensive literature on the doge and his office. The standard biographical history of all of the doges is still Da Mosto 1977.
17 A third oath was performed on the day after his coronation.
18 For analysis and a more detailed account of the typical coronation, see Pertusi 1965, 64–79; Muir 1981, 282–89; Boholm 1990, 132–43; Casini 1996. Andrea Marini gave an account of the investiture and coronation ceremonies of the fourteenth century that is short on specifics of the ritual but most effective at conveying the splendor and beauty of the setting, costumes, and music in the Basilica. *De pompa ducatus venetorum*, ed. Arnaldo Segarizzi. Nozze Pavanello-Vittorelli (Venice: Istituto Veneziano d'Arti Grafiche A. Nodari, 1903). Sanudo on the inauguration of Antonio Grimani in July of 1521: Sanudo 1879–1903, vol. 30, cols. 479–90; Sanudo on the inauguration of Andrea Gritti, May 21, 1523: Sanudo 1879–1903, vol. 34, cols. 158–59.
19 The book is variously identified in Sanudo, ceremonials, and other sources as a missal, an evangeliary, or a Gospel Book (*Vangelo*). On these manuscripts, see Chapter 1. A ceremonial of 1539 only specifies that before the doge is invested he *"iurat super quator S. Evangeliastatum, et honorem Ecclesia S.ti Marci bona fide et sine fraude conservaze ..."* ASVe, Collegio, Cerimoniali, reg. 1, fol. 4v (new foliation 18v). A copy of a ceremonial of 1564 in the Marciana most specifically requires a missal or evangeliary. Fol. 70r: *"Della creation del Ser.mo principe ... Ser.mus D.ns super altare Sancti Marci super sacra dei evangelia (et qua li sia uno mesal over l'evangelistaria da giurar supra) ..."* Additions to Bonifacio's text specify that the book is "the big one covered in gold cloth": *"el grando*

coperto de panno d'oro – el Ser.mo mete la mano sul ditto libro," Bartolomeo Bonifacio, *Rituum cerimoniale*, BMVe, Lat. III, 172 (2276). On Bonifacio, see Sinding-Larsen 2000; Pertusi 1965, 78.

20 Argued by Michelangelo Muraro 1961.

"*propeterea vadit pars, quod quando Serenissimus Princeps futurus et sui successores fuerint electi, acceperintque vexillum Sancti Marci ad altare delatusque fuerit per plateam, et in Palatium redierit super scallas illus ad accipiendum juramentum a Dominio, tunc immediate post jusjurandum predictum in capite Serenitatis sue per juniorem Consiliarum ponatur veta et per seniorem Consiliarum ponatur biretum predictum ducale dicentem hec tantum verba: Accipe coronam Ducatus venetiarum.*" ASVe, Collegio, *Cerimoniali*, reg. 1, fol. 4v (later numbered fol. 18v). This manuscript records legislation through the sixteenth century. For legislation establishing the coronation ceremony in 1485, see ASVe, Collegio, *Cerimoniali*, reg. 1, fol. 60r; Lorenzi 1868, 97–98; Musatti 1888, 118–19; Wolters 1987, 82–84; Muir 1981, 286.

21 ASVe, Maggior consiglio, Deliberazioni, Stella 1480–1502, fols. 57v and 60r. Lorenzi 1868, 97–98; Schulz 1983, 98–100, 145–52.

22 Girgensohn ed. 2004. The *Promissione* codex is not always mentioned in the ceremonials, but is specified in that for Leonardo Loredan: ASVe, Collegio, *Cerimoniali*, reg. 1, fol. 4v (new foliation 18v): "*Ascenditq(ue) per scallas maiores, in quae superiori parte, Consiliarii, et capitan expectantes eius Cel. rem excipiunt: Astantibusque Electoribus, Senior Consiliarius proposito codice ducalis promissionis, accipit iuramentum a celsitudine sua servandi promissionem ipsam.*"

23 "*non altremente che se questo Principe fosse uno del corpo loro.*" Sansovino 1581, fol. 177r; Sansovino 1663, 471; Cecchetti 1864, 34; Fasoli 1973, 279; Casini 1993; discussion in relation to the later portrait of Antonio Grimani: Wolters 1987, 104.

24 "*Sicut principale insigne Ducatus Serenissimi Principis nostri est biretum, quod Serenitas sua in capita gestat …*" Lorenzi 1868, 97–98.

25 Cecchetti 1864, 27.

26 The symbolism of the monetary value of the gems as denoting the wealth and power of Venice must have become all the more powerful in 1343, when the Byzantine empress Anna of Savoy gave Venice precious stones from the Byzantine crown as collateral for a huge loan of 30,000 ducats. The debt was not repaid, and the stones never returned. Hetherington 2008.

27 On the waxing and waning of the embellishment of the *zoia*, see Cecchetti 1864, 26–31; Pazzi 1996. The relevant chapter in the *Promissione* is known first in that of Francesco Foscari: "*De habendo unam zoiam et unum bucentaurum a comuni. LXXXXIII …*"

Procuratores vero nostri ecclesie Sancti Marci debent tenere modum in faciendo reduce ipsam zoiam ad talem levitatem et abilitatem quod possimus ipsam portare in capite in solemnitatibus ordinatis, sicut tenemur per nostrum promissionem." Girgensohn 2002–3, 101–2. See Cecchetti 1864, 48–49, for the extensive list of jewels included in the renovation of the *zoia* in 1557. See also Gallo 1967, 193–97; Pazzi 1996, 60–1. The gems of the *zoia* were dispersed in the aftermath of the fall of the Republic. The watercolor by Grevembroch depicts it as it looked in the eighteenth century. Grevembroch states that the number of gems makes it worthy of a prince. Grevembroch, "Preziosa Corona Ducale," *Varie Venete Cose*, I. BMCVe, MS Gradenigo Dolfin 65, vol. 1, fol. 76.

28 Ernst Kantorowicz, *The King's Two Bodies: A Study in Mediaeval Political Theology* (Princeton: Princeton University Press, 1957); Muir 1978, 148; Casini 1993.

29 Jean Starobinksi, *Largesse* (Chicago: University of Chicago, 1997); Muir 1981, 285–86.

30 *Promissione* of Renier Zen: "*Et debemus dare infra medium annum post introitum nostri regiminis Beato Marco apostolo nostro et evangeliste unum pannum laboratum ad aurum valentem a libris denariorum Venetorum XXV supra.*" Graziato 1986, 19, 57. Initially the doge was required to spend at least 25 "*libris denariorum,*" but the minimum cost to be spent on the altar cloth went up to 40 ducats in the *Promissione* of Nicolò Marcello (doge 1473–74). In the sixteenth century the actual amount spent on the cloths was almost four times that amount. Cecchetti 1864, 155. On these tapestries and their display see also Gallo 1953. Among other duties, the doge also was required to give money and wax for candles to the Basilica of Saint Mark throughout the year, as specified first in the *Promissione* of Pietro Gradenigo of 1289. Graziato 1986, 161.

31 From the years 1400 to 1600, the average age of a doge upon election was seventy-two. By comparison, the average age of the pope upon election was fifty-four. Finlay 1978, 157.

32 Wolters 1987, 95–96; Davanzo Poli 1999, 153 n. 5.

33 Those surviving are: A fragment featuring a portrait of a doge, apparently Antonio Grimani (Venice, Correr Museum; discussed further later in this chapter), Gallo 1967, 256; a full piece featuring a portrait of Doge Alvise Mocenigo I, elected 1570; a full piece featuring a portrait of Doge Marin Grimani, elected 1595 (both Venice, Museo di San Marco). This last was designed by Domenico Tintoretto and produced in the Medici tapestry in Florence, and was only consigned in 1598. Gallo 1967, 258–60; Davanzo Poli 1999, 156–60.

34 Sansovino 1604, fol. 74v. Wolters 1987, 95–96; Davanzo Poli 1999.

35 Sansovino also specified that the doge was to have a coat of arms made. These hung in the Sala dello Scudo,

where the doge received official visitors. After his death it was moved to the Basilica. Guisconi 1556, 14; Wolters 1987, 93.

36 Guisconi 1556, 14.

37 Such portraits were called *orazioni* by Francesco Zanotto in the nineteenth century, as a term comparable to the now less commonly used English equivalent "oration," as prayer or supplication to God. But the paintings are referred to simply as "images," "portraits," or "paintings" (*immagini, ritratti,* or *quadri*) in the documents of their payment. Documents for such payments are collected in Lorenzi 1868. Zanotto 1853–61; Lorenzi 1868; Muraro 1975, 433. Sinding-Larsen 1974, 30–44; Wolters 1987, 93–135; Humfrey 1993, 82–83. For a general history of portraiture of the doge in the sixteenth century, see Weber 1993. Art historians today call these paintings votive portraits, a term implying they were made in fulfillment of a particular vow or wish, which was not the purpose of these images. But in keeping with the modern tradition, I will use the term "votive" to discuss this class of portrayals of a person, usually the patron, in a devotional attitude towards an image or embodiment of the sacred. Strictly speaking, these also did not function as the inspiration for devotion, and in that sense are not *devotional* images, rather, they are memorials of exemplary pious and grateful leaders.

38 Attributed to Pietro Lombardo or one of his sons (Tullio or Antonio), Doge's Palace, Venice. Wolters 1990, 165–70; Deborah Howard, "The State," in Humfrey, ed. 2007, 33–91 (35).

39 There was another cycle in the Sala del Consiglio dei XXV (Hall of the Council of Twenty-five) by the end of the fifteenth century. Marin Sanudo also alluded to a room in the private quarters of the doge that had a cycle of portraits. Part of the Sala del Consiglio dei XXV cycle survives in the Museo Correr. Marin Sanudo, *Le vite dei Dogi*, ed. Angela Caracciolo Aricò (Rome/ Padua: Editrice Antentore, 2001); Wolters 1987, 85–87; Meyer zur Capellen 1971, 70, 73; Weber 1993.

40 In his last testament Agostino bequeathed Bellini's painting to the Monastery of Santa Maria degli Angeli in Murano, to hang on the high altar, but it now hangs in San Pietro Martire of Murano. It is debated as to whether the painting hung during Agostino's lifetime in the doge's apartments in the Doge's Palace, or in his family palace. Wolters 1987, 96; Goffen 1989, 99–102; Roeck 1991, 38–45; Gentili 1992.

41 These often are listed in inventories. Annette Weber provides a list of painted portraits of doges in Weber 1993.

42 "*De tenendo vasa argentea pro nostro usu.*" Girgensohn ed. 2004, 73.

43 "*Delle vesti di seda che dobbiamo portare.*" *Promissione* 1595, 12.

44 Sansovino 1664, 472. I have found the earliest reference to this requirement in the *Promissione* of Foscari of 1423: Capitolo CXIIII, "*De bavaro quem portare debemus …*" Girgensohn ed. 2004, 123. The *bavero* with the red mantle is for the most part reserved for images of the doge in fourteenth-century Venetian art. Other officials or important personages are typically illustrated as wearing the *bavero*, but with a *manto* of a different color.

45 Roeck 1996, 81. The broadest statement of this begins with the *Promissione* of Doge Pietro Lando (doge 1539–45): "*Quod non faciamus armam nostrum neque imaginem neque literas significantes nomen nostrum extra Palatium, neque in aliqua terrarium aut locorum nostrorum. Et non possumus facere, nec fiery permittere in aliquot loco extra Palatium armam nostram.*" Sinding-Larsen 1974, 133.

46 On the tomb sculptures of the doges, see Simane 1993; Pincus 2000.

47 *Promissione* of Jacopo Contarini, ASVe, [Secreta] Collegio, Promissioni, n. 1, I (ex-codici Brera 277), fols. 25r–30v. Graziato 1986, 82–105 (103). "*Tenemur insuper quibuslibet duobus mensibus facere nobis legi presens nostrum capitulare promissionem Veneciarum per ordine et distincte.*"

48 First included in the *Promissione* for Doge Pietro Gradenigo, elected in 1289: "*Faciemus quoque infra tres menses postquam intraverimus in ducatum fieri duo capitularia similia isti, quorum unum stare debeat in cancellaria, aliud in procurati<a> Sancti Marci, tertium apud nos; que tria Capitularia sint bulla plumbea communita.*" Graziato 1986, 132–63 (160–61). *Promissio Serenissimi Venetiarum ducis Serenissimo Francisco Lauredano Duce* (Venice: Typographia Ducali Pinelliana, 1752): 164.

49 *Promissione ducale* of Francesco Foscari, Girgensohn 2004, Chapter VII, "*De observando capitula capitularis consiliarorum.*"

50 Cozzi 1980.

51 This was published two days after the death of Doge Sebastiano Venier (1577–March 3, 1578). "*MDLXXVIII Die 8. Martii. In Majori Conseglio … L'anderà parte, che li conseglieri, che di tempo in tempo faranno alla Banca, sieno tenuti ogni anno la prima settimana del mese di ottobre, avanti, che si dia sagramento a questo conselgio, di andar in camera del serenissimo principe, et alla loro presenza far, che li sia letta la Promission sua de verbo ad verbum, come sta, e giace. Dovendo di piu ricordar alla Sublimita Sua l'obligo, ch'ella ha di osservarla, secondo il giuramento, che dovera far alla presenza di questo conselgio, il giorno a questo deputato, il qual li sia poi dato secondo il consueto nel giorno predetto.*" ASVe, Maggior consiglio, Deliberazioni, Libro Frigerius, fol. 32v. Musatti interprets this decree as indicating that the manuscript was by this time too lengthy to read every two months, but that requirement remained in the *Promissione*. Musatti 1888, 139–40.

52 Musatti 1888, 140; Trebbi 1984, 101–02.

53 *"1595. Adi 8 aprile. nel maggior conseglio. vacante Ducatu.*

"*Perche nel rimanent della Promission Ducale, in varii tempi dalla prudenza di questo conseglio aumentata, e regolata, si comprende bastar d'avantaggio, che vi sia data intiera essecution; da mo' sia preso; che a cadauno delli conseglieri nostri superiori sia sotto debito di sagramento imposto, che esequendo quanto per li loro capitulari li viene espressamente commesso, di haver presso di loro la sudetta promissione, cosa, che non ha havuto essecution fin'hora, debbano spesso, et diligentement, vedendo, et considerando il contenuto di quella, ogni principio di Mese conferir tra loro, et ritrovando, che in qualche parte sia mancato della dovuta essecution, debbano tutti insieme sotto l'istesso debito di sagramento, o in camera, o con quell'altra opportunita, che stimeranno migliore avvertirne sua serenità, accio, che sia diligente essecutrice della volontà di questo conseglio per essempio di ciascuno; al qual effeto siano fatti far sei simili essemplari di detta Promissione, oltra quella di sua serenità, et quelli da i secretarii nostri alla Leggi, consignati ad ogni Consigliero nel principio della sua Consigliaria, con obligo di restituirlo; perche possi esser consignato al successore, come é conveniente, e é disposto per la forma del capitulare sopradetto.*" *Promissio Serenissimi Venetiarum ducis Serenissimo Francisco Lauredano Duce* (Venice: Typographia Ducali Pinelliana, 1752): 164.

54 On a general decline throughout Europe in belief in the efficacy of oaths, see Prodi 1992.

55 These were printed until the election of the last doge, Ludovico Manin, in 1789. Musatti 1888, 140–42. This requirement that the doge have two copies of his original manuscript made remained in the *Promissione* text after they came to be printed, but it is not clear if it was followed. Girgensohn, ed. 2004, 107 (Capitolo 101). See also the *Promissio Serenissimi Venetiarum ducis Serenissimo Francisco Lauredano Duce* (Venice: Typographia Ducali Pinelliana, 1752): Capitolo 101.

56 Bartolomeo Cecchetti, "Costituzione istorica degli archivi veneti antichi, 1200–1872," *Atti del Regio Istituto Veneto di Scienze, Lettere ed Arti*, Ser. 6, v. 2 (1872–73): 7–74, 333–81, 595–633 (72–73).

57 *"1463, 3 decembre. Refferisco io Ulixes di Aleoti haver dado de comandamento a Lunardo Belin pentor over miniador fa la promission del Serenissimo miser lo Doxe per parte ducati 4 oro i qual mie die second uxanza esser restituidi e pagadi per questio offitio."* ASVe, Ufficiali alle Rason vecchie 1458–68, reg. 25: 138. Von Hadeln 1911, "Nachrichten über Miniaturmaler:" 168.

58 BL, Add. MS 15816. Moretti 1958. For summaries of research on the manuscript, see Giordana Mariani Canova in Alexander, ed. 1997, 84, cat. 27;

on Leonardo Bellini, Susy Marcon, "Bellini, Leonardo," *DBMI* 76–78. The wording of the document is unclear as to whether Bellini was paid for overseeing the entire production of the manuscript or just the illumination, but the payment of 4 ducats corresponds with rates paid recently to miniaturists on the mainland. For example, the Venetian patrician Leonardo di Marin Sanudo (d. 1478, father of the famous diarist Marin Sanudo) paid illuminators for miniatures in 1458, while he was in Ferrara at the court of Borso d'Este, as a representative of the Republic. Leonardo's records show, for example, that he spent 1 ducat for one part of a miniature of Saint Paul to a Master Vielmo (who has been identified as the prominent Guglielmo Giraldi). ASVe, Giudici di Petizion, Rendimenti (or rendiconti) di conto, b. 955. This account book of Leonardo Sanudo, bound in leather, with a lending list at the end, was first discussed by Martin Lowry. Lowry 1991, 28–36, 44, n. 82. Transcribed in Fremmer but mistakenly identified as written by Lorenzo Sanudo. Fremmer 2001, 162–63, 416–21. The actual manuscript for which Sanudo made the numerous payments has been identified as a Virgil now in Paris (BnF, Lat. 7939A). The colophon states it was copied by Leonardo Sanudo in 1458 while he was a representative of the Venetian Republic in Ferrara at the court of Borso d'Este. The illumination of civic documents was much less extensive than for many other kinds of books with longer texts or illustration traditions, such as Bibles or histories. Therefore, although the wording of the document referencing the Moro *Promissione* is vague, it seems likely that the 4 ducats were to cover only the illumination by Leonardo Bellini, and not the writing and binding. The illumination of the British Library *Promissione* is limited in scope but sumptuous enough to be the object of such expenditure. Giordana Mariani Canova in Alexander, ed. 1994, 109, cat. 42; Giordana Mariani Canova, *Guglielmo Giraldi, miniatore estense* (Modena: Franco Cosimo Panini, 1995) with catalogue by Federica Toniolo: 57–62, 154, nn. 23–33.

59 Giordana Mariani Canova in Alexander, ed. 1994, 109. On the manuscript of Lucius Caecilius Firmianus Lactantius, *Works*, Leonardo Sanudo, scribe, Leonardo Bellini, miniaturist. BMVe, Lat. II, 75 (=2198). A record of payment by Sanudo exists for this as well. See especially Susy Marcon in Zorzi, ed. 1988, *Biblioteca Marciana*, 136; Giordana Mariani Canova 1995, 807–8.

60 See n. 58 above and Chapter 4, n. 66; Israel 2007, 62. Leonardo Bellini also may have illuminated a Commission for another of the doge's nephews, Lorenzo di Giovanni Moro, elected Duke of Crete in June of 1462, or shortly after the doge's election. Commission of Francesco di Nicolò Zane, elected procurator *de ultra* on March 16, 1462, BMVe, Lat. X, 113 (=3508); Commission of Lorenzo Moro as Duke of Crete, NYPL,

Spencer MS 126. On Lorenzo Moro, nephew of Doge Cristoforo Moro, see Israel 2007, 52.

61 ASVe, *Guida generale*, 933.

62 The office was instituted in 1364, but there were preceding iterations of it. On the *Rason vecchie*, see ASVe, *Guida generale*, 933.

63 On manuscript illumination for the Este court, see Anna Maria Visser Travagli, Giordana Mariani Canova, Federica Toniolo, *La miniatura a Ferrara: dal tempo di Cosmè Tura all'eredità di Ercole de' Roberti* (Modena: Franco Cosimo Panini, 1998). As tutor of Doge Foscari's sons, Aleotti was also a familiar of a previous doge. Jennifer Fletcher, "Bellini's Social World," in Humfrey, ed. 2004, 13–47.

64 Leonardo was the son of Jacopo's sister Elena and her husband Pietro, a *"remèr"* or boat-builder. Daniel Wallace Maze, "Giovanni Bellini: Birth, Parentage, and Independence," *Renaissance Quarterly* 66 (2013): 783–823 (800, n. 68).

65 Transcriptions and translations in Eisler 1989, 172, 512, 531. See also Jennifer Fletcher, "Bellini's Social World," in Humfrey, ed. 2004, 13–47.

66 Brown 1996, 32; Beverly Louise Brown in Christiansen and Weppelmann, eds. 2011, 31–32. In addition, Aleotti helped settle a case for Mantegna, the son-in-law of Jacopo Bellini, in his effort to free himself from obligations to his adopted father and teacher Squarcione, in Padua. On Aleotti see Paolo Rizzi, "Aleotti, Ulisse," *DBI* 2 (1960); Neff 1985, 352–53; McHam 2013.

67 Alexander, ed. 1995, 11–20.

68 This must be considered an initial conjecture as to how to categorize the kinds of ownership and use.

69 Dieter Girgensohn, personal communication June 1, 2002.

70 *Promissione* of Jacopo Tiepolo, ASVe, Miscellanea atti diplomatici e privati, b. 2, n. 89. Discussion and transcription in Graziato 1986, 7–22. *Promissione* of Marin Morosini, ASVe, [Secreta], Miscellanea ducali e atti diplomatici, b. VII, f. 1. Discussion and transcription in Graziato 1986, 23–39.

71 Girgensohn, ed. 2004.

72 See, for example, ASVe, [Secreta] Collegio, Promissioni, reg. 1 (1225–1435). Contains the *Promissioni* of Doges Jacopo Tiepolo to Giovanni Gradenigo. Graziato 1986, 7–9; Tommaso Gar, "I codici storici della Collezione Foscarini conservata nella Imperiale Biblioteca di Vienna," *Archivio Storico italiano* 5 (1843): 474, n. 277; Hurlburt 2006, 205, n. 9.

73 This illuminated leaf also was stolen but has been restored to the archives. ASVe, [Secreta] Collegio, Promissioni, reg. 3, fol. 7. Mariani Canova 2005, 174.

74 J. Paul Leonard Library, San Francisco State University, De Bellis La. 12. http://bancroft.berkeley.edu/ digitalscriptorium/
Giustino, son of Gherardino da Forlì, wrote an inscription in an Antiphonary of 1365 with miniatures by the same or a similar hand, but it is not clear whether Giustino was the miniaturist or the scribe. Levi D'Ancona 1967; Susy Marcon, "Giustino di Gherardino da Forlì," *DBMI* 315–16.

75 Douay-Reims Psalm 91:13 (King James 92:12): *"Justus ut palma florebit et sicut cedrus ..."* on fol. 31r. A precedent for a historiated initial with a full-length image of a councillor pointing to his *Capitolare* opening text is evident in the opening leaf to the *Capitolare* of the councillor (BMCVe, Cl. III, 326, fol. 4r) with the *Promissione* of Doge Andrea Dandolo (BMCVe, Cl. III, 327, fol. 3a), and therefore dateable to about 1343.

76 On the Easter Service, see Cattin and Di Pasquale, eds. 1990–92, vol. 3, 40–41. Depending upon when the illuminations were made, the quote also may reference the various victories in war of Venice under Contarini's dogeship, including against Trieste (1368–69), against Francesco il Vecchio Carrara (1373) and during the war of Chioggia against Genoa (1378–81). Francesca Cavazzana Romanelli, "Contarini, Andrea," *DBI* 28 (1983).

77 Pertusi 1965, 88; Cecchetti 1864, 40; Foscari *Promissione*, Ch. 94: *"Quod in quolibet statu et casu tam meroris quam corozi in solennitatibus zoiam et vestes portabimus ... pro consolation et honore civitatis ... Pro honore vero ducatus tenemur facere fieri nobis infra sex menses postquam intraverimus in ducatu ad minus unam pulcram robam laboratam ad aurum, quam portare debeamus, sicut convenit pro honore ducatus."* Girgensohn, ed. 2004, 101–3.

78 Da Mosto 1977, 141–42; Francesca Cavazzana Romanelli, "Contarini, Andrea," *DBI* 28 (1983).

79 This is spelled out in the first chapter of the councillor's *Capitolare*, which is titled: *"Di haver à casa il Capitolar, et la promissione del Ser.mo Principe, le quali si restituiscano nel fine del Reggimento. Ancora son obligato haver à casa mia uno Capitolar in scriptis, et leggerlo tutto, òvero farmilo legger una fiata al mese almeno, et similmente la promissione del Ser.mo Principe..."* *Capitolare* of Pietro Morosini as *consigliere* of Santa Croce, 1578, BMCVe III, 148, f. 2r. <http:// nbm.regione.veneto.it/Generale/BibliotecaDigitale/ caricaVolumi.html?codice=19> [Accessed December 2017]. The impersonal use of some such manuscripts is suggested by the payment of 12 soldi to the *Cancelleria superiore* by the *Camerlenghi di comun* in 1381 for a *Promissione* with a councillor's *Capitolare*. Acts of the commissary of the Grand Chancellor Rafaino Caresini (ASVe, Procuratori di S. Marco, Misti, b. 148, n. 6). Cecchetti 1886, 361.

80 The earliest of these is the *Promissione* of Pietro Ziani of 1205, BMVe, Lat. XIV, 72 (=4273).

81 BMVe, Cod. Lat X, 189 (=3590), fol. 5a. It is bound in leather with traces of the original metal fixtures. Susy Marcon in Zorzi, ed. 1988, *Biblioteca Marciana*, 104–5.

82 See n. 74 above.

83 Venice, Biblioteca Giustiniani Recanati Falck, cl. IV cod. 410. Marcon 2005, 286–88.

84 Other illuminated copies of his *Promissione*, but which have no coat of arms, include one in Finarte Semenzato, *Asta a Venezia, Abbazia di San Gregorio* (Venice: 5 May 2003): cat. 29; BMVe, Lat. X, 191 (=3556); ASVe, [Secreta] Collegio, Capitolare dei consiglieri veneti, reg. 4, fol. 5r.

85 Venice, Biblioteca Giustiniani Recanati Falck. First attributed to Cristoforo Cortese by Mirella Levi D'Ancona by comparison with the signed miniature in the Wildenstein Collection. Levi D'Ancona 1956, 32; Galli 1997, 238–43. It is not clear if the style of this illumination accords with the time period of the doge's election, or if it may have been done later. Cortese seems to have worked as a painter of panels as well. He was greatly sought after by the monastic communities in Venice and on the mainland to illuminate liturgical books, by the confraternities called *scuole* to illuminate their rule books (*mariegole*), and by individuals to also illuminate secular texts. Mariani Canova 2009, 276–83, especially 281. For more on Cortese and the manuscripts he signed, see Susy Marcon, "Cortese, Cristoforo," *DBMI* 176–80; Humphrey 2007; Humphrey 2015.

86 A *Promissione* of Antonio Venier is illuminated with a portrait of Doge Foscari, and has no heraldry. Therefore, despite the high quality of the miniature in the document, it probably was not intended for the doge. BMVe, Lat. X, 190 (=3555).

87 This *Promissione* is the first known to adopt the iconography of Mark offering a book, as already found in a document of the fourteenth century for the *Capisestieri*. ASVe, Signori di notte al civil, Capitolare dei capisestieri, 1348.

 See Chapter 1, n. 27, on the new identification of the restored head, which has been identified as a copy of a sculpture of Cristoforo Moro, instead of Foscari. The monument, nevertheless, honored Foscari.

88 "*Cum non de nostra fortitudine vel prudentia, sed de sola processit clementia Creatoris, in cuius arbitrio et voluntate universa sunt posit, quod ad culmen ducalis dignitatis pervenerimus, vos hactenus in ecclesia Beati Marci evangeliste Domini gloriosi, qui patronus noster est et signifer in omnibus, aggregati, quantam erga nos habueritis dulcedinem caritatis ibi perfecte demonstrastis, cum ad prolationem eligentium vos vice nostra et nomine, in celum manibus elevatis, Deum omnes unanimiter glorificastis in voce laudis magnifica et exultationis, quoniam per intercessionem gloriosissimi evangeliste sui Marci nos in ducem vobis dederat et rectorem.*" Girgensohn, ed. 2004, 15.

89 First attributed to Cristoforo Cortese by Mirella Levi D'Ancona by comparison with a signed miniature in the Wildenstein Collection, Musée Marmottan Monet,

Paris. Levi D'Ancona 1956, 32; Galli 1997, 238–43.

90 Romano 2007, 48–49.

91 Schulz 1978, 9–12; Pincus 1976, 402–4; Schulz 1999; Romano 2007, 323–28, 415, n. 221.

92 Galli 1997, 238.

93 Romano 2007, 177–78; 297–99.

94 As first suggested by Sinding-Larsen 1974 and Wolters 1987.

95 Moro was the patron of the altar dedicated to Saint Clement in the Church of San Marco, and he had a portrait of Bernardino also placed upon it. Other elements of this altar have been substantially changed, but it retains the inscription naming the doge, and the date of 1465. Schulz 1983, 167–73; Israel 2007, 89–90, 103–5.

96 Israel 2007, 157ff., esp. 182–84.

97 Pincus 1981, 131.

98 This contrast of showing the doge wearing his *camauro* in the lunette, but the *biretum* below, is also in the tomb monument for Doge Andrea Vendramin (d. 1478), originally in the Church of Santa Maria dei Servi, but now also in the Church of Santi Giovanni e Paolo. Stedman Sheard 1971; Anne Markham Schulz in Pavanello, ed. 2013, 160–71.

99 Andrew Butterfield, "Monument and Memory in Early Renaissance Florence," in Ciappelli and Rubin, eds. 2000, 148–49. A wax head of Doge Alvise IV Mocenigo (doge 1763–78) survives with the *rensa* and *corno*. It was displayed in the Scuola di San Rocco, now Treasury of the Scuola di San Rocco. Julius von Schlosser, *Geschichte der Porträtbildnerei in Wachs* (Vienna and Leipzig: F. Tempsky and G. Freytag, 1911). Translations with commentaries: *Ephemeral Bodies: Wax Sculpture and the Human Figure*, ed. Roberta Panzanelli (Los Angeles: Getty Research Institute for the History of Art and the Humanities, 2008); Julius von Schlosser, *Storia del ritratto in cera*, with introduction by Marco Bussagli (Milan: Meduas, 2011): 76–79, fig. 8.

100 On burial rituals, see Muir 1981, Casini 1993.

101 Such a composition was reprised in the sculptures and paintings of the tombs of such doges as Bartolomeo Gradenigo (doge 1339–42), in the center of the sarcophagus in San Marco, and in the lunette of the tomb of Michele Steno (doge 1400–13) formerly in Santa Marina. These images also precede the surviving votive images that were commissioned for each doge in the Ducal Palace by the term of Leonardo Loredan, in the early sixteenth century. Pincus 2000, 114.

102 His medal by Antonello della Moneta has the same reverse as in Foscari's medallion. Pollard 2007, 176, cat. 157.

103 Ugo Tucci, "Monete e banche nel secolo del ducato d'oro," *SDV* 5 (1996), *Il rinascimento: società*: 735–805 (769, 788).

104 NYPL, Spencer MS 40. Mariani Canova 1969, cat. 66; Mariani Canova in Jonathan Alexander, James

Marrow, and Lucy Freeman Sandler, eds., *The Splendor of the Word: Medieval and Renaissance Illuminated Manuscripts at The New York Public Library* (London: Harvey Miller, 2005): 25–27, with relevant bibliography on the miniaturist.

105 *"Cum tuto el chor."* Another banderole has the initials "S.D.H.E.T.G.," as yet undeciphered.

106 *"O MATER MEMENTO MEI."* See for example the inclusion of a version of this text in a banderole in the portrait of Anne of Cleves in her famous Book of Hours, produced in Utrecht around 1440. She is shown holding her Book of Hours, in devotion to the Virgin and Child, in the miniature opening Matins. PML, MS M.917, fol. 1v.

107 Pincus 1981; Schulz 1983, 44–64, 171–77; Brown 1996, 112–15.

108 BMCVe, Cl. III, 322. Given by Emmanuele Antonio Cicogna. Mariani Canova 1969, cat. 16.

109 There is a strong influence of an illuminator involved in Borso d'Este's Bible, Franco dei Russi. BMVe, Lat X, 238 (=3509). Susy Marcon in Zorzi, ed. 1988, *Biblioteca Marciana*, 158.

110 The volumetric monumentality of God the Father and the facial types are very similar to the work of Bartolomeo Vivarini in these same years, as for example in his image of Saint Augustine in the polyptych of the Frari of 1473. This panel, one of three that remain from the once much larger Santi Giovanni e Paolo polyptych, is signed and dated. Rodolfo Pallucchini, *I Vivarini (Antonio, Bartolomeo, Alvise)* (Venice: Neri Pozza, 1961): 121, cat. 167.

111 See for example Bartolomeo Vivarini, *Christ as Salvator Mundi*, Grappa, Museo di Bassano.

The miniaturist also presented his patron in a drastically reduced scale in a Commission/Oath of the procurator Andrea di Nicolò Lion, elected later that same year on November 10, 1473. BMVe, Lat. X, 358 (=3517). Sinding-Larsen 1974, 176.

112 Sansovino 1581, fol. 177v. Cecchetti claimed that Marcello was the first doge to wear the gold brocade *corno* with gems with the gold vestments, but does not cite any sources. Cecchetti 1864, 27. On the nomenclature of red colors in Venice, see Hills 1999, 204.

113 Ildefonso Tassi, OSB, *Ludovico Barbo 1381–1443* (Rome: Edizioni di storia e letteratura, 1952): 111.

114 On the *Gesuati*, see Gaetano Moroni, *Dizionario di erudizione storico-ecclesiastica* 30 (Venice, 1895): 108–10; Barstow 2000.

115 Martinioni, writing before the *Gesuati* were disbanded, described some of the gifts in the church given by Marcello, including tapestries and silver for the altars, all of which bore his coat of arms. Sansovino 1663, 270–71. The wealth of the old *Gesuati* church, probably including Marcello's gifts, was seized by the Republic when the order was abolished, and was partially used to fund the wars against the Ottomans.

116 Corner 1758, 442–43.

117 The "IHS" monogram of the *Gesuati* is figured on the verso of a medal for Nicolò Marcello, made while he was doge. Voltolina 1998, 75–76.

118 Girgensohn 2002–3, 272–73; Giuseppe Gullino, "Marcello, Nicolò," *DBI* 69 (2007).

119 On the history of the monument and the Church of Santa Marina, see McAndrew 1980, 127; Zorzi 1971, vol. II, 371–73; Anne Markham Schulz in Pavanello, ed. 2013, 150–57.

120 The relics of this saint are in Treviso, and he is patron of that city. The Church of Santa Marina was dedicated to Liberalis in the ninth century, and there was an entire chapel dedicated to that saint. God the Father tops the ensemble. Today the figure of God is recessed in a niche in the wall. Representations of the tomb when it was still in Santa Marina show him as a free-standing pinnacle, in which case he would have been more prominent, but still not approaching his centrality in the miniature. The tomb is illustrated in Giovanni Grevembroch, "Monumenta veneta," 1759, MS Gradenigo Dolfin 228, vol. 3, fol. 33; McAndrew 1980, 126–32.

121 On this manuscript leaf and its provenance, see the Epilogue. On the evolution of the architectural frontispiece in Venice, see Margery Corbett, "The Architectural Title-page. An attempt to trace its development from its humanist origins up to the sixteenth and seventeenth centuries," *Motif* 12 (1965), 48–62; Armstrong 1981, 19–26; Lew Andrews, "Pergamene strappate e frontespizi: I frontespizi architettonici nell'epoca deli primi libri a stampa," *Arte Veneta* 55 (1999): 6–22; Nicholas Hermann, "Excavating the Page: Virtuosity and Illusionism in Italian Book Illumination, 1460–1520," *Word & Image* 27, 2 (2011): 190–211.

122 *Tre Inquisitori sul Doge Defunto.* Muraro 1961, 309. On Agostino Barbarigo, see Franco Gaeta, "Barbarigo, Agostino," *DBI* 6 (1964); Brunetti 1925. On his patronage of the arts, Gentili 1992.

123 BMCVe, Cl. III, 160.

124 Armstrong 1990.

125 Marin Sanudo il Giovane, *Le Vite dei Dogi (1474–94)*, vol. II, ed. Angela Caracciolo Aricò (Rome/ Padua: Editrice Antenore, 2001): 507; Musatti 1888, 118–19; Muraro 1961; Wolters 1987, 82–84; Muir 1981, 286.

126 Brown 1996, 164–69.

127 Brown 1996, 164–69.

128 Such a succession of doges as brothers was repeated in the sixteenth century, when Girolamo Priuli (1486–1567) succeeded his younger brother Lorenzo Priuli (1489–1559).

129 On this painting, see n. 40 above. In 1493, the Senate considered the *zoia* not magnificent enough and had it embellished with many new jewels, including a diamond and ruby in possession of the office of the procurators. Cecchetti 1864, 27.

130 For the broader outlines of the history of the church and a plan, see Fogolari 1924; Fogolari 1946, 157–82; Moschini Marconi 1955. On the surviving *corno* in cloth on a moulded leather base, of either Doge Agostino or Marco Barbarigo (now in the Correr), see Monnas 2009, 184–87.

131 Although traditionally assigned to Antonio Rizzo, according to the regulations of Antonio Rizzo's job as *protomaestro* of the Ducal Palace, he would have been prohibited from working on outside projects. Recent archival research has identified two of the sculptors of the tomb, Giovanni Buora and Bartolomeo di Domenico Duca, but the documents also suggest that they did not create the figures of the doges. Schulz 1983, 191–4. Bernd Roeck, "Zu Kunstaufträgen des Dogen Agostino Barbarigo (1419–1501): das Grabmonument in der Chiesa della Carità in Venedig und die *Pala Barbarigo* Giovanni Bellinis," *Zeitschrift für Kunstgeschichte 55* (1992): 1–34; Wolters 2008, 81.

132 By Suor Isabella Piccini, dated 1692. British Museum, Prints & Drawings, 1925, 0728.12. The church was suppressed in 1807. The print does not convey that sections of it also probably were painted and gilded. Wolters 2008, 81. On Isabella Piccini, see Di Vaio 2003. Munman 1968, 89, n. 3; Augusti 2001.

133 *Promissione* of Doge Antonio Grimani. BL, Add. MS 18000, fols. 6v, 7r. Chambers in Martineau and Hope, eds. 1983, 395, with previous bibliography.

134 On Antonio Grimani's career, see Viggiano 1997; Gaier 2002; Roberto Zago, "Grimani, Antonio," *DBI* 59 (2002); Cooper 2005; Raines 2006.

135 Antonio Grimani as procurator *de citra*, 1494. BMCVe, Cl. III, 158. Mariani Canova 1968–69, 328, n. 24; Dorigato 1986, cat. IV.23, 151–52; Chambers 1997, 34–38. Lilian Armstrong attributes the illumination to a follower or assistant of the Pico Master (personal communication, April 20, 2012). His Commission as Captain General of the Sea in Dalmatia of July 29, 1494, is in the British Library. It has no illumination and has been rebound. BL, Add. MS 15145.

136 Casini 2001, 225–26.

137 Commission of Antonio Grimani as procurator *de supra* of San Marco, 1510, BMCVe, Cl. III, 906. Mariani Canova 1968, "La decorazione," 332; Mariani Canova 1968–69, 106; Zuccolo Padrono 1972, 12; Dorigato 1986, IV.27, 154; Chambers 1997, 34–38.

138 Sanudo describes the election and coronation in Sanudo 1879–1903, vol. 30, cols. 479–90. Muir 1981; Hostetter Smith 1999.

139 See Introduction and Epilogue.

140 Gaier 2002, 150–51.

141 Sanudo 1879–1903, v. 34, col. 134.

142 Gaier 2002, 162–72. In fact, after his death, Vettor was himself pushed out of his own chapel project for San Francesco della Vigna by his younger brother Giovanni. On the complicated and long history of projects to commemorate Antonio in tomb monuments, see Gaier 2002, 149–78, 457–65. On the church and its decoration in general in the sixteenth century, see Foscari and Tafuri 1983.

143 It cost about 151 ducats. Gallo 1967, 254–56; Wolters 1987, 104–6.

144 "*con la figura di San Marco, del Ser.mo Principe Grimani, et de tre Done, cioè tre Virtù.*" ASVe, PSM, Procuratori de supra, Catastico. This and the payment documents for the piece to Rost from Biblioteca Nazionale di Firenze, Manoscritti, Nuovi acquisiti, n. 52, elucidated in Gallo 1967, 254–56; Wolters 1987, 104–6. Also described in Stringa 1610, 222.

145 It already was listed as in bad condition in an inventory of 1791, with an additional note that it subsequently burned. Fragment of the *paliotto* of Doge Antonio Grimani, c.1558. Venice, Museo Civico Correr. Gallo 1967, 256; Gallo 1953.

146 British Museum, Prints & Drawings, 1938, 1210.2. H. Tietze and Tietze-Conrat 1944, 244 (as Giuseppe Porta); Wolters 1965 (as Giuseppe Salviati, design for an altar covering); Richardson 1980, 125–26 (as Andrea Schiavone); Alessandro Ballarin, "Jacopo Bassano e lo studio di Raffaello e dei Salviati," *Arte Veneta* 21 (1967): 89–90; C. Loisel, *Musée du Louvre, Cabinet des Dessins, Inventaire Général des Dessins Italiens, VII, Ludovico, Agostino, Annibale Carracci* (Paris, 2004): 56; Sara dell'Antonio, "Per Andrea Schiavone designatore," *Studi sul disegno padano del Rinascimento*, ed. Vittoria Romani (2010): 225–320 (244–46).

147 "*un disegno del panno d'altere del dose Antonio Grimani;*" "*un disegno per un panno d'altare del dose Antonio Grimani con le vertù et vitii con le cornise dorate ...*" Collezionismo 2007, 339.

148 Marin Sanudo states it was obligatory also for the doge to give an altar cloth to the Church of Santa Maria Formosa. Marin Sanudo, *De origine, situ et magistratibus urbis Venetae. La città di Venezia (1493–1530)*, ed. Angela Caracciolo Aricò (Milan: 1980).

149 On the tomb, see Anne Markham Schulz in Pavanello, ed. 2013, 142–49.

150 As noted by Gaier 2002, 173, n. 227; T. C. Price Zimmermann, *Paolo Giovio: The Historian and the Crisis of Sixteenth-Century Italy* (Princeton: Princeton University Press, 1995): 49–50. Giovanni Battista Egnazio, *De exemplis illustrium virorum Venete ciuitatis, atque aliarum Gentium* (Paris: Apud Bernardum Turisanum, via Iacobea, sub Aldina Bibliotheca, 1554): 59ff.; Paolo Giovio, *Elogia virorum bellica virtute illustrium veris imaginibus supposita, quae apud musaeum spectantur* (Florence: in officina Laurentii Torrentini dvcalis typographi, 1551): 228ff.

151 Carlo Volpati, "Paolo Giovio e Venezia," *Archivio Veneto* 15 (1934): 132–56 (139, 144).

152 "*verso la felice memoria.*" The document also specifies the painting should not cost more than 171 ducats.

March 22, 1555. Lorenzi 1868, 289–90, documents 619 and 622; Zanotto 1853–61, vol. II, Tavola 64; Sinding-Larsen 1974, 34; Wolters 1987, 101–3; Bergstein 1986; Ettore Merkel, entry in *Tiziano* (Venice: Marsilio, 1990): 364–67; Giovanna Nepi Scirè gave an excellent overview of the history of the commission and the vicissitudes of conservation and restoration in Nepi Scirè 1979. Lorenzi 1853–61, doc. 623; Nepi Scirè 1995, 84.

In addition, a month after Antonio Grimani died, the Council of Ten ordered the Salt Officers to pay Titian 25 ducats, for painting the portrait of the defunct doge to add to the series in the Hall of the Great Council. June 3, 1523. Lorenzi 1868, 176–77, doc. 377.

153 By contrast, they previously had specified the composition of the votive painting for Doge Marcantonio di Domenico Trevisan (*c*.1475–1554) in detail, and would do so for the painting for Lorenzo di Alvise Priuli (1489–1559). See for example the resolutions on the painting memorializing Lorenzo Priuli (doge 1556–59) for the *Collegio* of 1563. Lorenzi 1868, 284–85, doc. 608; 321–22, doc. 680; 363–64, doc. 761. On Antonio Grimani's lingering notoriety, see A. Pilot, "L'elezione del doge Grimani e una canzone inedita," *Pagine Istriane* 2, 2 (1904): 9.

154 Foscari and Tafuri 1983.

155 Monacelli 2008.

156 Titian was working on the painting in 1566 when Vasari saw it in the artist's home among other works in progress. Nepi Scirè 1995, 84.

157 Indeed it seems Doge Marin was able to provide the inscription of Antonio's name, if not his portrait, in the monument to Pietro di Antonio Grimani at Sant'Antonio. Gaier 2002, 178.

158 The restoration conducted in 1977–78 removed much of the overpainting by Marco Vecellio and of successive restorations, primarily leaving the basic composition by Titian. Titian was responsible for the general composition, but his nephew and pupil Marco Vecellio added two lateral paintings and painted over Titian's work to integrate the three canvases. Nepi Scirè 1995.

159 Tagliaferro 2005, 360.

160 There are ships in the background in the view of the Bacino of Venice, probably from the Punta di Sant'Antonio, the location of an early proposed memorial to him. Gaier 2002, 174.

161 The *Promissione* miniature may have been finished shortly after the doge's election, and probably by 1530, when the miniaturist Bordon died. David Chambers in Martineau and Hope 1983, 395, cat. H5; Hostetter Smith 1999, 52–56; Gaier 2002, 175 n. 235. On the miniaturist Benedetto Bordon: Armstrong 1996. On the Second Grifo Master, to whom this painting is also attributable, see Alexander 2016, 105.

162 Hostetter Smith 1999, 41.

163 See also the portraits of Doge Francesco Venier (doge 1554–56) by Palma Giovane in the Senate Hall, and Doge Andrea Gritti (doge 1523–38) in the votive painting that Tintoretto repainted for the *Collegio*.

164 BMCVe, Cl. III, 324. Zuccolo Padrono 1971, 66–67. The manuscript is bound in red velvet on wooden boards, with impressions of the lost metal fixtures. The manuscript was written in an elegant chancery hand by the notary Giulio di Camillo Zamberti, who signed it on the last folio. There is another copy of Venier's *Promissione* in the Correr, but it has no illumination. BMCVe, Cl. III, 611. Binding attributed to Andrea di Lorenzo (the Mendoza Binder) by Hobson 1999, 245.

165 The commission for the tomb was given to Jacopo Sansovino and his workshop. On the tomb, and for transcriptions of his will and other relevant documents, see Boucher 1991, 118–24, 211–12, docs. 173–75; Monacelli 2008.

166 Sinding-Larsen 1974, 247; Wolters 1987, 198; Mason Rinaldi 1984, cat. 536.

167 Commissions of Francesco di Giovanni Venier: as *Podestà* of Brescia, 1531, never illuminated, BMCVe, Cl. III, 783; as Lieutenant of Friuli, 1534, lacking first leaf, PML, MS M.553; as *Podestà* of Verona, 1550, lacking first leaf, PML, MS M.546.

168 Leuven, Sabbe Library, Berchmanianum Collection, MS 18 BK.

169 Sotheby Parke Bernet, London, *The Bute Collection of Forty-Two Illuminated Manuscripts and Miniatures; sold by order of the Most Honourable the Marquess of Bute, June 13, 1983*, lot 37. Now Venice, Biblioteca Giustiniani Recanati Falck.

170 *Promissione* of Doge Pietro di Giovanni Lando, elected 1539, BMVe, Lat. X, 316 (=3136).

A copy of the *Promissione* of Doge Lorenzo di Alvise Priuli (elected 1556) was written out by Giovanni Vitali in 1558, but does not have any heraldry or illumination. Since Vitali did lots of work for the procurators, he may have created this as one of the copies required for their consultation. BL, Stowe 917. The manuscript has been rebound.

171 Da Mosto claims there is a document from the seventeenth century recording a payment of 40 ducats for a *Promissione* manuscript but does not cite his source. Da Mosto 1977, xxvi.

172 London, V&A, n. 3127 (MS 1214). Watson 2000, 21–46 (45); Watson 2011. Vitturi was elected as ducal councillor in 1593, 1596, 1600, and 1608, and was one of the most influential patricians of the late sixteenth-century. On Vitturi, see Grendler 1990, 84–85.

CHAPTER 4: THE OATH OF THE PROCURATORS

1 This chapter is indebted to David S. Chambers's study of the procurators and their Commissions, Chambers 1997. There often was not great consistency in the

texts of these documents, and the actual commission as phrased by the doge sometimes was left out. Nevertheless, in documents of payment for them they usually are called *Commissioni*, while the main page to be illuminated was the *Giuramento*. The documents will be called here Commissions, Oaths, or Commissions/Oaths. Like the rectors, the procurators were not designated by the doge, but were elected in the Great Council. Some fully digitized Commissions of procurators in the Museo Correr library are available at http://www.nuovabibliotecamanoscritta.it/BMCVe.html.

2 The ruling will be discussed further later.

3 A new church of appropriate size and dignity was needed to house the saint's remains, and to connect Venice with the mythical founding of the patriarchate and Mark's special blessing. Demus 1960, 52–54; Demus 1984. For a general study of the procurators and their role in the Basilica of Saint Mark, see Boito and Ongania, eds. 1888–92; Pompeo G. Molmenti, "The Procurators of S. Mark," Boito, ed. 1888, 101–23; Pompeo Molmenti, "I procuratori di San Marco," in *Studi e ricerche di storia e d'arte* (Turin: L. Roux, 1892): 57–81.

4 Rando 1996, 81–82.

5 Demus 1960, 54.

6 The literature on the patronage of the procurators is extensive. See especially Howard 1975; Bruce Boucher, "Il Sansovino e i Procuratori di San Marco," *Ateneo Veneto* 173 (n.s. 24) (1986): 59–74; Agazzi 1991; Boucher 1991; Cooper 2005, 40–44; Deborah Howard, "The State," in Humfrey, ed. 2007, 33–91 (54–68); Howard 2011.

7 Hirthe 1986, "Die *Libreria* des Jacopo Sansovino: Studien zu Architektur und Austattung eines öffentlichen Gebäudes in Venedig"; Hirthe 1986, *Il "foro all'antica" di Venezia: La trasformazione di Piazza San Marco nel Cinquecento*, especially 30.

8 On the history of the office of the procurators, see Mueller 1971; Alfredo Viggiano, "I procuratori di San Marco," in Viggiano, ed. 1994, 11–56; Chambers 1997.

9 Since there was an unequal distribution of work from the *sestieri*, as prescribed in the oldest extant *Capitolare* of their duties (of 1320), the procurators *de ultra* also absorbed duties related to the *sestiere "de citra"* of Cannaregio. Mueller 1971, 112.

10 Mueller 1971, 114–17; Chambers 1997, 30–31.

11 On the early evolution of the special relationship of the procurators to the Evangelist, see Rando 1996, with relevant bibliography. Chambers 1997, 28–29.

12 This School should be distinguished from the confraternity, or *scuola*, of San Marco. Howard 1975, 8–37; Hirthe 1986, "Die *Libreria* des Jacopo Sansovino"; Hirthe 1986, *Il "foro all'antica" di Venezia*, 29; Howard 2011.

13 Deborah Howard, "The State," in Humfrey, ed. 2007, 33–91 (54–68).

14 This analysis was made by David Chambers in Chambers 1997, 38–43. In this period, the Council of Ten also allowed patrician youths access into the Great Council at the age of eighteen by payment of 200 ducats, rather than having to win the lottery called the Barbarella to gain entrance at eighteen, or otherwise wait until the age of twenty-five. Fassina 2007, 95.

15 Bruce Boucher, "Il Sansovino e i Procuratori di San Marco," *Ateneo Veneto* 173 (n.s. 24) (1986): 59–74; Howard 1975, 18–21, 36; Boucher 1991, 37–43; Chambers 1997.

16 Chambers 1997, 49.

17 The festivities and ceremonies of the inauguration of a procurator are described by seventeenth- and eighteenth-century sources: Manfredi 1602, 11; Vincenzo Maria Coronelli, *I Procuratori di San Marco riguardevoli per dignità e merito* (Venice?: 1705): 16–17. Lina Urban, "La piazza cerimonie e feste," in Morolli, ed. 1994, 224–27; Chambers 1997, 25–26.

18 Pettoello 2005.

19 This chapel must have been relatively private, for Sanudo claims that in all his previous fifty-five years he had never been inside it. He was allowed in only to attend Mass as a guest of the procurator *de citra* Antonio di Nicolò Tron (d. 1524) in 1521. Sanudo 1879–1903, vol. 30, cols. 393–94. Urban 1998, 225.

Antonio Foscari, "Il cantiere delle 'Procuratie Vecchie' e Jacopo Sansovino," *Ricerche di storia dell'Arte* 19 (1938): 61–76; Gian Paolo Mar, Paola Mar, and Monica Zanforlin, "La Fabbrica," in Viggiano, ed. 1994, 113–70 (117). Adriana Augusti, "L'apparato decorativo," in Viggiano, ed. 1994, 171–210 (173).

To my eye the portrait of Paolo Belegno (fig. 4.1) is generic, but what constitutes a true portrait is open to debate.

20 Described as in the offices of the procurators by Manfredi 1602, 28. Elizabeth C. G. Packard, "A Bellini Painting from the *Procuratia di Ultra*, Venice: An Exploration of its History and Technique," *The Journal of the Walters Art Gallery* 33/34 (1970/71): 64–84; Chambers 1997, 85.

21 "*di venerando & grave aspetto.*" Sansovino 1581, fol. 111r.

22 "*fra i ritratti degni di memoria, è molto singolare il quadro di Hieronimo Zane.*" Sansovino 1581, fols. 110v–11r. On the procurators' quarters see Gabriele Morolli, "Vincenzo Scamozzi e la fabbrica delle procuratie nuove," in Morolli, ed. 1994, 11–116; Chambers 1997, 50–61.

23 On the portraits: von Hadeln 1911, "Beiträge zur Tintorettoforschung," 41–58; Giovanna Nepi Scirè, "Introduzione, Le procuratie vecchie," in Morolli, ed. 1994, 5–10; Chambers 1997. Jacopo Tintoretto, *Portrait of Antonio Cappello as Procurator "de Supra,"* 1523–64, Venice, Accademia, Inv. 236. Rossi 100, cat. 127. Jacopo Tintoretto, *Portrait of Jacopo Soranzo as*

Procurator "de Supra," 1522–51, Venice, Accademia, Inv. 145. Rossi 99–100, cat. 125. Parrasio Micheli, *Portrait of Girolamo Zane as Procurator "de Ultra,"* 1568–71, Venice, Accademia, Inv. 1028. Manfredi 1602, 21–28; Sansovino 1604, fols. 216v–218r; Sansovino 1663, 297–307. Moschini Marconi, 142, cat. 230. There is a drawing by Parrasio of Zane in Berlin, in which he is represented with other patricians in a study for a painting, now destroyed, made for the Doge's Palace. Detlev von Hadeln, *Venezianische Zeichnungen der Spätrenaissance* (Berlin: Cassirer, 1926): plate 20.

24 With the aid of the archival notes of Gustaf Ludwig, Detlev von Hadeln initiated the matching of archival documents and descriptions with the portraits in von Hadeln 1911, "Beiträge zur Tintorettoforschung," 41–58. Nepi Scirè, "Introduzione," in Morolli, ed. 1994, 9; Miguel Falomir, "Tintoretto's Portraiture," in Falomir, ed. 2007, 101.

25 Now in the Accademia, Venice, Inv. 145. Moschini Marconi 1962, 224–25, cat. 396. It was originally in the form of a lunette, but was probably altered by Tintoretto and his son Domenico to form a rectangle to fit in the new rooms of the rebuilt offices of the procurators later in the century. Marco Boschini's guide gives a better sense of the sheer number of these portraits in the two entry rooms of each division of the procurators, most by Tintoretto. Marco Boschini, *Le minere della pittura …* (Venice: Francesco Nicolini, 1664): 92–98; see also lists of paintings in Manfredi 1602; Sansovino 1604. Some of the portraits were painted posthumously. If they are dated, the date refers to the time of election and not when the portrait was painted.

26 Vecellio calls this kind of sleeve a *dogalina*, but the term was slippery, as it was also used for the tight-fitting inner sleeve worn by others. The large open sleeve was also called a *ducale* sleeve. Vecellio 1598, fol. 104r; Newton 1988; Vitali 1992, 176, 180.

27 Vecellio 1598, fol. 104r; Newton 1988, 9–26; Rosenthal and Jones 2008, 589.

28 Vitali 1992, 46.

29 See, for example, the portrait of a Venetian patrician, probably a procurator, of 1580–83, now in the National Gallery of Art, Washington, D.C., and a foot higher than the Soranzo portrait. National Gallery of Art, Samuel H. Kress Collection, 1952.5.79. On Tintoretto and institutional portraiture, see Hüttinger 1968; Friedrich Polleross, "'Della Belezza & della Misura & della Convenevolezza.' Bemerkungen zur venezianischen Porträtmaler anlässlich der Tintoretto-Austellungen in Venedig und Wien," *Bruckmanns Pantheon* 53 (1995): 33–62; Miguel Falomir, "Tintoretto's Portraiture," in Falomir, ed. 2007, 95–114 (101).

30 Charlotte Townsend-Gault, "Symbolic Facades: Official Portraits in British Institutions since 1920," *Art History* 11, 4 (December 1988): 511–26.

31 Tintoretto was paid for restoring portraits of procurators already by 1554. Von Hadeln 1911, "Beiträge zur Tintorettoforschung," 51, 53, 54.

32 Tintoretto had received partial payment for these portraits by 1573. Von Hadeln 1911, "Beiträge zur Tintorettoforschung," 54–55, docs. 8, 1. He was paid also to create portraits, presumably from life, of current procurators such as Marcantonio Barbaro, Andrea Dolfin, and Jacopo di Francesco K. Soranzo, grandson of the Jacopo Soranzo previously discussed, in the late 1570s. See for example von Hadeln 1911, "Beiträge zur Tintorettoforschung," 54, docs. 14, 16, 19. In 1590 Jacopo Tintoretto was compensated with 60 ducats for work for the new *Procuratie* to portray all the procurators and doges who had been imaged in the earlier, and now destroyed, offices. A few years later his son Domenico was paid for having restored thirty-two paintings of doges and procurators in new offices damaged by humidity. "*nel racconzar tutti li ritratti di procuratori et dosi, quali erano nella procuratia vecchia*" (in 1592 and 1596). Although Tintoretto and his circle comprised the most famous painters of procurators, in the sixteenth century payments were recorded to a number of others, including Lambert Sustris, a Francesco *pittor*, and Parrasio Micheli. Von Hadeln 1911, "Beiträge zur Tintorettoforschung," 56, docs. 25, 26.

33 ASVe, PSM, Procuratori de supra, Chiesa, reg. 2, Cassier Chiesa, 1534–41; ASVe, PSM, Procuratori de supra, reg. 51, Quaderno Chiesa 1560–67. Chambers 1997, 46, n. 46, 65.

34 Marcon 1995.

35 An earlier manuscript for a procurator *de ultra*, which was probably illuminated but which has lost its opening leaf, is BMVe, Lat. X, 354 (=3516). The date of the last statute is 1365, and the document has no eschatocol. The manuscript has beautiful initials, with fine marginal pen flourishes.

36 BMCVe, Cl. III, 315. Belegno was elected on March 8, 1367, and the eschatocol (fol. 36v) is dated to the following day: "*Data in nostro ducali palatio. ano ab incarnatione domini nri yhesu xpi. millesimo trecentesimo sexagesimo septimo. die nono mensis marcii. indictione quinta.*"

37 BnF, Lat. 4727. Modern binding. On Pietro di Jacopo Corner, see Giorgio Ravegnani, "Corner, Pietro," *DBI* 29 (1983). Corner's work as procurator and patron is immortalized more substantially in the inscription that names him as one of those overseeing the great iconostasis in the Basilica by Jacobello and Pierpaolo dalle Masegne, of 1394. Boito 1888, 451.

38 BMCVe, Cl. III, 775. On this master see Marta Minazzato, "Maestro della Commissione Donato," *DBMI* 528–29.

39 As procurator, Donato was involved in overseeing the restoration of the Basilica, which had been badly

damaged after the fire of 1419, and the inauguration of the Mascoli Chapel in 1430, which was to acquire its famous mosaics over a span of some thirty years following. Michelangelo Muraro, "The Venetian Arti and Mascoli Chapel Mosaics," *Art Bulletin* 43, 4 (December, 1961): 263–74; Merkel 1973, 65–80. Paolo Da Peppo, "Donato, Bartolomeo," *DBI* 40 (1990).

40 *il Ricco di San Trovaso*, Norfolk, Holkham Hall, MS 643. Chambers 1997, 83.

41 On Francesco di Pietro Barbarigo, see Giorgio Cracco, "Barbarigo, Francesco," *DBI* 6 (1965).

42 Another in the style of Cristoforo Cortese is that of Nicolò K. di Francesco Bernardo (d. 1462), procurator *de ultra*, elected March 19, 1458. Norfolk, Holkham Hall, MS 647. Levi D'Ancona 1968, fig. 8; Chambers 1997, 84.

43 Syson and Thornton 2001, 12–36, 80.

44 Hans Baron coined the term "civic humanism" to describe this ethos as a response to despotism, and identified it as emerging in late fourteenth-century Florence, with such figures as the Chancellors of the Republic Leonardo Bruni and Coluccio Salutati as key protagonists. Baron 1966. On the influence of Baron, and assessment and criticism of his thesis – that revived ideals from ancient Greece and the Roman Republic in Florence and Venice made them havens of democracy in an age moving towards absolutism – see James Hankins, "Introduction," in Hankins, ed. 2000, 1–13.

45 See especially Nicolai Rubinstein, ed. "Political Theories in the Renaissance," in *The Renaissance: Essays in Interpretation* (London: Methuen, 1982): 153–200; King 1986.

46 From Sabellico's oration *De usu philosophiae*, in Marcantonio Sabellico, *Opera* (Venice: per Albertinum de Lisona Vercellensem, 24 December 1502): fol. 79, translation from King 1986, 23. See also King 1986, 42–49.

47 Finlay 1980; Queller 1986. While the specifics of this ethos shifted over time, because for centuries Venice remained an oligarchic Republic by contrast to Florence, republican ideals remained central there longer. Hans Baron, "The vita activa," in *In Search of Florentine Civic Humanism: Essays on the Transition from Medieval to Modern Thought* 2 (Princeton: Princeton University Press, 1988): 66–67. For a more in-depth study of the service and sense of duty of one prominent patrician, Marcantonio Barbaro, see Howard 2011.

48 Vienna, ÖNB, Cod. 438*. Mariani Canova 1995, 803. On Francesco Barbaro, see Percy Gothein, *Francesco Barbaro: Früh-Humanismus und Staatskunst in Venedig* (Berlin: Verlag die Runde, 1932); King 1986, 321–24; Germano Gualdo, "Barbaro, Francesco," *DBI* 6 (1964); Deborah Howard, "I Barbaro come collezionisti rinascimentali," *Collezionismo 2008*, 192–205.

49 King 1986.

50 Niccoli was one of the earliest collectors of ancient coins and sculptures in Florence, and discovered the first complete copy of Pliny's *Natural History*. Patricia Lee Rubin, "Understanding Renaissance Portraiture," in Christiansen and Weppelmann, eds. 2011, 2–25 (12).

51 *De re uxoria*. The dedication copy sent to Lorenzo de' Medici is Florence, Biblioteca Laurenziana Plut 78.25. The scribe was identified as Michele Germanico by Albinia C. de la Mare in "Humanistic script: the first ten years," *Das Verhältnis der Humanisten zum Buch*, eds. F. Krafft and D. Wuttke (Boppard: Kommission für Humanismusforschung, Mitteilung, 4, 1977): 89–108.

The *De re uxoria* has been partially translated into English, with an introduction, by Benjamin G. Kohl in *The Earthly Republic: Italian Humanists on Government and Society*, eds. Benjamin G. Kohl and Ronald G. Witt (Philadelphia: University of Pennsylvania Press, 1978): 179–230. Carole Collier Frick, "Francesco Barbaro's *De re uxoria*: A Silent Dialogue for a Young Medici Bride," in *Printed Voices: The Renaissance Culture of Dialogue*, eds. Dorothea B. Heitsch, Jean-François Vallée (Toronto and Buffalo: University of Toronto, 2004): 193–205.

52 Margaret L. King, "Caldiera and the Barbaros on Marriage and the Family: Humanist Reflections of Venetian Realities," *The Journal of Medieval and Renaissance Studies* 6 (1976): 19–60; King 1986, 92–98, 323–25.

53 Giovanni degli Agostini, *Istoria degli scrittori veneziani*, vol. 2 (Venice, 1754): 119; Germano Gualdo, "Barbaro, Francesco," *DBI* 6 (1964). Francesco himself married the noblewoman Maria Loredan in 1419 and had four daughters and a son. His son Zaccaria (*c*.1422–1492) also was knighted and became procurator (elected *de citra* March 14, 1487). Zaccaria shared with his father a passion for the study of antiquity, but his interests were more archeological, epigraphic, and antiquarian than literary. On his manuscript of epigraphic inscriptions, see Zorzi, ed. 1988, *Collezioni di antichità a Venezia*, 376.

54 Diller 1963.

55 Marino Zorzi, "I Barbaro e i libri," in Marangoni and Stocchi, eds. 1996, 363–83 (370), with relevant bibliography.

56 Zorzi, ed. 1988, *Collezioni di antichità a Venezia*, 371.

57 Columbia University Library, Rare Books and Manuscripts, Plimpton MS 017. Paul Kristeller, "Un codice padovano di Aristotele postillato da Francesco e Ermolao Barbaro: il manoscritto Plimpton 17 della Columbia University Library a New York," *La Bibliofilia* 50 (1948): 162–78.

58 Francesco Barbaro, *Epistolario*, ed. Claudio Griggio, 2 vols. (Florence: Olschki, 1991, 1999): 1, 18. On the letters and decoration by Andrea Contrario of two of the manuscripts of these works, see Barile 1993, 67–69.

59 On the development of the illusionistic devices in frontispieces, see Chapter 3, n. 121.

60 Michele Salvatico has been identified also with the copyist who signed his name Michael Germanicus. Rosario Contarino, "Contrario, Andrea," *DBI* 28 (1983); Claudio Griggio, *Copisti ed editori del 'De re uxoria' di Francesco Barbaro* (Padua: CLEUP, 1992).

Claudio Griggio and Albinia C. de la Mare, "Il copista Michele Salvatico collaboratore di Francesco Barbaro e Guarniero D'Artegna," *Lettere italiane* 37 (1985): 345–54. Barile 1993, 72–73. On the identification of Germanicus with Selvatico, and on the Latin script inflected with elements from Greek scripts developed by notaries and members of the Venetian chanceries, see also Elisabetta Barile, *Littera antiqua e scritture alla Greca. Notai e cancellieri copisti a Venezia nei primi decenni del Quattrocento* (Venice: Istituto Veneto di Scienze, Lettere ed Arti, 1994).

61 Alexander 1977, 12–13; Alexander, ed. 1994, 15. Mariani Canova 2009, 334; Albinia C. de la Mare and Laura Nuvoloni, *Bartolomeo Sanvito: The Life and Work of a Renaissance Scribe* (London: Association Internationale de Bibliophilie, 2009): 130.

62 National Gallery, London, NG696. Peter Humfrey, "The Portrait in Fifteenth-Century Venice," in Christiansen and Weppelmann, eds. 2011, 48–63 (50).

63 Barbaro's collection was cited again in the sixteenth century by Enea Vico. Zorzi, ed. 1988, *Collezioni di antichità a Venezia*, 16; Georgia Clarke, "Ambrogio Traversari: Artistic Advisor in Early Renaissance Florence?," *Renaissance Studies* 11, 3 (August 2008): 166–67, with relevant sources. Marianne Pade discusses the translations by Guarino and Barbaro of sections of Plutarch's *Lives* in Marianne Pade, *The Reception of Plutarch's "Lives" in Fifteenth-Century Italy* (Copenhagen: Museum Tusculanum Press, 2007): vol. 1, 179–230, 345–47. On Barbaro as a collector of coins, see Favaretto 1990, 48, n. 28.

64 *Malo mori quam fedari.* Francesco's adoption of the emblem predates its use in 1465 by Ferrante of Aragon, King of Naples, for his Order of the Ermine. Maria Francesca Tiepolo, "Il linguagio dei simboli. Le arme dei Barbaro," in Marangoni and Stocchi, eds. 1996, 133–91 (146–48); Moretti 2001.

65 Maria Francesca Tiepolo, "Il linguagio dei simboli. Le arme dei Barbaro," in Marangoni and Stocchi, eds. 1996, 133–91 (134–39).

66 Commission documents for procurators by Leonardo Bellini or his workshop/followers: Commission of Francesco Pr. di Nicolò Zane (d. 1474), elected *de ultra* March 16, 1462. BMVe, Lat. X, 113 (=3508); Commission of Andrea Pr. di Antonio Pr. Contarini (d. 1472), elected *de supra* April 2, 1463. BMVe, Lat. X, 315 (=3755); Commission of Domenico Pr. di Giovanni Diedo, elected *de supra* April 15, 1464. ISGM 2.b.2.5. Moretti 1958, plate 42b; Mariani Canova 1968, "Per Leonardo Bellini"; Commission of Nicolò Pr. di Giovanni Marcello (*c.*1399–1474), elected

de supra March 1, 1466. BMVe, Lat. X, 238 (=3509); Commission of Ludovico, also called Alvise, Dr. K. Pr. di Antonio Foscarini (d. 1480), elected *de ultra* May 29, 1468. BMCVe, Cl. III, 13. Levi D'Ancona 1968, fig. 16, cat. 20, 144; Commission of Andrea Pr. di Nicolò Lion (d. 1478), elected *de supra* November 10, 1473. BMVe, Lat. X, 358 (=3517); Moretti 1958, plate 43, 44a; Commission of Bernardo K. Pr. di Leonardo Giustinian (d. 1489), elected *de citra* December 18, 1474. BMCVe, Cl. III, 657. Moretti 1958, plate 44b. Chambers 1998, 84.

67 "*vetusto more.*" Alexander 1977, 13. The motif of angels holding up an inscription could be found by artists and patrons in Carolingian manuscripts that copied antique prototypes, as well as in ancient tomb sculpture, and in early Renaissance adaptations of the motif in sculpture. The scheme appears in Italian manuscript painting already by the mid-fourteenth century. For the emergence of *putti*, or *spiritelli*, in sculpture, see Dempsey 2001. An early example in manuscript painting: The signed illumination by Nicolò di Giacomo da Bologna in Giovanni d'Andrea, *Novella in libro Decretalium*, Milan, Ambrosiana, B.42, Inf. Illustrated in Angela Daneu Lattanzi and Marguerite Debae, *La miniature italienne du Xe au XVIe siècle* (Brussels: Bibliothèque Royale Albert Ier, 1969): 22, cat. 17, plate 4.

68 Of Andrea Pr. di Antonio Pr. Contarini (d. 1472), elected April 2, 1463. BMVe, Lat. X, 315 (=3755); and of Domenico di Giovanni Diedo, elected April 15, 1464. ISGM, 2.b.2.5.

69 BMVe, Lat. X, 358 (=3517). Susy Marcon in Zorzi, ed. 1988, *Biblioteca Marciana Venezia*, 160–61.

70 English translation: Johannes of Speyer's Printing Monopoly, Venice (1469), *Primary Sources on Copyright (1450–1900)*, eds. Lionel Bently and Martin Kretschmer, www.copyrighthistory.org; *Venezia 1469. La legge e la stampa*, ed. Tiziana Plebani (Venice: Marsilio, 2004): 33–34.

71 Howard 1975, 17–28; *Bessarione e l'Umanesimo*, ed. Gianfranco Fiaccadori, catalogue for the exhibition at the Marciana Library in Venice (Naples: Vivarium, 1994).

72 On Girolamo in Venice, see Mariani Canova 1995, 825–34. For an extensive biography of the artist, with relevant bibliography, see Federica Toniolo, "Girolamo da Cremona (dei Corradi)," *DBI* 56 (2001); Federica Toniolo, "Girolamo da Cremona," *DBMI* 310–15.

73 Cambridge University Library, Add. MS 4121. Paul Binski and Patrick Zutschi, *Western Illuminated Manuscripts: A Catalogue of the Collection in Cambridge University Library* (Cambridge: Cambridge University Library, 2011): 447–48, cat. 466; Chambers 1997, 32, fig. 11.

74 Giuseppe Gullino, "Erizzo, Antonio," *DBI* 43 (1993). See BMCVe, MS Prov. Div. 511 C/I: *Scritture famiglia Erizzo.* In Antonio's Commission, the large opening gold initial and the collar of a captive lioness in the

lower right-hand corner are etched with pseudo-Arabic letters. Such decoration was common already in Venetian manuscript illumination over 100 years earlier, and resembles the effect of inlaid metalwork from the Levant, which was popular in Italy. On this work, see Sylvia Auld, "Master Mahmud and Inlaid Metalwork in the 15th Century," in Carboni, ed. 2007, 212–25.

75 Sabbe Library, Berchmanianum Collection, MS 18 BK. Formerly Nijmegen, Berchmanianum. Gerard Isaac Lieftinck, *Manuscrits datés conservés dans les Pays-Bas: catalogue paléographique des manuscrits en écriture latine portant des indications de date. Part I: Les manuscrits d'origine étrangère (816–ca.1550)* (Amsterdam: North Holland Publishing Co., 1964): 112, n. 257, plate 425; vol. 2, 275. The miniatures of this master were first isolated as by a Master of the Giuramenti after his work in these documents, and then drawn into the oeuvre of an artist named after the miniature of personified Virtues on an architectural frontispiece opening a large printed volume of Gratian's *Decretals*, printed by Nicolas Jenson. Gratian, *Decretum* (Venice: Nicolas Jenson, 1477). Gotha, Forschungs- und Landesbibliothek, Mon. Typ. 1477, 2° (12). Mariani Canova 1969, 157, cat. 84; Andrea De Marchi in Baldissin Molli and Mariani Canova, eds. 1999, 356. Andrea De Marchi in Baldissin Molli and Mariani Canova, eds. 1999, 353–57, cat. 145.

The figure of Saint Anthony in the opening "I" is very similar to the figure of Aristotle opening the first volume of an illuminated printed edition of his works illustrated by Girolamo da Cremona, Antonio Maria da Villafora, and Benedetto Bordon. Aristotle, *Opera* (Venice: Andreas Torresanus de Asula and Bartholomaeus de Blavis, 1483). PML, 21194, 21195. Lilian Armstrong, entry in Alexander, ed. 1994, 204–5, cat. 101. On Antonio Loredan: Giuseppe Gullino in *DBI* 65 (2005).

76 In the so-called portrait of Bernardo Bembo by Hans Memling, of *c.*1471–74, the sitter holds up a coin of Nero to show the viewer. Dagmar Korbacher in Christiansen and Weppelmann, eds. 2011, 330–32. Nalezyty 2017, 31–36.

77 Gasparo Contarini, *La Republica e i magistrati di Vinegia* (Venice: per Baldo Sabini, 1551): 22. Gasparo (1483–1542), son of Alvise, was of the Madonna dell'Orto branch (*ramo*) of the Contarini family.

78 BMCVe, Cl. III, 313. Juvenal, Satire 8, verse 20. Bertuccio di Marin Contarini, of the *ramo* "Londra," later "Porta di Ferro." His brother Leonardo also was a procurator. His Commission as procurator is BMCVe, Cl. III, 314, and his biography by Franco Rossi is in *DBI* 28 (1983). Bertuccio's testament, in which he expresses his wish to be buried in Sant'Andrea della Certosa, is discussed in Alvise Zorzi, "I Contarini 'Londra' o 'Porta di Ferro' da Santa Ternità," in Mario Piantoni and Laura De Rossi, eds. *Per l'arte da Venezia all'Europa. Studi in onore di Giuseppe Maria Pilo, 2.*

Da Rubens al contemporaneo (Venice: Edizioni della Laguna, 2001): 605–7.

79 *tota licet ueteres exornent undique cerae*
atria, nobilitas sola est atque unica virtus.
Paulus uel Cossus uel Drusus moribus esto,
hos ante effigies maiorum pone tuorum.

(8.19–22)

Translation by Susanna Morton Braund, *Juvenal and Persius* (Cambridge, MA, and London: Harvard University Press, 2004): 323–25.

80 Eva Matthews Sanford, "Renaissance Commentaries on Juvenal," *Transactions of the American Philosophical Society* 79 (1948): 92–112.

81 In addition to the manuscripts discussed in the text, the following are attributable to Benedetto Bordon and his workshop or followers: Commission of Nicolò Dr. K. Pr. Michiel (d. 1518) as procurator *de supra*, 1500, BMVe, Lat. X, 112 (=3507). Chambers 1997, 85, n. 314; Benedetto Bordon, Commission of Girolamo di Antonio Giustinian, procurator *de ultra*, 1516, BMCVe, Cl. III, 203. Chambers 1997, 85, n. 316; Benedetto Bordon workshop, Marco Pr. di Alvise Pr. da Molin (d. 1566), procurator *de citra*, 1522, BMVe, It. VII, 2598 (=12490). Chambers 1997, 85, n. 318; Bordon workshop, Pietro Pr. di Alvise Marcello (d. 1555), procurator *de ultra*, 1526, Groningen, Universiteits Bibliotheek, MS 130. Illustrated in Gerard Isaac Lieftinck, *Manuscrits datés conservés dans les Pays-Bas: catalogue paléographique des manuscrits en écriture latine portant des indications de date. Part I: Les manuscrits d'origine étrangère (816–ca.1550)* (Amsterdam: North Holland Publishing Company, 1964): no. 44, plates 441–43. Chambers 1997, 86, n. 322.

82 The earliest example of this motif in a procurator's Commission is in that of Antonio Grimani as procurator *de citra* of 1494, where it takes place in the opening initial (fig. 0.3).

83 "*ex op(er)e virtutis q. praestantia in patriam praestitis.*" Windsor, Royal Library, MS RCIN 1081196. Chambers 1997, 43–44.

84 Antonio's son Leonardo (1523–1576) also achieved great positions of power in the state. But as an important patron of Andrea Palladio and a collector of ancient coins and statues, Leonardo did not follow his father's model of civic service. He became more renowned for spending his family's wealth, causing him to have to borrow money from his own son Alvise to pay off debts. On Leonardo Mocenigo as collector, see Linda Borean, "Leonardo Mocenigo," in *Collezionismo 2008*, 297–98; Cooper 2005, 163–69.

85 "*Per omnia tu iudex cave ne declines a iusto.*" Harvard College Library, Houghton Library, MS Typ 543. Chambers 1997, 86. See also the document for Marcantonio Venier of 1554, and comments in Appendix 2.

86 Elected March 26, 1522. BnF, MS Smith Lesouëf 17. The manuscript was rebound in the eighteenth century.

Chambers 1997, 85. On the Trees Master, see Zuccolo Padrono 1972, 16–18.

87 Jacopo Soranzo il Vecchio was one of the patricians who supervised Jacopo Sansovino and other artists in the extensive adaptation of the large hall, then known as the Libreria (later the Sala del Scrutinio), in the Ducal Palace for meetings of the Senate. Soranzo did, however, vote mostly against Sansovino in the legal proceedings concerning the collapse of a vault of the Library brought against him from 1545 to 1547. Boucher 1991, vol. 2, 152, 274, n. 75; Hirthe 1986, "Die *Libreria* des Jacopo Sansovino," 132.

88 Chambers 1997, 86.

89 The surviving leaves and manuscripts are for the patricians Girolamo di Vettor Bragadin (d. 1546), Giulio di Giorgio Contarini (d. 1575), and Girolamo di Andrea Marcello (d. 1533). The Commission/Oath of Girolamo Bragadin is BMVe, Lat. X, 224 (=3798). Zuccolo Padrono 1971, 58, fig. 80; Chambers 1997, 85, n. 323. The leaf from the Commission/Oath of Giulio di Giorgio Contarini is BL, Add. 20916, fol. 5. Bradley 1896, 273–74, 253, fig. 2; Zuccolo Padrono 1971, 56, fig. 79; Chambers 1997, 85, n. 325. The leaf from the Commission/Oath of Girolamo di Andrea Marcello is now in Paris, Musée Marmottan Monet, Wildenstein Collection. Levi D'Ancona 1956, 35, cat. 60; Chambers 1997, 85, n. 324. Only the opening leaf for the Commission of Girolamo Bragadin remains intact within the original document, but it appears to have been mended and repasted into the book.

The Commission of Pietro di Alvise Marcello (d. 1555), elected procurator *de ultra* in 1526, similarly has a portrait of the procurator taking his oath from a book offered by Mark, but the painting is by Benedetto Bordon, or a miniaturist working in his style, and is similar to the document for Gasparo da Molin, elected *de citra* in 1526.

90 Private collection, formerly Munich, Julius Böhler; Lucerne, Kunsthandel A. G. (F. Steinmeyer). Manfredi 1602, 27; Pallucchini and Rossi 1982, vol. 2, 131–32, cat. 6, vol. 2, fig. 6; William R. Rearick, "The Portraits of Jacopo Bassano," *Artibus et Historiae* 1, 1 (1980): 99–114 (108); William R. Rearick, "Reflections on Tintoretto as a Portraitist," *Artibus et Historiae* 16, 31 (1995): 51–68 (56, 66, n. 18); *Natura e maniera tra Tiziano e Caravaggio: le ceneri violette di Giorgione*, eds. Vittoro Sgarbi and Mauro Lucco (Milan: Skira, 2004): cat. 107, 308–9; Echols and Ilchman 2009, 120, entry 1. Michel Hochmann in *Tintoretto: A Star Was Born*, ed. Roland Krischel (Cologne and Paris, 2017): cat. 36, 143, 153. The document image could aid in dating the Tintoretto portrait, for the miniature clearly is dateable to around 1538, the time of Marcello's election. Since the painting by Tintoretto portrays Marcello as substantially older, the oil portrait may have been executed a number of years later.

91 By paying for election as procurator at the very young age of thirty-one, he could refuse appointment as commander of a commercial galley (*sopracomito*). The appointment as *sopracomito* would have taken him out of active political life for some time. Sansovino 1663, 170–71; Giuseppe Gullino, "da Lezze, Giovanni," *DBI* 31 (1985). In this way, Giovanni bypassed the requisite tour of duties by which procurators came to election by merit.

92 BMCVe, Cl. III, 14. Chambers 1997, 46–47. ASVe, PSM, Procuratia de supra. Cassier Chiesa 1534–41, r. 2. Von Hadeln 1911, "Nachrichten über Miniaturmaler," 167. That same year, Jacopo signed a miniature in a Psalter for the Monastery of San Giorgio Maggiore. Levi D'Ancona 1962; Susy Marcon, "Giallo, Jacopo del," *DBMI* 263–65. In December of 1538, Jacopo del Giallo was paid 5 ducats for illuminating a choir book, presumably for use in the Basilica of San Marco. April 29, 1539, ASVe, PSM de supra, Chiesa, reg. 2, unnumbered page. See more details on the entry in Chambers 1997, 46, n. 121.

93 Christopher Cairns, *Pietro Aretino and the Republic of Venice. Researches on Aretino and his circle in Venice 1527–56* (Florence: Leo S. Olschki, 1985): 16–30; Maria Giovanna Sarti, "Giallo, Iacopo del …" *DBI* 54 (2000); Giuseppe Gullino, "da Lezze, Giovanni," *DBI* 31 (1985).

94 Pietro Aretino, *Il primo libro delle lettere* (Milan: G. Daelli and C. Editori, 1864): 155–56.

Aretino subsequently wrote to Jacopo as a friend, congratulating him on the birth of a son on May 7, 1542. Jacopo had died by 1543, and Aretino wrote of his sadness over his death, and praised his assistant Antonio Bernieri, da Correggio. In 1545, Aretino wrote to Bernieri a letter in which he again expressed his sadness over Jacopo's demise. Aretino, *Dialogo nel quale si parla del giuoco con moralità piacevole* (Venice: 1543), reprinted in Pietro Aretino, *Le carte parlanti* (1543), eds. Giovanni Casalegno and Gabriella Giaccone (Palermo: Sellerio, 1992), 373; *Lettere sull'arte di Pietro Aretino*, eds. Fidenzio Pertili and Ettore Camesasca (Milan: Edizioni del Milione, 1957): vol. 1, 120ff.; vol. 3, part 2, 336ff.; Maria Giovanna Sarti, "Giallo, Iacopo del …" *DBI* 54 (2000). No works are known by Bernieri, who was protected and highly esteemed by Aretino.

95 Giuseppe Gullino, "da Lezze, Giovanni," *DBI* 31 (1985).

96 As in the work of Donatello, Mantegna, and Jacopo Bellini but also would feature prominently on the Library frieze designed and supervised by the Florentine Jacopo Sansovino, as *proto* of the procurators of San Marco. Antonio Foscari, "Festoni e putti nella decorazione della Libreria di San Marco," *Arte Veneta* 38 (1984): 23–30.

97 Now Museo Archeologico, Fragment of Sarcophagus

with Rape of Prosperpine, Inv. 1887, n. 167–66 (legato Grimani 1586). Foscari 1984, 27.

98 ASVe, PSM de supra, Chiesa, reg. 2, unnumbered pages. See Chambers 1997, 46, n. 123, for details. Pietro di Francesco Grimani (ramo "B", "S. Boldo," d. 1553).

99 Szépe 2009.

100 The quality of Colonna's work was approved by the sculptor and architect Jacopo Sansovino, in his capacity as proto. Chambers 1997, 46, n. 124–26. On the miniaturist Colonna, Susy Marcon, DBMI 271–72.

101 Two Commissions of procurators have the same simple decorative scheme painted by the T.° Ve Master: Tommaso di Michele Contarini (c.1459–1554), procurator de citra, elected in 1543, BMVe, Lat. X, 96 (=2250); Marcantonio di Cristoforo Venier (d. 1556), procurator de citra, elected in 1554, BMCVe, Cl. III, 321 (detached leaf).

102 Vio 1980, 193; Chambers 1997, 62, 69, 79–80.

103 The uniformity of the three documents for the procurators de ultra, elected in 1537 (Giulio Contarini, Girolamo Marcello, and Girolamo Bragadin) may already reflect this payment limit. Decree of the Great Council, September 11, 1580: ASVe, Maggior consiglio, Deliberazioni, reg. 31, fols. 71v–72r. The decree was first published by Bartomeo Cecchetti, "Le Commissioni dei Procuratori di San Marco," Archivio Veneto 30 (1885): 455–56; revised transcription in Chambers 1997, 81–82. Partially translated into English by Jennifer Fletcher in Chambers and Pullan, eds. 1992, 409.

104 The relevant documents from the registers of the Cassier chiesa of the Procuratia de supra (ASVe) were first published (from the notes of Gustav Ludwig) by Detlev von Hadlen. Von Hadeln 1911, "Beiträge zur Tintorettoforschung," 55, nos. 14, 15. Miguel Falomir, "Tintoretto's Portraiture," in Falomir, ed. 2007, 453. Tintoretto, it must be admitted, was notorious for often undercutting his competition through low pricing of his paintings. Nichols 1999, 114–15.

105 Von Hadeln 1911, "Beiträge zur Tintorettoforschung," 41–58. For the most recent discussion of such portraits by Tintoretto, see Falomir 2007, 95–114. The portraits were first described in Sansovino 1581, fols. 110v–111r. Subsequent editions document the growing number and changed locations of the portraits, Chambers 1997, 50–56.

106 Commission of Girolamo Zane, procurator de citra, 1568, BL, King's 156, and Commission of Alvise Tiepolo, procurator de citra, 1571, ASVe, Archivio Tiepolo, II consegna, b. 5, n. 10. Chambers 1997, 66–67, figs. 25–26.

107 Detailed expense requests submitted to the procurators de supra in 1577 by Vitali are fully transcribed in Chambers 1997, 61–71, 79–80. See also Vio 1980, 192–202.

108 On the position of Captain General "da mar" and its

evolution in the seventeenth century, see Casini 2001, 219–70.

109 A description of the "degno ordine" granting him his baston as captain general in the Church of San Marco during the feast of Easter of 1570 was published. The account was printed in an eight-folio, short bulletin written in a journalistic manner: "Today, under very clear skies, the Baston of the General of the Sea was given to Girolamo Zane in the manner following …" "Tutte le solennità et allegrezze fatte In Venetia, nel dare il Baston generale al Magnifico et Clariss. Sig. Hieronimo Zane, meritissimo generale de l'Armata in Mare de la Illustrissima Signoria di Venetia. Con altri Avisi notabili circa la Nuova Guerra principiata da essi Signori, contra gl'Infideli" (Verona: Sebastiano e Giovanni dalle Donne, n.d.). Republished as Ad Antonio Cucchetti nel giorno in cui si fa sposo a Vittoria Pinaffo (Venice: Tipografia della Gazzetta, 1880).

110 Patricia Fortini Brown, "Painting and History in Renaissance Venice," Art History 7 (1984): 263–94.

111 Chambers 1997. An illustration of the costume of Greek nobles is in Vecellio 1598, 418.

112 Titian, Francesco Maria I della Rovere, Duke of Urbino, 1536–38, Galleria degli Uffizi, Florence. On the broader historical, artistic, and literary background of the image of men in armor, see Garton 2008, 83–124. Sebastiano Venier as captain general, Vienna, Kunsthistorisches Museum n. 694, Pallucchini and Rossi 1982, cat. 147.

113 BL, King's 156. Colophon: "Presbyter Ioannes Vitalis Brixianus scripsit, literis aureisque ornavit hunc librum Anno salutis M.D.L.XVIII" (f. 72v). The manuscript has been rebound. Chambers suggests that the document illuminations were made afterwards, Chambers 1997, 64.

114 Tucci 1974.

115 Barbaro VII, 34: 324. ASVe, Testamenti, Atti Cesare Ziliol 1259.521 and 1263 iv. 861 (February 10, 1569). On Girolamo Zane's career, see Samuele Romanin, Storia documentata di Venezia (Venice: 1857), vol. VI: 288–99; Tucci 1974, 409–33; Chambers 1997, 64; Raines 2006, 311–20; Fenlon 2007, 157–65.

116 Parrasio Micheli, Girolamo Zane, Venice, Accademia, Inv. 1028, in deposit at the Istituto Universitario di Ca' Foscari. Moschini Marconi 1962, 142–43, cat. 230. Newton 1988, 26.

117 See for example portraits of Marcantonio Barbaro, Howard 2011, 9–10, figs. 7–8.

118 Detlev von Hadeln, "Parrasio Micheli," Jahrbuch der Königlich Preussischen Kunstsammlungen 33 (1912): 149–72 (158, fig. 4); Moschini Marconi 1962, 142–43, cat. 230; Mancini 1999.

119 The miniatures of the document have been referenced by scholars to propose Zane as the sitter in other portraits by Tintoretto. But the comparison of the images of him in the manuscript with portraits in oil

remind us of the difficulties in identifying the sitters of portraits, for the face of the same man can be very different from various angles and in progressive stages of his life. In the sixteenth century, there was an established practice of keeping a *ricordo*, or painter's record, of a person portrayed in artist workshops, and it appears that the artist used two preparatory drawings, or *ricordi*, to convey the different sides of Zane's face. For example, Zane's beard is more closely shaved in the left-hand miniature. William R. Rearick identified Zane in a painting by Tintoretto in the Armand Hammer Collection, Los Angeles, and in another in the National Museum, Warsaw, cat. 34679 (listed and illustrated in Pallucchini and Rossi 1982, vol. 2, 99, cat. 122). William A. Rearick, "Reflections on the Venetian Cinquecento in Light of the Royal Academy Exhibition," *Artibus et Historiae* 9 (1984): 74. A *ricordo* could be reused for paintings for various destinations and altered with different clothing and backgrounds. Likewise, as with the Commissions of procurators of 1537 by the T.° Ve Master, a general model for costume and pose could be reused with different faces. Falomir, ed. 2007, 105–12.

120 *The Garden of Love*, with initials in the lower right-hand corner usually interpreted as "M. A.," but the second initial is indeterminate, for it also could be an "R". Cambridge, Fitzwilliam, 31.K12–61. Attribution of the print to Marco del Moro by Adam Bartsch, *Le peintre graveur*, vol. 16 (Leipzig: J. A. Barth, 1870): 206–8; *The Illustrated Bartsch*, ed. Henri Zerner (New York: Abaris, 1979), vol. 32: 315, 319.

121 Alessandro Ballarin, "Considerazioni su una mostra di disegni veronesi del Cinquecento," *Arte Veneta* 25 (1971): 92–118 (115). Also on the difficulty of assessing Moro's oeuvre: Enrico Maria Guzzo, "Del Moro (Dal Moro, Moro), Marco," *DBI* 38 (1990). The most recent study of him is in Cordellier and Sueur, eds. 1993, 134–38.

122 Leaf detached from the Commission to Girolamo Zane as Captain of Padua, 1544. Dublin, Chester Beatty Library W219.

123 A medal by Andrea Spinelli of Zane also features the penitent aspect of Jerome. National Gallery of Art, Washington, D.C., Inv. 1957.14.1008 a, b.

124 He was given the right to burial there in 1562 and the altar was finished in 1564. Sartori 1956, 78; ASVe, Notarile Testamenti Cesare Ziliol, 1259, n. 521, 86v and 1263 (copy), 86v–88r, February 10, 1569. Partially transcribed in Finocchi Ghersi 1998, 157–59, n. 66. The sculpture by Alessandro Vittoria of Jerome survives, but much of the altar was dismantled in the eighteenth century. The altar originally also held stucco figures by Vittoria of Saints John the Baptist, Peter, Andrew, and Leo. Finocchi Ghersi 1998.

125 One can compare the imagery to two Commissions of a different and older Girolamo di Bernardo Zane (S. Stin):

as *Podestà* and Captain of Verona, 1528, BMCVe, Cl. III, 742; as Captain of Verona, 1528, Boston Public Library, Md. MS 143 (MS 1564). In this latter document, Jerome is shown as a cardinal.

126 Lisbon, Museu Calouste Gulbenkian, Inv. L.A. 140, previously Engel-Gros Sale, 1921. Marcon 1999, 42, with pertinent bibliography, 49, n. 32. Chicago, Newberry Library, MS Wing ZW 1.575. Da Mula's portrait by the workshop of Tintoretto, for the offices of the procurators, is in the Accademia, Inv. 587. Moschini Marconi 1962, 255, cat. 445. On da Mula as a patron of Tintoretto, see Frederick Ilchman in Falomir, ed. 2007, 333–37. Chambers 1997, 67, 87.

127 Anna Contadini, "Sharing a Taste? Material Culture and Intellectual Curiosity around the Mediterranean, from the Eleventh to the Sixteenth Century," in Anna Contadini and Claire Norton Farnham, eds. *The Renaissance and the Ottoman World* (Burlington, VT: Ashgate, 2013): 23–62; Anna Contadini, "Threads of Ornament in the Style World of the Fifteenth and Sixteenth Centuries," in Gülru Necipoğlu and Alina Payne, eds. *Histories of Ornament from Global to Local* (Oxford: Oxford University Press, 2016): 290–305.

128 Michel Hochmann, "La famiglia Grimani," in *Collezionismo 2008*, 207; Giuseppe Gullino, "Grimani, Marino," *DBI* 59 (2002).

129 BMCVe, Cl. III, 738, as *Podestà* of Brescia, 1571 (with original layered and painted binding); BMCVe, Cl. III, 744, as ducal councillor; BMCVe, Cl. III, 740, as Captain of Padua, 1587 (with original leather layered and painted binding). Each opens with a blank folio, upon the verso of which is the opening text. The records of his expenses as doge do not mention the *Promissione*. This accords with the tradition that the decoration would have been paid for by the state. By contrast, the Commission of Marin's father, Girolamo di Marin Grimani (1496–1570), as Captain of Verona (1550) is lacking its opening leaf, suggesting that it was nicely painted. Oxford, Bodleian, Laud misc. 712. See Epilogue, n. 10. On Girolamo di Marin, see Michela Dal Borgo, "Grimani, Girolamo," *DBI* 59 (2003).

130 ASVe, Archivio Grimani e Barbarigo, b. 20. Notatorio, December 17, 1589. The payment is transcribed in Hochmann 1992, "Le mécénat de Marino Grimani," 44, 51, n. 43. The parchment (*bergamina*) cost 20 lire and was purchased from the bookseller, or *liberer* (*libraio*), "al relogio," or at the clocktower of San Marco. This was the same source the scribe Giovanni Vitali used for purchasing membrane for writing earlier Commissions of the procurators. Hochmann transcribed it as 200 lire. For the binding, Marin broke down the payments as 18 lire for the velvet; for the silver and fixtures, 9 lire; for the actual cost of having it bound, 10 lire (so 37 lire, or 5.6 ducats). Gold and silver ducats were of different value. One gold ducat = 6 lire and 4

soldi. One lira = 20 soldi. One gold ducat = 124 soldi. Chambers 1997, 79–80.

131 For example, Michael Bury has convincingly argued that the initials "B. M." in various states of etchings by Marco's father, Battista del Moro, are in fact the monogram of a printer or print dealer. Michael Bury, "New Light on Battista del Moro as a Printmaker," *Print Quarterly* 20 (2003): 123–30 (129).

132 Vasari highlighted in particular a now-lost miniature by Battista of Saint Eustace's vision of the crucifix in the antlers of a stag. Vasari 1906, vol. 5: 296–97, 423–24. The most recent assessment of Battista del Moro's career, with relevant bibliography, is Pierpaolo Brugnoli and Diana Pollini, "Per una biografia di Battista del Moro," *Atti dell'Accademia roveretana degli Agiati*, series 8, vol. 10 (2010): 191–207.

133 Leonardo Fioravanti, *Dello specchio di scientia universale ...* (Venice: Gli Heredi di Marchiò Sessa, 1572), fol. 47r–v. The earlier editions of 1564 and 1568 do not mention Marco del Moro.

134 Von Hadeln 1911, "Beiträge zur Tintorettoforschung," 118, 141; Von Hadeln in Ridolfi 1965, vol. 1, 333, n. 2; vol. 2, 121; Giangiorgio Zorzi, "Nuove rivelazioni sulla ricostruzione delle sale del piano nobile del Palazzo Ducale di Venezia dopo l'incendio dell'11 maggio 1574," *Arte Veneta* 7 (1953): 123–51 (134–36).

135 Barbaro Cicogna 2501, 117; Barbaro Cicogna 2504, 17.

136 The signature is "MAR°.ANG .V. F", Paris, Musée du Louvre, Inv. 2799. This drawing was in the *Libro de' disegni* of Giorgio Vasari. The cartouche of the frame (not illustrated) carries the attribution to Baccio Bandinelli, but this may have been due to an error in remounting on the part of E. Jabach. Cordellier and Sueur, eds. 1993, 134–35.

137 See for example the painting by Bonifacio de' Pitati for the Camerlenghi Palace. Venice, Accademia, Inv. 845. Moschini Marconi 1962, 62–63, cat. 104.

138 The paintings were touched up in the early eighteenth century by Sebastiano Ricci, and it is hard to make out Marco del Moro's style from them. Richard Cocke, *Veronese's Drawings* (Ithaca, NY: Cornell University Press, 1984): 197–99. The payments by the Salt Officers to Marco del Moro are documented from February 23, 1576, to March 16, 1577. Von Hadeln 1911, "Beiträge zur Geschichte des Dogenpalastes," 31–32.

139 Signed "MARCO A. DEL MORO F," Venice, Accademia, Inv. 1041; Moschini Marconi 1962, 7, cat. 5.

140 Wolters 1987, 247–55.

141 Staale Sinding-Larsen, "The Changes in the Iconography and Composition of Veronese's *Allegory of the Battle of Lepanto* in the Doge's Palace," *Journal of the Warburg and Courtauld Institutes* 19, 3/4 (July–December, 1956): 298–302.

142 On these projects see Martin 1991; Hochmann 1992, "Le mécénat de Marino Grimani."

143 See for example the paintings for the document of the procurator Luca di Salvador di Luca Dr. Michiel (1520–1596), which also celebrate him simultaneously as a warrior and as charitably administrating his duties as procurator (Chapter 7).

144 ISGM 2.c.1.2. His manuscript was bound in red velvet, which originally had metal fixtures. Szépe 2004. Contarini was knighted by Henry IV, King of France. Da Mosto 1977, 354–75; Gino Benzoni, "Contarini, Francesco," *DBI* 28 (1983). They were named "Porta di Ferro" after the fifteenth-century iron gate of the palace near the Church of San Francesco della Vigna. Francesco's great-great-grandfather was the procurator Bertuccio. The branch of the family died out in 1799 and the gate was taken down in the nineteenth century. Eze 2016, 201–2.

145 PRO, 30/25: 104/7; PRO, 30/25: 104/9.

146 "*Deo et Patriae omnia debeo/ soli deo honor e gloria.*"

147 A tomb monument to him with a portrait bust was sponsored by his nephews for the Church of San Francesco della Vigna.

148 BMCVe, Cl. III, 946. Antonio Grimani "ai Servi" was portrayed with his Commission manuscripts in the portrait of him now in Vicenza (fig. 0.22). Another seventeenth-century example is the Commission of Vincenzo di Domenico Cappello (1570–1658) as procurator *de ultra*, 1632. BMCVe, Cl. III, 190.

149 Udine, Civici Musei.

150 Fondazione Querini Stampalia, n. 219/259. Giuseppe Maria Pilo, "Per una datazione probabile del ritratto del procuratore e provveditore generale da mar Daniele IV Dolfin," *Arte documento* 12 (1998): 122–29.

151 See for example *Azione drammatica pel glorioso solenne ingresso alla dignità procuratoria di san marco di sua eccellenza il Signor Cavaliere D. Aurelio Rezzonico* (Venice: Giambattista Novelli, 1759). Described and illustrated in Pettoello 2005, esp. 189–340, 504–91. Eleanor M. Garvey, "Some Venetian Illustrated Books of the 18th Century in the Harvard College Library," *Bulletin du bibliophile* 2 (1999): 293–310.

CHAPTER 5: THE CHARGE TO THE RULERS OF EMPIRE

1 The generally unchanging formula is "*Nos* (reigning doge's name) *Dei gratia Dux Venetiarum. Committimus tibi nobili viro* (patrician recipient's name) *dilecto civi et fideli nostro.*"

2 Nevertheless, a Bernardo Fogari was called "*miniatore publico*" by Giovanni Andrea Rota in his description of the coronation of Morosina Morosini Grimani as dogaressa in 1597. This could mean that the Republic kept some miniaturists on salary at this date. Fogari

apparently designed and oversaw the creation of a temporary triumphal arch commissioned by the Guild of the Butchers, under the counsel of the lawyer Attilio Facio. Attilio Facio, *Lettera nella quale si descrive l'ingresso nel palazzo ducale della Serenissima Morosina Morosini Grimani …* (Venice: Giov. Ant. Rampazetto, 1597): 19–20.

3 Brown 1996; Carboni, ed. 2007.

4 There is debate on the use of the term "empire" for Venice. Monique O'Connell, "Class History: Officials of the Venetian State," in O'Connell, ed. *c.*2009, paragraphs 182–202. The literature on Venetian maritime trading and possessions is vast. For recent orientations, see Crouzet-Pavan 2002; O'Connell, ed. *c.*2009.

5 Monique O'Connell, "Class History: Officials of the Venetian State," in O'Connell, ed. *c.*2009, paragraph 193. For orientation to the rich recent research on Venice and the mainland, and the debates among patricians over Venetian expansion in the fifteenth and sixteenth centuries, see Tagliaferri, ed. 1981; Alfredo Viggiano, "Il Dominio da terra: politica e istituzioni," *SDV* 4 (1996), *Il rinascimento. Politica e cultura*: 529–75; Gaetano Cozzi and Michael Knapton, *Storia della Repubblica di Venezia: dal 1517 alla fine della Repubblica* (Turin: UTET, 1992): 212–13; Crouzet-Pavan 2002, 97–137 (133); Sergio Zamperetti, "Immagini di Venezia in Terraferma nel '500 e primo '600," *SDV* 6 (1994), *Dal rinascimento al barocco*: 925–42.

6 For some examples of illuminated manuscripts of the statute books of cities and territories subject to Venice, see *Gli statuti dei comuni e delle corporazioni in Italia nei secoli XIII–XVI* (Rome: Edizioni de Luca, 1995): 105–19. Benjamin G. Kohl created a list of the earliest printed editions of such statute books in "The World of Early Printing and Vassar College," in *Incunabula in the Vassar College Library* (Poughkeepsie: Vassar College, 2003), 28–32.

7 The term *podestà* evolved from the term *praetor*, referring to Roman administrators of justice. The term was adopted by early city-states in Italy in general to convey voluntary acceptance of governance from another town. Amelot della Houssaia 1681, vol. 2, 595–96. Patricia Fortini Brown is working on an important book project on Venetian governance abroad entitled "Venice Outside Venice." Relevant publications include Patricia Fortini Brown, "Becoming a Man of Empire: The Construction of Patrician Identity in a Republic of Equals," in Avcıoğlu and Jones, eds. 2013, 231–49; Patricia Fortini Brown, "Ritual Geographies in Venice's Colonial Empire," in Rolf Strom-Olsen and Mark Jurdjevic, eds. *Rethinking Early Modern Modernity: Methodological and Critical Innovation since the Ritual Turn: Essays in honor of Edward Muir* (Toronto: Centre for Reformation and Renaissance Studies, 2016):

43–89; Patricia Fortini Brown, "The Venetian Loggia: Representation, Exchange, and Identity in Venice's Colonial Empire," in Sharon E. J. Gerstel, ed. *Viewing Greece: Cultural and Political Agency in the Medieval and Early Modern Mediterranean* (Turnhout: Brepols, 2016): 209–35.

8 These were the *Provveditore generale da mar*, who resided in Corfu, the *Provveditore generale* or *Lieutenant* of Friuli, who served in Udine, and the *Provveditore generale* of Dalmatia, who resided in Zara.

9 Ventura 1964, 45–50; Cozzi, ed. 1980, 94ff. and 156ff.; del Torre 1986, 217ff. Monique O'Connell, "Class History: Officials of the Venetian State," in O'Connell, ed. *c.*2009, paragraphs 182–202.

10 Sansovino 1581, fol. 175r. Wolters 1987, 150; Gaier 2002, 107, n. 374.

11 For a summary of some of these rules and when they were developed, see Tentori 1782–90, vol. 2, 266. For the printed editions of some Commission manuscript texts, see the Bibliography of Printed *Ducali* Texts in the present book.

12 Scholarship that emphasizes Venetian rule as overweening and disastrous for a region includes Agostino Zanelli, "La devozione di Brescia a Venezia e il principio della sua decadenza economica nel secolo XVI," *Archivio Storico Lombardo* XXXIX, fasc. XXXIII (1912): including 51–61. Stephen D. Bowd argues for a more interactive arrangement in *Venice's Most Loyal City: Civic identity in Renaissance Brescia* (Cambridge, MA: Harvard University Press, 2010). Donatella Calabi, "Città e territorio nel Dominio da mar," *SDV* 6 (1994), *Dal rinascimento al barocco*: 943–77.

13 Wolters 1987, 150; Del Torre 1986, 219ff.; Neher, "Verona and Vicenza," in Humfrey, ed. 2007, 252–84.

14 Giuseppe Gullino, "Quando il mercante costrui la villa: le proprietà dei Veneziani nella Terraferma," *SDV* 6 (1994), *Dal rinascimento al barocco*: 875–924.

15 Bouwsma 1968, 74–79.

16 Tagliaferri 1973–79; Ventura 1994.

17 Tatio's books can be considered as bids for patronage. The texts were dedicated to Venetian patricians; Marin Pasqualigo, and Ottaviano di Giovanni Antonio Valier as *Podestà* of Verona in 1573. Tatio 1564; Tatio 1573.

18 HLSM, EL 9 H13, 33. A Commission of Agostino di Benedetto Bembo as Proveditor of Asola, of 1548, with simpler illumination: BFQS, Cl. IV, Cod. 10 (=1066).

19 "*Virtutis illustris comes/ benefatorum merces.*"

20 Andrea Alciato, *Emblemata* (Lyons: Guillaume Rouillé, 1548): 41.

21 Andrea Alciato, *Emblemata* (Lyons: Guillaume Rouillé, 1548): 19. "*Sobriè vivendum: & non temerè credendum*" and "*Ecce oculata manus credens id quod videt …*" Translated as "Live soberly; do not believe readily" and "See here a hand with an eye, believing

what it can see." Andrea Alciato, *Emblemata* (Lyons: 1550), trans. and annotated by Betty I. Knott with an introduction by John Manning (Aldershot and Brookfield, VT: Scolar Press and Ashgate, 1996): 22. Agostino went on to serve as a ducal councillor and on the Council of Ten.

22 Giovanni di Agostino Bembo's Commission as procurator *de ultra*, 1601: BFQS, Cl. IV, Cod. 24 (=661). It was not illuminated. Chambers 1997, 88.

23 December 1243, to Leonardo Querini as *Conte* of Zara (Zadar, Croatia). ASVe, Collegio, Commissioni rettori e altre cariche, b. 1, n. 11.

24 An early one is that for Domenico Michiel as *Podestà* of Chioggia, 1357. ASVe, Collegio, Commissioni ai rettori ed altre cariche, b. 1, n. 1. It has the monogram of Rafaino Caresini (Grand Chancellor 1365–90) on the inside of the top wrapper.

The classic form of the Commission as nested within a membrane wrapper, with the title and monogram of the Grand Chancellor on the front of the wrapper, is already established in the Commission to Nicolò Giustinian as Captain of Treviso, of 1367, also with the monogram of the Grand Chancellor Rafaino Caresini. ASVe, Collegio, Commissioni rettori e altre cariche, b. 1, n. 2.

25 These were then given a title, and/or signed with the monogram of the Grand Chancellor on top. See, for example, the opening leaf with monogram of Giovanni Dedo, Grand Chancellor 1482–1510, in the Commission to Pietro di Giovanni Pr. Cappello as *Podestà* of Brescia, 1501, Berlin, Staatliches Bibliothek, MS Hamilton 224. Boese 1966, 110.

The overall size of these manuscripts is usually a modest quarto (around 24.5 × 17.5 cm), by contrast to the larger folio size of most *Promissioni* (up to 35 × 25 cm), and therefore Commissions were less imposing but more convenient to handle and carry around. In the early sixteenth century, some of these manuscripts, as in the case of the councillor and procurator *ducali*, were produced in formats mimicking the popular octavo or *libro da mano* format of literary texts read for pleasure. See for example the Commission to Domenico di Maffei Contarini (1451–1533) as Captain of Verona, of 1508 (20 × 13 cm). BMCVe, Cl. III, 308. Tools for navigating the text often were added, including an index. Sometimes the patrician recipient himself seems to have provided his own index according to the alphabetical order of material. An example is the Commission to Marcantonio K. di Carlo Contarini (1505–1546) as *Podestà* of Padua, 1539. Padua, Biblioteca Civica, B.P. 1175 (with opening illumination by the T.° Ve Master, Zuccolo Padrono 1975, 54).

26 Examples of such manuscripts, such as that for the *cattaveri*, were discussed in Chapter 1. The Commissions of ambassadors were supposed to be returned to the state when their assignment was completed, for the sake of state security. Donald E. Queller, *Early Venetian Legislation on Ambassadors* (Geneva: Droz, 1966), 48.

27 My calculations are based on the *Rulers of Venice* database, which lists elections to 1525, and examination of the *segretario alle voci* records for the subsequent period by comparison with the evidence of the surviving *ducali*. In 1494, overall 858 officers were elected to the Great Council, and of these around 107 would have received a Commission manuscript. Andrea Mozzato calculates the number of offices of patricians from 1400 to 1540 in O'Connell, ed. *c*.2009, paragraphs 104–13. Andrea Zannini "L'impiego pubblico," *SDV* 4 (1996), *Il Rinascimento. Politica e cultura*: 415–63 (461–62). See also Introduction, n. 45.

28 ASVe, [Secreta] Collegio, Formulari di commissioni. Although this was made a requirement only in 1601, there exist earlier *formulari*, indicating it was common practice. Salmini *c*.2009. On the campaign to clean up the statutes of the Commissions in 1527, see Cozzi 1980, 299–30.

29 The scribal hands vary, but there is great consistency in the formatting of the page, including the ruling in ink, in a pattern most favored in Venice in the fifteenth century for secular, usually literary, manuscripts, reminding us of the humanist training of chancery scribes. This is the pattern "11" as catalogued by Albert Derolez in *Codicologie des manuscrits en écriture humanistique sur parchemin* (Turnhout: Brepols, 1984), vol. 1: 86–88.

30 See, for example, the illustrations of concluding Commission text leaves in Unterkircher 1976, vol. 4, plates 160, 185, 248, 295, 335, 381, 388, 42; Lucchi, ed. 2013, 46, fig. 14.

There are many inconsistencies in the production of Commissions. There are documents that are illuminated and bound but lack the entire eschatocol, or are missing elements of it. Sometimes a notary or secretary other than the *Segretario alle voci* signed the Commission. Discrepancies in hands show that the name of the patrician was sometimes inserted after the writing out of the rest of the Commission, suggesting that some of these were written out before elections, and again, that a number of scribes participated in transcription from the master manuscript.

31 This text opens as "*Voi haverete de sallario …*"

32 Da Mosto 1937–40, vol. 1, 132–33; ASVe, *Guida generale*, 939, Index 159 bis.

33 Paul C. Hamilton, "The Palazzo dei Camerlenghi in Venice," *Journal of the Society of Architectural Historians* 42, 3 (October 1983): 258–71.

34 The locations of many of the workshops of miniaturists can be found through study of the contracts of apprentices (*garzoni*) with their masters. ASVe, Giustizia Vecchia, Accordi dei garzoni. Szépe 2009.

35 The leaves of the membrane wrapper could become the fly-leaves when the book was bound. See for example

the Commission to Nicolò Dr. di Francesco Tiepolo (1502–1542) as *Podestà* of Brescia, of 1525, which has the monogram of Girolamo Dedo, Grand Chancellor (1524–28), on the fly-leaf. Philadelphia, University of Pennsylvania, Codex 1134. There exist many documents that were bound without being ever illuminated.

36 Manno 1995, *I mestieri di Venezia*, 122–26.

37 Hobson 1989; Nuvoloni 2000.

38 Cottrell 2000, 660.

39 Tentori 1782–90.

40 The Commission to Alessandro Bon as *Podestà* and Captain of Belluno, of 1408, was never illuminated, but has a membrane wrapper. BMCVe Cl. III, 8.

 Some manuscripts were illuminated but never bound. See for example, the Commission to Girolamo di Domenico Trevisan, *Podestà* and Captain of Mestre, 1488. BMCVe, Cl. III, 9.

41 Following Venetian convention, "Candia" will be used to designate both the city Candia, now called Iraklion, and the island of Crete.

42 BL, Add. MS 41659. The Commission to Nicolò Muazzo as Captain of Candia, of 1411, may have the earliest surviving pen-flourished initial in a Commission. ASVe, Collegio, Commissioni ai rettori ed altri cariche, b. 1, 13 bis.

 Another early Commission in codex form but unilluminated is that to Giovanni Moro as *Conte* of Pola (Pula, Istria), 1391. ASVe, Collegio, Commissioni ai Rettori ed altre cariche b. 3, n. 53.

43 NYPL, Spencer MS 126. On Lorenzo Moro, nephew of Doge Cristoforo Moro, see Israel 2007, 52.

44 The use of mulberries as a reference to the Moro name in the coat of arms is repeated in the opening painted border, in a style related to Benedetto Bordon, of the Commission to Cristoforo di Lorenzo di Antonio Moro as *Podestà* and Captain of Ravenna, of 1496. That manuscript has unfortunately lost its binding. ASVe, Collegio, Commissioni ai Rettori ed altre cariche b. 3, n. 70.

45 On office-holding on Crete in this period, see especially O'Connell 2009. Maria Georgopoulou, "Late Medieval Crete and Venice: An Appropriation of Byzantine Heritage," *Art Bulletin* 77, 3 (September, 1995): 479–96.

46 Brown 1996, 172–74.

47 Brown 1996; Rosand, "Giorgione, Venice, and the Pastoral Vision," in Robert Cafritz, Lawrence Gowing, and David Rosand, eds. *Places of Delight* (Washington, D.C.: The Phillips Collection, 1988): 20–81.

48 Ceferino Caro Lopez, "Gli Auditori Nuovi e il Dominio di Terraferma," *Stato, società e giustizia nella Repubblica veneta (sec XV–XVIII)*, ed. Gaetano Cozzi (Rome: Jouvence, 1980), vol. 1: 259–316.

49 The itinerary was not published in Sanudo's lifetime. R. Fulin published the text of the earliest manuscript now in the Marciana Library. R. Fulin, *Diarii e diaristi veneziani: Studi* (Venice: Marco Visentini, 1881):

1–48. Rawdon Brown published the second and more complete version of the text from a manuscript now in the Benedictine Library of San Giorgio Maggiore, Padua (MS 996), in Sanudo 1847. The manuscript has been recently published in Sanudo 2008, *Itinerario per la terraferma veneta nel 1483 di Marin Sanudo*; Sanudo 2010. R. Fulin published the text of an earlier edition now in the Marciana Library. R. Fulin, *Diarii e diaristi veneziani: Studi* (Venice: Marco Visentini, 1881): 1–48.

50 Sanudo 1847, iv–vi; John E. Law, "The Venetian Mainland State in the Fifteenth Century," *Transactions of the Royal Historical Society*, 6th series, 2 (1992): 153–74; Brown 1996, 156–62; Michael Knapton and John E. Law, "Marin Sanudo e la Terraferma: istituzioni e società," in Sanudo 2010.

51 BMVe, Lat. X, 272 (=3373).

52 On the figure of *Venetia*, or Venice personified, see Rosand 1984; Rosand 2001; Tagliaferro 2005.

53 BMCVe, Cl. III, 59. *"Dedisti leticiam in corde meo."* The other motto states: *"Giama per volgia a nullo el peso torsi."* Nicolò Muazzo's highest office abroad was as Captain of Vicenza, 1489. Di Luzio 1985–96, 25–27, 31–33.

 On this master, see Armstrong 1990, 9–39, 215–53; Lilian Armstrong, "The Pico Master: A Venetian Miniaturist of the Late Quattrocento," in Armstrong 2003, vol. 1, 233–338, with additional attributions to the master; Beatrice Bentivoglio-Ravasio, "Maestro del Plinio di Giovanni Pico della Mirandola," *DBMI* 635–42. Lilian Armstrong's article of 2003 includes a complete list of *ducali* by this miniaturist except for the Commission as procurator of Vettor Soranzo (discussed in Chapter 4) and a Commission to Benedetto di Bernardo Soranzo as *Podestà* of Bergamo, 1490, BL, Add. MS 23713.

54 See Chapter 3 and Appendix 2.

55 Bethlehem, PA, Lehigh University, 234252. John C. Hirsh, *Western Manuscripts of the Twelfth through Sixteenth Centuries in Lehigh University Libraries* (Bethlehem, PA: 1970): 29, cat. 21. This is the only post for which Valier would have received a Commission. On the miniaturist, called the First Pisani Master, and the Virgil miniature, see Helena Szépe, "Modes of Illuminating Aldines," in David S. Zeidberg, ed. *Aldus Manutius and Renaissance Culture: Essays in Memory of Franklin D. Murphy* (Florence: Leo S. Olschki, 1998): 185–200 (190–92, fig. 6).

56 BL, Add. MS 24897. See such sea creatures also in the Commissions by the Master of the Rimini Ovid, whose oeuvre was defined by Armstrong 1993; Simonetta Nicolini, "Maestro dell'Ovidio di Rimini," in *DBMI* 612–14; Luchs 2010. A manuscript that can be added to the oeuvre of the Master of the Rimini Ovid: Commission to Francesco di Benedetto Barbarigo as *Podestà* of Murano, 1493, ASVe, ex-sala Regina Margherita MS LXXVI-41. Di Luzio 1985–86, photo 22a.

57 Another Commission by this Antonio Maria da Villafora is for Bernardo di Benedetto Balbi (d. 1534) as *Podestà* of Montagnana, 1496, BMVe, Lat. X, 342 (=3807). For the most recent discussions on Antonio Maria da Villafora and Pietro Barozzi, see Laura Paola Gnaccolini, "Antonio Maria da Villafora," *DBMI* 36–40; Mariani Canova 2009; Toniolo 2012.

58 One work out of many by the "Gold Dots Master" is the illumination in the Commission to Girolamo di Leonardo Moro as *Podestà* of Pirano, 1510. San Francisco State J. Paul Leonard Library, De Bellis La. 13.

59 "*Tegmen tuum protectio me,*" Berlin, Deutsche Staatsbibliothek, MS. Hamilton 224. Boese 1966, 110. On this artist, see Susy Marcon, "Maffei, Alberto," *DBMI* 712–14. To the list of works can also be added the pen flourishes in a Book of Hours in the Newberry Library, Chicago. MS 86 (234360). Szépe 1997, 47, fig. 15.

See also Andrea di Francesco Erizzo (d. 1530) as *Podestà* and Captain of Rovigo, 1503. New Haven, Yale University Libraries, Lillian Goldman Law Library, Rare Book Collection, MssJ V53, n. 1/1.

There is another Commission to Pietro di Giovanni Pr. Cappello (d. 1524) as *Podestà* of Vicenza, 1496, illuminated in the style of Antonio Maria da Villafora. Strasbourg, Bibliothèque Nationale et Universitaire, MS.0.295. *Catalogue des manuscrits en écriture latine portant des indications de date, de lieu ou de copiste*, eds. C. Samaran and R. Marichal, vol. V, by Monique Garand, M. Mabille, and J. Metman (Paris: 1968), 417.

60 Pincus 2000.

61 On the development of monuments on church façades in Venice, see Gaier 2002.

62 Setton 1976–84, vol. 2 (1978), 283–85. Attribution to Nicolò di Giovanni Fiorentino by Anne Markham Schulz: Schulz 1978, 25–30.

63 Gaier 2002, 453–55.

64 Andrew Butterfield, *The Sculptures of Andrea del Verrocchio* (New Haven: Yale University Press, 1997): 170–74.

65 Berlin, Deutsche Staatsbibliothek, MS Hamilton 222. Boese 1966, 109.

66 Attributed to Giovanni Buora as sculptor. The painter is unknown. Mehler 2001, 98–108, plates 87–92; Luchs 2011, 68–69; Anne Markham Schulz, "One old, and nine new, attributions to Giovanni Buora," *Rivista d'arte* Ser. 5, 1 (2011): 39–77. A painted portrait of him by Giovanni Bellini, which is now lost, was displayed by his grandson Girolamo Marcello when Michiel visited his collection. Frimmel 1896, 90; King 1986, 212–13; Goffen 1989, 192.

67 BMCVe, Cl. III, 85. Armstrong 1990, 36, cat. 82.

68 Setton 1976–84, vol. 2 (1978), 517–18.

69 Trevisan was in the good graces of the church because he had brought back a relic of the holy blood from Constantinople in 1479 and donated it to the Frari in 1480. Schulz 1991, 206–9.

70 Anne Markham Schulz disputes all previous attributions of the tomb to various sculptors. Schulz 1991, 206–9; Mehler 2001, 119–23; Luchs 2010, 69–71.

71 Wolters 2000, 192–93.

72 BnF, MS Lat. 4730, fol. 1r. Armstrong 1990, 26, fig. 37. The composition is a variation of the format found in the Commission by the Master of 1489 for Paolo di Pietro da Canal (d. 1485) as consul of Alexandria, in which Paolo's patron saint kneels in front of the Virgin and Child. BnF, MS Lat. 4729, fol. 2r. Armstrong 1990, 36, fig. 39.

73 Moscow, Russian State Library, Fund 183, no. 456, fol. 1r. Zolotova 2012, 81, 367, cat. 32. Perhaps an assistant to Bordon illuminated a Commission to Angelo di Pietro Gradenigo as Captain of the Merchant Galleys to Beirut, elected in 1492, for the style is very similar but in a weaker hand. The miniature has the rare imagery of the doge handing the Commission to the new *rettore*. St. Petersburg, National Public Library, Lat. Q.v.II.12. Voronova and Sterliogov 1996, 270–71, cat. 355.

74 Giuseppe Gullino, "Contarini, Domenico," *DBI* 28, 1983.

75 Hoepli Sale, May 3, 1928, lot 180, and Ulrico Hoepli, *Incunables, manuscrits, livres rares et prècieux autographes musicaux ...* (Zurich: Kunsthaus zur Meise, October 29, 1937), lot 77. BMCVe, Cl. III, 308.

76 Sanudo 1879–1903, vol. 8, col. 343, June 5, 1519: "*In questi zorni gionseno li burchij di rectori di Verona, maxime quell di sier Domenego Contarini, capitanio, fino la chareta, naranzeri e maze da distinder drapi. Fo gran mormoration da tutti; et lhoro rectori sonseno ozi qui per terra.*" He later notes that Domenico "*havendosi porta mal a Verona ...*" Sanudo 1879–1903, vol. 9, col. 413.

77 See for example such documents attributed to Bordon as the *Promissione* of Doge Grimani, 1521, and the Commission of the procurator Antonio Mocenigo (figs. 0.5 and 4.12).

78 Berlin, Kupferstichkabinett, 78.C.30. Wescher 1931, 117. Francesco purchased the position as ducal councillor for the *sestiere* of Canareggio in 1515 for 1000 ducats. The Commission for that post is BnF, Italien 1340. The portrait by Titian of Francesco's father Marin is cited as having been in the Ca' Garzoni at San Samuele, in the Cicogna copy of Barbaro's Genealogy. Barbaro Cicogna 2501, fol. 24r.

79 BL, Harley 3403. Commission to Francesco di Nicolò Barbarigo as Captain of Vicenza, 1522. Cambridge, Fitzwilliam Museum, MS 188, item 4. Morgan, Panayotova, Reynolds, eds. 2011, vol. 1, 84.

80 Fondazione Magnani Rocca, Mamiano di Traverseleto, Inv. N. 3. Wethey 1969–75, vol. 1, cat. 61; Ilchman, ed. 2009, 96–97, 290, cat. 2.

81 Zuccolo Padrono constructed the identity of the "Trees

Master" from this manuscript. Zuccolo Padrono 1972, fig. 18. Commission to Filippo di Alvise Basadonna as Captain of the Galleys to Beirut, 1523. Cambridge, Fitzwilliam, MS 188, item 3. Morgan, Panayatova, Reynolds, eds. 2011, Part II, vol. 1, 158. A manuscript illuminated by the Trees Master in the same year is the *Institutio et Confirmatio Congregationis S. Giorgii in Alga*, April 16, 1523, for Pietro Marin. Biblioteca del Seminario Vescovile, Padua, MS 440. Illustrated in Giordana Mariani Canova, "Per la storia della chiesa e della cultura a Padova: manoscritti e incunaboli miniati dal vescovo Pietro Donato ai canonici lateranensi di Giovani di Verdara," *Studi di Storia Religiosa Padovana dal Medioevo ai Nostri Giorni*, ed. Francesco G. B. Trolese (Padua: Istituto per la Storia Ecclesiastica Padovana, 1997): 168.

82 Manuscripts granted to captains of the galleys that led merchant ship expeditions were among the earliest to have more highly decorated initials and borders. See for example the Commission to Pietro di Jacopo Loredan (d. 1479) as Captain of the Merchant Galleys to Aiges Mortes in Provence, 1473. BMCVe, Cl. III, 43. On the merchant galley convoys and their captains, see Judde de Larivière 2008.

83 Sanudo 1879–1903, vol. 55, cols. 365–66, 527–28, 552, 638–39. Alwyn A. Ruddock provides an account gathered from archives in Southampton and other English sources, *Italian Merchants and Shipping in Southampton 1270–1600* (Winchester: University College, 1951): 132, 230–31.

84 Sanudo 1879–1903, vol. 56, cols. 28, 125, 443–44, 887–88. *Calendar of State Papers and Manuscripts, Relating to English Affairs existing in the archives and collections of Venice*, ed. Rawdon Brown (London: Longman, Green, Longman, Roberts, and Green, 1864): vol. 1, cxxiv; Judde de Larivière 2008, 219.

85 BnF, MS Dupuy 955. François Avril, "Un miniature titianesque: la *commissione* du doge Francesco Donato à Jacopo Celsi de 1550," Toniolo and Toscano eds. 2012, 361–64. An illuminated Commission for Jacopo's father Girolamo di Stefano (d. 1567) as *Podestà* of Budua (in Montenegro), 1526, is in The Hague, Koninklijke Bibliotheek, MS 71 G 64.

86 It was demolished around 1832. I would like to thank Claudia Lestani for suggesting to me that the façade may have been intended as that of San Ternità. Zorzi 1971, vol. 2, 389–90.

87 As Avril has noted, Celsi was buried in the Church of the Celestia; F. Avril, "Un miniature titianesque: la *commissione* du doge Francesco Donato à Jacopo Celsi de 1550," Toniolo and Toscano, eds. 2012, 361–64. Zorzi 1971, vol. 2, 347–38.

88 BL, Add. MS 18846, fol. 1r. Foucard 1857, 121–26.

89 Muraro 1961; Schulz 1978; David Rosand, "Venetia e gli dei," in Tafuri, ed. 1984, 201–15. The practice of electing public officials to head convoys of privately funded galleys gradually declined and ended after Lepanto. Judde de Larivière 2008, 219.

90 Stedman Sheard 1992.

91 Cunnally 1999; Stahl, ed. 2009.

92 Genoa, Raccolta Durazzo, A V 13. *I manoscritti della Raccolta Durazzo*, ed. Dino Puncuh (Genoa: Sagep, 1979): 130–32. By contrast, ancient coins were copied already in *c.*1320 by Giovanni Mansonario to illustrate his *Historia Imperialia* with portraits of emperors, and painters of manuscripts in fifteenth-century Florence often represented actual cameos, gems, and coins. Haskell 1993, 26–45; Giovanna Lazzi, "Gli occhi del dragone. Gemme dipinte nei manoscritti del Quattrocento," *Pregio e bellezza. Cammei e intagli dei Medici*, ed. Riccardo Gennaioli (Florence: Museo degli Argenti, 2010): 28–35.

93 Maria Antonietta Grignani, "Badoer, Filenio, Pizio: Un trio bucolico a Venezia," *Studi di filologia e di letteratura italiana offerti a Carlo Dionisotti* (Milan and Naples: Riccardo Ricciardi, 1973): 77–115.

94 David Rosand, "Giorgione, Venice, and the Pastoral Vision," in Robert Cafritz, Lawrence Gowing, David Rosand, eds. *Places of Delight: The Pastoral Landscape* (Washington, D.C.: The Phillips Collection, 1988): 20–81.

95 Giovanni Badoer, "Phylareto a Laurea sua cathena," BMVe, It. IX, 351 (=6486), fols. 60–77. The manuscript opens with the phrase "INFAUSTI. ET.AMICORUM" as the title page and the opening text page to the *Arcadia* has Venier's coat of arms. The *Phylareto* opens with "VICTORIA" in gold capitals on a red banderole and laurels. Printed editon: *Per nozze Baglioni-Giustinian*, ed. G. P. Baglioni (Venice: 1830). Donata Battilotti and Maria Teresa Franco, "Regesti di committenti e dei primi collezionisti di Giorgione," *Antichità viva* 4–5 (1978): 58–86 (61–64); Paul Holberton, "La bibliotechina e la raccolta d'arte di Zuanantonio Venier," *Atti dell'Istituto Veneto di Scienze, Lettere ed Arti* 144 (1985–86): 173–93; Rosella Lauber, "'Il vero oracolo di Vinegia tutta.' Il 'Bravo' di Tiziano e Giovanni Antonio Venier, muovendo l'animo al 'firmamentum,'" *Studi tizianeschi* 2 (2004): 11–30; Rosella Lauber in *Collezionismo 2008*, 320.

96 Pietro Bembo congratulated him on his vindication. Venier was appointed after this period first as ambassador in France to Charles V, then as lieutenant at Udine, and finally as Orator at Rome. Rosella Lauber in *Collezionismo 2008*, 320.

97 PML, MS M.354.

98 See Chapter 4, the section "Unity and distinction." Zuccolo Padrono 1972, 324–25, n. 27.

99 "*Dignum laude virum (Musa) vetat mori; Coelo Musa beat.*" Horace, Carmina (IV, 8, 28).

100 As discussed in Chapter 2, with Daniele di Costantino Renier and Francesco Bragadin he reformed the rules of the Great Council in 1528, and on June 29 of 1531

he was elected *Podestà* of Padua. Angelo Ventura, "Badoer, Giovanni," *DBI* 5, 1963.

101 Cozzi 1980, 131, n. 21.

102 Andrea Fulvio, *Illustrium imagines* (Rome: Iacobum Mazochium Romane Achademie Bibliopo, November 1517). The miniaturist has left out the lettering imitating coins in the woodcut images. The woodcuts have been traditionally attributed to Ugo da Carpi, but are assigned by John Cunnally to Giovanni Battista Palumba. Cunnally 1999, 70–87.

103 Plates XXv, VIIr, XVIr. Favaretto and Ravagnan, eds. 1997, 243. See for example Michele Asolati, "Francesco Petrarca und seine numismatische Sammlung," and "Die Geschichte der venezianischen Münzsammlungen," in Frings, ed. 2002, 72–74, 220–31.

104 Fittschen 1985; Favaretto and Ravagnan, eds. 1997, 156; Irene Favaretto, "L'immagine e il suo doppio. Le sculture dello statuario e l'artista del Cinquecento: copie, imitazioni e 'invenzioni' all'antica," in Favaretto and Ravagnan, eds. 1997, 108.

105 On the fame and copying of the "Vitellius," see especially Stephen Bailey, "Metamorphoses of the Grimani 'Vitellius,'" *The J. Paul Getty Museum Journal* 5 (1977): 105–22; Jean-René Gaborit, "Le 'Vitellius de Venise' ou comment un Romain anonyme fut proclamé empereur," *D'après l'antique*, eds. Jean-Pierre Cuzin, Jean-René Gaborit, Alain Pasquier (Paris: Éditions de la Réunion des musées nationaux, 2000): 298–311; Fittschen 2004. An engraving of the sculpture by Martin Rota from the late sixteenth century similarly re-creates the lateral sides as was done in the miniature, suggesting that there may have been an existing copy or image so rendered from which these were both copied. A number of the versions became rather free interpretations. The image in the manuscript furnishes lateral sides and provides a costume down to the shoulders. The original sculpture, unlike many during the Renaissance, was never touched up to look like this. *Imperatorum, Caesarumque. Viginitquatuor Effigies. A. Iulio usque ad Alexandrum Severum ex antiquis marmoribus ac numismatibus desumptae.* Vienna, Albertina Museum. Milan Pelc, *Život i djela Šibenskog bakroresca Martina Rote Kolunića* (Zagreb: Nacionalna i sveučilisna knjižnica, 1997): fig. 86. Jacopo Contarini is discussed further in Chapter 6.

106 See for example the bust of Carlo Zeno of *c.*1498, and those of the sculptor Simone Bianco. On the development of antique-style portrait busts in Venice, see Irene Favaretto, "Simone Bianco: Un scultore del XVI secolo di fronte all'antico," *Numismatica e antichità classiche* 14 (1985): 402–21; Luchs 1995.

107 Badoer may have requested these pseudo-cameos and the portrait bust in part in reference to the great cycle of ancient heroes in the Sala Virorum Illustrium, initially frescoed in the fourteenth century under the Carrara through the influence of Petrarch. This cycle was destroyed by fire around 1500, the time during which Giovanni would have been studying there, so the cycle and its loss may have made a great impression upon him while a young student. The new fresco cycle of illustrious men, still in place today, was painted under the order of a Girolamo Corner, Captain of Padua from 1539 to 1540, about eight years after Badoer's service. Bodon 2009.

108 BL, Add. MS 15518. On the twentieth-century naming of this master, see Epilogue n. 108.

109 PRO, 30/25: 104/4.

110 PRO, 30/25: 104/5; PRO, 30/25: 104/8.

111 BL, Add. MS 20916, 16.

112 Cicogna 1847, 77. On the practice of division of labor and copying in portraits, see Miguel Falomir, "Tintoretto's Portraiture," in Miguel Falomir, ed. *Tintoretto* (Madrid: Museo Nacional del Prado, 2007): 95–114; Giorgio Tagliaferro and Bernard Aikema, with Matteo Mancini and Andrew John Martin, *Le botteghe di Tiziano* (Alinari 24 Ore, 2011).

113 See for example the request in the testament of Domenico di Pietro Tiepolo (d. 1597) to be buried in the habit of a capuchin monk. ASVe, Notarile, Testamento, Galeazzo Secco, b. 1190, n. 172.

114 Leaf detached from a Commission to Alessandro di Nicolò Contarini as *Podestà* of Bergamo, 1586. BL, Add. MS 20196, fol. 20.

115 For some detached examples, see Philadelphia, Free Library, Lewis E M 47:6 and 47:11.

116 Venice, Cini Foundation, MS 6. T. Kimball Brooker, Chicago. Brooker 1988. Helena Szépe in Medica and Toniolo, eds. 2016, 383–88.

117 For example, see the Commission to Giovanni Francesco di Girolamo Basadonna (1512–1552) as *Podestà* of Colonia, 1542, Princeton University Library, Garrett 161.

118 The relationship between gender and meaning in allegory is complex, and has been addressed variously across disciplines. Warner 1985; Teskey 1996; Quilligan 2010. James J. Paxson discusses how personification and allegory are often not distinguished adequately in scholarship, in Paxson 1994, 1–3. On Veronese's use of allegory, see Hope 1985.

119 Skinner 2002, 62–63.

120 ÖNB, Cod. 5884. Hermann 1931, 229–31, plate 73.

121 Signed by the sculptors of Tuscan origin Pietro di Niccolò Lamberti and Giovanni di Martino da Fiesole. Anne M. Schultz, "Revising the History of Venetian Renaissance Sculpture: Niccolò and Pietro Lamberti," *Saggi e Memorie di Storia dell'Arte* 15 (1986): 9–61, 137–222.

In his representation of the Virtues, Bordon also may have been influenced by such miniaturists as the Master of Seven Virtues, with whom he worked on the miniatures for a printed book after which that master is named: a copy of the *Decretals* of Gratian for the

great patron Peter Ugelheimer of Frankfurt, printed by Nicolas Jenson in 1477. The opening leaf of this book of canon law shows Virtues inhabiting a classicized monument in a landscape. *Decretum Gratiani* (Venice: Nicolas Jenson, 1477). Gotha, Forschungs- und Landesbibliothek, Mon. Typ. 1477, 2° (12). Illuminated by Girolamo da Cremona, Master of the Seven Virtues, and Benedetto Bordon. Andrea De Marchi, "Decretum Gratiani," in Baldissin Molli and Mariani Canova, eds. 1999, 353–57, cat. 145.

122 Leaf detached from a Commission to Vettor di Marcantonio Michiel as *Podestà* and Captain of Mestre, elected in both 1552 and 1555. Cremona, Museo Civico D88. The patrician and office are given on the verso. Unfortunately, the sitter's age has been obscured by damage to the leaf. *Notizie storiche del castello di Mestre dalla sua origine all'anno 1832, e del suo territorio* (Venice: Angelo Poggi, 1839): 305. Puerari 1976; Gino Castiglioni, Sergio Marinelli, eds. *Miniatura Veronese del Rinascimento* (Verona: Museo di Castelvechio, 1986): 38, fig. II.21; Marinelli 2008, fig. 64. For miniatures in the style of De Mio, see also a leaf detached from the Commission of Bartolomeo di Marco Magno as *Podestà* and Captain of Conegliano, of 1565: BL, Add. MS 20916, fol. 31.

123 On Michiel's notebook as a source and on printed editions, see Jennifer Fletcher, "Marcantonio Michiel: His Friends and Collection," *The Burlington Magazine* 123, 941 (1981): 453–67; Jennifer Fletcher, "Marcantonio Michiel, *che ha veduto assia*," *The Burlington Magazine* 123, 942 (1981): 602–9; Schmitter 1997, 27–37; Monika Schmitter, "The Dating of Marcantonio Michiel's 'Notizia' on Works of Art in Padua," *The Burlington Magazine* 145, 1205 (August 2003): 564–71; Rosella Lauber, "'Opera perfettisima': Marcantonio Michiel e la 'Notizia d'opere di disegno,'" in *Collezionismo 2008*, 77–116.

De Mio painted several other Commissions for members of the Michiel family for which only the opening leaves remain, but in these cases the texts identifying the relevant patricians by Christian name are not visible. Marinelli 2006; Marinelli 2008.

124 Rosand 1984; Rosand 2001; Tagliaferro 2005.

125 Giovanni Pillinini, "Bragadin, Antonio," *DBI* 13 (1971). His *relazione* is published in *Podestaria e capitanato di Brescia*, ed. Amelio Tagliaferri (Milan: Giuffrè, 1978): 107–10.

126 According to Sansovino, writing in 1561, the iconographic program of the three halls of the Council of Ten was devised by Daniele Barbaro. Schulz 1968, 97–101.

127 *Relazioni dei rettori veneti in terraferma xi. Podestaria e capitanato di Brescia*, ed. Amelio Tagliaferri (Milan: Giuffrè, 1978): 107–10.

128 Cooper 2005, 230–32.

129 In Bonifacio de' Pitati's painting, God blesses a scene of the Annunciation, which unfolds over the two outer panels, a reference to the founding of the city on the feast of the Annunciation. Cottrell 2000, 671.

130 Commission of Doge Pasquale Cicogna (1585–1592) to Tommaso Morosini dalla Sbarra (as per the coat of arms). Indication of the location of Morosini's appointment as *podestà* and captain was never filled in, or erased. BL, Add. MS 20916, fol. 22. Szépe 2001; Kaplan 2010, 139; Jonathan Bate and Dora Thornton, *Shakespeare: Staging the World* (Oxford: Oxford University Press, 2012): 183–84. Anne-Marie Eze, entry for the leaf in the British Library online catalogue; personal communication with Anne-Marie Eze.

131 84:12 "*Veritas de terra orta est: et iustitia de caelo prospexit.*" The central image is very similar to a later drawing of Venus and Amor, dated 1596, made by Hans Rottenhammer while he was in Venice. Rottenhammer painted cabinet miniatures, and his drawing may have been influenced by this leaf, or by a similar drawing by the miniaturist Bodovino. Frankfurt am Main, Städelisches Kunstinstitut, Inv. cat. 1895. Andrew John Martin in Aikema and Brown, eds. 2000, fig. 203.

132 Paris, Musèe du Louvre. Département des Objets d'art, Inv. No. MR 251.

133 Karen C. C. Dalton, "Art for the Sake of Dynasty: The Black Emperor in the Drake Jewel and Elizabethan Imperial Imagery," in Peter Erickson and Clark Hulse, eds. *Early Modern Visual Culture. Representation, Race, and Empire in Renaissance England* (Philadelphia: University of Pennsylvania Press, 2000): 178–214. She also summarizes alternative interpretations. David S. Shields has interpreted the Drake Jewel as an argument for unity with Africans in wresting control of the New World from Spain. "The Drake Jewel," *Uncommon Sense*, 118 (Spring, 2004); http://oieahc.wm.edu/uncommon/118/drake.cfm [Accessed December 20, 2016].

134 Wolters 1987; Brown 1996, 168.

135 Anne-Marie Eze will develop this argument further in a forthcoming article. See n. 130 above; Kaplan 2010.

136 "*Iustitia et pax osculatae sunt.*" The theme of Justice and Peace was associated with the feast of the Visitation celebrating the Visit of the Virgin Mary with Elizabeth. Services on that day, July 2, include a prayer indicating that the solemnity of the Visitation will bring an increase of peace, while the Gradual for the day proclaims that "the sun of justice has arisen from the Virgin." The four Virtues of the psalms, Love, Faithfulness, Righteousness, and Peace, generally are associated with the Annunciation to the Virgin. Voelkle 1998.

137 BL, Add. MS 20916, fol. 26. See also one for a member of the Bragadin family, BL, Add. MS 20916, fol. 27, and one in a leaf from a Commission to Alvise di Bernardo Belegno as Lieutenant of Udine (1593), BL, Add. MS 20916, fol. 21. On Bonifacio de' Pitati's paintings for the Camerlenghi, see Giorgio Faggin, "Bonifacio ai Camerlenghi," *Arte Veneta* 17 (1963): 79–96; Simonetta

Simonetti, "Profilo di Bonifacio de' Pitati," *Saggi e Memorie di Storia dell'Arte* 15 (1986): 83–134; Cottrell 2002, 671, fig. 22. The theme had appeared already on the reverse of a medal for Doge Antonio Grimani of *c.*1523. NGA, Kress 1957.14.757. Pollard 2007, 205.

138 Juergen Schulz, "Cristoforo Sorte and the Ducal Palace of Venice," *Mitteilungen des Kunsthistorischen Institutes in Florenz* 10, 3 (June 1962): 193–208 (193). BL, Add. MS 20916, fol. 26; BL, Add. MS 20916, fol. 28.

139 Wolters 2000, 255–63, figs. 250–51.

140 See, for example, the Commissions to Alvise di Nicolò Loredan (d. 1536): as Count of Pago, 1515; as *Podestà* of Monfalcone, 1522, BnF, Lat. 4736; as *Podestà* and Captain of Conegliano, 1530, BnF, Italien 1010. Marsand 1835–38, entry number 428, 490–91; as *Podestà* and Proveditor of Martinengo, 1534, BnF, Lat. 4741.

 Alessandro di Antonio Badoer (d. 1541) as Captain and Proveditor of Riva and Salò, 1540, BnF, Lat. 4743. His other Commissions in the BnF, Paris: as *Podestà* of Portobuffolé (province of Treviso), 1515, BnF, Lat. 4732; as *Podestà* of Abbazia, 1525, BnF, Lat. 4738; as Count and Proveditor of Lesina, 1531, BnF, Lat. 4740. There is a Commission for his son Antonio, also in Paris: Antonio di Alessandro Badoer (1513–1562) as Councillor of Canea (Chania, Crete), 1543, BnF, Lat. 4744.

141 Commission to Francesco Tiepolo as Captain of Vicenza, 1597 (ASVe, Tiepolo II, b. 170, n. 853), bound in wood boards with red velvet brocade and missing the metal fixtures and *bolla*; and Commission to Francesco Tiepolo as Captain and *Podestà* of Treviso, 1605. ASVe, Archivio Privato Tiepolo II, busta 170, n. 852, bound in wooden boards with red velvet and missing the metal fixtures and bolla. Tiepolo lived from November 22, 1555, to March 1614, and also served as ambassador to Moscow, from where he returned in 1560. For further biographical information, see *Relazione del capitano Francesco Tiepolo ritornato dal reggimento di Vicenza 27 luglio 1600* (Venice: Visentini, 1877); *Relazione della Moscovia attribuita al serenissimo sier Francesco Tiepolo fatto l'anno 1560*, ed. Aurelio Magrini (Venice: Giuseppe Cecchini, 1877); Corner 1749, vol. 12, 34–35. His other *relazioni* are published in *Podestària e capitanato di Vicenza*, ed. A. Tagliaferri (Milan: Giuffrè, 1976): 107–11, and *Podestària e capitanato di Treviso*, ed. A. Tagliaferri (Milan: Giuffrè, 1975): 117–24.

 On the Tiepolo *fondo* in the archives, see Andrea Da Mosto, "L'Archivio Tiepolo," *Gli Archivi Italiani* 2 (1915): 4–5, 131–36. Mason Rinaldi 1976–77: 193–212.

142 Hochmann 1992, "Le mécénat de Marino Grimani," 51, n. 42.

143 Szépe 2001, 72–76; Helena Szépe, "Merli, Alessandro," *DBMI* 760–61.

144 Known in Italy as San Sabba, Santa Sabba, or Saba and San Saba, and as Saint Sava/Savva. The chapel is described by Stringa 1604, 107r–108r; Sansovino 1663, 37–38; Corner 1749, vol. 12, 34–35. Roberto Diana, Maurizio Matterazzo, Giorgio Tosi, *La chiesa di Sant'Antonino Martire in Venezia: sestiere di Castello* (Venice: Tipografia Veneta, 1976); Tiziana Favaro, ed. *Chiesa di Sant'Antonin. Storia e restauro* (Venice: Ministero per i Beni e le attività culturali, Soprintendenza per i Beni Architettonici e Paesaggistici di Venezia e Laguna, 2011).

145 These are described and illustrated by Mason Rinaldi 1984, 117–18, cats. 342–52, figs. 165–74; Stefania Mason, "La capella di San Saba a Sant'Antonin: committenza e devozione nella Venezia di fine Cinquecento," in Favaro, ed. 2010, *Chiesa di Sant'Antonin. Storia e restauro*, 135–52. On the chapel: Victoria Avery, "*Ridotta à perfettione*: The Rebuilding of the Cappella di San Sabba in Sant'Antonin and Artistic Practice in late *Cinquecento* Venice," in Favaro, ed. 2010, *Chiesa di Sant'Antonin. Storia e restauro*, 153–80.

146 Corner 1749, vol. 12, 340–55; Tramontin 1965, 195, 232–33.

147 Recorded by the notary Fabrizio Bevazzano, in ASVe, Notarile, Inventari, Fabrizio Bevazzano, b. 56, n. 219, and b. 58, nn. 191, 192, 193.

PART III OPENER

1 "*tener a memoria sempre di esser nasciuti Gentil'homini di Venetia, et non Signori ne' Duchi …*" Cavalli and Bertèle 1935, 95.

CHAPTER 6: CELEBRATION AND COMMEMORATION OF THE RECTOR

1 "*rettore con le opere virtuose, e giouevoli alla città debba lasciar di se memori a posteri.*" Tatio 1573, 113.

2 The topic of the artistic patronage of rectors abroad is immense. For a recent general assessment and specialized studies, see Georgopoulou 2001; Boccato and Pasqualini Canato 2001; Gino Benzoni, "La città del Buon Governo: Venezia," in Pavanello, ed. 2004, 93–108; Vincenzo Mancini, "'Sotto specie di laude': immagini celebrative di magistrate in Terraferma," in Pavanello, ed. 2004, 113–30. See also the relevant articles by Dennis Romano, Sarah Blake McHam, Gabriele Neher, and Andrea Bayer in Humfrey, ed. 2007. Patricia Fortini Brown gives an incisive case study in Brown, "Becoming a Man of Empire: The Construction of Patrician Identity in a Republic of Equals," in Avcıoğlu and Jones, eds. 2013, 231–49.

3 ASVe, *SAV*, Accettazioni di Cariche. The volumes relevant to this study are reg. 1 (1540–46), reg. 2

(1556–1665), reg. 3 (1595–1604). Claudia Salmini has found that autograph declarations are rare in the first volume but become common by the third. The date of this signed acceptance of office does not correspond with the date written in the Commission.

4 *"Quai parole devi usar nello accettar del Reggimento."* The fine for not complying was 100 ducats. Commission to Francesco di Andrea Marcello (1530–80), Proveditor of Peschiera (del Garda), 1570, Florence, Laurenziana, Ashb. 1096, fol. 28v.

5 Cappelluzzo 1992, 66–67.

6 The Commission for this post survives but was not illuminated: Commission to Paolo di Zaccaria Contarini as *Podestà* of Verona, 1561. BMVe, It. VII, 1372 (=8098). The voyage is discussed in Orietta Pinessi, "La *Disputa* di Paolo Veronese. Un'opera 'singolare,' una storia singolare," *Arte documento* 24 (2008): 92–101 (94). The manuscript was only published in the nineteenth century: Nuziali Zajotti-Antonin, *Descrizione del viaggio fatto da Venezia a Verona da Paolo Contarini eletto Podestà di Verona e del suo solenne ingresso in quella città nel giugno 1562* (Venice: Tipografia La Venezia, 1880).

Accounts of entries of rectors published shortly after the event are rare but do exist, for example: Bernardino Martinelli, *Applauso nel felicissimo Ingresso dell'Illustriss. Signor B. Donado al reggimento della Città di Trivigi* (Venice: G. Sarzina, 1625); Leone Borso, *Per il felicissimo ingresso al governo della citta di Trevigi del ... podestà e capitano Domenico Leoni, panegirico ...* (Treviso: Girolamo Righettini, 1642); Giovanni Battista Penada, *La festa del prato in occasione del solenne ingresso di s.e. Domenico Michiel podestà di Padova canzone ...* (Padova: per Giovambatista Penada, 1778). Raines 2006.

Francesco di Marcantonio Bernardo was an important collector of antiquities. His Commission as *Podestà* of Verona of 1559 (BMCVe, Cl. III, 289) has an opening miniature by the Mannerist Master featuring Venice as Justice and Virtues, but all the other documents for him have lost their miniatures: as *Podestà* and Captain of Brescia, 1563 (BMCVe, Cl. III, 729); as *Podestà* and Captain of Vicenza, 1549; as *Podestà* and Captain of Crema, 1555 (BMCVe, Cl. III, 731); as Captain of Padua, 1569 (BMCVe, Cl. III, 733). On the miniature: Zuccolo Padrono 1969, 9, 11. On Francesco Bernardo: Hochmann 1992, *Peintres et Commanditaires á Venise (1540–1628)*, 358–59.

7 An important early surviving example is a painting by Vittore Carpaccio of the entry of Sebastiano K. di Sebastiano Contarini (d. 1532) into Capodistria in 1516. Originally in the Sala del Consiglio, Palazzo Pretorio in Capodistria (now Koper). Elisabetta Francescutti, in *Histria opere d'arte restaurate: da Paolo Veneziano a Tiepolo* (Milan: Electa, 2005). The Commission to Sebastiano Contarini as *Podestà*

and Captain of Justinopolis (the ancient Roman name for Capodistria) is now BMCVe, Cl. III, 46.

8 Commission to Giovanni di Sebastiano Badoer as Proveditor of Cividale in Friuli, 1580, WAM, W.487. Commission to Melchiorre di Gasparo Salamon, as *Podestà* of Este, 1561. Venice, Cini Foundation, Inv. 22507. Helena Szépe in Massimo Medica and Federica Toniolo, eds. 2016, 375–80, cat. 141.

9 Susy Marcon in Milvia Bollati, ed. *Ridono le carte: Renaissance and Medieval Illuminations* (London, Paris, Lugano: Brisigotti Antiques, Les Enluminures, Longari Art, 1998). The office of proveditor general in Dalmatia actually was elected in the Senate. Lorenzo Moro was elected on March 14, 1558, and was to enter office on August 12 of that year. ASVe, *SAV*, Elezioni in Senato, reg. 2, fol. 39v. He served subsequently as Proveditor of Marano, 1562–64.

10 The formal ceremony of Silvestro di Bertuccio Valier receiving the keys and staff of his command as Captain of Padua from the outgoing Captain Massimo di Bertuccio, his brother, was portrayed by Pietro Damini in a large painting installed in the Palazzo del Podestà of the city (*c*.1619–21). Palazzo del Municipio (formerly Palazzo del Podestà), Comune di Padova, Settore Musei e Biblioteche. Vincenzo Mancini, "'Sotto specie di laude': immagini celebrative di magistrate in Terraferma," in Pavanello, ed. 2004, 113–30. Anna Paola Massarotto has identified the actual staff of office passed between the brothers, which now is exhibited in the Palazzo Zuckermann, Musei Civici, Inv. N. 940. Massarotto 2004, 181–83.

11 BL, Add. MS 20916, fol. 25. The style of the miniature is of the very late sixteenth century. The heraldic arms are of the Belegno, and the saint behind Mark is Alvise. This may, therefore, be from a Commission to Alvise di Bernardo Belegno (1538–1606). The Christ Child grants a scepter of rule to Andrea di Giovanni Pesaro as Proveditor of Zante, 1570, in a leaf detached from a Commission, HLSM, EL 9 H 13, 9. See also the detached leaf with no coat of arms with a patrician being handed the baston, HLSM, EL 9 H 13, 12. Dutschke 1989, 1: 25.

12 Raines 2006, vol. 1, 220. Descriptions in Gaspare Morari, *Prattica de' Reggimenti in terraferma di Gaspare Morari Padovano* (Padua: Giuseppe Corona, 1708): 39–40, 45.

13 Gregorio Sarmede, *Compendio de gli Honori fatti al Clariss. Sig. Vincenzo Capello dalla magnifica città di Cividal di Belluno nel fine del suo Illustrissmo Reggimento* (1598) (Nozze Sperti-Fagarazzi) (Belluno, Deliberali: 1883); Gaier 2002, 247–48.

14 Commission to Vincenzo di Domenico Cappello (1524–1604) as *Rettore* of Belluno, 1598. Norfolk, Holkham Hall, Handlist no. 644. His Commission as a ducal councillor, of 1562, is similarly restrained. Norfolk, Holkham Hall, Handlist no. 645. *A Handlist*

of *Manuscripts in the Library of the Earl of Leicester at Holkham Hall, abstracted from the catalogues of William Roscoe and Frederic Madden and annotated by Seymour de Ricci* (Oxford: Oxford University Press, 1932): 54–5.

15 The norm of a *relazione* presented by a rector upon his return, and recorded in writing, was instituted in 1524 under Andrea Gritti. Many of these are published in Tagliaferri 1973–79.

16 Tatio 1573, 113–17.

17 Sergio Zamperetti, "Immagini di Venezia in Terraferma," *SDV* 6 (1994), *Dal rinascimento al barocco*: 925–42.

18 BL, Add. MS 21414. Nuvoloni 2000, 81–109.

19 Paolo Carpeggiani, "G. M. Falconetto. Temi ed eventi di una architettura civile," in Lionello Puppi and Fulvio Zuliani, eds. *Padova. Case e palazzi* (Vicenza: Neri Pozza, 1977): 94–99, with relevant bibliography.

20 ASVe, Provveditori, Sopraprovveditori e Collegio alle pompe, pezzo 7 (Decreti relative alla terraferma). Gaier 2002, 107–9.

21 "*Che li rettori non possano spender alcun danaro in fabriche*

"*Osserverai la infrascritta parte presa in pregadi adi xxx.agosto M.D. XXX.iii viz, sono fare dalli rettori nostri di tempo in tempo molte spese in fabriche, et adornamenti della citta, et pallazzi, et in altri lochi le qual sono inutile et qualche volta dannose alla citta nostre, et in esse si consuma una grande quantita di denari talmente, che li stipendiati et provisianaii nostri, et quei che custodiscono le citta le porte non possano haver li sui pagamenti con incommode, et danno grandissimo delle cose nostre à che essendo necessario fare bona provisione: L'andera parte che de qui innanzi nessuno delli rettori o camerlenghi si nostri si da mar come da terra non possono spender in principiar, ne proseguir fabriche di sorte alcuna principiata senza ordine di questo consiglio ne far adornamenti, ne arme, ne altro delli denari della sig.:a nostra di condennationi. ne altri danari di camera ne danari di commune senza licentia di questo consiglio sotto pena de pagar del suo, et al ritorno are in questa citta non possano andar a capello, ne esser provati, se non haveranno una delli scrivani della camera di non haver fatto alcuna spesa di tal sorte senza licentia di questo consiglio.*" As written in Commissions to *rettori* after 1533.

22 Many of these are recorded in ASVe, Provveditori, Sopraprovveditori e Collegio alle pompe, pezzo 1, Capitolare (1562–1691), and ASVe, Provveditori, Sopraprovveditori e Collegio alle pompe, pezzo 7, Filze.

23 "*Io ... eletto ... giuro alli santi evangeli di Dio di non contravenire ne per me ne per altri nel andare stare et tornare dal presente regimento in modo alequno imaginabile ne premetero che si contravenga alle deliberation in proposito di pompa, et in particolare a quelle del 1609 22 del mese di giugno ma di eseguirle*

et farle oservar inviolabilimente da cadauno.*" ASVe, SAV, Registri e filze diversi (1609–1795), Giuramenti dei rettori di osservare le leggi suntuarie (October 1609– April 1637).

24 For the *Provisioni contro le pompe dei rettori* of 1691, see Benucci 2009, 10–11.

25 Gaier also provides transcriptions of some of the relevant documents. Gaier 2002, 107–10.

26 He married Elisabetta di Benedetto Giustinian in 1502.

27 Felix Gilbert, "Venice in the Crisis of the League of Cambrai," *Renaissance Venice*, ed. J. R. Hale (Totowa, NJ: Rowman and Littlefield, 1973): 274–92 (287).

28 Sanudo 1879–1903, July 30, 1517, vol. 24, 433.

29 Also called Palazzo dei Trecento.

30 "*sichè fu excellentissima intrada.*" Sanudo 1879–1903, July 30, 1517, vol. 24, 433.

31 University of Pennsylvania, Schoenberg, LJS 59. *Transformation of Knowledge: Early Manuscripts from the Collection of Lawrence J. Schoenberg*, ed. Crofton Black (London: Paul Holberton Publishing, 2006): 151. Bordon reused this scheme of the recipient before the seated Virgin and Child in the Commission to Pietro di Marco Loredan as Consul to Alexandria, Egypt, of 1521. BMCVe, Cl. III, 73.

32 Concina 1983; Schweizer 2002, 166–327; Schweizer 2003, 15–36.

33 The initial project was designed by Fra Giovanni Giocondo and the definitive plan was by Bartolomeo d'Alviano. The Gateway was attributed to Guglielmo Grigi by Tommaso Temanza, *Vita dei più celebri architetti, e scultori veneziani* (Venice, 1778): 126–30. Matteo Ceriana, "Grigi (de Grigis), Guglielmo, detto il Bergamasco," *DBI* 59 (2003).

34 "*Paulus Nanus Geo. F. Aug. Princ. Nep. P. R. Pref. F.*"

35 "*hic vie nane terminus.*" Santalena 1894, 68; Santalena 1901, 285; Schweizer 2002, 176. A full transcription of the portal text is in Federici 1803, vol. 2, 22–25.

36 This has tempted some authors to claim the sculptures were made by Pietro Lombardo, but that famous sculptor died in 1515, or before Nani's term. They are attributed to Pietro Lombardo in Federici 1803, vol. 2, 22–25. On Pietro Lombardo, see Guerra, Morresi, Schofield, eds. 2006.

37 *Ad Illustris. P. Ven. Paulum Nanum Tarvisii Praetorem Praefectum Q. Liber ...* Cambridge, MA, Harvard University, Houghton Library, MS Typ 168H, Wieck 1983, 126, fig. 46.

Text on fol. 16v praising the artist and sculpture of the Nani gate:

Ad Petrum Sculptorem Leonis portae nanae
Marmore conspicuum sic coelas Petre leonem;
Marmoreum ut vivum nempe putetur opus
Sic oculos, sic ora trahis, sic pectoris ampli
Est iuba mirifico sculpta magisterio
Sibilat aura iubis; horrent quoque lumina flammis
Ipsa que si nequeant ora rugire facis

Certa manus quam nec tenuis vel linea fallit
Quaeque ipsum posset vincere Praxitilem ...

38 ÖNB, Cod. Ser. N. 1778. Unterkircher 1976, 157. Text page illustrated vol. 2, fig. 84. None of these manuscripts is listed in the catalogue of the Nani library dispersed in the eighteenth century (Jacopo Morelli, *Codices manuscripti Latini Bibliothecae Nanianae* [Venice: Antonio Zatta, 1776]). Most went to the Marciana, but some were sold to other collections. Cicogna 1847, 580, nos. 4372–77.

39 The lion paired with a serpent-like figure recurs on a ceremonial helmet now in the Armeria of the Palazzo Ducale. It is quite possible that the extension of the helmet originally terminated in a face, to create a harpy as in the sculpture and manuscript, and that the helmet was made for a member of the Nani family. Armeria, Ducal Palace, Venice, Inv. C 34. Umberto Franzoi, *L'Armeria del Palazzo Ducale a Venezia* (Venice: Canova, 1990), cat. 22, plate 8.

40 Concina 1983. In 1528 Paolo's daughter married Andrea di Francesco Grimani (d. 1563), of the San Boldo branch, an offshoot of the branch of San Luca. Sanudo 1879–1903, vol. 50, col. 133.

41 Sanudo 1879–1903, vol. 55, cols. 488–91; on *piffari* in ceremonies, see Kurzman and Koldau 2002.

42 Cicogna 1824–53, vol. 2 (1827), 75–76.

43 Paolo died on July 26. The tomb is noted by Sansovino 1581, fol. 81r; Cicogna 1824–53, vol. 2 (1827), 75–76. On this church, see John McAndrew, "Sant'Andrea della Certosa," *Art Bulletin* 51 (1969): 15–28.

44 "*veramente regia.*" Sansovino 1581, fol. 81r.

45 Bernardo Nani, *Alcune Memorie della Famiglia Nani Nobile Veneta*, ASVe, Misc. Cod. 1, Storia Veneta 34 (gia Misc. Cod. 579), inserted between fols. 78 and 79.

46 The angel points to a page with the heading "Book VI" (the rest of the text is illegible), perhaps referencing that section in Matthew. But Chapter 6 of Matthew opens with a caution not to display one's piety publicly, and thus would be a criticism of the image itself. The painting is now in the Museo Civico of Bassano. Cicogna 1824–53, vol. 1: 243–44; Grendler 1990: 78. Zorzi 1971, vol. 2: 325. Giuliana Ericani in Brown and Marini, eds. 1993, 256–57, cat. 2. Soranzo was *podestà* from February 1536 to July 1537. Scholars have assumed that the young girl is Soranzo's daughter without presenting documentary evidence that he had a daughter with that name. Payment for the painting, described simply as "un quadro de la Madona con san Matio, s. Lucia et el suo retrato," by Soranzo is recorded in the Bassano account books in several installments, and the painting was installed on December 15 of 1536 (Muraro, ed. 1992, 94v–95r). Although no daughter Lucia is recorded in birth records, Soranzo had married Lucia Barbarigo, daughter of Andrea and granddaughter of Doge Marco, in 1518. A daughter Marietta, also not recorded in birth records

or genealogies, is listed as a beneficiary in Matteo Soranzo's testament of 1547. It seems likely, then, that he had a daughter named Lucia, named after his wife, who was portrayed in the painting but who did not live to the time of his testament of 1547. ASVe, Notarile, Testamenti, Atti Francesco Fadini, b. 414, n. 75 and n. 101. As to the identity of the young man to the far left, he has been surmised to represent Matteo's brother Francesco (d. 1541) because of the presence of Saint Francis. Matteo Soranzo also purchased a painting, now lost, of "*un Christo a la colona con el retrato del suo cavaliere.*" This *cavaliere* is named Marcantonio in receipt for payment from him ("*misier Marcantonio, cavalier del magnifico contra scrito Podestà,*" Muraro, ed. 1992, 94v–95r). Such cavaliers were essentially bodyguards, companions, or servants. Given the swagger and sword of the man depicted, could he be meant to represent the *podestà*'s cavalier Marcantonio?

47 This leaf was at one time detached, folded, and then pasted into another Commission, that of Francesco di Andrea Marcello (1531–1580) as Proveditor of Peschiera of 1570, Florence, Laurenziana, Ashb. 1096. The Commission to Lorenzo Cappello as *Podestà* of Bassano, from which this leaf is detached, is in the Giustiniani Falck Collection, Cl. IV, cod. 48. This Lorenzo di Pietro di Francesco is not to be confused with his contemporary Lorenzo di Pietro di Giovanni Cappello (1555–1603).

48 Ottone Brentari, *Storia di Bassano e del suo territorio* (Bassano: 1884): 474–79. Lorenzo has been lauded as the Venetian *podestà* most beneficial to Bassano, and the city commissioned at least five lapidary inscriptions honoring him throughout the city.

49 It is unclear if Leandro made it in Bassano or Venice because it seems he already was a member of the painters' guild in Venice by this date.

50 Archivio Patriarcale di Venezia, Status Animarum, b. 4: Sta Maria Formosa, libro dello stato delle anime 1593: "*Il Clar.mo Sig. Lorenzo Capello, figlio Zuanne, Pietro, Regina figlioli, camilla e cattarina serve, pietro servitor, m. zuanne maestro da scuola.*" Lorenzo Cappello had been widowed twice: he had been married to Marina Zorzi (or da Lezze) in 1573 and Betta Molin in 1578. Numerous eulogies were addressed to Lorenzo upon his departure. Brentari 1884; Gerola 1903.

51 Another detached leaf from a Commission, from which the first name of the rector and location of the region to be governed are missing, probably also was made for Lorenzo Cappello, for he is recognizable as the same auburn-haired man, now receiving the Commission document from Doge Pasquale Cicogna (doge 1585–95), Cambridge, Fitzwilliam Museum, Marlay Cutting It. 55. Morgan, Panayotova, Reynolds, eds. 2011, vol. 1, 180.

52 BMVe, It. VII, 741 (=7507). Francesco di Francesco

Gradenigo (da San Lio, 1576–1614) is represented with his wife Francesca di Bernardin di Andrea Loredan (whom he married in 1600), his son Leonardo (b. 1608), and the first of four daughters. Susy Marcon, entry in Marino Zorzi and Susy Marcon, eds. *Grado, Venezia, i Gradenigo* (Venice: Biblioteca Nazionale Marciana/Edizioni della Laguna, 2001): 387–88. See also the detached leaf, no name or date indicated but with the Venier coat of arms. Williamstown, MA, formerly Collection of Robert L. Volz, now Sterling and Francine Clark Art Institute, Department of Prints and Drawings, 1986.52. Rafael Fernandez, *A Scene of Light and Glory: Approaches to Venice* (Williamstown, MA: Sterling and Francine Clark Art Institute, 1982): cat. 21.

53 Now National Gallery, Washington, D.C. Patrons' Permanent Fund 1997.21.1. William R. Rearick in Brown and Marini, eds. 1993, 288–89. Montuori 1999.

54 Pietro Pizzamano as *Podestà* and Captain of Bassano, 1544, London, BL, Add. MS 20916, fol. 6; Zuccolo Padrono 1971. Pietro Pizzamano as Rector of Sitia, Crete, 1545, Bruce Ferrini, *Medieval & Renaissance Miniature Paintings* (Akron, OH: Bruce Ferrini, 1995): cat. 58 (Sitia is misidentified as Siria, or Syria); Sotheby's London, Bond Street, *Western Manuscripts and Miniatures*, June 22, 2004, lot 4240. There is a Commission for Pietro's father: Giovanni Andrea di Michele Pizzamano as *Podestà* of Conegliano, of 1499. It has an opening border illuminated by Alberto Maffei with images of Pizzamano's patron saints John the Baptist and Andrew. BL, Egerton 762.

55 The scene is taken mainly from the narrative according to Luke (5:3–11), although elements are from the description by Matthew (4:18–22) and Mark (1:14–20).

56 Montuori 1999. A rector's Commission would have been one of a number of important documents and books to consult that he would have taken with him to his post, and the portraits in his manuscripts could be used as visual prototypes while abroad. An oration in praise of Pizzamano was written upon his departure from Bassano by the poet Camillo Giraldo. While at his subsequent post in Bergamo, in 1560, Pizzamano had Giraldo's text copied, with illustrations added in pen and ink by Giovanni Fortunato Lolmo. Lolmo seems to have copied the profile portrait of Pizzamano in this manuscript directly from the Bergamo Commission. In other words, in giving a copy of the Bassano oration to Lolmo to copy, Pizzamano probably also gave him the Commission as a visual model for the portrait. Bassano del Grappa, Archivio del Museo, MS 35–c.29, fol. 1. Giovanni Fortunato Lolmo (illustrator). Camillo Giraldo, *Oratio de laudibus Petri Pizamani Praetoris Bassanensis*, 1560; Montuori 1999, 13–19.

57 November 25, 1549. Cappelluzzo 1992, 133–34.

58 Simone Facchinetti and Novella Barbolani di Montauto, in Facchinetti 2004, 32–33, 150–51.

59 "*il quale fece somiglianti ritratti, onde soleva dir*

Titiano a' Rettori destinati dalla Republica alla città di Bergomo, che si douessero far ritrarre dal Morone, che gli faceva naturali." Ridolfi 1965, 147. Whereas most *rettori* of Venetian territories in this period were elected in the Great Council of Venice, the citizens of the Val Seriana, including of Clusone, were allowed to elect their *podestà* themselves from among the patricians of the Veneto, and often chose Venetian patricians. Da Mosto 1940, vol. 2, 6; Gregori 1979, 315–16, cat. 215. Capi del Consiglio di dieci, Lettere dei Rettori ed altre cariche, Lettere da Clusone, b. 18.

60 "*Nobile per casa.*" Vecellio 1590, fols. 110v–110r; Vecellio 1598, fols. 85v–86r.

61 HLSM, EL 9 H 13, 6. Dutschke 1989. See for example also the costume of Giovanni Antonio di Alvise Foscarini (1522–1598) in the leaf detached from his Commission as Proveditor of Gambarare, Dolo, and Morenzano, of 1563. Médiathèque de Roanne, Boullier 50, Viallon-Schoneveld 1994, 68.

62 G. N. Doglioni, *La città di Venetia con l'origine e governo di quella* (Venice: Antonio Turini for Giacomo Franco, 1614): fol. 15v, PML, PML 76228.

63 Pinacoteca di Brera, Milan, inv. 334. Gregori, Rossi, et al., eds. 1979, 280–81, cat. 138. Humfrey 2000. Both of these paintings were still in their respective family collections in the early seventeenth century. Simone Facchinetti has suggested that the sitter in a portrait by Moroni in the Museum of Fine Arts, Reims, can be identified as a Venetian *podestà* by the *zimarra*. Facchinetti 2004, 154.

64 "*CUM BERGOMI PRAETURAM SUSTINERET MDLXV.*"

65 On the codpiece in Renaissance portraiture, see Simons 1994. Navagero's *relazione*, presented to the Senate upon his return in 1565, discusses the social discord and difficulties with the fortress construction. It is printed in *Podestària e Capitanato di Bergamo*, ed. Amelio Tagliaferri (1978): 67–68.

66 On the identity of the sitter, see Vilmos Tatrai in Keyes, Barkóczi, Satkowski, eds. 1995, 190–91; Szépe 2000; David Ekserdjian in Ekserdjian, ed. 2010, 238, with previous bibliography. On Jacopo Foscarini, see Blake de Maria, "Jacopo Foscarini, Francesco Barozzi, and the Oracles of Leo the Wise," in Avcioğlu and Jones, eds. 2013, 219–29.

67 On Jacopo Contarini di Pietro di Jacopo of San Samuele as patron of art and architecture, see Hochmann 1987; Favaretto 1990; Hochmann 1992, *Peintres et Commanditaires*, 252–62; Hochmann 2002; Hochmann 2004; Scarpa 2005; Michel Hochmann, "Giacomo Contarini," in *Collezionismo 2008*, 260–61; Cooper 2005, 221–23. On his book collection, M. Zorzi, 1987, 184–86.

68 On the program, see Chapter 7. Wolters 1966; Sindig-Larsen 1974, 8, 21.

69 There is a reference in an inventory of the seventeenth century to a portrait by Moroni in the Contarini palace.

Vilmos Tatrai in Keyes, Barkóczi, Satkowski, eds. 1995, 190–91.

Citing the importance of his collection to his own reputation and honor in his testament of 1595, Jacopo established the inheritance of his collection along the lines of the primogeniture of each generation, until the line would become extinct, after which it was to go to the Republic. Much of the collection, such as the *Rape of Europe* by Paolo Veronese now in the Palazzo Ducale, did end up in public collections after the last descendant, Bertuccio di Girolamo Contarini (1638–1713). *Collezionismo 2007*, 139, n. 81.

70 The official report of May 29, 1579, presented by Jacopo Contarini to the Senate on his return from duty as *Podestà* of Bergamo is published in *Podestària e capitanato di Bergamo*, ed. Amelio Tagliaferri (Milan, 1978): 129–49. There are numerous documents pertinent to his ruling of Bergamo in his personal archive now in the Archivio di Stato. "Archivio proprio di Giacomo Contarini," ed. Maria Francesco Tiepolo, ed. and revised by Franco Rossi, ASVe, Inventario 311/4.

71 BL, Add. MS 16996. Consul 1590–93. "Tiziano" was written below the opening image at a later date. *Relazione del NH ser Vincenzo Dandolo console in Egitto*, eds. Alessandro and Maria Palazzi (Venice: Grimaldo, 1873).

72 The text identifying the post is illegible, but was granted in the years of Doge Marin Grimani, therefore from April 26, 1596, to December 25, 1605, and the *segretario alle voci* records reveal Muazzo as serving in those years at this post. ASVe, *SAV*, Maggior consiglio, reg. 8 (1595–1602).

73 HLSM, EL 9 H 13, 15; HLSM, EL 9 H 13, 13. Described in Dutschke 1989, vol. 1, 25. For another such personal image of Venetia, see also a leaf of a member of the Baseggio family: *Illuminations, Gouaches, Drawings from the 12th to the 17th centuries*, catalogue 1 (Paris: Les Enluminures, 1992), 40–41, entry 16. On the *corno* hair arrangement, Vecellio 1598, 129v–130r.

74 Cavalli and Bertelè 1935, 92–93.

75 Achille Olivieri, "Cavalli, Marino," *DBI* 22 (1979); Grendler 1990, 60–61.

76 Commission to Marin Cavalli as Captain of Vicenza, 1535, Roanne, Médiathèque de Roanne, Boullier 14; Commission to Marin Cavalli as Captain of Brescia, 1552, Roanne, Médiathèque de Roanne, Boullier 16. Viallon-Schoneveld 1994, 29–30, 32.

77 Cavalli was particularly concerned that his body be the only one deposited in his tomb. "*Voglio che l'mio corpo sia sepolto nella chiesa di San Zuanepolo nella nostra capella de San Michiel, nel casson de pietra viva che ho ordinate io che si faccia, ove niun altro doppo me sia sepolto, per non agionger una ad un'altra putredine.*" ASVe, Testamenti, Atti Cesare Ziliol, b. 1260, n. 760 (January 7, 1571). Transcribed in Cavalli and Bertelè

1935, 30. See also Luchs 2011, 78, fig. 99; Pavanello, ed. 2013, 258.

78 Achille Olivieri, "Cavalli, Marino," *DBI* 22 (1979).

79 This building is also called Palazzo Moroni because the present building was designed by the architect Andrea Moroni, completed 1541. Roberta Lamon, *Palazzo Moroni e gli edifici comunali circostanti* (Padua: Comune di Padova, 2008).

80 Elisabetta Saccomani with relevant bibliography in Ballarin and Banzato 1991, 158; Vincenzo Mancini, "'Sotto specie di laude': immagini celebrative di magistrate in Terraferma," in Pavanello, ed. 2004, 113–30. The patron saints of Padua – Justine, Prosdocimo, Anthony of Padua, and Daniel – frame the central group. In the inscription on the painting, Marin Cavalli's role in diplomacy with Germany is emphasized.

81 He also emphasized that he wanted his capital to go to his sons and their legitimate sons, so that they could be members of the Great Council in perpetuity *per stirpem*, through bloodline and not through purchase. ASVe, Notarile, Testamenti Atti Ziliol b. 1260, n. 760. In 1569, Marin purchased the first floor of the great palace near the Church of San Vidal built by the Marcello family, which is now called Palazzo Cavalli-Franchetti, and which was his *casa da statio*.

82 Marin Cavalli, *Informatione dell'offitio dell'ambasciatore*, Vienna, ÖNB, Cod. 6555, fols. 27r–52r. From the collection of Doge Marco Foscarini (1695–1763). Achille Olivieri, "Cavalli, Sigismondo," *DBI* 22 (1979). Sigismondo's career was especially distinguished but, because he served primarily in diplomatic work rather than as rector, no Commissions as rector were made for him.

83 Marin Cavalli, *Informatione dell'offitio dell'ambasciatore*, Vienna, ÖNB, Cod. 6555, fols. 27r–52r. Transcribed in Cavalli and Bertelè 1935, 40.

84 Cavalli and Bertelè 1935, 59–60.

85 Marin recommended dressing in silk, but of the highest quality. He suggested only black, "lionato," or *pavonazzo* (blue). Velvet was discouraged because it got worn out and damaged more easily. Cavalli and Bertelè 1935, 45.

86 Cavalli and Bertelè 1935, 82–83.

87 "*Nundum Exp.to XLV.to AN:*" *Matura* is probably intended as the active imperative of *maturare*. Marin Cavalli, *Informatione dell'offitio dell'ambasciatore*, c.1563, transcribed in Cavalli and Bertelè 1935, 52–53. The motto is inscribed also on the heraldry of Marin Cavalli's tomb; see later discussion. Although the Commission he has his hands upon, complete with lead *bolla*, has a red binding stamped with gold, the current manuscript binding boards are covered with a thick pile velvet similar to that of his *stola*. The remains of silk ties suggest this was the original binding of the manuscript.

88 Dresden, Sächsische Landesbibliothek, Staats- und Universitätsbibliothek, Mscr. Dresden F 169. Karl Schnorr v. Carolsfeld, *Katalog der Handschriften der Königl. Öffentlichen Bibliothek zu Dresden* (Leipzig: B. G. Teubner, 1882; Dresden, reprint 1979 with annotations on which manuscripts were lost or damaged in WWII): 415; Robert Bruck, *Die Malereien in den Handschriften des Königreichs Sachsen* (Dresden: C. C. Meinhold & Söhne, 1906): 403–4.

89 Cavalli and Bertelè 1935, 92–93.

90 BMCVe, Cl. III, 868. The Commission to Antonio Cavalli as *Podestà* of Brescia of 1595 is not illuminated, although the scribes left the opening leaf blank for a miniature. BMCVe, Cl. III, 886.

91 The artist, perhaps Giovanni Maria Bodovino, used the same general pose in the Commission to Alberto di Angelo Badoer (1540–1592) of 1584, but in this detached miniature the Rector Alberto places his hand on his chest as he looks out at what may have been a devotional image on a facing leaf. Leaf detached from the Commission to Alberto Badoer as *Podestà* of Verona, 1584. Cambridge, Fitzwilliam Museum, Marlay Cutting It. 51. Morgan, Panayotova, Reynolds, eds. 2011, vol. 1, 178. From 1579 to 1582 Alberto was ambassador to the court of Rudolf II of the Hapsburgs and thereby granted the imperial ensign of the crowned double-headed eagle, which is displayed below him, and which remained in the family heraldry. On Badoer, see Aldo Stella, "Badoer, Alberto," *DBI* 5 (1963).

92 June 19, 1582. "*quanto sia fragil questa nostra vita & quanti accidenti di morte ella sia sottoposta & volendo prima ch'io vadda con mio marito al suo reggimento della patria del friulli desponer le cose mie & far testamento.*" BMCVe, MS Prov. Div. ca. 2408/4, fol. 1.

93 Muir 1998. Despite Franceschina's wish to be buried next to her husband, it seems they did not have a happy marriage. Antonio was suspected subsequently of poisoning his wife. Barbaro GD, vol. 2, 199r.

94 Commission to Jacopo di Francesco Soranzo as *Podestà* of Brescia, 1562. St. Petersburg, Historic-Scientific Archive of the Institute of History at the Academy of Sciences of Russia, Coll. 46, carton 56, n. 5. Ekaterina Zolotova, "Il Maestro delle commissioni del doge Girolamo Priuli 1559–1567). Cenni sulla personalità artistica," in Lucchi, ed. 2013, 87–92. The hand of the miniaturist of this leaf was studied by Giulia Maria Zuccolo Padrono as one of a number of miniaturists working in a mannerist style (Zuccolo Padrono 1969). Giordana Mariani Canova identified this leaf as created by one of the hands of this group, and she cited a Commission to Francesco Tron as by the same hand (Commission to Francesco di Paolo Tron [b. 1529] as Proveditor of Peschiera, 1562, BMCVe, Cl. III, 202. Mariani Canova 1978, 64–65, cat. 110). The miniaturist subsequently has been named the Mannerist Master (Szépe 2001, 71; Helena Katalin

Szépe, "Painters and Patrons in Venetian Documents," in Lucchi, ed. 2013, 51). Ekaterina Zolotova has defined the work of this artist more carefully as the "Maestro delle Commissioni del doge Girolamo Priuli" and intriguingly linked his work to the prints of Enea Vico, a suggestion that deserves further study (Ekaterina Zolotova, "Il Maestro delle commissioni del doge Girolamo Priuli (1559–1567). Cenni sulla personalità artistica," in Lucchi, ed. 2013). Since this Master worked before and after the term of Girolamo Priuli as doge (September 1, 1559–November 4, 1567), and because a number of other miniaturists painted in Commissions during the term of Doge Priuli, the name Mannerist Master will be retained here. Commission to Giovanni K. di Francesco Soranzo as *Podestà* of Bergamo, 1567, WAM, W.493. Szépe 2001, 59–62. His Commission as *Bailo* of Constantinople of 1566 is not illuminated. BL, Add. MS 21395.

95 Private collection. Vincenzo Mancini, "'Sotto specie di laude': immagini celebrative di magistrate in Terraferma," in Pavanello, ed. 2004, 113–30.

96 WAM, W.493.

97 New Haven, Yale University, Lillian Goldman Law Library, Rare Book Collection MssJ V55 n. 2. The miniature in this manuscript can be attributed to Giovanni Battista Clario da Udine, who was documented as illuminating choir books for the Church of San Marco in 1568. On this miniaturist see Susy Marcon, "Clario Giovan Battista/Giovan Battista da Udine," *DBMI* 161–63.

98 The documents for the councillors do not incorporate the more elaborate coats of arms used in the Commissions as *rettori*, perhaps indicating that the patricians had less say in their illumination. *Capitolare* of Jacopo di Francesco Soranzo as ducal councillor (illuminated by the T.° Ve Master). Warsaw, National Library, Boz 20. Zuccolo Padrono 1971, 69–70, fig. 102. My thanks to Barbara Dzierżanowska of the National Library for further information about the manuscript. The Commission of Jacopo and Giovanni's brother Lorenzo di Francesco Soranzo (1519–1579) as ducal councillor of 1572 is illuminated with Saint Lawrence with his grill. BMCVe, Cl. III, 206. There are two portraits of Lorenzo by Tintoretto: Falomir, ed. 2007, 266–68.

99 Gaier 2002, 264.

100 Surviving procurator *de supra* records show that Jacopo's Commission as procurator was written out by Giovanni Vitali, who scripted the Commissions of at least three other procurators from 1570 to 1575. Chambers 1997, 68, 79–81. On Jacopo's career and related art patronage, see Pilo 1997; Paul 2007.

101 It was mentioned by Ridolfi in 1648 as in the Hall of the Podestà in Padua – surely the place for which Soranzo intended it. Wolters 1987, 150; Elisabetta Saccomani with relevant bibliography, in Ballarin and Banzato

1991, 158; Vincenzo Mancini, "'Sotto specie di laude': immagini celebrative di magistrate in Terraferma," in Pavanello, ed. 2004, 113–30; Gaier 2002, 265.

102 These portraits include one formerly in the collection of W. P. Chrysler, Jr., sold at auction in 1989 (Sotheby's, New York, June 1, lot 27), one in the Musée des Beaux-Arts, Bernay, and a third in a private collection. Rossi 1982, 109; Bertina Suida Manning, "Titian, Veronese and Tintoretto in the Collection of Walter P. Chrysler, Jr.," *Arte Veneta* 16 (1962): 49–59 (54–57).

103 November 7, 1599. ASVe, Notarile, Testamenti, Atti Giulio Ziliol, b. 1244, n. 382. Gaier 2002, 497.

104 Two of Giovanni Soranzo's sons, Francesco (1557–1608) and Girolamo (1569–1635), also had illustrious careers. They both were eventually knighted, and Girolamo became a procurator. Francesco was elected *Podestà* of Belluno in 1585, and was the first to have a bust of himself erected on the Palazzo dei Rettori there, in 1592. As noted in Chapter 5, this became a tradition in Belluno, and besides inscriptions and coats of arms, eventually at least fourteen busts of Venetians came to be erected on the Palazzo del Consiglio and Palazzo dei Rettori. His Commission for the post is merely illuminated with a full-page heraldic emblem. BMCVe, Cl. III, 915. On Francesco Soranzo: Gaier 2002, 246–48.

105 Gaier 2002, 267.

106 See Gaier 2002, 263–69, 495–501, for extensive documentation and analysis of the Soranzo monument at Santa Giustina. Andrew Hopkins, *Baldassare Longhena and Venetian Baroque Architecture* (New Haven and London: Yale University Press, 2012): 166–67.

CHAPTER 7: SERVICE, STATE, AND EMPIRE

1 The literature on the battle and celebration of it is enormous. See, with extensive bibliographies: Maddalena Redolfi, ed. *Venezia e la difesa del Levante da Lepanto a Candia 1570–1670* (Venice: Arsenale, 1986); Fenlon 2007; Cecilia Gibellini, *L'immagine di Lepanto: la celebrazione della vittoria nella letteratura e nell'arte veneziana* (Venice: Marsilio, 2008); Paul, ed. 2014.

2 Muir 1981; Giurgea 1987; Urban 1998; Fenlon 2007. For all of these kinds of festival, see also Sanudo 2008, *Venice, città excelentissima*, 485–533.

3 Muir 1981; Fenlon 2007.

4 Bifolio dated December 20, 1569. ASVe, Ufficiali alle Rason vecchie, *Documenti della cassa grande* 1510–1572, b. 378, pieces not numbered. Sanudo described the *Giovedì grasso* proceedings of 1533: Marin Sanudo, *Il giovedì grasso in Venezia nell'anno 1533* (Venice: Fratelli Visentini, 1898); Padoan Urban 1983.

5 For the events of 1162 celebrated on *Giovedì grasso*, see Muir 1981, 156–70.

6 Muir 1981, 160–61, 178–79.

7 Muir 1998; Sanudo 2008, *Venice, città excelentissima*, 518–20. Muir 1981, 156–66.

8 Brown 1996.

9 Philine Helas, *Lebende Bilder in der italienischen Festkultur des 15. Jahrhunderts* (Berlin: Akademie Verlag, 1999): 127–53; Lilian Armstrong, "The Triumph of Caesar Woodcuts of 1504 and Triumphal Imagery in Venetian Renaissance Books," in Silver and Wyckoff, eds. 2008, 53–72; Larry Silver, "Triumphs and Travesties: Printed Processions of the Sixteenth Century," in Silver and Wyckoff, eds. 2008, 15–32.

10 Tagliaferro 2005, 85.

11 Bodovino and workshop, *Venice as Justice with a Globe at her Feet*, leaf detached from the Commission to Daniele di Sebastiano Foscarini (1530–1595) as Lieutenant of Udine, 1578. HLSM, EL 9 H 13, 19. Dutschke 1989, 26–27. "*Fiat Pax in Virtute tua et abundantia*," *Venice as Justice Ruling over the Globe, with Peace and Abundance*, leaf detached from the Commission to Alvise di Bernardo Belegno (1539–1606) as Lieutenant of Udine, 1593, BL, Add. MS 20916, fol. 21.

See Also Morgan Master, *Venice as Justice Seated on a Chariot, Attended by Virtues*, leaf detached from a Commission to Nicolò Malipiero during the reign of Girolamo Priuli (doge 1559–67). BL, Add. MS 20916, fol. 12. This may be the same Nicolò (di Giovanni Antonio) Malipiero who, in 1557, commissioned of Palladio the Villa Moro Malipiero (now called Villa Rigoni Savioli) near Abano Terme, in the province of Padua. The villa has frescoes attributed to Giovanni Battista Zelotti.

Bodovino and workshop, *Venice as Justice Seated on a Lion*, leaf from a Commission with no heraldry or text, HLSM, EL 9 H 13, 18. Dutschke 1989, 26.

Bodovino workshop, *God the Father Presiding over Charity and other Virtues*, detached leaf from a Commission to a Venier, HLSM, EL 9 H 13, 14. Dutschke 1989, 26.

See also Mannerist Master, *Venice as Justice*, HLSM, EL 9 H 13, 21. Dutschke 1989, 27; Morgan Master, *Venice Receives the Sword and Scales of Justice*, detached leaf from a Commission to a Pasqualigo, HLSM, EL 9 H 15, 35. Dutschke 1989, 28; Mannerist Master and workshop, *Giovanni Paolo di Giovanni Gradenigo (1544–1607) as "Podestà" and Captain of Feltre*, 1569, BL, Egerton 756; Venetian Master, *The Triumph of Faith*, detached leaf from a Commission with no coat of arms or text, HLSM, EL 9 H 13, 11. Dutschke 1989, 26; Bodovino workshop, *Justice and Abundance*, detached leaf pasted into the Commission from Doge Silvestro Valier to Antonio di Andrea da Mula (b. 1659) as Lieutenant of Udine, 1700, BL, Add. MS 17034.

12 "*ad restaurandam civitatem.*" ÖNB, Cod. 5890. Unterkircher 1976, 55. The original facing leaf has been excised.

The Reports of the Venetian Provveditori in

Zakynthos (Zante), 16th–18th Centuries, ed. Dimitris Arvanitakis (Venice: Hellenic Institute, 2000).

13 HLSM, EL 9 H13, 25 and EL 9 H13, 26. Dutschke 1989, 27. In 1574, as Lieutenant of Udine, Girolamo went with 500 gentlemen from the country on horseback and 200 *fanti* (infantrymen) to the confines of the territory to meet Henry III of France on his way to Venice. *Campidoglio veneto*, vol. II, fol. 95v. On the king's reception in Venice, see Fenlon 2007, 193–99. Girolamo Mocenigo's *relazione* is printed in *La patria del Friuli (Luogotenenza di Udine)*, ed. A. Tagliaferri. *Relazioni dei rettori veneti in terraferma*, vol. 1 (1973): 89–94.

14 Tagliaferro 2006.

15 Pallucchini and Rossi 1982, vol. 1, 262.

16 HLSM, EL 9 H13, 25. Dutschke 1989, 27.

17 Rosand 1984; Rosand 1991; Tagliaferro 2005; Caroline Wamsler, "Picturing Heaven: The Trecento Pictorial Program of the Sala del Maggior Consiglio in Venice," PhD thesis, New York, Columbia University, 2006; Jean-Pierre Habert, ed. *"El Paraíso;" un concurso para el palacio de los Dux* (Madrid: Fundación Colección Thyssen-Bornemisza, 2006).

18 Now in private collections. *Luca Michiel as Provveditore Generale*, Christie's London, King Street, Old Master & British Drawings & Watercolours, July 10, 2014 (sale 1538), lot 107; *Luca Michiel as Procurator "de Citra,"* Christie's London, South Kensington, Old Master & British Drawings & Watercolours, December 2, 2014 (sale 5877), lot 11.

19 The other leaf shows Saint Mark promoting Charity to Michiel, here dressed in his robes as procurator, while Faith and Hope stand behind him. The meaning of the image is proclaimed by the inscription in the frame: "Charity in performing the office of procurator will lead to glory." Manfredi recorded Michiel's painted portrait in a third room in the *ridotto* of the *de citra* procurators (with Giovanni Soranzo and Girolamo Zane). Manfredi 1602, 22–28. A marble bust of Michiel was placed on his epitaph, which also celebrates him as warrior and procurator. This memorial was furnished by his brothers Alessandro and Pietro on the right wall of the nave of the Church of Santa Caterina di Mazzorbo. The sculpture now is in the Seminario Patriarcale, Venice. Vittorio Moschini, *Le raccolte del Seminario di Venezia* (Rome: Libreria dello stato, 1940): 9. Luca married a daughter of Francesco di Paolo Zen in 1580, but he had no sons. He was elected as one of the *provveditori* for the Doge's Palace in 1587. *Del tesoro politico, La parte terza e quarta* (Frankfurt am Main: Impensis J. T. Schönwetteri, 1612), 306–7; Grendler 2000, 77–78; Cooper 2004, 293. The woman with a snake is remarkable in resembling the famous Minoan "snake goddess" figurines, presumed to have been first discovered in temple repositories at Knossos by Arthur Evans in 1903. Was this imagery in fact known by the sixteenth century? On the association of Jupiter with

Crete and for a discussion of the antiquarian interests of Venetians, see Johanna D. Heinrichs, "The Topography of Antiquity in Descriptions of Venetian Crete," in Avcioğlu, Nebahat, and Emma Jones, eds. 2013, 205–18.

20 On Duodo, see especially Giuseppe Gullino, "Duodo, Francesco," *DBI* 42 (1993); Szèpe 2001, 70–76; Fenlon 2007, 302–10. On Duodo as a collector, see Linda Borean, "Francesco e Domenico Duodo," in *Collezionismo 2008*, 274–75.

21 BMCVe, Cl. III, 193. The binding has been attributed to the Mendoza Binder by Anthony Hobson. I would like to thank Sheramy Bundrick for the translation. Hobson 1999, 101, 103, fig. 54. This and many manuscripts, books, and other materials were donated to the Correr in the late nineteenth century by the heirs to the Duodo, the Balbi Valier family. On the life of Francesco Duodo, see Giuseppe Gullino, "Duodo, Francesco," *DBI* 42 (1993).

22 Sansovino 1581, fol. 138v. Sansovino 1604, fol. 258r; Linda Borean, "Francesco e Domenico Duodo," in *Collezionismo 2008*, 274–75.

23 Edinburgh University Library, MS La. III. 795/1.

24 Rosand 1984, 177–96.

25 "*Diligite iustitiam qui iudicatis terram.*" The inscription "LM" at the base of the monument appears to have been added by a later owner.

26 Dutschke 1989, vol. 1, 27.

27 Stefania Mason Rinaldi dates the painting to c.1593. Since Doge Francesco Venier died in 1556, it is possible that a compositional model was formulated much earlier, but no records exist for one, by contrast to the survival of a record of the Commission in 1555 to Titian to paint his portrait destined for the Hall of the Great Council. Lorenzi 1868, 288; Mason Rinaldi 1984, 142, cat. 536, fig. 201. Palma Giovane adapted the general composition for his votive portrait of Marcantonio Memmo (doge 1612–15) in the Great Council Hall, in which figures personifying territories in which Memmo was rector, identified by the coats of arms on their statute books, accompany him. Mason Rinaldi 1984, 143, cat. 541, figs. 575, 577, 578.

28 "*non nobis domine non nobis ... gloria tibi soli.*"

29 McAndrew 1980, 348–57; Stahl 2001, 303.

30 Cicogna 1824–53, vol. 3, 177–79.

31 HLSM, EL 9 H 13, 10. Dutschke 1989, 25. The rest of the manuscript is in the Edinburgh University Library, MS La. III.795/2.

32 See the absence of such imagery in Nante, ed. 2004.

33 Margaret Finch, "The Cantharus and Pigna at Old St. Peter's," *Gesta* 30, 1 (1991): 16–26; Justin Greenlee, "*Quod vocatur paradiso*: The *Pigna* and the Atrium of Old St. Peter's," (MA thesis, Tuscaloosa: University of Alabama, 2014).

34 Ulisse Aldrovandi, *Di tutte le statue antiche, che per tutta Roma ...* in Lucio Mauro, *Le antichità della città di Roma* (Venice: Giordano Ziletti, 1556): 313.

35 Garton 2008, 98–104.

36 Wilson 2005, 186. On the use of imagery across media in framing Lepanto and Venetian identity see also Wilson 2005, 140–63, 186–201; Tagliaferro 2006; Fenlon 2007.

37 Giovanni Casoni, *Guida per l'Arsenale di Venezia* (Venice: Giuseppe Antonelli, 1829): 18, cat. 'G'. The presumed armor of Duodo now is displayed in the Sale d'Armi of the Doge's Palace: Umberto Franzoi, *L'armeria del Palazzo Ducale a Venezia* (Venice: Canova, 1990): 68, cat. 3. A list of the armor that remained in the family palace at Santa Maria del Giglio is in a manuscript by Teodoro Amaden, *Duodo Bellator*, cited by Cicogna 1824–53, vol. 6, 901.
 The armor of Sebastiano Venier, by contrast, had been acquired by Archduke Ferdinand of Tyrol for his arms museum at Ambras Castle, near Innsbruck, by 1601. Sylvia Ferino-Pagden in Bacchi, Camerlengo, and Leithe-Jasper, eds. 1999, 292–93.

38 HLSM, EL 9 H 13, 20. Duodo probably supplemented the allowable amount disbursed by the *Procuratia* to have his Commission as procurator illuminated, for the miniature is particularly fine. Dutschke 1989, 27.

39 The figure of Christ shows a remarkable resemblance to that in the altarpiece of the resurrected Christ by Tintoretto, of 1565, which is still in the Church of San Cassiano in Venice. Pallucchini and Rossi 1982, vol. 3, fig. 383. The enslaved Ottomans are portrayed similarly to the bound "Turk" in Titian's allegorical portrait of Philip II in the Prado, Madrid (*Allegory of the Victory of Lepanto*), of 1573–75. Wethey 1969–75, vol. 2, 132–33, cat. 84.

40 Giuseppe Gullino, "Duodo, Francesco," *DBI* 42 (1993).

41 Commission to Francesco Duodo, *Capitano delle galee grosse, per la guerra "turchesca,"* May 23, 1570. Collection of texts from 1569 to 1573 recording Francesco Duodo's election as captain "*delle galee grosse*" and praises by Marcantonio Colonna, Don Juan of Austria, and others for his part in the victory at Lepanto. BMCVe, Cl. III, 304. Balbi Valier donation. See also *De' fatti egregi del cl.mo et ill.mo Sig. F. D. nel capitaneato delle galee grosse armate*, BMCVe, MS P.D. 11c. Balbi Valier donation.

42 Frederick Ilchman identified Francesco Duodo as the sitter in an oil painting, perhaps by Titian. Frederick Ilchman, "A Rediscovered Late Portrait by Titian," in Kenneth Clark, Frederick Ilchman, and David Rosand, *Rembrandt and the Venetian Influence* (New York: Salander-O'Reilly Galleries, 2000): 22–27. David Jaffè has suggested the painting should be associated instead with Palma Giovane. "New thoughts on Van Dyck's Italian Sketchbook," *The Burlington Magazine* 143, 1183 (2001): 614–24.

43 Museo Storico Navale, Venice, Inv. 952. Illustrated in Kenneth Clark, Frederick Ilchman, and David Rosand, *Rembrandt and the Venetian Influence* (New York: Salander-O'Reilly Galleries, 2000): 25.

44 Both are described and illustrated in Martin 1998, cats. 4 and 5, 102–5, plates 101, 102; Thomas Martin, entries in Bacchi, Camerlengo, and Leithe-Jasper, eds. 1999, 298–301. Martin believes the plaster bust to be the autograph model by Vittoria for the marble bust, but that there was workshop participation in the stone portrait.

45 "*con quegli adornamenti et epitaffio che parerà alli mei comissarii et heredi et questo sia in memoria delle [mie] fatiche fatte ad honor della Maesta Divina et utile della nostra patria.*" ASVe, Notarile, Testamenti, Atti Vincenzo Conti, b. 240, n. 155. Nov. 16, 1592, Testament of Francesco Duodo (written out by Duodo); ASVe, Notarile, Testamenti, Atti Vincenzo Conti, reg. 241, fols. 33–36, written out by Conti. The testament is partially transcribed in Puppi and Puppi Olivato 1974.

46 Sansovino 1604, fol. 89v. Martinioni, in his edition of Sansovino's guide, makes no mention of the standards, but highlights the relic of the arm of Saint Giustina, donated to the church by Francesco's descendant Francesco di Alvise Duodo (1598–1652), in 1651. This particular relic supplemented her image in Duodo's altarpiece. Sansovino 1663, 114.

47 Giuseppe Giurato, "Lepantò (MDLXXI–MDCCCLXXI)," *Archivio Veneto* 1 (1871): 247–97.

48 Marco Morin, "La battaglia di Lepanto: alcuni aspetti della tecnologica navale Venezia" (conference paper, Meditando sull'evento di Lepanto, Istituto di Studi Militari Marittimi, Venice, November 8, 2002), http://www.storiadivenezia.net/sito/saggi/morin_lepanto.pdf.

49 Alessandro Vittoria left the Venier portrait to the state in his testament of 1608. It was probably made around the same time as the Duodo bust, and it is unclear what original destination was intended. It is now above the door of the stairs leading to the Sala d'Armi. Thomas Martin in Bacchi, Camerlengo, and Leithe-Jasper, eds. 1999, 290–91.

50 This monument faces a series of stepped churches, the first of which is believed to have been commissioned either by Francesco or his son Pietro. L. Puppi and L. Puppi Olivato 1974; Guido Beltramini, "La villa per Francesco e Domenico Duodo," in F. Barbieri and G. Beltramini, eds. *Vincenzo Scamozzi 1548–1616* (Venice: Marsilio, 2003): 301–9; Loredana Olivato, "Percorsi devozionali ed esibizione del potere: Vincenzo Scamozzi a Monselice," *Tra monti sacri, "sacri monti" e santuari; il caso veneto. Atti del convegno di studi, Monselice, 1–2 Aprile 2005*, eds. A. Diano and L. Puppi (Padua: Il poligrafico, 2006): 135–45.

51 Palluchini and Rossi 1982, vol. 2, 254, cat. A113.

52 "*di bona et quieta natura sempre inclinata alla virtù* …" It was Alvise who expressed the desire that his father's portrait bust by Vittoria, still in the palace in 1611, be placed in Santa Maria del Giglio, according to Francesco's request. Linda Borean, "Francesco e Domenico Duodo," in *Collezionismo 2008*, 274–75.

53 On Pietro Duodo, see Giuseppe Gullino, "Duodo, Pietro," *DBI* 42 (1993). The five surviving *ducali* for him in the Correr were for posts not typically illuminated, and do not have any decoration. On his book collecting and bindings, see Ludovic Bouland, "Livres aux armes de Pierre Duodo, pas de Marguerite de Valois," *Bulletin du bibliophile* (1920): 66–80; Raphaël Esmerian, *Bibliothèque Raphaël Esmerian* (Paris: G. Blaizot and C. Guérin, 1972–74), Part I (June 6, 1972): 94–96, lots 59–61; Paul Needham, *Twelve Centuries of Bookbindings, 400–1600* (New York and Oxford: The Pierpont Morgan Library and Oxford University Press, 1979): 98.

54 Roberto Valandro, *Il Monte sacro di Monselice. Un itinerario giubilare euganeo* (Monselice: 1999); Roberto Valandro, "Tra devozione e pietà popolare. Il santuario delle Sette Chiese di Monselice," in Antonio Diano and Lionello Puppi, eds. *Tra monti sacri, "sacri monti" e santuari; il caso veneto. Atti del convegno di studi, Monselice, 1–2 Aprile 2005* (Padua: Il poligrafico, 2006): 147–62.

55 Francesco's brother Domenico (d. 1597), who became procurator *de ultra* in 1592, also requested in his testament of a year earlier to be buried in the Church of Sant'Angelo, in the habit of a capuchin monk. ASVe, Notarile, Testamenti, Atti Galeazzo Secco, b. 1190, n. 172. September 1591.

56 An inventory of the goods possessed by Francesco's grandson Girolamo di Alvise (1602–1660) in the Duodo palace in Venice, in the parish of Santa Maria Zobenigo, was made in 1660. In it is described an elaborate library with paintings of "*virtuosi*." Another inventory of the books in this library, made in 1674, lists over 1500 volumes. Linda Borean, "Francesco e Domenico Duodo," in *Collezionismo 2008*, 274–75.

57 Bardi 1587, signatures H7v–H8r.

58 On Venetian images of its territories and subjects, see Wolters 1987, 260–65. For the program of the Great Council Hall and Sala del Scrutinio, see Sinding-Larsen 1974; Umberto Franzoi, *Storia e leggenda del Palazzo ducale di Venezia* (Venice: Storti, 1982); Wolters 1987, 267–310; Tagliaferro 2005; Tagliaferro 2006; Wolters 2010, 158–59.

59 On the program and editions of it see Tagliaferro 2006, 339, n. 6. On Jacopo (Giacomo) Marcello, see Cooper 2005, 167, 217.

60 "*nel medesimo soffitto vanno tre quadri grandi, li quali sono circondati da quelle imprese, et esempi, uno ovato per testa, et uno quadro in mezzo, che sono i resultanti da dette imprese, et esempi di virtù.*" Wolters 1987, 310; Sinding-Larsen 1974, 224, n. 3.

61 Tagliaferro 2006, 340.

62 Sinding-Larsen 1974.

63 Ridolfi 1965, vol. 1, 326; Sinding-Larsen 1974, 224–25; 231.

64 Wolters 2010.

65 Sinding-Larsen has shown that this and the scene by Palma are strongly influenced by images on ancient coins that would have been known to patricians at the time because of their illustration in Sebastiano Erizzo's discourse on coins and medallions, extensively illustrated with engravings of coins owned by Venetian collectors, published around 1559. Sinding-Larsen 1974, 224; Sebastiano Erizzo, *Sopra le Medaglie de gli Antichi, con la Dichiaratione delle Monete Consulari, & delle Medaglie de gli Imperadori Romani* (Venice: Bottega Valgrisiana, 1559).

66 Mason Rinaldi 1984.

67 Jacopo Tintoretto, *Homage of the Ambassadors to Doge Nicolò da Ponte*, Hall of the Great Council. Described in Ridolfi 1965; Schulz 1969, 108; Wolters 1987, 322–23.

68 Bardi 1587, fols. 45v–46.

69 Bardi 1587, fol. 46v. Bouwsma 1968, 223–26.

CONCLUSION: MANUSCRIPTS AND MYTHS OF STATE

1 "actively circulated memory that keeps the past present as the *canon* and the passively stored memory that preserves the past past as the *archive*." Aleida Assmann, "Canon and Archive," *Cultural Memory Studies: An International and Interdisciplinary Handbook* (Berlin: de Gruyter, 2008): 97–106.

2 Alexander, ed. 1997; Alexander, ed. 2008; Bauman 2001; Calvillo 2003; Elena M. Calvillo, "*Il Gran Miniatore* at the Court of Cardinal Alessandro Farnese," in Campbell, ed. 2004, 163–75; Elena Calvillo, "Inventive Translation, Portraiture, and Spanish Habsburg Taste in the Sixteenth Century," in *The Spanish Presence in Sixteenth-Century Italy*, Piers Baker-Bates and Miles Pattenden, eds. (Farnham: Ashgate, 2015), 175–97 (190); Alexander 2016.

3 *Libro del Patriarcato di Aquileia, comincia del Beato Marco Evangelisto che fu primo vescovo di Aquileia*, ASVe, Misc. Codici I, Storia Veneta, reg. 48.

4 Daniele di Francesco Barbaro was designated patriarch in 1550 and served until 1570, Alvise di Leonardo Giustinian was appointed in 1570 and served until 1585, Francesco di Marcantonio Barbaro (nephew of Patriarch Daniele Barbaro) was appointed in 1593 and served until 1616.

5 Laven 1966–67, 87.

6 Paschini 1960; Howard 2011, 54–55.

7 On the medieval rivalry of Aquileia and Venice for patriarchal authority, see Dale 1997, 7–9.

8 Documented as in Domenico Grimani's collection in his first will of October 2, 1520, in which he wishes it to remain in the family with Vincenzo Grimani as *fede commessario*. Recorded as purchased from Antonio Siciliano in his second and final will, drawn up in August,

1523. First Testament of Cardinal Domenico Grimani, October 2, 1520, drawn up at Noventa. ASVe, S. Antonio di Castello, Canonici regolari, X. fol. 45. Second Testament of Cardinal Domenico Grimani, August 16, 1523. ASVe, S. Antonio di Castello, Canonici regolari X, fols. 54–56 (54v). Both transcribed in Giorgio E. Ferrari, "Die Dokumente," in Grote, ed. 1973, 91.

Manuscripts of the four Gospels (Gospel Books) had existed in a fairly uniform format since the fourth century, and were typically displayed in the ritual of the Mass. Breviaries emerged later in the Middle Ages as compilations of material organized for use in the Divine Office (or Liturgy of the Hours) primarily by the clergy.

9 "*quod Breviarium, tanquam rem nobilissimam et pulcherrimam, ostendere debeat personis honorificis, quandocunque oportunum fuerit ...*" First Testament of Cardinal Domenico Grimani, October 2, 1520, ASVe, S. Antonio di Castello, Canonici regolari, X. fol. 45. Giulio Coggiola, "Kapitel I," in de Vries and Marpurgo, eds. 1903–08, vol. 1, 5–55 (16–17); Giorgio E. Ferrari, "Die Dokumente," in Grote, ed. 1973, 91. English translations of the documents in Gian Lorenzo Mellini, Giorgio E. Ferrari, Mario Salmi, *The Grimani Breviary, Reproduced from the Illuminated Manuscript belonging to the Biblioteca Marciana* (Woodstock, NY: Overlook Press, 1972): 263–65.

10 Marin definitively succeeded Domenico as patriarch when his uncle died in August of 1523, three months after his grandfather Doge Antonio. For more detailed biographies of Domenico and Marin Grimani, see Paschini 1943; Paschini 1960; Calvillo 2003, 25; Gino Benzoni and Luca Bortolotti, "Grimani, Domenico," *DBI* 59 (2003). More generally on the Grimani cardinals as collectors: Caterina Furlan, "Domenico, Marino e Giovanni Grimani tra passione per l'antico, gusto del collezionismo e mecenatismo artistico," in Caterina Furlan and Patrizia Tosini, eds., *I cardinali della Serenissima* (Cinisello Balsamo: Silvana, 2014): 31–73.

11 After a full copy of the original source, ASVe, S. Antonio di Castello, Canonici regolari X 54–56. Transcribed by Giorgio E. Ferrari, "Die Dokumente," in Grote, ed. 1973, 91.

12 The claim of the title of patriarch for Giovanni was disputed by other members of the family seeking it for their offspring, and because Giovanni was not a cardinal, it instead was reserved for Daniele Barbaro in 1550.

13 "*libro singolare senza paragone.*" Gallo 1952, 44–45.

14 See Chapter 5, the section "Antiquarian portraits."

15 Laven 1966–67; Trebbi 1984, 60–64; Tafuri 1989, 8–10; Gino Benzoni, "Comportamenti e problemi di comportamento nella Venezia di Giovanni Grimani," in Favaretto and Ravagnan, eds. 1997, 17–37; Gino Benzoni and Luca Bortolotti, "Grimani, Giovanni," *DBI* 59 (2003); Howard 2011, 22, 83–84.

16 Gallo 1952, 46, with inscription of the relevant document.

17 Marcantonio was a direct descendant of Procurator Francesco Barbaro, discussed in Chapter 4. On the history of Grimani and then state possession of this document, see Giulio Coggiola, "Kapitel I," in de Vries and Marpurgo, eds. 1903–08, vol. 1, 5–55; Giorgio E. Ferrari in Grote, ed. 1973, with a partial transcription of the relevant documents 91–93.

18 Sansovino 1604, fol. 208r; relevant documents transcribed by Giorgio E. Ferrari in Grote, ed. 1973, 91–92. The procurators *de supra* from the 1570s to 1590s ranged from five to six because of the supernumerary appointments through payment: Marcantonio di Francesco Barbaro (elected 1572 by merit, d. 1594), Girolamo di Cristoforo da Mula (elected 1572 by payment, d. 1607), Andrea di Giovanni Dolfin (elected 1573 by payment, d. 1602), Jacopo K. di Alvise Foscarini (elected 1580 by merit, d. 1603), Francesco di Fantin Corner (elected 1584 by merit, d. 1585), and Jacopo di Jacopo Emo (elected 1584 by merit, d. 1594).

19 Above the medal portrait of Domenico: "*DOMINICI CARD GRIMANI OB SINGULAREM ERGA PATRIAM PIETATEM. MUNUS EX TEST. PATRIAE RELICTUM.*" Above the portrait medal of Doge Grimani: "*QUOD MUNUS ANTONIUS PRINCEPS ET PATER CUM AD SUPEROS ESSET REVOCATUS APPROBAVIT.*" The sources of the portraits apparently were two independent medals. The one by Domenico Grimani was made in 1513 by Vettore Gambello, called Camelio. Voltolina 1998, 200–10, n. 162.

20 As Coggiola noted, while Michiel describes the February miniature, he calls it January. Giulio Coggiola, in de Vries and Marpurgo, eds. 1903–08, vol. 1, 88. The Grimani Breviary calendar illuminations have long been recognized as based on those of the *Très Riches Heures*, Chantilly, Musée Condé, MS. 65. Paul Durrieu, "Les Très Riches Heures du Duc de Berry conservées à Chantilly, au Musée Condé, et le Bréviaire Grimani," *Bibliothèque de l'École des Chartes* 64, 3–4 (1903): 321–8.

21 "*Ivi son inminature de man Zuan Memelin, carta ..., de man de Girardo da Guant carta 125, de Livieno da Anversa carta 125,*" transcribed in Frimmel 1896, 104; and Giorgio E. Ferrari, in Grote, ed. 1973, 91. Michiel wrote this around 1543, and his identifications probably correspond with the artists known today as Hans Memling, Gerard Horenbout, and possibly Lieven Bening.

Modern scholars have identified more hands in the breviary: the Master of James IV of Scotland, Alexander Bening, the Master of the David Scenes in the Grimani Breviary, Simon Bening, and Gerard David. Calkins 1998; T. Kren, M. W. Ainsworth, and E. Morrison, "Breviary of Cardinal Domenico Grimani," in Kren and McKendrick 2003, cat. 126, 420–24.

22 Winner 1977; Calvillo 2003, 94; Michel Hochmann, "La famiglia Grimani," in *Collezionismo 2008*, 219.

23 The Book of Hours is considered the lay counterpart of a breviary but could also be used by clergy. Breviaries contain the texts for the performance of the Divine Office throughout the liturgical year and include the calendar, *temporale* (Proper of Time), *sanctorale* (Proper of Saints), and Common of Saints. The central text of a Book of Hours is the Little Office of the Blessed Virgin Mary but these manuscripts also typically include numerous other components, including a calendar. A number of the pages in the celebrated Book of Hours painted by Giulio Clovio for his subsequent patron Cardinal Alessandro Farnese, from 1540 to 1546, quote images and their sequence from the breviary. For example, in the Grimani Breviary, a miniature of the Descent of the Holy Spirit faces one of the Tower of Babel, to open the feast of Pentecost in the Proper of Time. Clovio chose to open the Hours of the Holy Spirit, breaking with standard illumination subjects, with the same sequence of the Descent and Tower of Babel. He also closely imitated the composition and style of the Tower of Babel miniature. The manuscript was named the Farnese Hours after Clovio's patron Farnese, but in El Greco's portrait of Clovio of c.1571 (Naples, Museo Nazionale di Capodimonte), Clovio identifies himself with the manuscript by pointing to it. Farnese Hours, PML MS M.69, fols. 106v–107; Grimani Breviary, fols. 205v–206r. The Tower of Babel miniature has been most recently attributed to the Master of James IV of Scotland, T. Kren, M. W. Ainsworth, and E. Morrison, "Breviary of Cardinal Domenico Grimani," in Kren and McKendrick, eds. 2003, cat. 126, 423, n. 3. A full facsimile of the Farnese Hours has been published with a valuable commentary by William Voelkle. Voelkle and Golub 2001. On the texts of the Farnese Hours see also Calvillo 2003, 246–85.

24 Vasari 1906, vol. 7, 569. In the Farnese Hours, Clovio often created the illusion of displaying a collection of all kinds of objects in and on frames. In this sense the manuscript was like a *studiolo* for the collector. This method of collecting objects and displaying them was practiced previously by Clovio in his Stuart de Rothesay Hours for Cardinal Marin Grimani. Swann Short 1998; Calvillo 2003, 56–57.

Such a virtual collection is visually and conceptually akin to some actual collections of objects, and also to Giorgio Vasari's now-dispersed collection of drawings originally mounted by him in notebooks. See Chapter 4, n. 136. Vasari was not the first to amass a large collection of drawings, but his systematic approach and the role of his collection in producing his history and biography of artists were new. Mounted on pages with decorative frames, and assembled in volumes by order of artist, his collection attests to the importance he placed on drawing not only as source material, or as models for artists to emulate, but also as relics of the actual hand of an artist ("*reliquie di man propria*," as he put

it, when describing his drawings by Oderisi da Gubbio). This was an important factor in a new understanding of art and collecting, where the artist takes over the saint's traditional position as conduit to the divine. Vasari retained for drawings the value ascribed to relics as indexes, but the important person indexed is an artist, not a saint. It is the artist's index that has become most revered by collectors and art historians. Ragghianti Collobi 1974, 27.

25 See Chapter 1, the section "Written by the hand of Mark." Stringa's more extensive treatment of the Basilica of Saint Mark and its treasures than either that of Sansovino or Martinioni is explained in part by the fact he was a Canon of the Basilica. Stringa 1610, 63; Sansovino 1663, 102.

26 Sansovino 1604, 208r–v: *Libreria di San Marco*.
"*Nè voglio tralasciar di dire in questo luogo quello, che è non men notabile & degno di memoria delle predette cose, che non era al tempo del Sansovino, ma posto questi ultimi anni in capo di questa sala, dirimpetto alla porta. È adunque questo uno scrittoio, overo studiolo nobilissimo. Trovasi, egli tutto di Ebano, & intersiato di finissime pietre di diverse sorti, con sedici colonne di finissimo alabastro ... In questo vi si custodisce tra le altre cose un nobilissimo Breviario, lasciato già per testamento di Domenico Grimani Cardinale alla Signoria. Egli si trova scritto a mano di carta pergamine 831. con la sua coperta di argento tutta dorata, e di molte figure, miniate con diligentissima maniera ornata ... È adunque degno d'esser annoverato tra le cose notabili il detto Breviario; poi che egli è di grandissimo, et inestimabil valore, così per l'esquisita diligenza, che s'è usato nel farlo, come perche non si trova cosa simile in altro luogo: & seben sono molti anni, che è stato fatto, è stato tuttavia con tante accutezza custodito, che il tempo non gli ha fatto nocumento alcuno ...*"

27 For a history of this *studiolo*, see Massinelli 1990. Gino Benzoni and Luca Bortolotti, "Grimani, Giovanni," *DBI* 59 (2003). The design and contents of the *studiolo* as described in 1593 are transcribed in Levi 1900, 5–8. It held some thirty-nine bronzes and seventy-two cameos. For an understanding of the broader context of Grimani collecting, see Perry 1993; Hochmann, "La famiglia Grimani," in *Collezionismo 2008*, 207–23.

28 Gallo 1952, 52–54.

29 "The little study of ivory, with pillars of alabaster and rare stones, and carved images (in which an old breviary of written hand, and much esteemed, is kept) are things very remarkable." On the Treasury and the Gospel: "The Procurators of Saint Marke, keepe this treasure, and make no difficulty to shew it to strangers of the better sort ... In the upper Vestry they shew the picture of the Virgin, painted by Saint Luke's hand, and the ring of Saint Marke, and his Gospell written with his owne

hand ..." Moryson 1617, 81. On the breviary, see Moryson 1617, 86.

30 Giulio Coggiola, "Kapitel I," in de Vries and Marpurgo, eds. 1903–08, vol. 1, 5–55.

31 Corner 1758, 198. Corner gives a detailed history of opinions about the authenticity of the manuscript as in Mark's hand in Corner 1749, vol. 10, 176–79, 280–85.

For further discussions of the ways in which the 'artist's hand' was discussed and considered in Renaissance literature and in contracts, see Barolsky 1995; O'Malley 1998; Kemp 2000. On the artist's hand, signature, and monogram in the context of print, see Koerner 2006.

32 This feast ceased to be celebrated in 1966 due to deliberations of the Second Vatican Council.

33 Described and illustrated in Giulio Coggiola, "Kapitel I," in de Vries and Marpurgo, eds. 1903–08, vol. 1, 5–55 (52, 55). On Morelli, see Riccardo Burigana, "Morelli, Jacopo," *DBI* 76 (2012).

34 The first full facsimile, in black and white, was completed in 1908. De Vries and Marpurgo, eds. 1903–08. The full-color facsimile: *Breviario Grimani [ms. Lat I 99=2138, Biblioteca Nazionale Marciana, Venezia]* (Rome: Salerno Editrice, 2009). *Breviario Grimani: Nota di Commentario all'edizione in facsimile*, ed. Andrea Mazzucchi (Rome: Salerno Editrice, 2009).

On the early history of facsimiles of the breviary, see Giulio Coggiola, "Kapitel I," in de Vries and Marpurgo, eds. 1903–08, vol. 1, 5–55 (51–55), and Giorgio E. Ferrari, "Select Bibliography," in Grote, ed. *The Grimani Breviary*, 1973, 272–73.

35 On fol. 339v. see Erik Drigsdahl, "Flamske illuminered handskrifter," *Humaniora* 197–76 (1977): 38–41. Further discussion by Drigsdahl at http://manuscripts.org.uk/chd.dk/misc/AB1515.html [Accessed December 23, 2016]. On the signature as index, see Harris 2000, 160–83.

36 See for example the Commission to Nicolò di Marco Contarini as *Podestà* and Captain of Capodistria of 1708, with apocalyptic imagery and numerous inscriptions. BMCVe Cl. III, 938.

37 Davis 1962.

EPILOGUE: THE DISPERSION AND COLLECTING OF *DUCALI*

1 John Ruskin, "The Sea Stories," in *The Stones of Venice*, vol. 2 (first published London: Smith, Elder, and Co., 1853) (New York: John B. Alden, 1885): 71.

2 On the acquisition, placement, and later interpretations of the *spolia* in Venice, see Demus 1960; Perry 1978; Jacoff 1993; Brown 1996, 15–25, 29; Marina Berlozerskaya and Kenneth Lapatin, "Antiquity Consumed: Transformations at San Marco Venice," in Alina Payne, Ann Kuttner, Rebekah Smick, eds.

Antiquity and its Interpreters (Cambridge: Cambridge University Press, 2000): 83–98; Robert Nelson, "High Justice: Venice, San Marco, and the Spoils of 1204," in Panayotis L. Vocotopoulos, ed. *Byzantine Art in the Aftermath of the Fourth Crusade: The Fourth Crusade and its Consequences* (Athens: Akademia Athinon, 2007): 143–51; Maguire and Nelson 2010.

On Venetian acquisition of treasures and relics housed in the Treasury of San Marco, see especially Gallo 1967; Hahnloser, ed. 1965–72; Pomian 2004; Perry 2015.

3 Jerome, *Chronicle*, 314. A number of the elements Venetians took from Byzantium had been lifted from cities further east. Jaś Elsner, "From the Culture of *Spolia* to the Cult of Relics: The Arch of Constantine and the Genesis of Late Antique Forms," *Papers of the British School at Rome* 68 (2000): 149–84 (154).

4 Zorzi 1987, 333. See also his listing of the great patrician collections of the late eighteenth century: 333–45. On the despoliation of Venice under Napoleon, and subsequent events: Zorzi 1971; Plant 2002, 26, 36–39.

5 Alberto Rizzi estimated that only a third of the 6782 well-heads counted in 1858 remain in Venice and discusses their dispersion in Rizzi 1981, 1–35. John Pemble notes their rapid decline in numbers in the nineteenth century, and their popularity as garden ornaments among wealthy British collectors. Pemble 1995, 126. Anna Tüskés, "La storiografia delle vere da pozzo veneziane," *Ateneo Veneto* 3, 12 (2013): 265–76.

6 On domestic interiors in Venice and their furnishings, see especially Brown 2004; Brown 1996; Palumbo Fossati Casa 2012.

7 "*molte onorate memorie*," quoted in Romanelli 1998, 13.

8 See Introduction, n. 51.

9 H. O. Coxe, *Bodleian Library. Quarto Catalogues. II. Laudian Manuscripts*, reprint of 1858–85 with corrections, editions, historical introduction by R. W. Hunt (Oxford: Oxford University Press, 1973): xix–xx, cols. 507–10.

10 H. O. Coxe, *Bodleian Library. Quarto Catalogues. II. Laudian Manuscripts*, reprint of 1858–85 with corrections, editions, historical introduction by R. W. Hunt (Oxford: Oxford University Press, 1973): xxi. The one Commission in Laud's collection that retained its miniature was the earliest of the group and had lost its binding. The manuscript has only a damaged border illumination by the T.° Ve Master. Laud misc. 533 for Francesco di Pietro Foscarini as *Podestà* and Captain of Bassano, 1533. Rebound, probably nineteenth century. Otto Pächt and J. J. G. Alexander, *Illuminated Manuscripts in the Bodleian Library Oxford*, vol. 2, Italian School (Oxford: Oxford University Press, 1970): 99. The Commission to Girolamo di Marin Grimani (father of Doge Marin) as Captain of Verona (1550)

was also donated by Laud without its opening leaf (Laud misc. 712).

11 Watson 1995; de Hamel 1996; Wieck 1996; Watson 2000; Hindman and Rowe, eds. 2001; De Laurentiis and Talamo 2011; Federica Toniolo, "Le miniature della Fondazione Giorgio Cini," Medica and Toniolo, eds. 2016, 11–66. For historiographical study of illumination as the focus of the history of art, see Braesel 2009; Ada Labriola, "Alle origini della storia della miniatura. Storiografia e collezionismo," in Tartuferi and Tormen, eds. 2014, 97–117.

12 See Introduction; Cicogna 2001, 769.

13 Introduction, n. 51.

14 Z. S. Fink, "Venice and English Political Thought in the Seventeenth Century," *Modern Philology* 38, 2 (1940): 155–72; Brian Pullan, "The Significance of Venice," *Bulletin of the John Rylands Library of the University of Manchester* 56 (1974): 443–62 (450); Eglin 2001.

15 Contarini's text was originally completed in the 1530s. Felix Gilbert, "The Date of the Composition of Contarini's and Giannotti's books on Venice," *Studies in the Renaissance* XIV (1967): 172–77.

16 Contarini and Lewkenor 1599. The first edition of Contarini's text was published in Latin in Paris as Contarini 1543. It was first translated into Italian and published in Venice in 1545, and in many subsequent editions in Venice and abroad. David McPherson, "Lewkenor's Venice and its Sources," *Renaissance Quarterly* 41, 3 (Fall 1988): 459–66.

17 Contarini and Lewkenor 1599, fol. A2r.

18 Z. S. Fink, "Venice and English Political Thought in the Seventeenth Century," *Modern Philology* 38, 2 (1940): 155–72; David C. McPherson, *Shakespeare, Jonson, and the Myth of Venice* (Newark, London and Toronto: Associated University Presses, 1990); Rosand 2001, 4, 7–10. Lewkenor's edition of Contarini also influenced the literary imagination – Shakespeare's characterization of the city and society of Venice in *Othello* is said to have been based in good measure upon Lewkenor's book. McPherson 1990. Nonetheless, Peter G. Platt reads the introductory poems of Lewkenor's edition and Shakespeare's plays as questioning the myth of Venice: "The Meruailouse Site: Shakespeare, Venice, and Paradoxical Stages," *Renaissance Quarterly* 54, 1 (Spring 2001): 121–54 (134).

19 Eglin 2001: 2–5.

20 Contarini and Lewkenor 1599, fol. A2r.

21 Rosenthal 1992, 11–26.

22 See especially Brown 2004, 1–5. *Coryat's Crudities. Hastily gobled up in five Moneths travells in France, Savoy, Italy, Rhetia ...; Newly digested in the hungry aire of Odcombe in the County of Somerset, and now dispersed to the nourishment of the travelling Members of this Kingdome* (first published London: W. S. Stanby, 1611). Coryat 1905, 2–3.

23 Coryat 1905, 416–22.

24 Francesco Sansovino, *Delle cose notabili che sono in Venetia* (Venice: Sansovino, 1561) and numerous later editions; Vecellio 1590; Vecellio 1598; Franco 1610; McPherson, "Lewkenor's Venice and its Sources."

25 Charles Hughes, *Shakespeare's Europe: A Survey of the Condition of Europe at the end of the 16th century. Being Unpublished Chapters of Fynes Moryson's Itinerary* (1617), 2nd edn. (New York: Benjamin Blom, 1967); James Howell, *SPQV. A survey of the signorie of Venice, of her admired policy, and method of government, etc. with a cohortation to all christian princes to resent her dangerous condition at present* (London: Richard Lowndes, 1651).

26 Eglin 2001, 6.

27 Francis Haskell, "Venetian Art and English Collectors of the Seventeenth and Eighteenth Centuries," *Verona Illustrata* 12 (1999): 7–18; Stephen Orgel, "Idols of the Gallery: Becoming a Connoisseur in Renaissance England," in Peter Erickson and Clark Hulse, eds. *Early Modern Visual Culture: Representation, Race, and Empire in Renaissance England* (Philadelphia: University of Pennsylvania Press, 2000): 251–83. Francesca Pitacco, "Dal secolo d'oro ai secoli d'oro. I collezionisti stranieri e i loro agenti," *Collezionismo 2007*, 103–19; Lucy Whitaker, Martin Clayton, Aislinn Loconte, "Introduction," in *The Art of Italy in the Royal Collection: Renaissance & Baroque* (London: Royal Collection Publications, 2007): 11–42; Christina M. Anderson, *The Flemish Merchant of Venice: Daniel Nijs and the Sale of the Gonzaga Art Collection* (New Haven and London: Yale University Press, 2015).

28 Chantilly, Musée Condé, MS 799. *Description ou traicté du government et regyme de la cyté et seigneurie de Venise. Catalogue général des manuscrits des Bibliothèques publiques de France* (1928): 163. The entire manuscript is described and transcribed by Paul Meyer in P. M. Perret, *Histoire des relations de la France avec Venise* (Paris and Leipzig: H. Welter, 1896): 239–304.

Marcantonio Sabellico's books on Venetian history and magistracies, published in the late fifteenth century, are possible sources for this text. Marcantonio Sabellico, *Decades rerum Venetarum* (Venice: Andrea Torresano, 1487); Marcantonio Sabellico, *De venetiis magistratibus* (Venice: Antonio de Strata, January 1488 m.v.).

29 Gennaro Toscano, "Giovanni Bellini et la France (XVIe–XXe siècles): Les aléas d'une reconnaissance," in Gennaro Toscano and Francesco Valcanover, eds. *Da Bellini a Veronese. Temi di arte veneta* (Venice: Istituto Veneto di Scienze, Lettere ed Arti, 2004): 197–230 (198).

30 Laura De Fuccia, "Residenti, viaggiatori e 'curieux' francesi," in Linda Borean and Stefania Mason, eds. *Il Collezionismo d'arte a Venezia. Il Seicento* (Venice: Marsilio, 2007): 125–39.

31 Now in the Musée National du Château, Versailles. Jean Hubert, "La peinture vénitienne du xvie siècle dans les collections royales de François I à Louis XIV," in Gennaro Toscano, ed. *Venise en France. La fortune de la peinture vénitienne des collections royales jusqu'au XIXe siècle* (Paris: École du Louvre, 2004): 15–38; Patrick Michel, "La peinture vénitienne en France aux xvii et xviii siècles, *Venise en France*: 39–61.

An early Commission acquired for a French collector is that of Pietro di Iseppo Bollani (b. 1563) as *consigliere* of Rettimo of 1589, purchased in Venice in 1629 by a Fabert. Paris, BnF, Italien 1012. The two illuminated leaves are quite damaged. Marsand 1835–38, vol. 1, 493.

32 Now Paris, BnF, Réserve Ad. 134.4. A full facsimile of the manuscript is published in Isler-de Jongh and Fossier 1992. De Maria 2010, 30–31.

33 *Catalogue des Livres de la Bibliothèque de feu M. J. B. Denis Guyon* (Paris: Chez Barrois, 1759): 23, n. 1474. This manuscript was purchased with others from the Guyon Collection by the Duc de la Vallière: Guillaume-François de Bure, *Bibliographie instructive: ou, Traité de la connoissance des livres rares et singuliers. Histoire*, vol. 1 (Paris: De Bure, 1768): 203–12, n. 4271. The Duc de la Vallière then had a five-page historical description of the manuscript printed on vellum to preface the book in 1761; *Catalogue des livres de la Bibliothèque du duc de la Vallière*, vol. 1, no. 3 (Paris, 1783): 31–33, n. 4527; Guillaume-François de Bure, *Catalogue des livres du cabinet de feu m. Gaignat* (Paris: Guillaume de Bure, 1769): n. 2638; Purchased by the Bibliothèque Nationale at the de la Vallière sale "as part of a conscious move to appropriate French patrimony for the state." Hindman and Rowe, eds. 2001, 32. Blake de Maria discusses the manuscript in light of original citizens and events in the Mediterranean in de Maria 2010, 30–34.

34 The price was even noted in Cheney 1867–68, 27; Jacopo Morelli, *Dissertazione intorno ad alcuni Viaggiatori eruditi veneziani poco noti* (Venice: Zatta, 1803). Republished in Jacopo Morelli, *Operette*, vol. 2 (Venice: Alvisopoli, 1820): 137; Foucard 1857, part D: "Di alcune miniature veneziane esistenti in Francia," 110–14.

35 Isler-de Jongh and Fossier 1992, 75–78.

36 Quoted in Favaretto 1990, 199. See also Pomian 1990, 97.

37 Federico Montecuccoli degli Erri, "Il Console Smith. Notizie e documenti," *Ateneo Veneto* 33 (1995): 111–91 (174). On Smith as a collector, see Frances Vivian, *Il Console Smith mercante e collezionista* (Vicenza: Neri Pozza, 1971); Haskell 1980, 299–310.

38 Lotte Hellinga-Querido, "Notes on the Incunabula of Consul Smith," in *The Italian Book, 1456–1800: Studies presented to Dennis E. Rhodes on his 70th birthday*, ed. D. V. Reidy (London: The British Library, 1993): 335–48; Antony Griffiths, "The Prints and Drawings in the Library of Joseph Smith," *Print Quarterly* 8, 2 (June, 1991): 126–39; Stuart Morrison, "Records of a Bibliophile: The catalogue of Consul Joseph Smith and Some Aspects of his Collecting," *The Book Collector* 43 (1994): 27–58.

39 The books acquired by the king are described in *Bibliotheca Smithiana, seu Catalogus librorum D. Josephi Smithii Angli per cognomina authorum dispositus* (Venice: Giovanni Battista Pasquali, 1755); the Zane manuscript is listed on cxxvii, col. ii. Along with the other items of the Smith Collection, this manuscript was given to the British Museum in 1823 by George IV and is now BL, King's 156. Discussed in Chapter 4, in the section "Controversies over funding."

40 BL, Add. MS 18000. *Catalogo dei libri raccolti dal fu signor Smith e pulitamente Legati* (Venice: 1771): 133; S. Baker and G. Leigh, *Bibliotheca Smithiana; ou catalogue de la rare et precieuse bibliothèque de feu Mr. Joseph Smith …* (London: 1773): n. 967, sold for £1.12; Thomas Rodd; February, 1850, acquired by the British Museum at Thomas Rodd's sale: *Catalogue of the extensive and valuable collection of manuscripts in all languages, formed by the late eminent bookseller Mr. Thomas Rodd …* (London: 1850), lot 251; *Catalogue of additions to the manuscripts in the British Museum in the years 1848–1853. mss. 17278–19719* ([London]: Trustees of the British Museum, 1868), 69. D. S. Chambers in Martineau and Hope 1983, 395, cat. H5. This manuscript was discussed in the Introduction and Chapter 3.

41 Foucard 1857, 127; *Catalogo dei libri raccolti dal fù signor Smith e pulitamente legati* (Venice: 1771): 133. On Smith and the Royal Collection: Haskell 1980, 391–94.

42 Giovanna Nepi Sciré, "Aspects of Cultural Politics in 18th-Century Venice," in Jane Martineau and Andrew Robinson, eds. *The Glory of Venice: Art in the Eighteenth Century* (New Haven and London: Yale University Press, 1994): 67.

43 The despoliation of pictures was described by Don Giacomo della Lena, Spanish Vice-Council in Venice, sometime around 1800. Francis Haskell, "Some Collectors of Venetian Art at the End of the Eighteenth Century. Della Lena's 'Esposizione istorica dello Spoglio, che di tempo in tempo si fece di Pitture in Venezia,'" *Studies in Renaissance & Baroque Art presented to Anthony Blunt on his 60th Birthday* (London and New York: Phaidon, 1967): 173–78.

44 Jacopo Soranzo was a direct descendent of Giovanni K. Pr. di Francesco, discussed in Chapter 6, in the section "Trans-generational success: family advice and comportment."

45 J. B. Mitchell, "Trevisan and Soranzo: Some Canonici Manuscripts from Two Eighteenth-Century Collections," *The Bodleian Library Record* 8, 3 (1969): 125–35; Federica Toniolo, "Matteo Luigi Canonici,"

in Tartuferi and Tormen, eds. 2014, 467–70.

46 NYPL, Spencer MS 40. Giordana Mariani Canova, "Promissio illustris domini Nicolai Tron," Alexander, Marrow, and Freeman Sandler, eds. 2005, 25–28. On Canonici and Sneyd, see Munby 1972, 109–10.

47 S. Romanin, *Storia documentata di Venezia* 10 (Venice: P. Natarovich, 1853–61): 129.

48 Lafitte 1989, 278, 318.

49 When Napoleon had the Arc de Triomphe built to commemorate his victories of 1805 and 1806, he had the horses ornament the top. Dorothy M. Quynn, "The Art Confiscations of the Napoleonic Wars," *The American Historical Review* 50, 3 (1945): 437–60 (441); Vittorio Galliazzo, *I cavalli di San Marco* (Treviso: Canova, 1981).

50 The final official list delivered to Paris from Venice cites a total of 241 manuscripts, 120 incunabula, fifty Aldines, fifty music books, and a cameo of Jupiter to take the place of thirty books. The selection reflects Van Praet's personal interests in editions printed by Aldus Manutius and the earliest printed books. Anthony Hobson, "Appropriations from Foreign Libraries during the French Revolution and Empire," *Bulletin du Bibliophile* 1 (1989): 255–72 (319, n. 1).

51 A few also came from the Monastery of Santa Giustina in Padua. Zorzi 1987, 352–54; Hobson 1989, 255–72; Lafitte 1989, 318–20.

52 Zorzi 1987, 322.

53 On the iconoclasm of symbols of Mark, see bibliography in Rizzi 1990, 18, n. 2.

54 Lafitte chronicles the seizures of books and art objects in Venice in 1797, but archival material and *ducali* were not taken. Lafitte 1989; Hindman and Rowe 2001, 51.

55 Some other service books as well as archival documents stored in the Basilica relating to the *Procuratia* of San Marco were eventually consigned to the new Italian state archives. Zorzi 1987, 356, 529–30; Susy Marcon, "I codici della liturgia di San Marco," in Cattin and Di Pasquale, eds. 1990–92, vol. 1, 189–272 (208, 251); ASVe, *Guida generale*, 884–87.

56 *Evangelistarium*, BMVe, Cod. Lat. I, 100 (=2089). On the manuscript and its miniatures, see Giordana Mariani Canova, "La miniatura nei libri liturgici marciani," in Cattin and Di Pasquale, eds. 1990–92, vol. 1, 149–88 (180–82, 248–51); Susy Marcon, "I codici della liturgia di San Marco," in Cattin and Di Pasquale, eds. 1990–92, vol. 1, 248–51; Marcon 1995, 127–29; Marta Minazzato, "Maestri dell'Epistolario, dell'Evangelario e del Messale di San Marco a Venezia," *DBMI* 428–31; Helena Katalin Szépe, "Doge Andrea Dandolo and Manuscript Illumination of the Fourteenth Century," in Toniolo and Toscano, eds. 2012, 152–56.
Levi D'Ancona 1956, fig. 18; Paris, Musée Marmottan Monet. Inv. M6079–M6083. *La Collection Wildenstein*, Musée Marmottan Monet, Paris, 1980, item 70. The cuttings have been taken out of the frame.

57 André Grabar in Hahnloser, ed. 1965–72, cat. 36: 48–49; Marcon 1995, 129–30; Ioli Kalevrezou in Helen C. Evans and William D. Wixom, eds. *The Glory of Byzantium: Art and Culture of the Middle Byzantine Era A.D. 843–1261* (New York: Metropolitan Museum of Art, 1997): cat. 41, 88. Marcon 2007.

58 Cattin and Di Pasquale, eds. 1990–92, vol. 1, 29.

59 ÖNB, Cod. 438* (formerly Foscarini 226). Tommaso Gar, "I codici storici della Collezione Foscarini conservata nella Imperiale Biblioteca di Vienna," *Archivio Storico Italiano* 5 (1843): 283–449. On the Foscarini sale in general see Zorzi 1971, 336–39. On this manuscript, Mariani Canova 1995, 803–05.

60 Cecil Hilton Monk Gould, *Trophy of Conquest; the Musée Napoléon and the creation of the Louvre* (London: Faber and Faber, 1965): 123.

61 ASVe, codices ex-Brera 277 and 308. A list of codices sent to the Brera and returned in 1869 is listed in ASVe, Indice 240. Tommaso Gar, "Nuova serie di codici mandati a Vienna dalla direzione della biblioteca di brera nell'anno 1837," *Archivio Storico Italiano* 5 (1843): 453–70; Tommaso Gar, "Nuova serie di codici mandati a Vienna dalla direzione della biblioteca di brera nell'anno il 22 febraio 1842," *Archivio Storico Italiano* 5 (1843): 471–76 (474).

62 ASVe, [Secreta] Collegio, Promissioni, reg. 2, ex-Brera 308; ex-Sala Margherita LXXVII n. 12. See Katzenstein for collation of the original manuscript and missing folia. Katzenstein 1987, 127–28. Three illuminated leaves are missing from this manuscript. The leaves were described and illustrated in various publications before they were despoiled. For the opening leaf of the *Promissione* (fol. 1r): Elena Berkovits, *Un codice dantesco nella biblioteca della r. Univ. Di Budapest* (Budapest: Franklin, 1931): 19; Da Mosto, *L'Archivio di Stato di Venezia* 2 (Rome: Biblioteca d'arte editrice, 1940), plate IX.
For the opening leaf to the councillor's *Capitolare* from the the same manuscript, Laudedeo Testi, *Storia della pittura veneziana* (Bergamo: Istituto Italiano d'arti grafiche, 1909): 514; Pompeo Molmenti, *La storia di Venezia nella vita privata* (Bergamo, 1911): 248; Elena Berkovits, *A Budapesti Egyetemi Konyvtar Dante-Kodex* (Budapest: 1928): 46, fig. 18. This leaf was briefly placed on the market: Maggs Bros. Ltd., *Illuminations*, catalogue 1283 (London: Maggs, 1999): cat. 3, with illustration; Christie's, London, *Valuable Illuminated Manuscripts, Printed Books and Autograph Letters* (London: Christie's, Wednesday June 2, 1999): cats. 2, 9.
The location of fol. 39r, with illuminated initials on both recto and verso, is unknown. On the recto is the incipit to the text, *De hiis corrumperint virginem/vel violaverint maritatam/quid fieri debeat* (Chapter 90 here but Chapter 98 in Francesco Foscari's *Promissione*), illustrated with a girl being seduced in an "S." (*Si autem ad audientiam nostram...*) Verso: *De faciendo puniri*

illud qui extraxerit mulierem (Chapter 91 but Chapter 99 in Francesco Foscari's *Promissione*. Girgensohn 2004, 103–07.) This miniature is illustrated in Berkovits 1928, 46, fig. 19. The miniaturist of this leaf is probably the same as that of many miniatures in a Dante manuscript now in Budapest, and in the Epistolary for San Marco made at the same time as the Evangeliary. For the most recent assessment of this miniaturist, see Giorgio Fossaluzza, "Provenienza del codice, fortuna critica, stile e carattere illustrativo delle miniature," in Gian Paolo Marchi and József Pál, eds. *Dante Alighieri Commedia. Biblioteca Universitaria di Budapest Codex Italicus 1. Studi e ricerche* (Verona: Szegedi Tudománegyetem and Università degli Studi di Verona, 2006): 51–84.

On this theft, when a number of entire illuminated manuscripts and individual leaves were taken, see Humphrey 2007, 45–46.

63 Munby 1967, 15.

64 Wieck 1996, 238; Hindman and Rowe 2001, 55; Eze 2010; Elena De Laurentiis, "Sale of the collection of Abbot Luigi Celotti," in de Laurentiis and Talamo 2011, 345–62. More generally on Celotti as dealer, see also Anne-Marie Eze, "Abbé Celotti and the Provenance of Antonello da Messina's 'The Condottiere' and Antonio de Solario's 'Virgin and Child with St John,'" *The Burlington Magazine* 151 (October 2009): 673–77.

65 For instance, a Crucifixion miniature by Apollonio de' Bonfratelli set a record for sale at £91, a price comparable to those paid for Old Master paintings. Sandra Hindman and Michael Heinlein, "A Connoisseur's Montage: *The Four Evangelists* Attributed to Giulio Clovio," *Art Institute of Chicago Museum Studies* 17 (1991): 154–78, 181–2 (168).

66 Thomas Frognall Dibdin, *The Bibliomania or Book-Madness*, ed. P. M. Danckwerts (Richmond upon Thames, London: Tiger of the Stripe, 2004); Hindman and Rowe 2001, 42–43.

67 William Young Ottley, *A Catalogue of a Highly Valuable and Extremely Curious Collection of Illuminated Miniature Paintings, of the Greatest Beauty, and of Exquisite Finishing, Taken from the Choral Books of the Papal Chapel in the Vatican during the French Revolution; and Subsequently Collected and Brought to This Country by the Abate Celotti* (London: Christie's, May 26, 1825). Lot 31: 11–12. "A Frame, height 19 ¾, width 15, ornamented with arabesque borders; and within it a highly studied Miniature, height 13 ½, width 8 ½, executed, as it is believed, by Giovanni Bellini, A.D. 1485; upon the occasion of Augustin Barbadico, being elected Doge of Venice …"

68 Sold for £6.6.0. Came by descent to Sir Brinsley Ford and given to Francis Ford in 1965. Currently Mr. and Mrs. Ford, London. 33 × 21.5 cm. Brinsley Ford, *The Ford Collection*, 1 (Leeds: The Walpole Society, 1998): 27, with entry by Francis Russell, 59–60, cat. RF11;

Eze 2010; De Laurentiis and Talamo 2011, 345–47 (attributed to Benedetto Bordon).

69 On this miniaturist, see Chapter 2, the section "The Painters of *ducali*," and Chapter 3, "Agostino di Francesco Barbarigo."

70 Wieck 1996, 238. The idea that Celotti was also attempting to avoid import taxes has been disproved by Anne-Marie Eze. Eze 2010.

71 G. Valentin, "Literaturberichte und Anzeigen," *Zentralblatt für Bibliothekswesen*, 27, 7–8 (July–August, 1910): 367; Munby 1967, 65.

72 *Catalogue of the Very Beautiful Collection of Highly Finished and Illumined Miniature Paintings, the Property of the Late William Young Ottley, esq.* (London: Sotheby's, May 11–12, 1838).

73 Hindman and Rowe 2001, 68. Richard Ovendon, "The Libraries of the Antiquaries (*c.*1580–1640) and the Idea of a National Collection," in *The Cambridge History of Libraries in Britain and Ireland*, eds. Elisabeth Leedham-Green and Teresa Webber (Cambridge: Cambridge University Press, 2006), vol. 1: 527–61. On the early circulation uses and collecting of single leaves, see also Francesca Manzari, "Tipologie di strumenti devozionali nella Lombardia del Trecento. I Libri d'ore e l'Offiziolo Visconti," in Milvia Bollati, ed. *Il Libro d'Ore Visconti. Commentario al codice* (Modena: Panini, 2003): 144; Kathryn Rudy, *Postcards on Parchment: The Social Lives of Medieval Books* (New Haven and London: Yale University Press, 2015): especially 244–54; Massimo Medica, "Le miniature fuori contesto. Da immagini di devozione a oggetti per il collezionismo," in Medica and Toniolo, eds. 2016, 66–97.

74 Pietro Toesca, "Un capolavoro dell'oreficeria Veneziana della fine del Dugento," *Arte Veneta* 5 (1951): 15–20; Hans R. Hahnloser and Susanne Brugger-Koch, *Corpus der Hartsteinschliffe des 12. –15. Jahrhunderts* (Berlin: Deutscher Verlag für Kunstwissenschaft, 1985): 85–86; Amy Neff, "Miniatori e 'arte dei cristallari' a Venezia nella seconda metà del Duecento," *Arte Veneta* 45 (1993): 2, 6–19; Letizia Caselli, "L'Ornamento dei santi. Arte orafa e miniature sotto cristallo nel '200 e '300 Veneziano," in *Oreficeria sacra a Venezia e nel Veneto. Un dialogo tra le arti figurative*, Letizia Caselli and Ettore Merkel, eds (Treviso: Canova Edizioni, 2007): 85–101; Silvia Spiandore, "Miniature veneziane sotto cristallo: l'altare portatile di Firenze e la croce di Foligno," *Rivista di storia della miniatura* 16 (2012): 35–45, 10; Massimo Medica, "Le miniature fuori contesto. Da immagini di devozione a oggetti per il collezionismo," in Medica and Toniolo, eds. 2016, 66–97.

75 Hans R. Hahnloser and Susanne Brugger-Koch, *Corpus der Hartsteinschliffe des 12. –15. Jahrhunderts* (Berlin: Deutscher Verlag für Kunstwissenschaft, 1985): 85–86.

76 Scholarship has focused solely on the mosaic icon. The frame is believed to be of the nineteenth century, but the miniatures surely are sixteenth-century Venetian,

or of the Veneto. Helen C. Evans, ed. *Byzantium: Faith and Power (1261–1557)* (New York and New Haven: Metropolitan Museum of Art and Yale University Press, 2004): 216–17.

77 *"quadretto di pieta, miniato, che tengo al letto della mia camera."* Foucard 1857–58, 111–14. ASVe, Notarile, Atti Marino Renio 1587, March 5.

78 Bachelard 1964; Stewart 1993, 36–45.

79 Frimmel 1896, 22–25. The reclining nude may have been also engraved by Giulio Campagnola. Arthur M. Hind, *Early Italian Engravings* (London: 1938–48): cat. 13. On a reconstruction of the sources for the miniature after Benedetto Diana, see Vienna, Graphische Sammlung Albertina, *Die Kunst der Graphik III. Renaissance in Italien. 16. Jahrhundert. Werke aus dem Besitz der Albertina* (Vienna: Albertina, 1966): 88.

80 On Michiel's notebook as a source and on future editions in progress, see Jennifer Fletcher, "Marcantonio Michiel: His Friends and Collection," *The Burlington Magazine* 123, 941 (1981): 453–67; Jennifer Fletcher, "Marcantonio Michiel, *che ha veduto assia,*" *The Burlington Magazine* 123, 942 (1981): 602–09; Schmitter 1997, 27–37; Monika Schmitter, "The Dating of Marcantonio Michiel's 'Notizia' on Works of Art in Padua," *The Burlington Magazine* 145, 1205 (August 2003): 564–71. Simonetta Nicolini has recently published an article examining Michiel's *Notizie* and the perception of miniatures in the fifteenth and sixteenth centuries in more detail: Simonetta Nicolini, "Come piccoli quadri. Appunti su alcuni fonti per la ricezione della miniatura tra XIV e XVI secolo," *Intrecci d'arte* 4 (2015): 6–35. On Pietro Bembo as a collector, see Nalezyty 2017.

81 Among numerous studies on the *studiolo* and collecting, Joy Kenseth focuses on the desire to contain a larger world through the collecting of small objects, in "The Virtue of Littleness: Small-Scale Sculptures of the Renaissance," in Sarah Blake McHam, ed. *Looking at Italian Renaissance Sculpture* (Cambridge: Cambridge University Press, 1998): 128–48. See also Syson and Thornton 2001.

 For collecting and the development of the *studiolo* more specifically in Venice, see also Fiings, ed. 2002, Brown 2004, 217–51; Bernard Aikema, Rosella Lauber, Max Seidel, eds. *Il collezionismo a Venezia e nel Veneto ai tempi della Serenissima* (Venice: Marsilio, 2005).

82 Philadelphia, Free Library, E M 47:10 (formerly collection of Thomas F. Richardson). The painting by Jacopo Bassano was commissioned by *Podestà* Luca Navagero, and was hung in the Palazzo Pretorio, Bassano. Now Museo Civico di Bassano, inv. 9. Paola Marini in Brown and Marini 1993, 528–29.

83 Other leaves include a *Crucifixion* for the Hours of the Cross, *Pentecost* for Hours of the Holy Spirit, and *Lamentation* for the poem "O intemerata." On the Second Grifo Master, see Susy Marcon, "Una aldina miniata," in *Aldo Manuzio e l'ambiente veneziano*

1495–1515, eds. Susy Marcon and Marino Zorzi (Venice: Il cardo, 1994): 107–33. Alexander 2016, 105.

84 PML, MS M.369, fols. 1–4.

85 Frimmel 1896, 82–83, 94; Schmitter 1997, 105–09. Otto Pächt first suggested that this manuscript, described by Michiel as illuminated by Jacometto, could be a breviary in the Bodleian Library, MS Canon. Lit. 410. *Italian Illuminated Manuscripts from 1400 to 1550* (Oxford: Bodleian Library, 1948): no. 69, 23. Lilian Armstrong discusses the attribution further in Armstrong 1981, 32–33, 48–49.

86 Collections of leaves are mentioned in the inventories of the miniaturists Gasparo Segizzi in 1576 and Giovanni Maria Bodovino in 1617. Isabella Palumbo Fossati Casa, "L'interno della casa dell'artigiano e dell'artista nella Venezia del Cinquecento," *Studi Veneziani* 8 (1984): 109–53 (143); Szépe 2009, 59.

 A Zuanne (Giovanni) Dimo of San Zulian owned about 1000 drawings in the seventeenth century. He was probably also a miniaturist, as the inventory of 1669 mentions "2 carte miniade fatte dal Dimo," and he lived in an area traditionally inhabited by miniaturists. Stefania Mason, "Dallo studiolo al 'camaron' dei quadri. Un itinerario per dipinti, disegni, stampe e qualche curiosità nelle collezioni della Venezia barocca," *Collezionismo* 2007, 3–43 (37, 41, n. 139).

87 Robert W. Scheller, *Exemplum: Model-Book Drawings and the Practice of Artistic Transmission in the Middle Ages (c.900–c.1470)* (Amsterdam: Amsterdam University Press, 1995); Alexander 1992.

88 Julius S. Held, "The Early Appreciation of Drawings," *Latin American Art and the Baroque Period in Europe, Studies in Western Art: Acts of the Twentieth International Congress of the History of Art 3* (Princeton: Princeton University Press, 1963): 72–95 (86). On the collecting of drawings by artists in Venice in the fifteenth and sixteenth centuries, see Stefania Mason, "Artisti collezionisti di disegni a Venezia tra Cinquecento e Settecento. Ipotesi di lavoro," in Catherine Monbeig Goguel, ed. *L'artiste collectionneur de dessin. II. De Giorgio Vasari á aujourd'hui* (Milan and Paris: 5 Continents Editions and Sociéte du Salon du Dessin, 2007): 57–69, 201–05.

89 Evelyn Karet, *The Drawings of Stefano da Verona and his Circle and the Origins of Collecting in Italy: A Catalogue Raisonné* (Philadelphia: American Philosophical Society, 2002); Evelyn Karet, *The Antonio II Badile Album of Drawings: The Origins of Collecting Drawings in Early Modern Northern Italy* (Burlington, VT: Ashgate, 2014).

90 Vasari wrote that some of his drawings by Cimabue, Gaddo Gaddi and Franco Bolognese were in some manner "*di minio.*" Licia Ragghianti Collobi, *Il Libro de' disegni del Vasari* (Florence: Vallecchi, 1974): 26–27, 157.

91 Alberti, *Della pittura*, Book 2, section 57. Rocco

Sinisgalli, *Il nuovo De Pictura di Leon Battista Alberti* (Rome: Edizioni Kappa, 2006): 257–58.

92 Vasari 1965, part 3, vol. 7, 446; Smith 1964; Jonathan J. G. Alexander, "Giulio Clovio 'pictor nulli secundus,'" in Alexander, ed. 2008, 11–60.

93 *Prints after Giulio Clovio*, ed. Miroslav Begović (Zagreb: Prints and Drawings Department of the Croatian Academy of Arts and Sciences, 1998).

94 Stefania Mason, "Dallo studiolo al 'camaron' dei quadri. Un itinerario per dipinti, disegni, stampe e qualche curiosità nelle collezioni della Venezia barocca," in *Collezionismo 2007*, 25–37.

95 Szépe 2009, 59.

96 A catalogue of materials taken from monastic libraries in 1797 provides a summary list by ducal era of the *ducali* leaves that were taken from the Salute, allowing us to discern that all but one were from the period of 1523 to 1606 (doges Andrea Gritti to Marin Grimani), but there is not enough detail to locate where the leaves are now. BMCVe, Miscellanea 38 (1957), transcribed in Samuele Romanin, *Storia documentata di Venezia* (Venice: P. Natarovich, 1861): X, 411.

 Giorgio Bergonzi's interest in *ducali* leaves must have been stimulated in part by his family's recent admittance to the patriciate in 1665, aided by a payment of 100,000 ducats. Linda Borean, "Il caso Bergonzi," in *Collezionismo 2007*, 202–21 (211).

97 Christie and Manson, *Catalogue of the Very Celebrated Collection of Works of Art, The Property of S. Rogers, Esq., Deceased* (London: Christie and Manson, 1856): 93, lot 1001.

98 Dublin, The National Gallery of Ireland, 2328. *Master European Drawings from the Collection of the National Gallery of Ireland* (Washington, D.C.: Smithsonian Institution, 1983): 12.

99 "*ricchissimo di miniature, pero di cattiva maniera.*" From the notes of Jacopo Morelli before 1792, BMVe, Cod. Ris. 73, *Museo archeologico marciano*: 145, bound out of order. Noted by Suzy Marcon, "I codici della liturgia," in Cattin and Di Pasquale, eds. 1990–92, vol. 1, 257.

100 Thomas Frognall Dibdin, *The Bibliographical Decameron; or, Ten days pleasant discourse upon illuminated manuscripts, and subjects connected with early engraving, typography, and bibliography* (London: Dibdin, 1817): clxxxvii.

101 William Young Ottley, *The Italian School of Design: Being a Series of Facsimiles of Original Drawings by the most Eminent Painters and Sculptors in Italy; with biographical notices of the artists, and observations on their works* (London: Taylor and Hesse, 1823): 579–80; Hindman and Rowe 2001, 60–62.

102 Marsand 1835–38, vol. 1, 489–92.

103 These manuscripts were from the Stuart de Rothesay sale of 1855 (274), lot nos. 3723 (dated 1507, sold for £1.1.0), 3724 (dated 1522, sold for £2.0.0), 3725 (dated 1523, sold for £2.0.0), all sold to the dealer William Boone. S. Leigh Sotheby and John Wilkinson, *Catalogue of the Valuable Library of the Right Honourable Lord Stuart de Rothesay, including many illuminated and important manuscripts, chiefly collected during many years' residence as British Ambassador at the Courts of Lisbon, Madrid, The Hague, Paris, Vienna, St. Petersburg, and Brazil* (London: Sotheby's, 1855). The British Library purchased thirty-three leaves and cuttings from this sale. Prices recorded in the Houghton Library, Harvard University copy of de Rothesay catalogue (1855): 274–75.

104 Commission to Vincenzo di Giovanni Donato as Count and Proveditor of Lesina (Hvar), elected in 1512, HLSM, EL 9 H13, 1. Szépe 2005, 442. For discussion of Giovanni Bellini's signatures in the context of broader artistic and cultural concerns, see Matthew 1998; Debra Pincus, "Giovanni Bellini's Humanist Signature: Pietro Bembo, Aldus Manutius and Humanism in Early Sixteenth-Century Venice," *Artibus et Historiae* 58 (2008): 89–119.

105 Commission to Giovanni Moro as Captain of Padua, 1531. BL, Add. MS 21414.

106 Cambridge, Fitzwilliam Museum, Marlay Cutting, It. 43. Francis Wormald and Phyllis M. Giles first pointed out this misnomer as editors of *A Descriptive Catalogue of the Additional Illuminated Manuscripts in the Fitzwilliam Museum Acquired between 1895 and 1979* (Cambridge: Cambridge University Press, 1982): 23–124; Morgan, Panayotova, Reynolds 2011, vol. 1, 159.

107 PML, MS M.353. The signature is on fol. 1v. See Chapter 2, n. 70.

108 Giulia Maria Zuccolo Padrono first named and outlined the career of this important miniaturist as the T°. Ve Master in the title of her article of 1971, but also as the T.° Ve Master in the body of the same publication. Subsequent scholarship refers to the artist as the T.° Ve Master. High-resolution photography allows one to clearly read the inscription as "T.° Vec' ¹Dep 1578" but the moniker T.° Ve Master is retained here to avoid confusion. Zuccolo Padrono 1971, 53–71; Susy Marcon, "Maestro T° Ve," *DBMI*, 712; Morgan, Panayotova, Reynolds 2011, vol. 1, 159. On Titian's signatures, see Matthew 1998.

109 Ruskin's dim view of Clovio is outlined in a description of Ruskin's lecture delivered in 1854, "The General Principles of Outline," in Edward Tyas Cook and Alexander Wedderburn, *The Works of John Ruskin* (London: George Allen, 1904): 491; Munby 1972, 159–60. On Ruskin's famous "rediscovery" of Tintoretto, see Nichols 1999, 24.

110 Cheney 1867–68, 3; Munby 1972, 112. Cheney's obituary in *Miscellanies of the Philobiblon Society* XV (1884).

111 Bradley 1891; Bradley 1896.

112 ASVe, *Guida generale*, 872–74.

113 Pemble 1995, 77–79; Gino Benzoni, "Ranke's Favorite

Source," in G. G. Iggers and J. Powell, eds. *Leopold von Ranke and the Shaping of the Historical Discipline* (Syracuse: Syracuse University Press, 1990): 45–57; De Vivo 2002; Filippo De Vivo, "How to Read Venetian *Relazioni*," *Renaissance and Reformation* 34, 1–2 (Winter–Spring 2011): 25–59; De Vivo 2013.

114 ASVe, *Guida generale*, 875. *Rawdon Brown and the Anglo-Venetian Relationship*, eds. Ralph A. Griffiths and John E. Law (Stroud: Nonsuch, 2005).

115 Ridolfi 1965; Marco Boschini, *Le ricche minere della pittura veneziana* (Venice: Francesco Nicolini, 1675); Sansovino 1663, vol. 2, *Quinto Catalogo...*: 22.

116 He eulogized them to combat the pessimists of the day, who saw all greatness only in the past, and whom he called *oggidiani* since they began their complaints with "*Oggidi*," or "These days." Padre Don Secondo Lancelotti, *L'hoggidi, ovvero il mondo non peggiore, ne piu Calamitoso del passato* (Venice: Giovanni Francesco Valvasense, 1680).

117 Pietro Zani, *Enciclopedia metodica delle belle arti* (Parma: Tipografia Ducale, 1820).

118 On Bodovino, see Szépe 2009, 57–61.

119 "*appartenuti all'erudizione delle cose patrizie ...*" Giovanni Rossi (1776–1852), *Documenti*, vol. 40. *Catalogo (estratti da) de manoscritti della Libreria Giustinian sulle Zattere, fatto dal Bibliotecario della Marciana Don Pietro Bettio*. BMVe, It. VII, 1463 (=9354); Rossi 40, nos. 1–236 (1r); Raines 1992, 95; Marcon 2005. The inventory of manuscripts in the Giustiniani Collection was copied by Rossi from a catalogue by Pietro Bettio (1769–1846). It records some fifty-one Commission manuscripts. Of these, twelve were already missing their opening illuminations, including the Commission to Lorenzo di Pietro Cappello as *Podestà* and Captain of Bassano, the leaf of which is now in a different manuscript in Florence (Biblioteca Laurenziana, Ashb. 1096, discussed pp. 208–9). Information about Angelo Lorenzo Giustinian Recanati, who also enriched the collection, was sent to me by Alberto Falck (1938–2003) in an email of September 10, 2002.

120 The collection, as it became enlarged through later bequests, was divided by category among several institutions, but intact *ducali* remain in the Library of the Museo Correr.

121 Haskell 1980, 381–83. Romanelli 1988, 13–28.

122 Pomian 1990, 256–67.

123 Di Luzio 1985–86; Dorigato 1986; Piero Lucchi, "Le Commissioni ducali del Correr tra Biblioteca e Museo," in Lucchi, ed. 2013, 7–24.

124 On manuscript acquisitions by the library, see now especially Barbara Vanin and Paolo Eleuteri, "Introduzione," in Vanin and Eleuteri 2007, ix–xviii (ix–xi). Piero Lucchi, "Le Commissioni ducali del Correr tra Biblioteca e Museo," in Lucchi, ed. 2013, 6–23.

125 An example is a leaf to Girolamo di Agostino Surian as *Podestà* of Padua, 1596, attributable to the artist Alessandro Merli. Museo Correr, Cl. II, 91. Mounted on board. Nineteenth-century writers describe such Commissions framed and exhibited on the wall at the Correr. Foucard 1857, 440; Cheney 1867–68, 68; Helena Katalin Szépe, "Painters and Patrons in Venetian Documents," in Lucchi, ed. 2013, 25–61 (34, 60, fig. 49).

126 Museo Correr, CL. II, 727, 728, and 729. Museo Civico di Cremona, D87. Marinelli 2006; Marinelli 2008. After consulting printed lists of *rettori*, Sergio Marinelli has suggested that the Correr leaves were made for Giovanni Michiel as Captain of Bergamo in 1554 and Angelo Michiel as *Podestà* and Captain of Rovigo in 1558. A search through the *Segretario alle voci* registers is needed to confirm that other members of the Michiel family did not hold positions as *rettori* in these years.

127 Museo Correr, Zoppetti Album A.N. 75 n. 2. There are eighteen *ducali* leaves in this album and they each also have been assigned separate Museum "Classe II" catalogue numbers. Giuseppe Pavanello, "Domenico Zoppetti," *Bollettino dei Civic Musei Veneziani* 30 (1986): 117–21.

128 For example, Alvise II Girolamo Contarini donated sixty-eight *ducali* in 1843. Zorzi 1987, 381.

129 Cicogna 1851; Cesare Foucard republished Cicogna's section on Venetian miniature painting from this publication in 1857 as "C. Della miniature veneziana," in Foucard 1857, 91–101.

130 "*levate dal libro formavano e formano tuttavia l'ornamento dei piu distinti gabinetti.*" Cicogna 1851, 17. Among contemporary collectors of Commission leaves he listed Luigi Celotti, Matteo Luigi Canonici, and L'Abate Tommaso de Luca. On collecting and scholarship of Venetian manuscripts in the nineteenth and twentieth centuries, see also Humphrey 2015, 41–46.

131 Cicogna 1851, 21, and echoed by Cheney 1867–68, 6.

132 He is identified as 'F. M.' in the annotations. BL, Add. MS 20758.

133 BL, Add. MS 20916. *Catalogue of Additions 1854–1860 mss. 19,720–24,026* ([London:] Trustees of the British Museum, 1875–77), 289. S. Leigh Sotheby and John Wilkinson, *Catalogue of the Valuable Library of the Right Honourable Lord Stuart de Rothesay, including many illuminated and important manuscripts, chiefly collected during many years' residence as British Ambassador at the Courts of Lisbon, Madrid, The Hague, Paris, Vienna, St. Petersburg, and Brazil* (London: Sotheby's, 1855). Recently these were catalogued in more detail by Anne-Marie Eze, and made available online.

134 Hindman and Rowe 2001, 64–65. The following were acquired from 1844 to 1858: BL, Add. MS 15145; 15816; 17347; 17348; 17373; 18000; 20916; 20979; 20980; 20981; 20982; 21414; 21990.

135 Holmes catalogue fol. 25r (notices of first leaves

of *ducali* without names or dates offered to the British Museum by Colnaghi, April 1846, purchased by Earl of Ashburnham); Bertram Ashburnham, 4th Earl of Ashburnham, *A Catalogue of the Manuscripts at Ashburnham Place* (London: C. F. Hodgson, 1853); Holmes compiled the catalogues of the Barrois Collection that Ashburnham had acquired, and an "Appendix." Paul F. Gehl, "Bertram Lord Ashburnham," in William Baker and Kenneth Womack, eds. *Nineteenth-Century British Book-Collectors and Bibliographers* (*Dictionary of Literary Biography*, vol. 184) (Detroit: Gale, 1997): 18; Ada Labriola, "Bertram 4th Earl of Ashburnham," in Tartuferi and Tormen, eds. 2014, 512–15.

136 Gehl 1997, 10–20.

137 Detached leaf of the Commission to Pandolfo di Iusto Guoro as Captain of Famagusta, Cyprus, in 1560/61. Temple University Libraries, Rare Books and Manuscript Collection, Philadelphia. Consuelo Dutschke, "Leaf from a Dogale," in Tanis, ed. 2001, 222–23. Christie's, London, *F. A. Woodcock and Other Collections*, February 4, 1924, lot 25. Leaf from a Commission, Philadelphia, Free Library, Lewis E M, 47:11. Zuccolo-Padrono 1971, 68–71.

138 Cambridge, Fitzwilliam Museum, It. 44. Morgan, Panayotova, Reynolds 2011, vol. 1, 160. In addition, five leaves were acquired already by 1806. Francis Wormald and Phyllis M. Giles, eds. *A Descriptive Catalogue of the Additional Illuminated Manuscripts in the Fitzwilliam Museum Acquired between 1895 and 1979* (Cambridge: Cambridge University Press, 1982): 123–31. Burlington Fine Arts Club and Charles Brinsley Marlay, *Catalogue of a Series of Illuminations from Mss. Principally of the Italian and French Schools* (London: Burlington Fine Arts Club, 1886): 5; Morgan, Panayotova, Reynolds 2011, vol. 1, 160.

Pietro di Giovanni was the only member of the Bollani family to be elected to this *reggimento* in the years of the doge's rule indicated on the reverse.

139 V&A, PDP, 3127. MS 1214. Tempestini 1987, fig. 4; Watson 1995, 32–33; Watson 2000, 35. Helena Szépe, "Merli, Alessandro," *DBMI*, 760–76.

140 Robinson purchased the leaf from the sale of Samuel Rogers, who had obtained it from the W. Y. Ottley Collection. Christie and Manson, *Catalogue of the Very Celebrated Collection of Works of Art, The Property of S. Rogers, Esq., Deceased* (London: Christie and Manson, 1856): 93, lot 1003; Foucard 1857, 133; Watson 2000, 35.

141 Quoted in *The English as Collectors: A Documentary Chrestomathy*, Frank Herrmann, ed. (New York: Norton, 1972): 184–85; Hindman and Rowe 2001, 62.

142 Leaf from a Commission to a member of the Contarini family, Philadelphia, Free Library, Lewis E M 27: 11. On Giuseppe Porta, see David McTavish, "Giuseppe Porta called Giuseppe Salviati," PhD thesis, Courtauld Institute of Art, 1981. On the artist and his ties to the Contarini, see Mattia Biffis, "Giuseppe Salviati a Venezia, 1540–1575," PhD thesis, Università Ca' Foscari, 2010–11.

143 Cremona, Museo Civico, D87. Puerari 1976, 95; Marinelli 2008. The motto in Spanish was that of Charles V after his victory with the Catholic princes of the Holy Roman Empire over the Lutheran Schmalkaldic League at the Battle of Muhlberg, and the apocalyptic imagery may be meant to reference the Protestant threat.

144 This is the case, for example, with a number of leaves in the British Library originating from the de Rothesay Collection.

145 Such is the case of the Commission to Francesco di Antonio Loredan (1540–1608) as Proveditor of Zante of 1598. The illumination from the workshop of Giorgio Colonna shows Venice as Justice, sitting on the lion of Mark with one foot on the globe. At her feet is a weight-measure and below, numerous coats of arms, not all of them of Venetian patricians. The arms of Loredan, to whom the rest of the manuscript was commissioned, are not included. This, then, must have been lifted from a manuscript destined for a Venetian magistracy or society linked to commerce, and bound into this manuscript at a later date. NYPL, Spencer MS 132.

146 Pemble 1995, 19.

147 Jacopo di Pietro Contarini had the palace built from which this name arose. Foucard 1857, 61–65.

148 WAM, W.484. Paolo di Dionisio Contarini as Captain of Candia, 1575. The manuscript is noted as having been in the Contarini delle Statue Collection by Edward Cheney. Cheney 1867–68, 79. It was purchased by Henry Walters from a private collection in Russia and bequeathed to the Walters in 1931.

149 Anna Paola Massarotto, "Illuminated official portraiture in Cinquecento Venice: The Collection of Dogal Commissions in the Public Record Office," MA dissertation, Courtauld Institute of Art, 1997–98.

150 BL, Add. MS 45539. Giovanni di Alvise Contarini (d. 1541) as Captain of Cyprus, 1538, with new, inscribed binding and printed dedication. Cheney 1867–68, 79; George Francis Hill, *A History of Cyprus* 3 (Cambridge: Cambridge University Press, 1948): 864–74.

151 Renamed the Médiathèque de Roanne. *Les Manuscrits Vénitiens du Fonds Boullier*, eds. Marie F. Viallon and Isabelle Suchel-Mercier (Roanne: Bibliothèque municipale de Roanne, 1994).

152 Biblioteca del Senato della Repubblica, *Gli Statuti dei comuni e delle corporazioni in Italia nei secoli xiii–xvi* (Rome: Edizioni de Luca, 1995). Michael Widener and Christopher W. Platts, *Representing the Law in the Most Serene Republic: Images of Authority from Renaissance Venice*. http://digitalcommons.law.yale.edu/itsta/7/ [Accessed December 26, 2016].

153 Cheney 1867–68, 72.

154 Cheney 1867–68, 68, 72. Edward Cheney's own collection including ducal documents was sold in

1886 by Sotheby's. *Catalogue of the Choice Library of the late Edward Cheney, Esq. comprising important illuminated manuscripts; splendid heraldic publications ...; finely illustrated works; history, voyages and travels; rare Italian and French authors ...* (London: Sotheby, Wilkinson, & Hodge, 1886). On Isabella Stewart Gardner's purchase of some of these *ducali*, see Eze 2016.

155 In his youth he dedicated himself to literary studies under the guidance of Paolo Manuzio before his extensive political career began in 1555. The Commission as Captain of Crete marked the last stepping stone towards the height of his career, for he subsequently was elected as *Bailo* at Constantinople in 1580. Paolo Contarini, *Diario del viaggio da Venezia a Constantinopoli di Paolo Contarini nel 1580* (Venice: Teresa Gattei, 1856).

156 Genealogists do not record that Contarini had any sons. R. Derosas, "Contarini, Paolo (Polo)," *DBI* 28 (1983): 258–305. In 1563 Contarini was elected *Podestà* and Captain of Feltre. The Commission for this earlier post has an elaborately illuminated opening text page with a miniature of female personifications of Faith, Justice, and Prosperity, attributable to Giorgio Colonna. It was previously owned by Edward Cheney. Sotheby's, *Catalogue of Western Manuscripts and Miniatures, comprising the property of the Earl of Rosebery and Midlothian D.L., the property of Dr. Warren G. Smirl, the property of the Public Library and Art Gallery, St. Johnsbury Athenaeum (sold by Order of the Trustees) and Miniatures from the Collection of the late Dr. Rosy Schilling and other properties* (London: Sotheby's, 1994).

The map of Crete is an almost exact copy of the map of the island printed by Donato Bertelli in Venice in 1574, including the figure of Neptune. Donato Bertelli, *Isoia di Candia*. Reprinted as Natale Bonifacio and Donato Bertelli, *Issoia D'Candia* (Venice: Donatus Bertellus, 2005). On Bertelli, see Bury 2001, 221–22. Ihor Ševčenko discusses and transcribes the Commission text in "Dogale pour Paul Contarini, capitaine de Candia," *Kretika Chronika* 4, 2 (1950): 268–80; *The World Encompassed: An Exhibition of the History of Maps Held at the Baltimore Museum of Art 1952* (Baltimore: Trustees of the Walters Art Gallery, 1952): n. 85, plate LIX.

157 "*Oh cessi una volta questa dispersione dei monumenti patrii! Non basta l'anatema della pubblica opinione, non basta, o signori!*" Foucard 1857, 61, 64.

158 Founded in 1867, the Fondazione Querini Stampalia also preserves the manuscripts and documents of that patrician family archive. *Archivio privato della Famiglia Querini-Stampalia inventario*, eds. Domenico Viola, Carini Venturini, Roberto Zago (Venice: Fond. Scientifica Querini-Stampalia, 1987).

159 M. Carter, *A Choice of Manuscripts and Bookbindings from the Library of Isabella Stewart Gardner, Fenway Court* (Boston: 1922). Szépe 2004, 233–35.

160 Norton was appointed Professor of Fine Arts at Harvard in 1875. Christopher S. Wood, "Art History's Normative Renaissance," *The Italian Renaissance in the Twentieth Century*. Acts of an International Conference, Florence, Villa I Tatti, June 9–11, 1999, eds. Allen J. Grieco, Michael Rocke, Fiorella Gioffredi Superbi (Florence: Leo S. Olschki, 2002): 65–92 (67). See now Eze 2016, which discusses Isabella Stewart Gardner's collecting of Venetian manuscripts and her association with Charles Eliot Norton in much greater detail.

161 Alan Chong, "Introduction: Romance and Art and History," in McCauley and Chong, et al., eds. 1994, xi–xviii; Marino Zorzi, "The Palazzo Barbaro before the Curtises," in McCauley and Chong, et al., eds. 1994, 191–202; Giovanna de Appolonia, "A Venetian Courtyard in Boston," in McCauley and Chong, et al., eds. 1994, 177–90.

162 Hillard T. Goldfarb, *The Isabella Stewart Gardner Museum: A Companion Guide and History* (Boston and New Haven: Isabella Stewart Gardner Museum, Yale University Press, 1995): 43.

163 ISGM P27e49. Leaf from a Commission to a Valier.

164 HLSM, EL 9 H13. Dutschke 1989, vol. 1, 29. The Holmes list locates these as already in the collection of the Earl of Ellesmere in 1855.

165 Wieck 1996, 246–47; Hindman and Rowe 2001, 219.

166 Hindman and Rowe 2001, 220.

167 *Ducali* purchased from Ongania in 1912 and missing opening leaves: MS M.543–M.548 and M.555. M.556 has minor illuminations. On the sale to Morgan of the Venier manuscript and Fry's highlighting of the value of the miniatures, see Eze 2016, 208–10.

168 Hindman and Rowe 2001, 224; Lilian M. C. Randall, "Preface," in Randall 1989: xi–xiii.

169 At least one was from Leo S. Olschki of Florence (1861–1940), through whom Walters obtained most of his Italian manuscripts. Two filtered through the collection of Edward Quaile, sold in 1901.

170 Wieck 1996, 248; Hindman and Rowe 2001, 232–37.

171 May 29. George R. Bodmer, "A. S. W. Rosenbach: Dealer and Collector," *The Lion and the Unicorn* 22, 3 (1998): 277–88. Sotheby & Co., *Catalogue of valuable printed books, illuminated & other manuscripts, autograph letters and historical documents, etc ... March 1926* (London: 1926).

172 de Hamel 1996.

173 This pastiche was in the Palazzo Soranzo-Van Axel in Venice in 1944. It may have been constructed by Count Dino Barozzi, the antiquarian dealer who bought and restored the palace in 1920. Giuseppe Morazzoni, *Le Cornici veneziane* (Milan: Luigi Alfieri, 1944): plate 53. The frame appears to have originally been a reliquary.

Glossary

all'antica In a style imitating the manner of ancient, especially Greek and Roman, works.

Arsenale The public shipyard of Venice.

avogadori di comun Board of three Venetian magistrates who functioned as state attorneys, but also were in charge of keeping track of the legitimacy of members of the Great Council.

bailo Title of some Venetian governors in the Mediterranean and of the Venetian ambassador-consul in Constantinople.

ballottino Young boy who collected and counted election ballots.

bavero (collar) Broad collar in ermine that was part of the ceremonial dress of the doge.

biretum Ducal cap, also called *corno*.

bolla Pendant seal for documents.

breviary Contains the prayers, chants, songs, and readings of the Divine Office (Liturgy of the Hours) for the liturgical year.

camauro di rensa Skull cap of fine linen worn under the *corno* or *zoia* of the doge, signifying his almost sacred status.

Cancelleria Chancery. The Venetian State Chancery was divided into three sections. The *Cancelleria inferiore* conserved the archives of the Doge and some of the minutes of notarial acts and testaments. The *Cancelleria ducale* held the archives of the principal arms of the state, including the Great Council, the *Signoria*, the *Collegio*, and the Senate, except for the series of documents reserved for the *Cancelleria secreta*, or "secret chancery."

Capitolare Book containing the rules and regulations of an office or officer of Venice.

captain (*capitano*) 1) Commander of a fleet, or 2) the governor (rector) of some subject towns or regions, who possessed civil, criminal, and military authority.

Captain General of the Sea Highest naval command.

cattaveri Venetian officials with many and varied duties, including overseeing incoming trade and state property. They eventually also held jurisdiction over Jews.

cittadino Non-patrician citizen of Venice. The *cittadini originarii* were a hereditary elite class granted exclusive access to certain posts in the state.

codex, codices Book form created by sheets folded, nested, and sewn along one edge.

codicology Study of the structure of the book.

Collegio (also *Pien collegio*) Cabinet of the Venetian Senate, composed of the *Signoria* and the *Consulta*, three boards of *savi* (wise men, or ministers).

Commission Commission of office with detailed regulations given to rectors, captains of merchant galleys, procurators of Saint Mark, and a few other elected offices.

Commissione ducale See Commission.

consiglieri ducali (also *Minor consiglio*) See ducal councillors.

Consiglio dei pregadi See Senate.

Consiglio di dieci See Council of Ten.

corno (horn) Term commonly used for the doge's cap, for it rose at the back in the shape of a horn. Key marker of the doge's princely status. Known as the *biretum* in Latin.

Council of Ten Powerful council made up of ten elected officials, as well as the doge, and the six ducal councillors.

dogale See *ducale*.

doge Head of Venice elected for life, at times also called *Serenissimo* (Most Serene) and Prince.

ducal councillors Six councillors of the doge, each representing one of six *sestieri*, who advised and oversaw the actions of the doge. They were charged with ensuring that he followed the rules of his *Promissione*.

ducale "Of the doge." In diplomatic terms, any document written in a doge's name, or signed by the doge, and typically directed to another official. In art historical terms, documents and rulebooks granted to recipients of primarily three offices that came to be embellished: the *Promissione* of the doge, the *Commissioni/Giuramenti/Capitolari* of the procurators of Saint Mark, and the *Commissioni* of the rectors and captains of merchant galleys.

epistolary Liturgical book containing readings for the Mass drawn primarily from the Epistles of Paul.

eschatocol Final section of a legal document, which may include the place and date of execution and signatures of witnesses or authenticators.

evangeliary Liturgical book containing sections of the four Gospels to be read during Mass or other public offices of the church, arranged according to the liturgical year.

garzone Italian for apprentice.

Giuramento Oath, or the text of an oath.

Governatori delle entrate Bureau of officials who controlled the offices that levied taxes on the *reggimenti* of both land and sea.

Grand Chancellor Head of the ducal chancery. Elected from the *cittadini orginarii*; held an honorary and symbolic position comparable to the doge.

Great Council See *Maggior consiglio*.

incunable Any book printed in Europe in the fifteenth century.

index In semiotic terms, an index establishes meaning along the axis of a physical relationship to a referent.

Libro d'oro (Golden Book) Collection of deliberations in the Great Council, including those defining who could be admitted to membership of the Great Council and how this was enacted. Also refers to the books containing the lists of nobles admitted.

lieutenant (*luogotenente*) Governor of a Venetian region.

Maggior consiglio (Great Council) Sovereign oligarchic assembly open to all legitimate patrician male adults. Most officers were elected by this council, although some elections and many important duties and functions were ceded to committees and the Senate.

membrane Animal skin prepared for writing and illumination. The support for *ducali* manuscripts. Without scientific examination it is difficult to determine from which animal the support comes. Strictly speaking, vellum is from a cow or calf, parchment from a sheep or lamb.

Minor consiglio See ducal councillors.

missal Book containing the texts read by a priest performing the Mass throughout the liturgical year. The texts vary according to 'use,' dependent upon geographical area.

paliotto Large altar covering (antependium, or altar frontal). Doges were required to donate one in cloth to the Church of Saint Mark.

patrono dell'Arsenale Direct supervisor of the Arsenale.

Patriarch of Aquileia Prelate of the episcopal see in northeastern Italy centered on the city of Aquileia.

podestà Civil governor of a Venetian town or territory.

Pregadi (also *Consiglio dei pregadi*) See Senate.

primicerio Vicar of the Basilica of Saint Mark.

Procuratia Buildings around Piazza San Marco in which the procurators had their apartments and offices, and the office itself.

procurators of Saint Mark (*procuratori di San Marco*) Procurators, eventually nine, elected for life. Originally responsible for the Basilica, they became treasurers of the Republic, distributors of charity, and custodians of private trusts.

Promissione ducale Text or manuscript containing the inaugural promise of the doge, his oath of office, and the regulations of office.

proveditor Venetian commissioner of a province, whose duties often were combined with military command. Special proveditors were elected by the Venetian Senate to oversee security and direct the military in various territories of the empire.

provveditore See proveditor.

Provveditori del sal (Salt Office) Provisors over the acquisition and production of salt, and of price regulation of salt. They collected large amounts of money, which was used in the financing of public buildings and their interior decoration.

proto Master builder and foreman of new construction but also maintenance of buildings in Venice.

Quarantia (Council of Forty) Top judicial authority of Venice.

Rason vecchie Office with a wide variety of duties, including funding the expenses for events and objects that honored the doge, as well as for other public festivals and ceremonies.

rector (*rettore*) Usually the general term for a governor of a subject city or territory, but sometimes used as a more specific title.

reggimento Territorial unit of the Venetian empire.

relazione Report by the Venetian *rettore* delivered upon return from his tour of duty. Also the report by a Venetian ambassador upon return.

restagno d'oro Ducal robe of gold-threaded brocade, which the doge was required to purchase after his election and wear on special occasions.

rettore See rector.

segretario alle voci Member of the ducal chancery and main official overseeing the details of elections in the Great Council, the Senate, and sometimes in the Council of Ten.

Senate (*Senato*) Council of about 300 men elected to perform the main deliberative functions of the Republic. Also called *Consiglio dei pregadi*.

serrate Series of legislations restricting membership of the Great Council.

sestiere One of six official districts of Venice (Cannaregio, Castello, Dorsoduro, San Marco, San Polo, Santa Croce).

Signoria Supreme government authority constituted by the doge, the ducal councillors, and the *Capi della quarantia* or three Heads of the Forty.

stato da mar Venetian Mediterranean empire.

stato da terra Venetian territory on the mainland.

stola Strip of velvet, wool, or brocade worn over the shoulder to the side, over the formal *vesta* robe (also called "toga"). Knighted patricians could wear one of gold cloth.

terraferma Venetian term for the mainland, also used to refer to the *stato da terra*.

traditio legis (handing over of the law) Iconographic theme in which Christ hands Peter a scroll or book in the presence of Paul, to illustrate the transmission of the Word and divine authority through the apostles.

Vangelo (Gospel) Used here to reference the manuscript of Mark's Gospel, now in three parts, believed during the Renaissance to have been written in Mark's hand. The section in the Treasury of the Church of Saint Mark in Venice is stored in a fourteenth-century box reliquary with a gilded silver cover.

zimarra Long open robe worn over other clothing, which was considered more casual attire than the *vesta* or toga worn by Venetian officials in Venice.

zoia The bejeweled version of the doge's *biretum*, or *corno*, worn only on special occasions.

Select Bibliography of Printed *Ducali* Texts

PROMISSIONI

Francesco Foscari Promissione Ducale 1423. Dieter Girgensohn, ed. Venice: La Malcontenta, 2004

Graziato, Gisella. *Le promissioni del doge di Venezia*. Venice: Il Comitato editore, 1986

Promissio Serenissimi Venetiarum ducis serenissimo Marino Grimani duce edita. Venice, 1595

Promissio Serenissimi Venetiarum ducis serenissimo Francesco Contareno duce edita. Venice: Tipografia ducale, 1623

Promissio Serenissimi Venetiarum ducis serenessimo Francisco Lauredano duce edita. Venice: Typographia Ducali Pinelliana, 1752

Promissio Serenissimi Venetiarum ducis serenissimo Ludovico Manino duce edita. Venice: Typographia Ducali Pinelliana, 1789

COMMISSIONI

Canzian, Dario. "Commissione del doge Giovanni Mocenigo a Giovanni Gabriel, capitano di Zara (1479). Zara, Research Library, MS 789," in Federica Toniolo, Giordana Mariani Canova, Cristina Guarnieri, Dario Canzian, eds. *Medioevo Adriatico: testi e immagini. Manoscritti miniati veneziani a Zara (secoli XIII–XV)*. CD-ROM. Padua: Università degli Studi di Padova, 2009

Cappelluzzo, Giovanni. *Lo "Statuto del Podesta" di Bergamo. Commissione dogale per Lorenzo Bragadin, 1559*. Bergamo: Provincia di Bergamo, Centro documentazione beni culturali, 1992

Caprin, Giulio. "Commissio potestatis Gradi," *Archeografo Triestino* n.s. 16 (1890): 13–184

Cicogna, Emmanuele Antonio. *Documenti storici inediti pertinenti alla citta di Portogruaro*. Portogruaro: B. Castiou, 1851

Fulin, Rinaldo. *La commissione del Doge Michele Steno al podestà e capitano di Belluno*. Venice: Marco Visentini, 1875

Hill, Sir John, "On the Commissions to Balthasar Trevisan (1489) and John Contarini (1538), Captains of Cyprus," *A History of Cyprus*, vol. 3, *The Frankish Period 1432–1571*. Cambridge: Cambridge University Press, 1972, 864–74

Leicht, Pier Silvestro. "La commissione di ser G. da Mula castellano e prov. di Corone e Modone," *Archivio Veneto* serie v, 38/39 (1946–47): 86–98

Maltezou, Chryssa A. *Ire debeas in rettorem Caneae. La commissio del doge di Venezia al rettore di Canea 1589*. Venice: Istituto Ellenico di studi bizantini, 2002

Rizzi, Alessandra, ed. *Le commissioni ducali ai rettori d'Istria e Dalmazia (1289–1361)*. Venice: Viella, 2015

See also scanned *ducali*, including Commission/Oaths of procurators of Saint Mark, in the library of the Museo Correr at: http://www.nuovabibliotecamanoscritta.it/ mostra_commissioni.html?language=it

Manuscript Sources

For genealogical sources see Index of Patricians (page 385)

LONDON

British Library (BL)
[J. H. Holmes] MS Addit. 20758
John H. Holmes. A list of Venetian Ducali [1367–1794] in the British Museum, the National Library in Paris, and various private collections, with sketches of arms, descriptions of medals of doges, etc.; with later additions in the handwriting of Sir Frederic Madden. Paper. 19th century

ROME

Archivio Storico Capitolino
Camera Capitolina

VENICE

Archivio Patriarcale di Venezia
Registri dei morti
Status animarum

Archivio di Stato di Venezia (ASVe)
Archivio Grimani e Barbarigo
Archivio Grimani Santa Maria Formosa
Archivio proprio di Giacomo Contarini
Archivio Tiepolo
Arti
 Dipintori
Avogaria di comun
 Nascite
 Matrimoni
Cancelleria inferiore
 Archivio del doge
 Miscellanea notai diversi – Inventari
Capi del Consiglio di dieci
 Giuramenti (dei rettori)
 Lettere dei rettori (dispacci)

Collegio
 Capitolare dei consiglieri veneti
 Cerimoniali
 Commissioni ai rettori ed altre cariche (Note: Most, if not all, of the Commissions located in this *fondo* came from private collections. Many were purchased by the ASVe and the relevant receipts are included in the *buste*)
 Formulari di commissioni
 Promissioni ducali
Consiglio di dieci
Dieci savi alle decime in Rialto
Giudici del proprio
Giudici di petizion
 Inventari di eredità
 Rendimenti di conto
Giustizia vecchia
 Accordi dei Garzoni
Maggior consiglio
 Deliberazioni
Miscellanea atti diplomatici e privati (doge)
Miscellanea codici, sec. XIV–sec. XX
Notarile, Testamenti, Notaries:
 Francesco Alcaini
 Francesco Boni
 Pietro Bracchi
 Vincenzo Conti
 M. A. de Cavaneis
 Zaccaria de Priuli
 Giacomo Gentili
 Giacomo Grasolario
 Alvise Schinelli
 Galeazzo Secco
 Cesare Ziliol
 Giulio Ziliol
Pacta e aggregate
 Indici
Procuratori di San Marco (PSM)
 Misti
 Procuratori "de supra"
 Cassier chiesa
 Catastico
 Quaderno chiesa

Provveditori al sal
Provveditori di comune
 Capitolare
Provveditori, Sopraprovveditori e Collegio alle pompe
 Capitolare
 Decreti relative alla terraferma
S. Antonio di Castello
Segretario alle voci (SAV)
 Accettazioni di cariche
 Elezioni in Maggior consiglio
 Elezioni in Senato
 Giuramenti dei rettori di osservare le leggi suntuarie
 (1609–37)
 Registri e filze diverse
Senato
 Deliberazioni
 Terra
Ufficiali al cattaver
Ufficiali alle Rason vecchie
 Documenti della cassa grande 1510–72, b. 378

Biblioteca del Museo Civico Correr di Venezia (BMCVe)
MS Correr Cl. IV, n. 163, Mariegola dei Depentori, 1676
MS Gradenigo Dolfin 65, Pietro Gradenigo and Giovanni
 Grevembroch, "Varie venete curiosità sacre e profane,"
 1755, 3 vols.
MS Gradenigo Dolfin 228, Giovanni Grevembroch,
 "Monumenta veneta," 1759, 3 vols.
Prov. Div. 252c, Girolamo Priuli, *Diarii*
Prov. Div. 511, *Scritture famiglia Erizzo*
Prov. Div. ca. 2408, *Famiglia Cavalli*

Biblioteca Nazionale Marciana di Venezia (BMVe)
Cod. Ris. 73 *Museo archeologico marciano*
It. VII, 813 (=8892) - 836 (=8915), *Consegi*
It. VII, 1463 (=9354) Giovanni Rossi, *Documenti*. Vol.
 40. *Catalogo (estratti da) de manoscritti della Libreria*
 Giustinian sulle Zattere, fatto dal Bibliotecario della
 Marciana Don Pietro Bettio
Lat. III, 172 (=2276) Bartolomeo Bonifacio, *Rituum*
 cerimoniale, after 1564

VIENNA

Österreichisches Nationalbibliothek (ÖNB)
Cod. 6555, ff. 27v–51r, Marin Cavalli, *Informatione*
 dell'offitio dell'ambasciatore

Bibliography

The identifying numbers of Latin passages of the Bible are from the *Biblia Sacra Vulgatae Editionis* (sponsored by Pope Sixtus V and prepared by Pope Clement VIII), first edition 1592, Milan, Edizioni San Paolo, 1995. All biblical passages in English are from the Douay version, the English translation of the Latin Vulgate.

Agazzi, Michela. *Platea Sancti Marci: i luoghi marciani dall'XI al XIII secolo e la formazione della piazza.* Venice: Comune di Venezia and Università degli Studi di Venezia, 1991.

Aikema, Bernard, and Beverly Louise Brown, eds. *Renaissance Venice and the North: Crosscurrents in the Time of Bellini, Dürer, and Titian.* New York: Rizzoli, 2000.

Aldrighetti, Giorgio. *L'araldica e il leone di San Marco: le insegne della Provincia di Venezia.* Venice: Marsilio, 2002.

Alexander, Jonathan J. G. "Venetian Illumination in the Fifteenth Century," *Arte Veneta* 24 (1970): 272–75.

——. *Italian Renaissance Illuminations.* New York: Braziller, 1977.

——. *Medieval Illuminators and their Methods of Work.* New Haven and London: Yale University Press, 1992.

——, ed. *The Painted Page: Italian Renaissance Book Illumination 1450–1550.* With contributions by J. J. G. Alexander, L. Armstrong, G. Mariani Canova, F. Toniolo, R. S. Wieck, and W. Voelkle. London and New York: Royal Academy of Arts and the Pierpont Morgan Library, 1994.

——, ed. *The Towneley Lectionary Illuminated for Cardinal Alessandro Farnese by Giulio Clovio: The New York Public Library Astor, Lennox and Tilden Foundations Manuscript 91.* New York: Roxburghe Club, 1997.

——. *Studies in Italian Manuscript Illumination.* London: Pindar Press, 2002.

——, ed. *Il Lezionario Farnese: Towneley Lectionary, Commentario.* Italian trans. of Alexander, ed. 1997, with additional essay by Elena Calvillo. Modena: Franco Cosimo Panini, 2008.

——. *The Painted Book in Renaissance Italy 1450–1600.* New Haven and London: Yale University Press, 2016.

Amelot de La Houssaie, Abraham-Nicolas. *La Storia del governo di Venezia, col supplemento, e lo Squittinio della sua libertà.* Translation of *Histoire du gouvernement de Venise.* Paris: 1677. Colonia, Geneva: Pietro del Martello, 1681.

Armstrong, Lilian. *Renaissance Miniature Painters and Classical Imagery: The Master of the Putti and his Venetian Workshop.* London: Harvey Miller, 1981.

——. "Il maestro di Pico: un miniatore veneziano del tardo Quattrocento," *Saggi e Memorie di Storia dell'Arte* 17 (1990): 9–39, 215–53.

——. "The Master of the Rimini Ovid," *Print Quarterly* 10, 4 (1993): 327–63.

——. "Benedetto Bordon, *Miniator*, and Cartography in Early Sixteenth-Century Venice," *Imago Mundi* 48 (1996): 65–92.

——. *Studies of Renaissance Miniaturists in Venice.* 2 vols. London: Pindar, 2003.

Augusti, Adriana. "Aspetti diversi del monumento Barbarigo nella Chiesa della Carità a Venezia," in Mario Piantoni and Laura De Rossi, eds. *Per l'arte. Da Venezia all'Europa. Studi in onore di Giuseppe Maria Pilo. Dall'Antichità al Caravaggio.* Venice: Edizioni della laguna, 2001, vol. 1: 131–35.

Avcioğlu, Nebahat, and Emma Jones, eds. *Architecture, Art and Identity in Venice and its Territories, 1450–1750.* Farnham, Surrey, and Burlington, VT: Ashgate, 2013.

Avril, François, and Nicole Reynaud. *Les manuscrits à peintures en France, 1440–1520.* Paris: Flammarion and Bibliothèque Nationale, 1993.

Bacchi, Andrea, Lia Camerlengo, and Manfred Leithe-Jasper, eds. *La bellissima maniera. Alessandro Vittoria e la scultura veneta del Cinquecento.* Trent: Provincia Autonoma di Trento, Servizio Beni Culturali, 1999.

Bachelard, Gaston. *The Poetics of Space.* Boston: Beacon Press, 1964.

Backhouse, Janet. *The Lindisfarne Gospels.* Oxford: Phaidon, in association with the British Library, 1981.

Baldissin Molli, Giovanna, and Giordana Mariani Canova, eds. *La miniatura a Padova: dal Medioevo al Settecento.* Modena: Franco Cosimo Panini, 1999.

Ballarin, Alessandro, and D. Banzato. *Da Bellini a*

Tintoretto. Dipinti dei Musei civici di Padova dalla metà del Quattrocento ai primi del Seicento. Rome: Leonardo-De Luca editori, 1991.

Bardi, Girolamo. *Delle Cose Notabili Della Città Di Venetia, Libri II. Ne i quali si contengono Vsanze antiche, Habiti ... Officij ... Huomini Illustri, Chiese ... Palazzi ... Nuouamente riformati, accresciuti, & abbelliti con L'Aggionta Della dichiaratione delle Istorie, che sono state dipinte ne i quadri delle Sale dello Scruitinio, & del gran Consiglio del Palagio Ducale.* Venice: Valgrisi, 1587.

Barile, Elisabetta. "Michele Salvatico a Venezia, copista e notaio dei Capi sestiere," in G. P. Mantovani, L. Prosdocimi, E. Barile, eds. *L'Umanesimo librario tra Venezia e Napoli. Contributi su Michele Salvatico.* Venice: Istituto Veneto di Scienze, Lettere ed Arti, 1993: 53–103.

Barker, Nicolas. *The Glory of the Art of Writing: The Calligraphic Work of Francesco Alunno of Ferrara.* Los Angeles: Cotsen Occasional Press, 2009.

Barolsky, Paul. "The Artist's Hand," in Andrew Ladis and Carolyn Wood, eds. *The Craft of Art: Originality and Industry in the Italian Renaissance and Baroque Workshop.* Athens and London: University of Georgia Press, 1995: 5–24.

Baron, Hans. *The Crisis of the Early Italian Renaissance: Civic Humanism and Republican Liberty in an Age of Classicism and Tyranny,* revised edn. Princeton: Princeton University Press, 1966.

Barstow, Kurt. *The Gualenghi-d'Este Hours: Art and Devotion in Renaissance Ferrara.* Malibu: Getty, 2000.

Baskins, Cristelle L., and Lisa Rosenthal, eds. *Early Modern Visual Allegory: Embodying Meaning.* Aldershot and Burlington, VT: Ashgate, 2007.

Bauman, Jennifer. "Giulio Clovio and the Revitalization of Miniature Painting at the Medici Court in Florence," in Milan Pelc, ed. *Klovićev Zbornik; minijatura, crtež, grafika 1450–1700.* Zagreb: Croation Academy of Sciences and Arts, Institute of the History of Art, 2001: 63–74.

Becker, David P. *The Practice of Letters. The Hofer Collection of Writing Manuals 1514–1800.* Cambridge, MA: Harvard College Library, 1997.

Bellavitis, Anna. *Identité, marriage, mobilité sociale: Citoyennes et citoyens à Venise au XVIe siècle.* Rome: École Française de Rome, 2001.

Belting, Hans. "Dandolo's Dreams: Venetian State Art and Byzantium," in Sarah T. Brooks, ed. *Byzantium, Faith and Power (1261–1557): Perspectives on Late Byzantine Art and Culture.* New York, New Haven, and London: Metropolitan Museum of Art and Yale University Press, 2006: 138–53.

Benucci, Franco. "Stemmi ed epigrafi del Palazzo del Capitanio e dei Camerlenghi," *Padova e il suo territorio* 24, 141 (2009): 10–13.

Benzoni, Gino, ed. *I Dogi.* Milan: Electa, 1982.

Bergstein, M. "*La Fede*: Titian's Votive Painting for Antonio Grimani," *Arte Veneta* 40 (1986): 29–37.

Bernstein, Jane A. *Print Culture and Music in Sixteenth-Century Venice.* New York: Oxford University Press, 2001.

Blair, Ann, and Jennifer Milligan. "Introduction," in "Toward a Cultural History of Archives," *Archival Science* 7, 4 (2007), special issue: 289–96.

Blake McHam, Sarah. "The Role of Pliny's Natural History in the Sixteenth-Century Redecoration of the Piazza of San Marco," in Luba Freedman and Gerlinde Huber-Rebenich, eds. *Wege zum Mythos.* Berlin: Gebr. Mann Verlag, 2001: 89–105.

——. *Pliny and the Artistic Culture of the Italian Renaissance: The Legacy of the Natural History.* New Haven: Yale University Press, 2013.

Blouin, Francis X. Jr., and William G. Rosenberg, eds. *Archives, Documentation, and Institutions of Social Memory: Essays from the Sawyer Seminar.* Ann Arbor: University of Michigan, 2005.

Boccato, Carla, and Maria Teresa Pasqualini Canato. *Il potere nel sacro. I rettori veneziani nella rotunda di Rovigo (1621–1682).* Rovigo: Minelliana, 2001.

Bodon, Giulio. *Heroum imagines. La Sala dei Giganti a Padova. Un monumento della tradizione classica e della cultura antiquaria.* Venice: Istituto Veneto di Scienze, Lettere ed Arti, 2009.

Boerio, Giuseppe. *Dizionario del dialetto veneziano.* 2nd edn. Venice: Giovanni Cecchini, 1856.

Boese, Helmut. *Die Lateinischen Handschriften der Sammlung Hamilton zu Berlin.* Wiesbaden: Harrassowitz, 1966.

Boholm, Åsa. *The Doge of Venice: The Symbolism of State Power in the Renaissance.* Gothenburg: Institute for Advanced Studies in Social Anthropology, 1990.

Boito, Camillo. ed. *The Basilica of S. Mark in Venice Illustrated from the Points of View of Art and History, by Venetian Writers under the Direction of Prof. C. Boito.* Venice: 1888.

Boito, Camillo, and Ferdinando Ongania, eds. *La Basilica di San Marco in Venezia illustrata nella storia e nell'arte da scrittori veneziani.* Venice: Ongania, 1888–92.

Borean, Linda, and Stefania Mason, eds. *Il collezionismo d'arte a Venezia: il Seicento.* (Collezionismo 2007.) Venice: Marsilio, 2007.

Boucher, Bruce. *The Sculpture of Jacopo Sansovino.* New Haven and London: Yale University Press, 1991.

Bouwsma, William. *Venice and the Defense of Republican Liberty: Renaissance Values in the Age of the Counter-Reformation.* Berkeley and Los Angeles: University of California Press, 1968.

Bradley, John W. *A Dictionary of Miniaturists, Illuminators, Calligraphers and Copyists, with References to their Works, and Notices of their Patrons: From the*

Establishment of Christianity to the Eighteenth Century.
3 vols. London: B. Quaritch, 1887–89.

——. *The Life and Word of Giorgio Giulio Clovio Miniaturist.* London: G. Norman & Son, 1891.

——. "Venetian Ducali," *Bibliographica* 2 (1896): 257–75.

Braesel, Michaela. *Buchmalerei in der Kunstgeschichte. Zur Rezeption in England, Frankreich und Italien, Cologne.* Weimar, Vienna: Böhlau Verlag, 2009.

Brand, Hans Gerhard. "Die Grabmonumente Pietro Lombardos. Studien zum Venezianischen Wandgrabmal des späten Quattrocento." PhD thesis, Friedrich-Alexander-Universität, 1977.

Bratti, D. Ricciotti, "Miniatori veneziani," *Nuovo Archivio Veneto* 2, 1 (1901): 70–94.

Bristot, Annalisa, ed. *Palazzo Grimani a Santa Maria Formosa. Storia, arte, restauri.* Verona: Scripta, 2008.

Britnell, Richard, ed. *Pragmatic Literacy, East and West, 1200–1330.* Woodbridge: Rochester, 1997.

Brooker, T. Kimball. "Sixteenth Century Bookbindings from Italy and France in the Library of T. Kimball Brooker." MA thesis, University of Chicago, 1988.

Brown, Beverly Louise, and Paola Marini, eds. *Jacopo Bassano c. 1510–1592.* Fort Worth: Kimbell Art Museum, 1993.

Brown, Horatio F. "The Constitution of the Venetian Republic and the State Archives," *Studies in the History of Venice,* vol. 1. London: John Murray, 1907.

Brown, Jonathan, and John Huxtable Elliott. *The Sale of the Century: Artistic Relations between Spain and Great Britain.* New Haven, London and Madrid: Yale University Press and the Prado Museum, 2002.

Brown, Patricia Fortini. *Venetian Narrative Painting in the Age of Carpaccio.* New Haven and London: Yale University Press, 1988.

——. *Venice and Antiquity.* New Haven and London: Yale University Press, 1996.

——. *Private Lives in Renaissance Venice: Art, Architecture, and Family.* New Haven and London: Yale University Press, 2004.

Brunetti, Mario. "Due dogi sotto inchiesta: Agostino Barbarigo e Leonardo Loredan," *Archivio Veneto-tridentino* 7 (1925): 278–329.

Brunettin, Giordano, ed. *Il Vangelo dei principi. La riscoperta di un testo mitico tra Aquileia Praga e Venezia.* Pordenone: Paolo Gaspari, 2001.

Burke, Peter. *Venice and Amsterdam: A Study of Seventeenth-Century Elites.* Cambridge, MA: Polity Press, 1994.

Bury, Michael. *The Print in Italy 1550–1620.* London: British Museum, 2001.

Calderhead, Christopher. *Illuminating the Word: The Making of Saint John's Bible.* Collegeville, MN: The Saint John's Bible, 2005.

Calkins, Robert C. *Illuminated Books of the Middle Ages.* London: Thames & Hudson, 1983.

——. "Gerard Horenbout and his Associates: Illuminating Activities in Ghent, 1480–1521," in Laurinda S. Dixon, ed. *In Detail: New Studies of Northern Renaissance Art in Honor of Walter S. Gibson.* Turnhout: Brepols, 1998: 49–68.

Callegari, Chiara. "*Disegni stampati* a Venezia nel Cinquecento. Cronologia – bibliografia – glossario.* Venice: Biblioteca Nazionale Marciana, 1999.

Calvillo, Elena M. "*Romanità* and *Grazia*: Giulio Clovio's Pauline Frontispieces for Marino Grimani," *Art Bulletin* 82 (2000): 280–97.

——. "Imitation and Invention in the Service of Rome: Giulio Clovio's Works for Cardinals Marino Grimani and Alessandro Farnese." PhD thesis, Johns Hopkins University, Baltimore, 2003.

Camille, Michael. "The *Très Riches Heures*: An Illuminated Manuscript in the Age of Mechanical Reproduction," *Critical Inquiry* 17 (Autumn 1990): 72–107.

Campbell, Lorne, Miguel Falomir, Jennifer Fletcher, and Luke Syson, eds. *Renaissance Faces: Van Eyck to Titian.* London: National Gallery, 2008.

Campbell, Stephen John, ed. *Artists at Court: Image-making and Identity 1300–1550.* Chicago: University of Chicago Press, 2004.

Campori, Giuseppe. "I miniatori degli Estensi," *Atti e Memorie delle RR. Deputazioni d Storia Patria per le Provincie modenesi e parmensi,* I, VI (1872): 245–73.

Caniato, Giovanni, and Michela Dal Borgo, eds. *Le arti edili a Venezia.* Rome: Edilstampa, 1990.

Cappelluzzo, Giovanni. *Lo "Statuto del Podestà" di Bergamo. Commissione dogale per Lorenzo Bragadin, 1559.* Bergamo: Provincia di Bergamo, Assessorato servizi sociali e cultura, Centro documentazione beni culturali, 1992.

Carboni, Stefano, ed. *Venice and the Islamic World, 828–1797.* New York, New Haven, and London: Metropolitan Museum of Art and Yale University Press, 2007.

Casini, Matteo. "Realtà e simboli del cancellier grande veneziano in età moderna (Secc. XVI–XVII)," *Studi Veneziani* 22 (1991): 195–252.

——. "'Dux habet formam regis.' Morte e intronizzazione del principe a Venezia e Firenze nel Cinquecento," *Annali della Fondazione Luigi Einaudi* 27 (1993): 273–351.

——. *I gesti del principe. La festa politica a Firenze e Venezia in età rinascimentale.* Venice: Marsilio, 1996.

——. "Immagini dei capitani generali 'da mar' a Venezia in età Barocca," in *Il "perfetto capitano" immagini e realtà (secoli XV–XVII).* Marcello Fantoni, ed. Rome: Bulzoni, 2001: 219–70.

Casini, Tommaso. *Ritratti parlanti. Collezionismo e biografie illustrate nei secoli XVI e XVII.* Florence: Edifir, 2004.

Cassandro, Giovanni. "Concetto, caratteri e struttura dello stato veneziano," *Rivista di storia del diritto Italiano* 36 (1963): 23–49.

Cattin, Giulio, and Marco Di Pasquale, eds. *Musica e liturgia a San Marco. Testi e melodie per la liturgia delle ore dal XII al XVII secolo. Dal graduale tropato del Duecento ai graduali cinquecenteschi*, 4 vols. Venice: Fondazione Levi, 1990–92.

Cavalli, Marino, and Tommaso Bertelè. *Informatione dell'offitio dell'ambasciatore di Marino de Cavalli il Vecchio*. Tommaso Bertelè, ed. Florence and Rome: Leo S. Olschki, 1935.

Cecchetti, Bartolomeo. *Il Doge di Venezia*. Venice: P. Naratovich, 1864.

——. *Sala diplomatica Regina Margherita*. Venice: P. Naratovich, 1880.

——. *Statistica degli atti custoditi nella sezione notarile*. Venice: P. Naratovich, 1886.

——. "Nomi di pittori e lapicidi antichi," *Archivio Veneto* 33, 1 (1887): 43–66.

——. "Saggio di cognomi ed autografi di artisti in Venezia, secoli XIV–XVI," *Archivio Veneto* 33, 2 (1887): 397–424.

Chambers, David S. *Patrons and Artists in the Italian Renaissance*, London: Macmillan, 1970.

——. "Merit and Money: The Procurators of St Mark and their Commissioni, 1443–1605," *Journal of the Warburg and Courtauld Institutes* 60 (1997): 23–88.

Chambers, David S., and Brian Pullan, eds. *Venice, a Documentary History, 1450–1630*. With Jennifer Fletcher. Oxford and Cambridge, MA: Blackwell, 1992.

Cheney, Edward. "Remarks on the Illuminated Official Manuscripts of the Venetian Republic," *Miscellanies of the Philobiblon Society* XI (1867–68): 3–95.

Chojnacki, Stanley. "Social Identity in Renaissance Venice: The second *Serrata*," *Renaissance Studies* 8, 4 (1994): 341–58.

——. *Women and Men in Renaissance Venice*. Baltimore: Johns Hopkins University Press, 2000.

Christiansen, Keith, and Stefan Weppelmann, eds. *Renaissance Portraiture from Donatello to Bellini*. New Haven and London: Yale University Press, 2011.

Ciappelli, Giovanni, and Patricia Lee Rubin, eds. *Art, Memory, and Family in Renaissance Florence*. Cambridge: Cambridge University Press, 2000.

Cicogna, Emmanuele Antonio. *Delle inscrizioni veneziane*. 6 vols. in 7. Venice, 1824–53.

——. *Della famiglia Marcello patrizia veneta*. Venice: 1841.

——. *Saggio di bibliografia veneziana*. Venice: 1847.

——. *Documenti storici inediti pertinenti alla citta di Portogruaro*. Portogruaro: B. Castiou, 1851.

——. *Corpus delle iscrizioni di Venezia e delle isole della laguna veneta di Emmanuele Antonio ovvero riepilogo sia delle Iscrizioni Edite pubblicate tra gli anni 1824 e 1853 che di quelle Inedite conservate in originale manoscritto presso la Biblioteca Correr di Venezia e dal 1867, anno della morte dell'insigne erudito, rimaste in attesa di pubblicazione*, vol. 1. Piero Pazzi, ed. Venice: Biblioteca orafa di Sant'Antonio Abate, 2001.

Concina, Ennio. *La macchina territoriale. La progettazione della difesa nel Cinquecento Veneto*. Rome and Bari: Laterza, 1983.

Contarini, Gasparo. *De magistratibus & republica Venetorum: libri quinque*. Paris: Michaelis Vascosani, 1543.

Contarini, Gasparo, and Lewis Lewkenor. *The Commonwealth and Government of Venice*. London: John Windet for Edmund Mattes, 1599.

Cooper, Tracy M. *Palladio's Venice: Architecture and Society in a Renaissance Republic*. New Haven and London: Yale University Press, 2005.

Cope, Maurice Erwin. *The Venetian Chapel of the Sacrament in the Sixteenth Century: A Study in the Iconography of the Early Counter-Reformation*. Garland edn. of PhD thesis, University of Chicago, 1965. Philadelphia and London: Garland, 1979.

Cordellier, Dominique, and Hélène Sueur. *Le dessin à Vérone aux XVIe et XVIIe siècles*. Paris: Éditions de la Réunion des musées nationaux, 1993.

Corner, Flaminio. *Ecclesiae Venetae antiquis monumentis*, 10 vols. Venice: G. B. Pasquali, 1749.

——. *Notizie storiche delle chiese e monasteri di Venezia e di Torcello*. Padua: Stamperia del Seminario appresso Giovanni Manfrè, 1758.

Coronelli, Vincenzo Maria. *Blasone Veneto o gentilizie insegne delle famiglie patrizie oggi esistenti in Venezia*. Venice: Tramontin, 1706.

Coryat, Thomas. *Coryat's Crudities. Hastily gobled up in five Moneths travells in France, Savoy, Italy, Rhetia ...; Newly digested in the hungry aire of Odcombe in the County of Somerset, and now dispersed to the nourishment of the travelling Members of this Kingdome*. Glasgow: James MacLehose and Sons and University of Glasgow, 1905.

Cottrell, Phillip. "Corporate Colours: Bonifacio and Tintoretto at the Palazzo dei Camerlenghi," *Art Bulletin* 82 (2000): 658–78.

Cowan, Alexander F. *The Urban Patriciate: Venice and Lübeck, 1580–1700*. Cologne: Böhlau, 1986.

Cozzi, Gaetano. *Stato, società e giustizia nella repubblica veneta*, 2 vols. Rome: Jouvence, 1980 and 1983.

Cranston, Jodi. *The Poetics of Portraiture in the Italian Renaissance*. Cambridge: Cambridge University Press, 2000.

Crescenzi, Victor. *Esse de maiori consilio. Legittimità civile e legittimazione politica nella repubblica di Venezia (secc. XIII–XVI)*. Rome: Sede dell'Istituto Palazzo Borromini, 1996.

Crouzet-Pavan, Elizabeth. *Venice Triumphant: The Horizons of a Myth*. Baltimore and London: Johns Hopkins University Press, 2002.

Cunnally, John. *Images of the Illustrious: The Numismatic Presence in the Renaissance*. Princeton: Princeton University Press, 1999.

Dale, Thomas E. A. "Inventing a Sacred Past: Pictorial

Narratives of St. Mark the Evangelist in Aquileia and Venice, c.1000–1300," *Dumbarton Oaks Papers* 48 (1994): 53–104.

——. *Relics, Prayer, and Politics in Medieval Venetia*. Princeton: Princeton University Press, 1997.

Da Mosto, Andrea. *L'Archivio di Stato di Venezia*, 2 vols. Rome: Biblioteca d'Arte Edizioni, 1937–40.

——. *I dogi di Venezia nella vita pubblica e privata*. First published 1939. Milan: Giunti Martello, 1977.

Davanzo Poli, Doretta. "I paliotti dogali," in Loretta Dolcini, Doretta Davanzo Poli, and Ettore Vio, eds. *Arazzi della Basilica di San Marco*. Venice: Procuratia di San Marco and Rizzoli, 1999: 153–61.

Davis, James Cushman. *The Decline of the Venetian Nobility as a Ruling Class*. Baltimore: Johns Hopkins University Press, 1962.

De Hamel, Christopher. *A History of Illuminated Manuscripts*, 2nd edn. London: Phaidon, 1994.

——. *Cutting up Manuscripts for Pleasure and Profit. The 1995 Sol. M. Malkin Lecture in Bibliography*. Charlottesville: Book Arts Press, 1996.

De Laurentiis, Elena, and Emilia Anna Talamo. *The Lost Manuscripts from the Sistine Chapel: An Epic Journey from Rome to Toledo*. Dallas: SMU, The Meadows Museum, 2011.

De Maria, Blake. *Becoming Venetian: Immigrants and the Arts in Early Modern Venice*. New Haven and London: Yale University Press, 2010.

De Montfaucon, Bernard. *Diarium italicum. sive Monumentorum veterum, bibliothecharum musaeorum &c. Notitiae singulares in Itinerario Italico collectae*. Paris: Joannem Anisson, 1702.

Del Torre, Giuseppe. *Venezia e la terraferma dopo la guerra di Cambrai. Fiscalità e amministrazione (1515–1530)*. Milan: Franco Angeli, 1986.

Dempsey, Charles. *Inventing the Renaissance Putto*. Chapel Hill and London: University of North Carolina Press, 2001.

Demus, Otto. *The Church of San Marco in Venice: History, Architecture, Sculpture*. Washington, D.C.: Dumbarton Oaks Studies, 1960.

——. *The Mosaics of San Marco in Venice*. Chicago and London: University of Chicago Press, 1984.

Derrida, Jacques. "Archive Fever," *Diacritics* 25, 2 (Summer 1995): 9–63.

De Vivo, Filippo. "Quand le passé résiste à ses historiographies: Venise et le XVIIe siècle," *Cahiers du Centre de Recherches Historiques* 28–29 (2002): 223–34.

——. "Ordering the Archive in Early Modern Venice (1400–1650)," *Archival Science* 10 (2010): 231–48.

——. "Heart of State, Site of Tension: The Archival Turn Viewed from Venice, c.1400–1700," *Annales: Histoires, Sciences Sociales* 68, 3 (2013): 699–728.

De Vries, Scato, and Salomonis Marpurgo. *Das Breviarium Grimani in der St. Markus-Bibliothek in Venedig; seine Geschichte und seine Kunst*, 3 vols. Leiden and Leipzig: A.W. Sijthoff and Karl W. Hiersemann, 1903–08.

Diller, Aubrey. "The Library of Francesco and Ermolao Barbaro," *Italia Medioevale e Umanistica* 6 (1963): 252–62.

Di Luzio, Bianca Maria. "Per un profilo di storia della miniatura veneziana: Promissioni, Giuramenti e Commissioni dogali nel Museo Correr di Venezia." Tesi di Perfezionamento. University of Padua, 1985–86.

Di Vaio, Luisa. "Suor Isabella Piccini," *Grafica d'arte: rivista di storia dell'incisione antica e moderna, e storia del disegno* XIV, 53 (January–March 2003): 8–13.

Dorigato, Attilia. "Emmanuele Antonio Cicogna bibliofilo e cultore di patrie memorie," *Bollettino dei Civici Musei Veneziani d'Arte e di Storia* XXX, 1–4 (1986): 143–66.

Dursteller, Eric, ed. *A Companion to Venetian History, 1400–1797*. Leiden: Brill, 2013.

Dutschke, Consuelo W. *Guide to Medieval and Renaissance Manuscripts in the Huntington Library*, 2 vols. San Marino, CA: Huntington Library, 1989.

Echols, Robert, and Frederick Ilchman. "Toward a New Tintoretto Catalogue, with a Checklist of Revised Attributions and a New Chronology," in Miguel Falomir, ed. *Jacopo Tintoretto: actas del Congreso internacional Jacopo Tintoretto*. Madrid: Museo Nacional del Prado, 2009: 91–150.

Eglin, John. *Venice Transfigured: The Myth of Venice in British Culture 1660–1797*. New York: Palgrave, 2001.

Eisenstein, Elizabeth L. *The Printing Revolution in Early Modern Europe*. Cambridge and New York: Cambridge University Press, 1983.

Eisler, Colin. *The Genius of Jacopo Bellini*. New York: Abrams, 1989.

Ekserdjian, David, ed. *Treasures from Budapest. European Masterpieces from Leonardo to Schiele*. London: Royal Academy of Arts, 2010.

Ericani, Giuliana, and Alessandro Ballarin. *Jacopo Bassano e lo stupendo inganno dell'occhio*. Milan: Electa, 2010.

Erll, Astrid, and Ansgar Nünning, eds. *A Companion to Cultural Memory Studies*. Berlin and New York: De Grutyer, 2010.

Eze, Anne-Marie. "Abbé Luigi Celotti (1759–1843): Connoisseur, Dealer, and Collector of Illuminated Miniatures." PhD thesis, Courtauld Institute of Art, 2010.

——. "'Safe from Destruction by Fire,' Isabella Stewart Gardner's Venetian Manuscripts," *Manuscript Studies: A Journal of the Schoenberg Institute for Manuscript Studies* 1, 2 (Fall 2016): 189–215.

Facchinetti, Simone, ed. *Giovan Battista Moroni. Lo sguardo sulla realtà 1560–1679*. Milan: Silvana, 2004.

Falomir, Miguel, ed. *Tintoretto*. Madrid: Museo Nacional del Prado, 2007.

——, ed. *El retrato del Renacimiento*. Madrid: Museo Nacional del Prado, 2008.

Farbaky, Pèter, and Louis A. Waldman, eds. *Italy and*

Hungary: Humanism and Art in the Early Renaissance. Florence: Villa I Tatti, 2011.

Fasoli, Gina. "Nascita di un mito," in *Studi storici in onore di Gioacchino Volpe.* Florence: Sansoni, 1958: 445–79.

———. "Liturgia e ceremoniale ducale," in Agostino Pertusi, ed. *Venezia e il Levante fino al secolo XV.* Florence: Leo S. Olschki, 1973: 261–95.

———. "Comune Veneciarum," in Gina Fasoli, ed. *Scritti di storia medievale.* Bologna: La Fotocromo emiliana, 1974.

Fassina, Giacomo. "The Reform of the Council of Ten in 1582–1583," *Studi Veneziani* 54 (2007): 89–117.

Favaretto, Irene. *Arte antica e cultura antiquaria nelle collezioni venete al tempo della Serenissima.* Rome: L'Erma di Bretschneider, 1990.

Favaretto, Irene, and Giovanna Luisa Ravagnan, eds. *Lo Statuario pubblico della Serenissima. Due secoli di collezionismo di antichità 1596–1797.* Cittadella: Biblos, 1997.

Favaro, Elena. *L'arte dei pittori in Venezia e i suoi statuti.* Florence: Leo S. Olschki, 1975.

Favaro, Tiziana, ed. *Chiesa di Sant'Antonin: storia e restauro.* Venice: Soprintendenza per i beni architettonici e paesaggistici di Venezia e Laguna, 2010.

Faye, C. U., and W. H. Bond. *Supplement to the Census of Medieval and Renaissance Manuscripts in the United States and Canada.* New York: Bibliographical Society of America, 1962.

Federici, Domenico Maria. *Memorie trevigiane sulle opera di disegno dal mille e cento al mille ottocento per servire alla storia delle belle arti d'Italia.* Venice: Francesco Andreola, 1803.

Fenlon, Iain. *The Ceremonial City: History, Memory and Myth in Renaissance Venice.* New Haven and London: Yale University Press, 2007.

Finlay, Robert. "The Venetian Republic as a Gerontocracy," *Journal of Medieval and Renaissance Studies* 8 (1978): 158–78.

———. *Politics in Renaissance Venice.* New Brunswick, NJ, and London: Rutgers University Press and Ernest Benn, 1980.

Finocchi Ghersi, Lorenzo. *Alessandro Vittoria. Architettura, scultura e decorazione nella Venezia del tardo Rinascimento.* Udine: Forum, 1998.

Fittschen, Klaus. "Sul ruolo del ritratto antico nell'arte italiana," in Salvatore Settis, ed. *Memoria dell'antico nell'arte italiana 2. I generi e i temi ritrovati.* Turin: G. Einaudi, 1985.

———. "Der 'Vespasiano Grimani' und seine Rezeption in der Kunst der italienischen Renaissance," in M. Fano Santi, ed. *Studi di Archeologia in onore di Gustavo Traversari,* vol. 1. Rome: Bretschneider, 2004: 365–73.

Fogolari, Gino. *La Chiesa di Santa Maria della Carità di Venezia.* Venice: R. Deputazione di Venezia, 1924.

———. "La Chiesa di Santa Maria della Carità di Venezia (ora sede delle Regie Gallerie dell'Accademia)," in *Scritti d'Arte di Gino Fogolari.* Milan: Ulrico Hoepli, 1946: 157–81.

Foscari, Antonio, and Manfredo Tafuri, *L'armonia e i conflitti. La chiesa di San Francesco della Vigna nella Venezia del '500.* Turin: Einaudi, 1983.

Foucard, Cesare. *Della pittura sui manoscritti in Venezia. Letto nell' I. R. Accad. di Belle Arti in Venezia il giorno 9 agosto 1857, in occasione della solenne distribuzione de' premii.* Venice: Giuseppe Antonelli, 1857.

Franco, Giacomo. *Habiti d'huomeni e donne venetiane con la processione della Ser.ma Signoria et altri particolari, cioè trionfi feste et ceremonie publiche della nobilissima città di Venetia.* Venice: Giacomo Franco, 1610.

Fremmer, Anselm. *Venezianische Buchkultur. Bücher, Buchhändler und Leser in der Frührenaissance.* Cologne, Weimar, Vienna: Böhlau, 2001.

Frimmel, Theodor von. *Der Anonimo Morelliano (Marcantonio Michiel's "Notizia d'opere del disegno").* Vienna: C. Graeser, 1896.

Frings, Jutta, ed. *Venezia! Kunst aus venezianischen Palästen; Sammlungsgeschichte Venedigs vom 13. bis 19. Jahrhundert; Kunst- und Ausstellungshalle der Bundesrepublik Deutschland, 27. September 2002 bis zum 12. Januar 2003.* Ostfildern-Ruit: Hatje Cantz, 2002.

Gaier, Martin. *Facciate sacre a scopo profano. Venezia e la politica dei monumenti dal Quattrocento al Settecento.* Venice: Istituto Veneto di Scienze, Lettere ed Arti, 2002.

———. "'ius imaginis nihil esse aliud, quam ius nobilitatis.' Bildpolitik und Machtanspruch im Patriziat Venedigs," in Jeanette Kohl and Rebecca Müller, eds. *Kopf/Bild. Die Büste in Mittelalter und Früher Neuzeit.* Munich and Berlin: Deutscher Kunstverlag, 2007: 255–82.

Galli, Alessandro. "Promissione del doge Francesco Foscari," in Miklós Boskovits, Giovanni Valagussa, and Milvia Bollati, eds. *Miniature a Brera 1100–1422. Manoscritti dalla Biblioteca Nazionale Braidense e da collezioni private.* Milan: Federico Motta, 1997: 238–43.

Gallo, Rodolfo. "Reliquie e reliquiari," *Rivista di Venezia* 12 (1934): 187–214.

———. "Le donazioni alla Serenissima di Domenico e Giovanni Grimani," *Archivio Veneto* V, 50–51 (1952): 34–77.

———. "Il paliotto del Doge Antonio Grimani," *Bollettino d'arte* 4, 38 (April–June 1953): 171–73.

———. *Il Tesoro di San Marco e la sua storia.* Florence: Leo S. Olschki, 1967.

Ganz, Peter, ed. *Das Buch als magisches und als Repräsentationsobject.* Wiesbaden: Otto Harrassowitz, 1992.

Garas, Klára. *Italian Renaissance Portraits.* Budapest: Corvina Press, 1965.

Garton, John. *Grace and Grandeur: The Portraiture of Paolo Veronese.* London: Harvey Miller, 2008.

Gentili, Augusto. "Il telero di Giovanni Bellini per Agostino Barbarigo: Strategia e funzione," *Prilozi povijesti umjetnosti u Dalmaciji* 32 (1992): 599–611.

Georgopoulou, Maria. *Venice's Mediterranean Colonies: Architecture and Urbanism.* Cambridge and New York: Cambridge University Press, 2001.

Gerola, Giuseppe. "Iscrizioni in onore dei podestà veneti sui muri di Bassano," *Nuovo Archivio Veneto* 6 (1903): 362–74.

Giovè Marchioli, Nicoletta. "Libri sacri, libri preziosi, libri magici," in Giordano Brunettin, ed. *Il Vangelo dei principi. La riscoperta di un testo mitico tra Aquileia Praga e Venezia*. Pordenone: Paolo Gaspari, 2001: 54–67.

Girgensohn, Dieter. "Il testamento del buon amministratore. Niccolò Marcello si prepara all'elezione ducale (1473)," *Atti dell'Istituto Veneto di Scienze, Lettere ed Arti. Classe di scienze morali, lettere, ed arti* 161 (2002–03): 239–82.

——, ed. *Francesco Foscari Promissione Ducale 1423*. Venice: La Malcontenta, 2004.

Gisolfi, Diana. *Paolo Veronese and the Practice of Painting in Late Renaissance Venice*. New Haven and London: Yale University Press, 2017.

Giurgea, Andrea. "Theatre of the Flesh: The Carnival of Venice." PhD thesis, University of California, 1987.

Goffen, Rona. "*Nostra Conversatio in Caelis Est*: Observations on the *Sacra Conversazione* in the Trecento," *Art Bulletin* 61, 2 (June 1979), 198–222.

——. *Piety and Patronage in Renaissance Venice: Bellini, Titian, and the Franciscans*. New Haven: Yale University Press, 1986.

——. *Giovanni Bellini*. New Haven and London: Yale University Press, 1989.

Granzotto, Orfea. "Legature di commissioni dogali a Venezia dal '400 a fine '700," *Sesto Forum Internazionale della rilegatura d'arte Venezia*. Venice: ARA Italia, 1999: 24–34.

Graziato, Gisella. *Le promissioni del doge di Venezia dalle origini alla fine del duecento*. Venice: Il Comitato editore, 1986.

Gregori, Mina, Francesco Rossi, et al., eds. *Giovan Battista Moroni (1520–1578)*. Bergamo: Azienda Autonoma Turismo, 1979.

Grendler, Paul F. *The Roman Inquisition and the Venetian Press*. Princeton: Princeton University Press, 1977.

——. "The Tre Savii sopra Eresia 1547–1605: A Prosopographical Study," *Studi Veneziani* 3 (1979): 283–342.

——. "Leaders of the Venetian State, 1540–1609: A Prosopographical analysis," *Studi Veneziani* 19 (1990): 35–85.

Grote, Andreas, ed. *Breviarium Grimani. Faksimileausgabe der Miniaturen und Kommentar*. Berlin: Gebr. Mann, 1973.

Grubb, James. "Memory and Identity: Why Venetians Didn't Keep Ricordanze," *Renaissance Studies* 8, 4 (1994): 375–87.

Guerra, Andrea, Manuela M. Morresi, and Richard Schofield, eds. *I Lombardo. Architettura e scultura a Venezia tra '400 e '500*. Venice: IUAV and Marsilio, 2006.

Guisconi, Anselmo (pseudonym for Francesco Sansovino). *Tutte le cose notabili e belle che sono in Venezia*. Venice: 1556.

Hahnloser, Hans R., ed. *Il Tesoro di San Marco*, 2 vols. Florence: Sansoni, 1965–72.

Halbwachs, Maurice. *On Collective Memory*. Lewis A. Coser, ed., trans., intro. Chicago: University of Chicago Press, 1992.

Hale, John R., ed. *Renaissance Venice*. Totowa, NJ: Rowman and Littlefield, 1973.

Hankins, James, ed. *Renaissance Civic Humanism: Reappraisals and Reflections*. Cambridge: Cambridge University Press, 2000.

Harris, Neil. "The History of the Book in Italy," in Michael F. Suarez, S. J. Woudhusen, and H. R. Woudhusen, eds. *The Book: A Global History*. Oxford: Oxford University Press, 2013.

Harris, Roy. *Signs of Writing*. London and New York: Routledge, 1995.

——. *Rethinking Writing*. Bloomington and Indianapolis: Indiana University Press, 2000.

Harvard College Library. *Illuminated & Calligraphic Manuscripts: An Exhibition Held at the Fogg Art Museum and Houghton Library, February 14–April 1, 1955*. Cambridge, MA: [n.p.], 1955.

Haskell, Francis. *Patrons and Painters: Art and Society in Baroque Italy*. 2nd edn. New Haven and London: Yale University Press, 1980.

——. *History and its Images: Art and the Interpretation of the Past*. New Haven and London: Yale University Press, 1993.

Heinemann, Fritz. *Giovanni Bellini e i Belliniani*. Venice: Neri Pozza, 1959.

Hermann, Hermann Julius. *Beschreibendes Verzeichnis der Illuminierten Handschriften in Österreich*. Part 6: *Die Handschriften und Inkunabeln der Italienischen Renaissance. Vol. 2: Oberitalien: Venetien*. Leipzig: Karl W. Hiersemann, 1931.

Hetherington, Paul. "The Jewels from the Crown: Symbol and Substance in the Later Byzantine Imperial Regalia," in Paul Hetherington, ed. *Enamels, Crowns, Relics and Icons: Studies on Luxury Arts in Byzantium*. Burlington, VT: Ashgate, 2008: 157–68.

Hills, Paul. *Venetian Colour: Marble, Mosaic, Painting and Glass, 1250–1550*. New Haven and London: Yale University Press, 1999.

Hindman, Sandra, and Nina Rowe, eds. *Manuscript Illumination in the Modern Age: Recovery and Reconstruction*. Evanston, IL: Block Museum, Northwestern University, 2001.

Hirthe, Thomas. "Die *Libreria* des Jacopo Sansovino. Studien zu Architektur und Austattung eines öffentlichen Gebäudes in Venedig," *Münchner Jahrbuch der bildenden Kunst*," 3rd series, 37 (1986): 131–76.

——. *Il "foro all'antica" di Venezia. La trasformazione*

di Piazza San Marco nel Cinquecento. Venice: Centro Tedesco di Studi Veneziani, 1986.

Hobson, Anthony. *Humanists and Bookbinders: The Origins and Diffusion of the Humanistic Bookbinding 1459–1559, with a Census of Historiated Plaquette and Medallion Bindings of the Renaissance.* Cambridge: Cambridge University Press, 1989.

——. *Renaissance Book Collecting. Jean Grolier and Diego Hurtado de Mendoza, their books and bindings.* Cambridge: Cambridge University Press, 1999.

Hochmann, Michel. "La collection de Giacomo Contarini," *Mélanges de l'École française de Rome. Moyen-Age, Temps moderns* 99, 1 (1987): 447–89.

——. *Peintres et Commanditaires à Venise (1540–1628).* Rome: École Française de Rome, 1992.

——. "Le mécénat de Marino Grimani. Tintoret, Palma le Jeune, Jacopo Bassano, Giulio del Moro et le décor du palais Grimani; Véronèse et Vittoria à San Giuseppe," *Revue de l'Art* 95 (1992): 41–51.

——. "Giuseppe Porta e la decorazione di palazzo Contarini dalle Figure," *Arte Veneta* 59 (2002): 238–46.

——. *Venise et Rome 1500–1600: deux écoles de peinture et leurs échanges.* Geneva: Droz, 2004.

Hochmann, Michel, Rosella Lauber, and Stefania Mason, eds. *Il collezionismo d'arte a Venezia. Dalle origini al Cinquecento.* (Collezionismo 2008) Venice: Marsilio, 2008.

Hope, Charles. "Titian's Role as Official Painter to the Venetian Republic," in *Tiziano e Venezia, Convegno internazionale di studi, Venezia 1976.* David Rosand, ed. Verona: N. Pozza, 1980: 301–5.

——. *Veronese and the Venetian Tradition of Allegory.* London: Proceedings of the British Academy, 1985.

Hostetter Smith, Rachel. "Providence and Political Innocence: The *Ballottino* in Venetian Art and Ideals," *Explorations in Renaissance Culture* XXV (1999): 40–66.

Howard, Deborah. *Jacopo Sansovino. Architecture and Patronage in Renaissance Venice.* New Haven and London: Yale University Press, 1975.

——. *Venice and the East.* New Haven and London: Yale University Press, 2000.

——. *The Architectural History of Venice,* revised edn. New Haven and London: Yale University Press, 2002.

——. "Architectural politics in Renaissance Venice," *Proceedings of the British Academy* 154 (2008): 29–68.

——. *Venice Disputed: Marc'Antonio Barbaro and Venetian Architecture, 1550–1600.* New Haven and London: Yale University Press, 2011.

Humfrey, Peter. "Competitive Devotions: The Venetian Scuole Piccole as Donors of Altarpieces in the Years around 1500," *Art Bulletin* 70 (1988): 401–23.

——. *The Altarpiece in Renaissance Venice.* New Haven and London: Yale University Press, 1993.

——. *Lorenzo Lotto.* New Haven and London: Yale University Press, 1997.

——. *Giovanni Battista Moroni: Renaissance Portraitist.* Fort Worth: Kimbell Art Museum, 2000.

——, ed. *The Cambridge Companion to Giovanni Bellini.* Cambridge: Cambridge University Press, 2004.

——, ed. *Venice and the Veneto.* Cambridge and New York: Cambridge University Press, 2007.

Humphrey, Lyle. "The Illumination of Confraternity and Guild Statutes in Venice, *c.*1260–1500: Mariegola Production, Iconography and Use." PhD thesis, New York University, Institute of Fine Arts, 2007.

——. *La miniatura per le confraternite e le arti Veneziane. Mariegole dal 1260 al 1460.* Verona: Cierre, 2015.

Hurlburt, Holly S. *The Dogaressa of Venice 1200–1500: Wife and Icon.* New York: Palgrave Macmillan, 2006.

Huse, Norbert, and Wolfgang Wolters. *The Art of Renaissance Venice.* Chicago: University of Chicago, 1990.

Hüttinger, Eduard. "Zur Porträtmaler Jacopo Tintorettos. Aus Anlass eines unbekannten Bildnisses," *Pantheon* 26 (1968): 467–73.

Ilchman, Frederick, ed. *Titian, Tintoretto, Veronese: Rivals in Renaissance Venice.* Boston: Museum of Fine Arts, 2009.

Isler-de Jongh, Ariane, and François Fossier. *Le voyage de Charles Magius 1568–1573.* Arcueil: Anthèse, 1992.

Israel, Janna. "The Picture of Poverty: Cristoforo Moro and Patronage of San Giobbe, Venice." PhD thesis, Massachusetts Institute of Technology, Dept. of Architecture, 2007.

Ivanoff, Nicola. "La Libreria Marciana," *Saggi e memorie di storia dell'arte* 6 (1968): 35–78.

Jacoff, Michael. *The Horses of San Marco and the Quadriga of the Lord.* Princeton: Princeton University Press, 1993.

Joannides, Paul. *Titian to 1518: The Assumption of Genius.* New Haven and London: Yale University Press, 2001.

Joost-Gaugier, Christiane L. "Poggio and Visual Tradition: 'Uomini Famosi' in Classical Literary Description," *Artibus et Historiae* 6, 12 (1985): 57–74.

Judde de Larivière, Claire. *Naviguer, Commercer, Gouverner. Économie maritime et pouvoirs à Venise, XVe–XVIe siècles.* Leiden: Brill, 2008.

Kallendorf, Craig. *Virgil and the Myth of Venice: Books and Readers in the Italian Renaissance.* Oxford: Clarendon Press, 1999.

Kaplan, Paul H. D. "Italy, 1490–1700," in David Bindman and Henry Louis Gates, Jr., eds. *The Image of the Black in Western Art, vol. III, From the "Age of Discovery" to the Age of Abolition. Pt. 1: Artists of the Renaissance Baroque.* Cambridge, MA: Harvard University Press, 2010: 105–6.

Katzenstein, Ranee. "Three Liturgical Manuscripts from San Marco: Art and Patronage in Mid-Trecento Venice." PhD thesis, Harvard University, 1987.

Kearney, James. *The Incarnate Text: Imagining the Book in Reformation England.* Philadelphia: University of Pennsylvania Press, 2009.

Keller, Hagen. "Vom 'heiligen Buch' zur Buchführung. Lebensfunktionen der Schrift im Mittelalter," *Frühmittelalterliche Studien* 26 (1992): 1–31.

Kemp, Martin. "The Handy Worke of the Incomprehensible Creator," in Claire Richter, ed. *Writing on Hands: Memory and Knowledge in Early Modern Europe*. Sherman, WA: University of Washington Press, 2000: 22–28.

Keyes, George, István Barkóczi, and Jane Satkowski, eds. *Treasures of Venice: Paintings from the Museum of Fine Arts Budapest*. Minneapolis: Minneapolis Institute of Arts and Abrams, 1995.

King, Margaret. *Venetian Humanism in the Age of Patrician Dominance*. Princeton: Princeton University Press, 1986.

Kleinschmidt, Irene. "Gruppenvotivbilder venezianischer Beamter im Palazzo dei Camerlenghi und im Dogenpalast," *Arte Veneta* 31 (1977): 104–18.

Koerner, Joseph Leo. *Dürer's Hands*. New York: The Council of The Frick Collection Lecture Series, 2006.

Krauss, Rosalind. *The Originality of the Avant-garde and Other Modernist Myths*. Cambridge, MA: MIT Press, 1985.

Kren, Thomas, and Scot McKendrick. *Illuminating the Renaissance: The Triumph of Flemish Manuscript Painting in Europe*. Los Angeles: J. Paul Getty Museum, 2003.

Kurtzman, Jeffrey, and Linda Maria Koldau. "*Trombe, Trombe d'argento, Trombe squarciate, Tromboni*, and *Pifferi* in Venetian Processions and Ceremonies of the Sixteenth and Seventeenth Centuries," *Journal of Seventeenth Century Music* 8, 1 (2002).

Lafitte, Marie Pierre. "La Bibliothèque nationale et les 'conquetes artistiques' de la Revolution et de l'Empire: les manuscrits d'Italie (1796–1815)," *Bulletin du Bibliophile* 1 (1989): 273–322.

Lancellotti, Secondo. *L'Hoggidi ovvero il mondo non peggiore, ne piu Calamitoso del passato*. Venice: Giovanni Francesco Valvasense, 1662.

Laven, P. J. "The *causa Grimani* and its Political Overtones," *Journal of Religious History* 4 (1966–67): 184–205.

Lazzarini, Vittorio. "Un maestro di scrittura nella cancelleria veneziana," *Archivio Veneto* V, 7 (1930): 119–25.

Leesit, Elizabeth. *Les manuscrits liturgiques du Moyen Âge*. Montreal: Montreal Museum of Fine Arts, 1987.

Lermer, Andrea. *Das gotische "Dogenpalast" in Venedig. Baugeschichte und Skulpturenprogramm des Palatium Communis Venetiarum*. Munich and Berlin: Deutscher Kunstverlag, 2005.

Levi, Cesare-Augusto. *Le collezioni veneziane d'arte e d'antichità dal secolo XIV ai nostri giorni*. Venice: Ongania, 1900.

Levi D'Ancona, Mirella. "Miniature venete nella Collezione Wildenstein," *Arte Veneta* 10 (1956): 25–36.

——. "Jacopo del Giallo e alcune miniature del Correr," *Bollettino dei Musei Civici Veneziani* 2 (1962): 1–23.

——. "Giustino del fu Gherardino da Forlì e gli affreschi perduti del Guariento nel Palazzo Ducale di Venezia," *Arte Veneta* 21 (1967): 34–44.

Lewis, Douglas. "An Early Series of Dynastic Portrait Busts by Alessandro Vittoria," *Artibus et Historiae* 18, 35 (1997): 113–34.

Logan, Oliver. *Culture and Society in Venice, 1470–1790: The Renaissance and its Heritage*. London: Batsford, 1972.

Lorenzi, Giambattista. *Monumenti per servire alla stora del Palazzo Ducale di Venezia*. Venice: Tipografia del Commercio di Marco Visentini, 1868.

Lotto, Alessandra. "Il collezionismo artistico dei Grimani di Santa Maria Formosa nel Cinquecento," *Venezia Arti* 17/18 (2003–04): 23–30.

Lowry, Martin J. C. "The Reform of the Council of Ten, 1582–3: An Unsettled Problem?" *Studi Veneziani* 13 (1971): 275–310.

——. *The World of Aldus Manutius: Business and Scholarship in Renaissance Venice*. Ithaca, NY: Cornell University Press, 1979.

——. *Nicholas Jenson and the Rise of Venetian Publishing in Renaissance Europe*. Oxford and Cambridge, MA: Blackwell, 1991.

Lucas, A. T. "The Social Role of Relics and Reliquaries in Ancient Ireland," *Journal of the Royal Society of Antiquaries of Ireland* 116 (1986): 5–37.

Lucchi, Piero, ed. "Collezioni," section in *Le Commissioni ducali nelle collezioni dei Musei Civici Veneziani*, special edn. of *Bollettino dei Musei Civici Veneziani*, Camillo Tonini and Cristina Crisafulli, eds, 3rd series, 8 (2013).

Luchs, Alison. *Tullio Lombardo and Ideal Portrait Sculpture in Venice, 1490–1530*. Cambridge and New York: Cambridge University Press, 1995.

——. *The Mermaids of Venice*. London: Harvey Miller, 2010.

Ludwig, Gustav. "Archivalische Beiträge zur Geschichte der Venezianischen Malerei," *Jahrbuch der Königlich Preussischen Kunstsammlungen* 26 (1905).

Macchi, Federico, and Livio Macchi, *Dizionario illustrato della legatura*. Milan: Sylvestre Bonnard, 2003.

Macola, Novella. *Sguardi e scritture. Figure con libro nella ritrattistica italiana della prima metà del Cinquecento*. Venice: Istituto Veneto di Scienze, Lettere ed Arti, 2007.

Magio, Alessandro. *Del modo di condursi nelle magistrature*. Bassano: della Remondiniana, 1807.

Maguire, Henry, and Robert S. Nelson, eds. *San Marco, Byzantium, and the Myths of Venice*. Washington, D.C.: Dunbarton Oaks, 2010.

Mancini, Vincenzo. "Tintoretto, Parassio Michiel e i ritratti di Andrea Dolfin," *Venezia Cinquecento* 9, 17 (1999): 77–90.

Manfredi, Fulgentio. *Degnità procuratoria di San Marco di Venetia. Descritta da Fra Fulgentio Manfredi Venetiano de Mi. Off. Theologo, e generale Predicatore*. Venice: Domenico Nicolini, 1602.

Manieri Elia, Giulio, ed. *Masterpieces Restored: The Gallerie*

dell'Accademia and Save Venice Inc. Venice: Marsilio, 2010.

Mann, Nicholas. "Petrarca e la cancelleria veneziana," *Storia della cultura veneta*, vol. 2. Vicenza: N. Pozza, 1976, 517–35.

Manno, Antonio. *San Marco Evangelista. Opere d'arte dalle chiese di Venezia*. Venice: Associazione San Bortolomio, Collegio urbano dei parrochio, Commissione chiese, Curia patriarcale, 1995.

——. *I mestieri di Venezia. Storia, arte e devozione delle corporazioni dal XIII al XVIII secolo*. Cittadella: Biblos, 1995.

Marangoni, Michela, and Manlio Pastore Stocchi, eds. *Una famiglia veneziana nella storia. I Barbaro: Atti del convegno di studi in occasione del quinto centenario della morte dell'umanista Ermolao. Venice, 4–6 Novembre 1993*. Venice: Istituto Veneto di Scienze, Lettere ed Arti, 1996.

Maranini, Giuseppe. *La costituzione di Venezia 2. Dopo la serrata del Maggior Consiglio*. Venice: 1931.

Marcon, Susy. "Riflessioni fra miniature e legatura d'arte," in Sibille Pino, Marina Regni and Laura Sitran, eds. *Sesto Forum internazionale della rilegatura d'arte. Venezia 1999*. Venice: ARA Italia, 1999: 35–50.

——. "La bibliothèque Giustinian-Recanati-Falck," *Bulletin du bibliophile* 2 (2005): 283–29.

——. "Oreficeria Bizantina per i volumi preziosi di San Marco," in Letizia Caselli and Ettore Merkel, eds. *Oreficeria sacra a Venezia e nel Veneto. Un dialogo tra le arti figurative*. Treviso: Canova Edizioni, 2007: 57–70.

——. "'Pax tibi Marce.' Le miniature veneziane di soggetto Marciano e Petrino," in Letizia Caselli, ed. *San Pietro e San Marco. Arte e iconografia in area adriatica*. Rome: Gangemi, 2009: 146–71.

——. ed. *I libri di San Marco. I manoscritti liturgici della basilica marciana*. Venice: Il Cardo, 1995.

Mariacher, Giovanni. *Il Museo Correr di Venezia. Dipinti dal XIV al XVI secolo*. Venice: Neri Pozza, 1957.

Mariani Canova, Giordana. "La decorazione dei documenti ufficiali in Venezia dal 1460 al 1530," *Atti dell'Istituto Veneto di Scienze, Lettere ed Arti. Classe di scienze morali, lettere ed arti* 126 (1968): 319–34.

——. "Per Leonardo Bellini," *Arte Veneta* 22 (1968): 9–20.

——. "Profilo di Benedetto Bordon, miniatore padovano," *Atti dell'Istituto Veneto di Scienze, Lettere ed Arti. Classe di scienze morali, lettere ed arti* 127 (1968–69): 109–121, plates I–XVIII.

——. *La miniatura veneta del Rinascimento, 1450–1500*. Venice: Alfieri, 1969.

——. "Miniatura e pittura in età tardogotica (1400–1440)," in Mauro Lucco, ed. *La pittura nel Veneto. Il Quattrocento*, vol. 1. Milan: Electa, 1989: 193–222.

——. "La miniatura veneta del Trecento tra Padova e Venezia," in Mauro Lucco, ed. *La pittura nel Veneto. Il Trecento*, vol. 2. Milan: Electa, 1992: 383–408.

——. "La miniatura a Venezia dal Medioevo al Rinascimento," in Rodolfo Pallucchini, ed. *Storia di Venezia. Temi: L'arte*, vol. 2. Rome: Istituto della Enciclopedia Italiana, 1995: 769–843.

——. "La miniatura del Trecento in Veneto," in Antonella Putaturo Donati Murano and Alessandra Perriccioli Saggese, eds. *La miniatura in Italia. 1. Dal tardoantico al Trecento con riferimenti al medio oriente e al occidente europeo*. Naples and Vatican City: Edizioni Scientifiche Italiane and Biblioteca Apostolica Vaticana, 2005: 164–76.

——. "La miniatura in Veneto," in Antonella Putaturo Donati Murano and Alessandra Perriccioli Saggese, eds. *La miniatura in Italia. 2. Dal tardogotico al manierismo*. Naples and Vatican City: Edizioni Scientifiche Italiane and Biblioteca Apostolica Vaticana, 2009: 331–71.

——, ed. *Miniature dell'Italia settentrionale nella Fondazione Giorgio Cini*. Vicenza: Neri Pozza, 1978.

Marinelli, Sergio. "De Mio miniatore," in Franco Bernabei and Antonio Lovato, eds. *Sine musica nulla disciplina ... Studi in onore di Giulio Cattin*. Padua: il Poligrafo, 2006, 409–11.

——. "De Mio nel Manierismo veneto," *Verona illustrata* 21 (2008): 87–93, figs. 56–63.

Marsand, Antonio. *I manoscritti italiani della Regia Biblioteca Parigina*, 2 vols. Paris: 1835–38.

Martin, John, and Dennis Romano, eds. *Venice Reconsidered: The History and Civilization of an Italian City State, 1297–1797*. Baltimore: Johns Hopkins University Press, 2000.

Martin, Thomas. "Grimani patronage in S. Giuseppe di Castello: Veronese, Vittoria and Smeraldi," *The Burlington Magazine* 133 (1991): 825–33.

——. *Alessandro Vittoria and the Portrait Bust in Renaissance Venice: Remodeling Antiquity*. Oxford and New York: Oxford University Press and Clarendon Press, 1998.

Martineau, Jane, and Charles Hope, eds. *The Genius of Venice 1500–1600*. London: Royal Academy of Arts, 1983.

Mason Rinaldi, Stefania. "Il libro dei conti della familia Tiepolo per la cappella di S. Sabba in S. Antonin," *Atti dell'Istituto Veneto di Scienze, Lettere ed Arti. Classe di scienze morali, lettere ed arti* CXXXV (1976–77): 193–212.

——. *Palma il Giovane: L'opera completa*. Milan: Electa, 1984.

Massarotto, Anna Paola. "The Venetian Civic and Military Governors in Padua during the Sixteenth Century: Raison d'État, Political Prestige and Public Promotion of the Arts." PhD thesis, Courtauld Institute of Art, 2004.

Massinelli, Anna Maria. "Lo studiolo 'nobilissimo' del Patriarca Giovanni Grimani," in Gustavo Traversari, ed. *Venezia e l'archeologia. Un importante capitolo nella storia del gusto dell'antico nella cultura artistica veneziana*. Rome: Giorgio Bretschnieder, 1990: 41–49.

Matthew, Louisa C. "The Painter's Presence: Signatures in Venetian Renaissance Pictures, *Art Bulletin* 80, 4 (December 1998): 616–58.

McAndrew, John. *Venetian Architecture of the Early Renaissance*. Cambridge, MA, and London: MIT Press, 1980.

McCauley, Elizabeth Anne, Alan Chong, Rosella Mamoli Zorzi, and Richard Linger, eds. *Gondola Days: Isabella Stewart Gardner and the Palazzo Barbaro Circle*. Boston and Venice: Isabella Stewart Gardner Museum and the Marciana Library, 2004.

Medica, Massimo, ed. *Haec sunt statuta. Le corporazioni medievali nelle miniature bolognesi*. Vignola: Rocca Medievale Boncompagni Ludovisi, 1999.

Medica, Massimo, and Federica Toniolo, eds. *Le miniature della Fondazione Cini*. Milan: Silvana, 2016.

Mehler, Ursula. *Auferstanden in Stein: venezianische Grabmäler des späten Quattrocento*. Cologne: Böhlau, 2001.

Merkel, Ettore. "La scuola di Andrea del Castagno nei mosaici marciana," *Atti dell'Istituto Veneto di Scienze, Lettere ed Arti. Classe di scienze morali, lettere ed arti* 131 (1973): 377–419.

——. "I mosaici rinascimentali di San Marco," *Arte Veneta* 41 (1987): 20–30.

——. "I mosaici del Cinquecento veneziano (1a parte)," *Saggi e memorie di storia dell'arte* 19 (1994): 73–140.

Meyer zur Capellen, Jürg. "Zum venezianischen Dogenbildnis in der zweiten Hälfte des Quattrocento," *Konsthistorisk Tidskrift* 50 (1981): 70–86.

Monacelli, Susanna. "Il Doge Francesco Venier dal ritratto al sepolcro," *Venezia Cinquecento* 18, 36 (2008): 43–64.

Moncada, Valentina. "The Painters' Guilds in the Cities of Venice and Padua," *RES* 15 (Spring 1988): 105–21.

Monnas, Lisa. *Merchants, Princes and Painters: Silk Fabrics in Italian and Northern Paintings, 1300–1550*. New Haven and London: Yale University Press, 2009.

Monticolo, Giovanni. "L'apparitio Sancti Marci ed i suoi manoscritti," *Nuovo Archivio Veneto* 9 (1895): 111–77, 475–82.

Montuori, Francesca. "La *Pesca miracolosa*: costruzione dell'immagine e narrazione del miracolo," *Venezia cinquecento* 9, 18 (1999): 5–??.

Moretti, Lino. "Di Leonardo Bellini, pittore e miniatore," *Paragone* 8, 99 (1958): 58–66.

Morgan, Nigel, Stella Panayotova, and Suzanne Reynolds, eds. *Illuminated Manuscripts in Cambridge: A Catalogue of Western Book Illumination in the Fitzwilliam Museum and the Cambridge Colleges. Part 2. Italy and the Iberian Peninsula*. 2 vols. Turnhout and London: Brepols and Harvey Miller, 2011.

Morolli, Gabriele, ed. *Le Procuratie nuove in Piazza San Marco*. Rome: Editalia, 1994.

Moryson, Fynes. *An Itinerary*. London: John Beale, 1617.

Moschini Marconi, Sandra. *Gallerie dell'Accademia di Venezia, Opere d'arte dei secoli xiv e xv*. Rome: Istituto Poligrafico dello Stato, 1955.

——. *Gallerie dell'Accademia di Venezia. Opere d'arte del secolo xvi*. Rome: Istituto Poligrafico dello Stato, 1962.

Mozzato, Andrea. "*Rulers of Venice (1332–1524)*. Alcune osservazioni sulla schedatura dei registri del Segretario alle Voci," *Reti Medievali Rivisti*, VI–2005/2 (July–December). http://www.rm.unina.it/rivista/dwnl/Mozzato.pdf [Accessed December 20, 2016].

Mueller, Reinhold C. "The Procurators of San Marco in the Thirteenth and Fourteenth Centuries: A Study of the Office as a Financial and Trust Institution," *Studi Veneziani* 13 (1971): 105–220.

Muir, Edward. "The doge as *primus inter pares*: Interregnum Rites in early Sixteenth-century Venice," in Sergio Bertelli and Gloria Ramakus, eds. *Essays Presented to Myron P. Gilmore*, vol. 1, *History*. Florence: La Nuova Italia Editrice for Villa I Tatti, 1978: 148–60.

——. *Civic Ritual in Renaissance Venice*. Princeton: Princeton University Press, 1981.

——. *Mad Blood Stirring: Vendetta in Renaissance Italy*. Baltimore: Johns Hopkins University Press, 1998.

Munby, A. N. L. *Portrait of an Obsession, the Life of Sir Thomas Phillips, the World's Greatest Book Collector*. Adapted by Nicolas Barker. New York: G. P. Putnam's Sons, 1967.

——. *Connoisseurs and Medieval Miniatures*. Oxford: Clarendon Press, 1972.

Munman, Robert. "Venetian Renaissance Tomb Monuments." PhD thesis, Harvard University, 1968.

Muraro, Michelangelo. "La Scala senza Giganti," in Millard Meiss, ed. *De Artibus Opuscula XL: Essays in Honor of Erwin Panofsky*. New York: New York University Press, 1961: 350–70.

——. "Venezia: Interpretazione del Palazzo Ducale," *Studi Urbinati di Storia, Filosofia e Letteratura* 45 (1971): 1160–75.

——. "Ideologia e iconografia dei dogi di Venezia," in Ivan Božić and Vojislav Djurić, eds. *O knezu Lazaru: nau ni skup u Kruševcu*. Belgrade: Filozofski fakultet, Odeljenje za istoriju umetnosti; Narodni muzej Kruševac, 1975: 421–36, figs. 1–21.

——, ed. *Il Libro secondo di Francesco e Jacopo dal Ponte*. Bassano del Grappa: G. B. Verci, 1992.

Musatti, Eugenio. *Storia della promissione ducale*. Padua: Tipografia del Seminario, 1888.

Nalezyty, Susan. *Pietro Bembo and the Intellectual Pleasures of a Renaissance Writer and Art Collector*. New Haven and London: Yale University Press, 2017.

Nante, Andrea, ed. *Santa Giustina e il primo Cristianesimo a Padova*. Padua: Museo Diocesano, 2004.

Needham, Paul. "Venetian Printers and Publishers in the Fifteenth Century," *La Bibliofilia* 100 (1998): 157–200.

Neff, Mary Frances. "Chancellery Secretaries in Venetian Politics and Society, 1480–1533." PhD thesis, University of California, 1985.

Negri, A. "Review of Edward Cheney, 'Remarks on the illuminated official manuscripts of the Venetian Republic'," *Archivio Veneto* 1 (1871): 429–34.

Nelson, Robert S., and Margaret Rose Olin, eds. *Monuments and Memory, Made and Unmade*. Chicago: University of Chicago Press, 2004.

Nepi Sciré, Giovanna. "La 'Fede' di Tiziano," *Quaderni della Soprintendenza ai beni artistic e storici di Venezia* 8 (1979): 83–91.

——. *Gallerie dell'Accademia di Venezia. Guida alla Quadreria*. Venice: Marsilio, 1995.

Newton, Stella. *The Dress of the Venetians, 1495–1525*. Aldershot and Brookfield, VT: Scolar Press, 1988.

Nichols, Tom. *Tintoretto: Tradition and Identity*. London, Reaktion, 1999.

Niero, Antonio, ed. *San Marco aspetti storici e agiografici. Atti del convegno internazionale di studi*. Venice, April 26–29, 1994. Venice: Marsilio, 1996.

Nuovo, Angela. *The Book Trade in the Italian Renaissance*. Leiden: Brill, 2013.

Nuvoloni, Laura. "Commissioni dogali: Venetian Bookbindings in the British Library," in David Pearson, ed. *"For the Love of Binding:" Studies in Bookbinding History Presented to Mirjam Foot*. London: British Library and Oak Knoll Press, 2000: 81–109.

O'Connell, Monique. *Men of Empire: Power and Negotiation in Venice's Maritime State*. Baltimore: Johns Hopkins University Press, 2009.

—— ed. *Rulers of Venice. Governanti di Venezia, 1332–1524: Interpretations, Methods, Database*. With articles by Benjamin G. Kohl, Andrea Mozzato, Monique O'Connell, and Claudia Salmini. New York: ACLS, c.2009. http://hdl.handle.net/2027/heb.90021.0001.001 [Accessed January 2, 2018].

O'Floinn, Raghnall. *Irish Shrines and Reliquaries of the Middle Ages*. Dublin: Country House, 1994.

Ogg, Oscar, ed. *Three Classics of Italian Calligraphy: An Unabridged Reissue of the Writing Books of Arrighi, Tagliente, Palatino*. New York: Dover, 1953.

O'Malley, Michelle. "Late Fifteenth- and Early Sixteenth-Century Painting Contracts and the Stipulated Use of the Painter's Hand," in Eckart Marchand and Alison Wright, eds. *With and Without the Medici: Studies in Tuscan Art and Patronage 1434–1530*. Aldershot and Brookfield, VT, 1998: 155–78.

Pächt, Otto. *Buchmalerei des Mittelalters*. Munich: Prestel, 1989.

Padoan Urban, Lina. "Feste ufficiali e trattenimenti privati," in G. Arnaldi and M. Pastore Stocchi, eds. *Storia della cultura veneta. Il Seicento 4/1*. Vicenza: Istituto Veneto di Scienze, Lettere ed Arti, 1983: 575–600.

Pallucchini, Rodolfo, and Paola Rossi. *Jacopo Tintoretto: le opere sacre e profane*, 2 vols. Milan: Electa, 1982.

Palumbo Fossati Casa, Isabella. *Intérieurs vénitiens à la Renaissance. Maisons, société et culture*. Paris: Michel de Maule, 2012.

Papadopoli Aldobrandini, Nicolò. *Le monete di Venezia*. First pub. Venice: Ongania and Libreria emiliana, 1893–1919. Bologna: Forni, 1977.

Paschini, Pio. *Storia del Friuli*, 3 vols. Udine: Istituto delle Edizioni Accademiche, 1934–36.

——. *Domenico Grimani, Cardinale di S. Marco*. Rome: Edizioni di Storia e Letteratura, 1943.

——. *Il Cardinale Marino Grimani ed i prelati della sua famiglia*. Rome: Facultas Theologica Pontificiae Universitatis Lateranensis, 1960.

Pastorello, Ester. *Tipografi, editori, librai a Venezia nel secolo XVI*. Florence: Leo S. Olschki, 1924.

Paul, Benjamin. "Identità e alterità nella pittura veneziana al tempo della battaglia di Lepanto," *Venezia cinquecento* 15 (2005): 155–87.

——. "'Erst kein Glück, und dann kam auch noch Pech dazu.' Die gescheiterte Karriere des Jacopo Soranzo (1518–1599) im Spiegel seines Grabmals," in Karolin Behrmann, Arne Karsten, and Philipp Zitzlsperger, eds. *Grab, Kult, Memoria. Studien zur gesellschaftlichen Funktion von Erinnerung; Horst Bredekamp zum 60. Geburtstag am 29. April 2007*. Cologne: Böhlau, 2007: 41–58.

——, ed. *Celebrazione e autocritica. La Serenissima e la ricerca dell'identità veneziana nel tardo Cinquecento*. Rome and Venice: Viella, 2014.

Pavanello, Giuseppe, ed. *Il Buono e il Cattivo Governo. Rappresentazioni nelle arti dal Medioevo al Novecento*. Venice: Marsilio, 2004.

——, ed. *La Basilica dei Santi Giovanni e Paolo*. Venice: Marcianum and Fondazione Cini, 2013.

Paxson, James J. *The Poetics of Personification*. Cambridge: Cambridge University Press, 1994.

Pazzi, Paolo. *Il corno ducale, o sia contributi alla conoscenza della Corona Ducale di Venezia volgarmente chiamata Corno*. Treviso: Grafiche Crivellari, 1996.

Pedani Fabris, Maria Pia. "Veneta auctoritate notaries." *Storia del notariato Veneziano (1514–1797)*. Milan: Dott. A. Giuffrè, 1996.

Pemble, John. *Venice Rediscovered*. Oxford: Oxford University Press, 1995.

Penny, Nicholas. *National Gallery Catalogues, The Sixteenth Century Italian Paintings: V. I. Brescia, Bergamo and Cremona*. London: National Gallery, 2004.

——. *National Gallery Catalogues. The Sixteenth Century Italian Paintings. V. II. Venice 1540–1600*. London: National Gallery, 2008.

Perry, David M. *Sacred Plunder: Venice and the Aftermath of the Fourth Crusade*. University Park, PA: Pennsylvania State University Press, 2015.

Perry, Marilyn. "Saint Mark's Trophies: Legend, Superstition and Archaeology in Renaissance Venice," *Journal of the Warburg and Courtauld Institutes* 40 (1978): 27–49.

——. "Wealth, Art, and Display: the Grimani Cameos

in Renaissance Venice," *Journal of the Warburg and Courtauld Institutes* 55 (1993): 268–74.

Pertusi, Agostino. "'Quedam Regalia Insignia.' Ricerche sulle insegne del potere ducale a Venezia durante il medioevo," *Studi Veneziani* 7 (1965): 3–123.

Pettegree, Andrew. *The Book in the Renaissance.* New Haven and London: Yale University Press, 2010.

Pettoello, Alberta. *I libri illustrati veneziani del Settecento: le pubblicazioni d'occasione.* Venice: Istituto Veneto di Scienze, Lettere ed Arti, 2005.

Peyer, Hans Conrad. *Stadt und Stadtpatron in mittelalterlichen Italian.* Zurich: Europa, 1955.

Pignatti, Terisio. *Veronese. Catalogo completo dei dipinti.* Florence: Cantini, 1991.

Pilo, Giuseppe M. "Il procuratore di San Marco Jacopo Soranzo Jr. e il ritratto recuperato di Jacopo Tintoretto gia in Procuratia di supra," in *Storia dell'arte marciana. I mosaic: atti del convegno internazionale di studi. Venezia 1–14 Ottobre 1994.* Venice: Marsilio, 1997: 209–21, figs. 1–12.

Pincus, Debra. *The Arco Foscari: The Building of a Triumphal Gateway in Fifteenth-Century Venice.* Garland Outstanding Dissertations in the Fine Arts. New York: Garland, 1976.

——. "The tomb of Doge Nicolò Tron and Venetian Renaissance Ruler Imagery," in Moshe Barasch and Lucy Freeman Sandler, eds. *Art the Ape of Nature: Studies in Honor of H. W. Janson.* New York: Abrams, 1981.

——. "Andrea Dandolo and Visible History: The San Marco Projects," in Charles Rosenberg, ed. *Art and Politics in Late Medieval and Early Renaissance Italy: 1250–1550.* Notre Dame, IN: University of Notre Dame Press, 1990: 191–206.

——. *The Tombs of the Doges of Venice.* Cambridge: Cambridge University Press, 2000.

Plant, Margaret. *Venice Fragile City 1797–1997.* New Haven and London: Yale University Press, 2002.

Pocock, J. G. A. *The Machiavellian Moment.* Princeton: Princeton University Press, 1975.

——. "Mito di Venezia e ideologia americana: A Correction," *Il pensiero politico* 12 (1979): 443–45.

Pollard, John Graham, with Eleonora Luciano and Maria Pollard. *Renaissance Medals, Vol. 1 Italy.* The Collections of the National Gallery of Art Systematic Catalogue, National Gallery of Art, Washington, D.C. New York and Oxford: Oxford University Press, 2007.

Pomian, Krzystof. *Collectors and Curiosities: Paris and Venice 1500–1800.* Cambridge and Cambridge, MA: Polity Press, 1990.

——. *Dalle sacre reliquie all'arte moderna. Venezia-Chicago dal XIII al XX secolo.* Milan: Il Saggiatore, 2004.

Porter, Roy, ed. *Rewriting the Self: Histories from the Renaissance to the Present.* London: Routledge, 1997.

Prodi, Paolo. *Il sacramento del potere: Il giuramento politico nella storia costituzionale dell'Occidente.* Bologna: Mulino, 1992.

Puerari, Alfredo. *Museo Civico "Ala Panzone."* Cremona: Libreria del Convegno, 1976.

Puglisi, Catherine, and William Barcham, eds. *Passion in Venice. Crivelli to Tintoretto and Veronese: The Man of Sorrows in Venetian Art.* New York and London: Museum of Biblical Art in association with D. Giles Ltd., 2011.

Pullan, Brian. "Service to the Venetian State: Aspects of Myth and Reality," *Studi Seicenteschi* 5 (1964): 95–147.

——. *Rich and Poor in Renaissance Venice: The Social Institutions of a Catholic State, to 1620.* Cambridge, MA: Harvard University Press, 1971.

——. *The Jews of Europe and the Inquisition of Venice, 1550–1670.* Totowa, NJ: Barnes & Noble, 1983.

Puppi, Lionello and Loredana Olivato Puppi. "Scamozziana – Progetti per la 'via romana' di Monselice e alcune altre novità grafiche con qualche quesito," *Antichità viva* XIII, 4 (1974): 54–80.

Queller, Donald. *The Venetian Patriciate: Reality versus Myth.* Urbana and Chicago: University of Illinois, 1986.

Quilligan, Maureen, "Allegory and Female Agency," in Brenda Machosk, ed. *Thinking Allegory Otherwise.* Stanford: Stanford University Press, 2010: 163–87.

Ragghianti Collobi, Licia. *Il Libro de' Disegni del Vasari.* Florence: Vallecchi, 1974.

Raines, Dorit. "Office Seeking, Broglio, and the Pocket Political Guidebooks in cinquecento and seicento Venice," *Studi Veneziani* 22 (1991): 137–94.

——. "Costumi e leggi veneziani di Giovanni Rossi. Catalogo dei documenti contenuti negli 86 volumi manoscritti della biblioteca Nazionale Marciana," *Miscellanea Marciana* VII–IX (1992–94): 243–384.

——. "L'Archivio familiare strumento di formazione politica del patriziato veneziano," *Accademie e biblioteche d'Italia* 64, 4 (1996): 5–38.

——. "Alle origini dell'archivio politico del Patriziato: La cronaca 'di consultazione' veneziana nei secoli xiv–xv," *Archivio Veneto* V, 150 (1998): 5–57.

——. *L'Invention du Mythe Aristocratique. L'image de soi du patriciat vénitien au temps de la Sérénissime.* Venice: Istituto Veneto di Scienze, Lettere ed Arti, 2006.

——. "The Private Political Archives of the Venetian Patriciate: Storing, Retrieving and Recordkeeping in the Fifteenth-Eighteenth Centuries," *Journal of the Society of Archivists* 32, 1 (2011): 135–46.

Randall, Lilian M. C. *Medieval and Renaissance Manuscripts in the Walters Art Gallery.* Baltimore: Johns Hopkins University Press and Walters Art Gallery, 1989.

Rando, Daniele. "Dal santo allo stato. L'Opus e i Procuratori di San Marco di Venezia dalle origini al secolo XIV," in Margaret Haines and Lucio Riccetti, eds. *Opera: carattere e ruolo delle fabbriche cittadine fino all'inizio dell'età moderna: atti della Tavola rotonda: Firenze, Villa I Tatti, 3 aprile 1991.* Florence: Leo S. Olschki, 1996: 71–119.

Randolph, Adrian. *Engaging Symbols: Gender, Politics, and Public Art in Fifteenth-Century Florence.* New Haven and London: Yale University Press, 2002.

Renier Michiel, Giustina. *Origine delle feste veneziane*, 6 vols. Milan: 1817.

Richardson, Brian. *Print Culture in Renaissance Italy: The Editor and the Vernacular Text, 1470–1600.* Cambridge: Cambridge University Press, 1994.

——. *Printing, Writers and Readers in Renaissance Italy.* Cambridge: Cambridge University Press, 1998.

Richardson, Francis Lee. *Andrea Schiavone.* Oxford and New York: Oxford University Press, 1980.

Ridolfi, Carlo. *Le maraviglie dell'arte Ovvero le vite degli illustri pittori veneti e dello stato.* Reprint of Detlev Freiherrn von Hadeln, ed. Berlin, G. Grote'sche Verlagsbuchhandlung, 1914–24, first pub. Venice: Gio. Battista Sgaua, 1648. Rome: Società Multigrafica, 1965.

Rizzi, Alberto. *Vere da pozzo di Venezia. I pluteali pubblici di Venezia e della sua Laguna.* Venice: Stamperia di Venezia, 1981.

——. "Il San Marco a San Marco. L'emblema lapideo della Repubblica Veneta nel suo cuore politico," *Ateneo Veneto* 28 (1990): 7–48.

——. *I leoni di San Marco.* Venice: Cierre Edizioni, 2012.

Roeck, Bernd. *Arte per l'anima, arte per lo Stato. Un doge del tardo Quattrocento ed i segni delle immagini.* Venice: Centro Tedesco di Studi Veneziani, 1991.

Romanelli, Giandomenico. "'Vista cadere la patria ...' Teodoro Correr tra 'pietas' civile e collezionismo erudito," in *Una città e il suo museo. Un secolo e mezzo di collezioni civiche veneziane.* Venice: Museo Correr, 1988: 13–28.

Romano, Dennis. *Patricians and Popolani: The Social Foundations of the Venetian Renaissance State.* Baltimore: Johns Hopkins University Press, 1987.

——. *The Likeness of Venice: A Life of Doge Francesco Foscari 1373–1457.* London and New Haven: Yale University Press, 2007.

Rosado, Maurizio. "Sigillum Sancti Marci. Bolle e sigilli di Venezia," in Stefania Ricci, ed. *Il sigillo nella storia e nella cultura.* Venice: Museo Correr and Jouvence, 1985: 109–48.

Rosand, David. *Painting in Cinquecento Venice: Titian, Veronese, Tintoretto.* New Haven: Yale University Press, 1982.

——. "Venetia figurata: The Iconography of a Myth," in David Rosand, ed. *Interpretazione Veneziane.* Venice: Arsenale, 1984: 176–96.

——. *Myths of Venice: The Figuration of a State.* Chapel Hill, NC: University of North Carolina Press, 2001.

——. *Drawing Acts: Studies in Graphic Expression and Representation.* Cambridge: Cambridge University Press, 2002.

Rosand, David, and Michelangelo Muraro. *Titian and the Venetian Woodcut.* Washington, D.C.: National Gallery of Art, 1976.

Rosand, Ellen. "Music in the Myth of Venice," *Renaissance Quarterly* 30 (1977): 511–37.

Rösch, Gerhard. *Der venezianische Adel bis zur Schliessung des Grossen Rats. Zur Genese einer Führungsgeschichte.* Sigmaringen: J. Thorbecke, 1989.

Rosenthal, Margaret F. *The Honest Courtesan: Veronica Franco, Citizen and Writer in Sixteenth-century Venice.* Chicago and London: University of Chicago Press, 1992.

Rosenthal, Margaret F. and Ann Rosalind Jones. *The Clothing of the Renaissance World: Europe, Asia, Africa, the Americas. Cesare Vecellio's Habiti antichi et moderni.* London and New York: Thames & Hudson, 2008.

Ross, James Bruce. "Venetian Schools and Teachers Fourteenth to Early Sixteenth Century: A Survey and a Study of Giovanni Battista Egnazio," *Renaissance Quarterly* 29, 4 (Winter 1976): 521–66.

Rossi, Paola. *Tintoretto. I ritratti.* Milan: Electa, 1982.

Rudt de Collenberg, Wipertus-Hugo. "Il leone di san marco. Aspetti storici e formali dell'emblema statale dela Serenissima," *Ateneo Veneto* 27 (1989): 57–84.

Salmini, Claudia. "Buildings, Furnishing, Access and Use: Examples from the Archive of the Venetian Chancery, from Medieval to Modern Times," in M. V. Roberts, ed. *Archives and the Metropolis.* London: Guildhall Library Publications in association with the Centre for Metropolitan History, 1998: 93–108.

——. "Venetian Elections and their Registration: The Historical and Archival Context of the Office of the Segretario alle Voci," in O'Connell, ed. *c.*2009, paragraphs 149–181.

Salzberg, Rosa. "Masculine Republics: Establishing Authority in the Early Modern Venetian Printshop," in Susan Broomhall and Jacqueline Van Gent, eds. *Governing Masculinities in the Early Modern Period: Regulating Selves and Others.* Burlington, VT: Ashgate, 2011: 47–64.

Sansovino, Francesco. *Venetia, città nobilissima, et singolare.* Venice: Iacomo Sansovino, 1581.

——. *Venetia, città nobilissima, et singolare.* With additions by Giovanni Stringa, ed. Venice: Altobello Salicato, 1604.

——. *Venetia città nobilissima, et singolare.* Giustiniano Martinioni, ed. Venice: Stefano Curti, 1663.

Santalena, Antonio. *Guida di Treviso.* Treviso: L. Zoppelli, 1894.

——. *Veneti e imperiali. Treviso al tempo della lega di Cambray.* 2nd edn. Venice: Ongania, 1901.

Sanudo, Marin. *Itinerario di Marin Sanudo per la terraferma veneziana nell'anno MCCCLXXXIII.* Rawdon Brown, ed. Padua: Tipografia del Seminario, 1847.

——. *I diarii.* Rinaldo Fulin et al., eds. 58 vols. Venice: Deputazione R. Veneta di Storia Patria, 1879–1903.

——. *Venice, città excelentissima: Selections from the Renaissance Diaries of Marin Sanudo.* Patricia H. Labalme and Laura Sanguineti White, eds. Linda L. Carroll, trans. Baltimore: Johns Hopkins University Press, 2008.

——. *Itinerario per la terraferma veneta nel 1483 di Marin*

Sanudo. Robert Bruni, Luisa Bellini, Marco Pasa, and Aldo Ridolfi, eds. Padova: CLEUP, 2008.

——. *Itinerario per la terraferma.* G. M. Varanini, ed. Reggio Emilia: Diabasis, 2010.

Scalon, Cesare, ed. *L'Evangeliario di San Marco.* Pordenone: Paolo Gaspari, 1999.

Scarfi, Bianca Maria, ed. *The Lion of Venice: Studies and Research on the Bronze Statue in the Piazzetta.* Munich: Prestel, 1990.

Scarpa, Chiara. "Ca' Contarini dalle Figure a San Samuele: un progetto a piu mani," *Annali di architettura* 17 (2005): 69–92.

Schmitter, Monica. "The Display of Distinction: Art Collecting and Social Status in Early Sixteenth-Century Venice." PhD thesis, University of Michigan, 1997.

——. "'Virtuous Riches:' The Bricolage of Cittadini Identities in Early Sixteenth-Century Venice," *Renaissance Quarterly* 57, 3 (Autumn 2004): 908–69.

——. "The *Quadro da Portego* in Sixteenth-Century Venetian Art," *Renaissance Quarterly* 64 (2011): 693–751.

Schulz, Anne Markham. *Niccolò di Giovanni Fiorentino and Venetian Sculpture of the Early Renaissance.* New York: NYU Press, 1978.

——. *Antonio Rizzo, Sculptor and Architect.* Princeton: Princeton University Press, 1983.

——. *Giambattista and Lorenzo Bregno. Venetian Sculpture in the High Renaissance.* Cambridge: Cambridge University Press, 1991.

——. "Niccolò di Giovanni Fiorentino in Venice: The Documentary Evidence," *The Burlington Magazine* 141 (1999): 749–52.

Schulz, Juergen. *Venetian Painted Ceilings of the Renaissance.* Berkeley: University of California Press, 1968.

——. "Jacopo de' Barbari's View of Venice: Map Making, City Views, and Moralized Geography," *Art Bulletin* 60 (1978): 425–74.

Schutte, Anne Jacobson. "Teaching Adults to Read in Sixteenth-Century Venice: Giovanni Antonio Tagliente's *Libro Maistrevole*," *The Sixteenth Century Journal* 17, 1 (Spring 1986): 3–16.

Schweizer, Stefan. *Zwischen Repräsentation und Funktion. Die Stadttore der Renaissance in Italien.* Göttingen: Vandenhoeck & Ruprecht, 2002.

——. "Städtische Repräsentation und Dogen–Ikonographie," *Concilium medii aevi* 6 (2003): 15–36.

Setton, Kenneth M. *The Papacy and the Levant, 1204–1571,* 4 vols. Philadephia: American Philosophical Society, 1976–84.

Silvano, Giovanni. *La Republica de' Viniziani. Ricerche sul Repubblicanesimo Veneziano in età moderna.* Florence: Leo S. Olschki, 1993.

Silver, Larry, and Elizabeth Wyckoff, eds. *Grand Scale: Monumental Prints in the Age of Dürer and Titian.* Wellesley, New Haven, and London: Davis Museum and Cultural Center, Wellesley College in Association with Yale University Press, 2008.

Simane, Jan. *Grabmonumente der Dogen. Venezianische Sepulkralkunst im Cinquecento.* Sigmaringen: Jan Thorbecke Verlag, 1993.

Simonetta, Marcello, ed. *Federico da Montefeltro and his Library.* Vatican City: Biblioteca Apostolica Vaticana, 2007.

Simons, Patricia. "Alert and Erect: Masculinity in some Italian Renaissance Portraits of Fathers and Sons," in Richard Trexler, ed. *Gender Rhetorics: Postures of Dominance and Submission in History.* Binghamton, NY: Medieval and Renaissance Texts and Studies, 1994: 163–75.

Sinding-Larsen, Staale. *Christ in the Council Hall: Studies in the Religious Iconography of the Venetian Republic.* Rome: L'Erma Di Bretschneider, 1974.

——. *The Burden of the Ceremony Master: Image and Action in San Marco, Venice and in an Islamic Mosque: The Rituum Cerimoniale of 1564.* Rome: Giorgio Bretschneider, 2000.

Skinner, Quentin. *Visions of Politics. Volume 2: Renaissance Virtues.* Cambridge: Cambridge University Press, 2002.

Smith, Webster. "Giulio Clovio and the 'maniera di figura piccole'," *Art Bulletin* 46, 3 (September 1964): 395–401.

Stahl, Alan. "The Coinage of Venice in the Age of Enrico Dandolo," in Ellen E. Kittel and Thomas F. Madden, eds. *Medieval and Renaissance Venice.* Urbana and Chicago: University of Illinois Press, 1999: 124–40.

——. *Zecca: The Mint of Venice in the Middle Ages.* Baltimore: Johns Hopkins University Press in association with the American Numismatic Society, New York, 2001.

——, ed. *The Rebirth of Antiquity: Numismatics, Archaeology and Classical Studies in the Culture of the Renaissance.* Princeton: Princeton University Library, 2009.

Starn, Randolph, and Loren Partridge. *Arts of Power: Three Halls of State in Italy, 1300–1600.* Berkeley: University of California Press, 1992.

Stedman Sheard, Wendy. "The Tomb of Doge Andrea Vendramin in Venice by Tullio Lombardo." PhD thesis, Yale University, 1971.

——. "Giorgione's Portrait Inventions, *c.*1500. Transfixing the viewer," in Mario A. di Cesare, ed. *Papers from the Twenty-first Annual Conference: Center for Medieval and Renaissance Studies.* Binghamton, NY: Medieval and Renaissance Texts and Studies, 1992: 141–76.

Stewart, Susan. *On Longing: Narratives of the Miniature, the Gigantic, the Souvenir, the Collection.* Durham, NC, and London: Duke University Press, 1993.

Stoddard, Roger E. *Marks in Books, Illustrated and Explained.* Cambridge, MA: Houghton Library, Harvard University, 1985.

Stollberg-Rilinger, Barbara, Matthias Puhle, Jutta Götzmann, and Gerd Althoff, eds. *Spektakel der Macht. Rituale im Alten Europa 800–1800.* Darmstadt: Wissenschaftliche Buchgesellschaft, 2008.

Stringa, Giovanni. *Vita di S. Marco Evangelista protettore Invitissimo della Serenissima Republica di Venetia.* Venice: Rampazetto, 1610.

——. *Vita di San Marco Evangelista protettore Invitissimo della Serenissimo Republica di Venetia.* Venice: Milocho, 1680.

Swann Short, Kathleen. "The Collection: Giulio Clovio and the Stuart de Rothesay Hours." MA thesis, University of South Florida, 1998.

Syson, Luke, and Dora Thornton. *Objects of Virtue: Art in Renaissance Italy.* London: British Museum, 2001.

Szépe, Helena Katalin. "The Book as Companion, the Author as Friend: Aldine Octavos Illuminated by Benedetto Bordon," *Word and Image* 11, 1 (January–March 1995): 77–99.

——. "Artistic Identity in the Poliphilo," *Papers of the Bibliographical Society of Canada* 35, 1 (Spring 1997): 39–73.

——. "Civic and Artistic Identity in Illuminated Venetian Documents," *Bulletin du Musée Hongrois des Beaux Arts* 95 (2001): 59–78.

——. "Isabella Stewart Gardner's Venetian Manuscripts," in McCauley et al., eds. 2004: 233–35.

——. "Distinguished among Equals: Venetian Manuscript Illumination," in Brigitte Dekeyzer and Jan van der Stock, eds. *Manuscripts in Transition.* Leuven: Peeters Publishers, 2005: 393–99.

——. "Venetian Miniaturists in the Era of Print," *The Books of Venice.* Lisa Pon and Craig Kallendorf, eds. Special issue of *Miscellanea Marciana* 20 (2009): 31–60, 517–25.

Tafuri, Manfredo, ed. *"Renovatio urbis." Venezia nell'età di Andrea Gritti (1523–1538).* Rome: Officina Edizioni, 1984.

——. *Venice and the Renaissance.* Trans. of *Venezia e il Rinascimento* by Jessica Levine. Cambridge, MA: MIT Press, 1989.

Tagliaferri, Amelio. *Relazioni dei rettori in terraferma,* 13 vols. Milan: A. Giuffrè, 1973–79.

——, ed. *Atti del Convegno Venezia e la terraferma attraverso le relazioni dei rettori, Trieste, 23–24 ottobre 1980.* Milan: A. Giuffrè, 1981.

Tagliaferro, Giorgio. "Le forme della Vergine: La personificazione di Venezia nel processo creativo di Paolo Veronese," *Venezia Cinquecento* 30 (2005): 5–158.

——. "Martiri, eroi, principi e beati: I patrizi veneziani e la pittura celebrativa nell'età di Lepanto," in M. Chiabò and F. Doglio, eds. *Guerre di religione sulle scene del Cinque-Seicento.* Rome: Torre d'Orfeo, 2006: 337–90.

Tanis, James R., ed. with Jennifer A. Thompson. *Leaves of Gold: Manuscript Illumination from Philadelphia Collections.* Philadelphia: Philadelphia Museum of Art, 2001.

Tartuferi, Angelo, and Gianluca Tormen, eds. *La fortuna dei primitivi: tesori d'arte dalle collezioni italiane fra Sette e Ottocento.* Florence: Giunti, 2014.

Tatio, Giovanni. *L'ottimo reggimento del magistrato Pretorio … ove brevemente si discorre in che modo si doverebbe governare qualunque Rettore di qual so voglia Città, ò Provincia, per conseguirne laude da' sudditi, et honore appresso il suo Prencipe.* Venice: Francesco de' Franceschi, 1564.

——. *L'immagine del rettore della ben ordinata città … ove si discorrono I modi, che dalla Fanciulezza per fino alla età virile si debbono tenere da quello, che deve esser eletto al governo d'alcuna città per dar di se sodisfattione à sudditi, & haverne commendation dal suo Prencipe.* Venice: Gabriel Giolito di Ferrarii, 1573.

Tempestini, Anchise. "Schede per la miniatura manieristica," in Luigi Menegazzi, ed. *Miniatura in Friuli crocevia di civiltà.* Pordenone: Grafiche Editoriale Artistiche Pordenonesi, 1987: 171–69.

——. *Giovanni Bellini: Catalogo completo dei dipinti.* Florence: Cantini, 1992.

——. "La 'Sacra Conversazione' nella pittura veneta dal 1500 al 1516," in Mauro Lucco, ed. *La pittura nel Veneto. Il Cinquecento,* vol. 3. Milan: Electa, 1999: 930–1014.

Tentori, D. Cristoforo. *Saggio sulla storia civile, politica, ecclesiastica e sulla corografia e topografia degli stati della repubblica di Venezia ad uso della nobile e civile gioventù.* Venice: Giacomo Storti, 1782–90.

Teskey, Gordon. *Allegory and Violence.* Ithaca, NY: Cornell University Press, 1996.

Tiepolo, Maria Francesca, ed. *Cartografia, disegni, miniature delle magistrature veneziane. Mostra documentaria.* Venice: Ministero per I Beni Culurali e Ambientali, Archivio di Stato di Venezia, 1984.

Tietze, Hans, and Erica Tietze-Conrat. *The Drawings of the Venetian Painters in the 15th and 16th Centuries.* New York: J. J. Augustin, 1944.

Todesco, Maria-Teresa. "Andamento demografico della nobiltà veneziana allo specchio delle votazioni nel Maggior Consiglio (1297–1797)," *Ateneo Veneto* CLXXVI (1989): 1–50.

Tomory, Peter. *The Bick Collection of Italian Religious Drawings.* Sarasota: The John and Mable Ringling Museum of Art, 1970.

Toniolo, Federica. "La Bibbia di Borso d'Este e i suoi miniatori." PhD thesis, University of Padua, 1990–93.

Toniolo, Federica, and Gennaro Toscano, eds. *Miniatura. Lo sguardo e la parola. Studi in onore di Giordana Mariani Canova.* Milan: Silvana Editoriale, 2012.

Tramontin, Silvio. *Culto dei santi a Venezia.* Venice: Studium Cattolico Veneziano, 1965.

Trebbi, Giuseppe. "La cancelleria veneta nei secoli XVI e XVII," *Annali della fondazione Luigi Einaudi* XIV (1980): 65–125.

——. *Francesco Barbaro, patrizio veneto e Patriarca di Aquileia.* Udine: Casamassima, 1984.

——. "Il segretario veneziano," *Archivio storico italiano* CXLIV, 527, 1 (1986): 35–74.

Tucci, Ugo. "Il processo a G. Zane mancato difensore di Cipro," in G. Benzoni, ed. *Il Mediterraneo nella seconda*

metà del '500 alla luce di Lepanto. Florence: Leo S. Olschki, 1974: 409–33.

Urban, Lina. *Processioni e feste dogali: "Venetia est mundus."* Venice: Neri Pozza, 1998.

Unterkircher, Franz. *Die Datierten Handschriften der Österreichischen Nationalbibliothek von 1501 bis 1600.* Vienna: Verlag der Österreichischen Akademie der Wissenschaften, 1976.

Vanin, Barbara, and Paolo Eleuteri. *Le mariegole della biblioteca del Museo Correr.* Venice: Marsilio, 2007.

Vasari, Giorgio. *Le vite de' più eccellenti pittori, scultori ed architettori*, 3 vols. Florence: Giunti, 1568.

——. *Le vite de' più eccellenti pittori, scultori ed architettori* in *Le Opere*, 9 vols. Gaetano Milanesi, ed. Florence: G. C. Sansoni, 1906.

——. *Le vite de' più eccellenti pittori scultori ed architettori* (1568). Paola della Pergola, Luigi Grassi, and Giovanni Previtali, eds. Revision of text by Aldo Rossi, part 3, vol. 7. Milan: Edizioni per Il Club del Libro, 1965.

Vecellio, Cesare. *Degli habiti antichi et moderni di diverse parti del Mondo.* Venice: Damian Zenaro, 1590.

——. *Habiti antichi et moderni di tutto il mondo. Vestitus antiquorum recentiorumque totius orbis di Cesare Vecellio; di nuouo accresciuti di molte figure.* Venice: Sessa, 1598.

Venni, Giovanni. *Le vicende del corpo di san Marco, 828–1928.* Venice: G. Scarabellin, 1928.

Ventura, Angelo. *Nobilità e popolo nella società veneta del '400 e '500.* 2nd edn. First pub. 1964. Bari: Laterza, 1994.

Viallon-Schoneveld, Marie. *Catalogue du fonds italien, XVIe siècle. August Boullier de la Bibliothèque municipale de Roanne.* Saint-Étienne: Publ. de l'Université de Saint-Étienne, 1994.

Viggiano, Alfredo, ed. *Le Procuratie Vecchie in Piazza San Marco.* Venice: Editalia, 1994: 11–56.

——. "Il processo al Capitano generale da Mar Antonio Grimani 'ruina de' christiani', 'rebello de' Venetiani' (1499–1500)," in Yves-Marie Bercé, ed. *Les procès politiques (XIVe–XVIIe siècle).* Rome: École Française de Rome, 1997: 251–72.

Vio, Gastone. "Giovanni Vitali, sacerdote Bresciano, operante a Venezia nel secolo decimosesto," *Brixia sacra. Memorie storiche della Diocesi di Brescia* 15, 3–6 (May–December 1980): 192–203.

Vitali, Achille. *La moda a Venezia attraverso i secoli. Lessico ragionato.* Venice: Filippi Editore, 1992.

Voelkle, William M. "Some New Observations on the Farnese Hours in the Morgan Library (M.69)," in Michelle P. Brown and Scott McKendrick, eds. *Illuminating the Book: Makers and Interpreters. Essays in Honour of Janet Backhouse.* London and Toronto: British Library and University of Toronto Press, 1998.

Voelkle, William M., and Ivan Golub. *Farnese Book of Hours with Illuminations by Giulio Clovio Croata.* Complete colour facsimile edn. of the MS M.69 of the Pierpont Morgan Library, New York, with commentary by Voelkle and Golub. Zagreb and Graz: Croatian Academy of Sciences and Arts, and Akademische Druck-u. Verlagsanstalt, 2001.

Voltolina, Piero. "Medaglie di magistrati veneti," part 1. *Rivista di numismatica e scienze affini* 94 (1992): 313–40.

——. "Medaglie di magistrati veneti," part 2. *Rivista di numismatica e scienze affini* 96 (1994/95): 284–92.

——. *La storia di Venezia attraverso le medaglie*, 3 vols. Venice: Edizioni Voltolina, 1998.

Von Hadeln, Detlev. "Nachrichten über Miniaturmaler," in Wilhelm Bode, George Gronau, Detlev Frhr. v. Hadeln, eds. *Archivalische Beiträge zur Geschichte der venezianischen Kunst: aus dem Nachlass Gustav Ludwigs.* Berlin: Bruno Cassirer, 1911: 161–69.

——. "Beiträge zur Tintorettoforschung," *Jahrbuch der Königlich Preussischen Kunstsammlungen* 32 (1911): 25–58.

——. "Beiträge zur Geschichte des Dogenpalastes," *Jahrbuch der Königlich Preussischen Kunstsammlungen* 32 (1911): 1–33.

Voronova, Tamara, and Alexander Sterliogov. *Western European Illuminated Manuscripts of the Eighth to the Sixteenth Centuries in the National Library of Russia, St. Petersburg.* Bournemouth, Dorset, and St. Petersburg: Parkstone Press and Aurora Art Publishers, 1996.

Wardrop, James. "A note on Giovantonio Tagliente," *Signature* 8 (1949): 57–61.

——. *The Script of Humanism: Some Aspects of Humanistic Script, 1460-1560.* Oxford: Clarendon Press, 1963.

Warner, Marina. *Monuments and Maidens: The Allegory of the Female Form.* Berkeley: University of California Press, 1985.

Watson, Andrew G. *Catalogue of Dated and Dateable Manuscripts c.700–1600, in the Department of Manuscripts, The British Library.* London: British Library, 1979.

Watson, Rowan. "Vandals and Enthusiasts. Views of Illumination in the Nineteenth Century," exhibition publication (London: Victoria and Albert Museum, 1995).

——. "Educators, Collectors, Fragments, and the 'Illuminations' Collection of the Victoria and Albert Museum in the Nineteenth Century," in Linda L. Brownrigg and Margaret M. Smith, eds. *Interpreting and Collecting Fragments of Medieval Books.* Los Altos and London: Anderson-Lovelace and Red Gull Press, 2000: 21–46.

——. "Some Non-Textual Uses of Books," in Simon Eliot and Jonathan Rose, eds. *A Companion to the History of the Book.* Malden, Oxford, and Victoria: Blackwell, 2007: 480–92.

——. *Western Illuminated Manuscripts in the Victoria and Albert Museum.* New York: Abrams, 2011.

Weber, Annette. *Venezianische Dogenporträts des 16. Jahrhunderts.* Sigmaringen: Jan Thorbecke Verlag, 1993.

Weigel, Thomas. "Begräbniszeremoniell und Grabmäler venezianischer Grosskanzler des 16. Jahrhunderts," in Joachim Poeschke, Britta Kusch-Arnhold, and Thomas Weigel, eds. *Praemium Virtutis. Grabmonumente und Begräbniszeremoniell im Zeichen des Humanismus*. Münster: Rhema, 2002: 147–74.

Wescher, Paul. *Beschreibendes Verzeichnis der Miniaturen Handschriften und Einzelblätter des Kupferstichkabinetts der Staatlichen Museen Berlin*. Leipzig: Verlagsbucherhandlung J.J. Weber, 1931.

Wethey, Harold E. *The Paintings of Titian*, 3 vols. London: Phaidon, 1969–75.

Wieck, Roger. *Late Medieval and Renaissance Illuminated Manuscripts 1350–1525 in the Houghton Library*. Cambridge, MA: Houghton Library, Harvard University Press, 1983.

——. "*Folia Fugitiva*: The Pursuit of the Illuminated Manuscript Leaf," *Journal of the Walters Art Gallery* 54 (1996): 233–54.

Wilson, Bronwen. "'il bel sesso, e l'austero Senato': The Coronation of Dogaressa Morosina Morosini Grimani," *Renaissance Quarterly* 52, 1 (Spring 1999): 73–139.

——. *The World in Venice: Print, the City and Early Modern Identity*. Toronto: University of Toronto, 2005.

Winner, Matthias. "Federico Zuccari und der Codex Grimani," in Otto Georg von Simson, Lucius Grisebach, and Konrad Renger, eds. *Festschrift für Otto von Simson zum 65. Geburtstag*. Frankfurt am Main, Vienna, and Berlin: Propyläen Verlag 1977: 295–309.

Witcombe, Christopher L. C. E. *Copyright in the Renaissance: Prints and the Privilegio in Sixteenth-Century Venice and Rome*. Leiden and Boston: Brill, 2004.

Witt, Ronald G. *In the Footsteps of the Ancients: From Lovato to Bruni*. Leiden and Boston: Brill, 2000.

Wolters, Wolfgang. "Über die Wandteppiche von San Marco," *Pantheon* XXIII (March/April 1965): 80–83.

——. "Der Programmentwurf zur Dekoration des Dogenpalastes nach dem Brand von 20 Dezember 1577," *Mitteilungen des Kunsthistorischen Institutes in Florenz* XII, iii/iv (1966): 271–318.

——. *Scultura veneziana gotica 1300/1460*. Venice: Alfieri, 1976.

——. *Storia e politica nei dipinti di Palazzo Ducale: aspetti dell'autocelebrazione della Repubblica di Venezia nel Cinquecento*. (Trans. of *Der Bilderschmuck des Dogenpalastes: Untersuchungen zur Selbstdarstellung der Republik Venedig im 16. Jahrhundert*. Wiesbaden: Steiner, 1983.) Venice: Arsenale, 1987.

——. "Scultura," in Umberto Franzoi, Terisio Pignatti, and Wolfgang Wolters, eds. *Il Palazzo Ducale di Venezia*. Treviso: Edizioni Canova, 1990.

——. *Architektur und Ornament. Venezianischer Bauschmuck der Renaissance*. Munich: C. H. Beck, 2000.

——. "Fragmente vom Grabmal der Dogen Marco und Agostino Barbarigo in der Villa Valmarana ai Nani bei Vicenza," in Maria Agnese Chiari, Moretto Wiel, and Augusto Gentili, eds. *L'attenzione e la critica. Scritti di storia dell'arte in memoria di Terisio Pignatti*. Padua: il Poligrafo, 2008: 79–84, 458–59.

——. *Il Palazzo Ducale di Venezia. Un percorso storico-artistico*. Caselle di Sommacampagna, Verona: Cierre Edizioni, 2010.

Woodward, David. *Maps as Prints: The Maps and Prints of Paolo Forlani. A Descriptive Bibliography*. Chicago: Newberry Library, 1990.

Zannini, Andrea. *Burocrazia e burocrati a Venezia in età moderna: I cittadini originari (sec. XVI–XVIII)*. Venice: Istituto Veneto di Scienze, Lettere ed Arti, 1993.

Zanotto, Francesco. *Il Palazzo Ducale di Venezia*, 5 vols. Venice: G. Antonelli, 1853–61.

Zille, Ester. "Il processo Grimani," *Archivio Veneto* V, 36–37 (1945): 137–94.

Zolotova, Ekaterina. *Western European Book Miniatures of the 12th–17th Centuries in Moscow Libraries, Museums and Private Collections*. Moscow: State Institute for Art Studies, 2012.

Zordan, Giorgio. *L'ordinamento giuridico veneziano*. Revised edn. Padua: Imprimitur, 2005.

Zorzi, Alvise. *Venezia scomparsa*. Venice: Electa, 1971.

Zorzi, Marino. *La Libreria di San Marco. Libri, lettori, società nella Venezia dei Dogi*. Milan: Mondadori, 1987.

——, ed. *Biblioteca Marciana Venezia*. Florence: Nardini Editore, 1988.

——, ed. *Collezioni di antichità a Venezia nei secoli della Repubblica (dai libri e documenti della Biblioteca Marciana)*. Rome: Istituto poligrafico e Zecca dello Stato, 1988.

Zuccolo Padrono, and Giulia Maria. "Miniature manieristiche nelle Commissioni dogali del secondo Cinquecento presso il Museo Correr," *Bollettino dei Musei Civici Veneziani* 14, 2 (1969): 4–18.

——. "Il Maestro 'T.º Ve' e la sua bottega: miniature veneziane del XVI secolo," *Arte Veneta* 25 (1971): 53–71.

——. "Sull'ornamentazione marginale di documenti dogali del xvi secolo," *Bollettino dei Musei Civic Veneziani* 17 (1972): 3–25.

Photographic Acknowledgments

AUTHOR: 1.6, 1.7, 3.2, 3.12, 3.17, 5.12, 5.30, 6.6, 6.8–6.10 | Author's archive: 6.35 | ALBI, Réseau des Médiathèques de l'Albigeois (Médiathèque Pierre-Amalric d'Albi): 0.6 | BALTIMORE, Walters Art Museum: 4.3, 6.1, 6.37, 9.14 | BERLIN, bpk/Deutsche Staatsbibliothek: 5.11, 5.13; bpk/Kupferstichkabinett/Dietmar Katz/Art Resource, NY: 5.21 | BETHLEHEM, PA, Special Collections, Lehigh University: 5.9 | BOSTON, Isabella Stewart Gardner Museum: 4.7, 4.36, 9.16 | BUDAPEST, Museum of Fine Arts: 6.25 | CAMBRIDGE, Cambridge University Library: 4.9; © Fitzwilliam Museum, University of Cambridge: 1.1, 4.23, 5.23, 5.25, 9.7, 9.11 | CAMBRIDGE, MA, Houghton Library, Harvard University: 6.11 | CHICAGO, T. Kimball Brooker: 5.37; Newberry Library: 2.11, 4.26, 7.8 | CREMONA, Museo Civico: 5.39, 9.13 | DRESDEN, Sächsische Landesbibliothek – Staats- und Universitätsbibliothek (SLUB): 6.32 | DUBLIN, © Trustees of the Chester Beatty Library: 4.24; National Gallery of Ireland: 9.5 | EDINBURGH, Edinburgh University Library: 7.12 | FLORENCE, Alinari Archives: 3.3, 4.22, 6.15; G.A.P. Srl Biblioteca Nazionale Centrale: 6.14 | GENOA, Cattanea Adorno, Raccolta Durazzo: 5.29 | ITHACA, NY, Division of Rare and Manuscript Collections, Cornell University Libraries/Carlo Naya: 1.8 | KEW, National Archives: 4.37, 5.33, 5.34 | LEUVEN, K. U. Leuven, Maurits Sabbe Library: 3.28, 4.10 | LONDON, British Library: 0.5, 3.6, 4.15, 4.20, 5.4, 5.10, 5.13, 5.22, 5.27, 5.32, 5.35, 5.36, 5.43, 5.44, 6.4, 6.5, 6.17, 6.26, 6.28, 9.15; © Christie's Images, Ltd. (2014): 7.10, 7.11; © The Trustees of the British Museum: 3.22; Royal Collection Trust/© Her Majesty Queen Elizabeth II 2015: 4.12; By Courtesy of the Trustees of Sir John Soane's Museum: 0.7; © Victoria and Albert Museum: 3.29 | LOS ANGELES, Getty Research Institute: 6.40, 7.22 | MCMINNVILLE, OR, Phillip J. Pirages: 6.19 | MOSCOW, Ekaterina Zolotova: 5.18, 6.34 | NEW HAVEN, Lillian Goldman Law Library, Rare Book Collection, Yale University: 6.38 | NEW YORK, Image © Metropolitan Museum of Art. Image source: Art Resource, NY: 1.9; Erich Lessing/Art Resource, NY: 4.21; Scala/Ministero per i Beni e le Attività culturali/Art Resource, NY: 6.24; Scala/Art Resource: 4.30, 5.24; De Agostini Picture Library/Publiaer Foto/Bridgeman Images: 0.1; De Agostini Picture Library/M. Carrieri/Bridgeman Images: 1.11; Cameraphoto Arte, Venice/Art Resource, NY: 4.25; bpk Bildagentur/

Fondazione Musei Civici di Venezia/Alfredo Dagli Orti: 5.31; New York Public Library: 3.14, 5.5, 5.6; Pierpont Morgan Library and Museum: 2.11, 5.28, 5.40, 6.23, 9.4; Wildenstein & Co.: 6.3 | NETHERLANDS, Private collection: 4.17 | OXFORD, Ashmolean Museum, University of Oxford/Bridgeman Images: 0.20; Bodleian Libraries, University of Oxford: 0.15 | PADUA, By permission of the Comune di Padova – Assessorato alla Cultura: 3.9, 6.31, 6.39 | PARIS, Bibliothèque Nationale de France: 0.16, 4.13, 5.17, 5.26; RMN-Grand Palais/Art Resource, NY: 5.21; Musée Marmottan Monet/Bridgeman Images: 4.16, 9.1 | PHILADELPHIA, Free Library of Philadelphia: 2.9, 9.3, 9.10, 9.12; University of Pennsylvania Libraries, UPenn, Schoenberg: 6.7 | ROANNE, Collection Médiathèque de Roanne: 6.29, 6.30 | SAN FRANCISCO, J. Paul Leonard Library, San Francisco State University: 3.7, 3.8 | SAN MARINO, CA, Huntington Library, Art Collections, and Botanical Gardens: 5.3, 5.42, 6.22, 6.27, 6.28, 6.36, 7.2–7.5, 7.7, 7.9, 7.13–7.15, 9.6 | SANTA CLARA, Blake de Maria: 4.28 | TAMPA, Rodney Paul Mayton: 5.1, 5.2; University of South Florida, Image courtesy of USF Special Collections: 6.21 | VATICAN, Photo Pontifical Commission for Sacred Archaeology: 2.6 | VENICE, Antichità Pietro Scarpa: 0.21; Archivio di Stato, Atto di concessione 56/2017: 2.3, 2.5, 2.8, 3.1, 4.31, 5.45–5.47, 5.49–5.51; Biblioteca Nazionale Marciana: 0.12–0.14, 1.5, 3.10, 3.16, 3.20, 4.8, 4.14, 5.7, 6.16; © Cameraphoto Arte, Venezia: 0.17–0.19, 1.2, 1.4, 1.10, 1.12, 1.14, 1.15, 2.4, 3.5, 3.13, 3.19, 3.21, 3.23–3.25, 3.27, 4.2, 4.4, 4.32–4.34, 5.41, 5.48, 7.17–7.21, 9.2; Fondazione Giorgio Cini: 6.2; Fondazione Giorgio Cini Fototeca: 1.13, 4.27, 4.35, 5.16, 6.13, 7.16; Fondazione Musei Civici di Venezia: 0.3, 0.4, 2.7, 2.10, 3.4, 3.11, 3.15, 3.18, 3.26, 4.1, 4.5, 4.11, 4.18, 4.19, 4.29, 5.8, 5.15, 5.20, 6.33, 9.8, 9.9; Archivio Naya-Böhm: 0.8, 0.9, 5.14, 8.1, 8.2; Licensed by "Giustiniani Recanati Falck Library:" 2.12, 3.11 | VICENZA, Collezione Banca Popolare di Vicenza: 0.22 | VIENNA, Österreichische Nationalbibliothek: 4.6, 5.38, 6.12, 7.6 | WASHINGTON, D.C., Law Library, Library of Congress: 1.3, 2.2; National Gallery of Art: 6.18, 7.1 | ZURICH, © 2015 Kunsthaus Zürich. All rights reserved: 6.20; Ulrico Hoepli, *Incunables, manuscrits, livres rares et prècieux autographes musicaux ...* (Zurich: Kunsthaus zur Meise, 1937): 5.19; Giuseppe Morazzoni, *Le Cornici veneziane* (Milan: Luigi Alfieri, 1944): 9.17

Index of *Ducali*, Illuminated Manuscripts, Illuminated Printed Books, Leaves, and Fragments, by Current Location

All Commissions and *Promissioni* discussed or cited in the text, whether illuminated or not, are listed in this index. All other illuminated manuscripts, printed books, and fragments discussed also are listed here. The last numbers in each entry refer to pages and endnotes in the present book. Page numbers in italic refer to illustrations. Manuscripts consulted solely for their texts are listed in Manuscript Sources.

One of the great revolutions in scholarship in the past two decades has been the digitization of collections. A detailed codicological catalogue with images of *ducali* in the Correr is now online, and many other collections are available similarly today to the researcher. In addition to consulting the indices in this book and the list of manuscripts below, I invite the reader interested in further researching *ducali* to consult the digital resources online of the relevant holding institutions.

For a database uniting material in various US collections, see the Digital Scriptorium: http://bancroft.berkeley.edu/digitalscriptorium/

A note on the dating of these manuscripts, and discerning information about the elected official and the original entire document from fragments: Most Commissions to rectors are dated in the eschatocol at the end of the manuscript. If the manuscript is fragmentary, but the names of the doge in office, the recipient, and/or the location of the post can be gathered, the date of election usually can be learned from the database *The Rulers of Venice* (O'Connell, ed. *c.*2009) and various other published sources, especially the series *Relazioni dei rettori veneti in terraferma*, edited by Amelio Tagliaferri (Milan: Giuffrè, 1973–79). To identify a recipient of a document and to distinguish him from his homonyms in the period after 1524, direct consultation of the *Segretario alle voci* election records is often necessary.

David S. Chambers gives a valuable list of the dates of election of procurators and a list of relevant surviving Commissions in Chambers 1997 (some additions and updates are given here in Appendix 2).

The dates of manuscripts and their illumination listed below are those given in the eschatocol, or if there is none, the dates of election.

M.546 Commission to Francesco Venier as *Podestà* of Verona, 1550 ~ 314 n167

M.553 Commission to Francesco Venier as Lieutenant of Friuli, 1534 ~ 314 n167

M.917 Book of Hours of Anne of Cleves, *c.*1440 ~ 312 n106

M.1082 Leaf from a Commission to Antonio Bragadin as *Podestà* of Brescia, 1567 ~ 186, *187*

Printed books:
PML 21194, 21195 (ChL ff907) Aristotle, *Opera*. Venice: Andreas Torresanus de Asulo and Bartholomaeus de Blasi, 1483 ~ 319 n75

PML 76228 Giovanni Nicolò Doglioni, *La città di Venetia*. Venice: Antonio Turini for Giacomo Franco, 1614, with painted images ~ 214, *215*

Wildenstein & Company
Leaf from the Commission to Lorenzo Moro as *Provveditore generale* of Dalmatia, 1558 ~ 199–200, *200*

Norfolk

Holkham Hall
MS 644 Commission to Vincenzo Cappello as *Rettore* of Belluno, 1598 ~ 332 n14

MS 645 Commission of Vincenzo Cappello as ducal councillor, 1562 ~ 332 n14

MS 647 Commission to Nicolò K. Bernardo as Procurator *de ultra*, 1458 ~ 317 n42

Oxford

Bodleian Library
MS Laud misc. 533 Commission to Francesco Foscarini as *Podestà* and Captain of Bassano, 1533 ~ 344 n10

MS Laud misc. 710 Commission to Michele Bon as *Podestà* of Montagnana, 1552 ~ 29, *30*, 297 n51

MS Laud misc. 711 Commission to Michele Bon as Proveditor of Cividale del Friuli, 1564 ~ 297 n51

MS Laud misc. 712 Commission to Girolamo Grimani as Captain of Verona, 1550 ~ 322 n129, 344 n10

MS Laud misc. 713 Commission to Michele Bon as *Podestà* of Bergamo, 1572 ~ 297 n51

MS Laud misc. 714 Commission to Michele Bon as *Podestà* of Brescia, 1586 ~ 297 n51

Padua

Biblioteca Civica
B.P. 1175 Commission to Marcantonio Contarini as *Podestà* of Padua, 1539 ~ 325 n25

Biblioteca del Seminario Vescovile
MS. 440 *Institutio et Confirmatio Congregationis S. Giorgii in Alga*, April 16, 1523 ~ 328 n81

Paris

Bibliothèque de l'Arsenal
MS 940 *Life and Passion of Saint Maurice* ~ 294 n12

MS 8596 Commission to Sebastiano Marcello as *Podestà* of Brescia, 1565 ~ 29–31, *30*

Bibliothèque Nationale de France (BnF)
Département des Manuscrits:
Dupuy 955 Commission to Jacopo Celsi as Captain of the Merchant Galleys to Alexandria, 1550 ~ 176–7, *176*, 328 n85

Ital. 1010 Commission to Alvise Loredan as *Podestà* and Captain of Conegliano, 1530 ~ 331 n140

Ital. 1012 Commission to Pietro Bollani as Consigliere of Rettimo, 1589 ~ 346 n31

Ital. 1340 *Capitolare* of Francesco de Garzoni as ducal councillor, 1516 ~ 327 n78

Lat. 4727 Commission of Pietro Corner as procurator *de supra*, 1367 ~ 289, 316 n37

Lat. 4729 Commission to Paolo da Canal as Consul of Alexandria, 1489 ~ 327 n72

Lat. 4730 Commission to Tommaso Loredan as Captain of the Merchant Galleys to the Barbary Coast, 1490 ~ *170*, 173, 185, 327 n72

Lat. 4732 Commission to Alessandro Badoer as *Podestà* of Portobuffolé, 1515 ~ 331 n140

Lat. 4733 Commission to Alvise Loredan as Count of Pago, 1515 ~ 331 n140

Lat. 4736 Commission to Alvise Loredan as *Podestà* of Monfalcone, 1522 ~ 331 n140

Lat. 4738 Commission to Alessandro Badoer as *Podestà* of Abbazia (Opatija), 1525 ~ 331 n140

Lat. 4740 Commission to Alessandro Badoer as Count and Proveditor of Lesina, 1525 ~ 331 n140

Lat. 4741 Commission to Alvise Loredan as *Podestà* and Proveditor of Martinengo, 1534 ~ 331 n140

Lat. 4743 Commission to Alessandro Badoer as Captain and Proveditor of Riva and Salò, 1540 ~ 331 n140

Lat. 4744 Commission to Antonio Badoer as councillor in Canea, 1543 ~ 331 n140

Lat. 4746A Commission to Sebastiano Venier as Captain of Brescia, 1561 ~ 297 n46

Lat. 7939A P. Virgilii Maronis, *Opera omnia*, with Servii, *Commentario*, 1458 ~ 309 n58

Lat. 10144 *Promissione* of Doge Pietro Loredan, 1567 ~ 297 n46

Smith Lesouëf 17 Commission of Jacopo Soranzo, il Vecchio, as procurator *de supra*, 1522 ~ 135, *135*, 319 n86

Smith Lesouëf 44 Commission to Marco Giustiniani as *Podestà* of Bergamo, 1583 ~ 297 n46

Département des Estampes et de la Photographie:
Réserve Ad. 134.4 Carlo Maggi, *The Voyage* of Carlo Maggi, *c.*1575 ~ 263, 346 n32

Musée Marmottan Monet, Collection Wildenstein
5 cuttings from the Evangeliary of the Basilica of Saint Mark, 14th century ~ 266, *267*, 347 n56

Leaf from a Commission of Girolamo Marcello as procurator *de ultra*, 1537 ~ 136, *137*, 320 n89

Philadelphia

Free Library
Lewis E 143 Commission to Marcantonio Contarini as Captain of the Merchant Galleys to Flanders, 1504 ~ 68, *68*

Lewis E M 27:11 Leaf from a Commission of a member of the Contarini family ~ 280, *282*, 352 n142

Lewis E M 47:6 Leaf from a Commission ~ 329 n115

Lewis E M 47:10 Miniature after Jacopo Bassano, *Christ and the Adulteress* ~ 270, *270*

Lewis E M 47:11 Leaf from a Commission ~ 278, *279*, 329 n115

Temple University Libraries
Rare Books and Manuscript Collection, CST Coll. (1560) Leaf from a Commission to Pandolfo Guoro as Captain of Famagusta, Cyprus, in 1560/66 ~ 279, 352 n137

University of Pennsylvania
Codex 1134 Commission to Nicolò Tiepolo as *Podestà* of Brescia, 1525 ~ 326 n35

Schoenberg, LJS 59 Commission to Paolo Nani as *Podestà* and Captain of Treviso, 1517 ~ 204, *205*

Schoenberg, LJS 304 Commission to Girolamo Priuli as *Podestà* of Brescia, 1575 ~ 297 n46

Prague

Metropolitan Chapter Library
MS Cim. No. 1 Gospel of Mark fragment, 6th century ~ 50, 300 n37

It. VII, 1372 (=8098) Commission to Paolo Contarini as *Podestà* of Verona, 1561 ~ 332 n6

It. VII, 2598 (=12490) Commission of Marco da Molin as procurator *de citra*, 1522 ~ 319 n81

It. IX, 351 (=6486) J. Sannazaro, *Arcadia*, and G. Badoer, *Phylareto*, 16th century ~ 178–9, 328 n95

Lat. I, 99 (=2138) Breviary of Cardinal Domenico Grimani ~ *19*, 20, *20*, 249, *250*, 252, 253–6, *255*, 342 n20, 343 n23

Lat. I, 100 (=2089) *Evangelistarium ad usum ecclesiae Sancti Marci, c.*1325–50 ~ 45, *45*, 266, 347 n59

Lat. II, 75 (=2198) Lucius Caecilius Firmianus Lactantius, *Opera*, 15th century ~ 309 n59

Lat. III, 111 (=2116) *Missale ad usum ecclesiae Sancti Marci, c.*1325–50 ~ 300 n42, 301 n46

Lat. X, 96 (=2250) Commission of Tommaso Contarini as procurator *de citra*, 1543 ~ 321 n101

Lat. X, 112 (=3507) Commission of Nicolò Michiel as procurator *de supra*, 1500 ~ 319 n81

Lat. X, 113 (=3508) Commission of Francesco Zane as procurator *de ultra*, 1462 ~ 309 n60, 318 n66

Lat. X, 189 (=3590) *Promissione* of Doge Michele Morosini, 1382 ~ *91*, 92, 310 n81

Lat. X, 190 (=3555) *Promissione* of Doge Antonio Venier, 1382 ~ 311 n86

Lat. X, 191 (=3556) *Promissione* of Doge Antonio Venier, 1382 ~ 311 n84

Lat. X, 224 (=3798) Commission of Girolamo Bragadin as procurator *de ultra*, 1537 ~ 136, *136*, 320 n89

Lat. X, 238 (=3509) Commission of Nicolò Marcello as procurator *de supra*, 1466 ~ 98, *99*, 312 n109, 318 n66

Lat. X, 272 (=3373) Commission to Giovanni da Molin as *Podestà* of Montagnana, 1474 ~ *164*, 166, 326 n51

Lat. X, 315 (=3755) Commission of Andrea Contarini as procurator *de supra*, 1463 ~ 318 n66, 318 n68

Lat. X, 316 (=3136) *Promissione* of Doge Pietro Lando, 1539 ~ 314 n170

Lat. X, 342 (=3807) Commission to Bernardo Balbi as *Podestà* of Montagnana, 1496 ~ 327 n57

Lat. X, 354 (=3516) Commission of a procurator *de ultra* ~ 316 n35

Lat. X, 358 (=3517) Commission of Andrea di Nicolò Lion as procurator *de supra*, 1473 ~ *130*, 312 n111, 318 n66, 318 n69

Lat. XIV, 72 (=4273) *Promissione* of Doge Pietro Ziani, 1205 ~ 310 n80

Fondazione Cini

Inv. 22507 (MS 6) Commission to Melchiorre Salamon as *Podestà* of Este, 1561 ~ 199, *199*, 329 n116, 332 n8

Museo Correr
CLASSE II
91 Leaf from a Commission to Girolamo Surian as *Podestà* of Padua, 1596 ~ 351 n126

727 Leaf from a Commission to a member of the Michiel family, 1556–59 ~ 351 n126

728 Leaf from a Commission to a member of the Michiel family, 1554–56 ~ 69, *69*

729 Leaf from a Commission to a member of the Michiel family, 1556–59 ~ 277, *277*, 282

A. N. 75, n. 2 Album of Domenico Zoppetti ~ 351 n127

Vienna

Österreichisches Nationalbibliothek (ÖNB)
Cod. 438* Commission of Francesco Barbaro as procurator *de citra*, 1452 ~ 125–6, *127*, 266, 317 n48, 347 n59

Cod. 5884 Commission to Marco Lando as Captain of Candia, elected 1516 and 1518 ~ 185, *185*, 329 n120

Cod. 5890 Commission to Lodovico Emo as Proveditor of Zante, 1573 ~ 232–3, *232*, 338 n12

Cod. Ser. N. 1778 Commission to Paolo Nani as Captain of Bergamo, 1521 ~ 196, 207, *207*, 334 n38

Warsaw

National Library
Boz. 20 *Capitolare* of Jacomo Soranzo as ducal councillor ~ 337 n98

Washington, D.C.

Library of Congress, Law Library
MS V. 42 *Capitolare* of the officers of the *cattaveri*, 14th century ~ 58–60, *59*, 302 n23

KKH8501.A17 V46 1369 *Statuta Veneta*, 14th century ~ 43, 300 n35

Williamstown, MA

Sterling and Francine Clark Art Institute
1986.52 Leaf from a Commission to a member of the Venier family ~ 335 n52

Windsor Castle

HM The Queen, Royal Library
MS RCIN 1081196 Commission of Antonio Mocenigo as procurator *de citra*, 1523 ~ *134*, 135

Zurich

Schweizerisches Nationalmuseum
LM 25893 Fragment from a Commission of Cristoforo Duodo as procurator *de ultra*, 1491 ~ 289

Current location unknown

Detached opening text to the ducal councillor's *Capitolare*, from a compilation of *Promissioni* with *Capitolari*, Maggs Bros. Ltd., *Illuminations*, catalogue 1283, cat. 3 ~ 347 n62

Promissione of Antonio Venier, Finearte Semenzato, Venice, *Asta a Venezia, Abbazia di San Gregorio*, May 5, 2003, cat. 29 ~ 311 n84

Commission to Domenico Contarini as Captain of Vicenza, 1499, Ulrico Hoepli, Zurich, *Incunables, manuscrits, livres rares…*, October 29, 1937, lot 77 ~ 171, 173

Commission of Andrea Giustinian as procurator of San Marco, 1532 (elected 1522), Christie's, London, *Valuable Books and Manuscripts*, July 12, 2017, lot 29 ~ 289

Roman privileges of citizenship to the Grimani, 1529 ~ 295 n17

Leaf from the Commission to Pietro Pizzamano as Rector of Sitia, Crete, 1544, formerly Bruce Ferrini; Sotheby's, London, *Western Manuscripts and Miniatures*, June 22, 2004, lot 4240; Philip J. Pirages; now private collection ~ 212, *212*

Leaf from a Commission to a member of the Baseggio family, Les Enluminures, *Illuminations, Gouaches, Drawings from the 12th to the 17th centuries*, catalogue 1, 1992, 40–41, entry 16; now private collection ~ 336 n73

Commission to Paolo Contarini as *Podestà* and Captain of Feltre, 1563, Sotheby's, London, *Catalogue of Western Manuscripts and Miniatures, comprising the property of the Earl of Rosebery…*, 1994 ~ 352 n156

Leaf from a Commission of Luca Michiel as procurator *de citra*, 1587, Christie's, London, South Kensington, *Old Master & British Drawings & Watercolours*, sale 5877, December 2, 2014, lot 11; now private collection ~ 234–5, *235–6*, 250

Leaf from a Commission of Luca Michiel as procurator *de citra*, 1587, Christie's, London, King Street: *Old Master & British Drawings & Watercolours*, sale 1538, July 14, 2014, lot 7; now private collection ~ 289

Commission leaf in a frame, formerly Palazzo Soranzo-Van Axel, Venice ~ 287, *287*

Index of Patricians
by Clan (*Casata*) and Branch (*Ramo*)

Note on Christian names: *Ducali* are written in Latin and the vernacular, and in many documents, especially in the fifteenth century, the Latin versions of Christian names were used, while in some sources Venetian versions of Christian names were employed. In scholarship since the nineteenth century, Italian versions of Venetian names often are preferred. Thus one might find the following names used for John: Ioannes (Latin), Zuanne (Venetian), Giovanni (Italian), and with variant spellings. For the most part I have maintained the convention of utilizing modern Italian versions of names. Some exceptions: "Alvise" is retained over the modern Italian "Luigi" for Louis, "Iseppo" for Giuseppe, "Vettor" (Vittore) for Vittorio, and "Marin" for Marino.

The difficulty in accurately constructing family trees is discussed by Patricia Fortini Brown in Brown 2004, 255. As sources on individual patricians and their genealogy I have used primarily the following, in addition to a variety of primary and secondary sources:

Relevant entries in the *DBI*.

Primary documents including testaments and registers of births in the Archivio di Stato, and family papers in the Biblioteca Marciana and Biblioteca del Museo Correr.

Girolamo Alessandro Capellari Vivaro Vicentino (1664–1748), *Il Campidoglio Veneto*, BMVe, It. VII, 15–18 (=8304–8307).

Various manuscript editions, with additions, of the genealogical volumes originally written by Marco di Marco Barbaro (1511–1570) to 1536, and now in Vienna (*Famiglie nobili Venete ordine alphabetico*, ÖNB, Codices 6155 and 6156).

Marco Barbaro, *Genealogie e origini di famiglie venete patrizie*. Recopied, with additions by Lorenzo Antonio da Ponte and Emmanuele Cicogna. 7 vols. BMCVe, MSS Cicogna 2498–2504 [Barbaro Cicogna].

Marco Barbaro, *Arbori de' patritii Veneti*. Recopied with additions by Antonio Tasca in 1743. 7 vols. ASVe, Miscellanea Codici Serie 1, Storia Veneta, 17–23 [Barbaro *Arbori*].

Marco Barbaro, *Genealogie e origini di famiglie venete patrizie*. Copied by Giuseppe Baldan for Pietro Gradenigo, 1729–31. 7 vols. BMCVe, MSS Gradenigo Dolfin 81, 1–7 [Barbaro GD].

Marco Barbaro, *Genealogie delle famiglie patrizie venete*, BMVe, Cod. It. VII, 15–18 (8304–8307) [Barbaro *Genealogie*].

Ricciotti Bratti, "Manoscritti riguardanti la storia nobiliare italiana: Museo Correr di Venezia," *Rivista Araldica* 6, 1 (1980): 179.

Although the genealogies are not always correct in all details, the overall outlines of the family trees generally correspond with information from archival sources, and reference to the family trees in Barbaro makes it easier to ascertain broader patterns of elections to office and interrelationships between patricians and their families. Nevertheless, the branch designations can vary across different manuscripts of Barbaro.

Note on dates: In Renaissance Venice, the year began on the first day of March, in the system known as *more veneto*. All dates given in this book are translated into modern usage.

Clan (*casata*) and branch (*ramo*)

References are given here to the family trees in the copy of Marco Barbaro's genealogy that is most legible: [Barbaro Cicogna] in the Correr Library (a photocopy is available for consultation in the reading room). The biographical details given here, based on research from a variety of sources, may differ from those given in that genealogy. For abbreviations, see page 11.

When a patrician's father's name is not known it can be impossible to distinguish him from others of his generation with the same name, and he therefore cannot be identified in the genealogies. These men are listed under their family name without reference to the genealogies.

Indentations indicate successive generations. Page references in the present book are given for individual patricians following his or her dates. Numbers in italics refer to relevant illustrations.

BADOER Cicogna 2498, fols. 41v–42r
 Giovanni Dr. K. di Renier (also cited as Ruzier) (c.1465–1531) ~ 60, 178–9, 180, *181*, 215

BADOER Cicogna 2498, fols. 43v–44r
 Andrea di Pietro (1515–1575) ~ 298 n62

BADOER (S. Giovanni Evangelista) Cicogna 2498, fols. 45v–46r
 Alberto di Angelo (1542–1592) ~ 297 n46, 337 n91

BADOER Cicogna 2498, fols. 50v–51r
 Paola di Alvise di Rigo (married Sebastiano di Fantin Marcello in 1539) ~ 297 n52

BADOER (S. Croce) Cicogna 2498, fols. 50v–51r
 Giovanni di Sebastiano (1542–1604) ~ *198*, 199, 202–3, *202*, 332 n8

BADOER (Sant'Agnese) Cicogna 2498, fols. 55v–56r
Alessandro di Antonio (d. 1541) ~ 331 n140
Antonio di Alessandro (1513–1562) ~ 331 n140

BALBI (Campo Rusolo) Cicogna 2498, fols. 76v–77r
Bernardo di Benedetto (d. 1534) ~ 327 n57

BARBARIGO (Primo) Cicogna 2498, fols. 106v–107r
Francesco (detto Galiazza) di Benedetto (d. 1526) ~ 326 n56

BARBARIGO (S. Polo) Cicogna 2498, fols. 107v–108r
Giovanni (Count) di Alvise (1773–1843) ~ 268

BARBARIGO (Primo) Cicogna 2498, fols. 108v–112r
Francesco Pr. di Pietro (il Ricco di S. Trovaso, or of the contrada of SS Gervasio e Protasio) (d. 1448) ~ 123
Marco Pr. Ser.mo di Francesco Pr. di Pietro (c.1413–1486) ~ 72, 81, 101, 102, 103–4, 103, 123, 128
Lucia di Andrea del Ser.mo Marco (married Matteo di Zaccaria Soranzo in 1518) ~ 334 n46
Agostino Pr. Ser.mo di Francesco Pr. (1419–1501) see General Index
Elena di Agostino Ser.mo (married Giorgio di Bernardo Nani in 1468) ~ 203
Agostino di Giovanni di Antonio (1516–1571) ~ 229, 238–9

BARBARIGO (di Candia) Cicogna 2498, fols. 124v–125r
Francesco di Nicolò (d. 1524) ~ 173, 174–5, 174, 327 n79

BARBARO (Primo) Cicogna 2498, fols. 132v–133r
Marco (Magadesi) (12th century) ~ 129
Francesco Dr. K. Pr. di Candiano (1390–1454) ~ 125–9, 127, 133, 152, 317 n51, 342 n17
Zaccaria K. Pr. di Francesco Dr. K. Pr. (c.1422–1492) ~ 317 n53
Ermolao di Zaccaria Pr. di Francesco Pr. (d. 1494) ~ 128
Daniele (Patriarch of Aquileia) di Francesco di Daniele (1514–1570) ~ 186, 330 n126, 341 n4, 342 n12
Marcantonio Pr. di Francesco di Daniele (1518–1595) ~ 242, 253, 316 n32, 342 n18
Francesco (Patriarch of Aquileia) di Marcantonio (1546–1616) ~ 341 n4

BASADONNA (Primo) Cicogna 2498, fols. 173v–174r
Giovanni Francesco di Girolamo (1512–1568) ~ 329 n117

BASADONNA (S. Boldo) Cicogna 2498, fols. 175r–176v
Filippo di Alvise (d. 1542) ~ 175–6, 176, 328 n81

BELEGNO (Primo) Cicogna 2498, fols. 191v–192r
Paolo Pr. di Stefano (d. 1373) ~ 114, 123, 316 n36

BELEGNO Cicogna 2498, fols. 193v–194r
Alvise di Bernardo (1539–1606) ~ 330 n137, 332 n11, 338 n11

BEMBO Cicogna 2498, fols. 205v–206r
Bernardo di Nicolò (1433–1519) ~ 319 n76
Pietro (Cardinal) di Bernardo (1470–1547) ~ 60, 130, 180, 269–70, 328 n96

BEMBO (S. Zan Decolà, Riva de Biasio) Cicogna 2498, fols. 215v–216r
Agostino di Benedetto (1518–1586) ~ 159, 159, 324 n18
Giovanni Pr. Ser.mo di Agostino (1543–1618) ~ 159, 325 n22

BERGONZI (aggregated into the patriciate in 1665, not in Barbaro genealogies)
Giorgio di Francesco (1613–1633) ~ 272–3, 350 n96

BERNARDO (Primo) Cicogna 2499, fols. 4v–5r
Nicolò K. Pr. di Francesco (d. 1462) ~ 317 n42

BERNARDO Cicogna 2499, fols. 7v–9r
Francesco di Marcantonio di Antonio (1514–1580) ~ 199

BOLLANI Cicogna 2499, fols. 36v–37r
Pietro di Giovanni (d. 1555) ~ 279, 281

BOLLANI Cicogna 2499, fols. 41v–42r
Pietro di Iseppo (b. 1563) ~ 346 n31

BON Cicogna 2499, fols. 50v–51r
Alessandro, elected Podestà and Captain of Belluno in 1408 ~ 326 n40

BON (Dalle Fornase) Cicogna 2499, fols. 52v–53r
Michele di Alvise Dr. (1527–1586) ~ 29–33, 31, 32, 260–1, 297 n51

BON (di Candia) Cicogna 2499, fols. 55v–57r
Matteo (17th century, but name of father unknown) ~ 269

BRAGADIN (Primo) Cicogna 2499, fols. 85v–86r
Girolamo Pr. di Vettor (d. 1546) ~ 136, 137, 320 n89, 321 n103

BRAGADIN (S. Marina) Cicogna 2499, fols. 86v–87r
Francesco di Alvise Pr. (1458–1530) ~ 60, 328 n100
Antonio Pr. di Andrea di Alvise Pr. (1511–1591) ~ 186, 187

BRAGADIN (in Barbaria delle Tolle) Cicogna 2499, fols. 88v–89r
Marcantonio di Marco (1523–1571) ~ 229

CANAL, da Cicogna 2499, fols. 135v–136r
Paolo di Piero (d. 1489) ~ 327 n72

CAPPELLO Cicogna 2499, fols. 157v–158r
Antonio Pr. di Giovanni Battista (1494–1565) ~ 120, 315 n23

CAPPELLO Cicogna 2499, fols. 160v–161r
Pietro di Giovanni Pr. (d. 1524) ~ 167, 167, 325 n25, 327 n59

CAPPELLO (al Ponte della Latte) Cicogna 2499, fols. 162v–163r
Lorenzo di Pietro di Giovanni K. (1555–1603) ~ 334 n47

CAPPELLO Cicogna 2499, fols. 163v–164
Vettor di Giorgio (1400–1467) ~ 167, 168–70, 173
Alvise di Vettor (d. 1520) ~ 169
Andrea di Vettor (d. 1493) ~ 169
Paolo K. Pr. di Vettor (d. 1523) ~ 169

CAPPELLO Cicogna 2499, fols. 170v–171v
Vincenzo di Domenico (1522–1604) ~ 200, 332 n14
Vincenzo Pr. di Domenico (1570–1658) ~ 323 n148

CAPPELLO Cicogna 2499, fols. 174v–176r
Lorenzo di Pietro di Francesco K. di Cristoforo (1543–1612) ~ 208–10, 209, 334 n47, 334 n50, 334 n51
Giovanni di Lorenzo di Pietro (1583–1647) ~ 209, 209
Pietro di Lorenzo di Pietro (1584–1634) ~ 209, 209

CAVALLI Cicogna 2499, fols. 194v–196r
Marin K. di Sigismondo (1500–1573) ~ 195, 197, 217–21, 218–19, 297 n46, 336 nn76–7, 336 nn80–1, 336 n85, 336 n87
Sigismondo di Marin K. (1530–1579) ~ 219
Antonio di Marin K. (1538–1601) ~ 221, 221, 337 n90

CELSI (S. Ternità) Cicogna 2499, fols. 202v–204r
Girolamo di Stefano (d. 1567) ~ 328 n85
Jacopo di Girolamo (1520–1571) ~ 176–7, 176

CICOGNA (Primo) Cicogna 2499, fols. 208v–210r
Pasquale Ser.mo di Gabriele (1509–1595) ~ 87, 112, 188, 303 n40, 330 n130, 334 n51

CONDULMER (alli Tolentini) Cicogna 2499, fols. 266v–267r
Domenico di Pietro (b. 1709), elected Podestà of Padua in 1772 ~ 298 n63

CONTARINI Not found in Cicogna or name of father unknown
Nicolò di Marco, elected Podestà and Captain of Capodistria in 1708 ~ 344 n36
Pietro, elected Captain of the Merchant Galleys to Beirut in 1551 ~ 284

CONTARINI Cicogna 2499, fols. 279v–280r
Jacopo Pr. Ser.mo di Domenico (1194–1280) ~ 87, 308 n47
Elisabetta Dogaressa (d. 1348), wife of Doge Francesco Dandolo ~ 84

CONTARINI Cicogna 2499, fols. 280v–281r
Federico Pr. di Francesco (1538–1613) ~ 122

CONTARINI (S. Trovaso/"degli Scrigni") Cicogna 2499, fols. 296v–297r
 Paolo di Zaccaria K. (1510–1566) ~ 198–9, 200, 332 n6
 Alvise II (called Girolamo) di Alvise II (called Pietro) (1770–1843) ~ 351 n128

CONTARINI Cicogna 2499, fols. 300v–301r
 Leonardo Pr. di Marin (d. 1487) ~ 319 n78
 Bertuccio Pr. di Marin (as Marco in O'Connell, ed. c.2009) (d. 1490) ~ 129, 133–5, *133*, 319 n78
 Giovanni di Alvise (d. 1541) ~ *284*, 319 n77, 352 n148
 Alvise di Francesco (1520–1552) ~ 182, *183*
 Bertuccio di Francesco (1529–1576) ~ 152, *153*
 Francesco Ser.mo di Bertuccio di Francesco (1556–1624) ~ 26, 152, *153*

CONTARINI (S. Francesco della Vigna) Cicogna 2499, fols. 301r–302v
 Nicolò di Alessandro (1658–1725) ~ 33, *33*, 298 n63

CONTARINI (dalle Figure) Cicogna 2499, fols. 302r–303v
 Jacopo di Pietro di Jacopo (1536–1595) ~ 180, 215–16, *216*, 221, 242, 243, 244, 282, 284, 352 n147

CONTARINI Cicogna 2499 fols. 303v–304r
 Andrea Pr. di Antonio Pr. (d. 1472) ~ 318 n66, 318 n68

CONTARINI (SS. Apostoli) Cicogna 2499 fols. 306v–307r
 Tommaso Pr. di Michele (d. 1554) ~ 321 n101

CONTARINI (alla Madonna dell'Orto) Cicogna fols. 308v–309r
 Gasparo (Cardinal) di Alvise (1483–1542) ~ 42, 133, 261, 262, 263

CONTARINI Cicogna 2499 fols. 313v–314r
 Sebastiano K. di Sebastiano (d. 1532) ~ 332 n7

CONTARINI (S. Felice) Cicogna 2499, fols. 324v–325r
 Marcantonio K. di Carlo (1505–1546) ~ 325 n25

CONTARINI Cicogna 2499, fols. 334v–335r
 Alessandro di Nicolò (1540–1604) ~ 182, *184*, 329 n114

CONTARINI (Sant'Antonio al Ponte dell'Arco) Cicogna 2499, fols. 336v–337r
 Paolo di Dionisio (1529–1585) ~ 283, *283*, 284, 352 n148

CONTARINI Cicogna 2499, fols. 344v–345r
 Contarina di Donato (d. 1493), Dogaressa, wife of Doge Nicolò Marcello ~ 100

CONTARINI (S. Benetto) Cicogna 2499, fols. 347v–348r
 Domenico di Maffei (1451–1533) ~ 170, *171*, 173–4, 325 n25

CONTARINI (SS. Apostoli) Cicogna 2499, fols. 349v–350r
 Bertuccio di Girolamo (1638–1713) ~ 336 n69

CONTARINI (S. Paternian) (Primo) Cicogna 2499, fols. 350v–351r
 Andrea Ser.mo di Nicolò (c.1305–1382) ~ 41, 89, 90–1, 92

CONTARINI (S. Agostin) Cicogna 2499, fols. 357v–358r
 Marcantonio di Alvise, elected Captain of the Merchant Galleys to Flanders in 1504 ~ 68, *68*

CONTARINI Cicogna 2499, fol. 361v
 Andrea di Pandolfo Contarini (1537–1584) ~ *40*

CONTARINI (Terzo, S. Silvestro) Cicogna 2499, fols. 362v–365r
 Giulio Pr. di Giorgio K. (d. 1575) ~ *136*, 137, 320 n89, 321 n103

CORNER Name of father unknown
 Giovanni, commissioned ceiling paintings for Palazzo Corner in 1542 ~ 297 n53
 Gabriel, elected *savio* of the *terraferma* in 1573 ~ 303 n43

CORNER (S. Samuele) Cicogna 2500, fols. 10v–11r
 Pietro Pr. (il Grande) di Jacopo (or Ferigo) (d. 1407) ~ 123, 316 n37

CORNER Cicogna 2500, fols. 11v–12r
 Francesco Pr. di Fantin (1521–1584) ~ 342 n18

CORNER (Primo) Cicogna 2500 fols. 15v–16r
 Marco K. Pr. Ser.mo di Giovanni (c.1286–1368) ~ 85

CORNER (S. Cassan) Cicogna 2500, fols. 23v–25r
 Girolamo di Giorgio (d. 1550) ~ 329 n107
 Franceschina di Giorgio di Girolamo Corner (married Antonio di Marin Cavalli in 1579) ~ 221

CORNER Cicogna 2500, fols. 43v–44r
 Flaminio di Giovanni Battista (1693–1778) ~ 99, 256

CORRER (Primo) Cicogna 2500, fols. 65v–66r
 Lorenzo di Angelo (1530–1584) ~ 65, 66–7, 68, 69, 287, 304 n57

CORRER (S. Giovanni Decollato) Cicogna 2500, fols. 69v–70r
 Teodoro Maria Francesco Gasparo di Jacopo (1750–1830) ~ 260, 276

DA CANAL see Canal

DA LEZZE see Lezze

DA MOLIN see Molin

DA MULA see Mula

DA PONTE see Ponte

DANDOLO (Primo) Cicogna 2500, fols. 84v–85r
 Francesco Ser.mo di Giovanni (c.1258–1339) ~ 84, 85, 97, 103, 266, 297 n55
 Andrea Pr. Ser.mo di Fantin (1310–1354) ~ 48, 266, 299 nn27–8, 310 n75

DANDOLO (Quarto) Cicogna 2500, fols. 90v–91r
 Leonardo di Girolamo (1512–1582) ~ 297 n46
 Vincenzo di Leonardo (1548–1632) ~ 216, *217*

DANDOLO (Sesto) Cicogna 2500, fols. 93v–94r
 Giovanni Ser.mo di Giberto (d. 1289) ~ 89

DE GARZONI see Garzoni

DIEDO (Primo) Cicogna 2500, fols. 116v–117r
 Domenico Pr. di Giovanni, elected procurator *de supra* in 1464 ~ *130*, 318 n66, 318 n68

DOLFIN Name of father unknown
 Domenico, alleged to have been given a ring by Saint Mark in 1094 ~ 52, 301 n47

DOLFIN (S. Salvador) Cicogna 2500, fols. 144v–145r
 Andrea Pr. di Giovanni (1540–1602) ~ 316 n32, 342 n18

DOLFIN (S. Pantalon) Cicogna 2500, fols. 147v–149r
 Daniele IV K. Pr. di Daniele II di Nicolò (1656–1729) ~ 152

DONÀ see Donato

DONATO (S. Ternità) Cicogna 2500, fols. 177v–178r
 Vincenzo di Giovanni (d. 1513) ~ 274, 350 n104

DONATO (Secondo) Cicogna 2500, fols. 185v–186r
 Bartolomeo Pr. di Alvise (d. 1431) ~ 119, 123, *124*
 Andrea Dr. K. di Bartolomeo Pr., elected to various offices from 1517 to 1545 ~ 123

DUODO (Primo) Cicogna 2500, fols. 211v–212r
 Leone di Pietro (b. 1415) ~ 162, *162*
 Tommaso di Pietro, elected Lieutenant of Udine in 1441 ~ 237
 Cristoforo Pr. di Luca (d. 1499), missing from Cicogna 2500, see Barbaro GD 81.3 fol. 234v ~ 289

GRITTI (Secondo) Cicogna 2501, fols. 112v–113r
 Andrea Pr. Ser.mo di Francesco (1455–1538) ~ 60, 62, 73, 87, 122,
 250, 302 n25, 303 n37, 314 n163, 333 n15

GUORO Not in Barbaro Cicogna. See ÖNB, Cod. 6155, fol. 200r
 Pandolfo di Iusto, elected Captain of Famagusta in 1561 ~ 352 n137

LANDO Cicogna 2501, fols. 137v–140r
 Marco di Pietro (d. 1531) ~ 185, *185*
 Pietro Pr. Ser.mo di Giovanni (1462–1545) ~ 122, 308 n45,
 314 n170

LEZZE, da (alla Misericordia) Cicogna 2501, fols. 148v–149r
 Giovanni K. Pr. di Priamo (1510–1580) ~ 70, 137–8, *139*, 140, 180,
 277, 290, 297 n46

LION (Primo) Cicogna 2501, fols. 162v–163r
 Andrea Pr. di Nicolò (d. 1478) ~ 129, *130*, 312 n111, 318 n66

LION Cicogna 2501, fols. 166v–167r
 Domenico di Agostino (1607–1654) ~ 332 n5

LOREDAN Cicogna 2501, fols. 203v–204r
 Pietro di Marco, elected Consul to Alexandria in 1520 ~ 333 n31

LOREDAN Cicogna 2501, fols. 206v–207r
 Maria di Piero di Alvise Pr. (married Francesco Dr. K. Pr. di
 Candiano Barbaro) ~ 317 n53

LOREDAN (Primo) Cicogna 2501, fols. 207v–208r
 Antonio K. Pr. di Jacopo Pr. (1420–1482) ~ 131, *132*, 141
 Pietro di Jacopo Pr. (d. 1479) ~ 328 n82

LOREDAN Cicogna 2501, fols. 213v–214r
 Andrea di Nicolò (d. 1513) ~ 237

LOREDAN Cicogna 2501, fols. 215v–216r
 Pietro Pr. Ser.mo di Alvise (1482–1570) ~ 297 n46

LOREDAN (S. Stefano) Cicogna 2501, fols. 217v–218r
 Leonardo Pr. Ser.mo di Girolamo (1436–1521) ~ 81–2, 85, 122,
 307 n22, 311 n101

LOREDAN (S. Luca) Cicogna 2501, fols. 220v–221r
 Alvise di Nicolò di Antonio (d. 1536) ~ 331 n140

LOREDAN Cicogna 2501, fols. 223r–224v
 Tommaso di Alvise (1453–1490) ~ *170*, 173, 185

LOREDAN (S. Aponal) Cicogna 2501, fols. 226v–227r
 Francesca di Bernardin di Andrea (married Francesco di Francesco
 Gradenigo in 1600) ~ 210, 334–5 n52

LOREDAN (S. Vio) Cicogna 2501, fols. 228v–229r
 Francesco di Antonio (1540–1608) ~ 352 n145

MAGNO Cicogna 2501, fols. 238v–239r
 Bartolomeo di Marco (1517–1582) ~ 330 n122

MALIPIERO (Secondo) Cicogna 2501, fols. 259v–260r
 Pasquale Pr. Ser.mo di Francesco (c.1392–1462) ~ 94, 288

MALIPIERO (Secondo) Cicogna 2501, fols. 265v–266r
 Camilla di Marcantonio di Giovanni (married Alvise di Giovanni
 Maria Muazzo in 1574) ~ 217

MALIPIERO (S. Marina) Cicogna 2501, fols. 270v–271r
 Nicolò di Giovanni Antonio (1524–1590) ~ *230*, 338 n11

MANIN Cicogna 2501, fols. 282v–283r
 Lodovico Ser.mo di Lodovico III Alvise (1725–1802) ~ 152, 265,
 309 n55

MARCELLO (Primo) Cicogna 2501 fols. 299v–302r
 Jacopo Antonio K. di Francesco (1398–1463/4) ~ *17*, 18, 64
 Nicolò "il Grande" di Marco (1508–1561) ~ 220, *220*

MARCELLO Cicogna 2501, fols. 301v–302r
 Sebastiano di Fantin (d. 1576) ~ 29–31, *30*, 297 n52

MARCELLO (Primo, S. Maria Formosa) Cicogna 2501, fols. 303v–304r
 Girolamo Pr. di Andrea (d. 1553) ~ 136, 137, *137*, 320 n89,
 321 n103
 Francesco di Andrea (1530–1580) ~ 332 n4, 334 n47

MARCELLO (S. Tomà) Cicogna 2501, fols. 306v–307r
 Jacopo di Cristoforo (c.1415–1484) ~ 168, 170–1, 172
 Pietro di Jacopo, elected Count of Sebenico in 1501 ~ 166–7, *166*
 Girolamo di Antonio (1476–1547) ~ 327 n66
 Jacopo di Antonio (1540–1603) ~ 215, 243, 244

MARCELLO Cicogna 2501 fols. 308v–309r
 Pietro Pr. di Alvise (d. 1555) ~ 319 n81, 320 n89

MARCELLO Cicogna 2501, fols. 309v–310r
 Nicolò Ser.mo di Giovanni di Bernardo (c.1399–1474) ~ 94–101, *95*,
 98–9, 288, 305 n76, 307 n30, 312 nn112–18, 318 n66
 Marina di Nicolò Pr. Ser.mo ~ 100
 Bernardo di Giovanni (d. 1456) ~ 100

MARCELLO (alla Croce) Cicogna 2501, fols. 312v–313r
 Jacopo di Andrea (1530–1603) ~ 215

MEMMO Cicogna 2502, fols. 21v–22r
 Marcantonio Pr. Ser.mo di Giovanni (1536–1615) ~ 246, 339 n27

MICHIEL Name of father unknown
 Domenico, elected *Podestà* of Chioggia in 1357 ~ 325 n24

MICHIEL (Primo) Cicogna 2502, fols. 52v–53r
 Domenico Ser.mo di Giovanni (d. 1133) ~ 129

MICHIEL (Rio Marin) Cicogna 2502, fols. 54v–55v
 Marcantonio di Vettor di Michiel (1484–1552), author
 of *Notizia...* ~ 185, 213, 254, 269–70, 271
 Vettor di Marcantonio (1529–1576) ~ 185, *186*, 213–14, *213*,
 330 n122

MICHIEL Cicogna 2502, fols. 67v–68r
 Nicolò Dr. K. Pr. (d. 1518) ~ 319 n81

MICHIEL (S. Giminiano) Cicogna 2502, fols. 60v–60r
 Luca Pr. di Salvador di Luca Dr. (1520–1596) ~ *234–5*, 235–6, 250,
 297 n46, 323 n143, 339 n19
 Pietro di Salvador (1523–1602) ~ 339 n19
 Alessandro di Salvador (1530–1612) ~ 339 n19

MICHIEL (In Procuratia) Cicogna 2502, fols. 72v–73r
 Domenico di Antonio K. (1732–1791) ~ 332 n5

MICHIEL Cicogna 2502, fols. 73v–74r
 Melchiorre (Marchiò) K. Pr. di Tommaso (d. 1572) ~ 138, 141, 290

MOCENIGO (Primo) Cicogna 2502, fols. 112v–113r
 Tommaso Ser.mo di Pietro Pr. (d. 1423) ~ 50, 93, 185, 288
 Leonardo Pr. di Pietro Pr. (d. 1442) ~ 119
 Pietro Pr. Ser.mo di Leonardo Pr. (1406–1476) ~ 107, *107*, 185,
 288
 Tommaso Pr. di Nicolò Pr. di Leonardo Pr., elected procurator
 de ultra in 1504 (d. 1517) ~ 120, *120*

MOCENIGO (Primo) Cicogna 2502, fols. 114v–115r
 Alvise K. di Tommaso (d. 1541) ~ 135
 Antonio Pr. di Alvise K. (d. 1557) ~ 134, 135, 327 n77
 Leonardo di Antonio Pr. (1523–1576) ~ 319 n84
 Alvise di Leonardo (1549–1598) ~ 319 n84

MOCENIGO (Primo) Cicogna 2502, fols. 116v–117r
 Francesco Pr. di Pietro (d. 1534) ~ 205

MOCENIGO (S. Samuele/Casa Vecchia/S. Stae) Cicogna 2502, fol. 119v
 Giovanni Ser. di Leonardo (1409–1485) ~ 288
 Alvise I Pr. Ser.mo di Alvise di Pietro (1507–1577) ~ 288, 232–4,
 253, 304 n63, 307 n33

MOCENIGO (in Calle dalle Rasse) Cicogna 2502, fols. 121v–122r
 Girolamo di Andrea Dr. (1523–1584) ~ 233, *233*, 234, *234*

MOCENIGO (S. Stae) Cicogna 2502, fols. 123v–124r (misfoliated)
Alvise IV Ser.mo (1701–1778) ~ 311 n99

MOLIN, da (Primo) Cicogna 2502, fols. 131v–132r
Giovanni di Cresio (d. 1484) ~ *164*, 166

MOLIN, da (d'Oro) Cicogna 2502, fols. 142v–143r
Gasparo Pr. di Tommaso (d. 1550) ~ 135, 320 n89

MOLIN, da (d'Oro, S. Fantin) Cicogna 2502, fols. 150v–151r
Betta di Vincenzo di Piero (married Lorenzo di Pietro Cappello in 1578) ~ 334 n50

MOLIN, da (d'Oro, S. Fantin) Cicogna, fols. 154v–155r
Marco Pr. di Alvise Pr. (d. 1566) ~ 319 n81

MORO Name of father unknown
Giovanni, Count of Pola in 1396 ~ 326 n42

MORO (S. Girolamo) Cicogna 2502, fol. 170v
Girolamo di Leonardo (d. 1539) ~ 327 n58

MORO (S. Fantin) Cicogna 2502, fols. 174v–175r; 176v–177r
Cristoforo Pr. Ser.mo di Lorenzo di Jacopo (1410–1470) ~ 76, *86*, 87–8, 89, 92, 94–7, 98, 104, 129, 288, 290, 299 n29, 311 n87
Lorenzo di Giovanni, elected Duke of Crete in 1462 ~ 162, *163*, 309–10 n60
Lorenzo di Jacopo (1521–1568) ~ 199–200, *200*, 332 n9

MORO Cicogna 2502, fols. 175v–176r
Cristoforo di Lorenzo di Antonio, elected *Podestà* and Captain of Ravenna in 1496 ~ 326 n44

MORO (S. Polo) Cicogna 2502, fols. 177v–178r
Giovanni di Damiano di Giovanni (1493–1539) ~ 202–3, *202*, 274, 350 n105

MOROSINI (S. Maria Zobenigo) Cicogna 2502, fols. 185v–186r
Marin K. Ser.mo di Angelo (d. 1253) ~ 90, 310 n70

MOROSINI (dalla Tressa/S. Tomà) Cicogna 2502, fols. 197v–198r
Nicolò di Zaccaria, elected Captain of Vicenza in 1531 ~ 181–2, *182*

MOROSINI dalla Sbarra (in Canonica) Cicogna 2502, fols. 209v–210r
Vincenzo K. Pr. di Barbon Morosini (1511–1588) ~ 140

MOROSINI dalla Sbarra (Terzo) Cicogna 2502, fol. 218v
Michele Ser.mo di Marin (1328–1382) ~ 91, 92, 288

MOROSINI dalla Sbarra (S. Polo) Cicogna 2502, fols. 232v–233r
Morosina Ser.ma di Andrea di Piero (married future doge Marin Grimani in 1559) ~ 323 n2

MOROSINI dalla Sbarra (S. Maria Formosa) Cicogna 2502, fols. 233v–233r
Tommaso di Francesco (1546–1622) ~ 187–8, *189*

MUAZZO Cicogna 2502, fols. 255v–256r
Nicolò, elected Captain of Candia in 1411 ~ 326 n42
Nicolò di Pietro, elected Captain of the Merchant Galleys to Aigues-Mortes in 1478 ~ *164*, 166, 326 n53
Alvise di Giovanni Maria (1546–1616) ~ 216–17, *217*

MULA, da (S. Vio) Cicogna 2502, fols. 269v–270r
Girolamo Pr. di Cristoforo (1540–1607) ~ *145*, 146, 342 n18
Antonio di Andrea (b. 1659) ~ 338 n11

NANI (dal Sesano) Cicogna 2502, fols. 283v–284r
Giovanni di Antonio Pr. (1665–1748) (married Lucrezia di Stefano Querini) ~ 295 n28

NANI dalla Bavola (in Cannaregio) Cicogna 2502, fols. 284v–285r
Paolo di Giorgio (c.1478–1551) ~ 203–8, *204*–7, 251
Agostino di Paolo (1508–1585) ~ 206, 207
Bernardo di Antonio (b. 1712) GD 81.5 fol. 316v ~ 207

NAVAGERO (Primo) Cicogna 2502, fols. 293r–294v
Antonio di Francesco (1532–1587) ~ 214–15, *216*

NAVAGERO Cicogna 2502, fols. 294v–295r
Luca di Bernardo (d. 1547) ~ 349 n82

PARTECIPAZIO Not in Barbaro Cicogna
Giustinian Ser.mo di Agnello (d. 829) ~ 116

PASQUALIGO Name of father unknown
Marin (Giovanni Tatio dedicated his book to him in 1573) ~ 324 n17

PESARO (S. Sofia) Cicogna 2503, fols. 57v–58r
Andrea di Giovanni, elected as Proveditor of Zante in 1570 ~ 332 n11

PISANI (S. Vidal) Cicogna 2503, fols. 91v–92r
Elena di Nicolò di Giovanni (married Girolamo di Giovanni Andrea Grimani in 1551) ~ 297 n47

PIZZAMANO (Primo) Cicogna 2503, fols. 103v–104r
Giovanni Andrea di Michele Pizzamano, elected *Podestà* of Conegliano in 1499 ~ 335 n54
Pietro di Giovanni Andrea (1512–1571) ~ 210–13, *211*, *212*, 217, 335 n54, 335 n56
Francesco di Giovanni Andrea (1508–1580) ~ 213

POLANI Cicogna 2503, fol. 118r
Pietro Ser.mo (d. 1148) ~ 79

PONTE, da Cicogna 2503, fols. 126v–127r
Nicolò Ser.mo di Antonio (1491–1585) ~ 87, 246, 288

PRIULI (Cannaregio) Cicogna 2503, fols. 142v–143r
Girolamo di Lorenzo (1476–1547) ~ 302 n11

PRIULI (S. Polo detti Grassi) Cicogna 2503, fols. 143r–144v
Girolamo Ser.mo di Alvise (1486–1567) ~ 288, 312 n128
Lorenzo K. Ser.mo di Alvise (1489–1559) ~ 288, 304 n63, 312 n128, 314 n153, 314 n170

PRIULI (S. Felice detti Scarponi) Cicogna 2503, fols. 146v–147r
Francesco Pr. di Giovanni Francesco (d. 1543) ~ 289
Francesco Pr. di Giovanni Francesco di Francesco Pr., elected procurator *de supra* in 1571 ~ 146
Girolamo di Antonio Pr. (d. 1583) ~ 297 n46

QUERINI Name of father unknown
Leonardo, Count of Zara in 1243 ~ 325 n23

QUERINI STAMPALIA (S. Maria Formosa) Cicogna 2503, fols. 168v–169r
Giovanni (Count) di Alvise (1799–1869) ~ 285

RENIER (S. Margarita) Cicogna 2503, fols. 219v 220r
Daniele Pr. di Costantino (1476–1535) ~ 60, 302 n26, 328 n100

SAGREDO (S. Sofia) Cicogna 2503, fol. 261v
Gianfrancesco di Nicolò Pr. (1571–1620) ~ 33, *33*, 67

SALAMON Cicogna 2503, fols. 271v–272r
Melchiorre (Marchiò) di Gasparo (1527–1576) ~ 183, *184*, 199, *199*, 236, 332 n8

SANUDO (S. Giacomo dall'Orio) Cicogna 2503, fols. 290v–291r
Leonardo di Marin (1427–1476) ~ 88, 309 n58
Marin di Leonardo (1466–1536) *see* General Index
Marco K. Dr. di Francesco (d. 1505) ~ 164

SEMITECOLO (Primo) Cicogna 2503, fols. 310v–311r
Benedetto di Nicolò (1523–1567) ~ 177, 178

SORANZO (Primo) Cicogna 2403, fols. 320v–321r
Matteo di Zaccaria (*balla d'oro* 1504–after 1549) ~ 208, *208*, 210, 334 n46
Lucia di Matteo ~ 208, *208*
Francesco di Zaccaria (1492–1541) ~ 208, 334 n46

SORANZO (Primo, S. Paternian) Cicogna 2503, fols. 325v–326r
Vettor K. Pr. di Nicolò (1410–1488) ~ 326 n53

SORANZO (S. Polo) Cicogna 2503, fols. 328v–330r
Jacopo Pr. di Francesco di Giovanni di Vettor (il Vecchio) (1467–1551) ~ 120, 121, *121*, 135, *135*, 221, 315–16 n23, 320 n87, 339 n19
Jacopo K. Pr. di Francesco di Jacopo Pr. (1518–1599) ~ 221–2, *222–3*, 297 n46
Lorenzo (called "Tocco d'Oro") di Francesco di Jacopo Pr. (1519–1579) ~ 337 n98
Giovanni K. Pr. di Francesco di Jacopo Pr. (1520–1603) ~ 135, 221, 222–3, *224*, 337 n94
Francesco K. di Giovanni K. Pr. di Francesco (1557–1607) ~ 223, 338 n104
Girolamo K. Pr. di Giovanni K. Pr. di Francesco (1569–1635) ~ 223, 338 n104
Jacopo di Sebastiano Pr. (1686–1761) ~ 265

SORANZO (Secondo, del Baston) Cicogna 2503, fols. 334v–335r
Benedetto di Bernardo, elected *Podestà* of Bergamo in 1490 ~ 326 n53

STENO Not in Barbaro Cicogna
Michele Ser.mo (1331–1413) ~ 163, 288, 311 n101

SURIAN Not in Barbaro Cicogna
Girolamo di Agostino (d. 1596) ~ 297 n46, 351 n125

TAGLIAPIETRA Not in Barbaro Cicogna
Pietro di Bernardino, elected *Podestà* of Vicenza in 1535 ~ *275*

TIEPOLO (Primo) Cicogna 2504, fols. 11v–14r
Jacopo Ser.mo di Lorenzo (d. 1249) ~ 39, 49, 83, 90, 310 n70, 310 n72
Nicolò Dr. di Francesco (1502–1542) ~ 325 n35
Stefano Pr. di Paolo (d. 1557) ~ 296 n46
Bernardo di Stefano Pr. (1526–1607) ~ 297 n46

TIEPOLO (dalla Misericordia or S. Aponal) Cicogna 2504, fols. 16v–17r
Alvise Pr. di Lorenzo da S. Felise (1529–1590) ~ 140–1, 148–9, *149*, 150–2, 189–92, 240, 321 n106
Francesco di Alvise Pr. (1555–1614) ~ 148, 189–92, *190–3*, 240–2, 252, 331 n141
Isabetta (Betta) di Alvise Pr. (married Francesco di Francesco Pr. Duodo in 1588) ~ 240

TREVISAN Cicogna 2504, fols. 42v–43r
Melchiorre (Marchiò) di Paolo "dal Banco" (d. 1500) ~ *169*, 171–2

TREVISAN (Terzo) Cicogna 2504, fols. 46v–47r
Domenico K. Pr. di Zaccaria, elected procurator *de ultra* in 1503 ~ 120, *120*
Marcantonio Pr. Ser.mo di Domenico K. Pr. (1475–1554) ~ 288, 314 n153

TREVISAN Not in Barbaro Cicogna
Girolamo di Domenico, elected *Podestà* and Captain of Mestre in 1488 ~ 326 n40

TRON (Primo, S. Stae) Cicogna 2504, fols. 53v–55r
Nicolò Pr. Ser.mo di Luca (d. 1473) ~ 94, 96, 97, 98, 99, 101, 265, 288
Antonio Pr. di Nicolò (or Stai) (d. 1524) ~ 315 n19
Paolo di Santo (1509–1580) ~ 297 n46
Francesco di Paolo (b. 1529) ~ 337 n94

TRON di Candia Cicogna 2504 fols. 55v–56r
Filippo Pr. di Priamo (d. 1556) ~ 97, 296–7 n46

VALIER (Primo) Cicogna 2504, fols. 68v–69r
Andrea di Giorgio (d. 1555) ~ *165*, 166
Silvestro di Bertuccio (1569–1622) ~ 332 n10
Massimo di Bertuccio (1565–1623) ~ 332 n10

VALIER Cicogna 2504, fols. 80v–81r
Ottaviano di Giovanni Antonio (b. 1535) ~ 324 n17

VENDRAMIN (S. Lunardo) Cicogna 2504, fols. 91v–93r
Andrea Pr. Ser.mo di Bartolomeo (1393–1478) ~ 288, 311 n98

VENDRAMIN (S. Marcuola) Cicogna 2504, fols. 92v–93r
Nicolò di Paolo (d. 1518) ~ 205

VENIER (Primo) Cicogna 2504, fols. 103v–104r
Antonio Ser.mo di Nicolò (*c*.1330–1400) ~ 78, *78*, 90, *91*, 92, 288, 311 n86

VENIER (Sant'Agnese) Cicogna 2504, fols. 108v–109r
Francesco Ser.mo di Giovanni (1490–1556) ~ 94, 111–13, *111*, *112*, 237, 246, 247, 288, 297 n46, 314 n163, 314 n167, 339 n27

VENIER (S. Vio) Cicogna 2504, fols. 113v–114r
Girolamo di Giovanni Andrea (1525–1598) ~ 27–9, *28–9*, 31, 297 n47
Giovanni Andrea di Girolamo (1551–1604) ~ 297 n47

VENIER (S. Canciano) Cicogna 2504, fols. 114v–115r
Giovanni Antonio K. di Jacopo Alvise (1477–1550) ~ 178–80, *179*, 253, 304 n70, 328 n96
Marin di Giovanni Antonio K. di Jacopo Alvise (1521–1593) ~ 69–70, *70*, 274, 304–5 n70

VENIER (Terzo) Cicogna 2504, fols. 116v–117r
Marcantonio Dr. Pr. di Cristoforo (d. 1556) ~ *140*, 319 n85, 321 n101

VENIER (S. Moisè) Cicogna 2504, fols. 119v–120r
Sebastiano Pr. Ser.mo di Moisè (*c*.1496–1578) *see* General Index

VENIER (ai Gesuiti) Cicogna 2504, fols. 121v–122r
Nicolò Pr. di Agostino (1525–1587) ~ 140

VITTURI Cicogna 2504, fols. 143v–145v
Giovanni Battista di Pietro (1537–1614) ~ 113, *113*, 282

ZANE (S. Polo) Cicogna 2504, fols. 166v–167r
Girolamo K. Pr. di Bernardo (1515–1572) *see* General Index

ZANE Cicogna 2504, fols. 168v–169r
Francesco Pr. di Nicolò (d. 1474) ~ 309 n60, 318 n66

ZANE (S. Stin) Cicogna 2504, fols. 170v–171r
Girolamo di Bernardo di Marco Pr. (d. 1543) ~ 322 n125

ZEN Cicogna 2504, fols. 185v–186r
Renier Ser.mo di Pietro (d. 1266) ~ 79, 307 n30

ZEN (S. Sofia) Cicogna 2504, fols. 190v–191r
Luca Pr. di Marco K., elected procurator *de ultra* in 1503 ~ 120, *120*

ZEN Cicogna 2504, fols. 202v–203r
Nicolò di Cattarin (1515–1565) ~ 17–18, 294 n11

ZIANI Not in Barbaro Cicogna
Sebastiano Ser.mo (1172–1178) ~ 80
Pietro Ser.mo di Sebastiano Ser.mo (d. 1229) ~ 310 n80

ZORZI (Quarto) Cicogna 2504, fols. 239v–240r
Marin Ser.mo (*c*.1231–1312) ~ 83

ZUSTINIAN *see* Giustinian

General Index

Page numbers in *italic* refer to the illustrations

codex form 13, 43, 45
Codussi, Mauro 237
coins 97, 131, 178, 237, 247, 328 n92, 341 n65
Collegio 26, 35, 60, 87, 160, 230, 253, 255
Colnaghi of London 279
Colonna, Giorgio 138, 274, 279, 281, 290, 352
 n145, 353 n156
 Commission to Benedetto Semitecolo, Alexandria
 177, 178
 Commission to Giovanni Badoer, Cividale in Friuli
 198, 199
 Commission to Girolamo Venier, Brescia and
 Riviera di Salò 28
 Commission to Lorenzo Moro, Dalmatia (leaf)
 199–200, 200
 Commission to Paolo Contarini, Feltre 353 n156
Colonna, Marcantonio 340 n41
Commission manuscripts of rectors (*Commissioni
 ducali*) 20, 21, 155–96, 257, 295 n27
 portraiture in 27–8, 180–3
 see also ducali documents
Commission/Oath with *Capitolare* of the
 procurators of Saint Mark 115–16, 119, 122–6,
 128–9, 131–53
 portraiture in 119–22, 126–36
 see also ducali documents
Concordia 159
consegi 58
consiglieri ducali see ducal councillors
Consilium sapientes (Council of Sages) 79
Constantinople 163, 265, 327 n69
 Sack of 260
Contarini family 280, 282, 283, 352 n142
Contarini, Gasparo
 Commonwealth and Government of Venice 42,
 133
conte (count) 157
Contrario, Andrea 128, 317 n58
contumacia 58
Cooper, Tracy 64, 186
Corfu 143, 231, 232, 236, 237
Corner family 186, 188
corno (doges' crown) 82–3, 82, 92, 95, 104–5
coronation of doges 80–3, 102
Correctors of the Ducal *Promissione* (*Correttori
 della promissione ducale*) 80
Correr Museum 23, 276–8, 283, 285
Cortese, Cristoforo 123, 311 n85
 Promissione of Doge Francesco Foscari 92–3,
 93, 288
Cortese, Cristoforo, style of
 Commission/Oath of Francesco Barbarigo 123
 Commission/Oath of Nicolò Bernardo 317 n42
Coryat, Thomas
 Crudities 262
Cossa, Jean 18
Council of Sages (*Consilium sapientes*) 79
Council of Ten (*Consiglio di dieci*) 26, 29, 77, 173,
 174
 deposes Francesco Foscari 94
 doges retake oath 87
 and elections 58
 inventory of art treasures 265
 portraits of doges 84, 108
 regulation of rectors 197–8, 203, 205
 writing masters 67, 68
Cozzi, Gaetano 60
Cremona 277
Crete (Candia) 26, 112, 143, 162–3, 210–12, 231,
 235–6, 257, 283, 283, 326 n41, 353 n156
Croatia 281
Crusade, Fourth 260, 265, 266
Cupid 235
cursus honorum (course of honors) 28
Curtis, Ariana 285

Curtis, Daniel 285
Cyprus 13, 143, 227, 229, 231, 283

da Ponte, Jacopo *see* Bassano, Jacopo
da Ponte, Leandro *see* Bassano, Leandro
dalla Schrimia, Zamaria 228, 229
dalle Masegne, Jacobello 317 n37
dalle Masegne, Pierpaolo 316 n37
Dalmatia 104, 157, 159, 199–200, 228, 231
Dalton, Karen C. C. 188
Damini, Pietro 332 n10
Daniel, Saint 336 n80
Dante Alighieri 275
de Luca, Tommaso 351 n130
de Mio, Giovanni 69, 330 n123
 Commission to a member of the Michiel family
 (leaf) 69, 69
 Commission to a member of the Michiel family
 (leaves) 277
 Commission to Bartolomeo Magno, Conegliano
 330 n122
 Commission to Vettor Michiel, Mestre 185, 186
De re uxoria (On Wifely Duties, Barbaro) 126, 133,
 317 n51
Dedo, Giovanni 325 n25
Dedo, Girolamo 326 n35
del Biondo, Priamo 67
del Moro, Battista (Battista d'Angolo) 147–8,
 323 n131, 323 n132
 Saint Eustace 323 n132
del Moro, Giulio 148, 200
del Moro, Marco 69, 116, 147–51, 152–3, 190,
 250, 290, 323 n138
 Christ with the Samaritan Woman at the Well
 148, 148
 Circumcision of Christ 150, 150
 Commission/Oath of Alvise Tiepolo 148–51,
 149
 Commission/Oath of Marin Grimani (lost) 147
 The Garden of Love 144, 144, 147
 Vault paintings and stuccos of the *Anticollegio*,
 Doge's Palace 149, 150, 150
del Moro family 147–50
Delisle, Léopold 286
della Lena, Don Giacomo 346 n43
Demus, Otto 49
di Gilillo, Jacopo 82
di Mazi, Carlo 303 n43
di sotto in su perspective 244
"Diana" (Benedetto Rusconi) 269
Diana of Ephesus 63
Dibdin, Thomas Frognall 268
 Bibliographical Decameron 274
Dimo, Zuanne (Giovanni) 349 n86
diplomatic gifts, manuscripts as 17, 18
Doge Priuli Master *see* Mannerist Master
doges
 abdication 79
 age upon election 29, 307 n31
 coats of arms 91, 92
 donations 83–4
 elections 56–8, 79, 105
 households 85
 inauguration and coronation 21, 80–3, 102
 material attributes 80
 oath 78, 79, 80–1, 82, 87, 90, 112, 256–7
 Palm Sunday procession 90
 and patronage of the arts 80
 person and office 79–81
 portraits 30, 80, 83–5, 94–5, 120, 161
 promise 20, 21, 77, 78, 257, 265
 status as symbol 80
 tombs 85, 95, 95
 vestments 82–3, 82, 85, 91
 see also Promissioni and Index of Patricians

Doge's Palace (Palazzo Ducale) 12, 13, 85
 Anticollegio 148, 149–50, 150
 Audience Hall of the Council of Ten 186, 187,
 230
 fires 186, 244
 Hall of the *Avogadori di comun* 31, 32, 48
 images of *Venetia* 29, 185, 186
 inauguration of doges 80–1
 inauguration of procurators 119
 paintings 36, 208, 244–7, 244–6, 250, 251
 Porta della Carta 46, 48, 93
 redecoration 186, 215–16
 Sala del Collegio 109, 119, 149, 150, 151
 Sala del Consiglio dei XXV 308 n39
 Sala del Maggior Consiglio 56, 57, 235, 244–7,
 244–6, 251
 Sala delle Quattro Porte, or Antipregadi 188, 249
 Sala dello Scrigno 62
 Sala del Scrutinio 215, 243, 244, 251, 320 n87
 Sala dello Scudo 307 n35
 Sala del Senato 112
 Sala delle Teste 180
 Scala dei Giganti 81, 81, 102–3, 104, 178
 sculptures 46, 46
 Senate Hall 188
 stucco work 69, 148
 Veronese's paintings in 149–51
 votive portraits 84–5, 94–5, 106, 108–10, 161,
 188, 246
Doglioni, Giovanni Nicolò
 *La Città di Venetia con l'origine e governo di
 quella...* 214, 215, 233
Dolfin bank 106
Dolfin family 298 n62, 301 n46, 301 n47
Dolomites 50
Dominic, Saint 111
Dominicans 99, 273
Donà, Bruno de 295 n17
Donà dalle Rose Collection 277
Dorsoduro 118
Dotti, Giovanni 286
Drake, Sir Francis 188
Drake Jewel 188, 330 n133
drawings, collecting of 271, 272, 343 n24
Drigsdahl, Erik 256
Duca, Bartolomeo di Domenico 313 n131
ducal councillors (*consiglieri ducali*) 26, 29, 79,
 82–9, 98–9
 Capitolare manuscripts of 21–2, 87, 89, 113,
 306 n6
Ducal Palace *see* Doge's Palace (Palazzo Ducale)
ducali documents
 bindings 33, 138, 161, 284, 286
 categories 20–3
 definition and problems of terminology 22
 dispersal and collecting of 259–87
 in family archives 64–7, 256, 261, 268
 fragmentation 259, 261, 266, 268–74, 284
 illumination 26–9
 miniatures in albums 271–3, 277–8
 and myth of Venice 23
 painters 69–70
 portraiture in 15, 23
 production of 87–8, 122–3, 136–40, 147,
 159–62, 250–1
 self-promotion in 23
 signatures and seals 43
 as status symbols 36, 249–51
 see also Commission manuscripts of rectors;
 Capitolari; Commission/Oath/*Capitolare*;
 Promissioni
ducats, gold 89
Duodo family 163

Allegory of the Victory of Lepanto 340 n39
Charles V at Mühlberg 200, 352 n143
Madonna and Child with Saints Catherine and Dominic, and a Donor 175, *175*
Pesaro altarpiece 208
Portrait of Andrea de' Franceschi 303 n32
Portrait of Francesco Maria I della Rovere 142, 238
Portrait of Marin de Garzoni 174, 327 n78
Titian and workshop (Marco Vecellio)
 Doge Antonio Grimani and "Faith" 106, 107, 108, *109*, 122, 249, 313 n152
Toeput, Lodewijk ("il Pozzoserrato") 263–4
tombs 85, 167, 168–73
 Doges Marco and Agostino Barbarigo 103–4, *103*
 Doge Francesco Dandolo 97, 103
 Doge Antonio Grimani 105, 108
 Doge Nicolò Marcello 95–7, *95*, 100–1
 Doge Pietro Mocenigo 107, *107*, 185
 Doge Cristoforo Moro 95
 Doge Nicolò Tron 97, 101
 Doge Francesco Venier 111
 Marin Cavalli 218
 Jacopo Marcello *168*
 Giorgio and Paolo Nani 207
 Melchiorre Trevisan *169*, 172
Torresanus, Andreas 72, *72*
Toscanella, Orazio 295 n14
trace of a hand 73, 252, 254, 256, 305 n92
traditio legis ("giving of the law") 49
traghetti (ferrymen) 118
Trau (Trogir) 159
Traversari, Ambrogio 128
Trees Master 283
 Commission to Filippo Basadonna, Galleys to Beirut 175–6, *176*
 Commission/Oath of Jacopo Soranzo, il Vecchio 135, *135*
 Institutio et confirmatio Congregationis S. Giorgii in Alga 328 n81
Trent, Council of (1545–63) 253
Très Riches Heures du Duc de Berry 20, 342 n20
Trevisano 138
Treviso 158, 163, 191, *192–3*, 204–8
Trieste 310 n76
The Triumph of Faith and a Parade of Virtues 222, *223*
trompe l'oeil 128, 130
Tron family 214, *214*
Turini, Antonio *233*

Uberti, Pietro 303 n35
 Two Avogadori di Comun and a Book Inscribed "Legum observantia longaeva felicitas" 62, *62*
Udine 29, 50, 221, 233, 237, 253
Ugelheimer, Peter 131, 330 n121
Ugo da Carpi 212, 329 n102
Ultan 301 n51
Umag 281
United States of America 285–7
Università dei stampadori e libreri 161
University of Padua 126, 178
uomini famosi tradition 178
Ursula, Saint 182, *184*
US Congress, Law Library 284

Vallière, Louis-César de la Baume le Branc, Duc de 263, 346 n33
Van Praet, Jean-Basile-Bernard 265
Vangelo (Gospel, here Gospel of Mark, believed to have been written in his own hand) 41–2, 49, 50–3, *50*, 73, 93, 116, 249, 251, 252–3, 254, 256, 260

Varotari, Alessandro (il Padovanino) 279
Vasari, Giorgio 19, 37, 66, 108, 254, 271, 274, 275, 276, 297 n53, 314 n156, 323 n132, 343 n24, 349 n90
 Libro de' disegni 148, 272, 323 n136
Vatican 64
vecchi faction 18
Vecellio, Cesare 121, 262
 A Venetian Noble at Home, from *Habiti antichi et moderni di tutto il mondo* 214, *214*
Vecellio, Marco 314 n158
Vecellio, Tiziano *see* Titian
Venetia (Venice personified) 185–7, 216–17, 235, 247
Venice
 constitution 42, 78, 126, 261, 282
 creation of nobility 23–4
 ducal chanceries and archives 42, 43, 53, 55, 56, 67, 68, 90, 122, 123, 155, 160, 173, 256, 272
 in eighteenth century 264–5
 ensign 36
 fall of the Republic (1797) 256, 264, 265–6
 festivals 227–32
 as gerontocracy 29
 lion of Saint Mark 40, 41, *42*, 46, 47–9, *47*
 myth of 23, 251, 261–2
 overseas territories 155, 156–8, *156–7*, 163–7, 205, 217, 232
 personification of 29–30, 185–7, 246–7
 relics of Saint Mark 50–3, *51*, 93
 as *la Serenissima Repubblica* 23
 sovereignty 243–7
 state debts 266
 statutes and legislation 42–6, 49
 wars with Ottomans 35, 97, 104, 116, 131, 143, 146, 156–7, 163, 170, 227, 229, 232–7
 Wedding to the Sea 105
Venier, Sebastiano di Moisè 143, 229
 armor 340 n37
 Commissions 112, *113*, 297 n46
 Promissione 112, 288, 308 n51
 portraits of 109–10, *110*, 142, *142*, 151, *151*, 238–9
Venier family *231*
Venus 187–8, 234–5, 262
Verla, Giovanni Maria 305 n2
Verona 158, 173–4, 180, 198–9, 200, 207, 217
Veronese, Giovanni 99
Veronese (Paolo Caliari) 29, 142, 149–51, 185, 186, 230, 259, 274, 279, 287
 Portrait of Agostino Barbarigo 238
 Preservers of Liberty 151
 Rape of Europa 336 n69
 Sebastiano Venier, Allegory of the Battle of Lepanto 109, 110, *110*
 Supper at the House of Simon 263
 Venetia 150, *150*, 151
 Venetian Peace (Pax Veneta) 246, *246*
 preparatory drawing *Sebastiano Venier, Allegory of the Battle of Lepanto* 151, *151*
Vespasiano da Bisticci
 Memoirs 72–3
vesta (toga) 213
vexillum (banner) 81
Vicentino, Andrea (Andrea Michieli)
 The Battle of Lepanto 243, *243*
Vicenza 173, *190*, 217
Vico, Enea 318 n63, 337 n94
Victoria and Albert Museum, London 282
Vienna 266
Vienna, Congress of (1815) 266
Villa Moro Malipiero, Abano Terme 338 n11
Vincenzo di Pietro 18
Virgil 165, *166*, 309 n58

virtues, personification of 185, 230–1
Visconti family 251
Vitali, Giovanni 68, 69, 122, 123, 138, 140–1, 143, 146, 304 n63, 314 n170, 322 n130, 337 n100
 Commission/Oath of Alvise Tiepolo 140
 Commission/Oath of Francesco Priuli 146
 Commission/Oath of Girolamo da Mula 146
 Commission/Oath of Girolamo Zane 140
 Commission/Oath of Lorenzo Correr 65, 66–7, 68, 69
 Commission/Oath of Jacopo Soranzo 337 n100
 Commission/Oath of Melchiorre Michiel 138
 Libro de l'osservanza de le ceremonie 304 n63
 Promissione of Doge Lorenzo Priuli 314 n170
Vitellius, Emperor 180, *181*, 215
Vittoria, Alessandro 240, 322 n124, 340 n49
 The Penitent Saint Jerome 145, *145*
 portrait bust of Francesco Duodo 240, *241*
 portrait bust of Marin Grimani 146
Vivarini, Bartolomeo 312 n110
votive portraits 30, 84–5, 94–5, 106, 108–10, 120, 308 n37

Waagen, Gustav Friedrich 282
Walters, Henry 286, 352 n148
Walters, William T. 286
Walters Master
 Commission to Girolamo Mocenigo, Udine (leaves) 233, *233*, 234, *234*
 Commission to Leonardo Emo, Zante 232–3, *232*
 Commission to Paolo Contarini, Candia 283, *283*
War of Cyprus (1570–73) 229
War of the League of Cambrai (1508–16) 202, 203, 205
Wedding to the Sea (*Sposalizio del Mare*) 105
Wieck, Roger 268
Wildenstein, Georges 265
Wilson, Bronwen 72
Wisdom of Solomon 236
Wolters, Wolfgang 23, 246
women, female personifications 183–8
World War II 266
writing masters 67–8
Wunderkammer 270

Yale University Law Libraries 284

Zamberti, Giulio di Camillo 314 n164
Zane, Girolamo K. Pr. di Bernardo 156, 321 n109
 Commission manuscripts 119, 140–6, *141*, *144*, 147, 148–9, 235, 238, 264, 297 n46, 321 n106, 322 n122, 339 n19
 disgrace 143, 229
 portrait of 120, 143, *143*, 238, 315 n23, 321 n119
Zanetti, Anton Maria the Younger 264, 286
Zani, Pietro 276
Zanotto, Francesco 308 n37
Zante (Zakynthos) 157, 232–3, 284
Zattere 99, 276
Zelotti, Giovanni Battista 185, 186, 230, 338 n11
 Venice Seated on a Globe 186, *187*
Zeno, Apostolo 264
Zeno, Carlo 329 n106
zimarra 215
Zio, Francesco 271
zoia (bejeweled *corno* of the doge) 82–3, *82*, 103, 116, 307 n47
Zoppetti, Domenico 278
Zorzi, Marina 334 n50
Zorzi, Marino 260
Zuccari, Federico 254
Zuccolo Padrono, Giulia Maria 296 n32
Zuoba di la caza (Thursday of the Chase) 228–9